Donatello among the Blackshirts

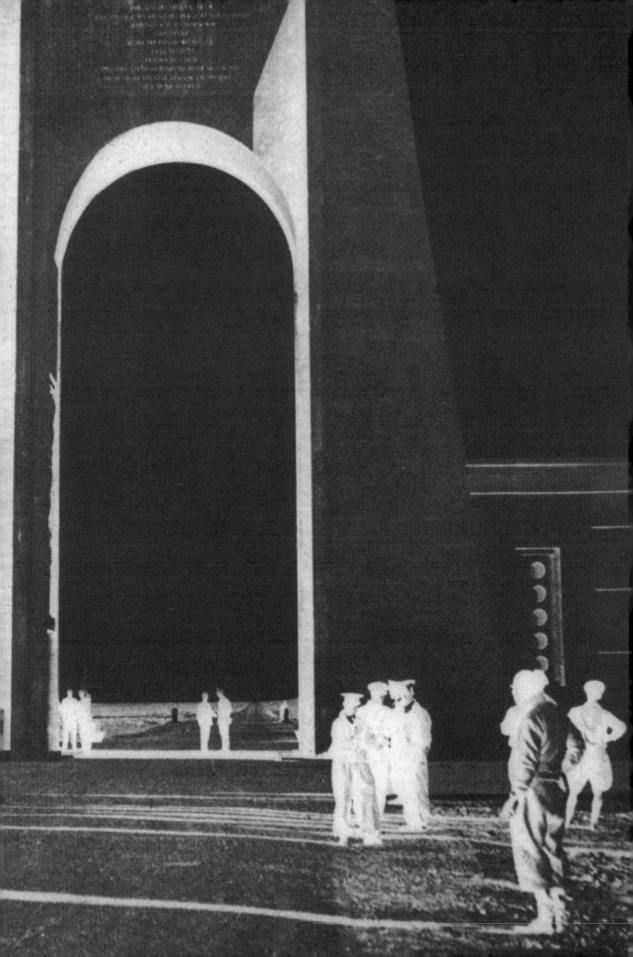

# Donatello among the Blackshirts

*History and Modernity in
the Visual Culture of Fascist Italy*

*Edited by*
Claudia Lazzaro and Roger J. Crum

CORNELL UNIVERSITY PRESS
Ithaca and London

First published 2005 by Cornell University Press
First printing, Cornell Paperbacks, 2005

Printed in the United States of America

*Library of Congress Cataloging-in-Publication Data*
Donatello among the Blackshirts : history and modernity in the visual culture of Fascist Italy / edited by Claudia Lazzaro and Roger J. Crum.
    p. cm.
  Includes bibliographical references and index.
  ISBN 0-8014-4288-5 (cloth : alk. paper) — ISBN 0-8014-8921-0 (pbk. : alk. paper)
    1. Art and state—Italy—History—20th century.  2. Fascism and art—Italy.  3. Art and history—Italy.  4. Art, Italian—20th century.  5. Donatello, 1386?–1466.  I. Lazzaro, Claudia, 1947–
II. Crum, Roger J.
  N8846.I8D66 2004
  709′.45′09041—dc22                              2004012143

Cloth printing          10 9 8 7 6 5 4 3 2 1

Paperback printing      10 9 8 7 6 5 4 3 2 1

# Contents

# IV. History as Fascist Spectacle and Exhibition

Donatello among the Blackshirts

# Introduction

*Claudia Lazzaro and Roger J. Crum*

ITALY TODAY, led by a media tycoon, has a thriving economy, sells "Italian design" with huge success to a covetous global market, and is a tourist mecca fed by claims to the greatest artistic patrimony in the world.[1] Despite arcane postwar politics and rampant corruption, a sustained republic has preserved a fragile union of diverse regions and extremes of right and left in the political spectrum. Nevertheless, multiple and overlapping issues of identity—Italian, regional, and European—face the nation, not entirely different from those elsewhere but deeply inflected by the legacy of Italy's past. There are economic disparities between the prosperous North (led by the Lega Nord, or Northern League) and the poor South, social and cultural tensions between native Italians and increasing numbers of non-European immigrants, and concerns about loss of Italian identity (and of regional identities) in the European Union. These issues threaten the idea of Italian identity that has evolved from the Risorgimento, the period of Italian national unification, and especially from Fascism. At the same time, neo-Fascists (now called post-Fas-

cists) have gained ground, accompanied by a renewed fascination with, and even admiration for, Mussolini.[2] Italy's vaunted artistic patrimony and flourishing tourist industry, whose mass appeal and organized efforts originated under Fascism, also produce significant burdens, from the need to restrict tourists to Venice to the controversial privatization of state property, including monuments, museums, archives, and, most recently, the Colosseum.[3]

In Rome, as elsewhere, the visible presence of Fascism is everywhere, although more ignored than noticed until recently, when controversies erupted over some of the Fascist interventions. These controversies have involved complicated issues: conflict between needs of the modern world and preservation of the past, cultural and political associations of architectural styles, memories produced—and also obliterated—by commemorative acts, and artistic confiscation as a sign of political power with subsequent demands for repatriation. Recent debates in Rome concern the return to Ethiopia of the Axum obelisk, seized by Mussolini in 1937, the replacement of the demolished Fascist structure housing the Ara Pacis with one by the American architect Richard Meier, and the excavation of the imperial fora buried beneath a major traffic artery that was constructed in 1932.[4] Despite attempts to forget history and to silence memory, the Fascist past remains insistently present. Indeed, much of our understanding of Italy's past prior to the twentieth century has come down to us mediated by the Fascist era.

We wish to express our appreciation to Paul J. Morman, dean of the College of Arts and Sciences at the University of Dayton, and Peter Kahn, associate dean of the College of Arts and Sciences at Cornell University, for their generous contributions to the publication of this volume. We thank Bernhard Kendler, Karen Hwa, and Karen Bosc of Cornell University Press for their guidance through this project. Finally, we acknowledge with gratitude and love the companionship of our spouses, James Cutting and Robin Crum, who have supported and assisted us through the genesis of *Donatello among the Blackshirts*.

Italy bears both the gift and the burden of its great cultural heritage. It is also a nation indelibly marked by the Fascist period's relationship to that past. The Fascist regime exploited the power of the visual at every turn, in public spectacles, theater, cinema, exhibitions, architecture, and photography. Yet the role of these and other visual media in invoking the past for ideological ends has rarely been investigated. This volume deals specifically with visual imagery that fused the past with the present. Italy's artistic tradition had long been the prerogative of the social and political elite, but under the Fascist regime, this tradition was widely publicized, reproduced, and explored in the popular press, so that it became familiar and accessible to a mass audience, in large part through modern technologies. The result was a visual literacy on an unprecedented scale. Images from ancient Rome appeared everywhere, especially the fasces (the bundle of rods carried by ancient Roman officers) and the she-wolf, in large and small scale, in a variety of styles and media, in public and private contexts, and in high and low art—photography, posters, journal covers, postage stamps, collages, lamps, knick-knacks, paintings, monumental sculptures, and architecture. Architects revived building types from classical antiquity, among them the triumphal arch, hippodrome, and forum, in both traditional and modernist versions. Old techniques reemerged, among them mosaic in the ancient Roman manner, traditional mural painting (by Mario Sironi and by schools in Siena and Florence), and Renaissance-style tin-glazed maiolica ceramics. Poses and gestures from ancient sculpture and other traditional art forms served as models for photographs of Mussolini as well as for modern sculpture. Excavations, restorations, and reconstructions both preserved the past and constructed an artificial past out of surviving remains. Public exhibitions, celebrations, and commemorations represented the past and demonstrated its significance to the present.

This volume brings together the historical and the modern in its subject, in its authors, who are scholars of both modern Italy and Italy's classical, medieval, and Renaissance past, and in its intended audience—all those interested in Fascism, modernism, and the art of Italy's past. This volume was inspired by a session entitled "The Appropriation of the Past in Fascist Italy," chaired by Claudia Lazzaro, at the annual College Art Association meeting in 2000. The authors represent the fields of modern and premodern art history, as well as literature, intellectual history, classics, and cultural studies. Scholars and the general public alike share an enthusiastic interest in Italy's cultural heritage, which the Fascist regime so widely publicized. That enthusiasm is matched by a renewed fascination with Fascist Italy, whose brazen exploitation of its own past and of the visual for ideological purposes has been the subject of extensive recent scholarship as well as considerable general interest. This volume addresses and brings together these two audiences—those engaged with Italy's past and those drawn to the Fascist era—since each period reflects and reinterprets the other.

The title of the volume purposely joins two unlike terms. The reference to the famous Renaissance sculptor Donatello evokes the celebrated period of Italy's past, enshrined in countless art history texts (and the subject of Roger Crum's essay). We juxtapose the name of this canonical artist with Blackshirts, the term for the military squads in the early years of Fascism, which later referred more generally to Mussolini's supporters. The jarring juxtaposition, evocative of modernist collage, also refers specifically to another similarly arresting pronouncement, "Donatello au milieu des fauves" (Donatello in the midst of the Wild Beasts). A French critic made this exclamatory statement in 1905 in his shock at finding a Donatellesque, Renaissance statue on exhibit in the discordant presence of modernist paintings by Henri Matisse and his associates. To be sure, in 1905 Matisse and Donatello existed awkwardly in the same room, but in the Fascist concern for making the past present and the present part of the past, Donatello was made to live more ably and purposefully "among the Blackshirts." Our book elucidates the historical and cultural underpinnings of that cohabitation, and explores the extent to which our art-historical knowledge of Italy's past is indebted to the seemingly dis-

cordant juxtaposition that resulted from Mussolini's interest in the visual past of Italy.

In Italy in the '20s, '30s, and '40s, a great interest in the nation's artistic and cultural heritage fueled an enormous investment in preservation, documentation, study, and emulation. During the Risorgimento, initiatives to recover and to restore Italy's glorious past, both regional and national, had begun, but nothing approached the magnitude witnessed in the Fascist era. Beginning in the '20s, institutes, libraries, university professorships, and the monumental *Italian Encyclopedia* were established. Excavations and restorations proceeded on an unprecedented scale. These projects aimed, in part, to reclaim Italy's cultural heritage from neglect and disinterest, from "foreigners" who had occupied Italian lands for centuries, from the humiliation of World War I with its limited spoils, and from the non-Italian scholars who, since the late nineteenth century, had dominated scholarship and had determined how Italy's artistic heritage was interpreted, represented, and received. Italians took over the representation of their own culture, in academic scholarship, in new popular journals, and in massive exhibitions. As a result of so many efforts, considerably more of Italy's artistic heritage became known than ever before. Among the examples noted in this volume alone are the Ara Pacis in Rome, the ancient city of Ostia, historical gardens, and rural architecture.

Interest in the past, particularly on such a grand scale as in Fascist Italy, is never disinterested. Ideology guided the choice of subjects in excavations and exhibitions, as well as the resources available and the deadlines imposed, with the result that some were carried out in great haste, without either documentation or plans to turn ephemeral displays into permanent resources for further study. As David Lowenthal argues in *The Past Is a Foreign Country,* the present is always implicated in the revival of the past.[5] Lowenthal discusses the tensions between past and present—conflicts, rivalries, and both benefits and burdens of the past—in different places and periods in history. In the case of Fascist Italy, the relationship between present and past was emphatic, intentional, and repeatedly articulated

visually as well as verbally. Many of the themes central to the Fascist regime, especially the evocation of ancient Rome and its empire, were already in place from the Risorgimento. Under the regime, however, these themes became far more pervasive, directed, and enlarged to colossal proportions, and were both juxtaposed with modernity and represented in modernist forms.

Lowenthal's title—*The Past Is a Foreign Country*—is particularly relevant to Fascist Italy: since Italy was not a unified nation until 1861, the past of the dominant regions of central Italy was indeed a foreign country for large segments of the peninsula. A familiar nationalist strategy is to create a shared past for a young nation; but in the case of Italy it was a nation that had strong and distinctive regional identities forged over many centuries.[6] The Fascist regime shaped the various available pasts into a new myth of the nation. It did so by homogenizing the differences among them, by subsuming them ambiguously into a narrative of continuity with classical antiquity, and by fusing the multiple pasts into a shared artistic patrimony. This patrimony encompassed the glories of Italy's different regions and histories.

Fascist revivals of the past also commonly aimed to demonstrate superiority and to legitimate the present. Italy's "splendid" past demonstrated its primacy in cultural terms, which in turn justified its claim to superiority in the political realm. The past that the regime most obviously and visibly called forth was that of the ancient Roman Empire, which provided proof of Italy's greatness, a model for Mussolini's political ambitions, and justification for Italy's invasion of Ethiopia. Ancient Rome supplied the precedent, or as the regime claimed, the "right," to empire in the twentieth century.

Both the central Fascist government and many regional and local entities revived, celebrated, and made relevant for the present other pasts of the peninsula as well: the Italy of the communes, city-states, and principalities, each with its own flourishing artistic traditions from the Middle Ages and Renaissance. These efforts worked to construct not only a shared past but also a specifically Italian past, untainted by for-

eign occupation. Local pride throughout Italy initiated the restoration of monuments and the celebration of heroes even before the '20s, but the Fascist regime used these acts of commemoration more pointedly to lend authority to present political activities. Restored communal palaces served as settings for Fascist mass events, and the office of *podestà*, reinstated in 1926, facilitated Fascist oversight in regional centers. Local artistic traditions and personages acquired new roles, celebrated more for their Italian and Fascist significance than for their regional associations. Donatello's famous statue *St. George* was recontextualized in a model displayed during Hitler's visit to Florence in 1938, and the literary heroes Petrarch, from the fourteenth century, and Leopardi, from the early nineteenth century, were reinterpreted to reveal messages of nationalist longing and ambition that were fulfilled in the Fascist empire. Maiolica sets from Forlì, which celebrated childbirth and which were reproduced from instructions in a sixteenth-century treatise, were placed in the service of a Fascist demographic campaign that incidentally revived the ceramic industry near Mussolini's birthplace of Predappio. An astonishing exhibition in Paris of the most celebrated works of Italian painting traced the "classical" tradition in painting from its origins through the baroque, despite the general disdain in Fascist Italy for the baroque era because of its association with foreign occupation. The Exhibition of the Italian Garden in Florence, like the narrative of Italian painting presented in the Paris exhibition, minimized regional styles and chronological differences so as to present gardens as variations on a classical and innately Italian style.

The vaunted past was also a burden, however. The cultural property of the peninsula's past had long defined Italy in the absence of any other claims to political significance on the world stage. The past also signified premodernity, and by the '20s Italy clearly needed to modernize and to industrialize. A major theme of our volume is the fusing of past traditions with modernity, which was essential to the political purposes of the return to the past. One of many ways that this was achieved was by linking the machine—the emblem of modernity and speed—with other symbolic visual images from the past. On the temporary façade of the Exhibition of the Fascist Revolution, for example, ancient Roman fasces appeared in monumental machinelike forms and materials. Mussolini himself pioneered the equating of the technological achievements of modern aeronautics with the engineering skills of the ancient Roman Empire. The Futurist *aeropittura,* or aerial painting, likewise merged images of aviators and figures in flight with those of the holy family and church architecture. This merger of the "religion" of speed with traditional religion further commingled such signs of the past and the modern as ancient Roman architecture and contemporary skyscrapers. Modern electric lights illuminated classical triumphal arches, and modernist arches reimagined the traditional form. Although generally the past was represented as secular, religious (or quasi-religious) imagery also appeared, often ambiguously and incongruously in explicitly modernist contexts. Among these were the Fascist piazza surrounding the restored Mausoleum of Emperor Augustus in Rome, the late Futurist paintings of Fillia and Benedetta, Sironi's exhibition installations and murals, and the Sacrarium of the Fascist Martyrs in the Exhibition of the Fascist Revolution.[7]

We have included a chronology, which integrates the events, monuments, and exhibitions discussed in this volume with significant moments in the Fascist period. Although the major political events are familiar, mapping the cultural initiatives onto them re-veals convergences, patterns, and developments in political and cultural policy. For example, the building of the new University City (Città Universitaria) began only months after the regime required professors to sign an oath of allegiance to Fascism in November 1931. In the early years of the regime—1922 to 1929—numerous institutions and activities engaged scholars and intellectuals, among them the national art history library, the *Italian Encyclopedia,* the Royal Academy of Italy, the journal *Capitolium* dedicated to Rome, the film agency LUCE, and the Museum of the Roman Empire (Museo del Impero). In those same years modernist painting and architecture flourished: in 1928 the First Italian Exposition of Rational Architecture took place, the Mussolini Forum in

Rome was begun, Mario Sironi designed two significant exhibition installations together with the architect Giovanni Muzio, and F. T. Marinetti launched the *aeropittura futurista* movement in 1929.

In Rome, the focus on Augustan monuments and imagery emerged only in the '30s, culminating in 1937 in the bimillennium or two-thousand-year anniversary of the birth of the emperor Augustus, a celebratory event that was preceded by the invasion of Ethiopia and proclamation of empire in 1936. In addition to many smaller ones, major exhibitions also took place in the '30s: Italian Art 1200–1900 (London, 1930), The Italian Garden (Florence, 1931), the Garibaldian Exhibition (1932), the Exhibition of the Fascist Revolution (1932), Italian Art from Cimabue to Tiepolo (Paris, 1935), the Augustan Exhibition (Rome, 1937–38), and the Universal Exposition of Rome (E42), planned from 1937 for 1942 but ultimately canceled. Big urban projects included the 1931 Master Plan of Rome, the University City (1932–35), EUR, as the new city that originated in the Esposizione Universale di Roma planned for 1942 is known, and the series of new towns that were constructed outside Rome beginning in 1932. Although several of the urban interventions in Rome had been initiated earlier, their inaugurations coincided with significant events of the '30s. Social and political exigencies, such as the invasion of Ethiopia and the demographic campaign, directly inspired the revival of Renaissance maiolica birth ware in 1938, which was surely also related to the founding of the Institute for Renaissance Studies in the previous year. Revivals of regional pasts continued throughout the Fascist period, from the restorations already under way early in the century to reinvented "medieval" festivals in Florence, Siena, and Arezzo in the '20s and '30s and documentary films on historic centers, such as that on San Gimignano produced in 1941.

Together the essays in this volume present the complexity of cultural activities under the Fascist regime, which included a great number and range of efforts that researched and recalled various pasts of the peninsula. The essays demonstrate that it is not always possible to align artistic styles with political positions. They suggest blurred lines between Roman and regional initiatives and between individual and institutional ones, as well as between significant scholarship and ideology and between coercion and voluntary participation. The ardent Fascists in the cultural sphere whose names appear in these chapters, among them Ojetti, Muñoz, Malaparte, and Sironi, encompass both traditionalists and modernists. In the debates between traditionalist and modernist camps in architecture, positions shifted and were not necessarily consistent with political conservatism or Fascist participation. For example, in 1938, the arch-Fascist writer Curzio Malaparte commissioned the Rationalist architect Adalberto Libera to build a modernist home for himself on the island of Capri. Politicized building activity occurred not only in public structures, designed by both traditionalists and the most famous modernist architects, but also in restoration and reconstruction of ancient, medieval, and Renaissance buildings, and of Renaissance and later gardens.

Recent scholarship has questioned the degree of Mussolini's direct involvement in all aspects of Fascist policy, including cultural activities, as it has also asked how centralized and how repressive his regime was.[8] Our essays provide numerous examples of the engagement of Mussolini, whether by approving a project, by setting deadlines, or by taking actions that suggest a greater investment of time and energy. They make equally clear that neither Mussolini nor one of his officials set in motion an overall preconceived program to guide all individual initiatives. We give examples of regional and government officials presiding together, and of regional officials operating independently of the central government along with scholars, intellectuals, and urban bourgeoisie. Ruth Ben-Ghiat, in her recent book, *Fascist Modernities,* argues that the Fascist regime constructed a complex patronage structure that purposefully drew "creative individuals into collaborative relationships with the state," with significant consequences—silence, imprisonment, and exile—leveled on those who did not take part.[9] Although Ben-Ghiat discusses writers and filmmakers, others have examined the participation of architects and artists. Scholars, art historians, academicians, and archaeologists sim-

ilarly responded to the funds and initiatives that the regime devoted to the study of the past. Antonio Cederna, a journalist and eloquent critic of Fascist urban interventions in Rome, categorizes archaeologists according to their degree of ideological participation in Fascism.[10] Similar categories could also be applied to the larger body of scholars who worked on the major exhibitions and research areas encouraged by the regime.

Various terms characterize the Fascist relationship with the past—return, revival, restoration, reclamation, reinvention, and, for the active work of the present on that past, construction of parallels and prefigurations. Appropriation can perhaps better define its nature. To appropriate, the art historian Robert Nelson explains, is to take something for one's own, with the implication of improper taking, in a process that is active, subjective, and intentional, whether positive or negative.[11] Nelson's definition of appropriation is pertinent to Fascist revivals as it points to their active nature with an intentional and political purpose, if not a specific agent. More recently, scholars have explained appropriation as an act of power in a relationship of unequal cultures and generally diverse cultural productions, which is particularly applicable to a colonial context, although Fascist appropriation is certainly a demonstration of power. A more serviceable model for Fascist Italy might be found in the nuanced studies in "The Cultural Processes of 'Appropriation,'" a special issue of *The Journal of Medieval and Early Modern Studies* published in 2002. The editors, Kathleen Ashley and Véronique Plesch, understand the act of appropriation as a complex process whereby "'cultural expressions' are brought to represent something different from their original purposes," with the aim of "creating and/or consolidating identity."[12] This notion of appropriation emphasizes the changed meaning of the original cultural production and its incorporation into the new, or, as in the present volume, the modern. Appropriation examined in this light also suggests that its purpose is ultimately a question of identity, as was the case in Fascist Italy.

These concepts of appropriation, along with memory and cultural translation, enable us to ex-

amine the complexities of the relationships that were set up with the past in Fascist Italy. For example, the Fascist regime's appropriation of the fasces as its emblem explicitly activated the original meaning of the fasces as a symbol of power, but with reference to Fascist Italy, not to ancient Rome. Although widely represented in antiquity on sculptural reliefs, the fasces came to serve new functions in the Fascist era, from architectural supports to ornaments on various domestic objects. These uses incorporated the fasces into modern industrial, political, and consumer culture. The new contexts added new meanings—about the modernity of the idea of the fasces and its direct address to the populace through mass-produced items. Appropriation also can refer to a variety of acts, among them restoration. The "restoration" that removed all later accretions from the Mausoleum of Augustus in Rome left a barren core that never existed in antiquity. Assuredly, the meaning of the Mausoleum remained—a colossal funerary monument by an all-powerful ruler. However, its new context in a piazza with modern structures, Fascist inscriptions, and the rebuilt Ara Pacis appropriated and altered that meaning, making the setting as much about Mussolini as about Augustus. The barren Mausoleum established a more direct connection between past and present, and also emerged more alien, more distant, and thereby more malleable for use in the present. Around a new monument created out of an old one, new memories could be formed, generally beginning with a mass public event at its inauguration. The actions of restoration, rebuilding, and ritual commemoration on surviving ancient remains "translated" them from one culture and period to another, an operation that works on collective memory and identity.[13]

In Ferrara, San Gimignano, and elsewhere, a modern idea of medieval architecture guided the restoration of medieval palaces, especially town halls, both before and during the Fascist era. Often these "restorations" involved the addition of merlons, crenellations, balconies, and loggias, and this occurred even when evidence for the appearance of such features on the original buildings was lacking.[14] The medieval past as represented

in these palaces became—and remains—a construction of the present. The process of restoration could also involve more specific forgetting and remembering. Diane Ghirardo demonstrates how the early twentieth-century restorations in Ferrara obliterated the memory of part of the city's past. The restoration of Ferrara's Palazzo del Corte was also an act of forgetting, since it emphasized the palace's function as a town hall and denied its role as a princely residence. At the same time, this act of forgetting disavowed the progressive aristocratic control over the former commune. Over time, the image of Ferrara's past selected by these restorations became its remembered past and collective identity.

Such altered memories should alert us to question how our current understanding of Italy's artistic past has been filtered through the selection, translation, and obliteration of the Fascist period. Several of our authors explicitly address our received understanding of the past, particularly Crum on Donatello's *St. George,* Lazzaro on Italian gardens, and Braun on the narrative of Italian painting. Our modern knowledge of Augustan Rome was formulated in the '30s, as Paul Zanker notes, in part through major excavations and restorations.[15] But how much does it also reflect Mussolini's glorification of Augustus and his use of the emperor to his own ends, which Wilkins discusses? We can lift the layers of history from the works of the past to reveal the interpretations of different moments, but we cannot know or even see the objects independent of those layers. All this begs the question of how much else in the history of Italian art also bears the marks of the Fascist intervention but has become seamlessly part of our modern interpretation of Italy's cultural patrimony as existing wholly unmanipulated by modern politics.

In the first of the four parts of our book, "Italy's Past as Mussolini's Present," the two chapters introduce the various pasts of the nation-state of Italy that had significance for the Fascist regime as well as the strategies and philosophical concepts of history that guided the visual representation of those pasts in the '20s and

'30s. Claudia Lazzaro's essay, "Forging a Visible Fascist Nation: Strategies for Fusing Past and Present," focuses particularly on the different ways of conceptualizing the Fascist narrative of continuity between the past of the Italian peninsula and its present under Fascism—as *romanità* (Romanness), *italianità* (Italianness), and innateness, which was expressed as the autochthonous, or the Italic. Lazzaro presents some of the ways of representing that continuity visually that were proposed through material objects, architecture, restorations, and exhibitions. In "To Make History Present," Claudio Fogu begins with the modernist concept of "historic," which found expression in the popular saying that Fascism makes history rather than writes it. All the essays in the volume demonstrate in some way Fogu's argument that it was not Fascism that gained legitimacy from its historical continuity with the past but that the past itself gained real presence and meaning only through the Fascist-historic act of representation. He contrasts the historical mode of representing the past with the Fascist historic in two exhibitions, the Garibaldian Exhibition and the Exhibition of the Fascist Revolution, which opened in sequence in 1932, with the curator Antonio Monti as a participant in each.

The three essays in part 2, "Antiquity," concern the comparison and juxtaposition of ancient Rome with modern interventions, technologies, and architectural forms. In "Augustus, Mussolini, and the Parallel Imagery of Empire," Ann Thomas Wilkins compares modes of appropriation of the two rulers, Mussolini and Roman emperor Augustus, and how the appropriations functioned as acts of power. Wilkins focuses on the monumental complex of the Campus Martius, constructed by Augustus and reconstructed by Mussolini, and the obelisks that each ruler imported from other cultures and distant settings. She closes with a discussion of the controversy surrounding Richard Meier's design for the pavilion that will eventually shelter the ancient Ara Pacis. Gerald Silk's essay, "'Il Primo Pilota': Mussolini, Fascist Aeronautical Symbolism, and Imperial Rome," demonstrates Mussolini's further identification with Augustus in parallels be-

tween the ancient Roman Empire and the revival of past glory heralded by modern aeronautics. Widespread visual imagery in journals, posters, photography, and exhibitions conveyed the linking of modernization with a new Fascist empire headed by Mussolini as "emperor-pilot" through such means as juxtapositions of ancient sculpture with representations of flight and speed.

In "Fascism *Triumphans:* On the Architectural Translation of Rome," Jobst Welge investigates the idea of cultural translation as an act of transferring political authority from past to present. Borrowing Pierre Nora's concept of sites of memory (*lieux de mémoire*), Welge demonstrates how the emblematic triumphal arch functioned as a historical palimpsest that carried into the Fascist era not only the symbolic freight of imperial Roman antiquity but also accumulated meanings through subsequent memorial events over time. Welge's examples range from the Arc de Triomphe in Paris to increasingly modernist and Fascist versions, one of them the "Phylenian" arch in colonial Libya, site of both an ancient Roman story and a triumphal spectacle for Mussolini's 1937 visit. The multiple meanings of that site are also evoked Silk's chapter, in a photograph of Mussolini's visit to Libya in which Mussolini on horseback is accompanied by soldiers in traditional Libyan costumes holding ancient Roman fasces.

Part 3, "Middle Ages and Renaissance," focuses on two periods that are understood in modern scholarship as clearly distinct but that were sometimes ambiguously conflated in the Fascist narrative of history. The essays implicitly question the paradoxical coexistence of efforts to revive and to reinforce regional identities and to fuse them into a common one that was classically inspired. The section begins with two chapters that challenge our accepted notion of medieval architecture in such former city-states and communes as Ferrara and San Gimignano. In both of these sites some of the major landmarks of the late medieval period are in fact reconstructions and reinterpretations of the '20s and '30s. Ghirardo and Lasansky examine the role of local officials versus that of the central government, and each offers a different context for understanding the reconstructions.

In "Inventing the Palazzo del Corte in Ferrara," Ghirardo investigates the restoration in 1924 of the façade of the Este family palace, which also housed civic administrative functions. The restoration, sponsored by the local cultural elite, aimed to render the appearance of a typical fourteenth-century town hall, despite its historical inaccuracy. Ghirardo argues that this restoration resulted from local pride, politics, and initiative that were for the most part independent of Fascist state policy. In "Towers and Tourists: The Cinematic City of San Gimignano," Lasansky examines the 1941 documentary film of the medieval Tuscan town of San Gimignano, *Belle torri*. She maintains that the medieval past is represented largely through Fascist restorations of the '20s and '30s, and that both film and restoration projects constituted a commodification of historical sites in the service of the regime's efforts to encourage national tourism and a shared cultural patrimony.

The Fascist uses of the early Renaissance are surprising. In "Shaping the Fascist 'New Man': Donatello's *St. George* and Mussolini's Appropriated Renaissance of the Italian Nation," Roger J. Crum discusses the significance of a large-scale model of Donatello's *St. George* that was placed among the street decorations for the visit of Hitler to Florence in 1938. Crum explores the transformation of the patron saint of the armorers' guild into an icon of the Fascist "New Man" and of Italy ready for war, and its association later in the twentieth century with ideas of liberty, perhaps in order to obliterate the memory of its Fascist appropriation.

The last two chapters in this section consider two revivals of very different Renaissance art forms. In "Mussolini, Mothers, and Maiolica," Jacqueline Musacchio examines the revival of tin-glazed earthenware, or maiolica, in the context of the Fascist demographic campaign that encouraged large families through legislation (both restrictive and coercive), incentives in ceremonies and awards, and visual and verbal propaganda. Beginning in 1938 the inducements for large families included maternal gifts of majolica birth ware, closely following Renaissance forms, which dignified motherhood by establishing parallels between the two time periods. In "Politi-

cizing a National Garden Tradition: The Italianness of the Italian Garden," Claudia Lazzaro examines the revival of interest from the '20s to the '40s in the Italian garden tradition and its reinterpretation through published scholarship, the 1931 Exhibition of the Italian Garden in Florence, and restorations of existing historical gardens. Twentieth-century notions more than historical evidence inspired these restorations, as they did the restoration of medieval palaces. Lazzaro argues for a nationalist basis of the construct of the architectonic garden, which was claimed to be expressive of the Italian spirit and which then determined much of later twentieth-century scholarship on Italian gardens.

The chapters in part 4, "History as Fascist Spectacle and Exhibition," examine how Italy's past acquired new meanings when it was represented in modern paintings, commemorations, celebrations, and exhibitions. These essays also demonstrate the transformation of the culture of the past from the province of the elite into mass culture through its presentation as spectacle and its modernist context. The first two chapters concern representations of the distant past—the late medieval through the eighteenth century—which were reframed to comment on the present. The final two chapters explore how the juxtaposition of imagery from the past with that of the modern world worked to make that past part of the modernist vocabulary.

Emily Braun's essay, "Leonardo's Smile," concerns the 1935 exhibition of Italian painting at the Petit Palais in Paris, De Cimabue à Tiepolo (From Cimabue to Tiepolo), which, from the earliest planning stages to the reception at home and abroad, used the cultural for political ends. A concomitant exhibition at the Jeu de Paume, L'Art Italien des XIXe e XXe Siècles (Italian Art of the Nineteenth and Twentieth Centuries), sought to link past artistic genius with modern Italian art and to suggest continuity from the nineteenth century to the current art under Fascism. Benjamin Martin's essay, "Celebrating the Nation's Poets: Petrarch, Leopardi, and the Appropriation of Cultural Symbols in Fascist Italy," examines the commemoration of the fourteenth-century Petrarch and the eighteenth-century Giacomo Leopardi in statues, monuments, stamps,

parades, and public events in their hometowns. The celebrations selected from and reinterpreted the work of these poets to emphasize their desire for a unified Italy and to reveal Fascist Italy as the fulfillment of those dreams.

The final two chapters demonstrate examples of "re-presenting the past and forging it into a new myth of the present," in the words of Jeffrey Schnapp. In "The Return of the Repressed: Tradition as Myth in Futurist Fascism," Christine Poggi demonstrates that the Futurists, although widely known for their emphatic rejection of the past and fetishizing of the machine, also evolved over twenty years toward an interest in representing the spiritual and with it, the past. Poggi explores this change in the paintings and writings of Fillia (Luigi Colombo) and Benedetta (Benedetta Cappa Marinetti). In "Flash Memories (Sironi on Exhibit)," Jeffrey T. Schnapp analyzes Mario Sironi's exhibition installations from 1928 through the '30s, and illustrates the extraordinary inventiveness with which Sironi fused modernizing and historicizing, with references to many pasts from ancient Roman to archaic Greek, Christian, and his own recent installations. In his 1933 "Manifesto on Muralism," here translated into English for the first time in an appendix to the chapter, Sironi offers his conception of mural painting as Fascist state art, although the proposal was not accepted as such.

The book closes with a brief reflection by the editors on Mussolini himself and specifically on the famous photograph of the ignominious display of the executed dictator that took place on April 28, 1945. When the Italians who had gathered that day in the Piazzale Loreto in Milan took the battered and dead bodies of Mussolini, his mistress, and his companions and strung them upside down, they collectively acted out a practice preserved in Renaissance painted images of criminals, which were displayed as both admonition and public defamation. The photograph of Mussolini has served a similar function of stigmatizing the memory of the deposed and debased leader of Italian Fascism. The analysis of this image calls for attentiveness to the visual imagery of the past that the photograph unconsciously evokes as well as to the Fascist regime's propagandistic use of public spectacle and mass circu-

lation of images, which the actions in the piazza and its photographic record overturned. Just as an awareness of the art of the past is essential to understand how the Fascist regime used visual images as an effective instrument of power, so too knowledge of the art of Italy's past is incomplete without an awareness of the role of Fascist Italy in studying, uncovering, restoring, and reinterpreting it.

# Italy's Past as Mussolini's Present

# Forging a Visible Fascist Nation

## Strategies for Fusing Past and Present

*Claudia Lazzaro*

THE NEED TO ASSERT a shared past emerged in various nationalist movements of the late nineteenth and early twentieth centuries, but Italy experienced this imperative particularly acutely, since it was unified as a nation only in 1861. Before that, Italy consisted of independent states with strong regional identities and distinctive languages, histories, and cultural traditions, occupied and fought over by foreigners during much of the preceding four centuries.[1] The political unification forged by the social and economic elite, who had a culture and language in common, excluded the poor and illiterate masses. Mussolini's efforts focused instead on establishing a much more widely shared national identity and on broadening the appeal of the same nationalist ideas that had been promoted from the time of unification.[2] This goal called for a rethinking of the role of the past in shaping an identity that could be shared by the inhabitants of all of Italy's different regions. To render that shared past usable further required making its relevance to the present immediately apparent and literally visible.[3] The Fascist regime also reappropriated Italy's past from the non-Italians who had claimed it: from travelers on the Grand Tour to foreign rulers over four centuries, and from ex-

patriates residing in Italy in the early twentieth century to contemporary scholars who dominated the study of Italy's artistic heritage. At the same time, the regime reclaimed Italian history from the old cultural-political elite and made it accessible to a wide range of people. This expanded the imagined community that shared a sense of belonging to the nation. Modernizing Italy was equally crucial to Mussolini's agenda, and from the start he encouraged intertwining the past with modernity. The glorious past would impel the movement from backwardness to a modern nation.

## Which Past? What Italy?

In a famous speech in 1926, Mussolini called for a Fascist art that could be "traditionalist and at the same time modern, that looks to the past and at the same time to the future."[4] Modernizing was essential to develop the young nation's economy sufficiently to satisfy Mussolini's ambition of transforming it into a major power. At same time, that aim needed a fixation on the past. The "New Italy" emerged not only from resurrecting the greatness of the peninsula's Roman past but also from overcoming the image of the old. A leitmotif of the travel book of John Gibbons, an American journalist who visited Italy in 1932, is the contrast between the old, the Italy of myth, and the "New Italy." Gibbons found that Mussolini had recast the "lazy, loafing, sun-loving people" as virile, athletic, hardworking modern

I thank Jane Caplan and Jeffrey Schnapp for comments on early drafts, and Dennis Doordan, Andrew Ramage, and Ann Vasaly for information and stimulating conversations. I am grateful for the hospitality and resources of CASVA at the National Gallery of Art, Washington, D.C., the American Academy in Rome, and the Rockefeller Center at Bellagio.

embodiments of ancient Roman strength.[5] The journalist's words recall Mussolini's own remark in 1915 that "in Italy there are not just mandolin players."[6] The inhabitants of the land where "tourists insisted upon treating the entire country as though it were one glorified art gallery"[7] may have welcomed the new militant image of power and authority. Long before, Mussolini had already had enough of "the representation of Italy with the innkeeper's hat, destination of all those idlers, armed with their odious Baedeker."[8] John Agnew argues that far from being overcome by Mussolini's efforts, the discourse of backwardness versus modernity has instead become a dominant representation of Italy by both native Italians and non-Italian observers, a self-perpetuating myth of Italy's own making. Discussions of Italian Fascism continue to grapple with this paradigm, claiming aspects of Fascism as "modernist" or "traditionalist." In present-day politics the question remains whether what is distinctively Italian about Italy is inherently backward.[9] The answers offered under the Fascist regime intended instead to obliterate this paradigm by fusing the past, the traditional, even the backward, with the modern.

Fascist Italy is generally distinguished from Nazi Germany in that Mussolini permitted, and even encouraged, the coexistence of a multiplicity of artistic trends, traditionalist to modernist, representational to abstract.[10] Recent scholarship acknowledges the widespread influence of Fascist ideology, equally in avant-garde and conservative trends.[11] Most artists and architects were neither fully distanced from Fascism nor totally compromised in the service of it, but scholarly attention focuses particularly on modernist movements and their relationship to Fascism. Is modernism a form of Fascism? No, obviously not. But what was the appeal of Fascism for modernists?[12] Similar questions can be asked about the archaeologists, scholars, and intellectuals who were invested in the past, and whose participation in Fascist ideology ranged from explicit to unintentional. Fascism represents a significant moment in the history of twentieth-century scholarship, as it does in the history of modernism. The regime encouraged and sponsored a massive investigation of the past, guided by its ideological purpose. The tainted results are deeply embedded in the later twentieth-century's received understanding of Italy's cultural and artistic heritage.[13] In the early twenty-first century, the influence of Fascism on scholarship still has not been fully revealed.

In the Fascist climate of openness to a multiplicity of artistic trends, what was required of the various styles in their bids for acceptance by the regime was to be "Italian." Referring neither to a regional nor to a national identity, "Italian" in this context means innately Italian, demonstrating *italianità,* or Italianness. Evoked from the time of unification, *italianità* encapsulated the claim of a collective identity and the implication of a common past. More fixed in meaning was the ideologically charged concept, also from unification, of *romanità,* which designated neither ancient nor modern Rome but rather the enduring Roman spirit, or Romanness. It signified the greatness of ancient Roman civilization and its uninterrupted manifestation through the centuries, the glory of the past continued into the present, the ancient Roman Empire reincarnated in the Fascist empire. The Fascist regime claimed legitimacy from its ancient precedent and justification for its focus on empire and on colonization of Africa. The reverse was also true. The foreign policy and need for empire "morally justified" the use of the past in a blatantly manipulative way.[14] The myth of *romanità* propagated the belief in the supremacy or primacy (*primato*) of Roman civilization, from which its civilizing mission in the world followed.[15] Anticipated even before unification in Abbé Gioberti's *The Moral and Civil Primacy of the Italians* of 1843, notions of primacy and *romanità* in Liberal Italy under Prime Minister Giovanni Giolitti appealed in particular to intellectuals and archaeologists.[16] Although these ideas had long circulated, how and by whom they were employed, and the intended audience, all differed in Fascist Italy.

The Fascist view of Italian history emphasized the continuity of Roman civilization from the ancient empire to the modern one. *Romanità* referred to the constancy of Roman culture, particularly the governing principles of law, justice, and order.[17] In this view, the ancient Romans handed these down to the peoples of the Italian

peninsula, who, over time, constituted a continuous lineage, or *stirpe.* However, this construction of ancient Roman civilization as a unitary and constant culture ignores the many nationalities, languages, and cultures that constituted the ancient Roman Empire. Further, to equate Italian history and identity with those of the Romans—to claim Roman history as national history—is also to deny the complexities of the Italian peninsula's past. Prasenjit Duara argues that constructing a nationalist identity involves the repression of alternate identities.[18] In Fascist Italy the exclusions are obvious in the archaeological and scholarly activities sponsored by the regime. For example, a nearly exclusive focus on the Roman past eclipsed the political interest in prehistoric archaeology at the time of unification until late in the Fascist period.[19] The excavation of imperial monuments in Rome simultaneously occasioned the wholesale destruction of many other pasts, including the archaic. To these conspicuous examples must be added the many less blatant choices of archaeologists and the exclusions of scholarship.

In the Fascist view of history, the modern nation of Italy had a past and a culture shared by all its peoples. Outside Rome, the period of the medieval communes could more effectively serve as a common past, particularly since it represented a time free from foreign domination. Under Fascism, however, the distinction between "medieval" and "Renaissance" was blurred, since the former represented a purely Italian culture, while the latter signaled a great age of cultural flourishing.[20] "Medieval," like *romanità,* denoted common cultural roots, but another kind of common past also proliferated under Fascism. Eric Hobsbawm explains that modern nations often claim to be the opposite of novel—rooted in the remotest antiquity, not constructed but "natural" human communities.[21] In Italy, "Italic" referred to such a "natural" community, with implications of innate, spontaneous, and constant—or autochthonous, to use the term in common currency. This may explain the interest in prehistoric archaeology at the time of unification and again in 1938, when planning began for an exhibition of Italian civilization. In that same year, the Fascist regime published the "Manifesto of Fascist Racism" and instituted anti-Semitic legislation.

The concept of *stirpe,* or lineage, evolved into one signifying race, and specifically bloodlines. A Neanderthal skull discovered in 1939 was deemed the "first Italian."[22] The term autochthonous appeared frequently in discussions of farmhouses and vernacular architecture, an interest that emerged at about the same time. The Fascist narrative of the history of Italy compressed and conflated these three aspects of the past—the "national" character of the peoples inhabiting the Italian peninsula through the centuries, the history of ancient Rome, and the medieval and Renaissance history of the communes and city-states.

Already in the early twentieth century, nationalism had permeated art historical scholarship. Under Fascism, however, the political agenda impelled scholarship. A recent study argues that the development and institutionalization of archaeology as a science depended on nationalism and was inextricably intertwined with it.[23] A nation needs a past, and that need fuels the development of scientific methods to unearth it. The same is true of scholarship on the past in general. In Fascist Italy, dramatic efforts and significant funds were dedicating to investigating the past and making it visible and available to large segments of the population. All access to the past is mediated, but our perpetual reinterpretations of it in the light of the present are of a different order than the blatantly political aim of constructing a homogeneous past for a nation without a unified history. The more massive the efforts, the more evident the guiding goals.[24] This chapter examines some of the strategies used during the Fascist regime to make visible the different pasts of the peninsula and the various concepts of native identity. Most important among the strategies was the constant fusing of past and present in myriad ways.

## Signs and Symbols

Emblematic images taken over from Roman antiquity and reproduced in innumerable contexts, scales, and materials made the past a living heritage. Through constant repetition, these images became widely intelligible and created a collec-

tive visual imagery, which substituted for a common language and culture.[25] The she-wolf that suckled the babies Romulus and Remus, founders of Rome, had long since epitomized the Roman people and symbolized the origins of Roman civilization. The famous bronze Capitoline *She-Wolf* is the earliest surviving major work of art made in Rome for a Roman patron, dating only about 250 years after the legendary founding of Rome in 753 B.C.E.[26] Its late-archaic style (perhaps by a Greek artist) with strong Etruscan influence illustrates the variety of artistic traditions in early Roman workshops.[27] As a representation of the beginnings of an art that can be called Roman, it fittingly symbolizes the origins of Roman civilization. The archaic aspects of the Capitoline bronze—stylized fur, abstracted facial features, patterned ribs and teats, and rigid, alert pose—give this image of origins an affinity with the stylization and abstraction of the art of the '20s and '30s. The she-wolf that appeared on the 1933 cover of *Capitolium* (figure 1), the journal of the Fascist Roman government, exploited the correspondence of archaic and modernist through the head turned sharply to face the viewer and the flattened neck. The drawing is signed by Antonio Muñoz, archaeologist, propagandist for Mussolini, and editor of the journal.

In antiquity, the she-wolf with the founding twins Romulus and Remus embodied the idea of Rome. Widely represented on reliefs, the image put the stamp of the capital on every region of the empire. Under Fascism, both ancient and modern versions of the she-wolf functioned similarly, as a symbol of the shared Roman origins of all the regions that constituted the Italian nation. In 1932, the American journalist Gibbons marveled at the tiny models of the Capitoline *She-Wolf* for sale not only in tourist towns but everywhere, "at prices from pence to shillings." The significance that Gibbons attributed to these objects must have resonated with the inhabitants of the small southern towns where he traveled: "Rome once conquered the world—and Italy may do it again."[28] The she-wolf was depicted in sculpture and mosaics, in models large and small, and on the masthead and occasionally the cover of the journal *Capitolium*. The image functioned as a sign of modern membership in a collectivity defined by classical culture. For example, when children joined the Fascist youth groups established by the regime, they became "sons and daughters of the she-wolf,"[29] and could easily identify with the suckling twins in the omnipresent visual images.

Both the she-wolf and the equally omnipresent fasces were already familiar images from unification.[30] The term *fascio*, signifying a political group (or human bundle), was already common in politics before Mussolini appropriated it; the term derived from the *fascio littorio*, the bundle of rods bound with an ax that ancient Roman lictors carried. Adopted as the official emblem of the Fascist regime in 1926 and giving Fascism its name, the fasces symbolized in modern Italy, as in antiquity, unity, authority, and the exercise of power.[31] Ancient reliefs commonly represented a row of vertical fasces in a rectilinear pattern, and Fascist structures bore similar modern versions. A fasces appeared on the same cover of the 1933 *Capitolium* as the provocative she-wolf (figure 1). From the mid-'20s, the fasces appeared everywhere—alone and in series, large and small, in traditional and modern guises, in public and domestic settings, and in kitsch as well as high art (to use Clement Greenberg's distinction in his famous essay of 1939).[32] The culturally sophisticated and highly influential Fascist official Giuseppe Bottai deplored the more prosaic official uses. He mocked what he saw in local Fascist headquarters and syndicate offices: "incredible painted wall decorations, horrible tinted-chalk busts in every corner . . . gilt stucco lictor's fasces that look to be bundles of kindling."[33] The proliferation of the fasces extended to all aspects of material culture: official stamps, medals, and stationery, and domestic lamps, desk accessories, jewelry, toys, and furniture. One such lamp of about 1940 in the traditional shape of the fasces was fabricated of modern materials—silver electroplate on copper.[34]

In the Victory Monument in Bolzano, the architect Marcello Piacentini for the first time rendered the fasces in monumental scale. Designed in 1926, the same year that the fasces became the official emblem of the Fascist regime, the Victory Monument resembles a classical triumphal arch but with giant fasces in place of columns. In this

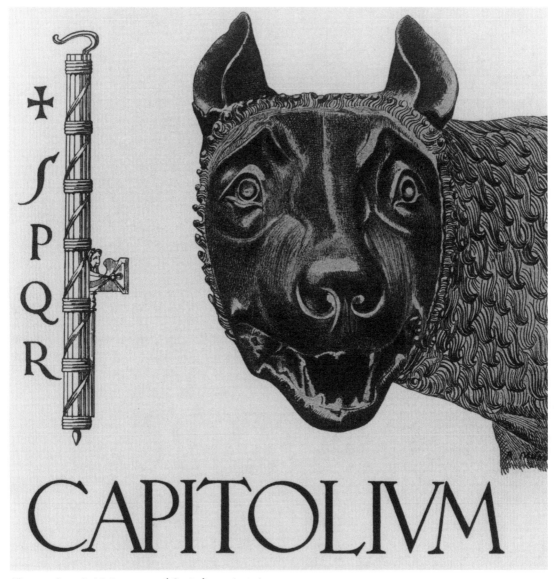

**Figure 1** Antonio Muñoz, cover of *Capitolium* 9 (1933).

setting, the monument carried more symbolic freight than simply the equation of classical and Fascist Italy. Bolzano is located in the highly contested territory of the Dolomites, the Alpine region between Italy and Austria, much of it Italian in language and culture. However, Bolzano itself, then called Bozen, was primarily German-speaking, with only 10 percent of its population Italian in 1921. Under Hapsburg rule in the fourteenth century and briefly in the early eighteenth century under the Napoleonic Kingdom of Italy, Bolzano

was subsequently returned to Austria. The peace treaty of 1919 "redeemed" it for Italy, along with the rest of the Trentino region. The Fascists seized control in the insurrection of 1922 and forced Italian identity on Bolzano.[35] The monument, which celebrates the Fascist victory over the local German-speaking inhabitants, claimed the region as Italian and Fascist Italy as continuous with ancient Roman Italy. From the start the monument was controversial and it has remained so.[36]

Soon abstracted, modernist versions of the

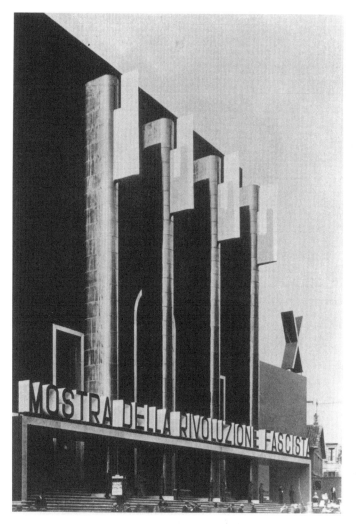

**Figure 2** Façade of the Exhibition of the Fascist Revolution, Palazzo delle Esposizioni, Rome, 1932. *Capitolium* 9 (1933).

fasces appeared in architecture as well, among them the monumental and avant-garde fasces on the temporary façade of the Exhibition of the Fascist Revolution in 1932 (figure 2). Designed by the Rationalist architects Adalberto Libera and Mario de Renzi, it replaced the nineteenth-century beaux-arts façade of the Palazzo delle Esposizioni. The four gigantic fasces emerged machinelike and black against the red wall, while the projecting geometric ax blades cast shadows in the strong Roman sunlight. Photographs of the façade taken at dramatic angles accentuated its modernity. Widely reproduced in journals, these photographs presented the public image of the exhibition. The modern design, materials, and photographic representations emphasized the modernity of these fasces, but the traditional symbolic form remained recognizable since the fasces had come to signify not the past but the Fascist incorporation of past into present.[37]

The geography of the "New Rome" conceived by Mussolini extended the reach of the city, with new centers forming modern gateways both north and south. Piazza Venezia (site of the Palazzo Venezia, Mussolini's headquarters from 1929) became both literal and symbolic center of the new Rome. Five miles to the north, a sports center, called the Foro Mussolini (Mussolini Forum), begun in 1928, initiated a new neighborhood. Five miles southeast of Piazza Venezia, development of another new quarter began. Called EUR (Esposizione Universale di Roma) for the projected international exposition of 1942 that never took place, it nevertheless grew

into a flourishing city as Mussolini had intended.[38] New, expansive traffic arteries connected these major centers. Inaugurated in 1930, the Via del Mare (Avenue of the Sea), originated at the Capitol and eventually continued to EUR, then beyond it to the ancient Roman seaport of Ostia (under excavation at that time), and finally to the sea. This and various other means linked the three urban foci—the new Mussolini Forum north of the city, the symbolic center of historical Rome, and ancient Ostia—conceptually, perceptually, and rhetorically. Past and present were overlaid in so many ways that extricating one from the other is impossible.

The Fascist preoccupation with narratives of history in which the past prefigures the present is evident in the naming of the sports complex. The Mussolini Forum (renamed the Italic Forum) associated the evocative Roman term with the dictator's name.[39] The broad pedestrian avenue there, the Viale dell'Impero, inaugurated in 1936, celebrated the conquest of Ethiopia and the establishment of the empire in that year. The black

and white marble mosaics on this avenue replicated in both style and technique the ancient Roman mosaics recently excavated at Ostia. From the first excavations there in 1909, Ostia assumed a mythic significance, and the excavations were intensified from 1938 to 1942. The ancient city where Aeneas, legendary founder of Rome, purportedly landed, symbolized the origins of Rome.[40] Modeled after cartoons by a group of artists that included Gino Severini, the mosaics on the Viale dell'Impero tell the story of Rome, from Romulus and Remus suckled by the she-wolf to the renewed empire with Mussolini's invasion of Africa.[41] In other sections, pairs of athletes in ancient style reveal as well the experience of Futurism and Cubism. Throughout, the words "Duce, Duce" are repeated insistently in rows. The decorative pattern of the border, probably the design of Angelo Canevari, consists of a sequence of fasces inspired by ancient reliefs but reduced to the most schematic rendering—a few lines and a rectangular block (figure 3). The simple lines are nevertheless unmistakably fasces,

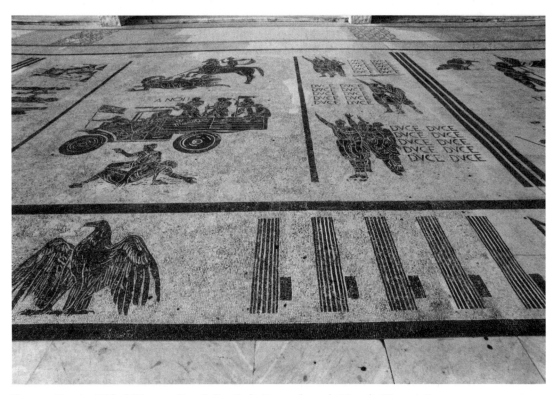

Figure 3  Mosaics, Viale dell'Impero, Foro Italico (Italic Forum, formerly Mussolini Forum), Rome, 1937.

since the fasces itself had become so encoded with modernity.

## Liberating the Past

To make emphatically visible the concept of *romanità* and the idea of a living past coterminous with the present necessitated a radical alteration of the city of Rome. Urban renewal began with the city's new role in 1870 as capital of a unified Italy, but the dramatic and unprecedented transformation of the city occurred in the two decades beginning in the early '20s. The Master Plan of 1931 launched most development projects of the Fascist era, including broad thoroughfares, piazzas, building complexes like the new university, neighborhoods, and an entire city. Many of these involved the excavation and restoration of ancient monuments, so that modernizing the city and emphasizing its past occurred simultaneously. Grand, imperial monuments were selected from countless ancient remains and were isolated by demolishing the surrounding dense urban fabric in a process characterized as a liberation. The restored remains emerged as "monuments," framed in large, modern piazzas or landscaped settings with the plane and cypress trees familiar from ancient literature. The liberation of ancient monuments also encompassed their integration into an overhauled urban scheme, whether new avenues or architectural contexts. The new arterial roads—long, straight, and broad—sliced through crowded neighborhoods, permitted modern automobile traffic through the city, and articulated the relationship between ancient and modern Rome by means of vistas and direct access.[42]

The most extensive Roman excavation project, which frequently involved demolition of slums (called *sventramento*) as well as construction of broad avenues, was the imperial fora of Caesar, Augustus, and their successors, from January 1932. Inaugurated in the same year, the Via dell'Impero (now Avenue of the Imperial Fora), created a vista between two monuments, the Colosseum and Palazzo Venezia, symbolizing respectively past and present. Aerial photographs emphasize the spatial and visual relationships

that required the demolition of the entire zone between the Colosseum and Piazza Venezia.[43] In this area, called the Velian hill, which was the site of the archaic city, prehistoric animal remains were found, along with wells and primitive tombs of the eighth century B.C.E. The demolition destroyed medieval and Renaissance monuments, among them a sixteenth-century garden and several churches, together with the archaic remains, and obliterated evidence of less valued centuries in ancient Roman history, including dwellings and gardens of the late republic. In his impassioned chronicle of this wanton destruction, the journalist Antonio Cederna contended that language was deployed along with bulldozers, in the process of constructing a visible nationalist past. Diminutives and derogatory suffixes in official accounts, such as *casupole, casacce, chiesuole,* and *chiesuoline* (huts, hovels, little churches, and tiny churches), diminished the significance of the destroyed structures.[44] All this occurred in great haste and with little documentation in order to finish for the anniversary of the March on Rome.

The massive archaeological and restoration activity in Rome under the Fascist regime privileged Augustan Rome, since Fascist propaganda emphasized parallels between the Rome of Augustus and that of Mussolini. Large-scale complexes, or small but intact structures, were also privileged at the expense of both remains of other periods and domestic and material culture.[45] All restorations follow certain criteria and principles, which implicitly embody notions about the past and necessarily reinterpret it.[46] The principal figure in charge of both restoration and urban renewal activities in Rome throughout the regime was Antonio Muñoz, restorer, art historian, enthusiastic Fascist in a variety of official positions, and designer of the she-wolf in *Capitolium*, the journal he edited (figure 1).[47] Muñoz subscribed to the current theory of restoration, which held that all later accretions should be removed and the original structure revealed. This approach nevertheless permitted replacing missing original elements with modern substitutions in the character of the period.[48]

The Ara Pacis, one of the greatest monuments of the Augustan age (13–9 B.C.E.), stands

today as an intact monument because of the significant resources expended and the impressive archaeological expertise in Fascist Italy. It demonstrates the current theory of restoration at its best. Embedded in the foundations of a medieval palace, the Ara Pacis was extracted with extraordinary ingenuity, skill, and patience, and then reassembled, together with most of the reliefs that had been dispersed (and copies of those that could not be acquired).[49] The monumental altar was erected on a parcel of land a short distance from its original location, between the Tiber River and the Mausoleum of Augustus. There it formed part of a large complex created for the celebration of the bimillennium of the birth of Augustus in 1937.

The reconstructed and reoriented Altar of Peace was enshrined within Vittorio Ballio Morpurgo's glazed temple-like structure, which, like the altar itself, was raised on a pedestal and approached by a monumental staircase (see figure 20 in chapter 3). The stripped-down, modernist fasces visible in the photograph from 1938 on the upper corners of the front façade were later removed, and the entire structure was recently torn down to make way for a replacement. A necessity of preservation, this encasing shell is treated in most accounts as either invisible (in photographs that crop it out or in texts that ignore it) or deplored. Deemed "banal" or worse, Morpurgo's structure nevertheless framed the ancient monument, literally and figuratively. It is through Fascist Italy that we can see the Ara Pacis at all. The current project to replace it with a structure by Richard Meier as part of a complex of buildings at the site may not have to do with architectural style alone but also with wiping out the memory that still adheres to the monument.[50]

A related campaign from 1926 to 1938 "liberated" the Mausoleum of Augustus, the emperor's ostentatious funeral monument, not only from the later accretions that completely obscured it but also from the cramped urban setting that "suffocated" it (in the words of Muñoz) and from its living function as a concert hall (figure 4).[51] The excavation answered a number of questions about the monument, but only a ravaged core remained after the removal of the additions of the twelfth, sixteenth, and early twentieth centuries.[52] Spiro Kostof has summed up the restoration process: "[The] mausoleum that had been in more or less constant use for centuries was transformed . . . into an authentic Roman ruin."[53] Or, following Dezzi Bardeschi on nineteenth-century restorations in Florence, we could say that what emerged was not the original itself (which is never entirely recoupable) but another, a double of the original.[54] The cypress trees planted on the first of the three circular tiers evoke Strabo's account of evergreen trees there, while modern structures designed by Morpurgo frame the bared core.[55]

The nearby Ara Pacis (at the left of figure 4) and the Mausoleum of Augustus in its piazza together produce a unified composition, albeit one that never existed in antiquity. Although Augustan monuments indeed filled this area, called the Campus Martius, the altar and tomb did not exist in any physical, iconographic, or symbolic relationship to each other. In the Fascist piazza, however, the two newly juxtaposed Augustan monuments symbolize both Augustan imperial greatness and its counterpart in the new Italy, which Mussolini proclaimed an empire in 1936.

The Fascist concept of "liberation" of ancient monuments, which obliterated other pasts and established a direct relationship with the present, can also be applied to various investigations into the past. Fascist-sponsored exhibitions and institutes, as well as the periodicals and scholarly activity that were initiated under the regime, could also be construed as liberating a past useful to the regime. The aspects of the past most relevant to the present were selected from an infinite number, freeing them from later accretions (contexts and interpretations in this case), framing and monumentalizing them, and establishing their significance for the present.

## Telescoping Past and Present

The efforts at linking the past with the modern in Fascist Italy aimed not only to emphasize the continuity between them but also to telescope, or fuse, different periods by eliminating everything extraneous that had accrued over the centuries and by focusing exclusively on common elements.

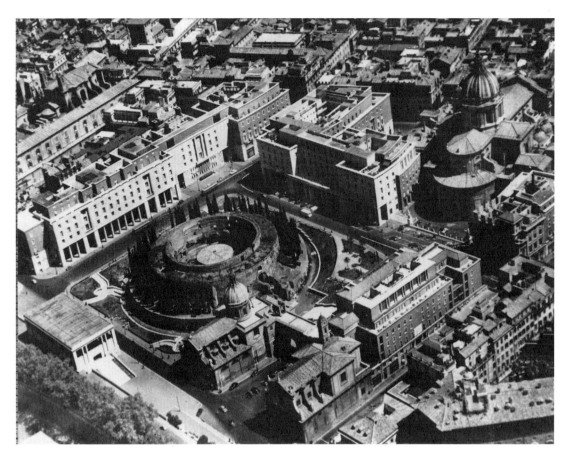

**Figure 4** Aerial view of Piazzale Augusto Imperatore. Fototeca Unione, FU 4371.

The Ara Pacis, enclosed and echoed by a modern building similar in general form, suggests a symbiotic relationship between past and present. Ancient Roman structures restored under Fascism influenced modern architecture; but modern designs also influenced the restoration and reconstruction of ancient buildings and gave them, as William MacDonald demonstrates, a "1930s" look. Excavations and publications made new models available; and architects worked on the restorations, resulting in the architectural intertwining of the two periods.[56]

In another telescoping strategy, the regime sponsored modern design activities in conjunction with the recuperation of the past. One of these, a competition for a garden in the "Italian" style, accompanied the 1931 Exhibition of the Italian Garden.[57] Journals such as *Capitolium* interspersed articles on historic sites in Rome with those celebrating Mussolini's excavations, restorations, and urban renewal projects. Such journals made the past familiar and established a shared cultural heritage, associating that past with current activities. Fascist-sponsored exhibitions pursued the same ends yet more aggressively. Past and present converged in the common practice of inaugurating an exhibition, restoration project, or new structure or avenue on a significant anniversary of ancient or Fascist Italy. The principal anniversaries were the March on Rome (October 28), the birth of Augustus (September 23), and the "birthday" or founding of Rome (April 21), which was also the Fascist Labor Day.[58] As we have seen, the result was work done in enormous haste, and with partial or nonexistent documentation.

## The Timelessness of the Past: The Augustan Exhibition of Romanness

Of the large exhibitions staged under the direct or indirect sponsorship of the regime, the Mostra Augustea della Romanità (Augustan Exhibition of Romanness) was second in importance only to the Exhibition of the Fascist Revolution. The extensive Roman exhibition ran for a year beginning in September 1937 at the Palazzo delle Esposizioni in Rome, in celebration of the bimillennium of the birth of Augustus and in conjunction with the restorations of the Ara Pacis and Mausoleum of Augustus. Giulio Quirino Giglioli, a professor at the University of Rome and an influential archaeologist who initiated the excavation of the mausoleum, also directed the exhibition. A prominent member of the Institute for Roman Studies (founded by intellectuals who were already proponents of *romanità* from pre-Fascist days), Giglioli was well-known for his vocal affiliation of archaeology with the aims of the regime.[59] In the catalogue, Giglioli stated the exhibition's objective as presenting the history of *romanità* from the founding of Rome in the eighth century B.C.E. to the "Church Triumphant" in the sixth century. Although focused on the great age of Augustus, the exhibition postulated continuous cultural and social ideals from Rome's origins into the Christian era. As one of its promoters explained, the exhibition also intended to illustrate the correspondence and continuity between Roman past and Fascist present, and the greatness of the Roman *stirpe*.[60]

The didactic exhibition displayed thousands of objects, all of which were reproductions: plaster casts, plastic models, reconstructions both miniature and life-size, and enlarged photographs.[61] So many artifacts and monuments of Roman antiquity had never been seen together before, although both the idea of an exhibition of reproductions and some of the objects themselves originated a quarter-century earlier. The nucleus of casts dated from the Archaeological Exhibition of 1911 (commemorating fifty years of Italian unity); the casts were later permanently installed in the Museum of the Roman Empire,

inaugurated in 1927, and in both Giglioli was a major participant.[62] The general idea of the Augustan Exhibition, some of the reproductions, and the ideological framework of the supremacy and civilizing mission of Roman culture were all inherited from the 1911 exhibition and 1927 museum.[63] Nevertheless, the differences in the Augustan Exhibition provide the key to distinguishing Fascist and pre-Fascist uses of the past.

The Augustan Exhibition assembled an enormously greater number of objects than the preexisting core, including over twenty-one thousand casts, about two hundred architectural and topographical models, and a vast photographic documentation. Among the collaborating scholars, Massimo Pallottino, a pupil of Giglioli and an archaeologist, had responsibility for a large number of rooms. The exhibition was significant for the sheer amount of information assembled in a library, photographic archive, and collection of numismatic casts, all of which provided the basis for further study of Roman art as well as the encouragement to do so.[64] The original plan to house the exhibition materials in a permanent museum with a study center was finally achieved in 1952–55, with the Museo della Civiltà Romana (Museum of Roman Civilization) at EUR.[65]

The organization of the Augustan Exhibition departed from those of the 1911 and 1927 installations by grouping materials not by region but in thematic categories, from "Law" and "Family Life" to "Hygienic Installations" and "Theaters and Amphitheaters." These categories aimed to represent the universality of Roman civilization throughout the empire and its logical and orderly evolution.[66] Works of art and architecture exemplified Roman history, culture, law, politics, and society, and manifested the unchanging values and institutions of Roman civilization.[67] Since the aim of the exhibition was continuity, not change over time, the objects were not displayed to demonstrate a development of style or content, or as products of their social and cultural context, since these all posit change. The Augustan Exhibition developed and elaborated the construction of the past that the term *romanità* implied. The organizational framework as

much as the wealth of material institutionalized this constructed past.

Giglioli understood that reproductions, rather than original objects, facilitated his aims. Although all museum displays to some extent remove art from tradition, they also enshrine the objects exhibited as unique and authentic works of art. Exhibitions of reproductions do the opposite: they remove the authenticity and uniqueness from the art object. Walter Benjamin, in his famous essay, "The Work of Art in the Age of Mechanical Reproduction," first published in 1936, the year before the Augustan Exhibition, argues similarly that a mechanical reproduction detaches the object reproduced from the fabric of tradition to which it belongs.[68] The reproductions in the Augustan Exhibition freed the works of art from their role as "art" and from their artistic traditions. This enabled the monuments to serve a more ideologically burdened narrative of the past. Giglioli explained in the catalogue that creating the exhibition from reproductions and reconstructions allowed the wealth of material to be arranged "in a rather more modern manner."[69] This could mean both relevant to present political purposes and also "modern" in an aesthetic sense.

Giglioli maintained that the architectural installations and innumerable explanatory inscriptions made the exhibition accessible to a general audience.[70] For the Augustan Exhibition a temporary façade again transformed the beaux-arts Palazzo delle Esposizioni, not a strikingly abstract one as that for the Exhibition of the Fascist Revolution, but a modernist version of a triumphal arch (see figure 32 in chapter 5).[71] Writing in large block letters entirely covered the walls on each side of the façade's centerpiece; the writing included the hortatory phrase "Let the glories of the past be surpassed by the glories of the future."[72] In his commentary in *Capitolium*, Pallottino affirmed that the key to the exhibition was to instill pride and responsibility for such an inheritance.[73]

The room installations, designed by various architects, displayed the reproductions of antiquities in dramatic settings with dominant, and sometimes huge, inscriptions, as in the Sala dell'Esercito (Room of the Army) (figure 5). Mario

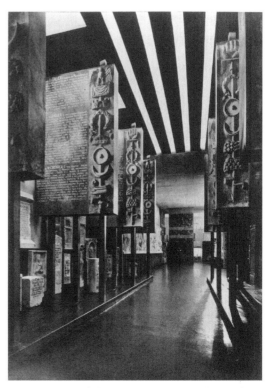

**Figure 5**  Room of the Army, Augustan Exhibition of Romanness. *Capitolium* 12 (1937).

Paniconi and Giulio Pediconi designed this and several other rooms, and later also the grand entryway for the 1942 Exposition at EUR. In 1931, Pediconi, a Rationalist architect, had become one of the three directors of the Fascist Syndicate of Architects.[74] The installations of the Augustan Exhibition are generally characterized as conservative and traditional in comparison with the installations of the Exhibition of the Fascist Revolution (see figures 14–18 in chapter 2 and figure 97 in chapter 14). If, however, the Augustan installations are compared instead with those of the 1911 exhibition and the 1927 museum, they can be understood as "modern" and "dramatic." The omnipresent inscriptions interspersed canonical ancient authors, Fascist mottoes, and Mussolini's own words, presenting them all as continuous and equivalent.[75] The modern materials and techniques of installation—plastic and glass, strong contrasts of lighting, partitions, broken wall surfaces, and rooms of varying shapes and dimensions—must have appealed to an audience accustomed to such devices from previous exhibi-

tions, films, and advertising. The installations to-gether with the inscriptions and juxtapositions of historical and contemporary objects would have made the overriding message of continuity with the Roman past compelling and "accessible."[76] Extensive publicity and reduced-price train tickets also worked to the same end.[77] The million visitors during the 406 days the exhibition was open must have learned much about Roman history, while also imbibing the propaganda.[78]

Such a juxtaposition of art objects and texts, both removed from tradition and context, posits a relationship of correspondence and similarity, not a historical, developmental, or narrative relationship, not model and copy, original and revival, or symbolic return. The juxtaposition implies a seamlessness between past and present. All objects and their reproductions, both ancient and modern, restored buildings and modern ones inspired by ancient examples but stripped of historical markers, embody not the original historical moment but a timeless and universal *italianità*.

## Italians Construct a National Culture

Gustavo Giovannoni, the influential architect and head of the architecture school in Rome, emphasized the importance of the panorama of Roman architecture presented in the Augustan Exhibition. He explained that for the first time all major architectonic works throughout the empire could be viewed together. This made possible their reevaluation since previously Roman architecture was little studied and generally undervalued in comparison with Greek and oriental traditions.[79] The exhibition provided the impetus to appreciate and to study Roman culture and artistic traditions, and reinforced the general concerns of the Fascist regime to encourage and to facilitate such study. Among the cultural and scholarly institutions founded in the Fascist period were the Institute for Roman Studies (1925), the Royal Academy of Italy (1926), and the National Institute for Studies on the Renaissance (established by royal decree in 1937). Giglioli belonged to the Institute for Roman Studies, a private group of proponents of *romanità* and empire, supported with grants from the

local Roman government.[80] To serve the Italian Institute for Archaeology and Art History, which was established in 1919, an Italian national library was inaugurated in Palazzo Venezia in 1922 and was expeditiously stocked.

In 1935, the archaeologist and art historian Antonio Muñoz gave a revealing account of the significance of the national library. He listed all the foreign institutes in Rome and explained that with the Italian library, Italian scholars no longer had to suffer the shame of seeking hospitality for their researches at the institutes of other nations.[81] Scholarship on Italian monuments would henceforth be sustained with Italian resources. The *Italian Encyclopedia,* initiated in 1925, provided another native Italian source for knowledge, especially of things Italian. The first volume appeared in 1929 under the directorship of Giovanni Gentile, philosopher, author of the "Manifesto of Fascist Intellectuals," and member of the Fascist Grand Council, the highest organ of the Fascist regime. Although not all authors of the encyclopedia entries were avowed Fascists, in 1931 an oath of allegiance to Fascism was required of all university professors.[82]

Attempts to revitalize Italian scholarly activities and to reclaim the Italian past from foreign "occupation" in scholarship by founding institutes and libraries can be understood as a reaction to the centuries of foreign domination in the history of the Italian peninsula.[83] Otto Brendel's *Prolegomena to the Study of Roman Art,* written in the mid-1930s, surveys the scholarship on Roman art, which non-Italian scholars dominated until the '30s. Brendel identified in this body of scholarship a nationalistic theory of artistic style, which emerged particularly in 1925 in the work of two German-language scholars. This theory posits that nations produce styles, and that the aim of scholarship is "to discover an inner coherence, i.e., an inherent *Romanitas,* in all Roman works," despite their tremendous diversity and many outside influences. Fascist cultural propaganda bore out Brendel's assessment of the implications of this theory: "[I]t is only one step further to the assumption that the entire history of Roman art . . . is only the evolution of a single inherent principle from its primitive or prehistoric origins to its final disintegration." In the

scholarship on Roman art, the result was an interpretation of Roman as "Italic," meaning native, constant, and manifesting national character.[84] The common practice of distinguishing stylistic characteristics that are innate and immutable within an ethnic group Brendel termed "nationalistic art criticism." In the early twentieth century, nationalism influenced scholarship on much more than Roman art, as illustrated by the powerful impact of nationalism on the conceptualization of both German and Italian garden traditions.[85] The nationalist approach to Roman art by non-Italian scholars set the stage for the assertion throughout the Fascist period of the constant character of Roman civilization, the denial of foreign influences on Roman art, and the exclusion of foreign scholars who studied it.

Under the Fascist regime, ideology infiltrated scholarship in a much more overt and profound manner than before and with far-reaching consequences. In an editorial in the first issue of *Le Arti* in 1938, Giuseppe Bottai, then minister of national education, announced that the journal would demonstrate that Italian art and criticism were conscious of their political function.[86] Concern with *romanità* stimulated the study of Roman culture at the expense of Greek, and the interpretation of Roman culture as superior, univocal, universal, and enduring in modern Italy. Investigations of the past paralleled contemporary concerns—among them, the relationship of ancient Romans with the Gauls and particularly Roman Africa.[87] In Fascist propaganda, the ancient Roman sphere of influence in Africa justified and legitimized Fascist Italy's imperialist activity there. The studies of classical scholars in the Institute for Roman Studies supported Italy's mission: to bring civilization, of which Rome was the source, to Africa.[88] Classicists were not alone in providing scholarly backing for the colonial expansion. As Henry Millon demonstrated long ago, even architectural historians in scholarly journals bluntly advocated an expansionist foreign policy, based on the precedent of Roman antiquity.[89] The endgame of *romanità* was empire, what Visser describes as "the mission to spread Roman virtues and values throughout the world,"[90] which both scholarly and more popular investigations supported. The Exhibition of Rural Architecture in 1936 displayed Italian structures together with similar ones from throughout the Mediterranean in order to demonstrate a timeless *mediterraneità*, the Mediterranean culture spawned by the Roman Empire and containing its essential values.[91] The exhibition asserted the autochthonous character of vernacular architecture in the Mediterranean, which in turn justified the reclaiming of territory in Africa from a "barbaric empire" to reinstate its rightful heirs, the "Empire of Rome."[92]

The construction of an Italian national identity entailed the repudiation of the foreign, in language, scholarship, and architecture. Establishing a common language was a particular priority in Italy, where regional dialects prevailed. In 1922, little more than fifty years after unification, there was no radio, no newspaper with a circulation of more than half a million, and widespread illiteracy, especially in the South.[93] The xenophobic effort to legislate "linguistic nationalism" attempted both to cleanse the Italian language of foreign importations and to obliterate historical regional dialects.[94] Fascist usage—terms, metaphors, speech patterns, and syntax—shared in the construction of a Fascist subjectivity. This usage appears in the rhetoric of architects and architectural historians as much as in Fascist manifestos.

Scholars in the Fascist regime also protected Italy's cultural legacy from foreign contamination. In 1927, Bottai explained one of the purposes of an Italian academy as preserving "the artistic patrimony of our race, which must be protected—as it is not today—not only from the harmful effects of time . . . but especially from foreign influence and contamination."[95] Academicians, he argued, should speak out against "intellectual and aesthetic aberrations of a foreign and barbaric nature." Scholars took up the challenge, one suggesting in 1936 that non-Italians writing about Italian art did not really know it and minimized its originality.[96] The chauvinistic implication, abetted by the Fascist regime, was that it was necessary to be Italian to study Italian art and to have access to its significance for the present. The law founding the Italian academy in 1926 stipulated among its goals keeping pure the national character, as well as affirming Italy's primacy in the arts and sciences.[97] The term "cultural autarchy," which alludes to the Fascist ideal of economic self-sufficiency, characterizes this

elimination from Italian cultural life of all foreign influences.[98]

## Italianness in Architecture

What style in art or architecture corresponded with this aim of cultural autarchy? A variety of stylistic trends coexisted in Fascist Italy, as illustrated by the Exhibition of the Fascist Revolution, the University City (Città Universitaria), Mussolini Forum (now Foro Italico), and EUR. All were collaborative projects on which architects and artists representing a range of traditional and avant-garde trends worked. Only in 1934, when Rationalist architects were widely criticized, did Mussolini pronounce judgment and contend that "it is absurd not to wish a rational and functional architecture of our time."[99] In 1937 Mussolini approved an "audaciously modernist" design for EUR, although its final form has seemed instead a triumph of classicism.[100] To be acceptable, however, each of the different styles had to be demonstrably distinctively Italian. Traditionalist, Novecento, and Rationalist architects all agreed on the importance of referring to the past; they disagreed on which past and how to incorporate it into architecture for the present.[101]

Ugo Ojetti, influential journalist and art critic, organizer of art exhibitions, member of the Royal Academy from 1930, founder of periodicals on the arts (*Dedalo, Pegaso,* and *Pan*), and ardent Fascist, most vocally and visibly advocated the conservative traditionalist camp in architecture.[102] This "ultra-refined conservative aesthete" was also a millionaire, president of Alfa Romeo, and board member of other major corporations.[103] Ojetti argued adamantly for the arch and column as the essential embodiments of Italian identity in architecture. As signs of the classical tradition in antiquity and from the Renaissance on, arches and columns were also heavily encoded with social and political meanings.[104] The traditionalist style was an obvious candidate for an official Fascist one. Its academic supporters included the architectural historian Gustavo Giovannoni, who in 1943 cited Hitler's *Mein Kampf* in explaining his view that until a "national" style developed, classical

architecture was a better alternative than the International Style.[105] Other architectural styles, similarly imbued with Fascist ideology, likewise claimed to represent Italian identity but based on different notions of what was enduring in Italy's cultural heritage.

## Finding the Italic in the Vernacular

The Rationalists' bid for *italianità* emerged emphatically in their defense against the charge that their modernist architecture with its international basis was foreign, even German.[106] In 1932, the same year as his winning entry for the Florence train station, Giovanni Michelucci published three photo-essays in the periodical *Domus,* which illustrated "contacts" between Italian architecture of the past and Rationalist architecture.[107] Michelucci did not present models from the past but rather "contacts" and "rapproachements," evidence of shared sensibility and affinity of spirit between two "artistic moments." His historical examples were not "renowned monuments," but "minor" and rural architecture—Tuscan farmhouses, fifteenth-century unarticulated stone walls, the painted architecture in fourteenth-century frescoes (figure 6). Michelucci's argument was that the new forms of modern architecture had their roots in a native tradition of pure and simple forms without precious materials, ornament, or the burden of representing a historical moment. To reinforce the visual relationships among his examples, Michelucci used the common technique of montage—cropping and overlapping photographs.

To argue shared formal values through striking similarities of simple, flat-roofed blocks and of contrasting masses and rectilinear voids required, however, a selective reading of the evidence. Michelucci ignored all markers of historical specificity or function (such as the sloped roofs of the farmhouses), as well as differences in materials, scale, and context. These photo-essays recall Benjamin's argument in "The Work of Art in the Age of Mechanical Reproduction" that photographs detach the original object from historical tradition.[108] The frescoes represent imaginary, not real, structures, and their modern counterparts are watercolors, not the buildings themselves. Further re-

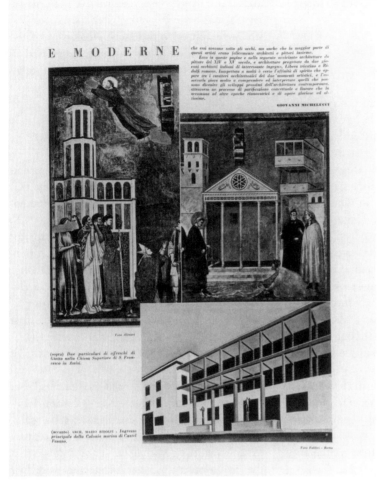

**Figure 6** Giovanni Michelucci, "'Contacts' between Ancient and Modern Architecture." *Domus* 5, no. 51 (March 1932).

moving the imagined structures from tradition is the overlapping of images, which emphasizes the photograph as distinct from the building it represents. Mechanical reproductions of theoretical buildings, juxtaposed and overlapped, "liberate" the buildings from any historical context. The buildings of the past, removed from the fabric of tradition, lose their uniqueness and are rendered ahistorical and timeless. The past thereby becomes modern as much as the modern is revealed to be traditional.

Investigation of rural and vernacular architecture flourished in Italy in the '30s, as a demonstration of *italianità*, and framed by the interest of the Rationalists. As with other aspects of the past literally and figuratively dug up in Fascist Italy, programmatic study and publication took place on an impressive scale. Until the mid-1920s,

Americans and the British dominated the investigation of rural architecture in Italy with such works as Guy Lowell's *Smaller Italian Villas and Farmhouses* (1916) and M. O. and K. Hooker's *Farmhouses and Small Provincial Buildings in Southern Italy* (1925). Many investigations by Italian authors followed, among them Giuseppe Pagano's articles in *Casabella* in 1935, exhibitions of rural architecture in 1936 and of the rural Tuscan house in 1937, and the 29-volume series *Richerche sulle dimore rurali,* which began in 1938.

"Indigenous," the modern Italian term that corresponds with the English "vernacular," conveys the understanding of rustic architecture in the '30s as unchanging, constant, spontaneous, and evidential of the natural and autochthonous. In his entry on rustic architecture in the 1936 edition of the *Italian Encyclopedia,* Plinio Marconi (editor in

chief of the periodical *Architettura*, the official organ of the Fascist union of architects) characterized it as natural and spontaneous, and as emerging from the native soil almost like the plants themselves.[109] In another metaphor, Marconi compared rustic architecture to simple, spontaneous, popular poetry. Like popular poetry, rustic architecture was not historically contingent. Various architectural camps affirmed the significance of an indigenous tradition, from Marconi with his middle-of-the-road traditionalist attitudes to the prominent architect Giuseppe Pagano, one of the radical members of the Rationalists.

In connection with the 1936 Milan Triennale, Pagano, together with Guarniero Daniel, organized the Exhibition of Rural Architecture, which demonstrated the collective Mediterranean character, or *mediterraneità*, of its examples. The installation consisted of photographs displayed in rows on large panels (figure 7). Their grouping according to formal similarities, independent of function and building type, worked again to detach them from historical and regional contexts. In this set of structures, the sequence of arches, through its repetition in seemingly endless examples, becomes the principal sign of rural architecture, with the implication that a common spirit inspired them all. The display of photographs also presents these structures as the solution to a functional problem, and as the demonstration of the gradual, teleological process that produced the most perfect and logical form.[110] The text extols "instinctive" and "primordial" logic, "autochthonous language," and "pure" aesthetics, in contrast to the "stylistically falsified" in traditionalist architecture.

Despite their different attitudes toward modern architecture, Marconi, Pagano, and Daniel all shared a belief in a native tradition that emerges from the soil. This view of rural architecture coincided with Mussolini's policy of "ruralism"—improving the arable land, stimulating agricultural production, and upholding the "timeless" and "traditional" values of rural life in the face of Italy's transition to an urban-industrialized nation.[111] Typical of the contradictions within Fascist policy and decision-making, a "return to tradition," which revived local festivals and traditions, occurred simultaneously with the effort to purge regional dialects of all that was not national.[112] The revival of regional culture provided the impetus for the classification of regional types in rural structures, although even within these subdivisions, rural buildings were framed as enduring and unchanging.

Enthusiasm in the '30s for rural and "indigenous" architecture inspired numerous publications, which in turn determined how rural architecture was to be studied and understood for nearly half a century. From about 1980, economic pressures on the countryside led to a renewed interest in rural structures and new directions in their study. The synchronic approach in most studies of farmhouses until the '80s, which emphasized the spontaneous, timeless, innately Italian, and authentic, classified regional types according to climatic and functional circumstances, with little concern for the histori-

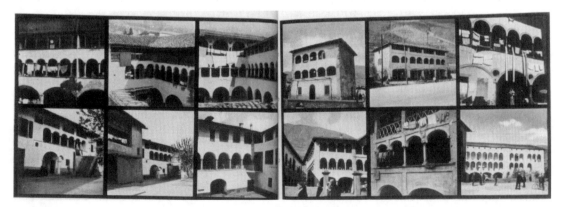

Figure 7  Giuseppe Pagano and Guarniero Daniel, *Architettura rurale italiana*, 1936, Exhibition of Rural Architecture.

cal circumstances of their development or their relationship to elite architecture. My own study of surviving examples of one building type, most dating from the sixteenth through the eighteenth centuries, demonstrates that, far from emerging from the soil, this type resulted from a complicated relationship between high and low, designed and vernacular architecture.[113]

The conception of rustic architecture as an autochthonous emanation from the soil and the notion of a timeless *romanità* passed on by a continuous lineage both emphasized the constant and unchanging, although they derived from different notions of origins: natural versus cultural. Opposing architectural traditions claimed to represent each in turn. Nevertheless, these two concepts with their corresponding architectural traditions merged in the projected Exhibition of Italian Civilization (Mostra della Civiltà Italiana) and in the structure to house it at the 1942 Universal Exposition of Rome. This exhibition aimed to demonstrate the constant and enduring qualities of the Italian people from prehistoric times to Mussolini, even though the unifying theme of the continuity and primacy of Roman civilization coexisted uneasily with a linear narrative of history.[114] This monumental endeavor required the participation of almost everyone connected with the universities, the Italian academy, research institutions, and public instruction. In the words of the distinguished intellectual historian Eugenio Garin, from 1936 on the enterprise was truly an "Olympics of Civilization, as the exposition itself was conceived."[115] The accompanying luxury journal, *Civiltà,* inaugurated in April 1940, featured essays that corresponded with the planned exhibitions, also by members of the Italian academy, university professors, and other intellectuals and cultural critics.[116]

The Universal Exposition planned for 1942 was canceled but only after the construction of a number of buildings on the site, among them the one intended to house the Exhibition of Italian Civilization (figure 8). The design of the Palazzo della Civiltà Italiana (Palace of Italian Civilization, now Palace of Labor) by a team of Rationalist architects, Giovanni Guerrini, Ernesto La Padula, and Mario Romano, responded to the stipulations of the competition. The seemingly contradictory requirements included reference to

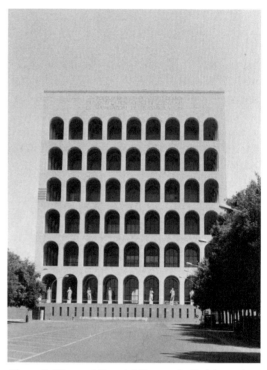

**Figure 8** Giovanni Guerrini, Ernesto La Padula, and Mario Romano, Palazzo del Lavoro (formerly Palazzo della Civiltà Italiana), EUR, Rome, 1938.

the classical tradition, but in a modern and functional form, and local materials with a minimum of steel.[117] The specifications on materials resulted from the policy of autarchy, or self-sufficiency in industrial and agricultural materials, following the sanctions imposed on Italy after the invasion of Ethiopia in 1935. (The original plan for EUR of 1937, however, called for huge structures sheathed in glass and steel.)[118] Criticism of the Palace of Italian Civilization at its completion as well as conflicting interpretations in the late twentieth century centered on the use of travertine revetment over a reinforced concrete skeleton, and the consequent disjunction between form and structure.[119] The spare, unornamented arches on all four sides and six stories refer at the same time to grand imperial architecture like the Roman Colosseum and to the vernacular Italian tradition demonstrated in the Exhibition of Rural Architecture (figure 7). Rows of superimposed arches characterize many other common building types as well, such as the late twelfth-century city gate, the Porta Vittoria, in Como (figure 9). This gate represents a common type, and probably not a direct influence, but the similarity suggests a

{}

and many similar structures built in the '30s while the Ostia excavations were under way. The modern buildings strikingly resemble the ancient ones in the broad, unarticulated walls and repeated arches, as well as in the effect produced: without decorative ornament, scale is hard to comprehend.[122] MacDonald described the style of the Palazzo della Civiltà Italiana similarly as "submodern" rather than modern, a "quasi-style" that evokes both traditional and modern, a kind of "late-antique modern."[123] The palazzo indeed demonstrates the "perpetual repetition" of the arch in the history of architecture on the Italian peninsula. It also shares with imperial Roman structures an imposing character precisely from the lack of classical orders and decorative ornament, which gives both the look of modernity and the feel of authoritarian rule. The exhibition to be housed within it would have had a similar imposing quality, if also a presumptuousness in scale and a heavy-handed use of the past, without, however, presenting a creative and modern narrative of Italian history that could have been a workable model for the future.

THE FASCIST REGIME profoundly influenced the investigation of the past. It stimulated scholarship in areas previously little studied by Italians, among them Roman art and architecture, vernacular architecture, and Italian gardens, and it fostered the excavation and restoration of surviving examples. All had an explicit relationship with contemporary architectural practice, and all also served propaganda purposes. As inscriptions and fasces were later removed from buildings, names of streets and buildings changed, and the rhetoric of violence and domination excised from scholarship, the crucial intervention of Fascism in these areas of study has been similarly erased. To recall this intervention now is not to invalidate or to condemn all study of the past under the Fascist regime. To point out the traces is necessary, however, in order to demonstrate that the received understanding of the past in the late twentieth and early twenty-first centuries bears the imprint of the uses to which those researches were put. Fascism is part of the history of twentieth-century scholarship, as it is a part of modernism.

**Figure 9** Porta Vittoria, Como, 1192. Photograph by the author.

conscious reference to architectural forms understood as indigenous.[120] Gaetano Minnucci, second in command at EUR, defended the Palazzo della Civiltà Italiana with the argument that the arch refers to the heritage of ancient Roman architecture and that the repeated arches allude to "the uninterrupted repetition of arches in the tradition of Italian architecture."[121] Late twentieth-century criticism interprets the arches in the travertine revetment predominantly as an expression of reactionary *romanità,* but they could also represent the Italic, or indigenous Italian, as Minnucci intimated. My point is that the building is purposefully encoded with multivalent signifiers, which refer at the same time to *romanità* and to the Italic, to classical and vernacular traditions, just as the exhibition that it was to house represented Italian civilization as monolithic from prehistoric to Fascist times.

The historian of classical architecture William MacDonald has pointed out the relationship between the "plain style" of imperial Roman architecture, which is particularly evident at Ostia,

# To Make History Present

*Claudio Fogu*

*No wonder, gentlemen, if side by side the shirkers of war we find the shirkers of history, who, having failed — for many reasons and maybe because of their creative impotence — to produce the event, that is, to make history before writing it, later on consume their revenge diminishing it without objectivity or shame.*

—Benito Mussolini, 1929

WITH THESE WORDS, delivered to the Fascist senate on May 24, 1929, Benito Mussolini—at last—offered a spectacle for which the whole Fascist intelligentsia had been waiting: a direct confrontation between the "Duce" of Fascism and the "laic pope" of liberalism, Benedetto Croce.[1] As the Fascist press was quick to remark, Mussolini's analogy between the shirkers of war and the shirkers of history was directed against Croce's negative response to the concordat between the Fascist state and the Vatican, and he connected it to the conspicuous absence of the Great War and Fascism from Croce's recently published *Storia d'Italia dal 1870 al 1914* (1928). But as Croce himself recognized twenty years after the fact, Mussolini's attack on his *Storia d'Italia* was directed at much more than this single book; it assailed the very "aesthetic-philosophical tenets" of historicism.[2] In fact, almost overnight, Mussolini's sentence was transformed into one of the most popular Fascist mottoes, "Il Fascismo fa la storia, non la scrive" (Fascism makes history rather than writes it), which, turn-

ing temporal succession into all-out opposition, tempered the polemical sting of Mussolini's phrase while sharpening its ideological stakes.[3] Below the polemical jab directed against Croce lurked the suggestion that the ideological opposition between Fascism and liberalism was based on two opposite conceptions of the relationship between *res gestae* and *historia rerum gestarum* (reality and image): Fascism *made history* by producing epochal events, whereas liberalism *wrote* it to unmake them.

Granted, Fascist ideology did not rest on a systemic philosophy of history comparable to the ones elaborated by Kant and Hegel for liberalism or Marx for communism. Yet Mussolini's attack on Croce, and the motto that derived from that attack, referred to a peculiarly Fascist vision of history that was never systematized discursively but rested on specific philosophical bases and resonated with long-standing popular cultural traditions. To begin with, the ontological dichotomy between liberal history-writing and Fascist history-making translated into ideological terms the reorientation of historical consciousness in the aftermath of the Great War from "history belonging to the past" to "history belonging to the present," as theorized by Giovanni Gentile, Fascism's prime philosopher and Croce's philosophical nemesis.[4] For Gentile, the peculiar Italian experience of the Great War had pushed Italian masses and leaders away from all transcendental (that is, historicist, idealist, and materialist) conceptions of history "belonging to the past," and toward the *actualist* notion of history that "be-

longs entirely to the present" (that is, "presupposes nothing because it is all present and immanent in the act of its construction").[5] With the end of the Great War, Gentile concluded, the Italian stage was set for the birth of a new political subject whose vision would be funded entirely on history belonging to the present.

Mussolini's image of Fascist history-making can thus be seen as a belated recognition that Fascism had constituted the new political subject invoked by Gentile in 1919. In this respect, Mussolini's words can be seen as providing an implicit confirmation that a certain "pre-established philosophical harmony" between actualism and Fascism had indeed existed long before 1923, when Gentile agreed to serve as minister of education in Mussolini's first government and began to openly support Fascism in his writings.[6] In fact, looking closely at Gentile's philosophy of history helps to appreciate the cultural depth of the Fascist vision of history. At a theoretical level, the actualist notion of history belonging to the present fits all the parameters of a quintessentially modernist philosophy of history. It certainly proposed a new way "of imagining, describing, and conceptualizing the relationship obtaining between agents and acts, subjects and objects, events and facts," which Hayden White describes as the landmark of all modernist conceptions of history.[7] And it surely participated in the evolution of modernist poetics after the Great War, characterized, according to James Longenbach, by the search for a new "historical sense" that would involve "the perception, not only of the pastness of the past, but of its presence."[8] From this perspective, actualist philosophy of history can be understood as theorizing a conflation of the historical and the historiographical act. This conflation eliminated the medium of (historical) representation between (historical) agency and (historical) imagination, thereby providing an ideological bridge between the Fascist rejection of political representation and the Futurist critique of aesthetic representation. In fact, I argue that this modernist trait made the expression of Fascist history-making particularly resonant with Futurist aesthetic principles.

Yet actualist philosophy of history also unveiled the popular cultural roots of the Fascist vision of history. Gentile's polarization of the notions of "history belonging to the past" and "history belonging to the present" reified and ontologized the discursive distinction between the idea of *historicalness*, meaning simply "belonging to the past," and that of *historic-ness*, inscribed since the dawn of modern historical culture in expressions such as "historic speech" "historic site," and "historic event." Historicness refers to the perception of an eventfulness that not only opens a new history but also signifies the past retroactively. In this respect, the Fascist vision of history can be understood as mobilizing a popular cultural paradigm of historic semantics that had been submerged, but not extinguished, by the establishment of modern historical culture.[9] Merging the related notions of eventfulness (event), unmediated presence (site), and signification (speech) elicited by the notion of historic-ness, the idea of making history attributed to Fascism a *historic agency* that acted on historical facts, representations, and consciousness. At the same time, the idea of making history associated the Fascist collective subject with the formation of a *historic imaginary* that declinated the past in the present tense and inscribed historical meaning under the immanent rubric of presence. In fact, probing a bit deeper into the genealogy of actualist philosophy of history helps us to understand that the Fascist rejection of history-writing was not to be taken literally but referred to a specifically "visual" notion of historical representation and consciousness.

Gentile's concept of history belonging to the present translated specifically the original meaning of the term historic devised by early modern grammarians to define the use of the present tense instead of the past in "vivid" narration of past events. In this crucial respect, actualist philosophy of history bonded the formation of the Fascist historic imaginary to the ancient rhetorical notion of vividness, *enàrgeia*. Originally the notion of *enàrgeia* was developed in ancient Greek historiography in order to refer to a special "effect of presence" obtained in narrative writing, and was translated in Latin rhetoric into *evidentia*. In time, however, *enàrgeia-evidentia* came to be inscribed at the center of the Latin-Catholic

notion of visual representation (*imago*).[10] As David Freedberg reminds us, the institutionalization and diffusion of this rhetoric of presence in Latin-Catholic visual culture was responsible not only for a long-standing subordination of the discursive to the visual but also for the formation of a peculiarly Catholic imaginary dominated by a mixture of fear of and attraction for "the ontological fusion" between the image and its prototype.[11] It should therefore not be surprising that the rhetorical intensification of presence in Catholic culture would survive in the popular cultural notion of historic eventfulness and find its theorization in a philosophical system, actualism, which Gentile had conceived as an immanent revision of Catholicism. Paraphrasing Freedberg, we may conclude that actualism gave philosophical form to a visual paradigm of historical consciousness grounded in a mixture of fear of and attraction for the ontological fusion of *historia rerum gaestarum* and *res gestae*. In so doing, actualism offered Fascism a modernist vision of history implicitly founded on the Latin-Catholic subordination of the discursive to the visual and the encoding of real presence in all forms of representation. What this means, however, is that Fascist history-making is not to be found in Gentile's elaborations of his actualist philosophy of history, or in the writings of actualist historians during the regime. The consolidation of the Fascist historic imaginary was predicated entirely on the institutionalization of a *historic mode of representation* at all levels of Fascist visual culture.

In the beginning, the Fascist historic imaginary coalesced around the celebration of the March on Rome as the historic event that confirmed the momentous reorientation of the historical imagination toward history belonging to the present that Gentile had posited in 1919. The March on Rome was ritualized as the historic event that ushered in not merely a new epoch but an epoch-making subject: a historic agent. This agent, of course, assumed immediately the imaginary semblance of Mussolini the history maker, and the image of Fascist historic agency found in Mussolini's historic speeches its first rhetorical incarnation. The "historic" encoding of Mussolini's word was just as much an affair orches-trated from above as it was dependent on the willing participation of the mass audience. In fact, the reciprocity of this process was no better illustrated than in the never-ending transformation of Mussolini's historic speeches into mottoes. At the same time, it was in the visual representation of recent national history that the connection between the popular and spontaneous construction of an imaginary Mussolini and the formation of a properly Fascist historic imaginary found the most proper means of expression in the second decade of the twentieth century. Whether in historical archives, museums, and exhibitions, or in historical monuments and commemorations, the Fascist politics of history did not settle for mere *lieux de mémoire* (sites of memory). Rather, these politics sought to create historic-production sites for the transformation of the idea of a Fascist historic agency into a historic mode of representation, and for its institutionalization at all levels of Fascist mass culture. In particular, the translation of the actualist conflation of the histori(ographi)cal act into specific image-making practices became the hallmark of an undisputed museo-technical leadership exercised by the curator of the Museum of Risorgimento in Milan, Antonio Monti.

As I have illustrated elsewhere, the curatorial principles and museo-technical innovations that Monti introduced were specifically aimed at replacing the fetishizing of memory value typical of late nineteenth-century history museums, with an absolute foregrounding of presence in representation.[12] In so doing, however, they also testified to the growing attraction that Futurist aesthetic principles exercised on visual history makers. Although Monti often referred to the Catholic principle of *invisibilia per visibilia* as the sole criterion underpinning his modernization of historical representation, his curatorial experiments were marked by an acute sensitivity to the synesthetic principles that had been posed at the foundation of Futurist art from Carlo Carrà's *La pittura dei suoni, rumori, odori* (1913) to F. T. Marinetti's manifesto *Tattilismo* (1921). For Monti, as for the Futurists, the mental-visual experience of the viewer was to be roused by sensory-visual stimulations aimed at fostering analogic rather than analytic processes of association. It was, in fact, in

Monti's contribution to the organization of two of the most significant historical exhibitions set up by the regime that we may find the thread that connected the institutionalization of the Fascist historic imaginary to the evolution of Fascist modernism.

## The Contest of Exhibitions

In 1932, two solemn anniversaries provided a unique opportunity for the Fascist regime to fix in ritual and in image the relationship between the Fascist present and the recent national past, from the Risorgimento to the Great War. Separated by four months, the celebration of the Cinquantenario Garibaldino, the fiftieth anniversary of the death of national Risorgimental hero Giuseppe Garibaldi (June 2), and that of the Decennale fascista, the tenth anniversary of the Fascist March on Rome (October 28), constituted in fact a single historic spectacle aimed at challenging and reversing the diachronic course of historical consciousness.[13] The ritual performance of the celebrations stressed the historic(al) incommensurability between Garibaldianism and Fascism by conveying the idea that it was not Fascism that gained legitimacy from the affirmation of historical continuity with the past but rather the past that gained real presence and meaning only through the Fascist act of historic representation. This was a message that was nowhere better communicated than in the two historic(al) exhibitions that crowned the two celebrations, the Mostra Garibaldina (MG) and the Mostra della Rivoluzione Fascista (MRF). These were connected spatially by being set up sequentially in the prestigious locale of the Roman Palazzo delle Esposizioni, much as they were connected rhetorically by Monti's involvement in both.

Undoubtedly the MG constituted Monti's curatorial masterpiece and the coronation of his museo-technical efforts. Here, at last, the Milanese curator introduced to the wider public all of the innovations he had experimented with in the second decade of the century: from the yellow glass to defend the most fragile documents from the sun, to the replacement of original manuscripts with photographic facsimiles, and the

exhibition of restored uniforms on mannequins designed by Monti himself. However, the originality of the Garibaldian exhibition was much more in its curatorial principles than in its aesthetic effects. The MG's itinerary was divided into four sections with distinct epistemological identities: Garibaldi's life and Garibaldianism (rooms 1–6 and 18–23); the transformation of the Garibaldian uniform over time (central gallery); Garibaldi's manuscripts (rooms 8–12); and popular representations of Garibaldi (rooms 13–17) (figure 10). The first section constituted the properly narrative part of the exhibition; the other three segments were organized around specific types of evidence: uniforms, manuscripts, and visual images. Their sequence was determined by what Monti boldly termed a "*poliaesthetic* criterion" but might be best understood as a staged confrontation between historical and historic modes of representation.[14]

Set up in twelve nonconsecutive rooms and along three corridors, the first part of the Garibaldian Exhibition covered the life of Garibaldi, his military feats, and his descendants' perpetuation of the Garibaldian tradition of military volunteerism. Although presented by Monti as the exhibition's "chronological" section, its itinerary was far from lacking in aesthetic value. All the rooms in this first section shared a number of characteristics. They all featured a centerpiece, sometimes flanked by comfortable armchairs (figure 11). The documents and small relics were grouped and exhibited in display cases placed either in the center or along the walls of each room. All representational items (paintings, drawings, photographs) were framed, hung at eye level from wires attached to the ceiling, and displayed at regular intervals along the walls of each room. Larger relics, sculptures, and uniforms were exhibited on isolated pedestals or in corner display cases.[15]

In the rooms of the MG's chronological section, documents and relics were presented as proper footnotes to the visual narrative of Garibaldi's life. The paintings, arranged in chronological order and alternating Garibaldi portraits with depictions of historical scenes, foregrounded the narrative realism of nineteenth-century historical representation. Unmistakably, the first section of

**Pianta della Mostra**

Sale
13

14-15

16-17

SALONE
D'ONORE

Sale
12

10-11

9

GALLERIA

Sale
18 - 19

Sale
20 · 21

Sale
22' - 23

·ROTONDA·

·ATRIO·

Sale
5 - 6

Sale
3 - 4

Sale
1 - 2

CUSTODE

**Figure 10** Floor plan, Garibaldian Exhibition, Rome, 1932. Archivio Centrale dello Stato.

the MG purposefully thematized, highlighted, and historicized the relationship between historical narrative and the nineteenth-century aesthetic of the beautiful.[16] Yet the aesthetic uniformity of these historical rooms did not dominate the whole exhibition. On the contrary, what followed them suggests that Monti had purposely arranged this entire section to undermine rather than to exalt the association of Garibaldianism with historical representation.

Exiting room 23, visitors found themselves back at the starting point of the exhibition's itinerary, this time facing a straight pathway toward the remaining three sections. In fact, what followed was a "gallery of uniforms," which, in

Monti's words, exhibited only "original" uniforms that had belonged to three generations of Garibaldian heroes: from those of Giuseppe Garibaldi's Risorgimental companions (Narcisio Bronzetti, Ippolito Nievo, Giuseppe Sirtori, and Luciano Manara) to that of Cornel Metzenger, who fought in the Garibaldian brigade in the Great War and earned multiple decorations. Among these uniforms, Monti singled out that of Sirtori, which "with his red shirt hidden by his black frock coat" evoked its allegorical double: the blood-stained black shirt of a Fascist *squadrista* shot and killed near Mentana while marching on Rome in October 1922. "A magnificent signification," Monti concluded, "of the spiritual relationship that links the two marches on Rome," the first called off by Garibaldi at Mentana in 1866, the second finally accomplished by Mussolini in 1922.

The unusual rhetorical flair that Monti expended on presenting the gallery of uniforms signaled that he considered this section to be his curatorial masterpiece. Contrasting the aesthetic of the beautiful encoded in the preceding section, the gallery was an emblematic exercise in the aesthetics of the sublime. A photograph taken from the perspective of the visitor entering the gallery shows that the uniforms were mounted on tailoring mannequins of the kind that Monti had introduced in the mid-1920s (figure 12). These mannequins were displayed inside ad hoc display cases placed at regular intervals on both sides of the corridor. The display cases, in turn, were placed on a two-step platform, which elevated them above eye level and compressed them against cantilevered walls on both sides. Clearly, in this section, as opposed to all preceding rooms, Monti finally took advantage of the spatial configuration and adaptability of the Palazzo delle Esposizioni. In so doing, however, he also dramatically modified the relationships among the viewer, the items displayed, and the aesthetic-epistemic code that presided over the arrangement of the first (narrative) section of the exhibition.

By shaping the architectural environment so as to maximize the viewer's apprehension of a series of metonymic items set up at a solemn contemplative distance, Monti tipped the balance

**Figure 11** Antonio Monti, room 20, Garibaldian Exhibition, Rome, 1932. Courtesy of the Società di Mutuo Soccorso Giuseppe Garibaldi, Rome.

dramatically between sensory-visual stimulation (things received through the senses) and mental-visual projection (images formed in our minds), which characterized the historical beautification of narrative in the first section. In the gallery of uniforms visitors were both sensory-stimulated and left unencumbered by an already visualized narrative. They were thus invited to transform the dialectic between spatial uniformity and the sequence of uniforms into a symbolic conception of historical time itself. For the ever-present face of the hero Garibaldi, dominating and controlling the beautiful tale of a heroic life in the first section, the gallery of uniforms substituted twelve shrines for the absent bodies of those who had fought in his name. To the narrative development of periods and *res gestae,* the gallery responded with a seriality that emphasized inherent infinity and uniformity—in a word, immanence. In contrast to the historical relationship between Garibaldi and Garibaldianism inscribed in the first section of the exhibition, the gallery of uni-

forms showed that the latter did not look back to Garibaldi's "Redshirts," but forward towards Mussolini's "Blackshirts."

Thus, the modernist aesthetics of spatial modulation and seriality in the gallery of uniforms succeeded in making palpable the historic signified (a term from semiotics) of the whole exhibition: the immanence of Garibaldianism in Fascism. In fact, the gallery was designed not only to form a purposeful contrast to the "historical" representation of Garibaldianism in the narrative section but also to stimulate the visitor visually in preparation for the perception of presence in the manuscript section and in the popular-images section. The separation of words from images in these last two sections capitalized on the sensory-visual stimulation generated by the gallery of uniforms. Isolated from all other representational items, Garibaldi's calligraphy and the paper on which he wrote created a sensory appeal that oriented the viewer's response toward an unmediated fusion of sign and signified. Sim-

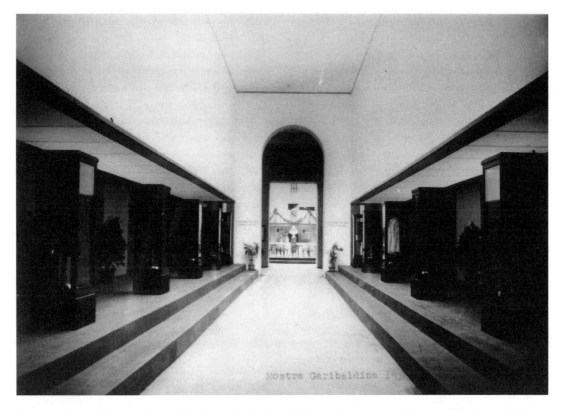

**Figure 12** Antonio Monti, Gallery of Uniforms, Garibaldian Exhibition, Rome, 1932. Courtesy of the Società di Mutuo Soccorso Giuseppe Garibaldi, Rome.

ilarly, in contrast to the historical paintings of the narrative section, the popular images of Garibaldi renounced historical realism in favor of a classic effect of *enàrgeia* in which Garibaldi's *res gestae* were made present to the contemporary viewer through the emotional reactions of popular witnesses.[17]

With its 200,000 visitors, the MG proved to be "the most popular" exhibition to date organized in the Palazzo delle Esposizioni and received unanimous acclaim from its reviewers.[18] The reviewers, however, were also remarkably split over what they found praiseworthy in the exhibition. A small group of reviewers focused exclusively on the narrative section of the exhibition, declaring the success of the MG in providing a "total view of an epoch," a "panoramic look at the history of Italy," or "a synthesis of the inviolable continuity of the Italian *stirpe*"[19] The majority, by contrast, drew their readers' attention exclusively to the last three sections of the exhibition, underscoring their rhetorical contigu-

ity, aesthetic originality, and representational power. No reviewers presented this view more emphatically and enthusiastically than the prince of Italian modernist critics, Pier Maria Bardi.[20] Throughout his review, Bardi referred to the MG as the "MOSTRA" (Exhibition), always in quotation marks and completely capitalized. Coming from the foremost Italian expert in press design, this typographical emphasis signaled unequivocally the MG's membership in that modernist species of exhibitions that Bardi had recently celebrated for having found in modern architecture their guiding aesthetic principle and which thus produced "new exhibition 'forms' that are 'art' in themselves."[21]

Short of providing proof for the mental oscillation of the Fascist subject between "history belonging to the past" and "history belonging to the present," the split reception of the MG strongly suggests that this exhibition was perceived as putting on stage a contest between historical and historic modes of representation, with

the latter being especially celebrated by modernist critics such as Bardi. No wonder, then, that Bardi himself would be among the first to stress the necessary connection between the Garibaldian Exhibition and the Exhibition of the Fascist Revolution that was to follow it within a few weeks. For Bardi, the main task of the Exhibition of the Fascist Revolution was to "integrate the Garibaldian [Exhibition] so as to clarify the ideal correlation between the two ventures."[22] What Bardi did not anticipate, however, was that the MRF would accomplish this task by emphasizing explicitly the incommensurability, rather than ideal correlation, between Garibaldianism and Fascism.

## The Fascist Historic Imaginary on Exhibit

*What opened in Rome is not simply "the exhibition"* (la mostra), *but something greater; it is "the demonstration"* (la dimostrazione) *of the Fascist Revolution. And here I employ the verb "to demonstrate" in its literary and figurative, as well as its mathematical and physical meanings. The show makes the Revolution plain, palpable, and intelligible, while at the same time providing proof, a definitive proof of the experiment's success, by calculation and figure. It took Fascism to revolutionize Italy in depth, before such an artistically revolutionary—and at the same time so very Italian and Fascist—idea could even be conceived.*

—Margherita Sarfatti, 1933

Just like the event to which it referred, this definition of the Exhibition of the Fascist Revolution written by Fascism's foremost art critic, Margherita Sarfatti, has justly commanded the attention of the many scholars who have studied the aesthetic, ritual, and political-religious aspects of Fascism's most successful cultural event.[23] Echoing Sarfatti's emphasis on the artistic value of the exhibition, most scholars have focused on the "Futurist," "Rationalist," "Sironian," or simply "modernist" imprint of the exhibition.[24] No at-

tention, however, has been given to the rhetorical and conjunctural context of Sarfatti's review. In the first place, Sarfatti's celebrated definition followed an explicit comparison between the MRF and the MG, in which the critic contrasted Monti's arrangement of "miles and miles of documents, aligned one after the other in a colorless series of pigeonholes" to the "work of art" created by the modernist artists-organizers of the MRF. For Sarfatti, therefore, the MRF was a historical representation of a whole new order, incommensurable to its predecessor. Second, Sarfatti's association of the term "demonstration" with "palpability" and "definitive proof" implicitly connected the modernist aesthetics of the exhibition to the rhetorical "effect of presence" (*enargèia*), inscribed in the Latin notion of *demostratio* (pointing at an invisible object). Disclaiming Bardi's expectations and quenching his enthusiasm for the MG, Sarfatti's review recognized and exalted the unique fusion of modernist aesthetics and Latin-Catholic rhetorical codes accomplished by the MRF, thereby highlighting how this historic demonstration had pushed aside and confounded not only the "MOSTRA" that had preceded it (the MG). What Sarfatti did not know, however, was that this representational feat was accomplished thanks to the contribution of the historian-curator she had implicitly criticized.

Monti had been involved in the organization of the MRF from the beginning. In 1928, the president of the Milanese Institute of Fascist Culture (IFCM) and future minister of popular culture, Dino Alfieri, had invited him to plan a historical exhibition of Fascism, to be called the Mostra Storica del Fascismo. Although that exhibition was never realized in Milan, Mussolini rerouted it to Rome to celebrate the tenth anniversary of the March on Rome in October 1932. When Alfieri was put in charge of organizing the Mostra della Rivoluzione Fascista, he selected Monti and the ex-Futurist journalist Luigi Freddi as his principal collaborators. From this organizing triumvirate would originate the overall design of the exhibition and the historic criteria that guided the thirty-four artists and the ten *storiografi* (eyewitnesses/historians) who were invited to create the exhibition.

That the first objective of the MRF's orga-

Figure 13  Floor plan, Exhibition of the Fascist Revolution, Rome, 1932. Archivio Centrale dello Stato.

nizers was to emphasize the incommensurability between this exhibition and any that had preceded it was made clear from the beginning via the modernist masque, composed of a red cubic structure and four gigantic pilaster-fasces that concealed the beaux-arts façade of the Palazzo delle Esposizioni. In particular, as Jeffrey Schnapp perceptively notes, this façade was aimed at disassociating the Palazzo delle Esposizioni from its recent association with Garibaldianism.[25] The MRF did not intend either to continue—as Bardi had imprudently anticipated—or merely to challenge the Mostra Garibaldina. Rather, the exhibition meant to overcome its predecessor as history and as representation. This intention was loudly announced by the metallic energy of the four freestanding fasces over seventy-eight fee high on the temporary façade of the Palazzo, but it was also painstakingly implemented in both the planning and the installation of the exhibition.

The exhibition was divided into two sections (figure 13). The first was a documentary-chronological section on the perimeter, composed of fifteen rooms (A–Q) that illustrated the revolution from the foundation of Mussolini's newspaper the *Popolo d'Italia* (November 1914) to the historic event itself, the March on Rome (October 28, 1922). The second was a central nonchronological section, composed of four larger rooms (R–U). Quite consciously, the route proposed by the exhibition exploited and expanded on Monti's division of the MG into a "historical" perimeter and a central "historic" section. In the MG, however, this separation had remained implicit and was only disclosed by its reviewers. By contrast, in the MRF, this division was explicitly stated in the catalogue, implemented in its organization with the utmost attention to detail, and rigidly codified in the architectural molding of the palace interior.[26] Rather than staging a con-

frontation between historical and historic modes of representation, the separation of the MRF's itinerary in two sections was aimed at enhancing dramatically the historic encoding of both: the perimeter staged a historic representation of Fascist historic agency, while the central section celebrated the formation and evolution of the Fascist historic imaginary itself.

The rooms on the perimeter were designed as if to give visual form to the actualist conflation of the histori(ographi)cal act. This determination was clearly stated and provided for in the "Traccia storico-politica della mostra del Fascismo" (Political-Historical Outline for the Exhibition of Fascism) written by Freddi in collaboration with Monti. The outline called on artists-historiographers "to depersonalize the exhibition so that the events themselves, more than people, may speak, and the personality of the Duce may be made present and emphasized."[27] What this meant in practice was that the exhibition was to center on a unique protagonist: not Mussolini in person, nor Fascism in general, but Mussolini's newspaper the *Popolo d'Italia*.[28] With all the allegorical references its title implied ("the people of Italy"), the *Popolo d'Italia* provided the organizers with the chronicle of events to be represented, as well as with the symbolic fulcrum and the representational code around which to unify the aesthetic eclecticism of the exhibition.[29] In the *Popolo d'Italia* the organizers correctly identified the perfect representational means to give visual form to the idea of Fascist historic agency.

Instead of producing figurative representations of Mussolini (of which only two appeared in the first ten rooms), artists and historiographers spared no efforts in depersonalizing the Duce and identifying him with the typeface of the newspaper. Phrases, mottoes, and entire passages from *Popolo d'Italia* editorials were reproduced in photographic or sculptural form and were plastered on all walls and ceilings of the exhibition to create a narrative thread that unified the heterogeneous aesthetics of the different rooms and events. At the same time, the original articles were displayed next to documents of the events to which they referred, so as to underline the documentary character of the narrative. In this way, all distinctions between document and commentary were first eliminated and then progressively inverted: in the Exhibition of the Fascist Revolution, the historical document ended up functioning as commentary to Mussolini's words embodied in the *Popolo d'Italia*. And this occurred nowhere more effectively than in the two rooms arranged by Monti himself: rooms C and D on the Italian intervention and victory in the Great War.

The figurative elements of Monti's rooms were architecturally isolated from the window-cased documents and the photomontages placed above them (figure 14). This arrangement gave maximum result to the dominant architectural element in both rooms: Mussolinian phrases extracted from the *Popolo d'Italia* and plastered in relief near the top of both walls and pilasters, which accommodated their longitudinal spread. Below the *scritte* (plastered phrases) the documents and relics of the years of suffering were contained in their frames, and all the figurative elements seemed tuned to the shaping *enàrgeia* of the Mussolinian sentence. This way, the sweep of the phrases throughout the perimeter referred directly to the historic agency of Mussolini's words that had infused order into the chaos of the war effort. At last, in the MRF, Monti had managed to merge modernist aesthetic codes with the historic mode of representation that he had been elaborating in the MG. At the same time, he had done so in keeping with the second criterion prescribed by the outline.

The outline repeatedly stressed that the exhibition and the building that housed it were to be perceived by the visitor as "a gigantic symphony," with a "dramatic and spectacular 'crescendo' leading to the final apotheosis."[30] From the point of view of Fascist discursive rhetoric, this musical image was neither particularly striking nor original. Yet this was also the same metaphor that Alfieri used in describing the exhibition's narrative as divided in "three *tempi*" (musical-theatrical acts) rather than historical periods. The reference, therefore, was not to the generic aesthetics of a *Gesamtkunstwerk* but to the organizers' specific desire to achieve a synesthetic encoding of the visual narrative (the transformation of visual stimuli into auditory appropriation). And it was through this synes-

**Figure 14** Antonio Monti, room C, Exhibition of the Fascist Revolution, Rome, 1932. Archivio Centrale dello Stato.

thetic encoding of the narrative itinerary (rooms A–Q) that the exhibition acquired its historic connotation.

Viewed as the exhibition's first *tempo,* the MRF's war rooms (A–D), designed by Freddi and Monti, were clearly united by the increasing classicism of the architectonic space and the incremental distinction between the different representational elements. The signified of their aesthetic crescendo was quite clear: the molding power of Mussolini's historic agency over the world of history. In this respect, the narrative thrust of these four rooms seemed to promise an imminent climax. Instead, entering room E, the visitor was thrust into a new representational space that unequivocally conveyed the energetic brevity of the revolution's second *tempo,* the brief period/act between the victory in the war and the

official birth of Fascism on March 23, 1919 (figure 15). This room depicted the conflict between the historic word of Mussolini and the chaotic reality of the immediate postwar period. The room's crowded figural space contrasted sharply with the rooms that preceded and followed it. Its massive figurative elements appeared to be impinging on the orderly progression of history, signified by the documents that were arranged in the window cases as if emerging from a printing press. To defend history from the assault of Bolshevism, and to create the necessary buffer zone to realign its course, Mussolini's statuary phrases stood duly quoted from *Popolo d'Italia* editorials that were included among the documents. In the final analysis, this room suggested that Mussolini's historic speeches were what had won over the chaos of history and its images, and thereby

**Figure 15** Arnaldo Carpanetti, room E, Exhibition of the Fascist Revolution, Rome, 1932. Archivio Centrale dello Stato.

prepared the visitor for the exhibition's third *tempo,* the proper "revolutionary" period/act between March 1919 and October 1922.

This final, and longest, *tempo* comprised the most diverse and artistically compelling rooms of the MRF's itinerary along the perimeter, as well as the most diverse aesthetic contributions, from those of the Futurist Enrico Prampolini, to those of the *Strapaesano* Mino Maccari, the Rationalist architect Giuseppe Terragni, and Novecento's leader, Mario Sironi. Yet despite the aesthetic eclecticism of these rooms, in their sequencing they did not disrupt the historic subtext firmly encoded in the first five. On the contrary, quite aside from the diverse aesthetic solutions that each team adopted for each room, the rooms all conformed to the organizer's rhetorical strategy in two fundamental ways. First, by continuing the plastering of walls with Mussolinian phrases and mottoes, the MRF's third *tempo* continued to elide the distinction between document and commentary, and to depersonalize the exhibition. Second, by intensifying the unity of figurative, verbal, and architectural languages, these ten rooms made history present to the viewer through a synesthetic crescendo that clearly climaxed in rooms O, P, and Q.

In contrast to the gloomy rooms that preceded it, room O was arranged by Giuseppe Terragni utilizing a host of shiny and reflecting materials. This choice not only intensified the visual experience of the viewer, but, by drawing the viewer's reflection in the space of the representation, it also elided the boundary between spectacle and spectator and in this way confounded all sense of self-identity before the viewer con-

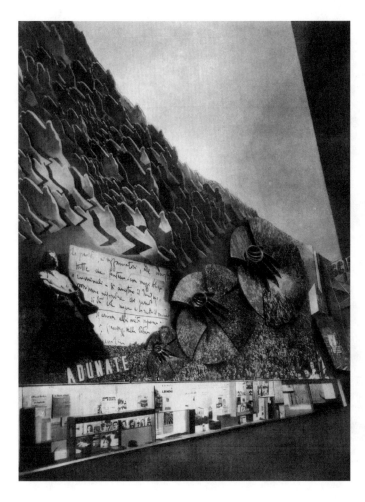

**Figure 16** Giuseppe Terragni, photomontage called *Adunate,* room O, Exhibition of the Fascist Revolution, Rome, 1932. Archivio Centrale dello Stato.

fronted the dominant figurative element in the room (figure 16). This huge allegory of the gatherings that had preceded the March on Rome abolished all remaining distance between the spectator and the representation. The reflected faces of the visitors were replaced by a photomontage of an amorphous mass of anonymous faces. The historic *enàrgeia* of Mussolini's *handwritten* words (". . . with blood the wheel is set in motion . . .") was visualized by the three wheels/turbines that transformed the gathered masses into the Fascist mass of the last revolutionary act. Finally, the stylized hands flying toward the gigantic X of the ceiling drew the spectator's attention toward the present (X = Decennale), thereby prefiguring the historic transformation of Terragni's hypervisual dynamism into the architectural classicism characterizing

the two rooms dedicated to the March on Rome (P and Q) arranged by Mario Sironi.

While the chromatism of these last two rooms of the perimeter section maintained a crucial aesthetic continuity with the crescendo of the preceding thirteen, the sheer materiality of their volumes and surfaces revealed an explicit intention of Sironi's to contrast them abruptly with the room that preceded them (figure 17). The passage from Terragni's to Sironi's aesthetics was a sharp and unequivocally synesthetic passage from optical to tactile appropriation. At the same time, rooms P and Q returned the visitors to the separation among iconography, documentary display cases, photomontages, and Mussolinian phrases that they had witnessed in the first *tempo* of the exhibition (compare figures 17 and 14). All of these elements, however, were magnified in scale

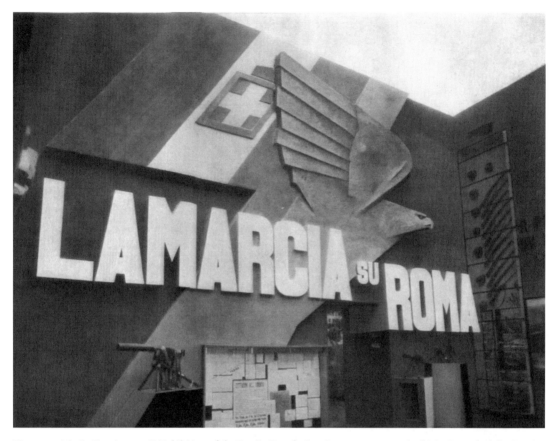

Figure 17   Mario Sironi, room P, Exhibition of the Fascist Revolution, Rome, 1932–34. Archivio Centrale dello Stato.

and clarified in their relations. In this way, Sironi achieved the most important rhetorical task assigned to him. The beginning of the narrative (the war) was retroactively recoded as simultaneous with its ending. Although the March on Rome was represented as immanent in the historical facts that preceded it, the meaning of these facts was made present to the spectator in reference to the historic event they led to.

Sironi's room Q ended the historic representation of the Fascist revolution but not the historic exhibition itself. The visitor was in fact thrust into the central corridor composed of four topical rooms: the Hall of Honor (room R) and the Gallery of Fasces (room S), both designed by Sironi; the Hall of Mussolini (room T) by Leo Longanesi; and the Shrine of the Martyrs (room U) by Adalberto Libera and Antonio Valente. As several scholars have emphasized, the organizers' choice to entrust Sironi with both the last two

rooms of the perimeter itinerary and the first two of the central one reflected not only the undisputed artistic status of Sironi as *primus inter pares* (first among equals) but also the organizers' utmost concern with ensuring continuity between the two sections of the exhibition.[31] However, this aesthetic uniformity should not blind us to the rhetorical encoding that unified the central section of the exhibition and separated it from the section on the perimeter.

The aesthetic-ritual woof of the central four rooms was woven by a thread that derived from the most symbolic provision called for by Freddi's outline: the reconstruction of Mussolini's first and last offices at the *Popolo d'Italia*. Assigned by Alfieri to rooms R and U, the two historic sites could not have more literally absolved their symbolic function of "hypericons" of the exhibition's historic mode of representation.[32] Isolated from the documentary section, they framed the MRF's

central section as an exercise in historic semi-otics. In this central space, the regime was re-vealed as a mental state of historic presence. Here the visitor was invited into the self-reflexive space of the Fascist historic imaginary itself.

Mussolini's first office, nicknamed the *covo* (den), was encased by Sironi in a tabernacle-like structure below a gigantic sculptural image of Mussolini holding a book and a rifle and facing the reproduction of the *Popolo d'Italia* front page announcing victory in the Great War. At the four corners of this structure stood eight columns made of authentic rollers from the original ones of the *Popolo d'Italia* printing press. Read in the light of the preceding fifteen rooms, all the signs inscribed in this historic site spoke a loud and physical language to the spectator. This was the language of the epic hero that the spectator had encountered throughout the exhibition: the *Popolo d'Italia*. The reconstructed *covo,* and the enlargement of the front page that announced victory in the war, demonstrated that the origin of the revolution transcended not only its histor-ical dates but also its historical hero, Mussolini. The suspended and constricted representation of the Duce as *Fascista perfetto* (perfect Fascist, which in Italian rhymes with book and rifle, *libro e moschetto*) was a literal allegory that effectively depersonalized Mussolini's supposed identifica-tion with the historic event. The *Popolo d'Italia,* quite simply, and with none of the allegorical overtones of the documentary section, was here revealed as the absolute guarantor of the new his-toric era.

The reconstruction of Mussolini's last office was located after Sironi's room S, in the Hall of Mussolini. Once again, the positioning of this second historic site was key to the semiotic en-coding of the whole section. Longanesi had di-vided the room into three spaces, as is evident on the floor plan (figure 13). The reconstructed last office was on the right side, while the left and cen-tral rooms presented a series of rectangular win-dow cases containing manuscripts, pictures, relics, and documents related to Mussolini's life. The sober classicism of these two spaces, and the double white-lined framing of the window cases, could not have more sharply contrasted with the materiality of Sironi's sculpturing of volumes and

masses. All of this made room T purposely "his-torical." Indeed, as Bardi polemically remarked, room T was "*deathly* historical."[33]

With their numerous documentary memen-tos of the six failed attempts on Mussolini's life framed by window cases resembling mortuary announcements in rooms that were soberly lit and shaped like coffins, the two documentary spaces of Longanesi's Hall of Mussolini could not have been more anticlimactic. Their aesthetic en-coding referred to the mortality of the Duce and purposely so. In fact, Longanesi's arrangement created as sharp a contrast as possible between these two historical rooms and the reconstructed last office, which, unlike the first one, was pre-sented as if it had been just left by Mussolini when he was called to Rome (the phone receiver left unhooked on the desk). As a concluding sign-post and a vivid sign of the historic protagonist, this historic site encoded the rest of the room as a historical representation under the sign of the historic. The contrast between the "historical" picturing of the left and center sections of the room and the *enàrgeia* of the reconstructed office made the semiotic relationship between the his-toric site and the historical representation palpa-ble: the historical Mussolini could die at any time, but Fascism/Mussolini, as historic agent—that is, regime/permanent revolution—would survive embodied in the *Popolo d'Italia* that had always sustained it.

Most plausibly, it was this last brief thought of Mussolini's mortality that the Shrine of the Martyrs was supposed to transfigure into a synes-thetic representation of the Fascist ritual par ex-cellence, the *Appello* (Roll Call). Entering room U, visitors found themselves in a dark and hemi-spheric space dominated by a huge metallic cross in the center bearing the inscription "For the Immortal Fatherland," and surrounded by the luminous word "*presente*!" (here!) repeated a thousand times. Surely this was a most reassur-ing transfiguration of Fascism into the restorer of the cult of the fatherland. And, as some scholars have already emphasized, this *gran finale* stressed the mystical bond between the Fascist leader and the Fascist collective.[34] Yet it did not end the MRF's historic *demostratio.* Although last in the sequence of nineteen rooms on the first floor,

Figure 18 Mario Sironi, Gallery of
Fasces (room S), Exhibition of the Fas-
cist Revolution, Rome, 1932–34.
Archivio Centrale dello Stato.

the Shrine was not the final room of the historic itinerary. As the floor plan indicates (figure 13), after visiting the Shrine, visitors were forced to retrace their steps, pass through Mussolini's room, and go through the Gallery of Fasces (room S) for a second time in order to exit the historic section and proceed to the upper floor. Sironi's Gallery of Fasces was the last room of the exhibition and its true historic climax.

On each side of the gallery stood a row of five massive, cantilevered pilasters whose shape recalled that of the Roman salute (figure 18). Alternating on the face of every other pilaster were the letters A and X, representing *anno decimo* (year ten), and on the protruding face of the cantilevered part of each pilaster, the date of a revolutionary year: on the right side (as one entered the room), 1914, 1915, 1916, 1917, and 1918; on the left side, 1919, 1920, 1921, 1922, and

ANNO I (first year). Judging from a series of preparatory sketches for this room discovered by Libero Andreotti, we may infer that Sironi understood gradually the central significance of this last room of the itinerary in relation to the whole exhibition.[35] In contrast to the secure design of the other rooms, these sketches show a complete change of mind between an early asymmetrical scheme and the final plan. More significantly, this final approach reveals a specific source of inspiration: Monti's "Gallery of Uniforms" at the Mostra Garibaldina (compare figures 12 and 18).

Sironi's pilasters clearly captured and expanded on the historic encoding of Monti's series of uniformed mannequins. At the same time, Sironi did not simply learn the lesson but also surpassed the attempt of his predecessor. Unlike Monti's space, Sironi's gallery was not isolated but rather framed between the two historic sites

of the exhibitions. It thus provided the semiotic key not only to the rooms that followed it but also to those that preceded it. Indeed, it provided the key to the whole exhibition.

Let us assume for the moment that, on first passage, the visitor, struck by the mystical atmosphere of the room, had failed to notice the synthesis of dates and had proceeded speedily toward the Hall of Mussolini. Having reached the Shrine, the spectator would have been forced to retrace his or her steps through the brief stretch of the Mussolini Hall, and down the long corridor of the Gallery of Fasces. Short of realizing a Fascist prototype of sublime architecture, this final inverted itinerary (U-T-S) must have drawn a response from the visitor. The second passage through the room would have acquired all the characteristics of a final rite of passage, a definitive initiation into the historic temporality of the Fascist epoch. Walking again through the gallery, the visitor would have been reexposed to Sironi's placement of dates, whose historic encoding could have been read only during this final passage. On his or her left side, the initiated visitor would have backtracked through the five years of the war act (1918–1917–1916–1915–1914); on the right side, he or she would have proceeded through the four years of the revolutionary act (1919–1920–1921–1922) all the way to year one of the Fascist era. The physical effect of seeing unknown faces going forward and backward in time might have made the historic encoding of the exhibition a phenomenological reality for many spectators. In what sense, however, did the Gallery constitute an "elementary synthesis of the period reconstructed by the Exhibition," as the catalogue claims?

It certainly did not in a literal sense, since nowhere on the ground floor did the exhibition reveal the intention to reconstruct or to represent in any way the first year of the Fascist era. Nor could it have formed such a synthesis even in a symbolic sense, since the sameness of the pilasters contradicted both the individuality of each year and the synesthetic crescendo enacted throughout the exhibition. The only answer is that the Gallery constituted a synthesis in a self-referential, historic sense. Completing the series of "ten" pilasters, the ANNO I pilaster allowed the ensemble to refer to the "X" sign of the Decennale ubiquitous in the perimeter section of the exhibition. The inclusion of the year I in the Gallery of Fasces encoded the MRF itself as a historic event. The gallery, in other words, offered an icon of a Fascist historic imaginary that had superseded the "revolutionary" one by imposing the temporal form of the Decennale on time itself. Like faithful Fascist soldiers of the revolution, the revolutionary years had taken their place within a new and solely Fascist (Italian/Roman/Latin) unit of historic time: the decade. This is what the historic exhibition of the Decennale most purely celebrated—the historic *tempo* (time/act/period) of the Fascist decade. This was a historic tempo that was meant to reorient Fascist historic imaginary away from "history belonging to the present" and toward "history belonging to the future." This tempo also provided a Fascist-modernist answer to the utopian time of Fascism's totalitarian rivals: the messianic one-thousand-years Reich of Nazism and the revolutionary five-year plans of the Bolsheviks.

## PART II
# Antiquity

IL FONDATORE
DELL' IMPERO FASCISTA

# Augustus, Mussolini, and the Parallel Imagery of Empire

*Ann Thomas Wilkins*

ALMOST TWENTY CENTURIES after the dawn of the Roman Empire, Benito Mussolini set out to co-opt the ideals, power, and patriotism of ancient Rome for his own ends. Although the Fascist leader and his regime emulated the late republic, particularly the age of Julius Caesar, the empire under Augustus and his successors provided Mussolini and his regime with grandiose visual and conceptual models.[1]

This chapter addresses the Fascist and post-Fascist appropriation and reinterpretation of ancient Roman monuments. During the Fascist period, Mussolini's regime restored Augustan monuments in the northern Campus Martius and incorporated obelisks into the urban fabric as had Augustus. Although Fascist response to and appropriation of Augustan Rome is my primary topic, I discuss post-Fascist responses to Mussolini's endeavors as well.

Appropriation is a continuous process. Mussolini and his architects well understood Augustus's techniques of visual propaganda and his appropriation of the Italic heritage; contemporary architects, such as Richard Meier, who is working with the Italian government on a new pavilion for the Augustan Ara Pacis (Altar of Peace), have in a similar spirit appropriated and

elaborated on the past. Each incarnation of the Ara Pacis, for instance, embellishes its original appearance and function, while making a statement of its own era. The Fascist appropriation, however, was but one part of a grand, coordinated scheme for a new Rome that glorified both antiquity and modernity at the expense of intervening periods; the Meier project, in contrast, makes a substantial local impact, but it is not part of a grander urban plan.

## Fascism and Antiquity

The Fascist movement was closely tied to antiquity. Even its name and most prominent symbol were derived from the fasces, a pre-imperial emblem of authority that provided both visual and psychological symbolism for Mussolini's regime.[2] In these and many other ways, Mussolini paid homage to ancient Rome through public symbolism. Furthermore, he openly associated himself with specific Roman figures. Shortly after the 1922 March on Rome, Mussolini compared himself to Julius Caesar and likened his own march to Caesar's famous journey from Gaul, across the Rubicon, and through the Italian peninsula.[3]

Mussolini's emulation of Julius Caesar, evident in the early years of Fascism, waned as the Fascist empire became a possibility and then a reality. The Duce's emphasis shifted away from Caesar (whose brief period of power and violent death were not to be envied), and ultimately to his grandnephew and adopted heir, Octavian

For their support, help, and suggestions, I thank my husband, David G. Wilkins; my daughters, Rebecca Wilkins and Katherine Wilkins; my sons-in-law, Chris Colborn and Tyler Jennings; and Jenny Bangsund, Roger Crum, Nicholas Jones, Claudia Lazzaro, Sara McVane, Stephen Newmyer, Paulo Tommaso Pagnotta, Paul Rehak, and Michael Skor.

(later known as Augustus), who became the ob-
ject of Mussolini's emulation.[4] In the '30s Mus-
solini refocused his appropriation of antiquity by
making Augustan Rome and Augustus himself
his primary models.

Mussolini emulated Augustus in a variety of
ways, including the achievement and mainte-
nance of an imperial position; the use of effective
propaganda, public display, and public ad-
dresses; and the development of urban projects
that enhanced Rome, recalled its imperial her-
itage, and glorified the man who had been the cat-
alyst for the empire.

Mussolini's path to leadership differed from
that of Augustus, but the end result of unques-
tioned political power was quite similar. Mus-
solini's published words and public speeches
illustrate his intent to model himself on his im-
perial predecessor. These suggest that Mussolini
positioned himself as Augustus's continuator,
both politically and militarily; they further reveal
that, like Augustus, Mussolini was given to self-
proclamation and boasting, as seen in Musso-
lini's announcement of the success of his 1936
conquest of Ethiopia: "A great event has taken
place. . . . Today, 9 May [1936], the fourteenth
year of the Fascist Era, the fate of Ethiopia has
been sealed. Our gleaming sword has cut through
all the knots, and our African victory now shines
with a pure light. . . . Italy at last has her Empire,
the Fascist Empire."[5] These words recall the ter-
ritorial claims of Augustus, who ordered armies
into Ethiopia and Arabia, and added Egypt to the
Roman Empire.[6] In similar fashion, Mussolini's
articulation of his desire for peace is reminiscent
of that of Augustus.[7] Furthermore, Mussolini
drew bold, public parallels between the Rome he
was planning and the city that had been the cen-
ter of the empire for his famed predecessor:

> Within five years Rome must appear marvelous
> to all the people of the world: vast, ordered,
> mighty, as it was in the time of the first emperor
> Augustus. You will continue to liberate the trunk
> of the great oak of everything that still oppresses
> it. You will create open space around the Augus-
> teo, the Theater of Marcellus, the Campidoglio,
> the Pantheon. Everything from the periods of
> decadence must disappear.[8]

Because of modern technology and im-
proved literacy, Mussolini was able to reach
many more people than had Augustus. Fascist
publications, for example, were numerous and
were widely distributed.[9] Mussolini also assured
the Italian people of the regime's strength and rel-
evance by means of grandiose exhibitions. In
1937 the Mostra Augustea della Romanità cele-
brated the bimillennium of Augustus's birth.
Held in Rome at the Palazzo delle Esposizioni,
where in 1932 the Mostra della Rivoluzione
Fascista had honored the tenth anniversary of the
March on Rome, the Mostra Augustea was in-
tended to generate national pride.[10] Augustus
was the pivotal figure in this extensive exhibition
that recorded the entire scope of ancient Roman
history. The didactic and propagandistic Mostra
Augustea aimed to demonstrate the continuity
between the Rome of Augustus and that of Mus-
solini.

Mussolini took pride in his architectural
contributions to Rome, as had Augustus in such
works as the Temple of Mars Ultor and the Fo-
rum of Augustus.[11] As Roman authors attest,
Augustus beautified the city and gave homage to
victory, peace, dynasty, and empire; he also en-
sured Romans a more stable, safer life.[12] He
erected monuments and planned architectural
complexes to express imperial power and to
mark the past, define the present, and inspire the
future.

Mussolini's grandiose plans for Rome in-
cluded extensive projects that ranged from new
houses, roads, and bridges to a sports center, the
Foro Mussolini, and EUR (Esposizione Univer-
sale di Roma), the setting for a major Fascist ex-
hibition that was intended to evolve into a
permanent suburb. Mussolini's urban renewal
projects, like their Augustan precedents, sug-
gested his intent to commemorate his heritage
and accomplishments as he built a better Rome.
The projects of both Augustus and Mussolini
also suggested impatience with and the desire to
correct the squalor and confusion left by prior
generations. According to Suetonius, Augustus
"found Rome built of bricks" and left it "clothed
in marble."[13] Later, Mussolini eliminated the
web of streets and tenements in areas such as the
Campus Martius, where he formed a grandiose

public piazza that was not only functional but also reminiscent of Augustan Rome and reflective of the Fascist regime.

Mussolini's sponsorship of the archaeological recovery of Augustan Rome was perhaps his most serious attempt to evoke the power of the first emperor.[14] The excavation and restoration of Augustan structures and their subsequent inclusion in a Fascist context strengthened the bond between the early empire and the Fascist regime. It was shortly after the March on Rome that Mussolini stated his intent to change the city physically both by excavating (or isolating) ancient structures and by building monumental Fascist architectural complexes.[15] Mussolini's restorations in the Forum of Augustus, particularly of the Temple of Mars Ultor, were begun in 1924 and honored both Augustus, its patron, and Julius Caesar, whose death it was vowed to avenge.

Mussolini's archaeological work in the northern Campus Martius played an even more prominent role in Fascist propaganda. The reconstruction of the Ara Pacis, the archaeological isolation of the adjacent Mausoleum of Augustus from the confusing complex of medieval and later buildings, and the incorporation of these two monuments into a Fascist architectural complex, the Piazzale Augusto Imperatore, were conceived—like the Mostra Augustea—to honor Augustus on the bimillennium of his birth and to suggest that Mussolini was his successor.

## The Campus Martius, Augustus, and Mussolini

The Campus Martius is a floodplain of the Tiber outside the sacred center of the ancient city. Perhaps at one time the property of the Etruscan Tarquin kings, under the Romans this area was dedicated to Mars, which gave the field its name. At the beginning of the republic, before construction projects reflected private wealth, the campus was a public area used for military drills and voting. Triumphal processions, in which spoils of war were displayed, also took place there. Augustus made a major impact on the northern part of the Campus Martius with a building program that ultimately included his

family mausoleum and the Ara Pacis, together with the Horologium, or Solarium Augusti, which served as a massive sundial. Rich in symbolism, the complex was intended to signify Augustan imperial glory.

The transition from the Roman Republic to the Roman Empire initiated cultural, ideological, social, and political changes. For Augustus—acknowledged as *primus inter pares* (first among equals)—family history and values, and the establishment of an imperial dynasty, were paramount. The concept of renewal and the creation of an Augustan peace were major themes of his ideology. The monuments he built in the Campus Martius served as memory, propaganda, symbol of the present, and vision of the future.[16]

The mausoleum, constructed in approximately 28 B.C.E., was probably conceived as an isolated structure and not part of the broader complex that later developed near it.[17] Augustus was in his thirties when he commenced construction on the mausoleum for himself and his family. It was a heady and unexpected move to build a prominent memorial and to establish a grandiose burial place so early in one's career. The scale and mass of the mausoleum suggest that it was conceived to endure both physically and symbolically. Prominent in the northern Campus Martius, the mausoleum commanded attention in the ancient city.[18]

Perhaps Augustus's purpose in erecting a monumental family tomb was to recall Etruscan tumuli, such as the so-called tomb of Aeneas, or republican circular tombs. Either source would have connected him with his Italic heritage.[19] Perhaps a reference to royal Hellenistic tombs was also intended.[20] It seems likely that rather than suggesting only one of these precedents, the mausoleum's design and function were intended to allow Augustus to make a number of references to his complex heritage and his imperial aspirations.

Although the form and function of the mausoleum recall diverse cultures, the hubris suggested by its size and appearance established the imagery of power and dynasty. The young Augustus may have had yet another agenda: by constructing such a monumental tomb in this location, he may have been making a statement about his loyalty to and

authority in Rome, in pointed contrast to his rival Marc Antony's eastern and distinctly non-Roman leanings.[21]

Some fifteen years after Augustus established the mausoleum, he began a new structure to the south. The Ara Pacis, Augustus's visual message of peace, prosperity, and fecundity, was dedicated in 9 B.C.E. on January 30, the birthday of his wife Livia. Situated at the edge of the Campus Martius on the border of the city's sacred center, the altar was erected to honor Augustus's return from Spain and Gaul in 13 B.C.E.[22] Conceived and executed well after the victory at Actium and Augustus's assumption of imperial power, the Ara Pacis celebrated the establishment of empire and dynasty as well as the pacification of the Roman world made possible by his military victories.[23]

In 10 B.C.E., when the Ara Pacis was still under construction, Augustus added another commemorative monument—an Egyptian obelisk to celebrate his victory at Actium and his annexation of Egypt. Placed approximately thirty feet west of the altar, the obelisk celebrated the recent past and symbolized a grander heritage. Functional as well as symbolic, this obelisk served as the gnomon, or marker, for the Horologium, a gigantic sundial with inlaid bronze markings on the travertine pavement.[24] As a red granite monument—supposedly the color of the sun—the hieroglyph-covered obelisk provided a visual point of reference for the other structures and surrounding gardens. It was topped by a gilt bronze globe symbolizing world rule surmounted by a second, miniature obelisk. At the main obelisk's base was a dedicatory inscription: "The Emperor Caesar Augustus . . . dedicated this gift to the Sun when Egypt was brought into the power of the Roman people." By making this dedication, Augustus (who in his own association with Apollo was personally connected with the sun) combined Egyptian precedent with Roman achievement.[25]

In addition to its day-to-day function, the Horologium marked two significant periods of time: the winter solstice under Capricorn, the sign under which the first emperor was conceived and under which he assumed the title "Augustus"; and the autumnal equinox, which often occurred on September 23, Augustus's birthdate.[26]

On the equinox, the obelisk's shadow directed the viewer to the Ara Pacis by falling through its doorway.[27] A monument originally created by the Egyptians was thus co-opted by Augustus to represent his victory over them and to elevate the emperor himself and his dynasty.

The three Campus Martius monuments must be understood in the context of their location. Close to but outside of the sacred center of the ancient city, the Ara Pacis connected visibly and symbolically with the Horologium. The obelisk, as war plunder, was appropriately placed in the campus where such military spoils were traditionally exhibited. Thus Augustus was following tradition while innovatively incorporating the exotic obelisk. The Horologium, the Ara Pacis, and the Mausoleum of Augustus all reflected both tradition and innovation in their glorification of the emperor, his dynasty, and his heritage. Centuries later, Mussolini would claim these Augustan monuments to reflect his own tradition and to glorify his own developing empire.

As the Roman Empire progressed after the Augustan period, more and grander structures such as the Hadrianic Pantheon continued to be built in the campus. After the empire's fall, the Campus Martius became a crowded center of medieval and Renaissance Rome, and eventually many ancient structures were destroyed. The Ara Pacis, for instance, was partially buried under a Renaissance palace, and portions of its sculptural decoration were scattered in private collections and museums. The Mausoleum of Augustus, on the other hand, has a varied history. In addition to being a source for marble, it was used as a fortress, a Renaissance garden, an amphitheater, a bullring, and finally—in 1906—a concert hall, as it remained until the Fascist intervention in 1936.

By the time of the Fascist intervention, plans for restoration work on the Augustan Campus Martius monuments had been in the making for several years.[28] Various reasons, both practical and propagandistic, explain Mussolini's decision for demolition of the post-antique structures that surrounded the mausoleum: Augustan history would be celebrated as the ancient monuments were released from the accretions of intervening generations, this area of the Campus Martius

would be made more beautiful, sanitation and traffic patterns would be improved, and the project would provide employment.[29] On the other hand, the social and economic impact was great, and the list of buildings, roads, and monuments demolished in this endeavor is long.

Excavations had been undertaken at the mausoleum in 1907 as it was being transformed into a concert hall. When work was resumed between 1926 and 1930, the tomb's design was clarified, and inscriptions and sculptural fragments were discovered.[30] By 1934, the work initiated by Mussolini had isolated the structure from the web of post-antique structures and surrounding roads. With the excavation came a change in status of the Augustan monument: from that of a functioning concert hall to that of an authentic "ruin" of ancient Rome. In isolating the mausoleum, Mussolini revived a monument that itself was a revival of Italic heritage. Although the new buildings of the piazza surrounding it were not completed until 1941, the work on the mausoleum, under the guidance of Antonio Muñoz, was finished by the bimillenary celebration of Augustus's birth. The renewal project that culminated in the Piazzale Augusto Imperatore represented extensive planning, archaeological investigation, demolition, and rebuilding.

Standing on a rooftop near the mausoleum on October 22, 1934, Mussolini publicly pronounced the demolition that would liberate the mausoleum in time for the bimillenary celebration of the birth of Augustus (figure 19).[31] "La parola al piccone!" ("Now let the pickax speak!") As he spoke these words, Mussolini positioned himself as the hero of this grand urban project: as a worker with pickax in hand as well as the sponsor and innovator of the project, he was, like Augustus before him, *primus inter pares*.

The Ara Pacis was another matter. Fragmented, partially buried, and with remnants of its reliefs scattered, it had been compromised as a coherent monument.[32] Ultimately, Mussolini decided not to display the recovered fragments in a museum setting but to reconstruct the monument as a whole. This decision allowed the altar to stand again as a monument and to enjoy a prominence equal to that of the mausoleum. For practical reasons, both the location and the axis

of the reconstructed altar differed from those of the original.[33] Furthermore, the altar's fragility necessitated protection from the elements. For this reason, the Fascist architect Vittorio Ballio Morpurgo was asked to design a concrete and glass structure for the altar that would provide both protection and emphasis (figure 20). The inauguration of the newly reassembled monument was held in 1937, the year of a bimillenary celebration of Augustus's birthday.

The two renewed Augustan monuments—mausoleum and altar—thus provided visual and ideological foci for the Fascist complex that embraced them. They were framed by Fascist buildings in the Piazzale Augusto Imperatore designed by Morpurgo (see figure 4 in chapter 1).[34] In closer proximity to each other than in the Augustan period, and without the context of the Horologium, the mausoleum and altar underwent a change in appearance and function. The third monument, the Horologium, was not a part of Mussolini's grand plan for the Campus Martius and has never been reconstructed.

The resulting piazzale is defined by four Fascist buildings, identified as buildings A, B, C, and D, which frame the excavated Augustan mausoleum. Three churches dating from the sixteenth through the eighteenth centuries interrupt the pattern of Fascist structures, and the reconstructed Ara Pacis in its Fascist pavilion separates the mausoleum from the Tiber.[35] Mussolini placed a bronze text of the *Res Gestae Divi Augusti* along the eastern side of the altar's enclosure, thus drawing attention to the first emperor's words in a prominent and public position. It was believed that after Augustus's death, the *Res Gestae* had been displayed at the entrance to his mausoleum. By placing the Augustan autobiographical text at the Ara Pacis, Mussolini ensured that the words of the first emperor would once again be prominently visible in the vicinity of the imperial tomb. Another Latin inscription on the façade of Fascist building B parallels the Augustan text. These words begin with a reference to Augustus and then describe Mussolini's own accomplishments, particularly his work on the Campus Martius (figure 21). The mausoleum in particular is cited for its "extraction . . . from the shadows of the centuries."[36]

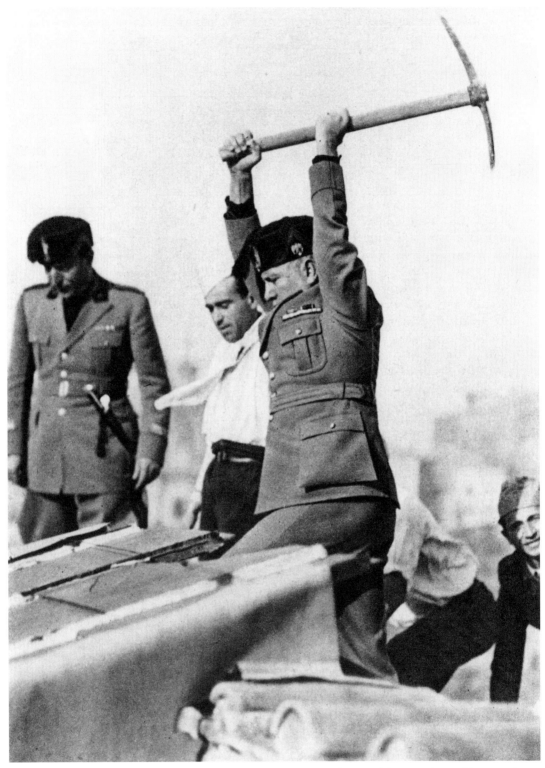

**Figure 19**  "La parol al piccone!" Mussolini with pickax initiating the "isolation" of the Mausoleum of Augustus in Rome, October 22, 1934. Armando Bruni, *Mussolini: Cento Istantanee* (Novara: Istituto Geografico De Agostini, 1942).

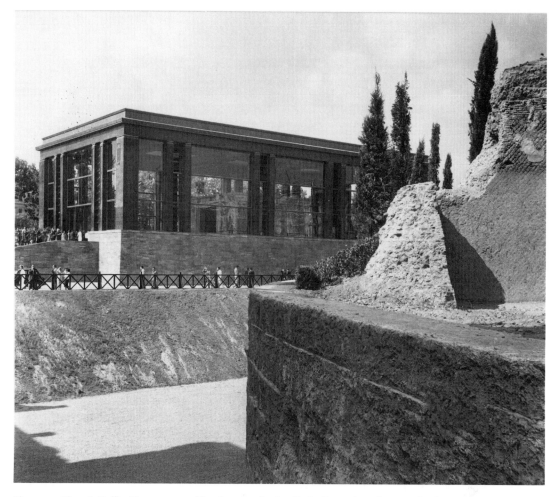

**Figure 20** Vittorio Ballio Morpurgo, pavilion housing the Ara Pacis, Rome, in a photograph of 1938. Fototeca Unione, FU 1040.

The magnitude of the Piazzale Augusto Imperatore indicated its importance. Visually impressive, the complex was functional as well. The streets between the mausoleum and other buildings allowed easy vehicular access, the structures provided commercial spaces, and the peristyle-like loggias offered protection from the hot Roman sun.

Fascist and ancient structures were united by the use of neutral colors, repeated designs, and sculptural friezes. To a certain extent, the friezes mimic those of the Ara Pacis. The visual correspondences may have been intended to merge buildings from different time periods into a coherent whole, thereby emphasizing the parallels between the two eras. Morpurgo's concrete and glass pavilion for the Ara Pacis blended in color and design with the surrounding buildings of the new complex, while its proportions and the steps leading up to it mirrored those of the reconstructed Augustan altar inside. The mausoleum, on the other hand, differs from Morpurgo's buildings as well as from the Ara Pacis in shape, material, and intent: the circular, unadorned, and nonfunctioning raw brick structure contrasts with the rectilinear modernity of Morpurgo's architecture and with the sculpted marble altar. Both ancient structures—one a nonfunctioning ruin, the other a reconstruction as a work of art—function as memorials, further setting them apart from the commercially oriented Fascist structures.

As indicated, three churches were integrated into the overall plan of the piazzale: San Carlo al

**Figure 21** Inscription on building B, Piazzale Augusto Imperatore, Rome. Photograph by David G. Wilkins.

Corso, San Girolamo degli Schiavoni, and San Rocco, which is directly next to San Girolamo and connected to it by a bridge. These churches contrast in form and decoration with the severity of the twentieth-century buildings. Perhaps the accommodation of churches to Morpurgo's plan for a complex uniting Augustan and Fascist Rome reflects the 1929 concordat with the Catholic Church, which acknowledged the independence of the Vatican. Although the architecture of the churches contrasts stylistically with the Augustan and Fascist structures, conceptually the presence of these buildings allows an expression of the unification of the three Romes—of Augustus, of the popes, and of Mussolini.

Religion appears elsewhere in the piazzale in concept, images, and inscriptions. Augustus, as is documented in the *Res Gestae,* built and restored temples.[37] So too Mussolini incorporated religion, specifically Christianity, into his Fascist agenda, as reflected in Morpurgo's plan for the piazzale.[38] For example, two panels, each re-

flecting ancient Roman precedent while representing Christian themes, express the unity of the Fascist complex. The central figure in a series of mosaic panels facing the Augustan monuments is Christ as Prince of Peace: Imperial Rome is recalled in medium, the papacy in subject, and Fascist Rome in style. Similarly, a Fascist sculptural relief of the Madonna and Child is stylistically reminiscent of the Tellus relief on the Ara Pacis.[39]

Mussolini's Piazzale Augusto Imperatore contrasts greatly with the old buildings and dark streets that previously masked the mausoleum in its guise as a concert hall. At the piazzale's completion, the openness and grandeur achieved by Mussolini and his advisors were impressive. Although the memory of intervening generations was substantially erased—with the exception of the churches—that of Augustus was renewed and his presence was enhanced, as a Fascist inscription states: "[T]he shades of Augustus are flying through the breezes."

## Mussolini and Obelisks

Although Mussolini chose not to incorporate the Horologium or the concept of marking daily time into the complex, he did not reject the use of obelisks in general. Instead, he capitalized elsewhere in Fascist Rome on the revival of this Augustan precedent. Obelisks were a novel and prominent type of monument that Augustus and his successors incorporated into the urban fabric of Rome. In fact, Augustus had brought four obelisks from Egypt to Rome. One ultimately functioned as the gnomon of the sundial, the second was placed in the Circus Maximus, and two smaller obelisks stood in front of the mausoleum. Made of red granite and lacking inscriptions, these two obelisks are believed to have flanked the building's entrance.[40] That these obelisks were paired and connected with a place of burial suggests that they were intended to follow Egyptian precedent and, perhaps, even to allude to the deification of Augustus.

The obelisks obtained by Augustus acquired new meanings when they were brought to Rome and set up in various locations. There they functioned symbolically as statements of power and self-promotion, and their reerection provided the occasion for elaborate Roman spectacles. What better way was there to make an impression than by having the means and engineering skill to move and then to reerect these spoils from exotic Egypt?[41] To this accomplishment must be added the symbolic value of the obelisks, which represented Augustus's control of time and space as well as his connection to the sun cult and monarchial precedent. In the '30s Mussolini revived the Augustan tradition of establishing obelisks at crucial locations in the city and incorporating them into the fabric of Rome.[42] In doing this he also imitated the ancient imperial practice of using obelisks to express the power of the victor and to emphasize the exotic nature of the vanquished.

Mussolini erected a new obelisk in the Foro Mussolini, a sports center built in 1934 and now known as the Foro Italico.[43] Constructed of marble blocks shaped to represent a fasces, topped with gold, and ornamented with an inscription reading MUSSOLINI DUX the Foro Mussolini

obelisk provided visual propaganda in its Fascist context. Its contemporaneous depiction on a postage stamp increased the power and validity of its message and made it possible to be seen throughout Italy.[44] Despite Mussolini's disgrace, the obelisk with its inscription has survived unaltered in its architectural context, a forum whose name and function have been changed; this monument with its prominent inscribed reminder of Mussolini has retained its place in the urban fabric of post-Fascist Rome.

The Foro Mussolini was the first of three grand projects that Mussolini intended to recall those of imperial Rome. The second, the new University of Rome, designed by Marcello Piacentini, was begun in 1932. The third project was EUR (Esposizione Universale di Roma), the new city that began as the site of a planned universal exposition in 1942. For this setting, another obelisk was begun in 1938, although it was not erected until 1959. An honorific monument sculpted by Arturo Dazzi and dedicated to Guglielmo Marconi, pioneer in radiotelegraphy, this obelisk is decorated with panels illustrating various aspects of Marconi's work, thus celebrating scientific expertise rather than military victory.

Another obelisk that the Fascist regime set up in Rome, the fourth-century monument that Mussolini brought from Axum in Ethiopia, is now infamous because of an ongoing debate about its rightful ownership (figure 22).[45] Transferred to Rome in 1937 after Italy's victory in Ethiopia, the obelisk was erected in time for the commemoration of the fifteenth anniversary of Mussolini's March on Rome. A treasured monument of Ethiopia's past glory, the obelisk was placed in front of the Ministry of Italian Africa in the Piazza di Porta Capena in a prominent setting that boldly announced Mussolini's imperial achievement.[46] Unique in appearance and shape and over seventy-eight feet high, the obelisk from Axum has a rectangular section, lacks a pyramidal apex, and is carved on all sides with designs resembling windows and doors. Its exceptional appearance signals its Ethiopian origin, just as the obelisks erected by Augustus are immediately identifiable as Egyptian. In the 1937 Mostra Augustea della Romanità, a photograph of this

**Figure 22**  Obelisk from Axum, Ethiopia, Piazza di Porta Capena, Rome. Photograph by Ann Thomas Wilkins.

monument formed part of a display that specifically linked Mussolini's authority over Ethiopia with Augustus's conquests. In the exhibition display, the Augustan Circus Maximus obelisk was flanked by the obelisk from Axum and by the so-called Lion of Judah, a bronze sculpture symbolizing the monarchy in Ethiopia, which Mussolini also took from Ethiopia.[47]

The parallel between Augustus and Mussolini and their conquered territories must have been obvious: with great expenditure of manpower and funds, Mussolini, like Augustus, appropriated a monument symbolic of its place of origin—a nation that had fallen to his troops—and reerected it in Rome. Furthermore, both Augustus's and Mussolini's obelisks celebrated victory while suppressing the brutality of war. Neither monument specifically honored those who fought; instead, each offered symbolic and honorific relevance for its own culture. In their monumentality and uniqueness, the obelisks ex-

alted Augustus and Mussolini, the individuals responsible for the Roman victories over two African nations.

Another ancient obelisk in Rome also was symbolically connected with Ethiopia. Originally from Heliopolis, this obelisk was erected in antiquity in the Temple of Isis in the Campus Martius. Rediscovered in the nineteenth century, the obelisk was reerected in front of the Rome railroad station after the Ethiopians defeated the Italians at the Battle of Dogali in 1887. The obelisk served as a memorial to the Italian soldiers killed in that battle.[48] Thus, an obelisk that had once stood in Egypt was moved in antiquity to a Roman temple dedicated to an Egyptian god, only later to become a monument in honor of Italians defeated in Africa. Perhaps Mussolini had this history in mind when he used the Axum obelisk as a symbol of his own victory over those who had defeated the Italians in 1887.

Augustus's use of obelisks was more complex than that of Mussolini in that the Egyptian monument that functioned as the Horologium's gnomon served practical as well as propagandistic and memorial functions. In the Campus Martius, real time was marked within a complex that symbolized victory, dynasty, heritage, and present empire. By obtaining his own monument from Axum, Mussolini made a statement about his power and the revival of empire. Just as the battle of Actium was crucial in the ascendancy of Augustus and the establishment of the Roman Empire, the Fascist invasion of Ethiopia brought to fruition Mussolini's imperial aspirations.

## Contemporary Judgment

By the early years of the twenty-first century, both the Axum obelisk and the Piazzale Augusto Imperatore had become controversial. Criticism has been leveled against both the obelisk's removal from Ethiopia and the architectural style of the piazzale. In the post-Fascist era, the Piazzale Augusto Imperatore has often been looked upon disdainfully with regard to both design and intent. It has been described as "without impact," "blatantly Fascist," "a colossal mistake," and "one of the least known and least attractive [squares in

Rome]."[49] The Fascist buildings have been dismissed as overwhelming and overshadowing of the exquisite quality of the Ara Pacis. In fact, many guidebooks have ignored the Fascist aspects altogether, or have referred to them only in passing. Among the more damning comments is this: "[The piazzale] fails to make the desired propagandistic impact, largely because Morpurgo's buildings deaden rather than fire the imagination."[50] The architect is sometimes excused: "Morpurgo [was] entrusted with the final design of the piazza and the new buildings ... [but] he shouldn't be alone held accountable for the ultimate failure of Piazzale Augusto Imperatore."[51] In 1960, Paul MacKendrick referred to the "deplorable neo-Fascist piazza"; and in 1965, Georgina Masson described the style of the Ara Pacis pavilion as "Lenin funerary" and "a strange erection" that "shelters one of the most beautiful classical monuments in Rome." Masson further maintained that she doubted that the pavilion "resembles anything else this side of the iron curtain."[52]

Morpurgo was Jewish, a fact that was probably irrelevant when he received the commission but which became more of an issue as Mussolini and the regime became progressively influenced by Nazi policy. In 1938–39, racial laws were initiated in Italy; it seems likely that problems for Morpurgo began during the Fascist era and that denigration of his work was at least in part based on increasing anti-Semitism. Similarly, post-Fascist criticism may be more anti-Fascist than specifically critical of Morpurgo. Rome's former mayor, Francesco Rutilli, is reported to have described the pavilion as "ugly" and "a symbol of the imperial and infelicitous taste of Fascism."[53]

## Contemporary Appropriation

Now, fewer than seventy years after the Fascist creation of the Piazzale Augusto Imperatore, this portion of the Campus Martius is again in flux. Morpurgo's enclosure for the Ara Pacis has been demolished, and the plan is to replace it with a new museum complex commissioned by Mayor Rutilli from the American architect Richard Meier.[54] The new pavilion, the design of which in some aspects recalls that of its Fascist predecessor, was to have been inaugurated in 2002 but was delayed in response to public criticism of the design. Whiter—perhaps reflective of the ancient altar's marble—and therefore more conspicuous, it is grander in size and scale but of similar rectangular design. The Meier structure is intended to include the Ara Pacis exhibition space, a 150-person theater, offices, storage areas, and a museum shop. The term "museum complex" conveys a subtle change in emphasis: the altar becomes primarily a work of art, and its restoration is no longer a reference to Fascist imperialism.

A document shared by Richard Meier Associates states the reasons for replacing the Morpurgo pavilion. "The existing building ... is unsatisfactory from an aesthetic, an environmental, a technical and functional point of view."[55] To some people, for whom the Fascist design of the original pavilion is distasteful, the new structure will enhance the appearance of the piazzale. Furthermore, since the Morpurgo pavilion has been deemed insufficient as protection for the altar, Meier's structure is designed to address the problem of preserving the altar. The positive aspects of this project, then, should be applauded: protection of the monument will be increased, while the absence of traffic will decrease pollution and noise. Instead of functioning solely as an encasement for the altar, the Meier structure will enhance the Augustan monument by providing specific areas for both scholarly and mercantile activities.

The Fascist piazzale that was conceived to surround the Ara Pacis was clearly intended to be commercial as well as propagandistic. The new Meier pavilion, however, will extend commerce and tourism (both foreign and Italian) and also encourage study of the altar as a work of art. The proposed addition of a book and gift shop will signal an expanded concept of the altar as a museum piece to be enjoyed, studied, and even duplicated in slides, books, and perhaps on elegant silk scarves. The Ara Pacis played a major role in Fascist propaganda; in twenty-first-century Rome, increased tourism and closely allied mercantile activity stand to again transform both the altar and the piazzale. The area that was once commodified and made more convenient for

pedestrians will focus primarily on the altar and, hence, on its originator, thereby honoring the military, dynastic, and artistic accomplishments of Augustus.

Yet despite the extravagant plans and commencement of the Meier project, many people have been angered and disappointed. Charles, Prince of Wales, has registered his opposition to Meier's new structure.[56] Students have protested with placards showing Mayor Rutilli's head atop what seems to be Mussolini's body, and graffiti on the fences surrounding the construction site have cursed Meier and have expressed sympathy toward "povero Augusto." The planned structure has also been compared to a gas station. The criticism of the replacement of the Fascist structure may imply a modicum of appreciation for Morpurgo's work or for the Fascist intent to integrate Italian history in a unified piazzale. In a sense, the ancient Roman concept of *damnatio memoriae*—the damning of one's reputation—has been recalled in the destruction of Morpurgo's pavilion. The Fascist agenda is now altered with the loss of this piece of Fascist architecture.

The focal points of Morpurgo's complex were the Mausoleum of Augustus and the Ara Pacis, which, ensconced in its Fascist protective cover, both glorified and eclipsed the ancient monument. Morpurgo's design for the piazzale created contrasts among the restored altar, newly liberated mausoleum, and Fascist structures, yet the Augustan monuments could not be fully separated from their Fascist context. The multipurpose group of related structures functioned symbolically to reference Fascist reverence for Augustan policy and the parallelism between two leaders and two empires. The focus of the Meier project is instead visually and conceptually on the Ara Pacis itself and thus on Augustus alone. The project is intended to reorient the piazzale's space and function and to transform the complex into a cultural center. The Ara Pacis will again become a symbol of ancient Rome. The anticipated complex, then, while still acknowledging the building project of the '30s, will focus intellectually and physically on Augustus. His intent will be renewed as Mussolini's will be diminished.

Once more, the piazzale will invite political and aesthetic interpretation. Although critical assessments of these complexes during and after their construction are difficult if not impossible to ascertain, observers during both the early empire and the late 1930s must have reacted to the notable change in the urban context that the projects produced. In his Campus Martius complex, for instance, Augustus paid homage to the past and defined the coming age. Yet how evident were these references to his contemporaries? Did they feel awe, remembering the recent victory at Actium, or did they merely register the monuments as part of the cityscape? Mussolini reasserted the significance of Augustus's monuments. Did the Italians in the '30s recognize the ideological connection between the Campus Martius obelisk, for instance, and the Axum stela, or is that a construct made possible only in retrospect?

It is difficult for us to separate Mussolini's megalomania and brutality from his avid dedication to resurrecting Augustus's rule. Our view of Fascist monuments is colored by the memory of political and military strife. One need only to look at guidebooks that either ignore the Fascist contributions or dismiss them as ugly or unworthy of discussion to understand how Fascism can be interpreted emotionally rather than historically. Certainly this attitude has affected our understanding of both concept and design of the Piazzale Augusto Imperatore. Mussolini's efforts metamorphosed Augustan statements of family, victory, peace, and empire into a contrived exposition, the erection of victory monuments, and a Fascist complex that physically and symbolically incorporated the mausoleum and the Ara Pacis and surrounded them with Fascist structures. Even the words of the first emperor were embedded into a Fascist matrix.

It is now time to look at Morpurgo's altered piazzale and his rehabilitation of the Augustan era with a less judgmental attitude. Perhaps we are still chronologically too close to the Fascist era to be able to acknowledge Mussolini's contributions to the exploration and renewal of ancient Rome. Yet our own perceptions of the Augustan age have in great part been formed by the actions and intentions of Mussolini's Italy. With Mussolini's impetus, Augustan monuments were returned to prominence. As Paul Zanker notes, our perception of the Augustan age was first formulated in the 1930s.[57] We need only re-

flect on what our understanding of Augustan contributions would be without Mussolini's impetus; without his grand design, for instance, the Ara Pacis might still have been lost to us as a coherent monument, and Augustus's mausoleum might still be rendered absurd as a venue for musical recitals.

As Augustus assimilated other cultures in order to link himself to his heritage and to proclaim his victories, Mussolini isolated Augustan Rome from that of intervening generations and thus honored his own ideological heritage. Whatever our twenty-first-century reactions to the Fascist Piazzale Augusto Imperatore, we must now look to a renewed public square that will ensure that Augustan visual propaganda will be more widely known and studied. Perhaps this renovation will fulfill Mussolini's words delivered in 1925: "[Rome] must be a city worthy of its glory and this glory must be continuously renewed in order to be handed down as the heritage of the Fascist era to future generations."[58] Perhaps even Mussolini will someday be recognized and acknowledged for his part in resurrecting the memory of the first emperor—no matter what his ulterior motives.

# "Il Primo Pilota"

## Mussolini, Fascist Aeronautical Symbolism, and Imperial Rome

*Gerald Silk*

THIS CHAPTER EXAMINES the role of aviation in Benito Mussolini's Fascist Italy and the links the regime forged between modern aeronautics and the Roman Empire. Mussolini—who described himself as an "aviation fanatic," and whose infatuation with flight may date to as early as 1909—believed that modern technology would propel Italy toward a glorious future that would be a reincarnation of her great Roman past. Shortly before Mussolini declared a Fascist empire, Guido Mattioli published his propagandistic tract entitled *Mussolini aviatore e la sua opera per l'aviazione* (figure 23).[1] In it he observed that Mussolini envisioned the "reconstruction and strengthening of Italian airpower as the ideal bridge between the past and present, reaching forward to the future."[2]

It is not my intention to suggest that most Fascist aeronautical images quote directly from visual sources in the past. Rather, I want to show how such images propagandistically developed correspondences between Mussolini and ancient Roman leaders, especially emperors, and situated the airplane as essential to the creation and administration of a modern empire, in a role similar to that of roads and sea power in the ancient Roman Empire. Moreover, these representations should not be understood as mere reflections or

repositories of Fascist political ideas. Through their form and content, these images helped to shape and to define Fascist politics and propaganda.[3]

Exploring the links between modern Fascism and ancient Rome through the theme of aviation also requires consideration of the general array of "Romanisms" that Mussolini invoked.[4] Although I shall not offer a long list and analysis of these other borrowings from the classical world, I shall note some of the more fundamental appropriations.[5] The use of such words as "appropriation" and "borrowing" to characterize the relationship of Fascism to ancient Rome is problematic, however. As Mussolini himself described it: "Rome is our point of departure and our point of reference; it is our symbol, and if you like, our myth. We dream of a Roman Italy, that is, [an Italy] wise and strong, disciplined and imperial. Much of the immortal spirit of Rome is reborn in Fascism: the *Fasces* are Roman; our combat organization is Roman; our pride and our courage are Roman: *Civis romanus sum* [I am a Roman citizen]."[6]

Mussolini implied that Fascism did not pilfer from the Roman past, but was a legitimate rejuvenator and heir of this grand legacy. With each reference to this past—whether it be an idea, an image, a ritual, a myth, a symbol—the Fascists hoped to demonstrate that in all spheres of life the "fall of the Roman Empire" was only temporary, so to speak. The Fascists believed they were reversing the "decline," creating a modern empire, which in the process was also a revival and

I thank for their assistance Jennifer Brushaber Calder, Contessa Maria Fede Caproni-Armani, Paolo Colombo, Roger Crum, Jane Evans, Mary Henderson, Claudia Lazzaro, Dominick Pisano, Manuela Proeitti, and Christopher Wilcox. A 2001 Temple University Research Study leave provided valuable time for work on this subject.

**Figure 23**  R. Francisi, dust jacket design. Guido Mattioli, *Mussolini aviatore e la sua opera per l'aviazione* (Rome: L'Aviazione, 1936).

continuation of the original *imperium*. Fascism proclaimed and laid claim to its racial Latin pedigree and its sense of destiny and historic continuity with its Italic ancestry. The Roman Empire served as an historically legitimizing imperative to modern Italian imperialism, carrying with it the principle of ancient Rome as one of the cornerstones of Western civilization, a culturally and morally edifying and civilizing force. As Guido Mattioli observed in the hours just prior to the 1922 March on Rome, the event through which Mussolini gained control of the Italian government: "He [Mussolini] was going to conquer not only a kingdom, but also take the reins of a civilization, thousands of years old."[7]

As other chapters in this volume demonstrate, ancient Rome was not the only "past" that Fascism enlisted. Later phases of Roman and Ital-

ian history and culture, such as the Christian era, the Renaissance, and the Risorgimento, became points of reference, but even these associations were often intertwined with ancient Roman roots. And neither the Fascists nor the Italians generally were unique in summoning aspects of Roman antiquity—imperial and otherwise—as validating historical paragons.[8]

Among the myriad ideas that the Fascists revived from the Roman past, the most important may have been the use of visual imagery as an ideological tool. The ancient Romans were hardly the first or the last in history to employ imagery propagandistically, but they used visual images masterfully and ubiquitously, in contexts that ranged from what we might label high to low. The Fascists both perpetuated and invoked the chauvinistically apposite tradition of their

ancient Roman predecessors. Mussolini most closely identified with Augustus, whom many consider the most adept Roman leader in the exploitation of a broad spectrum of imagery for political purposes.[9]

Mussolini became head of the Italian government as a result of the March on Rome, an event celebrated and commemorated throughout his regime. Principally a negotiated capitulation and exchange of rule, this episode was converted through Fascist propaganda into a dramatic revolutionary insurrection that harked back to the Roman past. Although Mussolini entered the city in the luxury of a train's sleeping car, Fascist propaganda reinvented the story as his crossing the Rubicon on horseback with his black-shirted legions, thus paralleling Julius Caesar's "coup d'état."

This nod to the past was accompanied by a glimpse into the future as airplanes roared overhead while Mussolini advanced into Rome. These "new fascist wings," as Mattioli dubbed them, "swooped toward the train in a sign of a salute," helping to transform the march into a multisensory, momentous phenomenon and recalling the propagandistic employment of multimedia spectacle in ancient Rome. Mussolini argued that Italy had underestimated the value of modern aviation, which could be remedied only through his Fascist reign. Thus for Mattioli the planes buzzing in the skies over Rome symbolized how Italy, through aviation and other means, would take wing. "The sky was streaked with many squadrons. The Italian aviators were now able to fly again," he said. "They had been grounded . . . by the defeatist regime." Only Fascism could set aviation and Italy on their proper and glorious path. "The march on Rome had had its own wings."[10]

The bond between the ancient and modern in aeronautical imagery is perhaps most vividly personified in the image of Mussolini as pilot. One key source for such portrayals, as well as for a variety of other propagandistic aeronautical images, is the Fascist aviation journal, *L'Ala d'Italia* (The Wing of Italy). Published from 1922 through 1943, a period that coincides with the years of Mussolini's reign, the periodical's first issues antedated his elevation to head of the government.[11] Over time, covers and mastheads carried varying slogans, including "National Periodical of Fascist Aviation" and "Born by the Will of Mussolini." In 1929, and for a few years thereafter, a winged ax, joining symbols of flight and Fascism, graced its cover (figure 24).

Originally intended for a specialized audience, *L'Ala d'Italia* initially dealt mostly with technical aeronautical matters. In the late '20s, however, its scope broadened, as artwork and photography became a staple, and articles addressed a variety of subjects, including art, caricature, dance, theater, cinema, literature, poetry, photography, architecture, music, fashion, politics, and *aeropittura futurista* and other Futurist activities. The publication also began including science fiction, humor, and short stories.[12] This appeal to a more popular audience attracted artists and intellectuals as both consumers of and producers for the publication; these individuals typified the importance of culture in and the qualified aesthetic tolerance of Mussolinian Fascism. This aura of cultural diversity—in which artists, in exchange for outlets and showcases, served the regime—poses questions about Italian Fascist cross-fertilization of art and politics, vanguardism and conservatism, and fine art and popular culture. Although the role of Futurism in Fascism is not the focus of this chapter, the mutual interest in aviation warrants mentioning. In 1929, F. T. Marinetti, the head of Futurism, launched a submovement, *aeropittura futurista* (Futurist aerial painting), terming it "the daughter of Fascist aviation and Italian Futurism."[13]

Although the March on Rome did not occur until late October, *L'Ala d'Italia* wasted no time in placing a photo of Mussolini at the controls of an airplane on the cover of the November 1922 issue. Putting Mussolini in the pilot's seat seemed to foretell his move only three months later to make the Italian Air Force the most Fascist branch of the military, with the Duce assuming the position of commissioner of aviation.

Mussolini was actually a competent flyer. The cover of *L'Ala d'Italia*, however, was not a mere document of this skill. At its most basic, this representation referred to Mussolini's position as a navigator-leader of the government and the military. He was portrayed as possessing the daring

**Figure 24**  Cover of *L'Ala d'Italia* (January 1931).

and intelligence to commandeer not only new technologies such as the airplane but also the nation toward a modern future. As Mattioli put it: "The pilot truly knows what it means 'to govern.' Because of this there exists an intimate spiritual connection between aviation and Fascism. In taking for the first time command of the airplane Mussolini must have experienced *physically* the will to govern. . . . This is the symbol of Aviator Mussolini[:] . . . [he] commands the airplane with the same calm strength with which he prepares to lead the people."[14] Flight and Fascism were depicted as synergistic: the facility required to pilot would help Mussolini govern the nation, and Mussolini's management skills would be essential in reorganizing and rebuilding the Italian Air Force, which was often felt to be in disarray.

The symbolism of "aviator" or "pilot Mussolini," especially its correspondence to the concept of Roman emperors, is perhaps best elaborated in Mattioli's hagiographic book, which contains both images and text. Most of the images are photographs, and many continue ideas introduced in the 1922 *L'Ala d'Italia* photo. Since these images date from the mid-1930s, they also address the role of aviation in the imperial aspirations of the regime. Consider the first three images in the book. The dust jacket bears a shot of Mussolini in aviator's garb at the controls of an airplane (figure 23). The actual cover contains an image of the aviator Mussolini's head in profile. Part of a roundel, it is a graphic reproduction of an anonymous and undated bronze and wood medallion, thus alluding to portrayals of leaders on ancient Roman coins and Renaissance medallions. The medallion itself (figure 25) bears the inscription "To Give Italy the Wings to Fly," which is not included in the illustration. The first num-

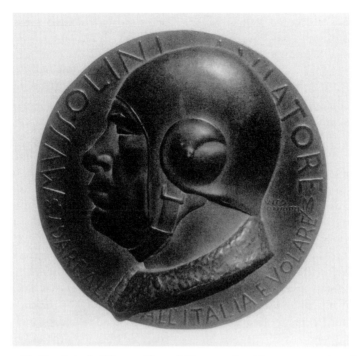

**Figure 25** Anonymous, *To Give Italy the Wings to Fly,* medallion, wood and bronze, approximately 16 inches in diameter, n.d. Maria Fede Caproni Collection, Rome.

bered plate of the book is a photograph of airman Mussolini again piloting a plane. Carrying the caption "Il Duce," an appellation derived from the Latin *dux,* it evokes the cult of the Caesars, even though the ancients preferred the terms *imperator* and *princeps.*

Each of these depictions shows Mussolini in profile, a venerable mode of representation especially popular on Roman coins and in Renaissance portraits. For the ancients, this perspective might simply have been a matter of utility. But it is tempting to speculate that its continued use not only acquired an authority associated with ancient Rome but also indicated superior rank, since the subject's eyes do not deign to make contact with all who are lower in status.[15]

Although these are all somewhat stiff portrayals, their horizontal orientation reinforces ideas of piloting and leadership. By being pictured in a plane's cockpit, gripping the rudder, determinedly gazing beyond and scanning the horizon, Mussolini becomes, in a sense, Italy's pilot and guide into the future. (In one image, the plane tilts upward slightly, implying ascent.) His

proficiency as aviator and as leader will allow him to achieve far-reaching and ultimately imperial goals.

The image of pilot may also have served as a model for the new man of the twentieth century, an idea in wide international circulation at the time, and certainly significant to Mussolini and Fascism.[16] Explaining the symbolism of Mussolini as pilot, Mattioli argued that "to fly . . . is to detach oneself from the body and soul of mediocrity; to rise above the 'ordinary.'"[17] Mussolini himself fervidly praised pioneering pilots, whose feats, comparable to those of Ulysses, Hercules, and the Argonauts, personified "an era perhaps more heroic than the Antique"; translated the "dream of Icarus . . . into reality"; and signaled the "beginning of a new epoch in history . . . the domination of man over nature, over life, over the universe." Modern aviators were "the first champions of the future race of supermen."[18] The portrayal of Mussolini as pilot was designed to imbue him with an equally exalted status that intermingled ancient, mythic, divine, heroic, and modern.

The representation of Mussolini as aviator is

but one of many guises he adopted. Italo Calvino, in his essay "The Dictator's Hats," recounts the myriad personae that Mussolini appropriated, concluding that as the Duce moved toward empire in the '30s these roles became increasingly military.[19] As a totalitarian leader, Mussolini frequently appeared in guises of authority, power, and machismo, indicating the martial fundamentals of controlling a nation and establishing an empire. In part of a provocative study of Italian linguistic discourse entitled *Fascist Virilities: Rhetoric, Ideology, and Social Fantasy in Italy,* Barbara Spackman analyzes the centrality of virility to Fascist symbolism and myth. She also acknowledges that yoking leadership to manly potency is hardly exclusive to dictatorships.[20]

The importance of aviation to Italy's expansionist ambition—that is, to found a new Roman Empire—is a leitmotif running through *L'Ala d'Italia.* The 1933 July–August double issue honored the mass squadron aerial crossing of the Atlantic led by Italo Balbo, Italy's minister of aviation and one of the *quadrumvirs* (imitating ancient Roman political administration) leading the Blackshirts in the March on Rome.[21] This voyage, which belatedly commemorated the tenth anniversary of the Fascist government, was one of several large-scale squadron endurance flights, which not only amazed the world but also put it on notice that Italy was capable of mounting considerable airpower for long-distance missions. "We should not overlook the political weight of this feat," Mattioli wrote. "The Atlantic Squadron, sweeping across the sky of the great stellar [American] Republic, was the offspring of a people renewed in their ancient history, the projection of a new political world arising from the Old World."[22]

When Balbo arrived in Chicago, the city, comparing his achievement to that of Christopher Columbus, declared Italo Balbo Day and renamed one of its thoroughfares Balbo Avenue. On his return to Italy, festivities culminated in a parade through the Arch of Constantine. As Mattioli described: "On the following morning [after Balbo's return], the Duce, in a highly significant symbolic gesture, wanted the columns of heroic airmen to march down the Triumphal Way and

under the Arch of Constantine. On this centuries-old route, the Roman ritual was revived with a spiritual continuity that made venerated ancient history and its monuments seem alive and contemporary. In one's mind, the centuries dissolve when the greatness of a rejuvenated glorious race shines."[23]

Futurist artists Bruno Munari and Riccardo Ricas ran an advertising and design agency, and *L'Ala d'Italia* was a client, for which they produced a photocollage of Balbo's triumphant return (figure 26). At the top, a cutout photograph of the lead plane that Balbo piloted is seen from below. The remaining hydroplanes at bottom are seen from above, landing on the sea and heading toward Italian soil. Arching waves of energy issuing from the propeller of Balbo's plane contain the word "DU-CE"—the common chant and rallying cry used to address and honor Mussolini—repeated over and over and growing in size along with the arcs.[24] Slicing across the center of the piece and moving backward into space are monumental, sturdy letters spelling "ITALIA," housing soldiers standing as erect as the letters. This lineup suggests a solid and mighty Italy made strong by the individuals who fight for and defend her, who subordinate their individuality for the totality of the nation, and who perhaps exhort the general population, which Mussolini wished to enlist as "citizen-soldiers."[25]

Stylistically a part of international modernist experimentation with photocollage, the piece weds the energy of roaring airplanes to the energy of Mussolini, transforming Balbo's accomplishment into a product of Mussolini's will, power, and governance. Mussolini becomes the generative "force" behind Balbo's feat.[26] The Duce provided the nearly superhuman vigor and vision that propelled Italian planes to great heights and across vast distances, an accomplishment that sent shock waves of Fascist glory (and its impending expanding empire) outward from Italian shores to the rest of the world. As one observer put it, Mussolini "launched" the pilots of this "Roman triumph" of the "conquest of the Atlantic."[27]

A 1933 poster by Luigi Martinati (the Wolfsonian, Miami Beach, Florida) celebrating the de-

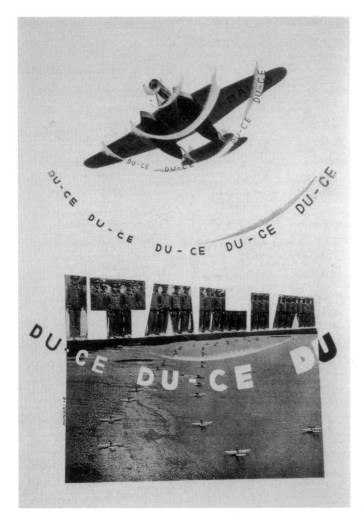

**Figure 26** Bruno Munari and Riccardo Ricas, "ITALIA: DU-CE." *L'Ala d'Italia,* July–August 1933, 88.

cennial crossing echoes this sentiment as planes seem to emanate from Mussolini's head. In this depiction, the Duce's head rises from the sea and looms over the Earth, positioning Mussolini in an ostensibly celestial realm, from where he can survey and ultimately control the Earth. This impassively staring head resembles sculptural portrayals of Mussolini, as well as antique three-dimensional representations of Roman emperors and religious icons.

Policy matched such depictions of the Duce's dominance. Mussolini greeted Balbo by removing him as head of the Italian Air Force (a post he had held since 1929) and appointing him governor of the Italian colony of Libya; at the same time he dismissed the head of the Italian Navy. Mussolini appointed *himself* to both posts, as the country embarked on its most ambitious push to become a major imperial power.

The Italian Futurist leader F. T. Marinetti also directly participated in the event that Munari and Ricas illustrated. Exploiter of modern public relations techniques, Marinetti advocated using radio and television as media of artistic expression, and he lauded Balbo's return in a live radio broadcast (that may even be suggested in the "DU-CE" photocollage by the echoing pulses that recall radio waves issuing from a tower). With his characteristic verbal brio, the Futurist leader greeted the armada:

Listen to the music of the sky with its mellowed tubes of pride, the buzzing drills of miners of the clouds, enthusiastic roars of gas, hammerings ever more intoxicated with speed and the applause of bright propellers. The rich music of Balbo and his transatlantic fliers hums, explodes, and laughs among the blue flashes of the horizon. . . . The crowd shouts with joy. The sun mirrors the creative Italian genius. . . . The delirious crowd yells: "Here he is, here he is, here he is! Duce! Duce! Duce! Italy! Italy!"[28]

Marinetti's words echoed his description of aviation in Futurism's christening broadside, the 1909 "Founding and Manifesto of Futurism": "the sleek flight of planes whose propellers clatter in the wind like banners and seem to clap like an enthusiastic crowd."[29] Like the Munari-Ricas collage, Marinetti's words also intertwine Balbo's feat, the energy of airplane engines, Mussolini's dynamic will, and the power of the nation.

Acknowledging the significance of transportation in the foundation and maintenance of the ancient empire, Mussolini concluded that air power was critical to establishing and overseeing a modern empire, although he did not neglect the two areas associated with Roman imperialism: roads and the navy.[30] Moreover, empire was not solely a chauvinistic ploy to flex bellicose muscles and to restore greatness to Italy, but it was proffered as a necessary condition for spreading and instilling the civilizing and didactic values that originally constituted and continued to define *romanità*.

After Italy's victory over Ethiopia in May of 1936, Mussolini declared the founding of a new Fascist empire in the spirit of the ancient *imperium*. In a famous speech given on May 9 from his Palazzo Venezia balcony, he proclaimed: "Italy finally possesses its Empire. A Fascist Empire, because it bears the indestructible marks of the will and power of the Roman fasces. . . . Salute, after fifteen centuries, the reappearance of the Empire upon the fateful hills of Rome."[31]

The June 1936 issue of *L'Ala d'Italia* announced the birth of a new empire with a photograph of Mussolini identified as *Founder of the Fascist Empire* (figure 27). Dressed in an aviator's uniform, Mussolini stands in the cockpit of an air-

plane, issuing a Fascist salute (a gesture claimed as originating in ancient Rome).[32] Though photographic, the shot appears indebted to Roman statuary, especially orators and in particular the famous Augustus of Prima Porta. Reference to this ancient Roman sculpture is especially telling and rich, since it is often regarded as a prime example of propagandistic imperial portraiture. Details about this piece remain complex and debated, but most agree that in its celebration of military triumph and delineation of Augustus's genealogy, the Prima Porta statue intertwines history and myth in order to elevate him to divine status. Augustus's muscularly idealized body and posture and gesture associated with great oratory are also usurped from earlier classical sculptural traditions.

The image of Mussolini as *Founder of the Fascist Empire* both assimilates related ideas and locates the Duce in the distinguished confraternity of such representations. The photograph embodies similar ingredients as the statue of Augustus, which personify the notion of modern emperor and empire: military prowess; distinguished Italic and perhaps semidivine pedigree; and persuasive and magnetic oratorical power. Moreover, the photograph does not simply borrow an image or motif from the past, but co-opts and enlists a potent visual tradition of which it becomes a part. This is similar to Gilbert Stuart's Lansdowne portrait of *George Washington* in the Pennsylvania Academy of the Fine Arts (1796), for example. Abundantly stocked with symbols that help define its message and meaning, Stuart's portrait is more importantly modeled on Roman imperial statuary (including the Augustus of Prima Porta) and French royal portraiture, particularly the painting of Bossuet by Rigaud, the portraitist of Louis XIV. As a descendent of a noble art historical lineage, the Lansdowne portrait by association imbues the person George Washington with nobility, while it also boosts Stuart to the standing of painter of important people. The implied greatness of the individual is derived, in part, from a tradition of grandeur established within the conventions of art itself. Thus, status and role not only can be indicated by packing a work with attributes, but they can also be implied through formal and art historically contextual means.

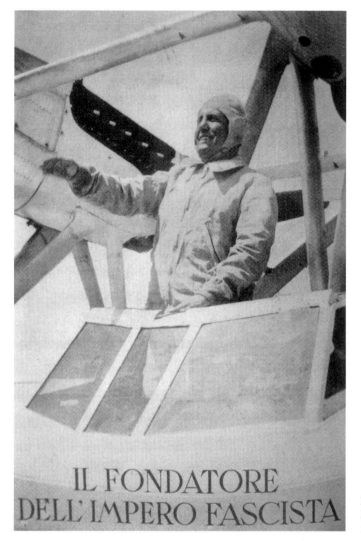

IL FONDATORE
DELL'IMPERO FASCISTA

**Figure 27** "The Founder of the Fascist Empire," *L'Ala d'Italia*, June 1936, 10–11.

*Founder of the Fascist Empire* might be seen as the culmination of the "pilot-leader" concept that had punctuated earlier pages of the magazine and had appeared in other venues as well, in descriptions and images of Mussolini as "Il Primo Pilota" (First Pilot) and "Pilota della nuova Italia" (Pilot of the new Italy).[33] For the frontispiece of his book recounting how he taught Mussolini to fly—*Iniziando Mussolini alle vie del cielo* (Initiating Mussolini into the Ways of the Sky), published in 1933—airman Cesare Redaelli recycled the 1922 *L'Ala d'Italia* photograph of pilot Mussolini, giving it the potent caption "The First Pilot of Italy" (figure 28).[34] As the "First Pilot," Mussolini positioned himself not only at the head of the government

and its military but also as a divine "first principle." This designation was a distorted derivation from the ancient appellation *princeps* or "first citizen," applied to Roman leaders and emperors. The name was in keeping with Mussolini's adoption of a range of personae, such as athlete, warrior, family man, statesman, musician, and even lion tamer, and he was given various appellations. Not only was he "The First Pilot," but also "L'Uomo della Provvidenza" (The Man of Providence, or God-sent Man) and "Padre del Popolo Italiano" (Father of the Italian People), which ultimately crystallized in the "Il Duce" moniker.[35] As for the pilot metaphor, Mussolini initially made good on his promise, boldly "piloting" Italy (through both his dictatorship and his air

**Figure 28** "The First Pilot of Italy," from Cesare Redaelli, *Iniziando Mussolini alle vie del cielo* (Initiating Mussolini into the Ways of the Sky) (Milan: Magnani, 1933).

force) into a new imperial phase. "It was during the Italo-Ethiopian conflict," Mattioli asserted, "that the might of the Wings of Italy were proved in action." The author ties Mussolini's actual and metaphorical piloting talents directly to the airpower Italy employed during the war. "The Duce personally tested the newest and most startling experimental war aeroplanes."[36] In addition, *L'Ala d'Italia* credited aerial bombing as crucial to the conquest of Ethiopia.

Munari's cover design for a special multilingual double issue of *L'Ala d'Italia* in October–November of that year—its internationalism reflecting Italy's imperialism—addresses this modern-ancient axis (figure 29). It consists of the image of a colossal statue of a generic Roman emperor-warrior, placed atop a classical pedestal, enclosed in a schematized drawing of a huge subdivided arch, suggestive of the Fascist revisions of classical architectural canons and the wing of an airplane. Soaring planes dot a cloud-filled sky. The sculpture, clearly meant to be classical Roman, is not identifiable as a specific emperor or leader. But the figure possesses attributes that imply military command, and its bent arm indicates oratory while it also functions like a metaphorical launching pad for the planes. The image reads from lower left to upper right, encouraged by the diagonal arrangement of upward climbing aircraft. This visual thrust not only amplifies the

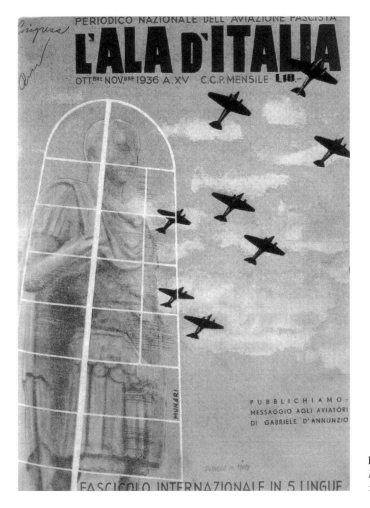

PERIODICO NAZIONALE DELL' AVIAZIONE FASCISTA
**L'ALA D'ITALIA**
OTT.bre NOV.bre 1936 A. XV    C.C.P. MENSILE    L10.

MUNARI

PUBBLICHIAMO:
MESSAGGIO AGLI AVIATORI
DI GABRIELE D'ANNUNZIO

FASCICOLO INTERNAZIONALE IN 5 LINGUE

**Figure 29** Bruno Munari, cover design, *L'Ala d'Italia,* October–November 1936.

idea that the statue propels the planes onward and upward but also implies that the solid and glorious classical past provides the foundation for a great Italian future. This is what Mattioli meant when he characterized Italian aviation achievements as "offspring[s] of a people renewed in their ancient history."[37] Furthermore, since Fascist propaganda fostered the notion that Mussolini, through courage, will, and management, "launched" the planes that brought fame and notoriety to Fascist Italy, the sculpture of the ancient Roman emperor became intermixed with the Fascist conception of Mussolini.

The next image in the magazine is a photo of Mussolini dressed in aviator's garb, labeled "Dux," followed on the facing page by the initial statement of the magazine. In somewhat awkward English it states: "The 'Ala d'Italia' in this first international issue . . . first of the Empire: . . . in which the aviation has given a new and decisive proof that its power is identical with the power of the nation."[38] Taken together, text and image again affirm the cult of the "great leader," or *ducismo,* in Fascist Italy, making the Duce heir to the Roman/Latin nearly divine and superhuman concept of *dux.*

Mussolini further exploited piloting and its symbolism to bolster this characterization, sometimes arriving at rallies in an airplane, as if descending from the heavens. As he spoke, squadrons thundered overhead, visually and acoustically echoing his overheated rhetoric. Engine noise mingled with the roars of cheering crowds (chanting "DU-CE"), serving as a potential example of the Fascist notion of the "Theater of the Masses." Mussolini sometimes marked the

anniversaries of the March on Rome by flying around the country, as if surveying his territory. These images and events raise issues central to Fascist culture regarding the relationship of vanguard style and reactionary politics, the spectacular and the quotidian, aesthetics and violence, and high culture and mass communication.

Incarnating Mussolini's propagandist cultic identification with the Emperor Augustus, the 1937–38 Augustan Exhibition of Romanness featured archaeological replicas and scale models of Roman monuments. The exhibition was part of a vaster celebration of the bimillennium of the birth of Augustus, which included excavation and restoration of the Mausoleum of Augustus at the expense of urban dwellings to fashion the Piazzale Augusto Imperatore. *L'Ala d'Italia* participated in these festivities by sponsoring the "Flight Plan over the Imperial Circuit," announced in January 1935. This aerial tour and survey were to include stops at the major territories and sites of the Augustan Empire, which also corresponded to the locations of modern airports. This tour was described as "an historical-archaeological crossing; . . . for the first time in the world, the airplane would be used . . . as an instrument of critical and cultural study. A flying University . . . a winged movement of intellectuals who want to understand and feel the signifi-

cance of *romanità,* being exposed to the living force of the ways of the Empire."[39]

At this time, aerial reconnaissance became an increasingly important instrument of archaeological surveys. Wedding aviation and excavation, *L'Ala d'Italia* published material on these united efforts, including aerial shots of Pompeii, which appeared directly following the "Imperial Flight Circuit" pages. *L'Ala d'Italia* also periodically published reproductions of North African aerial reconnaissance and bombardment photographs. Their similarity to bird's-eye views of archaeological sites produces a strange intermingling and confusion of images of excavation, destruction, restoration, and reconstruction.[40]

As one might imagine, visual images incorporating aeronautical themes, binding modern Fascist Italy to ancient Rome, occurred across a wide spectrum of media. They could be physically small though potentially broad in dissemination, such as a 1923 stamp commissioned to commemorate the first anniversary of the March on Rome and designed by Futurist artist Giacomo Balla (figure 30). Balla created a stagelike setting as fasces (bundles of rods attached to ax heads derived from an ancient Roman insignia of authority, which became the Fascist state emblem) function as a framing, or *repoussoir,* device, like theater or window curtains drawn

**Figure 30**  Giacomo Balla, sketch for a stamp, 1923, ink, 7 ½ × 10 ⅝ inches. Maria Fede Caproni Collection, Rome.

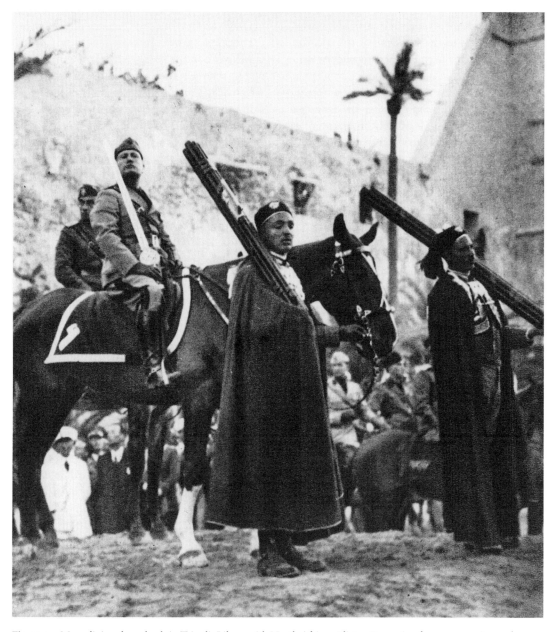

**Figure 31** Mussolini on horseback in Tripoli, Libya, with North African "lictors" carrying fasces, 1937. Armando Bruni, *Mussolini: Cento Istantanee* (Novara: Istituto Geografico De Agostini, 1942).

aside.[41] The Roman past sets the stage for and brackets a modern Fascist Italy. In a jingoistic celebration of the nation's military-industrial complex, billowing smoke from factory stacks encases soaring airplanes (reminiscent of flying swifts, a motif Balla explored earlier in his career), which circle the "Star of Italy."

Again, Fascism combined the greatness of past and present, adumbrating a grand future. In

ancient times, the fasces were carried by officials known as lictors, who cleared the way for Roman leaders. Mussolini co-opted this practice on his visit to Libya, where North Africans in the role of lictors shouldering actual fasces preceded the Duce on horseback, implying that Roman principles underlay, guided, and framed contemporary Fascism (figure 31). Mussolini becomes a condottiere here, claiming a place in a line of eques-

trian warrior-leaders (and their representations), stretching back to the classical world and running through the Renaissance to the present. Mussolini further mined the bundling concept inherent in the fasces, defining his Fascism as the great unifier that bound together the heterogeneous rods of the people of Italy and its colonies into a powerful coherent cluster. "Fascism," Mussolini asserted in 1932, "enforces discipline and uses authority. . . . Therefore, it has chosen as its emblem the Lictor's rods, the symbol of unity, strength, and justice."[42]

Roman idioms also inspired contemporary Fascist architecture, and the concept of the Third Rome was central to Fascist building and urban planning. The notion of the Third Rome, which originated with the Risorgimento, was understood as succeeding but also embodying ancient and Christian Romes.[43] Under Mussolini, the idea was implemented emphatically through massive urban renewal based on excavation and restoration of certain ancient monuments, the demolition of allegedly decadent architecture, and the institution of a new city plan for Rome, which mixed ideas from the ancient and modern in the service of a Fascist *romanità*.

Construction extended beyond the walls of Rome in a series of new towns. One of these, Guidonia, was devoted to aeronautics, specifically to flight experimentation, and Mattioli called it the "forge for aeronautical innovations, the beating heart of the progressive life of aviation."[44] This "city of the air," as Mussolini hailed it, contained testing facilities, housing, and civic institutions for those who lived and worked there.[45] By naming the town after General Alessandro Guidoni, a fallen Italian hero, airman, and engineer, Mussolini buttressed the cult of the hero in Fascism who willingly makes the ultimate sacrifice for the Fascist cause.

Photographs chronicle the founding of Guidonia in 1935, as Mussolini breaks ground with an ax, a tool not only recognized as a part of the fasces but also associated with demolition, excavation, and foundation. Erected on the reclaimed Pontine Marshes and completed in 1937, Guidonia enabled the Duce to claim that he had fulfilled the promises of Julius Caesar to put areas, such as marshland, to constructive use. "From Guido-

nia," Mattioli wrote, "the flights will be launched that bring to those obstinate obstructers of Italian expansion the sense of our strength and our will to conquer. The Duce will use this Air Force, which he has rebuilt and brought to a leading position among the Air Forces of the world, as a powerful political fulcrum."[46]

Aviation and ancient imagery cohabit in a set of floor mosaics that were installed at the Foro Mussolini (now the Foro Italico) shortly after Mussolini declared a modern Roman Empire (see figure 3 in chapter 1). One contains at its center the words "9 May XIV Year of the Fascist Era— Italy finally has its Empire," taken directly from Mussolini's proclamation of empire, which he delivered from his Palazzo Venezia balcony. At the very bottom of the mosaic, the Roman lion appears, flanked by stylized versions of fasces and huge Ms, standing for Mussolini. Several groupings of images sit above and below the words. At the top, a modern soldier plants the Italian flag in soil, as if claiming vanquished territory for the empire. A nearby toga-clad ancient, accompanied by another Roman lion, addresses the soldier and flag with the "Roman salute." Paired with this arrangement at the top of the mosaic are images of two airplanes joined by the Roman eagle. The symbol of the eagle, used in ancient Rome to precede legionnaires, was adopted as a Fascist insignia of the modern empire.[47] At the bottom a modern tractor signifies both the military and civilian activities of warfare and land reclamation, made explicit by two nearby clusters of men: one group carries the nearly timeless tools of excavation and construction, while another holds both ancient and modern weapons of war. This mosaic, influenced by antiquity in both style and medium, contains a mixture of references—man, machine, and animal; creation and destruction; fact and symbol; present and past— elucidating the meaning of empire. The Roman Empire is the generative force behind the Fascist empire. It provides the moral, military, and enlightening sanction and imperative to conquer, to reclaim, and to build on the territory that originally made up the ancient empire.

Large-scale exhibitions were a staple of the Fascist propaganda machine, and aviation received its due in several of these. The most impor-

tant was the Exposition of Italian Aeronautics, which opened in Milan in 1934. Designed to explicate the "historical, heroic, [and] mythic" role of Italian aviation, the exhibition followed in the footsteps of the famous 1932 decennial Exhibition of the Fascist Revolution in Rome.[48] The logo of the exhibition—fashioned by artists Constantino Nivola and Giovanni Pintori—was done in fresco, in the entry hall, and shows Mussolini in the center of the Italian aeronautical enterprise. As the catalogue explains: "The emblem, in the style of a photomosaic, brings together a blue wing and the badge of Italian airplanes and the figure of the orator Mussolini cut into a *fascio*."[49]

The catalogue also includes a photograph and a description of the entry façade, designed by Erberto Carboni. The photo features actual planes in a flight pattern overhead (echoing depicted ones below) and the commentary crystallizes many ideas embedded in Fascist aerial phenomena: "a blue ground, a formation of airplanes, a map of the world, a shining *fascio littorio*, symbolizing the supremacy of Italian flight."[50] On display was the aircraft from a legendary 1921 crash that Mussolini survived, further developing themes of heroism, martyrdom, and Icarus (with whom the Emperor Augustus also identified in order to promote divine ancestry). Modern, godlike man, embodied in Mussolini, who in defying death fulfilled the failed dreams of classical mythology, recycled the messianic resurrection of Christianity and reconnected with the "semidivine" Roman Emperor Augustus, offering yet another opportunity to deify "Il Duce."[51]

In this spirit, aeropainter Gerardo Dottori's 1933 *Portrait of Il Duce* as a quasi-divine, omnipotent and omniscient master, is perhaps more Pantocrator than pilot. A mammoth torso of Mussolini towers over a hilly landscape, his body enmeshed through Cubo-Futurist planes of form and force with the land out of which it seems to grow. These compositional planes further elide his head with the clouds and sky as aircraft revolve around but also seem to be controlled by this gigantic Mussolini. In a related spirit of divinity and dynamism, Renato Bertelli's 1933 *Continuous Profile of Il Duce* (the Wolfsonian, Genoa) offers a 360-degree, truly "in-the-round" sculptural transformation of the Italian leader into a spinning mechanomorph (a term the Futurists used to describe machine-man hybrids), fusing Mussolini with the energy and power of a whirling propeller or gyrating engine. Inscribed "DUX" at its base, the sculpture represents a technologically charged, modern-day version of a semidivine ancient Roman leader, who sees all and does it all. Tiziano Piccagliani, who fought in the Libyan war, made the expository *Synthesis* (private collection, Modena), which won top prize at the First Exhibition of the Art of the Empire, held in 1937 in Ethiopia. He assembled a mixed-media profile of Mussolini as an Arcimboldesque quasi-cyborg of familiar Fascist icons: fasces, tank, eagle, and airplane. The text included in the piece explains this conglomeration of elements, adding to the mix a description of Mussolini's explosive oratory, as if classifying it as another of the weapons embedded within.[52]

The medallion serving as the frontispiece for Mattioli's *Mussolini aviatore* carries an inscription that spells out the correspondences between flight and ascension: Mussolini would give Italy the wings to fly into the future and would take it to great heights (figure 25).[53] But Italy flew into increasingly turbulent air in the late '30s and early '40s, a crisis that raised doubts about Mussolini's ability to govern. As if in response, Verossi, who was classified by Marinetti as among the "combatant aeropainters," exhibited at the 1940 Venice Biennale his 1940 painting of pilot Mussolini in profile in the cockpit of a plane. Both the image and its title, *Do Not Disturb the Pilot* (Galleria Narciso, Turin), urge Italy to stay the course and to keep Mussolini at the controls. Nonetheless, the Duce's days at the helm were numbered: after his arrest in 1945, *L'Ala d'Italia*, which continued to publish, never again made any mention of Mussolini.

# Fascism *Triumphans*
## On the Architectural Translation of Rome

*Jobst Welge*

TO ASSOCIATE ITSELF with the grandeur of ancient Rome, Italian Fascism launched an ambitious program of urban and architectural renewal: a restoration that presented itself as an act of cultural translation in order to emphasize the transfer of political authority from the past to the present. In this chapter I investigate the ideology of historical translation in the architecture and architectural debates of Fascist Italy as well as the roots of that ideology in nineteenth-century culture. Although scholars like Richard Etlin, Spiro Kostof, and Giorgio Ciucci have provided comprehensive and detailed accounts of the changes in the urban and architectural landscape in Rome and throughout Italy, I focus here more specifically on the image of the triumphal arch. This, I argue, emerges as the most emblematic and self-reflective element of architectural translation in this period. As the quintessential symbol of *romanità*, the triumphal arch comes to embody both historical continuity and the desire to "transcend" historicism; it thereby turns *romanità* into a more immediate expression of the Fascist present.[1] In pursuing the use of triumphal arches, we gain insight into how the Fascist regime used and abused historical representation, and to what extent the uses of the arch wavered been historicism and modernity.

Triumphal arches are classic examples of what Pierre Nora calls *lieux de mémoire,* that is,

intentional self-representations of the nation-state. Their memorial or monumental function is, according to Nora, symptomatic of a society in which "memory" is no longer naturally given, but has been displaced by, or has mingled with, "history."[2] In Nora's view, modernity is distinguished by the "conquest and eradication of memory by history."[3] The presence of memorial sites in modern times is therefore essentially a staging of memory, marked by the interplay of memory and history. Nora explains: "These *lieux de mémoire* are fundamentally remains, the ultimate embodiments of a memorial consciousness that has barely survived in a historical age that calls out for memory because it has abandoned it." Memorial sites function therefore like an historical palimpsest to the extent that they are concerned with "administering the presence of the past within the present." They exceed the significance of historical objects in that they always refer back to themselves as "self-referential signs."[4]

Nora envisions these *lieux de mémoire* as located between life and death, memory and history. Insofar as nation-states consciously resort to the construction of memorial places, they clearly have to emphasize the "living" dimension of these sites. Yet it is self-evident that the more rhetoric that is expended on their living character, the more difficult it becomes to distinguish between the imposition of memory from above and its "organic" core. This is not the place to examine Nora's sometimes questionable nostalgia for an extinct memorial culture; instead I concentrate on how the Fascist nation-state made use

I thank Jeffrey Schnapp for his encouragement and help with this chapter, as well as Mia Fuller and Claudia Lazzaro for their thoughtful comments and numerous suggestions.

of and constructed memorial continuities, above all through reference to the civilization of ancient Rome. This ideological use of history built on the willful deployment of history in the nineteenth century, as it emerged in the state-orchestrated use of *lieux de mémoire*. By looking at both "literary" and architectural examples of triumphal arches, I am concerned with how Fascism attempted to reclaim ruins and to reactivate their historical potential.[5] As we will see, triumphal arches, as *lieux de mémoire,* were often invested with a characteristically *metonymic* function, insofar as they became signifiers for the (trans)historical force of "Rome" itself. Precisely because their symbolic burden was so great, they were often in danger of becoming merely archeological ruins. I investigate some key instances in which architects and planners tried to circumvent this danger, and in which different historical epochs intersected. Although my emphasis falls on the Fascist period, and in particular on the Mostra Augustea della Romanità (Augustan Exhibition of Romanness), I begin my account with a somewhat eccentric example that concerns the Arc de Triomphe in Paris. This primary symbol of nineteenth-century nationalist ideology tried to revive the medieval notion of imperial translation (*translatio imperii*).

We are in Paris in the year 1932. The Italian writer and arch-Fascist Curzio Malaparte and the American Glenway Wescott enter the apartment of Luigi Pirandello in the vicinity of the Place de l'Étoile. They are there to join Pirandello for dinner on the Champs Elysées. Pirandello is still in the bathroom:

> Suddenly, the voice of Pirandello called us from the bathroom. . . . Pirandello was stretched out in the bathtub. . . . It was almost like Marat in the bathtub, after he was killed by Charlotte Corday. The bathroom was dark, but from the window entered a striking shimmer, an intense light, extremely white, almost blue. It was the light of the triumphal arch at Étoile, illuminated by the bundles of lights from projectors . . . Pirandello sitting there in the tub, his face totally lit by the blue reflection, every hair of his pointed beard distinguished from the others, precise, alive. Like a mask from Crete, minotauric.

> From the tub Pirandello saw the triumphal arch erected in the night, shining with light. "It seems to me I'm on a ship," he said, "I'm floating toward that triumphal arch." He laughed sadly, with ironic melancholy, evidently contemplating death. That triumphal arch, at the end of his navigation, like a joke, an insult. "This tub is your *bateau ivre,*" I said to him. Pirandello raised his eyes, and as he turned his head over his right shoulder, he looked at me: "Yes, this is my *bateau ivre* . . . but that triumphal arch— what a terrible haven."[6]

Malaparte wrote this in 1936, at the time of Pirandello's death, as a recollection of his last encounter with the writer. In Malaparte's account, Pirandello's identification of the triumphal arch with death appears as a striking superimposition of historical periods. As Pirandello, the icon of Italian literary modernism, is drifting toward the symbol of nineteenth-century nationalism, the Arc de Triomphe, which is illuminated by the "blinding light" of the twentieth century, he is likened to Jean-Paul Marat. This ambiguous figure of the French Revolution was killed while writing in his bath. Although the image of the triumphal arch recalls the idea of literary fame and glorification, Malaparte describes Pirandello's decidedly simple vision of his own funeral: "He wanted to be carried away at daybreak, alone, even without his children, on a cart drawn by a meager horse (and at the end of the long street there wasn't a triumphal arch but the blue stripe of the invernal daybreak)."[7]

Pirandello's association of the triumphal arch with death can be traced back to the state funerals of Napoleon (1840) and of Victor Hugo (1855), whose coffins were ceremoniously placed under the Parisian arch.[8] The Arc de Triomphe functions as a symbolic site that accumulates a series of memorial "events" and the self-representations of various regimes, going well beyond the original intentions of its builder, Napoleon, after the victory of Austerlitz. It thus bears out the general rule that national monuments are often prone to a "latent anachronism," whereby the original intentions are superseded by the uncontrollable process of historical contingency.[9] The arch became the focal point for manifestations of

religious and patriotic sentiments—a fact illustrated in Victor Hugo's poem *A l'Arc de Triomphe*—as it also exemplified the broad tendency typical for the nineteenth century toward the sacralization of national monuments and the cult of the dead.[10]

## Arches and Marches

The Arc de Triomphe could almost be seen as an emblem of the French nineteenth century. During his sojourn in Paris, where in 1931 he published his famous treatise, *Technique du coup d'etat,* Malaparte deplored what he saw as the "bourgeoisification" of French nationalism. Malaparte explains in his treatise, referring to a generic Frenchman: "If Monsieur Eugène had been asked what the purpose was of the Arc de Triomphe, he would have been very embarrassed for not knowing an answer. He had never given it a thought. It is this embarrassment which unites the generations born after 1870."[11]

Malaparte himself, on the other hand, was fascinated by French triumphal arches because he saw in them a displaced and extended version of Italian and Roman grandeur. In various shorter writings he criticizes French nationalism for its failure to acknowledge the superiority of Italy, the "*Romanitas* as inspiration for centuries."[12] His fascination with the figure of Caesar, for instance, led him to a personal reenactment of the route of Caesar's Gallic conquests, the victory of Roman civilization over the native "barbarians": Caesar's *De Bello Gallico* as tourist guide. When Malaparte finally reached Provence, he found there "the Roman heart" of France, where the inhabitants regarded Caesar no longer as an enemy, but rather as "one of ours," as "notre César." The triumphal arch in Orange was for Malaparte the true symbol and center of French *romanità.* Although he engages in a critique of "historical objectivity," he praises the "popular imagination" for its intuitive grasp of Caesar's mythic presence in a landscape of Roman ruins. Malaparte sets up an opposition between the purely historical, academic conception of Caesar and the popular image of him current among the Provençal people. This "popular" image of Cae-

sar was not abstract and removed, but was a myth adapted to local circumstances. Malaparte implies that the universal appeal of Roman imperialism is predicated on its adaptability to different places. Reflecting on the Maison Carée in Nîmes, he remarks: "It is amazing that Rome appears perfect, concordant, in-place, in harmony with every part of the world, from the deserts of Africa, the steppes of Asia, the Danubian forests, to the farthest ends of Scotland."[13]

Despite his fascination with Roman architecture, Malaparte does not see ancient monuments as models for contemporary architecture. This is apparent in an editorial that he contributed in 1937 to a special issue of his journal *Prospettive* devoted to architecture. Malaparte writes:

> To express the revolutionary and imperial character of Fascist Italy through archeological reconstructions, triumphal arrangements of columns and capitals, pompous marble sepulchers, would be absurd and ridiculous. . . . The new urban settings of Sabaudia and Littoria, the Casa del Fascio in Como, the Santa Maria Novella train station in Florence, for example, express the revolutionary, imperial and ultramodern spirit and character of Fascist Italy much more, than, let us say, the station in Milan or the first part of Via Roma in Turin, or any of the many ugly architectural works through which, in the first years of Fascism, many architects of bad taste and antiquated antifascist mentality, some even famous, pretended to incarnate the creative, innovative and revolutionary spirit of Mussolini.[14]

It was in this spirit that Malaparte had the architect Adalberto Libera build his famous villa on Capri, the Casa Malaparte, as a showpiece for ultramodernist architecture. The villa is demonstrably in harmony with nature, and at the same time, it exemplifies the intersection between modernism and so-called Mediterraneanism, the attempt to infuse Mediterranean archaic forms with the spirit of the avant-garde. This tension between classical and modern forms, the cult of *romanità* and its colonial extension, were, of course, characteristic of Italian Fascism in general.[15] It is probably not by accident that Mala-

parte referred to "archeological reconstructions" in 1937, since that year in particular witnessed a large-scale promotion of Roman imagery.

At a broad propagandistic level, the Fascist state aimed primarily at the diffusion of images in order to bring the whole population into immediate contact with Italy's Roman legacy.[16] The Mostra Augustea della Romanità, inaugurated by Mussolini on September 23, 1937, the two thousandth anniversary of the birthday of Emperor Augustus, played a crucial role in the promotion of a nationalist, memorial consciousness. It also exemplified the regime's attempt to transcend a purely museological approach toward national memory. The archeologist and state deputy Giulio Quirino Giglioli, who had been engaged in the great archeological exhibition in 1911, directed the exhibition that he had proposed as early as 1932.[17] Replicas of Roman monuments and documents—from all over Europe as well as from Asia and Africa—were displayed next to inscriptions that featured patriotic quotations from Dante and Machiavelli to Mussolini. These inscriptions emphasized the long continuity of yearnings for a strong and unified nation. Numerous writings in this period elaborated on the perceived parallels between Augustus and Mussolini, including the perceptions that both were engaged in land reclamation, both celebrated colonial victories over the Ethiopians, and both erected triumphal arches. Significantly, the façade of the Palazzo delle Esposizioni on Rome's Via Nazionale, where the exhibition was held, was transformed into a monumental triumphal arch, with parallel inscriptions of "REX" and "DUX" (figure 32).[18] The façade stood in strong contrast to the modernist façade of the Mostra della Revoluzione Fascista that had taken place there in 1932 (see figure 2 in chapter 1). For both exhibitions the nineteenth-century beaux-arts palace was masked and transformed, but into two radically different and potentially conflicting versions of Fascism's aesthetic face: imperial classicism versus revolutionary modernism.[19] (The intervening five years may also have brought about a decrease in the revolutionary thrust of Fascist ideology.) However we might characterize the relationship between these two different

modes, Fascist architecture showed itself to be transformative of what was literally a nineteenth-century background. With regard to this concealed subtext, even a classical arch must have appeared as something *new*. The heavily stylized statues above the entrance, and the flat surface of the construction, all emphasized the anti-antiquarianism of Fascist *romanità* and its compatibility with modern forms of architecture. In fact, although the typeface of the Augustan Exhibition's entryway was distinguished by its Romanizing "V" and "G," all the other letters were largely continuous with the modernist typeface used for the Exhibition of the Fascist Revolution.

A closer look at the concept of the exhibition and its contents reveals that it was precisely not invested with museological notions of authenticity and archeological documentation, but that it aimed deliberately at the juxtaposition of ancient material with its modern reutilizations. For example, after passing through the entrance, visitors were confronted with a series of triumphal arches that illustrated this sort of living relationship between past and present. The exhibition catalogue explains the relationships:

> Three triumphal arches follow. The last of the ancients, Constantine's arch at Rome . . . was erected in order to celebrate the victory over Maxentius on October 28th 312 A.D., marking the advent of Christianity, and it was transported to that Ponte Milvio where on October 28th 1922 the Blackshirts marched, inaugurating the Fascist age.
>
> After the arch of Constantine there is the one at Bolzano, the first of the new Italy, a work by Italian academic Marcello Piacentini. It was erected in the redeemed city in order to exalt the great victory . . . and the martyrdoms of Battisti, Chiesa, Filzi. The inscription was inspired by the one on the monument to the fallen soldiers of the Dacian war, erected by Trajan in Adamclisi (Romania); the facsimile of the latter can be seen on the stairs that lead to the lower floor of the exhibition.
>
> Finally, there is the arch at the altar of the Phylenians in Cyrenaica, by the architect Florestano di Fausto, remembering the triumphal

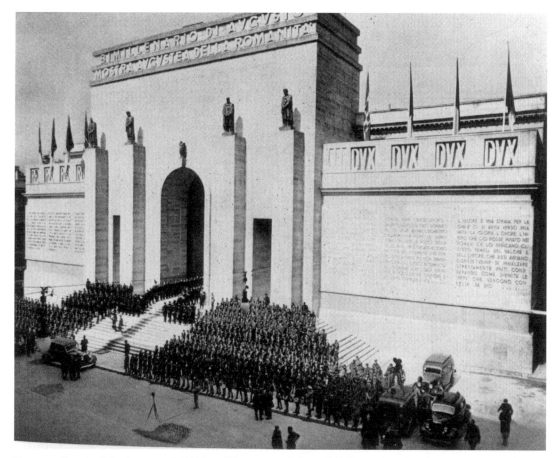

**Figure 32** Façade of the Augustan Exhibition of Romanness, Palazzo delle Esposizioni, Rome, 1937–38. *Capitolium* 12 (1937).

voyage of the Duce in Libya and the inauguration of the *strada littoranea* [lictor's, or Fascist, street], a work of Roman greatness.[20]

Triumphal arches are characterized here as sites of national memory that combine different historical moments as, for example, the advent of Christianity and the inauguration of Fascism in the Arch of Constantine. A similar sort of analogy, or historical intersection, was achieved by the juxtaposition of the obelisk of Augustus (symbolizing the Roman conquest of Egypt) and an obelisk from Axum (symbolizing the Italian conquest of Ethiopia). In terms of the exhibition's "demonstrative" purposes, however, the triumphal arch was the privileged image, precisely because the notion of a triumphal procession served to link the Roman past with the Fascist present,

which was thus constructed as the "Renaissance" of antiquity.[21]

The second arch noted in the catalogue, Marcello Piacentini's Victory Monument in Bolzano, was erected in 1928 as part of Mussolini's politics of Italianization in southern Austria.[22] The arch at Bolzano was designed as a sacrificial temple, with crypt, altar, and dedications to the "martyrs of the Trentino." Piacentini also constructed the Arco dei Caduti (Arch of the War Dead) in Genoa (1923–31), which was similarly designed as a sacrificial monument. The upper surface of the triumphal arch at Genoa is carved with images of weapons and battle scenes from World War I, and an altar in the crypt under the arch is inscribed with the names of the dead. The arches at Bolzano and Genoa were moreover very much indebted to the patriotic rites of the Risor-

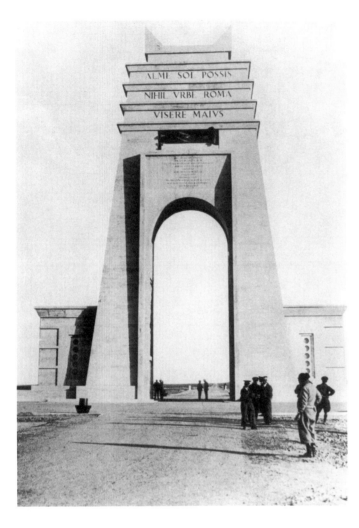

**Figure 33** Florestano di Fausto, triumphal arch, Libyan desert of Sirte, 1937. Paul Schmidt, ed., *Revolution im Mittelmeer: Der Kampf um den italienischen Lebensraum* (Berlin: Paul Schmidt, 1941).

gimento, which were typically related to occasions of national loss, grief, and nostalgia. For example, in the transfer of the remains of Garibaldi's first wife, Anita, from Genoa to Rome, a military parade passed under the Genoese arch.[23]

The last of the triumphal arches in the exhibition catalog, the "Phylenian" arch in colonial Libya, was erected after the great coastal highway was completed in 1937 (figure 33). On March 15 Mussolini, fashioning himself as the tolerant protector of Islamic culture, inaugurated the arch while en route to Tripoli to celebrate the first anniversary of the empire. Designed by Florestano di Fausto, the Libyan arch departs significantly from the model of the Roman classical arch. Pyramidal in shape with a central archway, it

bears an inscription from Horace's solemn *carmen saeculare* at its summit: ALME SOL POSSIS / NIHIL VRBE ROMA / VISERE MAIVS (O quickening sun, may naught be present to thy view more than the city of Rome). This phrase from Horace became a very popular saying in the Fascist period and was inscribed on a stamp commemorating the poet in 1936. In his writings on colonial Libya, the war veteran Rino Alessi rightly stresses the fundamentally novel aspects of this arch (which might well be compared to some experiments with triumphal arches by the French revolutionary architect E. L. Bouillée before 1789). Alessi writes: "The arch is not a work of traditional architecture. Its architect wanted to avoid having the symbol that eternalizes Fascist civilization between the sea and the desert be a rep-

etition of those arches of which Roman and Greek Africa is full; he wanted a new work in harmony with the architectural character of the cities and villages that emerge, or that renew themselves in Libya."[24]

The Libyan arch has to be seen within the context of colonial building and renovation projects, which sought to insert themselves into the still eminently malleable Libyan landscape, resulting in a calculated style of architectural syncretism.[25] This architectural syncretism, or "hybridity," might be seen as characteristic of colonial representation in general, as something that is neither identical with imperial imagery or the Italian motherland, nor completely continuous with indigenous, Islamic style.[26] According to Alessi's account, the architectural novelty of the arch stands for the novelty of civilization in what is imagined to be a blank space ("between the sea and the desert"), where "history" is erased only to uncover the "roots" of Italy.[27] Italian Fascism presented its colonial ambitions as a civilizing mission (including abolition of slavery and promotion of education), which would at the same time solve the problem of overpopulation at home. This civilizing mission was thus promoted as a counter model to the imperialism of the British, which was characterized as merely materialistic and exploitative (and therefore "Jewish"). The landscape of contemporary colonialism was typically interpreted as an opposition between merchants and idealists.[28] This can be explained partly by the fact that Libya was almost totally devoid of known natural riches, but the trope of material disinterestedness had accompanied the discourse of Western colonialism since its emergence during the early modern period. In fact, Italy gained no economic profit from this enterprise, a point that underscores to what extent this was a "prestige" project that allowed Italians to see themselves in the same league as other Western colonial powers.

The Libyan arch is built on a legendary site, the Areae Philaenorum, which in 500 B.C.E. had marked the borderline between the Greek possessions in Cyrene and the Carthaginian territory. According to Alessi, the plan of the provincial governor Italo Balbo to erect a triumphal arch on this site was inspired by a legendary story recounted in Sallust's *Bellum Iugurthinum* (9.3).

Alessi explains: "The Latin narrator has in fact inspired the governor of Libya who loves the stories of Rome, not as dusty pages of a book, but as inspirational sources for works that are in harmony with the constructive sense of Fascism."[29] Reminiscent of Malaparte's aversion to "archeological reconstruction," Alessi distinguishes Fascism by its virtue of *constructiveness*. In Sallust's story, in order to establish a borderline between Greek and Carthaginian possessions, an athletic contest is staged, pitting two sprinting youths from Cyrene against two from Greece. The youths start from opposite ends and the point where the two parties meet would henceforth become the national borderline. The two runners from Carthage ("the Phylenic brothers") prove victorious, but the biased jury denies their victory. Eventually the two runners commit suicide and are buried at the point they had reached in the contest. Alessi turns this mythical story into an emblem of Fascist heroism: "History or legend, this sacrifice belongs to the ethics of heroism, which develops in a thousand episodes in the course of Roman civilization and which represents today the most refined spiritual nourishment of the young, Fascist generations. It inspires the desire that the fatherland should extend to the point to which the blood of its best sons aspires."[30]

In honor of Mussolini's visit to Libya, Balbo arranged a triumphal spectacle that merged the ancient Roman ritual with a display of the latest modern technology. This was all the more dramatic for its staging in the desert. Ugo Ojetti, the popular writer and critic of the Fascist period, described the event: "The arch under the convergent reflectors is illuminated like an altar. On the circular place that surrounds it flaming tripods are lit: so much light that ten meters behind it is pitch-dark. With ever-increasing frequency airplanes are rumbling. A division of nomads on camels and a battalion of Libyans align themselves along the street. The sound of trumpets and drums signifies that the Duce is arriving. In the East the darkness is marked by a chain of lights: the cars of the convoy."[31]

This theatrical spectacle, the transformation from night into day, was tantamount to the transformation of the desert itself, the civilizing mission of colonialism. As Ojetti further boasts, the

building of the coastal highway itself was seen as a heroic undertaking. It introduced the very notion of construction and measurement into a landscape that had been otherwise ever shifting and unstable. At the same time, however, this colonialist intervention was legitimized as a *restitution* of a Roman essence. In Alessi's account, construction *and* archeology are invoked to justify each other: "[I]t can be said that every newly constructed place, every arch that is built, every classical monument that is revived from the sleep of centuries and brought back to life from the greedy and inconstant sands of the desert, are all works that eternalize the memory of our victories, that will prove to the traveler of Africa that the Italian dominion has nothing to fear, but much to hope for."[32]

The subtext of Italy's civilizing mission was the fact that during antiquity Libya had been a country rich in agriculture and in urban amenities, with booming cities such as Leptis Magna, Cyrene, and Sabratha. The Fascist narrative typically blamed Asian and African conquerors for the decline of what was praised as an "essentially Greco-Roman landscape."[33] The archeological reconstructions were thus accompanied by the renovation and building of mosques—a sign of professed tolerance of the indigenous Islamic population.

The victory of the Italian soldiers in Ethiopia was also celebrated by a military march, passing under the Arch of Constantine in Rome, which thus came to function as a symbol for the newly established link between Italy and its colonies, as well as between present and past. As the archaeologist Massimo Pallottino wrote in a newspaper article on this occasion, this arch was perceived as the visual embodiment of the historical continuity of Roman imperialism:

> In Rome boundaries between past and present do not exist, nor between the classical and the contemporary world. The monuments, the ruins, the memories do not belong to the reconstruction of the archeologist (however impassioned it might be), nor to the narration of the historian (however noble); they belong to the life that we are living. And it is only then that we will realize the true and profound signification of this har-

> monious arch that Constantine had erected next to the Flavian colossus and that good fortune has preserved to our day, in attendance of another empire and new triumphs.[34]

As Pallottino adds, the Arch of Constantine stands for the universal triumph of Christianity as well, and thus marks the endpoint of a teleological trajectory that began with Augustus's Ara Pacis. Significantly, Pallottino displays the same bias against "archeological reconstruction" that we observed in the writings of Malaparte. Mussolini himself asserted that "if the monuments are not enlivened by the beating heart of the people, they remain gravestones, cold, naked, sterile. It is necessary that these symbols of our eternal memory be surrounded by our faith. . . ."[35]

## Modern Times

We have seen not only that triumphal arches provided a powerful emblem for Fascism's alleged continuity with classical Rome but also that they were often prone to a merely "archeological reconstruction" that inevitably emphasized the historical gap. The architectural projects for the Universal Exposition of Rome (E42), planned for the year 1942, instead moved in a distinctively new direction. Although the buildings retain many classicist elements, it is classicism reinterpreted from a modernist perspective.[36] The poster designed for this exhibition (never realized because of World War II) features a huge rainbow-like arch facing the Via Imperiale; the arch was designed in 1937 by Adalberto Libera and the engineer Vincenzo Di Bernardino (figure 34). The arch was intended as a monumental entryway to the exhibition, and the Via Imperiale was to be used for military and political parades. According to Libera himself, the arch was the true symbol of the exhibition, just as the Crystal Palace had become the symbol of the London international exposition in 1851, or the Eiffel Tower of the Paris World's Fair in 1889.[37] The idea of the arch (planned variously in reinforced cement or aluminum) was favored also by Marcello Piacentini, the artistic director of the exhibition and a pivotal figure in the debate about

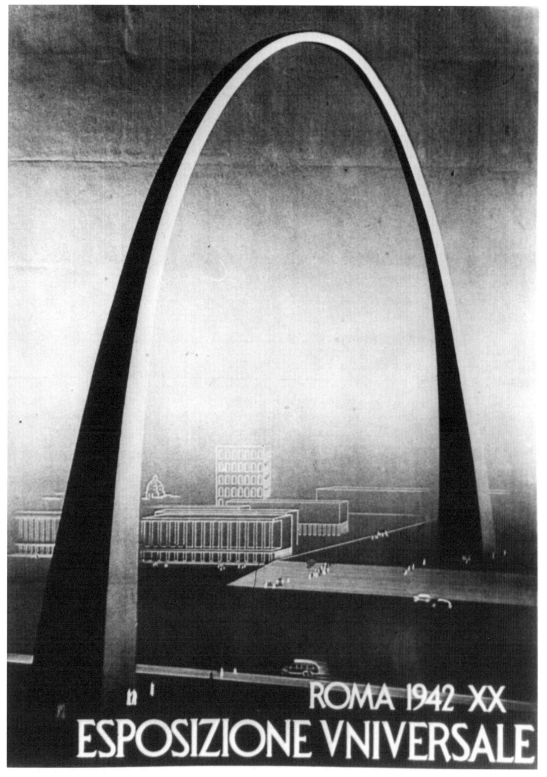

**Figure 34** Universal Exposition of Rome poster with arch designed by Adalberto Libera and Vincenzo Di Bernardino, 1937. Jefferson National Expansion Memorial/National Park Service.

architectural styles in these years, representing the most conservative, toned-down version of modernism. Piacentini conceived of the "luminous," light-reflecting arch as embodying the utopian aspirations of the exhibition, which was thematically centered on the material qualities of light, water, and glass. Libera described the arch in his proposal as "a rainbow in the Roman sky, a triumphal arch on the Via Imperiale, 200 meters of light, 100 meters of height without a kilo of steel."[38]

Although the triumphal arch for the exhibition site was never realized, it *did* come to life in the form of the Gateway Arch (figure 35), which, as a "gateway to the West," marks the city of St. Louis as a crucial stage for America's westward movement. The Finnish architect Eero Saarinen, winner of the 1947–48 national design competition for a monument in honor of Thomas Jefferson (the Jefferson National Expansion Memorial, sponsored by the city of St. Louis), constructed this enormous arch with a height of 630 feet. Completed many years later, in 1965, the Gateway Arch was soon criticized as a replica of the "Fascist" arch planned for the 1942 exposition.[39]

It is from this perspective of a modernist arch that one should look back on the *Polemica sulle colonne e gli archi* (Debate on Columns and Arches) that took place between Ugo Ojetti and Marcello Piacentini in 1933 in the journals *Pegaso* and *Casabella*. With regard to some of the mildly modernist projects in *stile littorio* (lictor's, or Fascist, style) that Piacentini was designing at the time (such as the new university building in Rome, or the Ministry of Communication), Ojetti accused Piacentini of having neglected the true spirit of architectural *romanità*. Ojetti argued: "Arches and columns are rejected in these present and future buildings, as if they were an infamous mark, a mark of old age, of decrepitude. Are we young, or not? Strange youth this, all renunciation. I know, a single curved arch would be enough to accuse you to be of the same race as, God forbid, Alberti or Bramante, Palladio or Bernini."[40]

In his Fascist *Querelle des Anciens et des Modernes,* Ojetti represented the ultraconservative position of traditional classicism. The same Ojetti who five years later expressed his enthusi-

asm for the Libyan "Arch of the Phyleni" here criticizes Piacentini for his perceived total rejection of the defining features of Roman architecture. Ojetti explains: "For more than twenty centuries the arch, the curve, and the column have been the signs of Rome. Arch and curve were not only visually the symbol of Rome, but in their substance and structure, through the way in which they did not cut through but rather embraced the space, the way in which they bent like another heaven, more secure, in order to protect man; the way in which they dominated and regulated opposite points."[41]

The writer and cultural critic Massimo Bontempelli, well-known for his promotion of Novecento aesthetics (a "calm" and classicizing version of modernism prevalent in the 1920s), was among those who defended the new Rationalist architecture against Ojetti's attacks. Typical of his advocacy of new artistic forms, Bontempelli argued that modernist architecture was not motivated by iconoclastic destruction (he repeatedly criticizes the "infantile impulses" of the Futurists), but rather represented the full realization of artistic contemporaneity. Bontempelli saw in Ojetti's fondness for arches and columns a perpetuation of the past that was meaningless unless it was translated into a contemporary expression of their utilitarian, functional essence:

> Columns and arches originated in the most rational way imaginable. The column was born not because man has to look up high, as you say rather prophetically, but out of the necessity for sustaining something: it is born as the necessary form for vertical support. The arch was born for reasons of statics of new materials, which is to say the disposition of wedge-shaped blocks, which could be sustained in no other way. When you have a column or an arch for its own sake, it is nothing but rhetoric.[42]

Bontempelli sees in the architecture of the Rationalist avant-garde not a wholesale rejection of Palladio and Bramante, but on the contrary a "fanatic" adherence to their legacy, precisely because a mere reproduction would result only in façades, "a crust or a mask over a new construction." I can only hint here at the ways in which

Figure 35  Eero Saarinen's Gateway Arch (detail), St. Louis, Missouri, May 31, 1966. Photograph by Ted McCrea, courtesy of Missouri Historical Society, St. Louis.

the contradictory developments of Fascist urbanism bear witness to these architectural debates. Piacentini was long regarded as one of the most powerful and influential architects involved in the imperialist refashioning of Rome, and we have seen how his triumphal arches in Bolzano and Genoa fit into this classicist style. Around the year 1936, however, when Mussolini declared the Italian Empire, emphasis shifted increasingly to an architecture that would be imperialist and modernist at the same time. The discussions regarding the ultramodernist Casa del Fascio in Como, for instance, draw parallels between imperialism and architecture. In this context, the revolutionary architecture of Giuseppe Terragni is set in opposition to Piacentini's "pseudo-antique," conservative style.[43]

Despite Terragni's Rationalist style, however, many of his projects for monuments employ the "classicistic" device of the triumphal arch in one form or another.[44] The unexecuted plan for

the war memorial in Como (1926), for example, consists of an eclectic combination of a tower, stairs, columns, and arches. The War Memorial in Erba Incino (1928–32) features a series of arches above a stone terrace. Like many of the arches we have considered, Terragni's buildings had a double function as both monument and gravesite. Yet, in Terragni's almost "postmodern" architecture, the triumphal arch is only one element among others in a complex, multidimensional arrangement. This tendency to divest the arch of its classical heaviness, to integrate it into the surrounding landscape, can also be observed in the arch designed for the Universal Exhibition; that arch was echoed in the multiple arch-like windows of the Palazzo della Civiltà Italiana (see figure 8 in chapter 1). This, the most emblematic building of the exposition, might in turn be linked to the *pittura metafisica* of Giorgio de Chirico, or the experiments with art and architecture at the Fifth Triennale in Milan (1933).[45]

Although Mussolini's promotion of Ojetti's principles after 1937 has been offered in explanation of the neoclassical style of the Universal Exhibition, it cannot be denied that experimentation with classical forms was a characteristic of Novecento Rationalism.

I have focused here on the use of triumphal arches within the culture of Italian Fascism in order to highlight how the ideology of *Romanitas,* prefigured in nineteenth-century nationalism, constantly struggled with the demands of modern representation. Since I used the figure of Malaparte as a guiding thread through this material, let me conclude with a glance at his postwar novel *La pelle* (*The Skin,* 1949), in which the post-Fascist Malaparte is concerned with the triumph *over* Fascism. The novel describes the painful and humiliating experiences in occupied Naples at the end of the war. The narrator Malaparte, working as an officer in the allied liberation armies, sees his own country, together with the Americans, caught up in a fatal network of military defeat and prostitution: "Tell me the truth, Jimmy, when you return to America, to your place in Cleveland, Ohio, will you enjoy telling how your victorious finger has passed under the triumphal arch of the legs of the poor Italian girls?"[46] A later chapter takes place in Rome, a site marking the ultimate defeat of the Fascist regime. As the Americans are about to celebrate their victory, Malaparte fears that the liberation of Rome will not result in an "intimate celebration," but instead will become the "usual pretext for triumphs and declamations." Ironically, though, it is Malaparte who advises his American friends to take the route of the ancient Caesars, to enter Rome on the Via Appia Antica, leading to the Via dei Trionfi and Via dell'Impero, where they are welcomed by the "triumphal cries of the defeated."[47] The Americans enter Rome as victors, like Caesar, Pompey, and Augustus before them, but also as foreign *ignoranti.* Malaparte, in fact, serves as a kind of tourist guide for their triumphant entry by pointing out to them the tomb of Cecilia Metella, the Colosseum, and so forth. For him, the notion of military triumphalism has lost its former attraction: "There is not a spectacle, as sad, as disgusting, as a man, a people, in triumph."[48]

# Middle Ages
# and Renaissance

CHAPTER 6

# Inventing the Palazzo del Corte in Ferrara

*Diane Yvonne Ghirardo*

FERRARA'S TWO CENTRAL piazzas, Piazza del Duomo and Piazza Trento Trieste, which extend along north/south and east/west axes, are framed by buildings that appear to the visitor to constitute the heart of the medieval and Renaissance city: the medieval cathedral of San Giorgio (1135), the loggia of the *calegari* (shoemakers), the Romanesque church and monastic cloister of San Romano, the picturesque loggia of shops lining the cathedral's southern flank, the bell tower, and the medieval Palazzo del Comune, which is across from the cathedral and is joined by a covered passageway (Via Coperta) to the medieval castle (1385). The only apparently ill-fitting element is the Palazzo della Ragione, which replaced the fourteenth-century palace destroyed by fire in 1945 (figure 36). Of the entire scenographic assemblage, the Palazzo del Comune (town hall), or Palazzo del Corte, seems to be the most authentically medieval, with its unadorned brick elevations, its roofline marked by high merlons, its massive clock tower, and its Gothic, bifore windows on the *piano nobile*.[1] But appearances can be deceptive, and so they are with the Palazzo del Corte (figure 37). The proudly "medieval" façade dates back only eight decades, to 1924, and bears only vague relation to any particular moment in the city's history.[2] Neither the authentic product of the aspirations to autonomy and shared governance of a medieval commune, nor the result of a Renaissance aristocratic leader's desire to celebrate family lineage and neo-imperial control, the palace instead embodies beliefs rooted in the political culture and

economic imperatives of early twentieth-century Italy.

Unified as a nation in 1861, Italy struggled over the next decades to consolidate the victories gained on battlefields by developing national loyalties among its diverse populations, in effect championing nationalism over *campanilismo,* or devotion to one's city. Doing so entailed achieving a delicate balance between celebrating the nation through reference to great moments in the peninsula's history and recognizing the local manifestations of greatness. No less important was transforming a fledgling capitalist economy that still harbored strong residues of feudal social and economic relations into a modern, industrial state, with all that this transformation signified about new sources of authority, state control through a centralizing bureaucracy, and the shift from a predominantly agricultural to an industrial economy. Modernizing meant more than shifting to industry, however; it also meant falling into line with other transformations taking place in modernizing economies, including exploiting a burgeoning tourism industry. None of these objectives was achieved without struggles over strategies and goals, conflicts best understood by examining specific events in Italian cities from the late nineteenth through early twentieth centuries, which, in the case of Ferrara, included its restoration projects.

In the aftermath of the Risorgimento and the end of the papal states in 1859, for the first time in over three centuries Ferrara and its province began to receive serious investments in agricul-

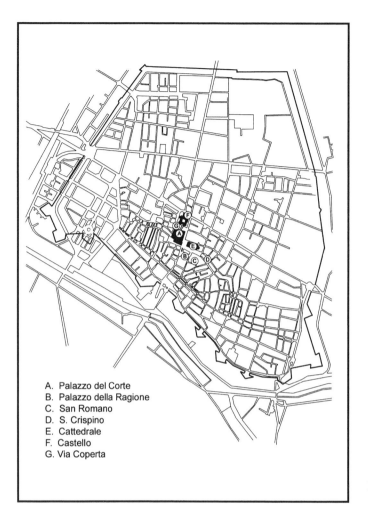

A. Palazzo del Corte
B. Palazzo della Ragione
C. San Romano
D. S. Crispino
E. Cattedrale
F. Castello
G. Via Coperta

**Figure 36** Map of Ferrara, showing buildings in monumental center.

ture, including major reclamation projects.[3] Not surprisingly, the city's leading scholars and cultural figures began to consider ways in which Ferrara's artistic, architectural, and cultural patrimony could be restored, and in particular, how these civic leaders could bypass the period of economic and cultural decline under the papacy and return to the era of the city's greatest cultural prominence, the centuries of Este dominion.[4] Emblematic of this effort was the painstaking research conducted by the engineer Filippo Borgatti to reconstruct the map of Ferrara as it was in 1597, immediately preceding the devolution of the city to the papacy.[5] Printed in the scholarly periodical *Deputazione di Storia Patria,* Borgatti's map identified private houses, public buildings, and numerous streets as they had been at the outset of the post-Este period. Although not entirely reliable, the map nonetheless testifies to post-Risorgimento Ferrara's flurry of interest in the Estense era. In the first years of the twentieth century, the movement to restore architectural monuments from the thirteenth through the sixteenth century was led by prominent Ferrarese cultural figures such as professors Giuseppe Agnelli and Eugenio Righini, and the engineer Giuseppe Maciga. Agnelli was particularly vigorous in his efforts to restore Renaissance Ferrara, including founding Ferrariae Decus, an organization dedicated to identifying and preserving the city's historic patrimony.[6] With the publication of a small book in 1918, Agnelli waged a campaign to reconstruct the bronze portraits of Marquis Niccolò III d'Este and Duke Borso d'Este. After sitting on each side of the Volto del Cavallo in the Palazzo del Comune since the fifteenth century,

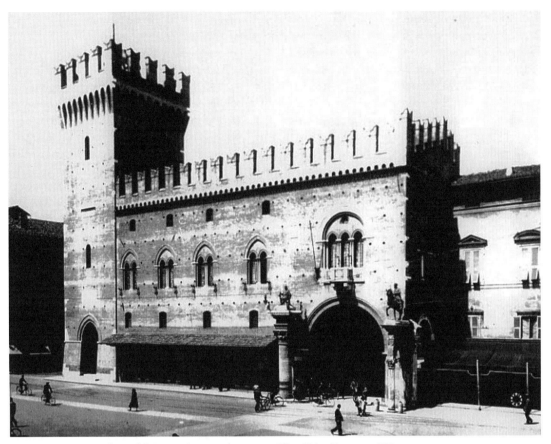

**Figure 37** Ferrara, Palazzo del Corte, photograph c. 1930. Alinari/ Art Resource, NY.

the statues had been torn down by French troops in 1796.[7] For Agnelli, Niccolò III and Borso represented two of the most important members of the Este family, men who had set the city on the path of greatness in architecture, art, and politics. Agnelli's campaign concluded in 1928, when the two statues, newly cast in bronze by sculptor Giacomo Zilocchi and donated by Maciga, finally graced their original pedestals that had stood empty for over a century.

The impulses that drove such restoration efforts were numerous: returning Ferrara to its rightful position as one of the most important Renaissance courts; voiding the actions of the papal government over the intervening centuries; framing the city to make it attractive to tourists; and funding activities that would help relieve unemployment. Once the Fascist government came to power in 1922, public works projects and programs dedicated to reviving the country's cultural

patrimony accelerated for many of the same reasons. Numerous restoration projects were already in the works before the Fascists came to power, and often those projects were not completed until the country was on the brink of World War II. The conventional interpretations of restorations or re-creations of historical buildings in Fascist Italy have emphasized the regime's aggrandizing efforts and attempts to gain legitimacy by linking contemporary events and figures (such as Mussolini) with significant rulers of the past.[8] In this chapter, I argue that such interpretations only partially explain attitudes toward history during the Fascist period. By themselves these explanations are too simple, and they do not take into account the complex realities of specific cities and their cultural elites. Whatever the political allegiances of Ferrarese scholars, intellectuals, and urban bourgeoisie prior to Fascism, they harnessed pet projects in their city to the Fas-

cist government's desire to emphasize Fascism as both forward-looking and deeply rooted in the past, celebrating not only how far Fascism had come but also the rich traditions from which it emerged.[9] When their visions did not cohere with those of the central government, local concerns, at least in Ferrara, took priority. Just how this happened on the local level I will explore by examining the project to re-create the fourteenth-century façade of the Palazzo del Corte in Ferrara.

In the first part of this chapter I offer a brief account of the building's history that focuses both on changing patterns of use and on what is known about the building's appearance since the fourteenth century. The second section examines the competition in 1923 to restore the façade. The chapter concludes with a discussion of the restoration of the Palazzo del Corte in relation to other restorations in Ferrara and elsewhere, and with some reflections on the relation of local interests to those of the centralizing efforts of the state bureaucracy in Rome.

## Historical Overview of the Palazzo del Corte

Ferrara's Palazzo del Corte began life as an Este family palace, probably in the first decades of the thirteenth century. The earliest reference indicates the presence of a palace on the city's main civic square, the Corte Vecchia. This *palacium marchionis,* or palace of the marquis, was already in place by 1285.[10] Much confusion surrounds the construction of the Torre di Rigobello on the building's flank and that of the prison tower adjacent to what was then the Palace of Justice, since various fourteenth- and fifteenth-century chronicles propose different dates, architects, and even locations. Although very little is certain, it seems clear that the Torre di Rigobello was embedded in the Este palace, the Palazzo del Corte, by the end of the fifteenth century, with the prison tower and the Torre dell'Arengo in what was then Palazzo del Comune (later Palazzo della Ragione) to the east and south of the Palazzo del Corte. Among the facilities housed in the Comune were the offices of the mayor (*podestà*), the

communal council meeting room, and the law courts.[11]

From this early period, only two images of the Palazzo del Corte survive. One occurs in Fra Paolino Minorita's city plan of 1322–25 (figure 38), and the other is a similar plan from the same time period in Paulus Venetus's map.[12] But neither offers much information about the appearance of the Palazzo Comunale and Palazzo del Corte; Venetus simply repeated his schematic representation of the city's gates by illustrating the Palazzo Comunale as two towers, the Arengo and the prison, separated by an arch for the Palazzo Comunale, and Minorita also showed two generic towers. Both artists also represented the Palazzo del Corte with two towers smaller than those of the Palazzo Comunale.

With the Torre di Rigobello at its corner, the building maintained an L configuration at least through the fourteenth century. Only in 1325 did construction initiate on the Palazzo della Ragione as a replacement for the Palazzo del Comune, which in turn signaled the transfer of some communal offices to the Palazzo del Corte. This process brought the city administration ever more firmly under the control of the Este family by progressively incorporating its offices into the family palace.[13] The only new architectural information about the palace from this period indicates that although the building was initially a one-story structure, at least some parts of it eventually rose to two stories, and that at least since 1362 the tower had held a clock.[14]

After the death of Niccolò III d'Este in 1441, the Twelve Savi (city councilors) commissioned a bronze equestrian portrait of him which, when complete, was placed beside the vaulted passageway on the Palazzo del Corte's façade, a spot soon known as Volto del Cavallo (Vault of the Horse).[15] When Borso assumed control of Ferrara in 1450, the Twelve Savi promptly ordered a bronze portrait of him as well. Depicting Borso sitting as administrator and dispenser of justice, the statue was initially erected on a high column in front of the Palazzo della Ragione.[16] In 1472, Ercole d'Este I, who had become duke of Ferrara the previous year, ordered the Borso portrait moved to the other side of the Volto del Cavallo, framing the entrance to what had increasingly be-

**Figure 38** Ferrara c. 1325, redrawn by author from map of Fra Paolino Minorita (Vatican Library, Codice Marciano, Vat. Lat. 1960, c. 267r).

come a combination family palace and communal office building with images of Ercole's two immediate predecessors.

Other than this scanty information, no further details about the architectural or urban qualities of the palace emerge until Ercole I became duke and initiated his extensive building programs throughout Ferrara and its territories; the programs included massive transformations of the palace beginning in 1472.[17] Two points are worth emphasizing about the Palazzo del Corte at the time Ercole I came to power. First, until nearly the end of the fifteenth century, the palace served primarily as the Este residence in Ferrara, along with the Castello Estense even as more and more communal offices were transferred to the palace during the fifteenth century. Second, because of its pivotal location in front of the cathedral and adjacent to the Palazzo della Ragione, the Palazzo del Corte provided both a backdrop

and a privileged viewpoint for major public events.[18]

The most significant changes to the Palazzo del Corte occurred under the reign of Ercole I, from 1471 to 1505. In addition to enlarging the building to include new wings to the north surrounding two spacious courtyards, Ercole constructed a raised, enclosed passageway, the Via Coperta, linking his chambers in the Palazzo del Corte to Castello Estense.[19] The courtyard that became the Cortile delle Duchesse had previously been a disorderly combination of wood storage, bakery, and kennel, but by 1481 it was a full-fledged garden with a fountain in the middle.[20]

Although the Palazzo del Corte had been host or backdrop to a variety of sacred pageants during the fifteenth century, theatrical productions occurred more frequently and with a new twist under Ercole. For the first time since antiquity, the Roman plays of Plautus and Terrence were

staged, beginning with the *Menaechmi* of Plautus on January 25, 1486. These performances continued through Ercole's death in 1505.[21]

Throughout Este dominion, then, the Palazzo del Corte was a setting for a diverse array of activities, enfolding the commercial and administrative, ceremonial and theatrical, political and personal, in a single structure. Sorting these activities into a single narrative is difficult, as is the case for the building's appearance. Scanty and irregular records, the absence of images before the early sixteenth century, and a virtually uninterrupted sequence of modifications, additions, and enlargements make it impossible to produce a convincing, definitive image of the building at any particular moment. Other than the most general information regarding the assembly of building masses and number of floors, available information primarily concerns the decoration of interior rooms until the mid-fifteenth century. Records from the many building activities that Ercole undertook over thirty years offer more detailed information.

In keeping with common practices of the period, from the late fifteenth century at least until 1532, from the Volto del Cavallo to the end of the *loggia di piazza,* erected on the eastern flank by Ercole in 1492, the façade above the loggia was painted in large, brightly colored squares, as were the walls inside the Cortile Grande, the palace's large internal courtyard. Painted merlons ran along the roofline.[22] The arcade of stone columns ran the length of this wing of the palace, and, as Thomas Tuohy notes, the ensemble bore striking resemblance to the decorative schemes of aristocratic buildings in Venice.[23] Indeed, the Palazzo Ducale in Venice received its distinctive red and white marble patterned façade above the grand loggia in the mid-fourteenth century, and this too was a structure that doubled as aristocratic residence and town hall.[24] In Ferrara, marking the division of this part of the palace from the older section to the south were the two gilded statues of Niccolò and Borso that framed the Volto del Cavallo and added another colorful and bright element to the façade. Inside the Cortile Grande, the decoration of the covered stairway, particularly the balustrade and the small pilasters, echoed the emphasis on Venetian motifs.

In 1472 three marble balconies were added to the massive Torre di Rigobello. The highest of the three projects out farther than the other two and is covered with a lead roof; twelve reliefs of the heads of Roman emperors once adorned the lower loggia.[25] Originally the tower was topped with twenty-two merlons, which Ercole ordered repainted in 1472, indicating that they had also previously been painted.[26] The woodcut view of Ferrara known as the *Alzato di Ferrara,* dating from around 1499, confirms that the Palazzo del Corte was topped with merlons, and although rendered in schematic fashion, the woodcut also confirms the presence of marble balconies and a stone loggia (figure 39).[27] It also shows the arched Gothic windows divided by pilasters, perhaps carved in marble, as were those inside the Cortile Grande, on the façade overlooking Via Cortevecchia.

During the sixteenth century, the Palazzo del Corte underwent significant changes. A fire in 1532 destroyed the *loggia di piazza* as well as the brightly colored façade above it and the Sala Grande, the large hall for festive events and theatrical performances. In 1553, the Torre di Rigobello fell to the ground, together with the marble balconies installed by Ercole. Alfonso II constructed a new loggia on the north of the palace to replace part of the one destroyed by fire, and a new Sala Grande was erected on the west, just south of Via della Rotta (now Via Garibaldi).[28] By the end of the century, the building bore little resemblance to the Palazzo del Corte as developed by Ercole—and even less to the original trecento palace. Even though the papacy took over the city in 1598, the palace remained in the hands of the Este family until the middle of the eighteenth century. Gianbattista Aleotti's map of 1605 and Ruggiero Moroni's plan of 1618 substantially agree on the condition of the palace at the beginning of the seventeenth century.[29] The ground floor consisted chiefly of shops, many of which the Este family no longer owned, as well as pantries, a laundry, and a cantina. Shops lined both the interior Cortile Grande and the exterior on Via Cortevecchia and Piazza del Duomo, as well as to the north under the loggia on Piazza Savonarola.

Communal offices continued to occupy many

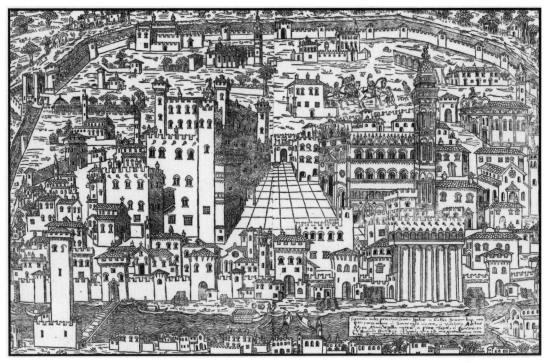

**Figure 39** View of Ferrara, woodcut, c. 1499. Biblioteca Estense Universitaria, Modena, Ms. Ital. 429 Alpha H. 5.3. Su concessione del Ministero per i Beni e le Attività culturali.

rooms in the palace, with quarters for Ferrara's communal administration (Il Maestrato) transferred from the Cortile Grande to spacious rooms facing the Episcopal palace by 1632 (figure 40). In the eighteenth century, Giuseppe Antenore Scalabrini lamented that the Cortile Grande had been reduced to storage for hay, carpenters'

shops, and an inn, the Ostaria del Cavalletto.[30] Numerous communal offices continued to be located in the Palazzo del Corte in the nineteenth century, aided by donations and purchases of parts of the palace from individual owners. Inside the Cortile Ducale, shoppers crowded around wooden market stalls seen as eyesores by

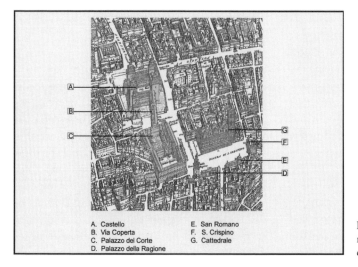

A. Castello
B. Via Coperta
C. Palazzo del Corte
D. Palazzo della Ragione
E. San Romano
F. S. Crispino
G. Cattedrale

**Figure 40** Andrea Bolzoni, plan of Ferrara, 1782, detail showing monumental center.

**Figure 41**  Ferrara, Piazza Trento e Trieste, nineteenth century; Palazzo della Ragione on the left, Palazzo del Corte in center.

the cultured bourgeoisie who despaired of the loss of so much of Ferrara's architectural patrimony.[31]

At each turn, modifications jostled with one another, each undertaken in fragmentary fashion, with the Palazzo del Corte no longer treated as a unified complex, but rather as discrete parts to be maintained or restored according to the interests of the city or of individual owners, a pattern that has largely continued to this day. The Ducal Chapel, for example, briefly a theater during the seicento, was reclaimed for religious functions a few decades later. The French closed it in 1796 and used it as a storage room, but by 1802 it had become a chapel again and was restored in fits and starts until it was closed definitively in 1893. The commune of Ferrara continued to use the space as a storeroom, and early in the twentieth century all exterior traces of its origins as a chapel were removed, three new windows were opened in the façade, and the ground floor became a movie theater, continuing as such well into the 1980s.

Nineteenth-century prints and photographs document that other than the Volto del Cavallo, the façade of the Palazzo del Corte was simply an anonymous, tile-roofed palace with virtually no trace of its thirteenth-century origins or its spectacular reinvention in the late fifteenth century (figure 41).

## The 1923 Competition

The 1923 competition for restoring the façade facing the cathedral and for reconstructing the Torre di Rigobello (now named Torre della Vittoria) inaugurated the most visible and certainly most extensive twentieth-century modifications undertaken on the palace.[32] The competition brief called for projects that would demonstrate the reconstruction of the fourteenth-century façade based on examination of the existing structure as well as on ancient documentation and drawings.[33] But the façade envisioned by the

competition was not that of an aristocratic palace—that is, the building's actual and primary use in the fourteenth century—but that of a *palazzo del comune,* or town hall. Ferrara's original Palazzo del Comune began to be transformed into a Palazzo della Ragione (Palace of Justice) in 1325, but many of the offices associated with the site were not incorporated into the Palazzo del Corte until the late fifteenth century. The Palazzo del Corte remained the sole urban residence of the Este family until after 1385, when the Castello Estense was initiated. The restoration project planned in Ferrara did not anticipate engaging this dual history, but instead envisioned the remodeled building as a town hall.

The commission that organized the competition drew from major historical and artistic organizations. These included Ferrariae Decus, which was dedicated to preserving and restoring the historical patrimony of the built environment; the Deputazione di Storia Patria, an official group of historians; the Società Benvenuto Tisi, concerned especially with the artistic patrimony; the technical school and veterans organization; associations of engineers and architects; and a group of cultural figures, among them the prominent librarian Giuseppe Agnelli, engineering professor Eugenio Righini, and engineer Giuseppe Maciga, who was the donor of the new bronze portraits of Niccolò and Borso. Within a few months, a more select jury of only seven members was empanelled, three from the historical and artistic organizations and four from the city's cultural community.[34]

On March 29, 1924, the jury rendered its judgment on the seven entries, each identified only by a motto.[35] Concluding that no design proposal entirely fulfilled the objectives of the competition, the jury therefore awarded no first prize. The project with the motto *Nobilitas Estensis* received second prize of 4,000 lire, and four other submissions each received an award of 1,500 lire: *In Bocca al Lupo, Obizzo, Sola Fides Sufficit,* and *Fidia.*[36] Of these, images of four entries and five written reports remain in the communal archives. Along with the jury's comments on the individual projects, these documents permit an evaluation of the objectives of the jurors and the contestants, as well as the standards ac-

cording to which the restoration was ultimately completed in 1924 and 1925.

As Giuseppe Castagnoli and Filippo Bordini commented in their project statement for *Nobilitas Estensis,* "When this project could not be inspired by reasons and particular motifs drawn from authentic historical parts, [the designers] aligned it with generic examples of the style of the era."[37] Indeed, as we have seen, little information about the appearance of the palace in the thirteenth and fourteenth centuries remains. Documentary and iconographic material begins to be available with some regularity only from the late fifteenth century, but unfortunately, the information is at times difficult to sort out. Nonetheless, the entrants and the jury confidently selected motifs and details. As the author of *In Bocca al Lupo* remarked, in the absence of adequate documentation, he could not propose a true restoration, but rather a design with typical fourteenth-century features.

Two examples from the reconstruction are useful to illustrate both the principles by which design decisions were made and the problems associated with the building's history. For example, in response to the competition requirement for a fourteenth-century reconstruction of the façade of the palace, each entry proposed merlons on the roofline. Indeed, the adjacent Palazzo della Ragione sported pointed merlons—as a result of the early nineteenth-century reconstruction—as did other medieval town halls, so this would appear to be a typical fourteenth-century feature (figure 42). But evidence for merlons on the Palazzo del Corte in the fourteenth century is absent. The much reworked late-fourteenth-century view based on the original of Bartolino Ploti da Novara in the two extant versions gives no hint of merlons on the roofline, nor is there any documentary evidence from this period to support such an interpretation. In the fifteenth century, however, particularly under Ercole I, abundant documentary evidence describes painted merlons on the façade of the Palazzo del Corte and inside the Cortile Grande, and two images from Prisciani's *Historia Ferrariae* and the 1499 view of Ferrara both depict merlons (figure 39). During the sixteenth century, however, a sketch for a stage set with the monumental core of Ferrara

**Figure 42** Palazzo del Corte before 1923, with Volto del Cavallo at the right.

and the Palazzo del Corte in the background (dating between 1532 and 1553) offers contradictory evidence.[38] Although this sketch is sufficiently detailed to illustrate the scaffolding on the Torre di Rigobello, the clock, the three tiers of marble balconies on the Torre di Rigobello, the two statues framing the Volto del Cavallo, the Gothic chimney in the façade of the palace, and even the cupola over the Scalone in the Cortile Grande, it omits merlons altogether.[39] Subsequent images in the seventeenth and eighteenth centuries also do not include merlons, nor were they reproduced in the nineteenth century. Only for the second half of the fifteenth century can we confirm the presence of painted merlons. Nonetheless, the organizers, jury, and contestants assumed that to convey the architecture of the trecento, merlons were essential.

The balcony above the Volto del Cavallo provides a second case. According to Giulio Bertoni and Emilio Vicini, the Palazzo del Corte had an iron balcony above the Volto del Cavallo in 1436.[40] Cittadella described how a wooden bridge was erected to allow the popes to go from the grand portal of the cathedral to the Palazzo del Corte; the bridge was employed by Pope Eugenio IV in 1438 and by Pope Pius II in 1459.[41] An iron balcony would have been easier to adjust to accommodate the bridge, especially if parts of the balcony had been removed. Unfortunately, as with many other features of the palace, the his-

tory of the iron balcony is anything but clear. Nevertheless, there was a consensus among Ferrara's cultural elite in the early twentieth century about the presence of such a balcony, since the entries that received prizes all included a balcony constructed of iron over the Volto. When erected, however, the balcony was no longer iron, but stone, for reasons that were not explained but that must have concerned discomfort with a balcony that would appear too modern.

Once the competition concluded, execution of the façade and the Torre di Rigobello (renamed Torre della Vittoria) were subsequently entrusted to the chair of the jury, Venseslao Borzani.[42] The early-twentieth-century restoration project did not include numerous elements known to have been part of the palace, chiefly those associated with the Torre di Rigobello, including the clock, the angel that emerged from a door, sounded the hour, and then returned through another door, and the three tiers of enclosed marble balconies with the portrait heads of Roman emperors. Ercole's grand Loggia di Piazza, designed by Biagio Rossetti, also was not reconstructed, nor was the Sala Grande above it. The bright chromatics that enlivened the façade from at least the mid-fifteenth century on were also omitted from the final project, and the two statues of Borso and Niccolò III d'Este were cast in bronze, but not gilded as had been the originals.

As the report on the *Nobilitas Estensis*

noted, in the absence of confirming documentation or archaeological remains, the restoration of the façade would proceed on the basis of the "style of the period in harmony with the fourteenth century ambience of Ferrara."[43] In this the jury and the designers who submitted proposals chose to follow an approach already well established in post-Risorgimento Ferrara: whether definitive evidence was present, if a structure did not cohere with the consensus of local experts on what they understood to be the "style of an era," restoration would transform the structure so that it did. Among the most egregious examples of this is the restoration of the house of Biagio Rossetti in 1910, in which the original staircase was destroyed and a new cornice was substituted for the existing, fifteenth-century one.[44] Palazzo Costabili (formerly, and erroneously, known as Palazzo del Ludovico il Moro) provides an even more telling case. Only partially completed in the first years of the sixteenth century, the building had been badly treated in the ensuing centuries, including having frescoes by Benvenuto Tisi (Il Garofalo) damaged by the Italian army during the Risorgimento. Over the course of nearly two decades of restoration, officials decided to "correct" the alternately closed and open pairs of arches in the upper loggia of the courtyard by opening them all to conform more closely with courtyards and loggias designed by Donato Bramante, which the officials believed to be more fully Renaissance.[45] In other words, when Ferrara's buildings did not conform to what local experts believed to be typical trecento or quattrocento architecture, the buildings were to be modified so as to fulfill that image.

Already in the nineteenth century, Ferrarese cultural figures had dismissed the *intonaci* (colored stucco surfaces) and traces of vivid chromatics on the city's medieval and Renaissance houses as signs of post-Renaissance decadence. In restoring and refurbishing these houses, the Ferrarese opted for exposed brick and terra-cotta surfaces as representing their true appearance, a choice that had more to do with contemporary notions about truth in materials than with Ferrara's historical past. Similarly, fixed ideas about the medieval and Renaissance appearance of houses, churches, and public buildings of all types undergirded historic preservation projects in Ferrara from the nineteenth century through World War II.

## Ferrara and the Revival of the Este Era

According to what criteria were restoration decisions undertaken? The years following the end of papal control and economic growth spurred by reclamation programs in the Ferrarese countryside increased the nostalgia among the city's cultural elite for the era of the Este domination, when the city's riches had adorned public and private buildings. The unification of Italy helped trigger a renewed feeling of *campanilismo* in many cities and towns, sentiments given force by the establishment of institutions entrusted with the task of identifying and preserving the country's monuments. In the late nineteenth century, Ferrara gave only scattered evidence of its past as one of the most brilliant Renaissance courts where some of Italy's greatest artists, musicians, and writers had flourished. Although the cathedral was largely intact, much of the Romanesque church of San Romano was masked by shops that had been built against its wall. Numerous buildings of significance, including most convents, had been demolished, and some palaces had been carved up into private residences, shops, or even stables.[46]

Neither the central government nor local government offices seemed able to maintain, let alone preserve, the city's architectural treasures, so private initiatives directed toward conservation of the city's cultural patrimony began to take shape. Among the objectives of these campaigns, restoring the image of Ferrara as a significant cultural center during the Renaissance clearly headed the agenda. As the city's *podestà,* Renzo Ravenna wrote to Benito Mussolini in 1932 regarding the celebrations planned for the four-hundred-year anniversary of the death of Ludovico Ariosto. The objective was to celebrate and to draw attention to the poet and "to the city which receives glory and splendour from his fame," a city "so rich with works of art and precious rooms, recalling the bright period of Este domination."[47]

Ferrariae Decus, one of the most important institutions created to help preserve the city's significant works of art, was founded in 1906; its founder, Giuseppe Agnelli, also served as its first president. The organization was dedicated to identifying, maintaining or restoring the city's treasures, including terra-cotta detailing even on the city's modest buildings, and to marshaling the economic resources and broad interest necessary to get the work done. Agnelli, who had been director of the Biblioteca Comunale Ariostea since 1892 and president of the Deputazione di Storia Patria since 1904, was also honorary inspector of monuments from 1908 to 1920 for the Italian state.[48] Since his university days, Agnelli also had enjoyed a close friendship with Corrado Ricci, general director of antiquities and fine arts since 1906 and a major arbiter of restoration and preservation prior to and during the Fascist period; Ricci shared many of Agnelli's views on the art and architecture of the past.

Although in 1910 Agnelli affirmed that in restoration projects the task was not to create the antique without solid documentation, he allowed that in the absence of such evidence, accepting changes, even disfigurations, might be necessary if they had been consecrated over time.[49] In prac-

tice, however, the cultural organizations disdained artifacts and transformations after the devolution of Ferrara to the papacy in 1598. Even the second half of the sixteenth century was brushed off as less significant than the period of the city's greatest flowering, from the fourteenth century through the early sixteenth century. Anything, regardless of size, that involved art and architecture of that era received support from these organizations. This included, among many others, the restoration of the Palazzina of Marfisa d'Este (1906 to 1938), of sixteenth-century ceilings in the house of Ludovico Ariosto, and of rooms in the Castello Estense, Palazzo Paradiso, Palazzo dei Diamanti, and Palazzo Schifanoia.

In the 1923 competition for the Palazzo del Corte, the jury's comments on the various entries revealed the jurors' preference for scenography and generic image (figures 43–46). Of *Nobilitas Estensis,* they remarked on the agreeable simplicity, but added that the upper part of the tower was too full, the windows too symmetrical; the jury also said the windowsills appeared to be of marble, although sills in fourteenth-century Ferrara were terra-cotta.[50] They found the *Obizzo* design not to be up to the quality of the research the contestant outlined in the accompanying re-

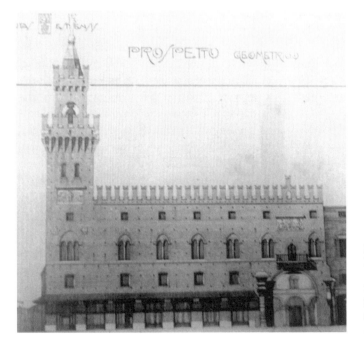

Figure 43  Giuseppe Castagnoli and Filippo Bordini, *Nobilitas Estensis,* 1923. Competition for the façade of the Palazzo del Corte, Ferrara. Archivio Storico Comunale di Ferrara, twentieth century, Patrimonio Comunale, file 26bis.

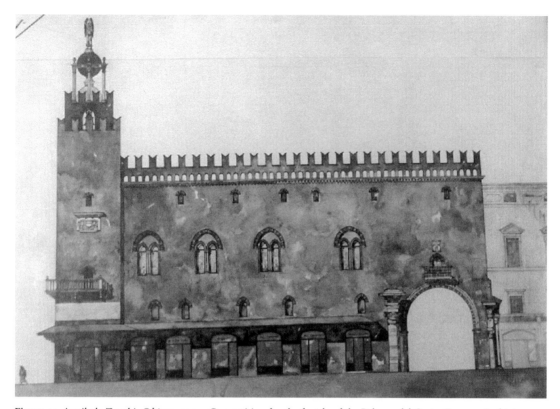

Figure 44 Annibale Zucchi, *Obizzo,* 1923. Competition for the façade of the Palazzo del Corte, Ferrara. Archivio Storico Comunale di Ferrara, twentieth century, Patrimonio Comunale, file 26bis.

port. According to the jury, this design exaggerated the characteristics of fourteenth-century Ferrarese architecture, with windows that were far too small, merlons far too large, and the upper part of the tower too low. The jurors liquidated (as in verbally demolished) *In Bocca al Lupo* with the observation that it was Tuscan rather than Emilian, although they were satisfied with the tower. They found that *Fidia,* with its great contrast between the simplicity of the tower and the richness of the exuberantly decorative façade, ignored the most important characteristics of a fourteenth-century building: simplicity and authority.[51]

Armed with the best features of the top five entries, the jury envisioned how the building should look—and indeed, how it believed a fourteenth-century town hall looked. With those notions in mind, the jury and city officials commissioned Borzani to complete the façade and the tower.[52] Borzani's correspondence with Ferrara's

office of public works illustrates that he was unconcerned with historical accuracy, particularly with regard to the tower. He explained that since a statue was to be placed on the tower to honor those who died in World War I, it should not be placed on top, where it would not be fully visible, but in the middle, "in a place [where it is] visible to and enjoyable by all."[53] However, the Ministry of Public Instruction did not agree with this and with other features of his design, calling the design arbitrary and unscientific, and, indeed, called a halt to the construction. Only the intervention of Italo Balbo, one of the leading figures of the Fascist regime and Ferrara's most famous Fascist, blocked the objections from Rome and allowed the work to be brought to conclusion.[54]

The story of Palazzo Costabili followed a similar path. Local cultural leaders wanted to open up the first-story loggia entirely, but the director of the Soprintendenza all'arte medievale e moderna dell'Emilia e della Romagna, Carlo

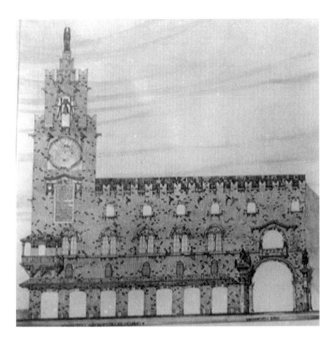

**Figure 45** Carlo Luppis, *In Bocca al Lupo,* 1923. Competition for the façade of the Palazzo del Corte, Ferrara. Archivio Storico Comunale di Ferrara, twentieth century, Patrimonio Comunale, file 26bis.

Calzecchi-Onesti, wrote to his superiors in Rome in 1934 of his reservations:

> A normal restoration in a monumental building should not be detached from the reality of the building itself. . . . [Regarding] the arcade of the gallery that runs along the upper floor of the palace . . . clearly the closure [of alternate paired bays] did not occur in a later period, the restoration should maintain the situation held to be the original and probably also the desired architectonic one. . . . Reopening the arcade . . . brings with it the need for significant reinforcement and support work, and the resolution of practical difficulties.[55]

Despite clear evidence that the alternation of two closed and two open arches in the upper loggia was original, Calzecchi-Onesti pointed out to his superiors in Rome that the *podestà* as well as many scholars, art lovers, and illustrious residents of Ferrara had expressed a strong desire to open the entire loggia. He therefore asked for a decision from Rome, where Balbo once again was in a position to intervene on behalf of the wishes of local officials. The reply two months later from the Consiglio Superiore per le Antichità e per le Belle Arti supported the wishes of the Ferraresi, and the loggia was opened.[56]

Yet another example of the same dynamics was the restoration of the statues of Niccolò III and Borso d'Este. Agnelli's chief obstacle in that instance was the absence of illustrations of the two portraits, despite their significance. As far as he knew, only two images in a fifteenth-century manuscript by Pellegrino Prisciani and a few sketchy references in city views testified to the statues' appearance.[57] Over objections of a commission appointed by the Ministry of Public Education that the statues designed by Zilocchi reflected neither the tenets of modern art nor the appearance of the originals, the new statues were approved by Mussolini after ardent pleas by Renzo Ravenna, *podestà* of Ferrara, and possibly the intervention of Balbo. Ravenna was a close friend of Balbo from school days, and their friendship persisted throughout the Fascist period, even after the racial laws of 1938 forced the Jewish Ravenna to resign as *podestà*.[58] When finally erected, the statues framed the vaulted opening in the Palazzo del Corte, which was still known as the Volto del Cavallo after the horse on which the Niccolò figure sat. Other than the Volto itself, the façade behind the two portraits constituted a radical transformation of the nineteenth-century elevation and, indeed, those of several earlier centuries.

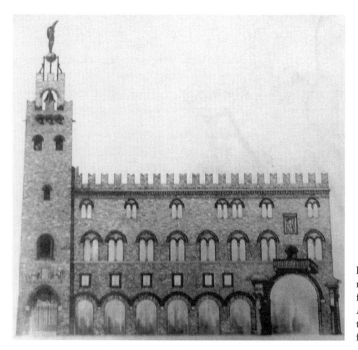

**Figure 46** Renzo Vancini and Leone Tunniati, *Fidia*, 1923. Competition for the façade of the Palazzo del Corte, Ferrara. Archivio Storico Comunale di Ferrara, twentieth century, Patrimonio Comunale, file 26bis.

Agnelli and other scholars in Ferrara understood the principles whereby monuments should be preserved and restored, which Calzecchi-Onesti had stated with precision, as had other regional and national figures beginning in the late eighteenth century. Nor did this new façade pass unlamented. In 1925, the leading figure in historic preservation and urbanism, Gustavo Giovannoni, described it as a typical false medieval façade, which rendered one of Italy's most beautiful piazzas "vulgar."[59] Nonetheless, image trumped historical accuracy, not only because popular images of trecento and cinquecento architecture were based on the architecture of Florence and Rome rather than that of Ferrara but also because so little remained to demonstrate Ferrarese architectural expression in those two eras. There was nothing particularly Fascist about this phenomenon, especially in Ferrara, where the 1831 restoration of the Palazzo della Ragione was as fanciful as that of the Palazzo del Corte a century later. The plans to open up the arches on Palazzo Costabili and to restore the bronze portraits of Borso and Niccolò III all preceded the advent of Fascism, as did the project to "medievalize" the Palazzo del Corte.

The course of Ferrarese restoration projects was remarkably similar to those elsewhere on the peninsula. In Pesaro, efforts to restore the Palazzo Ducale commenced in 1897 and persisted through the 1930s and into the postwar period.[60] At issue here too were battlements long absent from the façade, as well as windows and balconies. In this case too a special committee, appointed by the Ministry of Public Education's division of antiquities and fine arts with Giovannoni as one of its members, denied the city's request to restore the merlons and the corner balcony in 1923 on the grounds that "in general monuments should not be refurbished, because the additions and modifications they have successively undergone should be considered like pages of life and of the history of the buildings themselves, which must be respected."[61] Despite the committee's decision, local cultural and political forces prevailed, and the merlons were replaced. As in Ferrara, initiatives on behalf of a restoration program began long before the advent of Fascism, and the efforts of the centralizing state bureaucracy to adhere to one national standard were defeated by the desires of local interests to outfit in late medieval/early Renaissance garb the urban fabric.

Local interests appear to have been more

pressing than national or Fascist politics in achieving an aesthetically harmonious whole in the buildings of the Este era, which in turn would take their place in the march of Ferrara's history into the future. Removing the shops attached to the walls of San Romano, reconstructing the Torre di Rigobello, reinventing a medieval façade for the Palazzo del Corte—all these projects brought the piazza into a more stylistically coherent whole, however remote it may have been from the buildings' historical realities. As Annibale Zucchi, author of the *Obizzo* scheme, put it, "The building's restoration will take on a harmony and sobriety of form just as ancient art masterfully was reflected in every century."[62]

Although the Fascist party established headquarters in virtually every town and city on the peninsula, and although it has been described as a totalitarian government, the degree to which respected local figures could resist controls from the centralizing apparatus of the state in Rome in the domain of culture is surprising. The restorations in Ferrara—not only historically inaccurate but also at times entailing the actual destruction of manifestly original elements—were allowed to proceed when sufficient backing was marshaled from prominent local politicians and cultural figures. Did the state simply respond pragmatically in such cases? Probably in part. Having friends such as Balbo in high places also undoubtedly helped. Likewise, the local passion for recalling and restoring Ferrara's bygone grandeur certainly cohered with Mussolini's desire to impart pride in the Italian past by celebrating and highlighting its architectural accomplishments and distinguishing both Italy's past glories and its glorious future from those of other countries. Zucchi perhaps best expressed this convergence of views in post World War I Italy in the research report for his design, without ever referring to Fascism:

> The serious task of restorations, demanding complex studies based on historical research, in relation to constructive developments, [is] of a particular interest in this post-war [period]. It is like in the Renaissance, [when] artists tired of

gothic architectonic marvels wanted to dive into the study of classical work: So the present epoch manifests the tiredness with modern architectures from beyond the alps. Hence every city with high civic sense should not abandon its own antique work to the ravages of time.[63]

Whether local intellectuals such as Agnelli were yet Fascist is not the point: their cherished goals for restoring Ferrara finally found support—moral and financial—from the state government, a circumstance that could only have favorably disposed them toward the regime. But in this panorama of shared aspirations and pride, it is nonetheless striking that local organic intellectuals (to use Gramsci's term) felt sufficiently confident that their programs for restorations were not at variance with the overall objectives of the regime to insist on respecting decisions made at the local level. Indeed, they appealed to themes typical of the Fascist period—nascent nationalism and residual paternalism—to support their decisions. In arguing for the reconstruction of the statues of Niccolò III and Borso d'Este, communal counselor (and subsequently mayor) Renzo Ravenna contended that the project would be an Italian vindication of violence by foreigners and would also help to educate the population about ancient glories and memories.[64] It is also worth emphasizing that to complete the reconstruction of the Palazzo del Corte as a town hall, Ferrarese authorities occluded the building's history as a princely residence and indeed as an illustration of the progressive loss of communal governance to aristocratic control during the Renaissance. Arguably a preference for scenography rather than historical accuracy governed the actions of both the regime and the local intellectuals.[65] In short, achieving *l'antica armonia estetica* (the ancient aesthetic harmony) of Ferrara's monumental core required invention and interpretation, not meticulous history. It required instead history as a collective organizing force and agent of Fascist expansion but also as the proud expression of *campanilismo* and the triumph of local politics in the age of centralizing nationalism.

# Towers and Tourists
## The Cinematic City of San Gimignano

*D. Medina Lasansky*

IN 1941, A DOCUMENTARY film was shot in the small medieval hill town of San Gimignano (figure 47). Entitled *San Gimignano dalle belle torri* (San Gimignano of the Beautiful Towers), the black and white narrated film was directed by Raffaello Pacidi and produced by LUCE, the Fascist regime's cinematographic institute based in Rome. *Belle torri* was one of many documentaries filmed in Italian towns between the late '20s and early '40s. In several cases such films were shot following the restoration of a town's historic buildings and were intended to generate a patriotic interest in historic sites.[1] Five to ten minutes in length, these short films were distributed to commercial theaters throughout the country and, as required by law, were shown prior to the feature presentation at every public cinema.[2] As a result, they were a familiar component of the period cinematic experience.

Since the advent of the medium, Italian film had featured cities as protagonists.[3] More important, by compressing time and space, films such as *Belle torri* transported the viewer in spatio-geographic terms. They transformed the city into a cinematic cityscape, and in the process provided the audience with the opportunity to assume the role of urban flâneur.[4] More precisely, Italian documentaries were crafted and staged to

establish the parameters for the visitors' expectations and their field of vision. The films simultaneously encouraged travel to sites throughout Italy and harnessed the mobile gaze. In films such as *Belle torri,* the camera panned specific buildings, focused on architectural details, and framed urban vistas. By identifying important buildings and strategic vantage points for viewing cities, the films helped to educate the moviegoing audience about how to experience historic cities. With their carefully choreographed routes through cities and their informed narratives, the films were designed to configure the experience of the city. More important, because of their wide dissemination, these films democratized access to Italian cities.

Given that many Italians could not read a newspaper, and not everyone owned a radio, film reached a larger and more diverse audience than any other form of mass media. As such, the short documentary proved to be a highly effective tool of indoctrination. It was easily reproducible and could be widely disseminated to a captive audience. It was made available in even the most remote and rural locations. Outdoor movie screens erected in piazzas and trucks equipped with mounted projectors allowed films to be seen in towns that lacked proper theaters. Similar to the contemporary "culture" films that were controlled by the Kulturpflege of the German Ministry of the Interior, Italian documentaries were designed to reach people regardless of educational or occupational background.[5] With this scope, film provided the means to legitimize new

I thank Guillermo Abraham, Giuliana Bruno, and Mary Woods for reading an earlier draft of this chapter as well as the audiences of the College Art Association and the Italian Studies Colloquium at Cornell University, where versions of this work were presented.

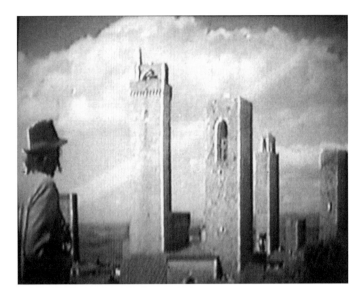

**Figure 47** Frame enlargement from the film *San Gimignano dalle belle torri*, 1941. Istituto LUCE.

party projects, to validate old ones, and to sustain interest in contemporary events.

As film historian James Hay notes, cinema played an important role in defining the "changing conception of the national and the popular" during the period of Italian Fascism.[6] In essence, the genre of contemporary film taught Italians how to become patriotic Italians. This was particularly the case with documentary films. Hundreds of LUCE documentaries were shot each year, encompassing topics ranging from proper child rearing to colonial expansion in East Africa.[7] In each case the subtext was one of celebrating the strength and ingenuity of the Fascist regime and of the Italian *popolo*. Within this framework, film provided a venue for reinforcing the ideas about Italian racial and cultural superiority that were promoted during the regime. Of particular relevance to this chapter is the documentary genre that featured cities as protagonists. These films taught the Italian public how to appreciate the three-dimensional space of the medieval past and how to become engaged tourists. In the process, the viewer became an active consumer of Italian history.

LIKE MANY TUSCAN TOWNS, San Gimignano was heavily rebuilt, publicized, and promoted as an ideal tourist destination during the regime.

Cinema was central to this project, as it proved to be a dynamic tool of visual recovery—making the Middle Ages both visible and visitable for the Italian public, while emphasizing the relevance of the past for contemporary culture. For the regime, film provided the lens through which the past could be remastered, or manipulated to serve ideological programs.

Although the Fascist-era documentaries assumed the guise of short travelogues, they were nothing less than government-sponsored instructional films. More precisely, the films officially sanctioned historic sites and encouraged Italians to visit them. The films taught Italians how to move through space with an objective. By amplifying certain sites and suppressing others, the films helped to structure a relationship between site, history, and contemporary Italian identity. In the case of San Gimignano, the objective was to focus on the city's medieval past to the exclusion of all else.

By mediating the experience of the urban environment, these films played an important role in defining a shared sense of national culture that was heavily dependent on Italian heritage. They provided the versatile tool for recasting the medieval city within modern terms. The audience was instructed to recognize the medieval roots of contemporary politics and culture. Film provided the means to mobilize the masses, to introduce

them to an art and architecture that was being re-stored and redefined as national heritage. In this way, modern Italy was defined within the conservative terms of traditional Italian culture.[8] Ultimately, documentaries such as *Belle torri* helped articulate a period tourist eye that was infused with contemporary political rhetoric.

By 1934, the supervision of film production had been placed under the control of the Ministry of Press and Propaganda.[9] The following year a national film school was founded to train young cinematographers. In 1937, Cinecittà, a film studio in Rome, was inaugurated. On that occasion Mussolini declared that "cinema was the regime's strongest weapon." The quote was emblazoned on the wall of the LUCE studio on opening day. As was the case with other mass media, the regime kept close control on how cinema was deployed.

Although feature films have been the subject of scholarly studies, the documentary genre has been neglected. Few copies of the material survive and little is known about its production. Although once a commonplace feature of the cinema experience, documentaries have yet to obtain their proper place in the landscape of Italian cinema studies. Through the discussion of *Belle torri*, this chapter will attempt to recuperate the role that this genre played in shaping a sense of national culture. By exploring the way in which documentary film worked in tandem with government-sponsored restoration projects and tourism initiatives to recuperate and to mediate the experience of San Gimignano's built environment, I will show how film was an important tool for staging history and eventually establishing a sense of historical amnesia.

*BELLE TORRI* WAS SHOT in the aftermath of Mussolini's successful invasion of Ethiopia, three years after the implementation of the country's so-called race laws, two years after the declaration of an alliance with Hitler, and during a time when Mussolini was eager to make conciliatory overtures toward the Vatican. This was a period in which the government's political and racist rhetoric was at its height. In Tuscany this discourse assumed a distinct flavor. In a region that boasted cities such as Arezzo, Florence, Lucca, Pisa, Siena, Volterra, and San Gimignano, the medieval and Renaissance past was used to reinforce the idea of a native Italian cultural and intellectual superiority. As a contemporary guidebook produced by ENIT (Ente Nazionale Italiana per il Turismo) noted, Tuscany was the "cradle of medieval and Renaissance civilization."[10] The region was widely considered to be the birthplace of *italianità*, or Italianness. As a result, the central government in Rome found that by establishing strong links to the autochthonous traditions of medieval Tuscany, contemporary political power could be strengthened.

The medieval and Renaissance period, more typically referred to as the *medioevo* during the regime, was flexibly defined to span the thirteenth through the sixteenth centuries in order to include Giotto as well as Titian, Petrarch as well as Pico della Mirandola, the era of the great condottieri coupled with the Renaissance dukes, and the independent city-state as well as the humanist court. During the regime, contemporary Tuscan literature, scholarship, photography, and film actively celebrated the sites, heroes, and institutions that best embodied a sense of Italian cultural domination, regardless of whether they were truly medieval. Within this context the communal-era city-state was celebrated for its political innovation; condottieri such as Francesco Ferrucci and Giovanni delle Bande Nere were put forth as models of superior virility and courage; Dante's prose was upheld as a defining moment in the formation of the Italian language; works of artists such as Giotto, Ghirlandaio, and Michelangelo were cited as evidence of unsurpassed genius; local saints such as Catherine of Siena were praised for their unparalleled compassion and good works; Renaissance festivals such as the Sienese *palio* and the Florentine *calcio storico* were understood to be the vestigial demonstrations of once powerful civic bodies; and structures such as Brunelleschi's dome of the Florentine Cathedral or the towers in San Gimignano were seen as spectacular examples of the marriage between technology and aesthetics.

These cultural icons provided the means to create a collective national culture that could be shared by disparate groups of Italians. Although

the familiar *romanità,* or celebration of Roman antiquity, helped to legitimize the regime's imperialist agenda, the politicized use of the *medioevo* proved to be an important tool for cultivating a distinctly national identity.[11] Indeed, Mussolini was referred to as a condottiere just as often as he was an imperial Roman general. It is important to remember that during the regime Italy was still a fairly young country, having been unified as the Kingdom of Italy only in 1861. Leaders of the PNF (National Fascist Party) were well aware that one of their greatest challenges was to foster a sense of a shared Italian culture among diverse regional and even language groups. The celebration of the medieval and Renaissance past provided them with the opportunity to do just this. Within this framework, the unique medieval and Renaissance features of towns such as San Gimignano could be emphasized while underscoring the idea of a larger sense of a shared culture.

*Belle torri* was a part of the media campaign designed to represent the medieval Tuscan countryside as the repository of the genius of the Italian people. By 1941, the cultural icons and historical figures celebrated in the film conformed to an easily recognizable cultural vocabulary for the contemporary film-going audience. The cinematic portrayal of the town's glorious medieval past was comfortably familiar to the period audience. It resonated with many PNF projects and philosophies. More simply, the idyllic representation of a pristine medieval town provided the opportunity to recast the present in the past. This hybrid meaning would have been readily apparent to the movie audience in 1941.

THE FILM OPENS with the sun rising over the scenic skyline of San Gimignano. As the camera pans the city and its surrounding countryside, the narrator claims that the city "is capable of transporting us back in time."[12] The film, we are told, will provide an opportunity "to rediscover the splendid testimony of what was once a reigning city." During the next seventeen minutes, the film does just that. By highlighting an impressive series of buildings, paintings, sculpture, and select elements of urban infrastructure, the film pre-sents an image of a medieval town that rivaled neighboring Siena and Florence in terms of urban amenities and artistic wealth (figure 48). A summary of the film's key moments illustrates how this is accomplished; such a synopsis is essential since there is only one known copy of the film and no surviving film stills.

The first evidence for the medieval character of San Gimignano in the film is found in the presentation of the thirteenth-century Pieve delle Cellole, a simple Romanesque church surrounded by a grove of cypress trees that is a few miles outside the town. Situated on the Via Francigena, the church was a convenient stopping point for pilgrims en route to Rome. According to local tradition, the complex welcomed people from all sectors of society, including the lepers who occupied the neighboring leprosarium during the thirteenth and fourteenth centuries.[13] The Pieve, with its almost modern simplicity, was of great interest to contemporary architects. Like much of rural Tuscan architecture, it was held up as a model of vernacular design. For architects such as the Florentine rationalist Nello Baroni, who photographed both the exterior and interior of the Pieve in 1935, autochthonous architecture provided a foundation for contemporary theoretical explorations.

The film quickly transports the audience from the religious realm to the secular by presenting a group of women washing clothes at the public fountains outside the city walls. Happily singing as they labor, the women present the image of domestic bliss. These industrious women, some of whom gracefully balance clothes baskets on their heads, do their laundry as it has been done for centuries (as the viewer is told by the narrator). The scene not so subtly reinforces the Fascist ideals of gender division and traditional values. The PNF supported a variety of projects ranging from the production of efficient house-cleaning tools to the Opera Nazionale della Maternità ed Infanzia that reinforced the woman's role as mother and domestic engineer.[14] In turn, the fountains, a series of large basins fed by running water, were an enviable urban amenity in any thirteenth-century city.[15] The fact that San Gimignano boasted ten large basins, a number greater than that of almost any other Tuscan lo-

**Figure 48** San Gimignano, with sites featured in *San Gimignano dalle belle torri* depicted in bold. Map by Fabian Bedolla and Raymond Kwok.

cale, demonstrates the extent to which the communal era government had been devoted to enhancing urban infrastructure and to maintaining public hygiene—civic improvements that the PNF later emulated.

The city's gates are featured next—drawing attention to the town's urban form. The narrator begins with "the picturesque gate" of San Giovanni on the southern side of the city at the intersection of the roads leading to Poggibonsi, Certaldo, and Volterra. Since the thirteenth century, the Porta San Giovanni had served as the principal entrance to the city. In quick succession the film then shows the gate of San Matteo at the northern edge of the city, the "more modest but no less suggestive" Porta Quercecchio to the west, and the Porta dei Becci. Similar to the fountains, these gates are impressive structures that

provide testimony to the importance of communally sponsored building projects designed for civic improvement, and in this case, security.

The camera then slowly pans the building façades that line the streets leading from these gates. The narrator announces that the structures along the Via San Giovanni and the Via San Matteo are the vestigial remains of Tuscan architecture. The viewer learns that San Gimignano uniquely embodies the full stylistic range of Tuscan design. As the narrator notes, the city boasts "the Romanesque of Lucca, the Gothic of Siena, and the Renaissance of Florence." What the viewer is not told is why San Gimignano had this unique cosmopolitan character. During the thirteenth and fourteenth centuries, San Gimignano was a town of unprecedented wealth. Residents profited from the town's position along the trade

routes of the Via Volterrana and the Via Pisana, operating a trading house in the port of Pisa and plying the Mediterranean as successful merchants. The regime's film cleverly overlooks this rather bourgeois aspect of the city's history in order to promote its more humble character—as if this were a more fitting image of the Italian *popolo*.

Arriving at the Piazza della Cisterna, which the film narrator calls "the harmonious center of the city," the viewer learns that the thirteenth-century cistern has provided clean drinking water for centuries. Once again, the viewer is told that medieval San Gimignano boasted the amenities that made urban life comfortable. As the narrator notes, the communal-era medieval government established an enviable sense of civility by initiating numerous civic projects. To an audience of 1941, this echoed Mussolini's own public works initiatives that were designed to improve both urban and rural life. The regime built new schools, hospitals, post offices, aqueducts, sewage systems, bridges, and entire towns in an attempt to enhance infrastructure throughout the country.

At this point in the film a tourist appears, a well-dressed woman who frequently pauses to admire her surroundings. The viewer's gaze follows her as she climbs to the "picturesque remains of the Rocca," the fortification that was built in the mid-fourteenth century, when San Gimignano fell under the control of Florence (figure 47). The Rocca is the highest point in the city, and it provides a unique panoramic view of the town and surrounding countryside. As if assuming the perspective of the tourist's gaze, the camera pans the impressive silhouettes of private palaces, towers, town halls, and churches. This panorama is followed by a series of stunning aerial views of the Piazza della Cisterna and surrounding streets, shot from the top of the Palazzo del Comune's Torre Grossa. The camera then scans the "harmonious form of the hills of the Elsa valley." These shots emphasize the symbiotic relationship between medieval San Gimignano and the territory under its control. This reference echoed Mussolini's own program of ruralization, a project that actively encouraged emigration to new towns founded in the countryside as a means

of populating rural regions and increasing agricultural productivity.[16] The PNF officially recognized the economic interdependence between city and countryside. Not surprisingly, the seignorial character of Mussolini's program of ruralization was repeatedly discussed in reference to a medieval social and corporate economic system.

The Torre Grossa was San Gimignano's highest tower, apparent in every view of the city, and visible from almost every point within the city. It is clear to today's visitor that the view from the top of the tower transforms the city and surrounding landscape into a scene of agricultural wonder. Only from the tower can one begin—to borrow the words of Roland Barthes—"to perceive, comprehend, and savor" the city's essence.[17] The panoramic bird's-eye view engages the viewer in a way that a more focused framing would not. It encourages the viewer to distinguish and to identify different features in the city. As such, this view begins to transform the city into an "intelligible object."[18] The view from the Torre Grossa allows both the tourist and the film audience to consume the town's past together with its present. The experience of the city is mediated not simply by the film but also by the architecture of the tower itself.

The film then turns to the art of San Gimignano. A group of monks lead the viewer into the Church of San Agostino, consecrated in 1298 and declared a national monument in 1927.[19] The narrator reminds the audience that the city's churches house works of the greatest artists from Florence and Siena. To prove this point, the camera slowly pans the fresco cycle by Benozzo Gozzoli, painted between 1462 and 1464 in the choir of San Agostino.[20] The film audience is introduced to each of the seventeen scenes from the life of the saint and is encouraged by the narrator to appreciate Gozzoli's "unparalleled narrative skill."

Prior to the Fascist era, scholars had dismissed Gozzoli's conservative style as a throwback to the previous century.[21] In 1907, the art historian and avid collector Bernard Berenson went so far as to claim that Gozzoli was a mediocre artist "with almost no feeling for what makes painting a great art."[22] Despite the established criticism, renewed interest in Gozzoli oc-

curred during the Fascist regime.[23] As the art historian Elena Contaldi enthusiastically noted in 1928, with the exception of Fra Angelico, "no artist was able to capture such an intense expression of pious religiosity and supernatural beauty in his figures."[24] Contaldi contends that Gozzoli was one of the hardest working and most productive painters of the period. He worked incessantly from 1444 to 1497. He was, in her words, "untiring."[25] As such, Gozzoli's productive fifty-year career provided a role model for the hardworking and pious Fascist. In addition, his straightforward, traditional, and easily legible narrative style was similar to public mural projects that the PNF sponsored elsewhere in Italy.[26]

In fact, during the 1930s, there was a resurgent interest in mural painting. Artists such as Mario Sironi frequently received government commissions.[27] Schools such as the Istituto d'Arte in Siena and the Scuola Artigiana d'Oltrarno Leonardo da Vinci in Florence were founded with government support to provide a place where traditional fresco painting could be studied in an environment that emulated the medieval apprentice system.[28] In 1933, Sironi collaborated with several artists on the "Manifesto della pittura murale," a treatise on mural painting that underscored the social and educational value of large-scale public art projects.[29] The renewed interest in the Gozzoli frescoes during the regime should be understood within this context. The Fascist-era audience would have appreciated the Gozzoli frescoes as a medieval prototype of an important contemporary art form. In its similarity to the frescoes of Giotto, Masaccio, and Piero della Francesca, which were widely praised by regime artists, the Gozzoli cycle provided an important example for a contemporary audience that was conditioned to recognize the social importance of the work. Finally, according to the *Belle torri* narrator, Gozzoli, like other artists of his generation, found inspiration in the Tuscan countryside. This alone earned him the respect of regime-era art historians.

In the film, the visit to San Agostino is followed by a quick stop at the church of San Bartolo to see the altar sculpted by Benedetto da Maiano. The viewer is then encouraged to pause briefly and to admire the rose window of the small thirteenth-century Church of San Jacopo—an important stopping point for pilgrims en route to Rome.[30]

San Gimignano, the narrator reminds the viewer, is a land of warriors and saints. The most famous of these was Saint Fina, a local girl who dedicated her life to administering to those poorer and sicker than she was. Fina died in an orphanage at the age of fifteen in 1253. Her death was memorialized in two frescoes by Domenico Ghirlandaio in a chapel in the Collegiata. As the film shows, Saint Fina's good deeds are remembered each March on the anniversary of her death, when young girls visit her humble home.

Saint Fina was one of the many saints whose piety, self-sacrifice, and abnegation of material goods were extolled during the regime. The most familiar of these were Saint Catherine of Siena and Saint Francis of Assisi, whose lives regime-era writers also celebrated. Using the lives of the saints in this manner had particular relevance after Italy's hostile invasion of Ethiopia in 1935–36. The sanctions that the League of Nations imposed against Italy following the invasion forced the Italian population to develop resilience to conditions of economic hardship. Having a series of role models in the various saints may have made this easier. In addition to Catherine and Francis, both of whom had a national reputation, such local saints as Fina were deployed as sources of inspiration for a regional audience. Fina's cult helped to reinforce the values of family and hard work that were heavily promoted by both the PNF and the Catholic Church. Details of Fina's life that conflicted with this image were conveniently suppressed.

The pious devotion exhibited by the young girls at Fina's house sets the stage for a visit to the Museo Sacra located in the Piazza Pecori adjacent to the Collegiata. Inside the museum the tourist, whose movements have been guiding the film viewer through San Gimignano, admires an impressive collection of religious art, including panel paintings from the Sienese schools of the fourteenth and fifteenth centuries, Pietro Torrigiani's figure of Christ, and Benedetto da Maiano's portrait bust of San Gimignano. The tourist then leads the viewer to the Civic Museum, where she admires two paintings by Fi-

lippo Lippi, a Madonna by Pinturicchio, and countless Etruscan funerary urns. The latter, as the narrator reminds the audience, provide "testimony to the Etruscan origins of the town," thereby reinforcing the notion of a Tuscan heritage that was distinct from the *romanità* celebrated in Rome.

The tourist then makes her way to the Piazza del Duomo. The camera quickly pans the Palazzo del Comune, the city's second town hall, built in 1288. This is, as the narrator notes, where Dante arrived in 1300, when he was sent as an ambassador from Florence to lobby for the formation of a Guelf league in Tuscany. The event was ceremoniously reenacted for the film. Figures dressed in medieval-style costume gather in the courtyard of the Palazzo. Dante's embassy quickly proceeds to the Sala del Podestà, where it is welcomed by a group of enthusiastic citizens of San Gimignano and the *podestà* Mino di Bartolomé. Although the film does not linger to document Dante's plea to the San Gimignano *popolo*, the audience is left to imagine the poet playing the role of politician, which would have been strikingly reminiscent of Gabriele D'Annunzio in modern Italy.[31] D'Annunzio, like Dante, was a prominent literary figure whose participation at Fiume and vocal support of Mussolini allowed him to assume a pivotal role in contemporary culture and politics.

As the bells chime the noon hour, citizens of San Gimignano descend upon the Collegiata for Mass. Inside the church the camera pans the impressive frescos: the Old Testament cycle by Bartolò de Fredi, the *Passion of Christ* by Barna da Siena, the *Martyrdom of Sebastian* by Benozzo Gozzoli, and the *Annunciation* by Domenico Ghirlandaio. Particular attention is awarded to two polychrome statues by Jacopo della Quercia, which frame the inside of the entrance wall. "The Virgin," the viewer is told, "captures the grace of every Tuscan girl." To emphasize this point, the camera quickly cuts to a group of attractive young women of San Gimignano gathered for Mass. As the organ plays, the camera pans the interior of the church. A Franciscan friar gives a sermon from the pulpit in the center of the aisle—the same pulpit, the viewer learns, from which Savonarola spoke in the fifteenth century (figure 49). In 1941, Savonarola's famous campaign for

censorship of the arts must have struck a chord with the increasingly conservative cultural programs sponsored by the regime. By the late '30s, the PNF had already begun to identify themes (such as agrarian life, motherhood, and marriage) that were deemed appropriate for government-sponsored initiatives, including exhibits such as the Venice Biennale. Such themes conveniently reinforced PNF-sponsored programs. In hindsight, the parallel between Mussolini and Savonarola is striking. The friar's abuse of power eventually led to his brutal execution in the Piazza della Signoria in Florence. Today, the resonance of this event with the downfall of the regime and execution of Mussolini and his closest advisors is uncanny.

The film ends with a climactic finale of the city's towers. Accompanied by a crescendo in the music, the camera quickly pans each of the impressive silhouettes of the thirteen surviving structures.[32] The combination of music and camera work is calculated to produce an impressive effect. As the narrator reminds us, these towers continue to define the dominant profile of the city.

IN MANY WAYS the documentary on San Gimignano assumed a form that was similar to a newsreel. Its director, Raffaello Pacidi, seemed to have understood that the conservative framing techniques, steady pacing, and narration would convey a sense of the unedited truth. Although *Belle torri* was in fact heavily edited, the impression that it was not provides us with an interesting point of departure. *Belle torri* was a carefully staged cinematic vision of the medieval city. By featuring strategic points in the town, the film encouraged the audience to absorb fully the town's characteristic historic features: the city gates, public piazzas, communal-era town hall, cathedral, period painting, sites where famous personages such as Dante and Savanarola once made appearances, and locations associated with Saint Fina. The film defined a canon of monuments within the city that the tourist should seek out. In the process, it laid out the scenic vantage points: the view of the towers from the Rocca, the Piazza della Cisterna from the Torre Grossa, and the

**Figure 49** Frame enlargement, *San Gimignano dalle belle torri*, 1941. Istituto LUCE.

Palazzo del Podestà from under the arch leading to the Piazza Pecori (figure 50). Ultimately the film conditioned the way in which its audience would interpret the built environment. Although the tourist in the film might appear to be an ordinary flâneuse, randomly experiencing the sites of San Gimignano, her visit is highly choreographed. She is led from one "medioevo" site to another. In the process, any evidence of the post-Renaissance is selectively edited from view. The film reveals no automobiles and no new construction. Carts pulled by oxen transport goods through the city streets. Monks and nuns dressed in their traditional garments contribute to a sense of timelessness. The only perceptible intrusion from the twentieth century is the sophisticated modern urban dress of the visiting tourist (a smart suit and felt hat typical of the period). As such, the film reaffirms the medieval character of the city by remapping the city's topographic and architectural relationships. The city's medieval character is emphasized to the exclusion of all else. The film presents a romanticized, nostalgic image of a town that appears to preserve its past intact and thereby to maintain a sense of cultural continuity.

Although contemporary films such as Dziga Vertov's *Man with a Movie Camera* (1929) or Walter Ruttman's *Berlin: Symphony of a City* (1927) draw on the frenetic pace and transitory qualities of modern life for both thematic and stylistic ends, *Belle torri* did the opposite. Unlike the Soviet and German avant-garde films that employ the provocative cinematic techniques of oblique angles, montage, composite forms, split screens, tracking, and fast pacing to convey a sense of the chaos within the modern city, *Belle torri* relies on a static camera and a horizontal

**Figure 50**  Frame enlargement, *San Gimignano dalle belle torri,* 1941. Istituto LUCE.

frame to underscore the tranquil nature of a city uncorrupted by modern life.[33] The film posits the modern achievements of Mussolini and the PNF within the unchanging topography of medieval tradition. As such, twentieth-century Italy is positioned within a timeless landscape that is distinctly Italian.

The film's narrator goes so far as to claim that contemporary physiognomies of San Gimignano natives are indistinguishable from those that Gozzoli painted on the walls of San Agostino in the fifteenth century. To reinforce this idea, the film compares the profiles of several male residents with those in the frescoes (figure 51), while the narrator asserts that the "pronounced, strong profiles of today's residents have been preserved intact and easily identifiable." The modern profiles are identical to those captured by Gozzoli in 1464. As unlikely as this might seem (and in fact, it is the narrator's comments, rather than any striking visual resemblance to the profiles of Gozzoli's figures, that are persuasive), the underlying

rhetoric is one of cultural and racial purity as defined by having roots in the Middle Ages. The message is clear. Here in San Gimignano, the Italian race has been preserved intact over five centuries. Such rhetoric was particularly important in the years following the 1936 conquest of Ethiopia, when the issue of race pervaded political rhetoric. As Ruth Ben-Ghiat notes, in these years race "became the determining factor in definitions of national identity, and appeared as a new marker of difference in both high and low culture."[34] After 1935, Italian politicians developed policies and cultural programs that reinforced Italian culture on explicitly racial terms. Within this framework, tracing Italian traditions to the medieval past was a way of legitimizing their Italic roots.

The Fascist regime viewed medieval Tuscany as the repository of native culture and Italic spirit—*italianità*. Towns such as San Gimignano that could be visited in their historic medieval state were presented as sites where an uncor-

**Figure 51**  Frame enlargement, *San Gimignano dalle belle torri,* 1941. Istituto LUCE.

rupted Italian character could be found. Citing Gozzoli's portraits was just one way in which this link was made. In the same way, the medieval city could be understood in reference to contemporary PNF programs, ranging from the development of urban infrastructure to the promotion of rural emigration. The sites and scenes that were filmed in San Gimignano were selectively chosen to resonate with current policies and practices while reinforcing racial and gender boundaries. Whether films such as *Belle torri* explicitly reminded the viewer of modern achievements or more subtly inspired pride and confidence in modern projects by claiming that they were inherited traditions, the medieval past was exploited as a means of establishing a precedent and sense of legitimacy for the present.[35]

Of course this idea of cultural continuity was artificially constructed. Not only was it forced through the edited cinematography, but it was also made emphatic through a series of reconstruction and restoration projects undertaken during the '20s and '30s. Eager to promote a sense of *italianità,* the Fascist government encouraged towns such as San Gimignano to "medievalize" their historic centers by restoring buildings and spaces to their so-called "original" and "native" form. At some sites this assumed an ephemeral transformation. This was the case for the celebrations held for the 1930 reintroduction of the medieval style *calcio storico* in Florence, where a procession of several hundred individuals dressed in historic costumes paraded through the city decorated with medieval-style flags, banners, and festoons. In most cases, however, this "medievalization" involved the *ripristino, restauro,* or *liberazione* (to cite terms frequently used during the period) of structures. The walled town of Monteriggioni, for example, was rebuilt in 1927 according to the city portrait by Giorgio Vasari in the Palazzo Vecchio in Florence. The newly re-created towers once again evoked the image of the "horrible giants" as described by Dante.[36] Elsewhere, buildings were renovated to appear as they might have during the fourteenth or fifteenth century. In Arezzo, buildings facing the two main piazzas were redesigned to reassert their "primitive artistic character" of period architecture.[37] They were restuccoed and repainted, while windows and doorways were reconfigured to reveal Gothic-style arches and heavy stone voussoirs. Towers were heightened and crenellations were added. Structures were "liberated" from the detritus of post-medieval construction. Of particular interest throughout Tuscany was the elimination of the baroque—a period considered to be antithetical to regime politics. The baroque was perceived as both foreign and feminine in contrast to the *medioevo,* which was hailed not only as native but also as

masculine, with its imposing town halls, virile towers, and formidable condottieri.

In San Gimignano, for example, the gate of San Giovanni was "liberated" from the seventeenth-century church of Madonna dei Lumi, which had been built against its northern side. The central nave of the small baroque church was removed in order to reveal the full height and width of the gate. As buildings were "liberated" from the suffocating evidence of the intervening centuries, they were subjected to a form of ethnic cleansing, designed to accentuate the emphatically native Italian elements, and those elements alone. Similar to the link made between the physiognomies of Fascist-era residents and those from the fifteenth century, twentieth-century architectural projects were designed to emphasize the idea of a pure and direct genealogical link between present and past.

Under the supervision of Roberto Paribeni (1928–33), director of the government's Office of Antiquities and Fine Arts (a division of the Ministry of Public Instruction), and his advisory council, which included well-known historians and architects such as Marcello Piacentini, Ugo Ojetti, Corrado Ricci, Gio Ponti, and Gustavo Giovannoni, Rome funneled money to the regional superintendents in Florence, Siena, and Pisa. These government offices in turn enthusiastically approved and funded a wide variety of restoration and reconstruction projects designed to enhance the medieval quality of cities and towns throughout Tuscany.[38] San Gimignano was no exception. A large percentage of the urban fabric was reworked during the '20s and '30s, including public buildings, private homes, ecclesiastical structures, and public piazzas. Façades of buildings along the principal streets of the Via San Giovanni and the Via San Matteo as well as those in the Piazza della Cisterna were reworked. Modern windows were replaced with medieval-style arched fenestration. Modern doors underwent a similar transformation. Decorative brickwork was added. The traces of arches were emphasized. The Sienese superintendents Gino Chierici (1919–24) and Péleo Bacci (beginning in 1924) oversaw these projects, with the design assistance of architect Egisto Bellini.[39] Between 1922 and 1939, the city was redesigned to as-

sume the appearance of a pristine, unadulterated, medieval town—uncorrupted by the intervening centuries. Bellini designed each of the many projects. With the help of Superintendents Chierici and later Bacci, Bellini personally supervised all construction work. He remained in close contact with local masons, woodworkers, and artists employed on the projects and made frequent trips to the town to discuss details with the local *podestà* (the medieval office reintroduced by Mussolini in 1926). Bellini's detailed drawings show that he designed even the minutest features of this medieval transformation, including decorative details for the hand-forged window grilles and door handles (figure 52). The extent to which the *ripristino* of San Gimignano was managed by government agencies underscores the degree to which the "medievalization" of Tuscany was a PNF objective.

The focus of the superintendent's interests was the Piazza del Duomo, where the city's two town halls and the Collegiata are located. The interior of the Collegiata was "restored."[40] New medieval-style stained-glass windows were designed for the choir. The frescoes, including those in the chapel of Saint Fina, were retouched. A new altar was designed to replace the existing baroque structure. On the southern side of the piazza, the thirteenth-century Palazzo del Comune was restored between 1929 and 1934. A ground-floor loggia was opened to communicate directly with the piazza; crenellations were added to the upper stories, and the abutting tower of the Ardinghelli family was raised an additional story (compare figures 53 and 54).

The San Gimignano *podestà*, in collaboration with the Fascist party and the Monte dei Paschi bank of Siena, financed the design of this fourteenth-century-style loggia—which as Bacci enthusiastically noted, would have predated the famous Florentine Loggia dei Lanzi by thirty years. The Palazzo del Podestà, on the eastern side of the piazza, was also restored. The windows on the top floor were opened and articulated by slightly arching forms. The early fifteenth-century clock was repainted, relocated, and made functional once again. In 1939 Guelf crenellations were added to crown the building. Houses to both the north and south of the

Figure 52  Egisto Bellini, proposed renovations to the house of the Fratelli Mangani, Via San Giovanni, San Gimignano, c. 1930. Soprintendenza ai Monumenti, Siena. Autorizzato con provvedimento n. 2 del 08/07/2002 della Soprintendenza per i Beni Architettonici e per il Paesaggio per le Province di Siena e Grosseto.

Palazzo were renovated to incorporate new medieval-style windows and doors. As an article in *La Nazione* noted, through these various projects the "harmonious noble architecture of the piazza" was finally resurrected.[41]

These restoration projects were arbitrary at best. They were not based on archaeological exploration or any other research into the form of local architecture. Instead, they were designed to reinforce an ideal image of medieval San Gimignano, devised by architect Bellini and Superintendents Chierici and Bacci. The image was loosely based on period examples drawn from Siena and Florence. According to Bacci's correspondence, the only criterion for the modern Romanesque-style altar that Bellini created for the Collegiata was that it be in "stylistic harmony" with the rest of the church.[42] The new stained-glass windows in turn were to be "believably fifteenth-century in style."[43] Not only was the new loggia of the Palazzo del Comune built following the forced interpretation of period documents,[44] but whether any such loggia ever existed remains unclear. This kind of arbitrary restoration was

typical of the period as contemporary civic pride was reborn in the reconstruction of imposing civic form. During the Fascist regime the health of architectural infrastructure, cultural identity, and political strength were understood to be inseparable.

Above all else, particular attention was paid to medieval town halls—the symbolic center of civic government, the heart of every medieval city, and the one structure that could arguably be said to represent the Italian *popolo*. During the late '20s and '30s, most Tuscan town halls underwent facelifts. These ranged from mild interventions to dramatic *ex nihilo* re-creations. In the case of San Giovanni Valdarno, one of the new towns founded by the Florentine republic in the mid-fourteenth century, the loggias of the Palazzo Comunale were reopened to articulate once again the public spaces of the building.[45] In Figline Valdarno, the idea of *liberazione* reached an extreme as the Palazzo Pretorio miraculously reemerged from the post-Renaissance architectural sediment between 1926 and 1930.[46] Once restored, many of these town halls were remod-

**Figure 53** Palazzo del Podestà, San Gimignano, c. 1900 (prior to the interventions sponsored by the Fascist regime). Collection of the author.

eled for public use. As in the case of San Gimignano, they became government office buildings, party headquarters, libraries, or museums—conveniently reinforcing their original function as centers of civic life.

Once reconstructed, the medieval Tuscan cityscape was packaged and presented to the public. During the '30s and early '40s, mass media and the newly formed tourist industry helped codify what we know today as "Tuscany." This was certainly the case with *Belle torri*. As the narrator and tourist lead the viewer through the city, the route they take passes a series of structures that had been recently restored to their idealized medieval condition. From the gate of San Giovanni to the interior of the Collegiata, the structures seen in the film had been subjected to the *ripristino* efforts of the superintendent's office. Even the collection of liturgical art housed in the

Museo Sacra was displayed according to the designs of Bellini. The restoration projects made the medieval buildings more appealing. As period-style windows, doorways, and merlons (such as those added to the Palazzo del Podestà) were reconstructed, buildings became more photogenic, and ultimately more cinematographic.[47]

By focusing on the medieval to the exclusion of all else, the film closely regulates what is seen. In this way, the film establishes control over what might otherwise be an unwieldy amount of information. As Ruth Ben-Ghiat notes, cinema harnessed the information presented about a site, and in so doing regulated the experience of that site.[48] In other words, film was an important tool for domestic propaganda. It was a cinematic guidebook that taught the audience what they could expect when visiting a town such as San Gimignano, and it also taught its viewers how to go about fulfilling those expectations. As such, film was the final stage in the restoration campaign, documenting and performing the reemergence of the past for an expectant mass audience.

It is important to note that the extent of reconstruction work was never made explicit during the regime. Although the general public might have known that the superintendent's office was involved with restoring towns such as San Gimignano, and although many people would have seen the construction in process, they would not have known exactly what was being done. For example, they would not have been aware that the loggia of the Palazzo del Comune or the crenellations of the Palazzo del Podestà were actually being constructed *ex nihilo*. Such details were often intentionally obscured in order to preserve the myth of cultural continuum. Although Superintendents Chierici and Bacci wrote frequently for scholarly journals such as the *Bollettino Senese di storia patria* and the *Miscellanea storica della Valdelsa* as a means of legitimizing their restoration efforts, they presented the projects as reconstructions rather than re-creations.[49] Herein lies a major distinction between the redesign of cities during the Fascist period and projects undertaken by architects working in the neo-medieval style of the nineteenth century. Although the former claimed they were restoring the city to its original form, the latter (architects

Figure 54 Palazzo del Podestà, San Gimignano, today. The loggia designed by Egisto Bellini and completed in 1936 is visible at the left. Photograph by the author.

such as Giuseppe Partini working in Siena or the Coppedè in Genova) celebrated their neo-historicist designs as pure fantasy. The first was insidious; the second was frivolous. Neither the 1941 moviegoing audience nor the visiting tourists were aware that the image of medieval San Gimignano was actually a product of the present.

FILM, AS WELL AS other mass media, played an important role in the burgeoning national pastime of tourism, and more specifically of heritage tourism.[50] The mass media made Italian heritage familiar and, more important, accessible to a wide audience.[51] For example, Fratelli Alinari, the Florentine photographic studio, supplied numerous images to period journals, simultaneously advertising its own business and the Tuscan landscape. An image of San Gimignano's Torre Grossa was published in 1929 in the monthly photo-essay entitled "Aspetti della bellezza toscana" in *L'Illustrazione Toscana*.[52] Coupled with

guidebooks, such as the informative *Guida storico-artistica di San Gimignano* written by San Gimignano historian Leone Chellini and published by Alinari, such images helped to standardize a vision of the medieval landscape. Again and again, the same structures were featured in these publications: town halls, towers, piazzas, gates, and other forms of civic architecture. Heritage tourism was deployed to reinforce the regime's utopian vision of urban typology—one whose architecture embodied civic power and the republican era.

By the '30s, a six-day workweek, new highway system, improved train system complete with frequent discount fares, and sponsored excursions enabled the urban working classes to visit sites such as San Gimignano for the first time, marking the beginning of what would become a standard Sunday afternoon activity. The regime's Opera Nazionale Dopolavoro, or OND, was particularly instrumental in this regard. The organization was responsible for organizing a

range of leisure activities for Fascist workers. By 1937, the organization boasted a membership of four and a half million.[53] The OND sponsored sporting events, cultural activities such as the Sienese *palio,* and the Festa dell'Uva in Impruneta. As Victoria de Grazia notes of the organization, the OND was "the regime's most effective instrument for carrying out Mussolini's new populist policies."[54] The OND also supported tourism to historic sites. By the mid-'30s, more than 1,500 trains were being sponsored by the OND each summer, traveling to small towns throughout the countryside.[55] As Ben-Ghiat observes in her study of Raffaello Matazzaro's 1933 feature film *Treno popolare,* which chronicled an organized trip to Orvieto, such outings provided a way to "mobilize and reaffirm popular traditions and traditional social practice" among the working classes.[56] The outings were "designed as a corrective to unstructured past times."[57] In other words, although new policies in the workplace awarded unprecedented leisure time to Italians, the regime increasingly controlled the way in which that leisure was utilized. Visiting sites was choreographed and controlled in a manner that suggests the regime's underlying philosophy of surveillance and of inculcating a sense of efficiency. In the Fascist regime, even tourism was to be an orderly and productive experience. As Ben-Ghiat suggests, Mussolini's dictatorship mediated modernity by regulating all forms of mass culture—including leisure.[58] If the itinerary followed by the tourist in *Belle torri* is any proof, tourism was a well-disciplined experience during the regime—with a well-defined set of objectives and behavioral codes.

As one might imagine, there was keen competition among Tuscan towns to define themselves as attractive destinations. This was particularly the case in Tuscany, where sites such as Siena, Florence, Volterra, and Lucca vied for the attention of tourists. As a rule, cities capitalized on their most easily identifiable, iconic monument. This is made explicitly clear in the imagery used for tourist brochures produced by the PNF. Pisa was represented by the leaning tower and Siena by the Torre della Mangia (figure 55). The unique features of San Gimignano included the remote siting, unusual panorama complete with thirteen of the original seventy-two towers, and a range of architectural styles that collapsed the architecture of Siena, Florence, and Lucca into one site.

In some towns the restoration of the built environment was coupled with a range of other activities so as to create an entire tourist package. In Siena, Florence, and Arezzo, centenary celebrations commemorated local medieval and Renaissance artists. Festivals such as the Sienese *palio,* the Florentine *calcio storico,* and the Aretine joust were redesigned during the '20s and '30s to appear more "coherently medieval."[59] In the case of Siena, the medieval past was made

Figure 55 Organization for Italian Tourism (ENIT) pamphlets of the 1930s. Ministero del Tesoro, Archivio delle Pubblicazioni dello Stato.

even more tangible and consumable through the introduction of the edible medieval product *panforte*. The dessert, made from a medieval recipe unearthed in the state archive in 1927, was packaged in a wrapper designed to evoke a medieval sensibility.[60] Other towns quickly imitated this idea, producing their own tasty variations. The San Gimignano version came in a colorful package that displayed the town's multi-towered panorama.

THE REGIME'S MEDIA campaign nationalized and democratized the experience of history for the Italian *popolo*. Thanks to the efforts of the PNF, the act of visiting historic sites was no longer an exclusive rite of the foreign bourgeois tourists of the previous century. Tourism was now redefined as a pursuit for the Italian people. The medieval past was made not only increasingly accessible but also accessible to all. This point is reinforced by the female tourist in *Belle torri*. By reclaiming the bourgeois traditions of travel to Italy, she domesticates the practice for an Italian audience. As this seemingly independent young woman enjoys the sights, the visit to an unknown town is transformed into a nonthreatening experience for men and women alike. By serving as the surrogate for the movie-viewing audience, she ensures that San Gimignano's medieval heritage will be preserved and valued by all. Through her demeanor, she teaches the contemporary audience how to respect the past. In so doing, this young woman guarantees the continuity of Italian culture, in much the same way that through her celebrated roles as devoted wife and mother, she guarantees the continuity of the Italian race.

The film thus reflects the changing role of tourism. The Grand Tour traditions of the eighteenth and nineteenth centuries, dominated by educated elite and middle-class foreign males, were to be replaced by a more inclusive form of tourism democratized for the Italian working classes and for women. This shift from foreign tourism to tourism for a national audience was a hallmark of the regime. Indeed, it was during the regime that the modern term for tourists, *turisti*, replaced the previously utilized term *forestieri*, or foreigners.

BY PROVIDING A GUIDE to the city, *Belle torri* figuratively reclaimed the image of Italy that had been shaped for years by prolific foreigners. From Richard Lassels in the sixteenth century to Henry James in the nineteenth century, the image and myth of Italy had been largely mediated by and for foreigners. By constructing an image of Italy that was intended for national consumption, the regime ensured that the image of Italy was no longer controlled abroad.

As I have noted, the restoration and celebration of towns such as San Gimignano were intended for an audience that was not only Italian but also working-class. The documentarist aesthetic that pervaded Fascist-period arts facilitated this reclamation of bourgeois paradigms for the *popolo*. As one scholar notes, the realist aesthetic provided the opportunity "to promulgate new antibourgeois values and codes of behavior."[61] Promoting travel through such documentary films as *Belle torri* and actualizing travel through enhanced affordable train service and organized tours, the regime brought Italy home.[62]

Although the visitors who arrived in San Gimignano during the nineteenth century might have stayed a week to experience a town (or longer in the case of Lilia Theobald, the main character in E. M. Forster's 1905 romance, *Where Angels Fear to Tread*), visitors in the '30s and early '40s were encouraged to visit during a single afternoon. As such, the very form of tourism became more cinematic as time and place were accelerated. Visiting a series of monuments in a short time became the new modus operandi. In this way, even leisure activities were affected by the regime's interest in creating a more efficient and productive nation. Gone were the days of the Grand Tour tourists who lingered for weeks, sometimes even years, studying and writing about the sites. The new breed of tourist operated within a modern framework that was dependent on new modes of perception, which while more fleeting were also heavily predigested.

A 1939 desk calendar published by the OND and widely distributed to Dopolavoro groups throughout the country exemplifies this well. Entitled *Italia bella*, the calendar is lavishly illustrated with a catalog of images depicting Italian monuments and sites—the vast majority of

**Figure 56** Fernando Pasta, Salvucci towers, San Gimignano, from 1939 OND calendar *Italia bella*. Collection of the author.

which are medieval or Renaissance—underscoring the extent to which that past was emphasized to the exclusion of others. Although the calendar encouraged readers to plan an itinerary of Italian cities, the sites were predetermined. San Gimignano was represented by an image of the Salvucci towers, scenically framed by the arch of the Torre Grossa (figure 56). Unknown to most viewers, the Casa Abbracciabeni, situated at the base of the Salvucci towers, was one of the structures that had undergone a Fascist *ripristino*. Regardless of the details, the OND calendar, not unlike the *Belle torri,* allowed a group of structures to be serialized for a captive audience. Armed with a series of images of sites that were worth visiting, the reader or viewer could begin to plan a weekend trip. This new leisure activity was closely monitored. The sites had been preselected. By establishing this canon of possible destinations, the regime taught Italians how to become tourists in their own country. As a result, people in Venice could recognize what San Gimignano looked like (even if they never trav-

eled to the town) and could even come to consider it a part of their own cultural identity, since it had been made as familiar to them as the Piazza San Marco. Just as the regime encouraged the physical fitness of its citizens through a variety of sports programs and organizations, it also encouraged cultural fitness through programs such as heritage tourism. Tourism, thus efficiently and effectively structured by the regime, emerged as the patriotic duty of a responsible and loyal Fascist.

We have come to associate the commodification of historical sites, where authenticity is suppressed by commercial objectives, with a postmodern consumer culture. And yet, as we have seen, tourism—dependent on a reconstructed, if not manipulated, sense of heritage guided by a political agenda—thrived during the Fascist regime. The regime was well aware that as a young country, Italy was in need of an accessible shared culture, and the historical landscape provided this. By encouraging interest in, and tourism to, various towns, the regime defined

a canon of sites, which became synonymous with Italian identity: Arezzo, Cortona, Lucca, Monteriggioni, San Gimignano, Siena, and Volterra. This canon continues to form the popularly held vision of the Tuscan landscape. This point is well made by a recent Alitalia advertisement for Tuscany, which proclaims, "Discover the soaring towers of San Gimignano, serene piazzas of Lucca, or noble pageantry of Siena." There is a reason that this reads like a Fascist film script. Mass media continues to sell the image of medieval Tuscany by instructing the audience how to experience place. More important, we realize the extent to which the understanding of place is, to borrow from Henri Lefebvre, a product of continuous cultural production.[63]

# Shaping the Fascist "New Man"

## Donatello's *St. George* and Mussolini's Appropriated Renaissance of the Italian Nation

*Roger J. Crum*

IN 1996 I ACCEPTED an invitation to deliver a lecture in honor of the one hundredth anniversary of the Kunsthistorisches Institut in Florence. Specifically, I was invited to address how the Institut had functioned as an active agent in my work.[1] Like the work of most scholars, my work is rarely, if ever, about the library per se. Nonetheless, I have found that what distinguishes a great library is that in the richness of its holdings, scholars are almost always guaranteed interesting accidents of research. So, upon receiving my invitation to speak, I easily recalled my own most recent "accident" in the Institut's library. Not long before, I had chanced upon a photograph in the Institut's photograph collection that represents a copy of Donatello's Renaissance *St. George* notably positioned in the midst of Nazi, Fascist, and Florentine imagery (figure 57). The peculiarity of this find and the particularity of its meaning form the subject of this chapter.

Donatello carved his *St. George* between 1415 and 1417 for the Florentine guild of armorers and swordsmiths, the Arte dei Spadai e Corazzai (figure 58). The sculptor's work was in-stalled in that guild's niche on the exterior of Orsanmichele, a structure that served as the church and main public facility of the collected group of Florentine guilds. The statue remained at Orsanmichele until 1892, when it was moved to the Museo Nazionale del Bargello, commonly known as the Bargello. The photograph illustrated here represents the state of the statue after its transfer to the Bargello and before its restoration in 1970. After the statue was moved to the Bargello, a bronze copy, produced in the late nineteenth century, was then placed at Orsanmichele; that statue remains there to the present day. The original statue and its bronze copy are both familiar works of art.[2] But at the Kunsthistorisches Institut, the photograph I found represents a quite unfamiliar *St. George*. What made that photograph such an interesting "accident" of research was that it represents Donatello's work out of its niche at Orsanmichele, out of its museum home in the Bargello, and even out of the Renaissance.[3]

The Institut's photograph provides information about the Fascist recontextualization and reconceptualization of Renaissance imagery. Although my goal in this chapter is to discuss this particular example of Fascist appropriation in terms of Mussolini's foreign and domestic policy of the late '30s, I am equally interested in sharing the circumstances of my research in the library that led to my pursuit of this topic. The two subjects are not unrelated: the scholar at work in the library as historical archive is often no less engaged than was the Fascist regime itself in the slippery process of interpretation and categoriza-

I thank Eric Apfelstadt, who convened the panel dedicated to the Kunsthistorisches Institut at the Thirty-Second International Congress on Medieval Studies, Kalamazoo, Michigan, 1997. I also thank Diane Cole Ahl, Robin Crum, Marvin Eisenberg, Jean Koeller, Marianne Lamonaca, Irving Lavin, Claudia Lazzaro, Eugene Marcowski, John Paoletti, Suzette Pico, Sheryl Reiss, Craig Hugh Smyth, David Wilkins, Sean Wilkinson, and the staffs of the Kunsthistorisches Institut, the Archivio Comunale di Firenze, and the Biblioteca Nazionale di Firenze.

**Figure 57** Copy of Donatello's *St. George* displayed for the visit of Hitler to Florence in 1938. Photograph by Arnold von Borsig (?).

tion of the past—activities themselves of recontextualization and reconceptualization. In general, I seek to explore who, what organization, or what period was and is responsible for establishing the meaning of Donatello's statue: Donatello himself, his Renaissance patrons, the Fascist regime, or even the modern scholar.

I was reading in the Institut's library about Florentine government in the early fifteenth century. The city was then shifting from a broadbased government of the guilds to a consensus regime identified more narrowly with an oligarchy. The Florentine humanist Leonardo Bruni became disturbed by this situation, fearing a loss

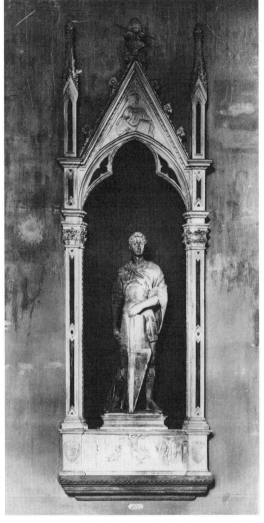

Figure 58 Donatello's *St. George,* before its restoration in 1970. Florence, Museo Nazionale del Bargello. Kunsthistorisches Institut, Florence, Neg. Bazzechi, no. 29115.

the shift from the late Gothic, in a work such as Donatello's *David* of 1408, to the Renaissance, in works such as the *St. George.* His suggestion was that Donatello and other artists developed the new Renaissance manner—with its greater sense of presence, assertiveness, and intellectual readiness—in response to tyrannical threats to Florence that the rulers of Milan and Naples posed.

Hartt based his argument on the work of Hans Baron, a historian of early Florentine humanism. In 1955 Baron published his magnum opus, *The Crisis of the Early Italian Renaissance: Civic Humanism and Republican Liberty in an Age of Classicism and Tyranny.*[6] In that work Baron argued for a causal relationship between political developments and humanist rhetorical culture in the late fourteenth and early fifteenth centuries. For Baron, humanist authors—such as Leonardo Bruni—were not ivory tower intellectuals. Instead they were engaged individuals whose works celebrated liberty and personal responsibility. Their civic humanism was born as a conscious response to forces of despotic tyranny that threatened the republican liberty of Florence. It was actually Baron himself who first raised the issue of Donatello's *St. George* as an embodiment of Florentine political ideals. "Those who recall Donatello's *St. George* of 1415–16—the first book of Bruni's *Historiae Florentini Populi* was also written in 1415—," Baron writes, "will be certain that even the arts did not remain entirely untouched by the climate of the time of the Florentine-Milanese struggle."[7] Working with Baron's thesis, Hartt saw Donatello's statue and other works of contemporary public sculpture as being predominantly of civic character and addressed "to the imagination of the man in the street."[8] Originally, the *St. George* held a sword or lance that projected boldly into the space of the passerby. Certainly the boldness of the statue's projection served as advertisement for the wares of the armorers' guild. But according to Hartt, *St. George* and other sculpted figures were also to be understood as protector figures and civic heroes.[9] For Hartt, Donatello's *St. George* transcended the immediate circumstances of guild patronage; it became an image of state in an era of uncertainty and danger.

of individual initiative in this new political environment.[4] As an art historian, I began to think of examples of Florentine Renaissance art from the same period in which individualism had been traditionally identified as a core element of the work's meaning. Immediately I recalled that in an essay of 1964, Frederick Hartt had presented Donatello's *St. George* as a symbol of Florentine independence and individualism. Entitled "Art and Freedom in Quattrocento Florence," Hartt's essay has become a model in (and beyond) Florentine studies for the political interpretation of art.[5] Hartt was interested in the question of outside influences on stylistic change as he explored

With Frederick Hartt's interpretation, I and many other scholars of at least my generation were first introduced to Donatello's statue. The existence of the Institut's photograph, however, significantly destabilizes this understanding of Donatello's work. What might the Institut's photograph mean in relation to Hartt's ideas? If Hartt was right, then what went wrong between the Renaissance and the modern period? Are copies of Renaissance works so free of the meanings that we associate with their originals? Does the assemblage represented in the Institut's photograph mean anything at all or was it simply a makeshift, poorly thought-out decorative solution for some Nazi and Fascist festivity? I had gone to the Institut's photo archive to think anew about Donatello's statue in terms of domestic politics and the theme of individualism in Renaissance Florence. With the Institut's photograph in hand, I weighed these questions as I found my thoughts of Donatello's work drawn somewhere between domestic and foreign affairs and awkwardly between the exalted Renaissance past and the more problematic modern era.

A notation on the Institut's photograph indicates that Arnold von Borsig gave it to the library. Since von Borsig was a photographer who was active in Tuscany in the '30s, it is possible that he himself made the image.[10] The location represented in the photograph is identifiable with a small, unnamed square in Florence that is adjacent to and immediately south of the Palazzo Pitti and a few steps north of the Piazza San Felice. A similar image was published in the Florentine newspaper *La Nazione* for May 6.[11] The image from *La Nazione* provided me with proof that what is represented in the Institut's photograph is a copy of Donatello's *St. George* that was positioned in Florence for Adolph Hitler's visit to the city in May 1938.[12]

Between May 3 and May 9, 1938, Hitler visited Italy, where he hoped to establish a military alliance with Mussolini. Both men were eager though cautious, and the Italians sought to make a strong impression on the Führer. Hitler went first to Rome and Naples, where he found both cities lavishly decorated with banners, flags, and light shows. These displays proclaimed the strength of Italy and the firmness of its friendship with Germany. Hitler's final stop was Florence. This visit occurred on May 9, the second anniversary of Mussolini's declaration of the Italian Empire. There the Nazi leader remained for a busy eight hours. Hitler arrived by train and was driven by motorcade through the city. This procession was followed by various receptions, historic games in the Boboli garden, and tours through the Uffizi Museum, the Palazzo Vecchio, the Palazzo Pitti, and Giorgio Vasari's Corridor, the passageway between the Palazzo Vecchio and the Palazzo Pitti. For Hitler's visit, the face of the city was transformed with ephemeral decorations, with the display looking something like a cross between a Renaissance regal *entrata* and the Nazi presentation of Nuremberg in Leni Riefenstahl's 1934 film, *Triumph of the Will*. This transformation was the work of the Florentine municipal government, and specifically the Office of Public Works and Urbanism under the direction of the engineer Alessandro Giuntoli. The office itself was established only a few months before Hitler's visit in May 1938, and in preparation for Hitler's arrival, Giuntoli engaged a small group of architects, engineers, artists, and planners to give Florence a festive appearance. What they produced was part local pride, part Fascist allegiance, and all propaganda for both foreign and domestic consumption.[13] In the eyes of the Fascists, the ephemeral transformation of Florence was so successful that Mussolini inscribed the words *Firenze Fascistissima 9 maggio XVI* in the commune's book of honor at the close of the day's events.[14] This inscription indicated how supremely Fascist Mussolini believed Florence appeared for his and the Führer's visit.

A large map of Florence that was made before Hitler's arrival traces several possible motorcade routes in different colors. The routes predictably follow the historic thoroughfares of the city and pass the city's principal monuments.[15] Dressed up with Fascist and Nazi regalia, Florence was readied for a tour clearly intended to showcase the best of the medieval and Renaissance city. A principal stopping point was the Palazzo Pitti. According to one of the projected routes, Hitler's car was to progress down Via Maggio, turn at the Piazza San Felice, and enter the Palazzo Pitti. In the end, Hitler's

motorcade instead bypassed the Via Maggio/Piazza San Felice approach to the Palazzo Pitti and entered the Boboli garden directly from the area of the Porta Romana, after having descended from the Piazzale Michelangelo at the south of the city. Yet despite the fact that the Via Maggio/Piazza San Felice approach was bypassed, this possible route received considerable attention by the planners. Extant proposals for this area substantially outnumber those for any other area in the city. It can reasonably be concluded from this evidence that the space in and around the Piazza San Felice, including the unnamed square immediately south of the Palazzo Pitti in the Institut's photograph, was envisioned as the visual and conceptual linchpin of the Führer's visit. This was so at least during the planning stages. That the area was in fact articulated with flags, banners, and a copy of Donatello's *St. George* is no small indication that the planners had reason to believe that Hitler's motorcade would pass by this location.

What did Donatello's *St. George* mean in the non-Renaissance context that was created for Hitler's visit? Of course, once Donatello's statue and the ideas associated with it were detached from the Renaissance, the work became a generic martial armature on which diverse interpretations could be hung. Italo-German relations before the war can yield insights into the Fascist meaning of the installation represented in the Institut's photograph. St. George was a knight and therefore a "military figure" of sorts, and Italy under Fascism was a militaristic state. Indeed, militarism and its mythology had characterized Mussolini's regime from its founding and continued to define its essence to the close of its history. "Fascism did not come to power through normal means," asserted Mussolini himself, but rather it "arrived there by marching on Rome *armata manu,* with a real insurrectional act."[16] By 1938, this founding mythology had become the actuality of the state, so much so that the Milanese *Corriere della Sera* celebrated Italy as *Italia guerriera*—Italy the warrior state.[17] Military symbolism was of central importance during Hitler's visit; according to *L'Illustrazione Italiana,* Rome was decorated for Hitler's arrival with a new "imperial and warrior face."[18] At every turn,

Mussolini wanted to convince Hitler of Italy's readiness to wage war; Hitler, for his part, was ready to be convinced and was eager for Italy to join an alliance. Donatello's *St. George,* with its famous sense of *prontezza,* or readiness, could well have projected the message that Italy under the Duce continued to be a ready, potent, and reliable force. Yet in the spring of 1938, Mussolini was still interested in playing the role of peacemaker in Europe. Reluctant to cancel his options with a military alliance, Mussolini sidestepped the issue and Hitler left Florence empty-handed.[19] Donatello's *St. George* could well have communicated Italy's *prontezza,* while still veiling the Duce's lingering desire for *distanza,* or distance.

From the point of diplomatic achievement, Hitler's visit to Italy—especially his eight hours in Florence—was a failure. Perhaps for this reason it has been given only passing notice by historians of the period. But these historians have overlooked something of importance in Hitler's time in Florence, which might otherwise be dismissed as mere tourism in the Renaissance city. The copy of Donatello's *St. George* that was positioned near the Palazzo Pitti was part of a much larger presentation of Florence as a city of culture, art, and history—Italy's Renaissance city for a reborn, Fascist nation. Given the historical identity of Florence, it might seem odd that Mussolini made it the conclusion of his forward-looking encounter with Hitler. Florence, as an old museum town, might have seemed antithetical to those objectives. By the '30s, however, Mussolini had begun to emphasize the historical strengths of the Italian people. Fascist Italy, like Nazi Germany, was to have historical underpinnings in traditions that were political, military, economic, and cultural. Mussolini, like the other dictators of the period, and especially Hitler, wished to mobilize the national past and its rich repository of visual imagery. What Florence and its art had to offer was the Renaissance, a period of renewal that was of interest to Mussolini and the Fascists.

Eventually various historic traditions were seen as shared between Italy and Germany, even when the connections were quite forced. The idea of shared traditions was, in fact, an important initial solution to the problem of establishing unity between these two very different nations.[20]

In September 1937, eight months before Hitler's visit, Mussolini's foreign minister and son-in-law, Galeazzo Ciano, wrote of this problem: "Will the solidarity between the two regimes suffice to form a real bond of union between two peoples drawn in opposite directions by race, culture, religion, and tastes?"[21] As Richard Etlin notes, Mussolini did not leave this issue to chance. According to Etlin, artists, writers, and architects became the instruments for creating bonds between the German and Italian people.[22] Apparently this plan paid off. On November 24, 1938, just over six months after Hitler's visit to Florence, the two nations signed a cultural accord. As one Italian newspaper noted, this was an act that was "truly decisive for the future of Europe."[23] A military alliance followed in the next year. In view of this progression from culture to alliance, it is difficult to regard Hitler's eight hours in Florence solely as a diversion into tourism. Certainly commentators at the time understood the role that culture and Florence itself played in establishing the bond between Nazi Germany and Fascist Italy. "At the end of this luminous Italian week," one Italian journalist wrote of Hitler's day in Florence, "we have seen that even politics, beyond the calculation of shared interests, can become ennobled and sublimated in a light of humanity, of amiability, and of poetry if it is the expression of two Revolutions that, like the Mussolinian and the Hitlerian, take inspiration from a great ideal."[24] That ideal was none other than the Italian Renaissance, of which Donatello's *St. George* had long been regarded as an essential component. Three years earlier, Walter Benjamin had written in reference to Fascism that "all efforts to render politics aesthetic culminate in one thing: war."[25] In 1938, the ephemeral transformation of Renaissance Florence constituted precisely the kind of aestheticized politics of which Benjamin warned. It is ironic that Donatello's *St. George,* the republican hero of Frederick Hartt's scholarship, seems earlier to have been engaged to reflect and to promote the new Fascist military state.

In the arena of domestic politics, Mussolini was interested in creating what he called the Fascist "New Man." The idea of the Fascist "New Man"—strong, modern, statist, and militaris-

tic—was a major theme of the Duce's agenda.[26] This theme was buttressed with allusions to the virtues of selfless medieval and Renaissance sainthood and to the chivalry of knighthood. In a Mussolinian conception, Donatello's *St. George* provided a suitable model for appropriation, for as an image of the "New Man," the statue could at once be Renaissance in its cultural weight and modern in its Fascist utility.

Fascist visual imagery reinforced concerns of the Fascist state. Moreover, Fascists expressed their concerns in a manner that suggested that the Fascist revolution was an ongoing enterprise. "Our movement," stated Mussolini, "is a continuous elaboration and transformation: it undergoes a work of unceasing revision, the only means to make of it an element of life and not a dead remain."[27] The question, then, is just what ongoing enterprise was being reinforced in Florence in 1938 with the installation of a copy of Donatello's *St. George* near the Piazza San Felice? What Fascist ideological musculature was hung on the martial armature of St. George?

Frederick Hartt actually suggested a path toward answering this question. In discussing the original statue, Hartt wrote of the work as a model for a transformed Florentine citizenry. Similarly, the transformation of the Italian man and the Italian nation was central to the Fascists' plan. Mussolini frequently declared the need for a "New Man" and for the creation of a new generation of Italians as citizen-soldiers. "Each of you," Mussolini urged in a speech in Milan on October 28, 1925, "must consider yourself a soldier: a soldier also when you are not wearing the uniform, a soldier also when you work, in the office, in factories, in yards or in the fields: a soldier tied to all the rest of the army, a molecule that feels and beats with the entire organism."[28] For Mussolini, the "New Man" and citizen-soldier should be "serious, intrepid, [and] tenacious."[29] Of course, the qualities "serious, intrepid, and tenacious" are clearly associable with Donatello's *St. George.*

Even before the Fascist era, Florentines had been involved in this reshaping of Italy and of Italians. In fact, certain of Mussolini's ideas were born within the Florentine avant-garde of the early twentieth century. The Florentine avant-

garde was centered on a group of writers and artists who founded the publication *Leonardo* and its successors *La Voce* and *Lacerba*. Prior to World War I, these individuals had voiced discontent with Italian liberal democracy. They and others called for the spiritual and cultural renewal and regeneration of Italy; the Futurists joined this initiative with their more notorious battle cry to action, change, and war.[30] This call ultimately played right into the Fascist hand. As Walter Adamson observes, the Fascists "appropriated this rhetoric and adapted it to more politically explicit but also more culturally impoverished and dangerous ends."[31] In contrast to the tired system of liberal government, Mussolini presented the alternative of a new, "very strong" and "virile" Fascist state.[32] On Florentine soil, these Fascist aims and the ideas of the native avant-garde eventually merged in *18BL,* a theatrical production of monumental scale staged in Florence in 1934.[33] Performed only once, on an outdoor stage some six football fields in size, the production had as its protagonist the celebrated Fiat truck, the 18BL. On this protagonist was loaded the thematic freight of the Fascist struggle for power and its vigorous transformation of Italian culture, society, and politics. In the final scene the heroic 18BL truck dies, but is spectacularly reborn in the guise of a great figure on horseback who is to be understood as Mussolini. Mussolini, so *18BL* makes clear, is the new Italian man, the model for all of Italy.

A kindred, though less pointed, message was presented in 1938 with the installation of the copy of Donatello's *St. George* that is represented in the Institut's photograph. With that installation the Renaissance statue was reborn in the context of an era distinctly concerned with reviving the greatness of the Italian nation. To be sure, Mussolini more frequently turned to ancient Rome as the glorious antecedent to the Fascist state. But for a Fascist nation remaking itself, what better strategy could be employed than looking to the Renaissance when the Italians, specifically the Florentines, had brought about a revival in art and in society?[34] It seems possible that Donatello's *St. George* was appropriated to underscore the much larger contemporaneous Fascist drive to shape the new Italian man.

The image of a saint was also not antithetical to the Fascist message of renewal. In fact, Fascism was promoted as a kind of secular religion. In 1932 Mussolini wrote: "Fascism is a religious conception, in which man is seen in his immanent relationship with a superior law, with an objective will that transcends the particular individual and elevates him to a conscious member of a spiritual society."[35] In *La dottrina del fascismo* of 1936, Fascism was defined as "a religious and military Order. It is religious because in its conscience it has a faith of its own; it is military because, obeying its own inner imperatives, it defends its faith and sacrifices itself for that faith. This is the mystical nature of Fascism, a militia of believers in a skeptical, weak-hearted world."[36]

Working within a "weak-hearted world," the Fascists sought to bring about the renewal of the Italian nation through violence. And with violence also came sacrifice and martyrdom for the regime. In 1922 Mussolini remembered fallen Fascists as follows: "Our friends have been heroes! Their gesture has been warlike. Their violence has been saintly and moral. We exalt them."[37] The Catholic Church definitely provided models for this hero/saint worship. Fascism, wrote one official in 1931, learned from "the greatest and wisest teaching in recorded history." And the model was not that of meek and humble saints, but "of those great and imperishable pillars of the Church, its great saints, its pontiffs, bishops, and missionaries: political and warrior spirits who wielded both sword and cross . . . on behalf of the Church's power and glory."[38]

This notion of vigilance, sacrifice, martyrdom, and sainthood permeated Italian society. Children were taught that "paradise lies where God's duty is done, and God's will is perceived through the will of the State."[39] A man who grew up with the regime wrote: "Fascism was presented . . . as a total concept, a religion, a divinity all its own. The State was all. It was the divinity to which everything should be sacrificed."[40] "It is absurd," wrote Achille Starace, Mussolini's secretary of the Partito Nazionale Fascista, "to believe in the possibility of perpetual peace. . . . Fascist education must be education for battle. Fascism believes in sanctity and

heroism."[41] The essence of these sentiments was certainly captured in Mussolini's motto for Fascism: "Believe, Obey, Fight." These sentiments were also presented in sculptural form in Florence in 1938 through the figure of the recontextualized warrior St. George.

In his scholarship Frederick Hartt presented Donatello's *St. George* as an everyday hero at the ready. Although the statue was originally positioned above eye level, *St. George* was still a hero of and among the people. With its former accessories of sword or lance, the statue originally must have projected boldly out of its niche and into the space of the passerby. *St. George* directs its gaze outward to the street, to what Hartt called the "world of obstacles and dangers."[42] The statue commanded an intimate reception, and Florentines would certainly have been close enough to accommodate this dialogue on civic responsibility. But the presentation of Donatello's *St. George* was rather different in the copy that was installed in the Fascist context of 1938. For Hitler's visit, the copy was located in a small piazza and presented high on a pedestal well above the heads of observers. Most probably the combination of the *St. George* and the tall base was arrived at for purposes of striking presentation in the tradition of Fascist monumentality. One example, among many, of Fascist monumentalizing is a drawing from 1934 that was entered in the design competition for the Palazzo del Littorio in Rome. In the drawing a monumental figure of Mussolini towers over those who ascend the steps of the projected palazzo. In this image Mussolini is the larger-than-life Fascist hero who poses with the fasces much as a soldier stands with a gun, or St. George with his shield.[43] In Florence of 1938, the Florentines did not move in proximity to the everyday republican hero saint of Frederick Hartt's scholarship. Rather, they moved well below an appropriated *St. George* who was presented as the hero above the people.

As he was both the Duce and the model for the new Italian man, Mussolini was very much a pedestaled leader. Mussolini's presentation as the elevated, larger-than-life leader was evident in any number of examples in which the Duce's image was visually presented, monumentalized, and stylized before the eyes of the Italian people. Cer-

tainly the image of Mussolini positioned on the balcony of the Palazzo Venezia in Rome or on other elevated platforms throughout Italy illustrated this notion of the pedestaled, larger-than-life leader.[44] As a result of being visually acculturated to understanding Mussolini in monumental terms, Italians became very familiar with the imposing figure of their Fascist leader. "In order to understand something of Fascism," wrote a parliamentary figure during the '30s, "one must consider the personality of its founder and its leader: Benito Mussolini. . . . The leaders of Fascism who surround him express the most bourgeois mediocrity. . . . Mussolini emerges above them in a conspicuous, absolute way, not as much for his intellectual vigor, his cultural, technical, and concrete preparation, as for the 'insolence' of his personality. . . . What counts is his personality. . . . The only theory that Fascism has is one person: Benito Mussolini."[45] Another Fascist wrote, "Benito Mussolini is not a man: he is the man. He is the one the Nation has been waiting for."[46] Along this same line of argument, Antonio Beltramelli entitled his 1923 biography of Mussolini simply *The New Man.*[47]

It is possible that the copy of *St. George* presented in Florence for Hitler's visit was to be understood as a Mussolini type. Hagiographic profiles of the Duce were common; he was referred to as a "social archangel" and even as an "envoy of God."[48] In her biography of the Duce, Margherita Sarfatti claimed that during the war, Mussolini had received so many wounds (fortytwo in all) that he seemed like "St. Sebastian, his flesh pierced as if with arrows."[49] Mussolini was also compared to St. Francis, for like the medieval saint, the Duce was regarded as having suffered and sacrificed for others.[50] In addition, he was praised as a condottiere, or warrior figure.[51] During Hitler's visit, both he and Mussolini were repeatedly referred to in the Italian press as the two condottieri.[52]

Most important, Mussolini was identified on at least one occasion with St. George. In the collection of the Wolfsonian in Miami Beach, Florida, a maiolica plate dated 1935 shows Mussolini as St. George in the act of slaying a dragon (figure 59). In this case the dragon is symbolic of the economic sanctions that were imposed by the

Figure 59 Eugene Colmo, *San Giorgio Benito Uccide il Mostro delle Sanzioni* (St. George Benito [Mussolini] Kills the Monster of Sanctions), maiolica plate, 1935. The Mitchell Wolfson Jr. Collection, The Wolfsonian-Florida International University, Miami Beach, Florida.

League of Nations after Italy's invasion of Ethiopia in 1935. This interpretation of the dragon is clearly indicated by the inscription on the plate's obverse that reads *San Giorgio Benito Uccide il Mostro delle Sanzioni XIV*.[53] It is significant that Mussolini was already identified with St. George as he sought to position himself and to assert his will in the mid-1930s in relation to the other European powers.

Behind this identification of Mussolini with St. George stood a history of martial identification of the Duce that reached deep within the symbolic past of the Fascist regime. This is evident from an installation of 1932 from the tenth anniversary exhibition of the Fascist state. In one of the main spaces of the exhibition, the image of a stylized Mussolini as a warrior with a sword appeared above a doorway; large letters adjacent to the image spelling *Dux* clearly identified the figure as Mussolini. Yet beyond even martial imagery, the type represented by Donatello's statue, a figure physically alert and intellectually ready,

conforms to the typology that Mussolini's handlers produced for him. In any number of guises, Mussolini was packaged as the ever youthful, vigorous, and engaged leader, and he was often photographed in poses of assertiveness and readiness not dissimilar from that of Donatello's *St. George*.[54]

The merging in Fascist propaganda of protagonist and spectacle, actor and audience could be rather fluid and complex in a situation like Hitler's visit to Florence. On that day Mussolini accompanied Hitler in a car through the city. On one level, the Duce served as Hitler's host and as half of the distinguished audience of warrior-leaders/holy warriors to the spectacle of the city with its festive decorations. But the Duce was also a protagonist. He was a vital part of the spectacle in motion that found resonance in the mirroring chorus of the decorated route through the streets of medieval and Renaissance Florence.[55] On other occasions, when Mussolini spoke, a disciplined populace responded by mirroring him

through the display of his title. In a photograph from the late '30s, Mussolini's speech in Venice is answered by an impressive example of this human choreography.[56] According to the Fascists, such a responsive populace had actually been shaped by the Duce in the image of the new Italian man. In some cases, this shaping or mirroring was even in Mussolini's own image. Examples of this mirroring are legion and even include a monumental living "M" that was made for Mussolini's visit to Valle d'Aosta in 1939, the use of Mussolini's image on a woman's bathing suit, and the obvious reference to the Duce in a photograph of a small boy shown in the uniform of the Figlio della Lupa (the son of the she-wolf). Notable in the photograph of the boy is the "M," or Mussolini, buckle, the black shirt, and, obviously, the portrait of the Duce himself.[57] Even Mussolini could join the audience and play a part in mirroring aspects of the Fascist spectacle for which he was variously responsible. In another photograph he is shown sitting front and center for a production of Sophocles' *Oedipus Rex*.[58] Leaving aside the issue of tragic drama, could anyone have failed to draw connections between the Greek king on stage and the Italian Duce as the principal member of the audience? Along this line, could the Florentine copy of *St. George* and Mussolini have been intended to mirror each other in 1938? As the planners envisioned the car moving past the space where the statue was positioned, did they plan for Donatello's *St. George* to become a stand-in for the Duce in a statuesque declaration of Mussolini's strength and preparedness for war? In the theater of war, this was certainly the role in which Hitler hoped to cast Mussolini. Of course foreign and domestic policy were linked in Fascist Italy. Something of both is actually suggested even when references are limited to the domestic shaping of the Fascist "New Man" and the symbolic reciprocity of St. George and Benito Mussolini.

In a discussion of World War II and of the Fascist "New Man," we are far removed from the Renaissance, from Donatello's *St. George,* and even from the modern historiographic discussion of Donatello's statue in relation to the Renaissance. Certainly it was the Renaissance, and not the war, that concerned Frederick Hartt and

Hans Baron when they wrote of Donatello's statue. Nevertheless, the two are not unrelated. Baron himself clearly intimated that his scholarship was influenced by World War II and the Allied struggle against Hitler, and recently historians have explored Baron's biography—especially his status as a refugee scholar—in an effort to reconsider the autobiographical evolution of his scholarship.[59] The question in the present context is whether Hartt's approach to the Renaissance was similarly influenced by his experience of the war in addition to his positive reception of Hans Baron's thesis about civic humanism and tyranny. A consideration of Hartt's first book, *Florentine Art under Fire,* inevitably urges thought along this line. Published in 1949, *Florentine Art under Fire* chronicles the author's experience as an Army officer who was assigned to a unit that was charged with locating and protecting works of art in the final stages of the war.[60] It is noteworthy that at one point Donatello's *St. George* makes an appearance in Hartt's narrative of his wartime experiences. Hartt's reference to the statue, which he discovered toward the end of the war at the Medici villa Poggio a Caiano along with other statues that the Germans had seized, clearly indicates his conception of the work as an adaptable symbol of Florentine independence. "Donatello's *Saint George*!" Hartt writes, struck by how nearly it could have been lost to the Nazis. "What loss could Florence have felt more keenly? The ideal hero, the saintly warrior, represented for the Florentines the very incarnation of the martial vigor of their lost republic."[61]

Hartt did not leave the war behind with his *Florentine Art under Fire.* It surfaced again in his monumental *History of Italian Renaissance Art,* first published in 1969. In this later work, Hartt's language in describing Italy and Italian art is the language of a man who has seen the face of modern warfare. He refers to plots of woodland "marshalled like battalions" on the Lombard plains and to "disciplined cypresses" that "guard" the Tuscan hills.[62] In addition to drawing on a military vocabulary for these descriptions, Hartt resorts to analogies from World War II when describing the political situation of Florence in relation to despotic powers of the early fifteenth century. For Hartt, the rulers of Renaissance Mi-

lan and Naples were "Hitlerian" in their ambitions to subdue Florence to their expansionist desires. Hartt supports this comparison by noting that Baron himself had compared the Florentine, fifteenth-century struggle to preserve its liberty to the Battle of Britain.[63] In contrast, Leonardo Bruni was, for Hartt, "a sort of Quattrocento Churchill" who served as "the great Chancellor of the Florentine Republic in its darkest moment."[64] These analogies were first incubated in Hartt's essay "Art and Freedom in Quattrocento Florence" of 1964. There Hartt takes a page from Winston Churchill's rhetoric and scholarship—and clearly acknowledges his source—when he refers to the struggle of Florence against Milan and Naples as the city's "finest hour."[65] In view of this evidence from Hartt's scholarship, it is not surprising that Hartt found in the refugee historian Hans Baron a kindred spirit in the approach to the Italian Renaissance.

In "Art and Freedom" Hartt first presented Donatello's *St. George* as a symbol of Florentine republicanism. The question then is twofold: whether this perspective also evolved from Hartt's experience of the war and whether he was aware of Hitler's visit to Florence in 1938 and of the transformation then of Donatello's *St. George* into a Fascist image. If so, were Hartt's ideas motivated by a desire to wrest Donatello's statue—that symbol of Florentine republican liberty—back from tyranny? Did he want to return it to its proper republican context? In 1938 Hartt was in Italy, and probably in Florence, while traveling as a recipient of a fellowship from New York University.[66] Several years later, the war interrupted Hartt's graduate studies. Making a direct connection between Hartt as the impressionable graduate student and the scene of Fascist imagery that is presented in the Institut's photograph would be convenient, but no direct evidence exists for such a connection. Nevertheless, if Hartt did witness this recontextualization of Donatello's statue, and subsequently sought to wrest the monument back from tyrannical appropriation, he was not alone. At the end of the war, Donatello's *St. George* became the image chosen to adorn a cover of *A Soldier's Guide to Florence,* a manual for service personnel in occupied Florence.[67]

Of course, Hartt would have consciously distinguished his interpretive act as retrospective and scholarly as opposed to the Fascist prospective and propagandistic use of the statue for the shaping of the "New Man." But I think for Hartt, perhaps more subconsciously than purposely, Donatello's *St. George* became his own warrior in a recollection of his former Fascist enemy. And I wonder whether, through the powerful influence of Hartt's scholarship, the *St. George* has become and will continue to be *our* ahistorical warrior as well. In this regard, I pose the additional question of how you, my reader, will now think, teach, or write about Donatello's *St. George.* Will you embrace the Fascist appropriation as part of the logical post-Renaissance history of Donatello's work? Or will you dismiss or suppress the statue's Fascist afterlife—as Hartt may have done—as nothing more than a curious, if not altogether misguided, manipulation of an unrelated Renaissance object? We—that is, Americans—generally and willingly accept into the canon of our pop visual culture Norman Rockwell's adaptation of Michelangelo's Prophet Isaiah from the Sistine Chapel for his wartime image of *Rosie the Riveter.*[68] But do we do so largely because we were victorious in the conflict for which Rosie riveted? As victors, are we less accommodating of the Fascist appropriation of Donatello's *St. George*? Like Frederick Hartt, we continue to live in a world of oppressive threats and real tyrannies. So perhaps, like Hartt, we may need Donatello's statue to be about freedom and independence, past, present, and future.

Finally, I return to the Kunsthistorisches Institut and to the moment of my finding the photograph that has been my subject throughout this chapter. The Institut's photograph is catalogued, not surprisingly, in a box with other photographs of Donatello's *St. George* and its original, architectural context at Orsanmichele. What is interesting is that this photograph that documents the Fascist appropriation of the visual past is thus recontextualized as an image of the Renaissance monument itself. It is literally catalogued as *the St. George* by Donatello. Are we to explain this recontextualization as merely a librarian's expedient decision for classifying and storing a collateral oddity? More dramatically, does the

photograph's place in the Donatello box imply some insistence on the Renaissance home and meaning of the statue? Or could its location in the library also constitute a subtle warning through the archival system of how the Renaissance is not fixed but is ever subject to manipulation and even abuse?

Probably mere convenience does explain the classification and storage of the photograph at the Kunsthistorisches Institut. And most likely no political agenda stood behind a librarian's effort to find a "Renaissance" home for this photograph in the Donatello boxes. Reception of the stored photograph, however, is a different matter, and here I can address with specificity my own reception and action vis-à-vis this peculiar archival find. At the Kunsthistorisches Institut, patrons of the library are encouraged to become catalogers of sorts. They are invited to make comments on the mounts of photographs; in this act they are free to suggest attributions, add information to the provenance, or provide references to relevant bibliography. Essentially, one is free to question,

augment, and change the archive. It is perhaps significant that this photograph in the Donatello box carries no remarks other than the reference that it was given by Arnold von Borsig. And I made none myself. I simply returned it to the box. On one level, I acted entirely passively toward this image, returning it dutifully to where it ostensibly belonged. But in actuality, my act was not passive, but active, just as my retelling of my actions—no less than my discussion of the photograph in this chapter—is a rather full declaration of my true perspective about Donatello's *St. George* and the balance of its meaning (and ownership) between the Renaissance and the Fascist era. Quite purposely, then, I returned Donatello's *St. George* to the Renaissance, where Hans Baron and Frederick Hartt had taught me that it belongs. In a single act of scholarly "objectivity" and "apolitical" engagement with historical "truth," I summarily suppressed the ability of others to appreciate this small piece of evidence for the Fascist appropriation of the Italian Renaissance.

CHAPTER 9

# Mussolini, Mothers, and Maiolica

*Jacqueline Marie Musacchio*

DURING THE FASCIST ERA large families were encouraged by the Italian state, and in particular by its leader, Benito Mussolini, through a carefully orchestrated and meticulously documented campaign that involved public policy, propaganda, and art. Much has been made of Mussolini's demographic legislation and its impact—or lack thereof—on the Italian population.[1] But modern scholars have overlooked one important aspect of this campaign: the brief revival, beginning in 1938, of the Renaissance custom of presenting new mothers with tin-glazed earthenware, or maiolica. As in the Renaissance, this custom was occasioned, at least partly, by Italy's population crisis. However, the Renaissance tradition was domestic; family members presented maiolica to encourage, to celebrate, and to commemorate pregnancy and childbirth, and the maiolica served as both a functional and decorative object. The Fascist tradition, on the other hand, was not only public but also part of the state-sanctioned activities that promoted large families.

Before examining this revival it is important to establish the Renaissance circumstances. Italian maiolica production became widespread in the early sixteenth century, and almost immediately special wares were made in conjunction with childbirth. Indeed, maiolica played a prominent

role in childbirth ritual, together with the wooden trays and bowls, sheets, clothing, charms, and even special foods that had been in use since the late fourteenth century.[2] This elaborate material culture demonstrates the emphasis put on the propagation of the family. Much of this was due to demographic concerns: the plague of 1348, and its recurring outbreaks over the next three centuries, had decimated the peninsula. For example, from a pre-plague high in the late 1330s of 120,000, the population of Florence had dropped to 37,000 by 1427.[3] Even as late as 1552, the population remained at about half the pre-plague level.[4] Such numbers were comparable in other urban areas of the Italian peninsula, where the plague similarly wrought havoc on the economy and on family life. In this context, a large family was often considered a mark of honor and prestige.

In late fourteenth-century Florence, childbirth objects—such as these trays, bowls, sheets, clothing, charms, and foods—seem to have developed as a result of this demographic catastrophe and its ensuing psychological impact. Painted wooden trays were especially popular from the beginning, but they were slowly superseded in the sixteenth century by maiolica wares. Both had imagery based in large part on contemporary sacred paintings of the birth of the Virgin Mary or of John the Baptist, but they also included important genre details such as elaborate linens, clothing, swaddling, toys, and accessories, with visitors offering gifts and congratulations to the new mother; in other words, they showed an ideal setting for a successful birth as it was per-

Versions of this chapter were presented at the College Art Association conference in Toronto (1998) and at Pennsylvania State University (1999). I am grateful to Gian Carlo Bojani at the Museo Internazionale delle Ceramiche in Faenza for assistance.

ceived during this period. The reverse of wooden trays, or the undersides of maiolica wares, often included even more deliberate encouragements to procreation. Some had representations of naked boys, symbolizing fertility in general and representing the much-desired male heir. The Renaissance belief in sympathetic magic and the maternal imagination, which allowed a woman to think she could engender the healthy male child she saw painted on these objects, likely determined this curious iconography.[5] The production and use of these objects lessened by the early seventeenth century; not coincidentally, this was the same time as the beginning of sustained demographic recovery.

The production of Fascist childbirth maiolica that began in 1938 was motivated, it seems, by contemporary artistic, scientific, historic, and demographic interests. The wares were produced in the same general shapes as their Renaissance predecessors, but they were painted with different imagery. Although Renaissance maiolica most often had scenes of childbirth or child care, Fascist maiolica was decoratively or symbolically painted (figure 60). Examined from our later perspective, the Fascist revival of Renaissance maiolica for childbirth was logical, since the two

Figure 60 Aldo Zama, maiolica childbirth set, 1941 (destroyed). Città di Faenza, *III Concorso Nazionale della Ceramica* (Faenza, 1941), 32.

periods shared a similar pro-family ideology. Yet production of Fascist wares ended after only a few years. Although Fascist officials must have hoped the maiolica would promote childbirth, statistics indicate no significant demographic change during this period. Furthermore, Fascist maiolica left little tangible evidence of its existence; photographs and news articles serve as the primary documentation, since no surviving example has been identified securely. Fascist maiolica never achieved the same level of popularity as Renaissance maiolica. But the revival indicates one of the ways in which Fascist leaders tried to inculcate a pro-family ideology among Italian citizens.

The revival of childbirth maiolica seems closely tied to the demographic imperatives of Mussolini. When Mussolini came to power in 1922, the Italian population stood at approximately thirty-eight million people. This was its lowest point in several centuries, a situation brought on by a number of different factors. Between 1916 and 1919 alone, the population had dropped by over one million. World War I losses, devastating influenza outbreaks, record numbers of emigrants, and high infant mortality all contributed. And population recovery was difficult, since many Italians were trying to limit family size, despite the Catholic Church's condemnation.

Reacting to these factors, the Fascist government placed great emphasis on childbearing. A large population was considered necessary for the strength of the nation. In his Ascension Day speech of 1927, Mussolini announced his unrealistic goal of sixty million Italians by the year 1950, an increase of over twenty million people.[6] He was motivated by both racism and imperialism: the regime was concerned about the growing population of non-Caucasian peoples, and the Fascists feared a loss of power in the larger European arena if their population did not increase. Within this context, the soldier and the mother were seen as the two ideal gender roles.[7] In fact, Mussolini equated childbearing with fighting for the country, stating in a later speech, "War is to men as motherhood is to women."[8] Indeed, motherhood was idealized as a woman's duty to the state.[9] This idea was evident in popular magazines like *L'Illustrazione Italiana* and *La Rivista*

*Italiana del Popolo d'Italia,* both of which contained articles and short stories dedicated to the culture of the Fascist regime. Photographs of women working the fields surrounded by their many children emphasized the importance of large families and represented Mussolini's strongest power base, the indigenous rural populations of central and southern Italy. And newspapers like *Corriere della Sera* printed running tallies of local births, deaths, and marriages on their front pages for further incentive.

This demographic campaign was untenable in economic terms, since Italy already had insufficient resources, high unemployment, and rampant poverty. But Mussolini's population imperatives were insistent. The regime promulgated an extensive series of laws to outlaw contraceptives and abortion, to discourage working women, and to promote marriage and children. Married men were given priority for jobs and promotions, and new couples qualified for government loans. Part of the loan was forgiven after the birth of each child, but the couple had to produce ten children to cancel the debt completely.[10] Special festivals promoting family life from earlier times were revived with great fanfare and were celebrated through photographs in popular magazines.[11]

In 1925, the Opera Nazionale della Maternità ed Infanzia (ONMI) was formed to provide food, medicine, advice, and clinic facilities for mothers and children. Some of the costs were paid with the proceeds from an income tax levied on bachelors between the ages of twenty-five and sixty-five.[12] The agency and its clinics were ostensibly organized to help women fulfill their maternal roles. Yet an examination of ONMI literature reveals that the major concern was with children and with increasing the population.

Funding for ONMI initiatives increased each year, but no corresponding growth in the birth rate occurred; clearly, other incentives were needed. Beginning in 1933, Mussolini designated December 24 as the Day of the Mother and Child. This was a deliberate attempt to link the Fascist state and its emphasis on childbearing to more established tenets of Christianity; attitudes toward procreation marked one of the few instances in which the Fascist government and the papacy agreed.[13] Evidence for this rather problematic alliance is

found in the annual awards given to the most prolific mothers on this holiday. For their efforts on behalf of the Italian state, the most fertile women from each province attended an award ceremony in Rome to receive Mussolini's personal thanks. The honorees also received medals of commendation and copies of Pope Pius XI's encyclical of 1930 (*Casti connubi*), which condemned working women, contraception, and abortion.[14] Obviously, these women did not need papal encouragement; with so many children, they probably did not use birth control and had no time to work outside the home. But the publicity these awards generated went a long way toward extolling the cult of motherhood on a local level. These women received nominal cash awards, were brought to Rome for ceremonies, and were photographed with utmost gravity in front of the monument to Vittorio Emanuele II, Italy's first king (figure 61). Their names were subsequently listed in local and national publications. In 1939, the lists included women like Annunziata Anastasio from the town of Merano in northern Italy, who had thirteen living children. Anastasio was one of the 188 women honored that year; as a group, they had a total of 1,624 living children.[15] Not every fertile woman was eligible for these prizes, however; regulations in some regions demanded at least twelve living children. Sons killed in war or otherwise defending the nation were counted, but illegitimate children or those born of parents not married in a church were not; careful questioning ensured that the couple had strong Fascist sympathies.[16] The Unione Fascista Famiglie Numerose, a government agency founded in 1937 to encourage and promote demographic policies, also awarded certificates and medals to prolific mothers. These medals, made of inexpensive stainless steel, were stamped with the image of a seated, Renaissance Madonna-inspired mother and child surrounded by six other children and Fascist symbols. Each medal was attached to a ribbon, and the number of aluminum bows pinned to the ribbon represented the number of children (figure 62). Mothers were encouraged to wear these medals at national celebrations, on civic holidays, and at public functions.[17]

Mussolini's personal participation in many of these maternal celebrations helped promote the

**Figure 61** Some of the ninety-four prolific mothers recognized by Benito Mussolini on the Day of the Mother and Child, 1934. *L'Illustrazione Italiana,* 30 December 1934, cover.

idea of the Duce as the prolific and virile father of all of Italy. This was obvious in the posters commissioned to promote the Day of the Mother and Child from the commercial artist Marcello Dudovich, better known for his elegant advertisements of Italian modernity for Rinascente department stores and Alfa Romeo.[18] Those advertisements employed a style more typical of avant-garde Paris than of the rural Italian countryside, and they celebrated the qualities of modern life the Fascist regime condemned. But Dudovich easily adapted to the needs of his new patrons and designed posters that effectively emphasized the Fascist stand on family life, making the same visual link to Renaissance images of the Madonna and Child apparent in the medals that prolific mothers received. This further implied Mussolini's potential sacerdotal role over motherhood, a religious reference that would not be lost on his deeply devout audience.

A similar connection between Mussolini and the procreative power of the Italian state was

fostered by events like the Day of the Wedding Rings, on December 18, 1935. The financially strapped Fascist state declared this one-time holiday following the sanctions imposed by the League of Nations when Italy invaded Ethiopia. On this day, women exchanged their gold rings for cheap tin or iron bands on the premise that the offering made them Mussolini's symbolic brides. Their offerings were then melted down for cash to help the government remain solvent.[19]

Because of both this indoctrination and a distinct lack of other options, many women from rural or uneducated backgrounds saw childbearing as their duty. The glorification of motherhood and maternity was insistent and hyperbolic. The popular press reported that under the Fascist regime, "maternity has recovered its poetry, its prestige, its ideal light, and has become defended, protected, and exalted."[20] But such blatant proselytizing did not work for the entire population. The more modern and educated city woman pre-

**Figure 62** Medal presented to a mother of nine children by the Unione Fascista Famiglie Numerose, stainless steel, c. 1939. Collection of the author.

ferred emancipatory ideas that ran counter to Fascist policy and its traditional vision of women.[21] Italian society had a difficult time balancing these competing female paradigms. As Italy's economy faltered, and as new businesses tried to appeal to the interest in modern living that contact with other industrialized countries had generated, a wide range of companies competed for the Italian population's money. To succeed, these companies had to appeal to modern women who could afford luxury goods. The ninety-four mothers who were recognized on the Day of the Mother and Child in 1934 were somber, capable, and proud of the medals presented to them for their fecundity (figure 61). They did not look like the slim, fashionably attired women featured in contemporary

advertisements. Yet such images existed side by side in popular journals. Much more than propaganda was needed to make the maternal lifestyle appealing to all women, and the state knew it.

Conveniently, there was an ideal role model for the virtues of procreation: the house of Savoy, the figurehead Italian royal family best represented in this period by Crown Prince Umberto II and his wife, Princess Marie José. As the wife of the heir to the House of Savoy, Marie José was entitled to her furs and jewels; these accessories helped boost Italy's image among the other royal families of Europe. But, in addition to her glamorous lifestyle and appearance, the princess was also fertile: she gave birth to three girls and one boy between 1934 and 1943.

Marie José's pregnancies were followed with enthusiasm by the Italian press. Popular journals featured photographs of citizens praying for the pregnant princess in front of street tabernacles in the days before her first delivery.[22] *L'Illustrazione Italiana* published a photograph of the Palazzo Reale in Naples, where Marie José was confined, with a tiny arrow to indicate her room to readers.[23] The princess delivered her first child, a girl named Maria Pia, on September 24, 1934; to celebrate, a large white ribbon was tied to the doors of the Palazzo Reale, in what was described as an ancient custom revived by the Fascist regime.[24] The little princess was baptized that December in the Cappella della Reggia in Naples, in an elaborate ceremony attended by a crowd of dignitaries and reported down to the last detail in the eager press.[25]

All women, of course, were not as fortunate as Princess Marie José, and maternal mortality rates in Italy were among the highest in industrialized Europe.[26] But these dangers were glossed over by the state as it used the Savoy births for propagandistic purposes, taking advantage of the public's interest in the growing royal family. Several initiatives were passed to support ONMI activities following royal births. For example, funds were granted to create new clinic facilities, named for royal offspring, in Rome, Como, Bologna, Cosenza, and Pesaro, various banks donated money to keep these institutions solvent, and other organizations funded gifts of cribs and baby accessories to new mothers.[27] However, despite both economic and patriotic encouragement, and despite the glorification of the royal role model, Italian marital and birth rates remained quite low; in fact, through the '20s, '30s, and early '40s, they dropped.[28]

Under these circumstances, it is surely not by coincidence that childbirth maiolica was revived in 1938. Fascist officials would have been aware of the demographic similarities between their era and the Renaissance.[29] Indeed, as early as 1921, historians were making parallels between the population of Europe after World War I and that of Europe after the Black Death.[30] Both periods suffered from catastrophically low populations that made contemporaries advocate and encourage

large families. This practice also accorded with the Fascist insistence on reinvesting in the Italian economy. The fact that children were considered valuable national products themselves was evident not only in the legislation passed during this time but also in the propagandistic images of maternal devotion circulated by advertisers and the popular press. These images employed visual tropes of long-standing popularity. The frequent focus on the child, at the expense of the mother, demonstrates the child-centric ideology implicit in both eras and harkens back quite deliberately to Christian imagery.

As a result of this heightened interest in children, new items like baby accessories were in great demand. Trade shows promoting these products became popular events, exhibiting and selling the modern equivalents of many objects previously depicted in Renaissance paintings. The increasing demand for these products revitalized the languishing craft industries and their formerly underemployed artisans, involving lace makers, weavers, dyers, woodworkers, and others in the baby-goods industry. Ceramists likewise prospered for the first time in decades. Maiolica was produced in what had become a relatively poor region of central Italy. But with the renewed interest in childbirth maiolica (and presumably large orders from the state to supply ONMI clinics), the formerly dormant kilns experienced a much-needed rebirth.[31] Mussolini himself was from the small town of Predappio, near Forlì, in the heart of this region; he took an interest in both the area and its economics, and he personally visited the annual ceramics competition in Faenza in 1939 to guarantee its funding in future years.[32]

But Mussolini was not the actual impetus behind the revival of childbirth maiolica; there is no evidence that he even knew what it was. Indeed, very little was known about childbirth maiolica prior to the Fascist revival. The only references in earlier literature were occasional inclusions in auction catalogs and a brief description in an article by Eugene Müntz in 1899, which had only a limited and academic circulation.[33] Although several examples were in public museums and private collections, scholars and collectors were

more interested in *istoriato,* or historiated, mai-
olica, with its complicated scenes from historical
and literary texts.

Giuseppe Alberti, a doctor and medical his-
torian, and Luigi Servolini, an artist and art his-
torian, were initially responsible for the revival.[34]
Alberti was especially interested in the history of
birthing customs, so he may have known of Re-
naissance practices.[35] But Servolini was likely the
main impetus. As the director of the Cultural and
Artistic Institute of Forlì from 1939 to 1952, Ser-
volini wrote many articles about maiolica, ar-
guably the most important artistic contribution
of that small city during the Renaissance. In fact,
there are two sixteenth-century pieces of child-
birth maiolica in Forlì's collections, which might
have provided him with immediate familiarity
with the genre.[36]

Certainly artists and Fascist officials looked
at surviving examples like those at Forlì for their
inspiration. They also examined the treatise on
maiolica production written by Cipriano Piccol-
passo before 1579. Known Fascist examples were
made up of interlocking wares, stacked together
to create vaselike shapes; although Renaissance
examples did the same, there was no complete
surviving example on which to base them. But
Piccolpasso's manuscript, now in the Victoria and
Albert Museum in London, was accessible in an
Italian edition of 1857.[37] It examines the full
range of sixteenth-century maiolica production,
including an extended discussion of childbirth
wares; the manuscript includes a drawing of an
interlocking birth set both assembled and disas-
sembled to illustrate the five pieces it comprised
(figure 63). According to Piccolpasso, the Renais-
sance set consisted of a tray, two bowls, and an
egg cup with its own cover, with each piece de-
signed to hold a specific food considered vital
to new mothers. Today fewer than 150 known
pieces survive, and never, it seems, more than two
pieces from any one set. Since Fascist artists and
officials had no actual surviving model for their
own interlocking sets, they must have relied on
Piccolpasso's text for the design of their wares.[38]

Like many elements of Fascist ceremony,
childbirth maiolica became the subject of an ex-
tensive propaganda campaign. The revival occa-

sioned numerous romanticized articles of dubi-
ous factual content in both the popular press and
scholarly journals.[39] For example, one author re-
ported that Renaissance childbirth maiolica was
often painted with rabbits, although no such ex-
ample is known today.[40] Another stated, with no
basis, that maiolica was typically presented to a
new mother by one of the godparents, or the
closest relative with the most children.[41] But no
matter what was written, the doctrinaire Fascist
demographic policy was solidly upheld. In fact,
in one of his three articles about the Fascist re-
vival, Servolini described maiolica birth wares as
"the symbol of the perpetuation of our strong
and robust race; they are a suggestive hymn to
maternity in its reconsecrated moral climate."[42]
The ONMI impulse to take childbirth out of the
hands of female midwives and into a more scien-
tific realm inhabited by university-trained male
doctors is likewise apparent. Authors compared
the dangerous conditions of previous years with
those under enlightened Fascist institutions.[43]
They made an attempt to inculcate healthy be-
havior through the use of the maiolica; mothers
were educated about their diets through a de-
scription of the various wares in the sets. The
deep bowl, for example, was recommended for
chicken broth, and the salt cellar for replenishing
salts lost through the exertion of labor.[44] These
maiolica wares were, of course, fascinating ob-
jects for historical and aesthetic reasons. But
propagandistic state support was key to their dis-
semination and use.

The earliest examples of Fascist birth maiol-
ica were made as professional premiums for the
participants at the annual meeting of the Italian
Society of Obstetrics and Gynecology in Perugia
in 1938.[45] On the afternoon of October 18, while
the doctors were discussing painless childbirth,
their wives were taken to Todi and Deruta, where
they received gifts from the local maiolica mak-
ers' consortium. That evening at dinner, the
participants received, along with a number of in-
digenous Perugian products, a modern reproduc-
tion of Piccolpasso's five-piece set.[46]

Childbirth wares also were distributed at the
gathering of Fascist mothers on May 28, 1939,
when seventy-five thousand women from all over

**Figure 63** Cipriano Piccolpasso, illustration and description of a maiolica childbirth set, *I tre libri dell'arte del vasaio* (before 1579), fol. 11r. Victoria and Albert Museum, London.

Italy went to Rome for ceremonies and parades.[47] Following this event, similar bowls were presented to women recovering from childbirth in the ONMI clinics. In describing this practice, Maria Vittoria Lazzi, the secretary of the National Obstetricians Union, stated that "the new mothers, of this new prolific and strong Italy, will have their trophies, their cups, won in the sacred contests to perpetuate the family and life."[48] Childbirth maiolica was envisioned as a reward for women who fulfilled their duties.

We have no information regarding the quantity of Fascist maiolica distributed, or the identity of the artisans who produced it. Indeed, the state may have exaggerated the use of these wares for propagandistic purposes. But it is clear that maternity and motherhood were promoted through these objects. In fact, the nationally funded ceramic competitions in Faenza in 1941 and 1942 included a category for the best reinterpretation of childbirth maiolica.[49] The bombing of the storehouses of the International Ceramics Museum in Faenza during World War II destroyed the winning vessels; only photographs remain as evidence of their appearance.[50] A comparison between Piccolpasso's manuscript and a winning entry from 1941 by the Antica Fabbrica Farina in Faenza shows that the Farina set was inspired by its Renaissance predecessor, despite its more modern aesthetic (figure 64). As a result of ONMI's policies and the publicity generated by popular articles and ceramic competitions, childbirth maiolica became prominent enough, at least in the media, to influence the rivalry between Forlì and Faenza for preeminence and civic pride. Each city proudly claimed that it had produced the earliest examples of Renaissance childbirth ware.[51]

Yet no surviving example of Fascist-era childbirth maiolica can be identified today. Photographs show that the Fascist-era wares adopted the shapes known from both Piccolpasso and surviving Renaissance examples. However, they were painted with decorative designs, although it was well known that Renaissance examples had birth or confinement scenes and other related narrative imagery. Fascist examples did not employ the didactic, encouraging, and sympathetic imagery of Renaissance wares; in all likelihood,

Figure 64 Antica Fabbrica Farina, maiolica childbirth set, 1941 (destroyed). Città di Faenza, *III Concorso Nazionale della Ceramica* (Faenza, 1941), 33.

**Figure 65** Luigi Servolini, maiolica childbirth set presented to Princess Maria José by the city of Forlì, 1940 (location unknown). *L'Illustrazione Italiana*, 10 March 1940, 304.

producing elaborate figurative scenes was too expensive. This economic factor may also explain the apparent attrition rate; scholars and collectors were not as interested in these decoratively painted wares as they were in Renaissance *istoriato*, so the modern wares did not find their way into museums or private caches. The target recipients seem to have been relatively poor rural mothers, who came to the ONMI clinics to give birth; surviving examples may well be in private hands. The Fascist-era wares have no particular features that would relate them immediately to either Fascism or childbirth without considerable knowledge on the part of the modern viewer.

Indeed, it is important to note that it was not the iconography that associated Fascist maiolica so conclusively to childbirth. Instead, it was the actual objects themselves, and their powerful connections to the demographic situation of the Renaissance, that drove the revival. To Fascist mothers, as to Renaissance mothers, these objects were "trophies" in the race to populate both family and country. But the Fascist wares were also part of a vast propaganda machine that tried to inculcate certain behavior and mores in its audience.

Although the promotional maiolica given at conferences and rallies and in ONMI clinics, as well as those produced for the ceramic competitions, were all important, the best way to bring childbirth maiolica into the mainstream was by linking it to a birth in the house of Savoy. To mark the birth of Princess Maria Gabriella in 1940, the city of Forlì presented her mother, Princess Marie José, with a maiolica birth set designed by Luigi Servolini (figure 65).[52] The princess's maiolica incorporated the traditional Renaissance shapes, using as models examples from the sixteenth century and Piccolpasso's manuscript, and it was painted with symbols

of the region and the house of Savoy, including heraldic eagles, the Romagna ring of hospitality, and the tree of life, all in harmonious colors dominated by Savoy blue.[53] Articles in the popular press publicized this set, ensuring its familiarity to a large audience, although it cannot be traced today. And despite all these efforts, within two years of the birth of Maria Gabriella, all references to Fascist childbirth maiolica end. It is unclear whether this was for lack of interest or for purely practical reasons: the birth rate simply did not increase.

During the Fascist era, Italian women were bombarded by propaganda that emphasized their duty to conceive and to raise children for the good of the state. For a short time, childbirth maiolica was a part of this campaign, but the origin of this ware in Renaissance tradition set it apart. In a way, this situated childbirth maiolica even further within Fascist ideology; the movement's emphasis on traditional lifestyles, crafts, and mores sought to locate its roots in earlier Italian society. And one of the most inventive ways to do that was by reviving the Renaissance practice of presenting maiolica to women on the occasion of childbirth.

# Politicizing a National Garden Tradition

## The Italianness of the Italian Garden

*Claudia Lazzaro*

ALTHOUGH ITALY BECAME a nation only in 1861, an idea of Italy existed long before. This idea incorporated both cultural and "natural" aspects of Italy: a place of beauty and great natural fertility, and a repository of classical culture. Beginning with Dante's *Divine Comedy* and on through the centuries, both natives and foreigners likened Italy to a garden.[1] As late as 1916, the American architect Guy Lowell characterized all of Italy as a "country-wide garden."[2] As Italy resembled a garden in its fertility and beauty, so too gardens from the Renaissance through the eighteenth century embodied the current notions of Italy. Some Renaissance gardens reproduced the local region in microcosm, while many others alluded more generally to the surrounding landscape. Gardens implicitly represented the idea of Italy with imagery that celebrated Italy's natural gifts and cultural riches. In the twentieth century, the Fascist regime encouraged and supported a renewed interest in the Italian garden tradition. Gardens still represented Italy, but a different Italy, the new idea of the Fascist nation, which in the '30s and '40s necessitated in turn a reinterpretation of Italian gardens. At the same time a sign of Italy's glorious classical past and of what is indigenous, arising from the land itself and

from the Italian spirit, the Italian garden tradition manifested Italy's cultural supremacy as well as its natural, even racial, superiority.

Of all art forms, gardens most vividly exemplify the instability of the past and the difficulty of recovering an original, fixed work of art unaltered by layers of interpretation. No fixed original of a garden can exist, since gardens change constantly and their former state can be known only through reproductions in another medium. The Italian garden tradition comprises gardens of three centuries, the sixteenth through the eighteenth, created in diverse climates and topographies, and influenced by different regional artistic traditions. Nevertheless, this variety of gardens has come to be understood as a distinct Italian tradition, which has roots in ancient Roman gardens, and which provides evidence of an Italian "nation" long before the existence of such a political entity. Against the framework of this garden tradition, however, is the ever-changing nature of gardens themselves, with the seasons, a year's growth in vegetation, fluctuating taste, neglect, and the work of time. The gardens that belong to this tradition reveal traces of the different moments in their history. Indeed, many were restored, sometimes radically, between the 1910s and the 1940s. The gardens that survive have come down to us layered with successive alterations, replantings, and restorations, and filtered through different modes of interpretation, particularly the restorations and reinterpretations during the Fascist era.

I thank Joachim Wolschke-Bulmahn for his encouragement, and Vincenzo Cazzato for his pioneering research and warm support. I presented versions of this chapter at Dumbarton Oaks, the Society of Architectural Historians, the Heinz Architectural Center in Pittsburgh, and Colgate and Cornell universities.

## Defining Garden Styles
## as National Styles

In the early twentieth century, much scholarship and criticism on art sought to define the characteristics of innate and enduring national styles. One example is the study of ancient Roman art in the first quarter of the twentieth century, which Otto Brendel has shown to be permeated with a quest for the common stylistic elements that constituted a continuous national Roman style.[3] The same was true for contemporary discussions of gardens. Writing on the landscape garden style in 1917, Frank Waugh asserted that styles are not just national but also racial, and that a national garden style, such as Japanese or Italian, embodies the characteristics of the gardens of an entire race.[4] This view assumes that Italian-style gardens emanate from an "Italian" spirit and consequently reflect a notion of Italy. But who determines what constitutes the Italian spirit and which notion of Italy? Who defines what the Italian garden is? In the case of Roman art, it was non-Italian scholars, especially Germans, as Brendel has demonstrated.[5] As Italy itself was the site of foreign occupation over the centuries, so too foreign scholars came to dominate the study of its art, including gardens, until around the third decade of the twentieth century. In the last years of the nineteenth century and in the early twentieth century, Americans, the British, and the Anglo-American expatriate community in Italy shared a great enthusiasm for Italian gardens. Numerous garden books by British and American authors translated the Italian garden into a reproducible commodity, spawning Italianate gardens in England and America, and Anglo-Florentine gardens, such as Bernard Berenson's Villa I Tatti in Tuscany.[6] For these authors, the Italian garden represented a harmony between nature and architecture, garden and countryside, which distinguished the Italian garden from both the extreme formalism of the French garden and the overwhelming naturalism of the English style.[7]

Once gardens were implicated in nationalism, they became a subject for serious scholarship by Italians.[8] By the '30s, Italians understood gardens to be part of what defined their nation. They aggressively reclaimed their cultural legacy from non-Italians, through research, publication, a major garden exhibition, restoration of existing gardens, and the integration of garden history into architectural training. The nationalist intent in the concurrent reinterpretation of the Italian garden tradition required the rejection of all "foreign" aspects of garden design. The English garden style, with its appearance of unaltered nature, had swept through Europe in the eighteenth century, but was adopted in Italy only late and reluctantly, and never lost its association with the foreign. Indeed, in the entry on the Italian garden in the *Italian Encyclopedia,* the prominent architect and urban planner Luigi Piccinato characterized the introduction of the English romantic garden to Italy as an "invasion."[9] "Natural" signified foreign, so that in order to assert their distinctly national style, Italians had to reject the Anglo-American notion of the Italian garden as a harmony between art and nature. Instead, Italians represented their own garden tradition as a work of art, architectonic, and strictly ordered, denying the existence of unaltered nature or natural garden areas (despite ample evidence to the contrary).

In the early twentieth century, Italians were not alone in finding in their native garden style an expression of national identity, national spirit, or even race. Joachim Wolschke-Bulmahn and Gert Groening have demonstrated the increasing politicization of the idea of a national German style in garden art from the first decades of the twentieth century through the '30s. In Germany, the garden architect Willy Lange, in a series of articles from 1900 to the 1930s, developed a concept of the "nature garden" as the inherently German style of gardens. This featured native plants, followed the model of the surrounding landscape, and rejected geometric and architectural forms in garden design. In Lange's view, garden styles, like nations, exist in hierarchical relationships. He declared the nature garden to be the highest level of garden art, and linked this assertion to current views in Germany of the superiority of the German people. In 1929 another garden architect, Alwin Seifert, promoted his own similar understanding of a nature garden, but in this case infused with terms and concepts that closely paralleled those of National Socialism.[10] Later writings espoused "race-specific"

gardens, "which have their origins in nationality and landscape, in blood and soil."[11] Germans and Italians conceptualized the distinctive and inherent national garden styles of their young nations in diametrically opposite ways—the nature garden and the architectonic garden, each of which rejects all aspects of the other. Fascist discourse and ideology influenced Italian writing on gardens of the '30s and '40s, but without the extreme of racial concepts and rhetoric in contemporary German accounts of the nature garden.

In Italy, the conceptualization of a distinctive and unified Italian garden tradition began essentially with the writings of Luigi Dami, in particular his influential book, *Il giardino italiano,* published in 1924 and immediately translated into English. A prolific and conservative art critic, Dami also wrote on Florentine artistic and literary culture, and collaborated on the *Atlante di storia dell'arte* (1925–33), a two-volume history of art. Dami characterized the Italian garden as a work of art—that is, the imposition of an artistic style on nature—in contrast to both the preceding medieval garden and the subsequent picturesque or landscape garden.[12] To support this contention, Dami focused exclusively on the geometric, regular, rigid, and stylized as the distinguishing characteristics of the Italian garden and the reason for its preeminence. In his emphasis on rationality, he rejected any positive role for nature in the garden. Dami propounded a teleological development of the Italian garden from medieval gardens to its culmination in the sixteenth-century garden, which he saw as a product of mind and will, "made by and for man, and in which he is king."[13] Just as Dami rejected the "natural" as foreign, so too he ignored the contributions of non-Italian scholars, among them Inigo Triggs and Marie Louise Gothein.[14]

Growing interest in Italian gardens led to the restoration of a number of them in the early years of the twentieth century, and many more in the '20s through the '40s. These restorations aimed to return the gardens to a general notion of their original state, not to modernize or to simply repair them.[15] As a result, they were planted with boxwood in massive geometric and architectonic forms in hedges and borders, patterns in the parterres, and labyrinths, in contrast to the great variety of plant materials in Renaissance gardens, the low and narrow hedges, and the blossoming herbs and flowers in the parterres.[16] The restorations sought to reproduce not the original planting, but rather the idea of the Italian garden as geometric and architectonic, with nature subordinate to human will, which Dami articulated and popularized. The restored gardens, with their architectonic character emphasized by thick boxwood hedges maintained with modern electric tools, in turn further influenced the conception of the Italian garden in later twentieth-century texts. Many of the familiar box hedges and rectilinear patterns in surviving Renaissance gardens date from the '20s to the '40s, among them the Villa Farnese at Caprarola (restored probably in the '40s) (figure 66). Others include the Villa Carlotta on Lake Como (restored between 1922 and 1924), the Villa Madama in Rome (restored 1925–28), the Villa Pisani at Stra (the '30s labyrinth of boxwood replaces one of hornbeam), and the Giardino Giusti in Verona (restoration begun 1946).[17] It is no surprise, then, to read in Piccinato's entry on gardens in the 1933 *Italian Encyclopedia* his understanding that the plants in Renaissance gardens were limited to evergreens, because they offered the greatest possibility for mass and architecture.[18] The restored gardens represent an idea of the Italian garden outside of time, as continuous from Roman antiquity to the present, not the gardens of any historical moment or fashion in planting. They emphasize the characteristics that in the Fascist period were believed to be distinctively Italian in the Italian garden style.

## The 1931 Exhibition: The Primacy of the Italian Garden

The chauvinism in Dami's writings evolved into a more emphatically ideological nationalist rhetoric in the influential Exhibition of the Italian Garden, held in Florence in 1931. As presented in this exhibition, the Italian garden tradition demonstrated both Italian identity and the superiority of Italy's cultural achievement.[19] It was "Italian" in both natural (or indigenous) and cultural senses. Typical of Fascist projects, the Exhibition of the Italian Garden was both

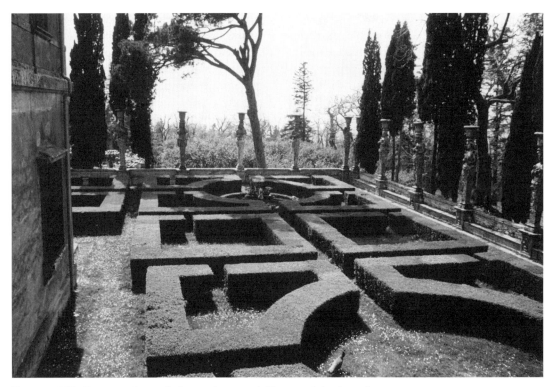

**Figure 66**  Villa Farnese at Caprarola (restored c. 1940s). Photograph by the author.

ambitious in scope and produced in haste (between November 1930 and its opening in April 1931). The scheduled opening date, April 21, the birthday of Rome, likewise signaled the significance of the exhibition to the larger Fascist political agenda.[20] In the same year, 1931, university professors were required to swear an oath of allegiance to Fascism, and only eleven refused to do so, among them the prominent art historian Lionello Venturi.[21]

The Exhibition of the Italian Garden aimed to demonstrate that in the field of gardens, Italy had "an indisputable primacy of time, quantity, and quality," in the words of Nello Tarchiani, director of Florentine museums and secretary general of the organizing committee.[22] Ugo Ojetti, president of the organizing committee, was a collaborator of the influential journalist and art critic Luigi Dami, who was an enthusiastic Fascist. In his preface to the catalogue, Ojetti stated that the exhibition intended "to return to honor an art that is singularly ours, which after having conquered the world, seems dimmed by other modes and hidden under foreign names."[23] The 1931 exhibition reclaimed the garden tradition as *Italian,* and not French, formal, or any other "foreign name."[24] It also chronicled the continuous two-thousand-year history of the Italian garden, from ancient Roman gardens until the arrival of the English garden in the eighteenth century (which, as Ojetti put it, swept like a rival conquering army through France and eventually Italy).

The Italian garden exhibition shared with others in the Fascist period a multimedia character, with over four thousand objects of many types filling fifty-three rooms of the Palazzo Vecchio. The exhibition added dramatically to the number of prints, early drawings, and photographs that Dami had gathered in *The Italian Garden.* The documentation amassed included measured drawings by the fellows of the American Academy in Rome, books, tapestries, embroideries, aerial photographs, and even some of the games played in gardens, as well as an old wooden merry-go-round. The exhibition also in-

cluded flower paintings through the centuries, real flowers from the Boboli garden, and artificial flowers of every sort, both traditional and modern, made of silk, glass, metal, straw, and wax, some from the Botanic Institute. In addition, models of ten gardens represented regional and period gardens from the thirteenth through the eighteenth centuries. In connection with the exhibition, several villas around Florence, Pistoia, and Lucca were opened to the public.[25] As with the Augustan Exhibition of 1937, the large array of objects gathered in the exhibition was intended to form the basis of a garden museum, a project that never materialized.[26] Nevertheless, this extraordinary enterprise made a considerable contribution to garden history.

## Geometry and Gender

Ugo Ojetti presented this singularly Italian cultural production as a symmetrical and architectonic garden that maintained "the continuous and orderly and visible dominion of man over nature." Nature, Ojetti continued, was made obedient and domestic; the Italian garden was a "garden of intelligence."[27] In a review of the exhibition in *Domus*, Gherardo Bosio took up the new rhetoric of conquest and control in Ojetti's preface.[28] Bosio defined the Italian garden as "subjugated" to the villa, the terrain and vegetation in "submission" to the will of the artist. With these metaphors he sought to convey the "unmistakable, male" expression of the Italian garden. At the time, Bosio was not alone in characterizing the Italian garden as gendered male. A review in *Il Popolo d'Italia,* the official newspaper of the regime, reported that the gardens chosen for related excursions still had intact "the original and male structure of our architecture."[29] The Italian garden was represented as a battlefield, a playground for men, in which nature was not just obedient and regulated but also subordinated and dominated. Such rhetoric is found neither in the Renaissance itself nor in the texts written only fifteen or twenty years earlier by non-Italian authors.

To define the Italian garden as totally architectonic and male is to frame it in opposition to the English-style romantic garden, in which nature predominated. In Ojetti's words, the Italian "garden of intelligence" triumphed over the romantic garden in a "perfect victory of the spirit over the confusion of nature."[30] In this idea of the garden, nature is under "the direct dominion of rational consciousness."[31] Male reason dominates a nature that for centuries was understood and personified as female.[32] The emphasis on maleness and virility in the discourse on the Italian garden corresponds with the rhetoric of Fascism. Like nature, subdued and subjugated in the male garden, the masses were gendered female. Mussolini himself proclaimed: "The mass is a woman!"[33] The populace was thought to share with women characteristics of impulsiveness, instability, and irrationality. The manly Mussolini and the virile Fascist state could then manipulate and control the populace,[34] as male intelligence dominated nature in the Italian garden. A vocabulary of masculinity was central to the rhetoric of Fascism.[35] A gendered language even framed the extensive urban interventions in Rome, which constructed wide traffic arteries while destroying surrounding neighborhoods: "weakness" in saving monuments was unworthy of the "masculine" spirit established by Fascism, in the "virile" and "imperial" urban planning of Fascist Italy.[36] Athletic training of the youth and encouragement of a "masculine" lifestyle were to implement the new idea of the nation. "Muscles" were a common metaphor in Fascist discourse, reinforced by photographs of Mussolini demonstrating his athletic prowess in various sports. The Fascist regime represented the new Italy (like the gardens that epitomized Italy) as male, virile, and strong—no longer soft and feminine, a terrain to be colonized by foreigners, literally or figuratively. In the new Italy of warriors and heroes, the manifestos of Rationalist architects were similarly filled with metaphors of battles, aggression, and violence.[37]

The metaphorical language of domination, control, and violence against nature in the context of gardens also resonates with the treatment of women under the Fascist regime. Laws of 1926 and 1927 prohibited women from holding certain government positions, including teaching history, philosophy, and Italian literature in public schools. They could be paid only half of male

salaries, after being charged double the tuition for males in secondary schools and universities.[38] Instead, women were encouraged in the role of child bearer to fulfill Italy's ambitions of empire.[39] Fascist society, like other societies, proved to be more complex than this, however, as recent studies of women under Fascism demonstrate, and ample evidence reflects tensions between the dominant patriarchal ideology and other contemporary images, voices, and private realities.[40] Nevertheless, the same rhetoric, assumptions about gender roles, and dominant ideology permeate accounts of Italian gardens beginning with the 1931 exhibition.

## Models and Modernism

In the garden exhibition, the huge Sala Grande of the Palazzo Vecchio displayed small-scale models of gardens complete with running water, called little theaters (*teatrini*), nearly ten feet in width and at least that in depth.[41] These miniature artificial gardens represented regional and chronological garden types, from ancient Roman to the late eighteenth-century romantic garden. As in contemporary restorations, inspiration came from a general idea of the historical periods, not documentation about specific sites, and that idea was as much modern as true to the past. Most of the models featured a central open area with vegetation principally relegated to the sides, which implicitly emerged as an enduring characteristic of the Italian garden. Each garden generally included an obvious architectural or decorative feature associated with the period and region, and some incorporated characteristic features of famous gardens. As in Germany, with its similarly recent unification of independent states, regional diversity consisted in local variations on the na-

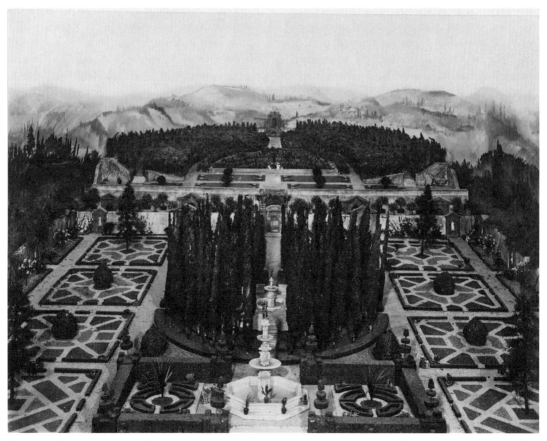

**Figure 67** Enrico Lusini, "The Florentine Garden of the Sixteenth Century," from the Exhibition of the Italian Garden, Florence, 1931. Alinari/Art Resource, NY.

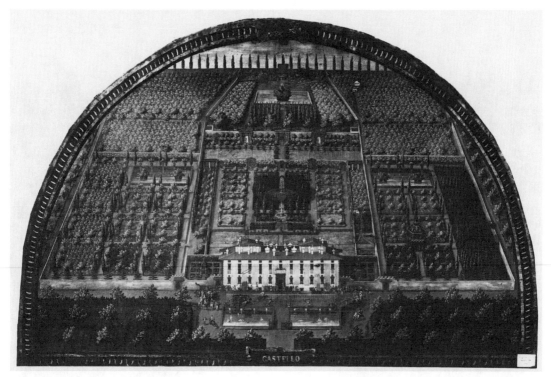

**Figure 68**  Giusto Utens, Villa Medici, Castello, 1599, Museo di Firenze Com'Era. Gabinetto Fotografico, Soprinten-denza per Beni Artistici e Storici di Firenze.

tional style, defined against distinctly foreign traditions.

The model of the "Florentine Garden of the Sixteenth Century" by Enrico Lusini bears an obvious, if superficial, resemblance to the sixteenth-century Medici garden at Castello, as represented in Giusto Utens's painting of 1599 (figures 67 and 68). In the 1931 model, a circle of huge cypress trees in the center of the garden contrasts strongly with the flat designs in the squares on each side. Nature is banished to the periphery, reduced to patterns on the ground, except for the cypress trees; but Lusini has transformed even these tell-tale features of the original garden at Castello into a wall-like circle of greenery. Although inspired by the sixteenth-century painting, the model illustrates the idea of the Italian garden as presented in the exhibition catalogue more than the historical garden. This is a garden in which plants are "humiliated by shears," as the catalogue explained.[42] How different from the sixteenth-century notion of a garden as a "third nature," in which "nature incorporated with art is made the creator and connatural of art"![43]

Lusini's model is a cultural artifact of its own time, not a Renaissance garden, but an Italian modernist overlay on one. The existing garden at Castello (figure 69) should not be mistaken for the original garden either. It is a sixteenth-century Medici garden, redesigned in the late eighteenth century to reflect the Enlightenment values of the Hapsburg-Lorenese rulers, as well as a twentieth-century garden in its planting, clipping, and grooming, all of which communicate the later twentieth-century notion of Renaissance gardens.

Lusini's model of the sixteenth-century Florentine garden shares the modernist aesthetic of contemporary posters for the exhibition, more than that of Utens's painting. In a surviving set of preliminary poster designs, the simplified and abstracted images of the gardens consist of planting beds in flat patterns, in contrast with tall, architectural, and schematic hedges (figure 70).[44] Vivid, flat colors reinforce the strong designs—this one with bright green hedges, yellow flat beds, and dark blue cypress trees. The schematic gardens in the posters resemble as well contem-

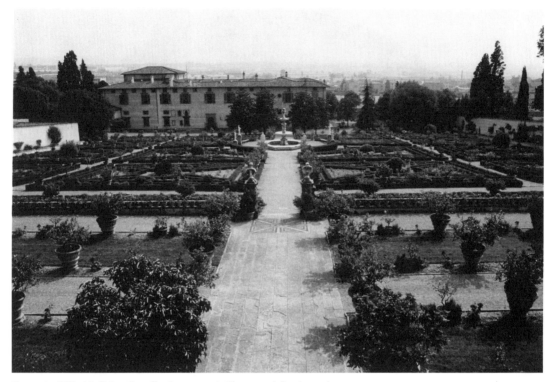

**Figure 69**  Villa Medici at Castello, begun 1538. Photograph by the author.

porary garden restorations, such as the Villa Far-
nese at Caprarola (figure 66), with their archi-
tectonic hedges, emphatic geometric shapes, and
boxwood in place of flowering plants. The mod-
els, posters, and restored gardens all reflect
Dami's notion of the architectural garden, which
subordinated nature to design, as all also dis-
played the modernist aesthetic of rationality,
geometry, and pattern.

Indeed, some of the architects who produced
models of the regional gardens for the 1931 ex-
hibition also restored historic gardens. Among
them were Augusto Chevalley, who did the Pied-
montese garden, Enrico Lusini, author of four
models (ancient Roman, fourteenth-, fifteenth-,
and sixteenth-century Tuscan), and Giuseppe
Crosa, responsible for the Genoese model.[45]
Luigi Piccinato, a prominent landscape architect,
urban planner, and author of the entry on Italian
gardens in the 1933 *Italian Encyclopedia,* de-
signed the model of the Roman garden between
the sixteenth and seventeenth centuries. In the
same year, 1931, Piccinato designed a park for

Monte Mario, part of a proposed ring of parks
around Rome, which displays similar architec-
tural constructions of vegetation.[46] Tall hedges
clipped into geometric arcades and rows of trees
cut into rectangular blocks flank a flat, open cen-
ter. The models of the regional gardens, restored
gardens, and newly designed gardens, all by the
same architects, worked together to construct the
idea of the Italian garden tradition presented in
the 1931 exhibition.

The exhibition also intended to demonstrate
the uses of historical gardens and the necessity of
referring to this tradition in order to produce
"truly Italian" modern gardens.[47] With the aim
of revitalizing contemporary garden design, the
exhibition sponsored competitions for public
and private gardens and displayed drawings
for the twenty-eight projects. The competitions
stipulated that the designs be both modern in
character and typically Italian.[48] The planning
commission elaborated: the modern garden must
have an exclusively Italian character and not dis-
play foreign influence, particularly of German

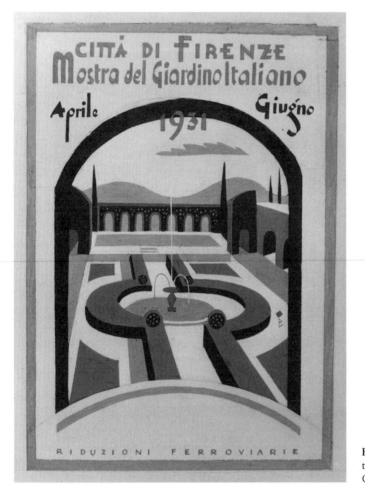

**Figure 70** Poster for the Exhibition of the Italian Garden, c. 1931. Archivio Communale di Firenze.

and English gardens.[49] Significantly, in those two garden traditions a natural rather than an architectonic character predominated.

Two entries divided the prize for the public garden, because, the jury explained, each embodied one of the stipulations, modernity and *italianità* (Italianness), more than the other.[50] The designers of both winning projects were Milanese architects: Ferdinando Reggiori, an established architect of the Milanese Novecento movement, and a pair of young architects, Giulio Minoletti and Alberto Cingria, at the time completing their degrees at the School of Architecture in Milan. In Reggiori's symmetrical design, prominent longitudinal and transverse axes subdivide the whole into quadrants, thus satisfying the requirements of Italian character and geometric plan.[51] Familiar elements of Italian gar-

dens—trees in rows, lawns, pergolas, pools, and fountains—reaffirm its Italian and nostalgic character. Despite the competition stipulations, the project of Minoletti and Cingria, however, suggests foreign influence, evoking the architecture of Le Corbusier or the Cubist paintings of Braque (figure 71).[52] Both design and manner of presentation depart dramatically from Reggiori's garden plan. The design predominates, through bright, large avenues standing out against dark shapes of vegetation and emphatic curving forms contrasting with rectilinear ones. The supplemental drawings of various garden features resemble the posters for the garden exhibition with strong patterns, flat areas of color, trees in regular silhouettes, and wall-like hedges.[53] In applying a modernist aesthetic to gardens, Minoletti and Cingria conceived traditional elements in new

**Figure 71** Giulio Minoletti and Alberto Cingria, "Design for a Public Garden," competition entry, Exhibition of the Italian Garden, 1931. *Achitettura e arti decorative* 10 (July 1931).

forms: the miniature mountain (familiar from Renaissance gardens) made geometric, terraces in overlapping rectangles, modernist curves rather than the hemispheres of Italian gardens or the serpentine designs of English ones, and the emphatic longitudinal axis shifted to one side of the garden. Nevertheless, the jury found the aesthetics of both projects acceptable but determined that neither satisfied equally the requirements of modernity and Italianness.

The competitions for modern gardens were open only to Italian architects, with landscape architects trained in botany or agronomy explicitly excluded.[54] In Italy, the renewal of garden art was the province of architecture. By contrast, in Germany, where the nature garden was construed as the national garden style, garden designers seeking to distinguish themselves from architects precipitated the renewal of garden art.[55] As the

Italian garden was understood as architectonic, rational, and ordered, so most prominent designers of gardens in Italy were primarily architects. All the designers of the model gardens in the 1931 exhibition, as well as the garden restorers, were architects. Even the Rationalist architect Giovanni Michelucci designed gardens: he won the competition for a small private garden a year before his famous commission for the Florence train station. His garden entry was deemed "sane, balanced, and Italian."[56] Indeed, Ojetti noted that the requirement for rationality in Italian gardens appealed to Rationalist architects.[57] Marcello Piacentini, principal architect in Fascist Italy, also designed a number of gardens between 1910 and 1930, most connected with old villas or palaces. Piacentini "restored" these into rectilinear and symmetrical gardens, in some cases replacing existing English-style gardens.[58]

## Italian Gardens, City Planning, and E42

The Italian garden tradition signified Italy's cultural supremacy, and at the same time served the needs of modern Italian cities. Urban planning, as practiced in Fascist Italy, depended on the same design principles as the Italian garden tradition: order, geometry, and symmetrical arrangement of rectilinear elements around an emphatic central axis. Since no professional training in city planning yet existed in Italy, the history of gardens instead provided instruction in planning principles. In the Scuola Superiore di Architettura, the new architecture school in Rome, Marcello Piacentini taught the basic planning course "Edilizia cittadina e arte dei giardini" (Civic Building and Art of Gardens), which was later changed to "Urbanistica" (City Planning).[59] For Piacentini, Italian gardens and city plans, both based on ancient Roman models, had everything in common, including their significance for the new Italy. His star pupil was Luigi Piccinato, garden designer and restorer, who in the same year as his entry on gardens in the *Italian Encyclopedia* designed Sabaudia, one of the new towns created under Mussolini.[60]

The conceptual relationship between Italian gardens and city planning determined the final design of the Universal Exposition of 1942 (Esposizione Universale di Roma, called E42), on a site five miles southeast of Rome. Planning of the complex began in 1937, directed by Piacentini as superintendent of architecture, parks, and gardens.[61] Already projected in the Master Plan of Rome of 1931, which Piacentini authored, the exposition grounds were from the start envisioned as a new city and a triumphal entryway from the sea to the old city of Rome.[62] E42 never took place, but the area has indeed become a flourishing commercial and residential center, now known simply as EUR (Esposizione Universale di Roma).[63] The vast exposition site—one and a quarter miles square, more than half meant to be planted—exceeded by almost three times the size of the great park of the Villa Borghese.[64] The ambitious plan anticipated pavilions and squares of enormous size and permanent materials, after transformation of the hilly, rugged, and volcanic terrain into level ground. Planning of the site

struggled with the contradictory requirements of ephemeral exhibition and permanent city, which affected everything from the design of the whole and its landscaping to such particulars as the width of the avenues.[65]

The permanent city emerged as the governing symbolic idea, as is evident in the hierarchical grid of the final plan (figure 72, top). Rigidly symmetrical and geometric, it has emphatic longitudinal and transverse axes, one a band of great ponds across the site called a "lake," although after successive modifications it lost its naturalistic shape. After the first plan, published in *Architettura* in April 1937, later versions eliminated the aspects of "romantic" landscaping and design that were thought appropriate to an ephemeral exhibition. A principal spokesman for the planning process was Gaetano Minnucci, director of services relating to the architecture, parks, and gardens of E42, who began his career as a Rationalist architect and polemicist, and later worked with Piacentini at the new Città Universitaria (University City).[66] Minnucci explained the development of the E42 plan: "The first [plans], more romantic and more concerned with landscape effects, were deserted for a more severe, rectangular, Roman composition."[67] The rigidly geometric and symmetrical final plan resulted not from an aesthetic or practical choice for such a large public space, but from an ideological imperative—a symbol not only of the Italian nation but also of the Italian race.

The exhibition site celebrated the Italian garden in its overall plan, in the many gardens within it, and also in a planned exhibition of the Italian garden.[68] Minnucci asserted that this new city would provide the impetus to renew the stupendous Italian garden tradition, to which he noted the conscious reference in its design. Earlier in his career, Minnucci had argued similarly for a new, modern, and Italian architecture, but one based on "a solid foundation in the classical tradition."[69] This was to be demonstrated in a small-scale garden within the complex, with a geometric and symmetrical design, terraces, and fountains, as well as a pavilion documenting the history of the Italian garden from its origins in antiquity to 1942.[70] By early 1940, however, all this had been eliminated from the plan.[71] Minnucci's description of the landscaping in the lake zone as "three

**Figure 72**  Plan of E42, with sources in Italian and French gardens. Marcello Piacentini, "Classicità dell'E42," *Civiltà* 1 (April 1940): 29.

mirrors of water" surrounded by gardens "framed in geometrical masses of greenery" calls to mind the modernist posters and models from the 1931 garden exhibition.[72] The Italian garden that the E42 design celebrates is the architectural garden of the '30s, influenced by both Fascist ideology and Rationalist design, but on the scale of a city, for which no precedent existed in either historical villas or public parks. Minnucci recounted the process of transplanting tens of thousands of centuries-old trees to the site to give it an appropriately historical look—to make a new garden old.[73]

In an article in the first issue in 1940 of the journal *Civiltà*, dedicated to the Universal Exposition, Piacentini presented E42 as a continuation of Italy's long tradition of regular planning and monumental complexes, from ancient Roman fora to Italian gardens. Explaining his title, "Classicità dell' E42" (Classicality of E42), Piacentini demonstrated the origins of the design in the classical cities of Greece, Rome, and Renaissance Italy, as well as in classical gardens, both Italian and French.[74] Piacentini presented his arguments through a photo-essay that juxtaposed aspects of E42, in plan and model, with their classical sources. He compared the plan of E42 to that of four gardens (figure 72). Below E42, at the upper left, is the early seventeenth-century Villa Aldobrandini at Frascati; at the center right is the sixteenth-century Villa d'Este at Tivoli, between two seventeenth-century French gardens, Versailles above and Marly below. Despite some resemblance in design, however, these gardens differ significantly in scale and in the relationship of the built to the planted. The gardens are predominantly green, with sculpture and architectural elements, while E42 has huge structures interspersed with vegetation. Although the juxtaposition of plans implies equality among them, the differences in scale and role of architecture profoundly affect how the regularity of each plan is experienced at the site.

The transformation of the naturalistic lake into a "mirror" of water was intended to confer on E42 "an aspect more in harmony with the spirit of the grand classical Italian villas."[75] Indeed, the three regular ponds create a cross axis of water similar on the plan to those of the Villa d'Este at Tivoli, but radically different in size, and parallel only to that of Versailles. In fact, in both scale and rigid geometry, the design of E42 has most in common with Versailles, the garden of the absolute monarch Louis XIV, not with the gardens of Italian cardinals. Piacentini considered French gardens merely an extension of the Italian tradition, since both exhibited the '30s view of Italian gardens as nature dominated by male rationality. The French models did not contradict Piacentini's assertion of the Italianness of the design of E42; it was instead that "Italianness" had come to mean something different. Both the plan of E42 and the current notion of Italian gardens shared with the hierarchical French plan the absolutist ideology that it signified.

In the first half of the twentieth century, two strongly contrasting conceptions of the Italian garden emerged, each based on assumptions about what is inherently Italian. Both were invested in the creation of new gardens based on historical ones, and each served nationalist aims: Americans and the English acquiring Italian culture, and Italians asserting their own superiority in cultural as well as political arenas. The Italian view is not a false conception, only an exaggerated and partial one taken for the whole, which had a profound influence on the received notion of the Italian garden in the second half of the twentieth century. Italian architects, critics, and scholars of every stripe participated in the reinterpretation of the Italian garden. The architectonic, ordered, rational, and male Italian garden of the '30s served Fascist ideology, and the discourse of the Italian garden resembled many others in Fascist Italy. In post-Fascist twentieth-century writing on Italian gardens, even by some of the same Italian authors, the rhetoric is softened and the extremes of "humiliation," maleness, and chauvinism deleted, but the essential understanding remains. The existing gardens and their representations in photographs and texts all bear the stamp of the Fascist moment in their history. The sixteenth- and seventeenth-century components are irrevocably fused with the restorations and reinterpretations of the '20s to the '40s. In their origins, as in the twentieth century, gardens are highly charged with issues of national identity, since they represent how a culture shapes the very land of the nation.

# History as Fascist Spectacle and Exhibition

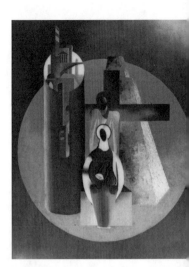

# Leonardo's Smile

*Emily Braun*

ON MAY 16, 1935, L'Art Italien de Cimabue à Tiepolo opened at the Petit Palais in Paris. It was the most spectacular assembly of Italian Renaissance and baroque art ever gathered for exhibition (figure 73). A joint French-Italian project, initiated at both diplomatic and curatorial levels, the show was enthusiastically sanctioned by Mussolini. "I want it to be magnificent," he stated. "If you encounter the least resistance, let me know."[1] In less than six months, loans were secured from Europe, the United States, and the Soviet Union. The French contributed their own rich holdings from the Italian Renaissance, such as Leonardo da Vinci's *Virgin of the Rocks* and *Virgin and Child with St. Anne* at the Louvre, as well as lesser-known treasures from provincial collections. Undoubtedly the greatest coup was having wrestled the most iconic images from leading Italian museums during the high tourist season. As one Italian bureaucrat quipped, "We'll do it the way Napoleon did, except that when the show is over, we'll bring everything back to Italy."[2]

The organizers aimed at creating an "ideal museum," emptying the Uffizi of Michelangelo's *Doni Tondo* and Titian's *Venus of Urbino,* the Brera of Mantegna's *Dead Christ* and Raphael's *Marriage of the Virgin* (figure 74). They claimed it to be the first major exhibition to include a section on the Italian Primitives. Even more extraor-

dinary was the presence of works commissioned for churches and taken out of *situ*—for example, Caravaggio's *Conversion of Saint Paul* from Santa Maria del Popolo in Rome, and Pontormo's *Deposition* from Santa Felicita in Florence. As Raymond Escholier, curator at the Petit Palais, stated accurately in his otherwise promotional texts: "We have never seen anything like this before, and we shall never see it again."[3] The unique opportunity to view "the most imposing collection of Italian masterpieces ever gathered in one place" resounded in the international reviews, as well as in the regime's propaganda at home. The results of the "spectacle," as it was proudly termed, were stupendous: some 650,000 attended the show during its two-month duration, one of the highest attendance records ever for a French museum.[4] Odes to Italy and Mussolini abounded in the mainstream French press. As F. T. Marinetti had observed in a prescient remark of 1920, "what better way to advertise the genius of Italy than to sell her museums abroad."[5]

The prototype for this form of cultural diplomacy—winning favor for Mussolini and Fascism north of the Alps—was the exhibition Italian Art 1200–1900 held at the Royal Academy's Burlington House galleries in 1930.[6] Many of the star attractions of the London show were procured again for Paris, among them Botticelli's *Primavera*, Piero della Francesca's *Duke and Duchess of Urbino*, Antonio Pollaiuolo's *Portrait of a Lady,* Carpaccio's *Courtesans,* and Donatello's bronze *David*. But De Cimabue à Tiepolo far surpassed the London show not only in the

For their research assistance I thank Jennifer Hirsh and especially Umbretta Missori at the Archivio Centrale dello Stato, Rome. My gratitude also to Andrea Bayer for her comments on the manuscript.

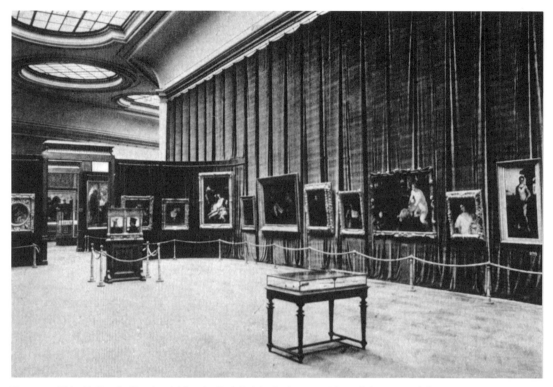

**Figure 73** L'Art Italien de Cimabue à Tiepolo, Petit Palais, Paris, 1935. View of the main exhibition room.

rarity and importance of the loans but also in sheer numbers. In fact, the Parisian show involved nearly twice as many loans: 490 paintings—of which two-thirds were from Italy—plus 110 sculptures, 240 drawings, and 600 objects. Prestigious foreign loans included Leonardo's *Madonna Litta* from Leningrad, and Tintoretto's *Susanna and the Elders* and Correggio's *Ganymede* from Vienna. Among the total haul were five paintings each by Giotto, Piero della Francesca, and Caravaggio, six each by Leonardo and Titian, and nine each by Mantegna and Raphael, not to mention ten by Tiepolo and fourteen by Tintoretto.[7] And whereas the London show merely confirmed the ambassadorial role of art in international relations, the Parisian enterprise was, from the start, far more blatant politically, its motives riding on diplomatic brinkmanship and colonial conquest. By 1935, England was already alienated from Mussolini's Italy; France was engaged in a dangerous liaison.

The exhibition at the Petit Palais drew its propaganda value from the Fascist appropriation of the Renaissance—the most prestigious period in the history of the fine arts, to which Italy could lay exclusive claim. As an international spectacle, the exhibition exploited this cultural capital to an unprecedented degree. The curators chose the "greatest" works of the "best-known" artists—a collection that only royalty or an emperor could command, as one observer aptly noted.[8] In fact, De Cimabue à Tiepolo was not so much about the objects themselves as about the spectacle of cultural power, of high art in the service of politics—especially Franco-Italian relations. The organizers were well aware that although this was a "gift" from Mussolini to the French Republic, the larger returns were for Fascist Italy. The exhibition was a stunning display of the regime's ability to triumph over logistical adversity and to enjoy international cooperation at a political moment when Mussolini was desperate to make Italy a player on the European stage.

The Fascists co-opted the Italian Renaissance concept of "humanism" to counter the impression of Fascism as a regime of thugs. The

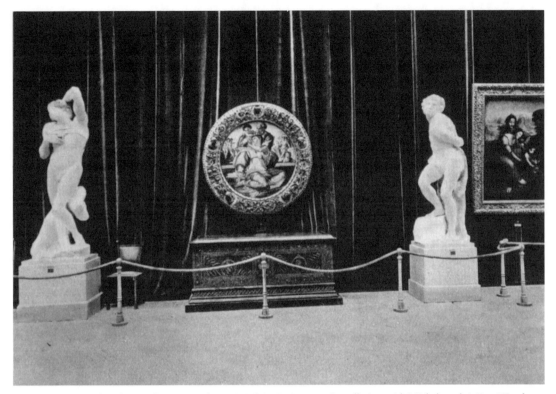

**Figure 74** L'Art Italien de Cimabue à Tiepolo, Petit Palais, Paris, 1935. Installation with Michelangelo's *Doni Tondo* flanked by his *Slaves* and Leonardo's *Virgin and Child with St. Anne* at the right.

symbolic capital of Italy's past allowed Fascist propagandists to distance the regime from the policies of Nazi Germany and the Soviet Union. Mussolini further needed France's approbation to pursue a Fascist colonial empire in East Africa. Above all, the "spiritual mission" of De Cimabue à Tiepolo legitimized Mussolini's claim to Ethiopia, for which the battle plan had been secretly drawn in 1932. The recuperation of the Fascist image in the eyes of the French public was exactly the goal of the exhibition, since it was the culmination of a diplomatic rapprochement between the two nations in the years 1933–35. For their part, the French interpolated the humanist discourse in official propaganda to draw Italy away from a possible Fascist bloc—to placate Mussolini and to isolate Hitler in an ever-more precarious European balance of power. The triumphant display of Italian masterpieces in Paris confirmed the creative genius of the Renaissance, but more to the point, it symbolized the "spiritual unity" between the two Latin nations.

Humanism—an ubiquitous term in the 1930s as some European nations rearmed themselves for war—referred to both the foundation and apogee of western civilization, and was synonymous with the culture of the Latin world. It assumed a shared set of "spiritual values"— namely, "man as the center of life and as the measure of all things."[9] The Italian Renaissance—art of beauty, harmony and sanctity—represented the "ideal model of man" and hence the "civilizing" mission at the heart of *latinità*. And the common ethnic and religious origins of the French and Italian peoples, so officials argued, determined their futures together as allies in the European arena. From the beginning, De Cimabue à Tiepolo was intended to be much more than a material history of culture. "As the Duce had wanted," proclaimed one Fascist spokesman, "it demonstrated the continuity of Latin civilization from the medieval ages to the present day; and the community that exists between the two direct descendents of Latin civilization."[10]

Neither the propagandistic uses of exhibitions nor the stridently nationalistic interpretation of the art-historical past were exclusively Fascist. The exhibitions of Italian art at the Royal Academy in 1930 and at the Petit Palais in 1935 were only two in a series of international surveys, among them Flemish, Dutch, Swedish, Swiss, and Canadian, that were held in London and Paris between the wars.[11] Exhibitions served the self-congratulatory marketing of the Fascist regime, and those envisioned for foreign consumption were but one part of a centralized system that also included the regional syndicates, the national Quadriennale and the international Biennale. Here too state-sponsored culture spectacles and the "aestheticization of politics" were not exclusive to totalitarian regimes. All of the strategies involved—self-promotional patronage, consensus building among the populace and intellectual class alike, opening up high culture to mass consumption—characterize the modern cultural politics of the Western powers. Building on the theories of Michel Foucault and Pierre Bourdieu, scholars have produced extensive analyses of the so-called "exhibitionary complex" as a means of indoctrinating a vast cross-section of the public.[12]

Nationalist and populist readings of cultural patrimony were standard from the early nineteenth century onward. With the birth of the modern state (and the discipline of art history), the evolution of style was joined to historical progress, and artistic development became the index of a people's growth and destiny.[13] The 1935 catalogue on Italian art, for example, bears comparison to that written for the enormous retrospective Chefs d'oeuvres de l'art français, organized by the same French museums at the Palais National des Arts in 1937. Though the national traits ascribed may have varied, the blatant chauvinism remained the same: "French art as the image of the French race," as the curator René Huyghe put it.[14] Nor were the Fascists the most extreme in this regard. Much mainstream art writing in the 1930s in France (not to mention, more obviously, Germany) was permeated by racial discourse of cultural "contamination," which was for the most part absent from the Fascist rhetoric of cultural "imperialism."

Since the Risorgimento, Italian writers and politicians had invoked the glories of the Italian past to construct national identity and international prestige. In the exemplary case of De Cimabue à Tiepolo, dictatorial power guaranteed otherwise impossible loans, controlled coverage in the media at home, and influenced reception abroad. Yet the propaganda of humanism was not without its blatant contradictions, especially when used to justify Fascist antiliberal and imperialist policies. Moreover, the Renaissance and baroque were sites of potential rupture and conflict in the fashioning of a seamless national image, as evident in the installation of the exhibition (figure 75). The art history of the period only accentuated the linguistic and regional diversity of the Italian peninsula: it was, after all, the story of Florentine art and Venetian art, of Romans, Lombards, and Bolognese, of Latin and vernaculars, of internal differences and independent city-states. And southern Italy was completely excluded from this Renaissance map. De Cimabue à Tiepolo revealed how the Fascist appropriation of the Renaissance past necessitated a series of discursive negotiations, especially when exported for propaganda abroad. The desire for a grand survey of Italian art had been circulating among French curators since the early 1920s, but became feasible only after the London precedent. The plan was presented to Mussolini early in 1933 by Henri de Jouvenel, special ambassador to Italy, who was a key player in the initial French diplomatic overtures. On May 14, 1934, Georges Huisman, *directeur général des beaux arts,* and Ambassador Charles de Chambrun met with Mussolini to confirm the dates for May–July 1935.[15] Planning for the exhibition came under the official auspices of the Sottosegretariato per la Stampa e la Propaganda, the Reunion des Musées Nationaux, the Ville de Paris and, most critically, the Comitato Italia-Francia. Comprised of well-connected businessmen and intellectuals, the Comitato Italia-Francia was dedicated to improving diplomatic relations through cultural exchange. Founded in 1933 and patterned after the Comité France-Italie (established a decade earlier), it coordinated its efforts with the French and Italian ministries for foreign affairs. The Comitato was led by Senatore Borletti, who served, along with de Jouvenel, as the copresidents of the exhibition's organizational committee. Bor-

**Figure 75** L'Art Italien de Cimabue à Tiepolo, Petit Palais, Paris, 1935. Floor plan.

letti, however, was ultimately responsible for overseeing the exhibition and its public relations (he also lent a Bellotto, a Guardi, and a Raphael from his personal collection).[16] The involvement of top government officials and power brokers from both countries underlined the strictly political goals of the professed "common love of beauty," a fact that was promoted rather than denied in the official press. As Escholier proudly recounted:

> "Above all it has nothing to do with politics," — they vehemently commended me, some two years after I had begun to develop the initial plans for a vast exhibition on Italian art in Paris, conceived in full accord with my friends, Henri de Jouvenel and le Comte de Chambrun. What was the response to such nonsense? After the wonderful exhibition organized in London, it was obvious that only a political rapprochement would prompt Italy and France to collaborate closely in the organization of an event so decisive as to hold up favorably with the wonders at Burlington House. This rapprochement came to pass, and with it, our wildest dreams were realized well and beyond anything we could have possibly imagined.[17]

In Italy, Mussolini delegated the project to his son-in-law, Galeazzo Ciano, head of the Sottosegretariato per la Stampa e la Propaganda. The main curatorial operation fell to the art historian Ugo Ojetti, who is best remembered for having organized the first exhibition on the Ital-

ian seventeenth and eighteenth centuries at the Palazzo Pitti in 1922, and who was also one of the driving forces behind the London show.[18] A member of the Fascist Royal Academy, Ojetti was a prodigious critic with conservative, antimodernist tastes. His influence over the Florentine museums, his connections with other European curators, as well as his seasoned dealings with the Fascist hierarchy guaranteed the success of the loans. Ojetti's leading role demonstrates how key decisions in the regime's fine-arts policy were made by qualified art professionals who were no mere bureaucrats. The scholarly imprimatur insured a certain credibility and quality that enhanced the political weight of the enterprise.

The archival documents attest to the armtwisting, threats, and obsequious gestures involved in the museum world and international relations.[19] The initial checklists were compiled beginning in late December 1934, just months before the opening. Ojetti balked at the wish list forwarded by the French and delivered by Borletti, claiming it to be full of errors and preposterously grand. He also refused to consider the French idea of including a small survey of ancient Roman art. Ciano gave directives to the Ministero dell'Educazione Nazionale, which had jurisdiction over the regional *soprintendenze,* to make sure the Italian museums would cooperate. Still, there were confrontations with local authorities over valuable works deemed too at risk to travel: Ettore Modigliani, soprintendente delle belle arti

of Lombardy, initially refused the request for Raphael's *Marriage of the Virgin* from the Brera, and Paduan officials struggled to keep Giotto's *Crucifixion,* which at that time still hung in the Arena Chapel. Organizers of rival exhibitions of Correggio in Parma and Titian in Venice were ordered to coordinate their loan requests with those of the Paris exhibition, so as not to compete for the same works of art.

As to packing and shipping, works within Italy were sent by train from the outlying areas to Turin, Florence, and Milan, where they were crated and loaded into sealed compartments. For security reasons the cars were then distributed among a total of fifteen trains for direct passage to Paris, bypassing customs inspection until they reached the final destination.[20] A military escort accompanied each of the shipments, though after the artwork crossed the border at Modane (between Turin and Grenoble), responsibility lay with the French national security forces.[21]

A pressing issue was that of expense. Ojetti and Borletti repeatedly asserted that to make France assume any economic burden for the expedition or insurance would make the Italians look cheap, and this would defeat the whole purpose of demonstrating Mussolini's largesse. To this end, the Duce agreed that no insurance would be necessary for objects owned by the state. The Comitato Italia-Francia assumed all other related costs, with the understanding that a percentage of the ticket sales, agreed to by the French, would reimburse its outlay. After working out an agreement with a consortium of Italian insurance companies (chosen over their French counterparts) for coverage of the other works, Borletti successfully lobbied the Ministro delle Finanzie to have taxes on the premiums reduced. Similarly, he obtained special considerations—this time from the Ministro delle Communicazioni and the Direzione Generale delle Ferrovie dello Stato—for reduced tariffs and direct trains to facilitate the passage and safety of the precious cargo.

Ojetti reported directly to the Sottosegretariato per la Stampa e la Propaganda, insuring the marriage of fine art and public spectacle, though in a manner significantly different from domestic exhibitions of mass culture. The government of-

fered fare discounts to encourage attendance—but this was standard practice for exhibitions within Italy. French officials also agreed to offer reduced train prices for both citizens and tourists. Far more telling were the luxury travel packages that were aimed at the target audience for this exhibition—the middle and upper middle classes, which had the time and money to make a trip abroad. Special arrangements were made with Italian publishers to import books on Italian art to be sold at the exhibition along with photographic images of the Duce. But the French immediately rejected the idea of a Fascist youth organization—the Gruppi Universitari Fascisti (GUF)—making an appearance at the opening: it was deemed too militaristic, and hence potentially provocative. Similarly, for the inauguration ceremonies, Fascist officials were instructed to wear tails and not uniforms.[22] Clearly the differing status between high art and base propaganda in the regime's cultural policies was maintained even in an exhibition aimed at the acculturation of the masses.

Above all, the Italians were intent on making a *bellissima figura* with the French. As Bortletti stated, the aim of the exhibition was "to mark, on fecund artistic ground, the first luminous affirmation of the renewed friendship between the two countries."[23] Though the French and Italian cultural avant-gardes were on intimate terms, the political relations between the two nations were abysmal and had been so long before the rise of Fascism. Their estrangement dated from 1881, when France preempted Italy's colonization of Tunisia. The status of tens of thousands of stranded Italian nationals in Tunisia was a constant source of tension and fueled Italian ambition to obtain its own African empire.

The Tunisian episode paled by comparison with the affront dealt to Italy after World War I. Italy had signed the Pact of London in April 1915, allying itself with France, Britain, and Russia only after assurances that it would gain long-desired territories along the Adriatic coast—Istria and Dalmatia—and strategic power in the Danube after the demise of the Austro-Hungarian Empire. But when the time came to dole out the territorial rewards, Italian expectations were rebuffed by the Western powers and stymied by

Woodrow Wilson's policies. Italy walked away from the Paris Peace Conference humiliated by what it termed a mutilated victory. Italian diplomats were particularly incensed by the new French control in the Danube region and the Balkans. For their part, the French were contemptuous of Italian ambitions, treating Italy as a second-rate nation. Mutual antipathy only increased in the '20s, fueled by the rise of Fascism, issues of re-armament and naval parity, and struggles over the fate of central and eastern Europe. Moreover, Mussolini was incensed by the refusal to allow him Ethiopia, since France and Britain had already carved up most of the African continent for themselves.[24]

But an alliance with France was critical for Mussolini in 1933–34, since Italy had good relations with neither Britain nor Germany. Britain consistently rebuffed Italian diplomatic and imperialist ambitions, and Mussolini and Hitler were mutually distrustful rivals. Above all, Mussolini feared German annexation of Austria, and the specter of an Anschluss loomed larger after the murder of Austrian chancellor Engelbert Dollfuss, Mussolini's protégé, by Austrian Nazis in August 1934. In the wake of the assassination, Mussolini rushed troops to the Brenner Pass and spoke out against Nazi barbarism and Hitler, whom he openly derided as a sexual degenerate. Significantly, only the British and Germans balked at the international loan requests for the Petit Palais exhibition, and both countries refused to send key pieces from their national galleries. (By contrast, all the other nations complied. American lenders included the Metropolitan Museum of Art, the Morgan Library, and several private collections through the intermediary of dealer Joseph Duveen.) A handwritten note added by Ojetti to one of the documents is particularly telling. It relates that key French diplomats had reported back from Berlin on the rejection of the loan requests: "You know that this is aimed at Italy, and due to Hitler; you know that to France alone they would have given everything."[25]

France's relationship with Germany, however, was no better. Already in 1931, in response to the new Austro-German customs union, Prime Minister Pierre Laval had offered the possibility of concessions in Ethiopia to Foreign Minister

Dino Grandi as part of an initial rapprochement. But the pressing need for a French-Italian alliance did not emerge until Hitler's rise to power. After becoming chancellor in January 1933, Hitler violated the re-armament treaty, spurning the League of Nations. He made his intention clear to carve a vast *Lebensraum* out of central and eastern Europe and to unite pan-European Germanic peoples under the Third Reich. France had the most to fear, and Britain was doing nothing to stop Hitler's aggression. Since Italy could go either way, the Quai d'Orsay (the French Foreign Ministry) understood that the moment had arrived to improve official relations on the basis of a common high culture, despite reservations about Fascism and the Duce's outspoken Francophobia. The French press was fed pro-Fascist coverage by its own government, including revised assessments of Mussolini's statesmanship. For the purposes of pushing forward with an agreement, in January 1933, de Jouvenel was sent on a six-month mission to Rome.[26]

Promoting the myth of Latin sisterhood served the diplomatic interests of the French, while it fulfilled Mussolini's long-standing ambition to be the *peso determinante* (decisive weight) in the balance of power between the Franco-British alliance and the Germans. The myth also allowed him to implement his imperialist plans through diplomatic extortion. The dream of an Ethiopian colony had impassioned Italian Nationalists since the late nineteenth century; now Mussolini engaged in belligerent policies of border skirmishes and provoked internal unrest as a prelude to economic domination or even military invasion. Yet he needed acquiescence from France to move forward on his colonial campaign.

And so in January 1935, Pierre Laval, then the French foreign minister, made his historic trip to sign the Rome Agreements with Mussolini (figure 76). Hammered out in public and secret meetings, the agreements called for cooperation in the event of German invasion, Germany's annexation of Austria, or Hitler's break with disarmament restrictions. Laval and Mussolini also reached a "tacit understanding" over Italy's plans to dominate Ethiopia economically and politically, though the possibility of a full-scale mili-

**Figure 76** Mussolini with French foreign minister Pierre Laval at the signing of the Rome Agreements, Rome, January 1935. *La Rivista Illustrata del Popolo d'Italia,* 8 January 1935.

tary attack was not specifically discussed. By going to Rome and signing the bilateral agreement, Laval and the French granted a new respectability to both the Duce and Fascism.[27] For the most part, the French public and press were prepared to accept the entente, and the right wing eagerly embraced it. For some, it was simply regarded as a necessary evil to isolate Germany and to ensure peace and security. But the dominant justification was that of the mythic Latin union: Italy and France were bound by a common ethnic origin, by the Catholic faith, and by the common military and cultural greatness of the ancient Roman Empire.[28] Only the radical left in France condemned Laval's "chicanery." The future head of the Popular Front government, Léon Blum, declared: "So Mr. Laval has arrived in Rome. . . . For the first time, a French Minister is the guest

of Matteotti's assassin. For the first time, a representative of the French Republic recognizes the Italian tyrant as a chief of state, by initiating a deferential visit. At the risk of disturbing the universal shouts of joy, the clamor, and adulation, we want, as Socialists and as Frenchmen, to voice our shame for all to hear."[29]

The inauguration of De Cimabue à Tiepolo four months after the Rome agreements ratified the accords "with the most magnificent assembly of spiritual values ever presented in a museum," as Huisman claimed.[30] In his opening speech, Ciano invoked the propaganda of humanism in not-so-veiled opposition to the Germanic world: "For us Latin peoples, the moral world has always been clearly designed—simple, limpid, solid, and safe; for other peoples it is like a forest with clearings but also with shadows and dark-

ness, where it is difficult to make one's way and where one must always move with circumspection and arms at the ready." He also addressed the question uniformly posed by the Parisian newspapers—did the idea for the exhibition precede or result from the Franco-Italian accords? "If the idea for this exhibition happened before the political rapprochement, then it proves that the conditions necessary for the latter had always existed in the realm of the spirit," he responded. "It is also a testament to the sentiments and realities that preside over our friendship: a love of beauty and a passionate attachment to a common civilization."[31]

The spectacle of creative genius drew even more popular support for Fascist Italy, which was now described approvingly in the mainstream French press as an authoritarian democracy. It was Mussolini himself, the "Duce of *latinità*," who wanted to demonstrate his goodwill to France and so he made things happen, allowing the nation's most jealously guarded treasures to arrive in the heart of Paris. "All of the Italian artists are amazing," commented the painter Albert Marquet, "but Mussolini is the most amazing of them all."[32] The press even opined that Italy had been wronged by decades of shabby treatment at the hands of French diplomacy.[33] The works of art were mesmerizing, they gushed, and all of Paris was "enchanted" by the "fairy-tale" atmosphere.[34] As Paul Valéry maintained in the opening text to the catalogue of the Petit Palais exhibition, the masterpieces on view carried particular weight at a moment of looming crises in the West: they confirmed Italy's and France's commitment to peace and to civilization itself. *Primavera*—not only Botticelli's painting but also springtime for French-Italian relations—had arrived.[35]

The Italian papers, in turn, could report that homage was dutifully paid to the Italian creative genius and to Mussolini's magnanimity. Humanism had won the day. The unrivalled quality and number of works—twice a many as in London, it was repeatedly stressed—proved the cultural primacy of the Italian race and its claim to the "world cup" of Western civilization. More to the point, the exhibition made palpable the Fascist doctrine of the spiritual life of the state—the national ideal of heroism, realism, and generosity.[36]

For his part, Ojetti proved himself as fine a public-relations man as an art historian. Writing in his regular column for *Corriere della Sera,* he asserted that Mussolini the poet had worked his art, shaping a political idea into a transcendental experience of the "eternal face of Italy." "Look at it straight in the eye," he advised the French, "now that you have returned cordially as a friend."[37] Unbiased or gently critical appraisals were rare, but the journal *L'Arte,* directed by Adolfo Venturi, was an exception. His son, Lionello Venturi, also an eminent art historian, had been in anti-Fascist exile in Paris since 1932. An anonymous review in *L'Arte*—small and subtle enough to avoid the censors—drew attention to the lack of new attributions or serious research involved in the enterprise, dubbing the London show to have been of more scholarly worth.[38]

Negative opinions were more evident in the uncensored French press, and as with the Rome Agreements, writers from the far left provided the dissenting voice. They used metaphors of dissembling, invisibility, and masking to describe the reality of what the audience at large, blinded by the beauty of the Renaissance, refused to see. Many moderate French reviewers conveniently ignored the politics and concentrated on the art, while a few chauvinistic observers lashed back against what they perceived as an attempt to vaunt Italian over French cultural achievements. The most skeptical reviewers drew attention to the politicians "hiding" behind the masterpieces, as the comments of neo-impressionist painter Paul Signac attest: "The exhibition of old masters at the Petit Palais—fine and good. But we are well aware of how they are exploited by Fascism, the oppressor of humane ideas."[39] But other liberal-minded critics rebuffed the claims of conspiracy as they embraced the prodigal Latin sister. Although Mussolini was clearly using the exhibition and its promotion to his advantage, "it would be absurd and anti-Latin," opined the center-left critic George Besson, "to presume that Giotto, da Vinci, Tintoretto are being paraded on the Champs Elysees with a blackshirt at the reins, for the purposes of demanding export quotas on gorgonzola and the repression of Abyssinian border bandits. *Romanité* is not taking cover at the Quai d'Orsay behind the Joconde, or Carpaccio's

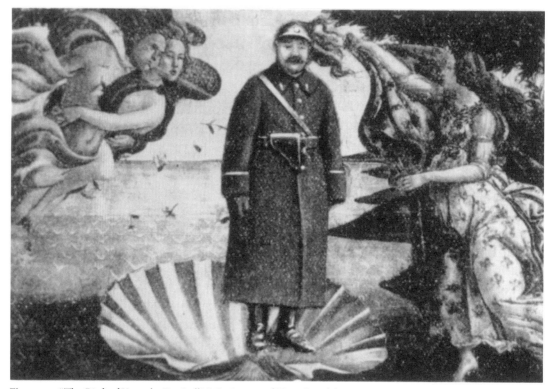

**Figure 77** "The *Birth of Venus* by Botticelli." Caricature of Pierre Laval from *La Bête Noire*, June 1935.

St. Ursula, or the Venuses and Saints—George and Sebastien—or the pederast Bacchus of Caravaggio, to 'procure' friends and allies."[40]

The avant-garde journal *La Bête Noire,* edited by Maurice Raynal and Edouard Tériade, launched the most searing accusation against the old-masters exhibition. One of its editorials was accompanied by a caricature of Laval in military uniform, standing on the half shell in the place of Botticelli's Venus (figure 77). For editors Raynal and Tériade, "selective blindness" was the operative metaphor for the public's infatuation with the exhibition: what the masses perceived as a garland of beautiful, Botticelli-like women draping flowers around the Petit Palais was, in reality, "a vulgar ring of military sentries, standing at attention, hand on the musket ready to fire." The editors were no less critical of the show and of the "sweaty crowd of people" who had no conception of what they were viewing. Because of the prodigious publicity surrounding Mussolini's beneficence, the general public failed to realize that many of the greatest pieces came from French collections. As *La Bête Noire* observed, the disproportionate excitement generated by this temporary exhibition proved how few people regularly visited permanent museum collections, or museums at all.[41]

If the press revealed fissures in the humanist bloc, so did the exhibition and its catalogue, especially with regard to the Fascist reading of Italian history. In Italy, the need to construct unity out of diverse peoples and regions only intensified after the Risorgimento because of the widespread conviction that unification had failed.[42] And this need was exacerbated under the Fascists as witnessed by their totalitarian drive to create a seamless narrative from the Rome of Augustus to Christian Rome to the Third Rome of Mussolini. The fictions and indeterminacies apparent in the writing of the Italian Renaissance at the Petit Palais point to the exaggerated claims of Fascist Italy to world cultural supremacy.

The catalogue and numerous supplementary publications—for the most part written by the French curators—trace the flowering of regional

styles and individual genius, the evolution from Florentine linearity to the painterly luminosity of Venice.[43] The story runs from the wellspring of mid-fourteenth-century Florence to the zenith reached with Raphael, Leonardo, and Michelangelo, to the last burst of pictorial originality in eighteenth-century Venice under Tiepolo. The catalogue's bibliography is telling, since it is overwhelmingly composed of foreign-language publications, particularly works by Bernard Berenson. And here was the Fascist predicament: indebted to foreign scholarship and appreciation, the prestige of the Renaissance was for like reasons resistant to manipulation by the Fascists, especially in an international context. Foreigners, such as Winckelmann, Burckhardt, Stendhal, Goethe, and Taine, crafted the image of Renaissance Italy—and it was often one of violence, intrigue, and debauchery. In short, the history of culture pointed to the lack of political unity and national identity during the Renaissance and baroque. Most problematic for the Fascists was how to connect these centuries to ancient Rome, creating an unbroken lineage of *latinità* and *italianità*.

In reviving the traditions of antiquity after centuries of eclipse, as the master narrative had it, the Renaissance gave birth to humanism and to an ideal beauty. Even as the Germans and "Goths" laid waste to Rome, they could not extinguish the spirit of ancient civilization, which survived amid the ruined grandeur. Though no longer an imperial power, Italy during the Renaissance conquered the world and spread her influence through creative genius. The euphemistic term "spiritual imperialism," prevalent in Fascist domestic propaganda, is noticeably absent in the catalogue for obvious reasons. Instead, the less belligerent "universality" is used to characterize Italian art and its mission. As expounded by Ojetti in his preface, this universality derived first from the continual presence of Rome, "which was never fully obscured, even in the darkest era"; second, from the influence of Byzantine art, which also kept the traditions from antiquity alive; and third, from the spirit and dogma of the Catholic Church, evident not only in religious painting but also in the "purity" and "clarity" of mythological scenes, portraits, and landscape. Following the official line, Ojetti argued for the

position of Renaissance Italy, and by extension, the present-day Italian nation, as the "spiritual center of Europe." Ciano similarly invoked the rhetoric of continuity in his opening speech: "Seeing the treasures gathered in the Petit Palais, one is tempted to believe that there was never a middle ages, that the idea of Rome was only in hibernation, to emerge full again with the Renaissance."

Political and social history are noticeably absent from the catalogue's analysis of the Renaissance, and they appear in the text only to account for the overall decline of Italian art beginning in the eighteenth century, as a result of the deleterious effects of foreign invasion. The problem remained of providing continuity from the Rome of the popes to the Third Rome of Mussolini. The answer was a pendant exhibition of nineteenth- and twentieth-century Italian art held at the Jeu de Paume, conceived in tandem with the Petit Palais event and held at the same time (figure 78). Similarly promoted by the Comitato Italia-Francia, the second exhibition was organized by Antonio Maraini, secretary general of the Venice Biennale, and one of the most obsequious, hence powerful, of Fascist cultural bureaucrats. In contrast to Ojetti, Maraini had the more challenging task of demonstrating a cultural rebirth under Fascism through the work of contemporary artists. As Maraini put it in a letter to the Duce, "We need to overcome the blind admiration for the past that already predetermines and overshadows appreciation of the present."[44] In February 1935, he sent his list to Ciano and Mussolini for approval: 400 works (paintings, sculpture, works on paper, and decorative arts) by 160 artists, 100 of them living.

With artists ranging from Canova to Carena, the exhibition argued for the continuity of *latinità* with the development of the Italian regional schools under the Risorgimento, as well as the unity of the arts and nation under Fascism.[45] Both sections of the show, however, posed serious problems of credibility and interpretation. Little known outside of Italy, the artists of the nineteenth century risked being overshadowed by their illustrious predecessors. Moreover, how would Italy's modest achievements hold up in Paris, capital of nineteenth-century art? As to contemporary art, domestic cultural politics

Figure 78  L'Art Italien des XIXe et XXe
Siècles, Jeu de Paume, Paris, 1935. View
of the Canova room, with the Hayez in-
stallation beyond.

played a role in determining which living artists would be represented, and here too, they had to compete with their better-known French counterparts. Maraini chose artists of established reputation, and those regularly featured at the Quadriennale and Venice Biennale, though favoring those of a classicizing bent and downplaying more radical modernists.[46] In a letter to Ciano, the contemporary sculptor and Royal Academician Romano Romanelli said he considered the whole enterprise a gross error: "We will have to go up against international collectors almost always Jews and Anglo Saxons, who have promoted French art to the detriment of others and with huge investments of capital. They have all the reasons to fight us and apart from a few acquisitions and the usual chatter from the press things will remain as before."[47]

But the French themselves promised the contrary: by acknowledging the achievements of Italian art since the Risorgimento, they would make up for the regrettable snubs of French diplomats over the last half century. In his preface to the catalogue, curator Andrè Dezarrois opined with patronizing zest that "the French ignorance of 19th century Italian masters (such as pictured here) constitutes a great injustice and we have even registered our surprise at the skepticism shown by the Italians as to the interest it might have abroad." He boasted correctly that the assembly of works at the Jeu de Paume formed a museum of nine-

teenth-century Italian art that did not even exist in Italy, inadvertently pointing to a weakness in the Italian cultural bureaucracy and in the nation's own self-image. Dezarrois and other commentators also identified the national essences apparent in the art, and in doing so, upheld the official Fascist line: the modern works on view proved the continuity of the Italian race and the resurgence of creative forces at the present moment.[48] As several critics in the press were quick to remark, *italianità* was even evident in the works of the expatriate Segantini and the *deraciné* Modigliani.

The exhibition at the Jeu de Paume started fittingly with Canova, "the sculptor of Napoleon," who—in a nice twist of historical fate—also repatriated the looted Italian treasures after the emperor's fall. "What would he say today," mused Maraini in his catalogue essay, "finding himself returning to Paris at the head of a new and numerous coterie of artists, worthy of being known and appreciated outside the borders of an Italy now united, powerful and respected?"[49] Yet the neoclassicism of Canova and Hayez was an importation, not an authentic Italian expression, as Maraini duly argued.[50] Only with the Risorgimento did Italian artists rediscover their indigenous traditions, returning to depictions of their own land and people. Though removed from the European limelight during the mid-nineteenth century, Italy had not forsaken its mission of spiritual expansion: instead, she had to concentrate

on her own internal fight for self-definition. Herein, critics used the obviously provincial character of the Italian regional schools as an argument for their sincerity and spontaneity. The Tuscan Macchiaioli—especially Giovanni Fattori—were held up as the supreme example, with critics drawing the connection between fifteenth- and nineteenth-century Florence. No matter that the style at the base was that of French impressionist naturalism. In fact, the press repeatedly used the French to validate the Italians. While sojourning in Italy, we are told, Corot and Degas admired the Macchiaioli, and the Italians in Paris, de Nittis and Boldini, were embraced by Manet and Denis, providing further proof of the Latin sisterhood.

The exhibition and discursive acrobatics surrounding it may not have convinced everyone of the strengths of modern Italian art, but even inferiority served a purpose for renewed French-Italian relations. What better way for the Italians to return the compliment paid to Italian art of the fourteenth through the eighteenth centuries than openly to acknowledge the dominance of the French in the nineteenth and early twentieth centuries? This acknowledgement also assuaged local fears that the French contribution to Western culture was somehow dimmed by the brilliance of the art at the Petit Palais. The Italians were too shrewd not to admit to the influence of the French, who from Ingres to Degas, so it went, perpetuated the classical ideal. And so it was truly moving, Ciano stated in his speech, to see the actual kinship between modern French and Italian art both descending from the same source, "the bosom of Rome."

If the artists in the first half of the exhibition were for the most part novelties, those in the second were "better known and more appreciated, thanks to the interest with which the entire world observes postwar Italy, the Italy of Fascism."[51] And whereas the first-floor itinerary focused on regional schools, the second floor of the Jeu de Paume had no organizational plan, noted Maraini, save the multiple creative energies bearing witness to "the spirit of renewal and a profound sense of tradition." The birth of a modern Italian art, like that of Fascism itself, emerged from the ardent nationalism of World War I and intensi-

fied after the March on Rome, so the catalogue texts explained. Despite his invocations of national unity, Maraini inevitably discussed the Tuscans and the Milanese, the traditionalists and the cosmopolitans, revealing the factionalism at work in the regime's own cultural politics. He betrayed the inability to square a seamless "spiritual bloc" with the obvious lack of any national style. Instead, the originality of each artist, Maraini was quick to point out, denied the possibility of any coerced ensemble on the part of the Fascist state. In other words, what better proof was there of the humanity of the present regime than the freedom to create—and to create in a pluralism of styles? The conservative French and international press confirmed that recent Italian art "had successfully resisted foreign influence" and had "finally restored its dignity." Eugeni d'Ors could claim the influence of Pollaiuolo on de Chirico, Piero della Francesca on Mario Tozzi: and so, "the most radical modernity is joined herein to the most venerable antique."[52]

Not everyone was convinced, however, of a flourishing of the arts, nor of the success of Mussolini's laissez-faire cultural policy in the arts. Was it perhaps the immobilized figures of Casorati or the enervated gladiators of de Chirico that prompted an anti-Fascist critic, Mario Mascarin, to write of the vacuity at the core of Fascist ideology? "If art reflects the system, then this system is flawed," Mascarin observed, "and Fascism is unmasked by the creative efforts it attempts to control."[53] For the most part, the French critics were silent on the contemporary section, preferring to look at themselves in the mirror of nineteenth-century Italian art. Despite the flattering (and patronizing) press, modern Italian art inevitably suffered by comparison with the French, let alone with the indigenous old masters. The reviews of the second show were few and overall less laudatory. As the gadfly editors of *La Bête Noire* put it, "The distance between the Italian art at the Petit Palais and that at the Jeu de Paume was not merely that of a bus ride or even a few centuries. It was something much greater than that."[54]

Indeed the Italian organizers knew well in advance that the obvious comparative weakness of the modern exhibition was not enough to an-

chor the slippery position of the Renaissance between the First and the Third Romes. What then could be done? How could the artistic achievement of the Renaissance be linked to Italy's colonial empire, past and present? In the midst of loan negotiations, Ojetti wrote to Ciano that the exhibition rooms of *De Cimabue à Tiepolo* should open with the bronze sculpture of the *She-Wolf* (*La Lupa*) placed between statues of Caesar and Augustus—"the founders of the Roman order," as the catalogue stated. The symbols of Latin origins and empire would be presented in the most obvious, if still cultural, terms, alongside a Roman colossus of the muse Melpomene (figure 75, room 1). Nevertheless, the governor of Rome, Giuseppe Bottai, would not lend the original statue of the *Lupa;* but Ojetti was insistent, so a copy was made instead. After all, Ojetti wrote, "The idea had caught on among the French and Italian organizers like wildfire."[55] The antiquities stood together under the central dome of the Petit Palais, painted by the celebrated French muralist Albert Bernard. It was an area announcing the humanist themes to follow through which all visitors would have to pass. The words of Raymond Escholier confirmed the celebratory effect of the entry rotunda: "This trinity, watched over by the *She-Wolf,* is there for a reason. It reminds us that art cannot live without security, the security which gives it its force."[56]

This blatant iconography of origins represented by the *She-Wolf* linked the Renaissance to the spirit of eternal Rome, but it also lay bare the imperialistic agenda of the humanist discourse; the placid beauty of painted Madonnas served to mask the brutality of colonial subjugation. In October 1935, three months after the exhibition closed, Italians swept into Ethiopia with a crushing military advance. For his part, Laval—with an ambiguity fitting Leonardo's *La Gioconde*—denied giving a free hand to invasion. He later contended that he had agreed only to Italy's economic domination—that is, a "peaceful penetration" of Ethiopia.[57] As part of the League of Nations, France, after all, could never have condoned invasion of a member. But Mussolini had intended a pummeling conquest all along. Fascism announced its humanistic mission by bombing the civilian population and attacking the under-equipped Ethiopian armies with poison gas. Under British pressure, the French then agreed to sanctions against Italy. In the context of the Petit Palais exhibition, the duplicity of the French-Italian rapprochement gave new meaning to Leonardo's *sfumatura* and enigmatic smiles.

# Celebrating the Nation's Poets

## Petrarch, Leopardi, and the Appropriation of Cultural Symbols in Fascist Italy

*Benjamin George Martin*

ON NOVEMBER 25, 1928, in the presence of King Vittorio Emanuele III, the Tuscan city of Arezzo unveiled a new national monument to Petrarch (figure 79). Born in Arezzo in 1304, Francesco Petrarca, father of humanism and master of the sonnet, now appeared portrayed in stone, high atop a massive sculptural group in marble by Alessandro Lazzerini. The inauguration of the monument was just the beginning of two full days of celebrations, exhibitions, conferences, performances, and high-profile visits to Arezzo, in honor of the poet. The day also saw the first session of a two-day conference on Petrarch, sponsored by Arezzo's own Accademia Petrarca and the Istituto Nazionale di Cultura Fascista (INCF), one of the main cultural institutions of the Fascist regime. The opening lecture, presented by the head of Arezzo's branch of the INCF, praised Petrarch's passionate love of Italy and his profound "worship" for the culture of ancient Rome (*culto infinito per la romanità*).[1] Later that day, Fascist government representatives, including Minister of Public Instruction Giuseppe Belluzzo, reviewed a parade of Arezzo's "Fascist forces" assembled for the occasion. These included the militia, the *fasci*, the Fascist syndicates, and the uniformed boys and girls of the town's Fascist youth groups.

On the Petrarch monument, below the standing figure of the poet, an elaborate base includes a busy and eclectic collection of elements drawn from Petrarch's life and poetry (figure 80). The front features a muscular male youth, arms outstretched, meant to be crying out for peace—*"pace, pace, pace"*—as in the closing words of Petrarch's famous patriotic poem, *Italia mia* (*Canzoniere*, CXXVIII). A young mother holds a child at the youth's feet, the Roman she-wolf suckles Romulus and Remus on the platform above, and Petrarch's beloved Laura is portrayed in a bas-relief tondo on the side of the statue. Cupid, who wounded Petrarch with the arrow of love (*Canzoniere* III, *Era il giorno*), crouches below, not far from a fasces—the symbol of both Petrarch's beloved ancient Rome and the Fascist regime that was honoring him now.

In 1937, Recanati, a small town in the Marche, erected a Roman-style triumphal arch in the main square in honor of the town's most famous son, the nineteenth-century poet and writer Giacomo Leopardi (1798–1837) (figure 81). Erected for the centenary of the poet's death, this arch honored Leopardi's love of ancient Rome at the same time that it celebrated Mussolini's recent declaration of empire. An updated re-creation of the kind of triumphal arch with which imperial Rome celebrated its victories, this modernist arch linked the conquests of the Fascist regime to those of the Roman Empire, while also deploying the symbols of both ancient Rome and the Fascist regime for the celebration of a local literary hero. Beginning with an early morning

Thanks to J. W. Smit and Victoria de Grazia for their thoughtful readings of an early version of this chapter, as well as to Silvana Patriarca, Marla Stone, Jennifer Bethke, and the editors of this volume. Research for this paper was conducted with the generous support of a Fulbright-Hayes fellowship in Italy, 1996–97.

Figure 79  Alessandro Lazzerini, Petrarch monument, Arezzo, 1928. ACS PCM 1928–30, 14-2-1526.

gathering of the town's Fascist organizations to pay homage before the home and birthplace of the poet, Recanati's celebration was honored by a visit from Giuseppe Bottai, the national education minister and prominent cultural leader. Recanati also hosted an assembly of Italy's prestigious Royal Academy, which rarely met away from Rome. Some of Fascist Italy's highest-level cultural figures were present, including the Futurist leader F. T. Marinetti and the critic and academician Massimo Bontempelli, famous for his involvement in the Novecento and Stracittà literary and artistic movements. Bontempelli gave the assembly's official commemorative speech, which was broadcast live on radio. This was followed by a rally in the piazza outside the town hall, a parade through the town led by Bottai, and a large public concert.[2]

In this chapter I examine some of the commemorative celebrations for Petrarch and Leo-

pardi as examples of a particular aspect of the Fascist engagement with the past, namely the way it celebrated the glories of the Italian high cultural tradition by honoring individual literary figures from Italy's history. Although the celebrations for these two authors stand out in number, size, and duration, they are representative of a larger pattern of similar events for cultural figures of all types in Fascist Italy. As such they form an interesting and relatively unexamined aspect of the regime's cultural politics. In the course of the Fascist period, commemorations, or *onoranze*, were held for Dante Alighieri, Ludovico Ariosto, Cino da Pistoia, Giosuè Carducci, Gabriele D'Annunzio, Antonio Fogazzaro, Ugo Foscolo, Giovanni Pascoli, and Torquato Tasso. Visual artists and composers, including Giotto, Brunelleschi, Raphael, Pergolesi, and Rossini, were also commemorated, along with a series of ancient Roman historical and cultural figures, such as Horace,

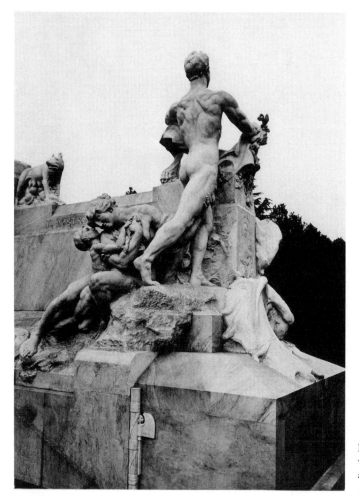

**Figure 80** Petrarch monument, detail with youth, mother and child, she-wolf, and fasces. ACS PCM 1928–30, 14-2-1526.

Virgil, and Titus Livius.[3] I focus here on literary figures not only because the celebrations in their honor seem to have been among the biggest of their kind but also because of the particular importance of language and literature in the history of Italian cultural nationalism. This background recommends these events as a means of exploring larger issues in the history of Italian cultural nationalism and of Italian cultural politics since the nation's unification in the mid-nineteenth century.

These commemorations can be understood as examples of the political appropriation of Italian cultural figures by the Fascist state. By celebrating these poets in a highly politicized and explicitly Fascist context, and by highlighting aspects of their work that were consonant with Fascist ideology and rhetoric, the commemorations helped to claim the authors for Fascism and to

make them politically useful to the regime. In this chapter, I explain what I think the regime aimed to accomplish with these appropriations in the larger context of Italian Fascist cultural politics and how these goals were achieved. In addition, I use the texts, photographs, and monuments that such events left behind to explore the strategies of Fascist cultural politics employed in the celebrations and the broader approaches to Italian history that these events reveal.

By examining the visual means used to represent and to commemorate Petrarch and Leopardi in the context of the celebrations held for them, this chapter seeks to draw parallels among some of the ways that the past was engaged and appropriated in Fascist Italy. These celebrations and the accompanying visual materials offer another example of the recovery of a "visual past"

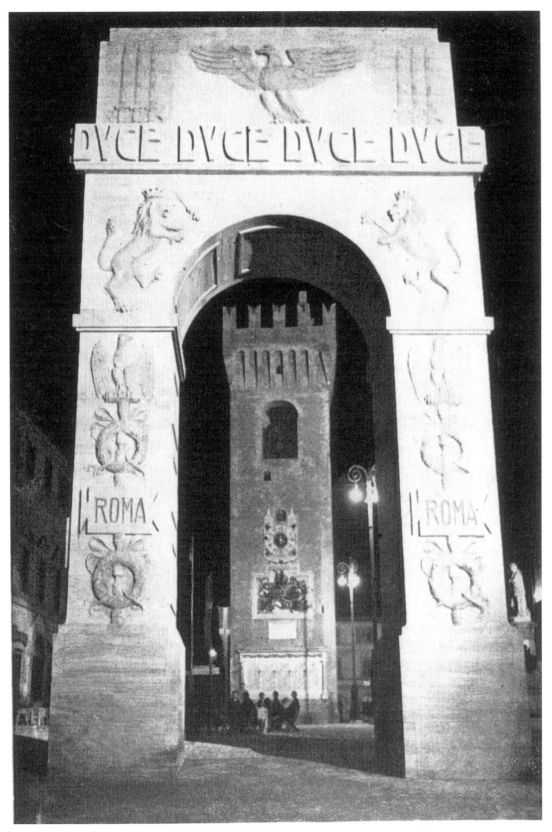

**Figure 81** Triumphal arch in Piazza Leopardi, Recanati, 1937. *Leopardi: Primo centenario della morte* (Recanti, 1938), between pages 38 and 39.

in the Fascist regime's efforts to appropriate the great figures of Italy's *literary* past. That the Fascists relied on the spectacle of mass rallies and on the creation of images and architectural forms in commemorations of poets reveals the importance of the visual arts and of material culture in the representation of the past in Fascist Italy, even when that past was more literary than visual. This is all the more interesting as events like these not only celebrated individual poets but also forwarded arguments about the continuity of Italian cultural tradition and the connection between past and present—ideas not normally easy to represent visually. In seeking to explain the cultural politics that surrounded the celebration of Italy's cultural heroes, I offer a detailed examination of the specific techniques—rhetorical and discursive but also visual and symbolic—that were employed in order to link these poets to Fascism and to appropriate them for the regime.

In these celebrations, certain features of the statues and other visual elements communicated their political nature. For example, even beyond the presence of a *fasces* on Petrarch's monument, the statue itself gives the overall impression of the kind of monument normally reserved for military and political heroes: a large figure standing sternly, and surrounded by images of his deeds in bas-relief below. The structure, size, and realist style of the statue all call to mind late-nineteenth-century representations of the heroes of the Italian Risorgimento, perhaps even more than they recall the statues of Dante that were also common at the time. In the case of the Leopardi arch, the ancient Roman themes and symbols used to celebrate this nineteenth-century poet also had quite specific political meanings in 1937.

The political tone of the Petrarch and Leopardi commemorations was made even more explicit by the speakers at both events, especially through their focus on the poets' "political sides." As the main organizer of the Petrarch commemoration reminded Mussolini in one of his requests for support, the "Italy [of] Benito Mussolini admires in Petrarch, more than the sweet lay poet of love, the man who, in an immortal song against foreign anger, announced with inspired prophesy the unity, independence, [and] greatness of the Italian fatherland."[4] And although Leopardi is

most famous for his pained musings on loneliness, suicide, and the beauty of nature, the celebrations in his honor presented the poet above all as an ardent nationalist, by focusing on those works in which he expressed his patriotic feelings for Italy. As his relative Count Ettore Leopardi explained during the celebrations, "If [Leopardi] was the Poet of great human suffering, he was also, powerfully, the Singer of the Fatherland."[5]

Even after these events were over, a surprisingly intense and heavily politicized engagement with these two poets continued throughout the remainder of the Fascist period and throughout the whole of Italy. The 1937 celebration in Recanati was, for example, the culmination of a whole summer of Celebrazioni Leopardiane that had been conducted all over the country for the centenary of the poet's death. These included Royal Academy events in Rome and in Naples, the site of the poet's tomb, which was also the destination of a "national pilgrimage" on June 14.[6] In addition, individual commemorative events were held around the country—including a lecture series in Florence at which Giovanni Gentile himself expounded on the philosophy of Leopardi—and around the world, at Italian cultural institutes in Europe, the Americas, North Africa, and the Middle East.[7] The removal of Leopardi's tomb in 1939 from the Neapolitan neighborhood of Fuorigrotta to the more tranquil setting of the Parco Virgiliano, next to the tomb of the Latin poet Virgil, was another occasion for patriotic celebrations of the poet from Recanati. These included another meeting of the Royal Academy, at which the noted writer and academician Giovanni Papini explained the link between Virgil and Leopardi, both of whom "did not sing only the chaste silences of the moon . . . but also sang the glories of this Italy, young and eternal, of this Italy of poets and warriors, which was and will be always victorious."[8] Papini also attacked an unnamed French Jewish literary critic, whom he called a "frenchified Israelite" (*quell'infranciosato israelita*) for having questioned the "Italianness" of Leopardi, striking a note of anti-Semitism in keeping with the atmosphere created by the regime's new racial laws and growing closeness to Nazi Germany. An increasingly aggressive and warlike tone surrounding com-

memorations of Leopardi had been in evidence already in August 1938, when Mussolini agreed to name a battleship of the Italian navy after him.[9]

Petrarch did not even have an anniversary year during the Fascist era, but he was nonetheless the subject of celebrations of the most varied type. Arezzo's Convegno Petrarchesco, for example, was repeated every year until World War II, such that a "Petrarch Week" was a staple public event of every fall of the Fascist years after 1928. During the war, Petrarch was commemorated in ever stranger and more explicitly political ways. In a 1941 edition of a journal devoted to celebrating Italy's achievements in its African colonies, Petrarch's *Africa,* his Latin epic on the conquest of Carthage by Scipius Africanus, was cited as justification of Italy's eternal right to bring civilization to Africa through conquest. Seeking to give contemporary relevance to one of Petrarch's least read works, the author presented it as "the poem of the Italian nation which yet again is called by destiny to win the battle for its existence in North Africa." And in July of the previous year, a division of the Italian Army on its way to the front stopped in Arquà, near Padua, where the soldiers gathered before Petrarch's tomb to hear an inspirational lecture in which the poet was presented not as a poet, but as a man, as an Italian, and as a "precursor of the greatness and independence of our Fatherland."[10]

In order to understand the seemingly incongruous politicization under Fascism of two writers now remembered above all for their poetry on love and the emotional life, it is important to realize that even before the Fascist era Italian literary figures were highly politicized. Before Italy's national unification in 1861, what was optimistically called the peninsula's "common language" was central to early Italian nationalism and to arguments for national unification. Furthermore, after unification the apparent continuity of the Italian literary tradition from Dante to the present continued to be used as a cultural counterweight to the lack of any continuous political or social unity in the peninsula. Thus the heroes of this linguistic and literary tradition played perhaps an even greater role in Italy's nascent national identity than cultural luminaries did in

other nations. The Italian literary critic Carlo Dionisotti has explained that already in the late eighteenth century the luminaries of the Italian literary tradition were recast as "the new saints of the civil and national religion."[11] Based on the nationalist view of the relationship between culture (especially language) and the nation, a strong connection began to be drawn between literary-cultural heroes and nationalist pride. Like many political or cultural symbols, however, some of these figures ended up as sites of highly politicized debate. The fierce disagreements that marked the sixth centenary of Dante's death in 1921 offer a case in point, especially as they took place in the atmosphere of near civil war that characterized Italy after World War I.[12]

Under Fascism, however, commemorations of this kind aimed to remove great Italians—like Petrarch and Leopardi, or Dante, Machiavelli, Garibaldi, or Julius Caesar—from the field of competing interpretations that had existed in liberal Italy by linking them to Fascism and to the state in such a way as to fix their meaning. Indeed, the Fascists tried to crush debate of all sorts, as the new regime sought to suppress political and class conflict, replacing debate about work, politics, or culture—in parliament or on the streets—with absolute national unity behind the Duce. Internal divisions of class or region, like allegiances to different political parties, were to be replaced by a single, uniform nationalism, the meaning of which the Fascists worked to control, and thus to place beyond debate. They sought to do this in no small part by claiming for themselves alone the nationalist heritage of the Risorgimento, and indeed the whole tradition of Italian patriotism.[13] Celebrations like those for Petrarch and Leopardi aimed to tie Italy's outstanding cultural figures and key symbols of cultural nationalism firmly to Fascism, insuring that the tradition they represented, and the legitimacy and prestige they conferred, would apply exclusively to Mussolini's regime.

This process of appropriation worked in two main ways. First, the commemorations of Italy's national poets linked these cultural icons to the Fascist regime through the context or "form" in which they were celebrated. The mass character of these events, deployment of Fascist symbols,

and presence of Fascist political personages, as well as the participation of both state and Fascist party organizations in their planning, created an explicitly Fascist context for the commemorations. This context alone already linked these events and the figures they celebrated to the regime. Second, in addition to the "form" of the celebrations, their *content* appropriated the authors, as cultural symbols, for Fascism. That is, the specific things said of the poets, and the ways their words were made to participate in Fascist discourses on patriotism, the nation, history, and ancient Rome, were central to the "uses" to which they were put in events of this kind.

In a somewhat different manner, the distinction between form and content can help to interpret the specific functions performed by visual elements in these commemorations. For example, the statue and arch erected for Petrarch and Leopardi, respectively, provided symbol-laden rallying points for the celebrations themselves, helping to create the context that made the events' political meaning clear. The form or style of the monuments—for example, the Risorgimento style of the Petrarch monument or the

ancient Roman triumphalism of the Leopardi arch—also offered political messages about both poets. But both of these artifacts also contain specific iconographic and symbolic content that relates them to themes in Fascist rhetoric or visual language. This linked the poets to these symbols, as well as to the ideas and themes that they evoked.

A body of scholarly literature on public commemorative events interprets this type of Fascist engagement with the past in terms of the structure or "form" of these events, as opposed to their content. Scholarship on commemorations and festivals in general, and Fascist public events in particular, has been concerned with such issues as the political meaning of the use, or appropriation, of public space, and of the emphasis on organization in Fascist cultural activities.[14] Applying the tools of this scholarship helps to identify some of the "formal" techniques used to appropriate the figures of Petrarch and Leopardi.

The most widely diffused photograph of the inauguration of Arezzo's national monument to Petrarch offers several indications of this kind of "formal" appropriation (figure 82). The photo-

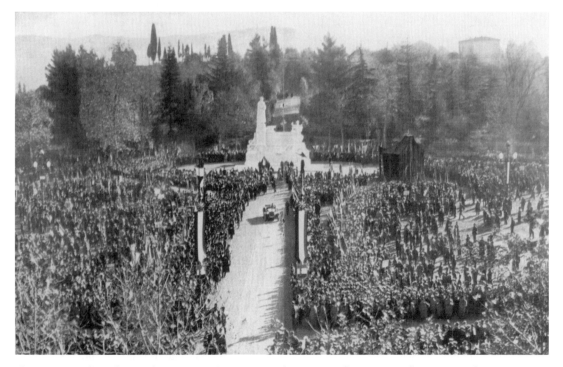

**Figure 82** Unveiling of Petrarch monument, Arezzo, November 1928. *L'Illustrazione Italiana*, 2 December 1928.

graph, taken from too far away to show the statue in any detail, mostly represents the crowd, thus highlighting the mass gathering that was successfully convened in honor of the poet. This image, which shows the crowd organized both hierarchically and "corporatively"—that is, by the professional, social, or paramilitary organizations (*corporazioni*) to which the assembled individuals belonged—evokes countless other images of the rallies, marches, and calls to order with which the Fascists laid claim to public space. But in this case a typically Fascist mass event honors the memory of a poet—a memory that was almost necessarily linked to the Fascist regime by the decidedly Fascist style in which it was celebrated. Indeed, that under Fascism commemorations of literary figures came to be celebrated as militaristic mass rallies was in itself a chief point of novelty with respect to their nineteenth-century counterparts.

A less forceful, but still important, interpretation derived from the literature on Fascist cultural politics might argue that through events such as these the regime used cultural figures as a pretext for mobilizing the people. Thus the inauguration of the Petrarch monument, or the Leopardi arch, could be seen as having provided an occasion, much like any other, for calling to order the uniformed masses, creating "Fascist spectacle," and appropriating public space on behalf of the regime.[15] The same photograph from Arezzo suggests that even poets could be used as a fulcrum around which to organize recognizably "Fascist" spectacles, which could then be photographically reproduced and mass distributed.[16] In this case, however, the diffusion of such images was also a means of popularizing a new symbolic role for Petrarch himself. This image presents him as a national hero, not merely a love poet or scholar, whose memory is suitably honored through celebrations like those for a military hero or a political figure. That the disciplined celebration in this photograph is recognizably "Fascist" claims the nineteenth-century nationalist cult of Italy's literary greats for the Fascist regime. It also demonstrates the Fascists' success in involving the masses in events of this kind, thereby using the nation's shared cultural past to create a national unity and community that had eluded Italy's liberal regime. An image like this suggested that

through such events, Fascism was bridging, on a cultural level, the deep divisions between state, elite, and masses that had plagued Italian social, cultural, and political life since unification.[17] That the king of Italy was present at this event only added to the multivalent character of the patriotic, cultural-nationalist, monarchist, and Fascist celebration. Ultimately, as speakers at the event and articles in the press made clear, credit for this new unity and vigor in honoring Italy's cultural heritage was due above all to Mussolini and his regime.

The presence at Leopardi's centenary festivities of Education Minister Bottai and the plenary session of Italy's Royal Academy performed a similar type of "formal appropriation." In addition to demonstrating the regime's seriousness about honoring the national cultural tradition, Bottai's attendance and the convening of the Academy associated the highest levels of the Fascist cultural apparatus specifically with one of Italy's great cultural and patriotic heroes. If Bottai and the academicians honored Leopardi with their presence, they themselves were also honored and legitimated by linking themselves to the powerful cultural capital of Giacomo Leopardi. The image of Bottai leading a massive and largely uniformed crowd though Piazza Leopardi (figure 83) furthermore blended the importance of his visit with a Fascist mass spectacle like the one organized earlier in Arezzo.

However, the specificity of this particular engagement with the past—the celebration of Italy's literary and cultural heritage—can best be appreciated through an approach that adds a discussion of content-based means of appropriation to the rich literature on what I have called "form." An analysis of the texts, images, and structures left behind by these celebrations—the speeches given at the celebrations, journalistic coverage and photographic record of them, commemorative volumes, and architecture and monuments built for these occasions—shows several ways in which these authors were made useful for Fascism.

One fruitful way of understanding the "content" of these celebrations is through close attention to the texts produced for them. These texts make claims about the poets and their work, and they do so with a particular language and

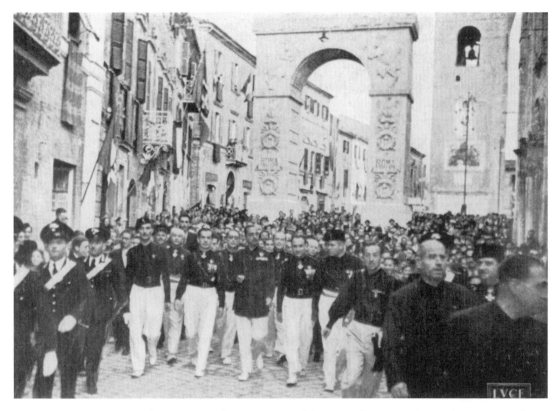

**Figure 83** Giuseppe Bottai with procession at the inauguration of the Leopardi centenary, Recanati, 1937. *Leopardi: Primo centenario* (Recanti, 1938), between pages 60 and 61.

rhetoric, all of which works to link the poets to Fascism. These textual techniques of appropriation are often paralleled by analogous visual ones, as for example through the symbolism with which these poet-symbols were represented. Furthermore, many of the same visual elements that established a "Fascist context" also have their own symbolic content and assumed particular valences with respect to the historical, literary, and cultural-symbolic figures of Petrarch and Leopardi.

The first and most purely "textual" of these strategies of appropriation is the use of characteristically Fascist language to discuss these poets. Many of the commemorative speeches and publications sounded the rhetorical notes of youth, action, faith, sacrifice, renewal, and redemption. These and several other tropes were drawn from a vocabulary of concepts and phrases that were associated with the Fascists. For example, in a speech discussing Petrarch's im-

portant role in the revival of the Latin classics, the event's local organizer and INCF leader Eugenio Coselschi described what Petrarch drew from the classical tradition in the following terms:

> No longer the sterile knowledge of beginners, no longer abstract formulas, but our very life, but the supreme reasons of life, but the bases of action, but the surest foundations for taking up again, in the new age, the paths of ancient glory, adapting them to the more rapid step of the new generations. To the men of his time He showed, in classical culture, in the Latin ideal, an unsurpassable model of power and of victory.[18]

In this one febrile paragraph on Petrarch, Coselschi mentions a new age and ancient glory, "life" and "action," a new generation with a faster pace, the "ideal" of ancient Rome, "power," and "victory." Without examining in detail the types and meanings of Fascist rhetoric, one recognizes that these phrases were a means of updating Pe-

trarch, of discussing him in the vitalist language characteristic of Fascism in order to show his applicability to the new Fascist era. Only under Fascism, it seems, could one describe Petrarch's work in classical philology as having adapted "the paths of ancient glory" to the "more rapid step of the new generations."

In Recanati, the city's mayor, Emilio Piccinini, explained the contemporary relevance of Leopardi by noting the virility and sense of sacrifice that he saw exalted by the poet: "He lives always in the destiny of the Fatherland and is alive indeed today, in which, in the development of events, are required virility of proposals, spirit of sacrifice, virtues proudly exalted by the Poet who from his infinite suffering, with spirit of rebellion, derived ever new resistance."[19] Again, language and ideas typically associated with the Fascists—virility, sacrifice, rebellion, and a rhetoric of force that borders on violence—are here applied to the poet, implicitly establishing a parallel between Leopardi and Fascism.

In Giovanni Papini's commemorative essay on Leopardi of 1939, the academician deployed a similar if more explicit rhetorical strategy, insisting at length on the tropes of youth, vitality, and Catholic faith in his presentation of the poet, and even linking these concepts to the idea of Italy itself. Combining a declaration of Italy's essential qualities with an attack on the materialism of an "old," French intellectual tradition, Papini declared that "the materialist enlightenment of France . . . took from the youth his faith in God and thus his faith in man and his destiny. . . . The dry rationalism of the French atheists made his spirit bitter and diffident, that is, old."[20] Now, however, in an Italy freed from this foreign influence, the poet can be separated from his world-weariness and his firmly avowed atheism. Italians, Papini suggests, can now appreciate that "Leopardi . . . signifies and represents poetry and youth, and we have always known, and today we know even better, that poetry and youth are among the most happy synonyms of the word Italy, and in particular of the Italy of today. It is precisely for this that Fascist Italy has honored and honors the ever young Italian poet Giacomo Leopardi."[21] Even for those of his listeners unable to appreciate the breadth of Papini's

Catholic, nationalist, and Fascist attack on the Enlightenment, the Leopardi who is presented is not only wrapped in the flag but also bathed in the aura of youth, novelty, and faith so essential to the myth and rhetoric of Fascism.

A similar appropriation by association can be seen in the deployment of Fascist symbols and iconography in the images produced for these commemorations, in the statues created for them, and in the events themselves. In a handbill for the Petrarch *onoranze,* an image of the poet is flanked by the seal of the Italian monarch and an image of the *fascio* (figure 84).[22] A stamp edition prepared in honor of Leopardi well before his anniversary year performed the same juxtaposition, framing a portrait of the melancholy poet with a *fascio* on each side.[23] Such images presented the symbol of the national poet together with the symbolic "language" of Fascism. Fascist iconography was also present in commemorative structures, such as the Petrarch monument or the temporary architecture erected in Recanati for the Leopardi commemoration. Furthermore, the regime symbols that clearly marked both structures also had specific content relevant to the poets. For example, in addition to standing for Fascism, the *fascio* itself, of course, also referred to ancient Rome, which was central to the Fascists' presentation of both these poets.

A second and more direct means of associating Petrarch and Leopardi to the regime was the argument, made with remarkable frequency by speakers at the celebrations and authors of commemorative articles, that the Italy of Fascism was the strong, free Italy of which these authors had dreamed. Long dead cultural figures were thus portrayed as would-be supporters of the regime, while the poets themselves took on new significance as "prophets" of the glory that Italy had achieved through Fascism. Count Ettore Leopardi stated this unequivocally in a speech in which he presented the Leopardi family's gift of the library and manuscripts of the poet to "the Fascist State, which has realized the idea and the prophecy expressed by the Poet in his patriotic songs." In the *Corriere Adriatico,* a local newspaper whose front page was dominated by the Leopardi events, one of the many articles on the celebrations expressed a similar sentiment, re-

Figure 84   Handbill, *Onoranze a Francesco Petrarca*, Arezzo, 1928. ACS PCM 1928–30, 14-2-1526.

porting that "Recanati lives its hour of glory" because the celebration of Leopardi "is taking place in that atmosphere of national power and strength that was the unique aspiration of the Poet."[24]

The view of these poets as prophets of a future national greatness was a common and frequently repeated idea. In the case of Petrarch, this view was even exploited in the telegram to Mussolini seeking support for the celebration in Arezzo, which declared that Petrarch "announced with inspired prophesy the unity, independence, [and] greatness of the Italian fatherland."[25] At Arquà in 1940, the auto-transport division "Torino" was told that Petrarch's status as prophet gave an almost religious significance to the memory of the poet: "Today, o soldiers of Italy, our Fatherland has leapt unanimously towards the bloody conquest of its certain future. It is a future marked by God through the centuries; and the memory of Petrarch, who predicted it, ac-

quires for us today the value of a rite." Turning to the present, the speaker explained that the realization of Petrarch's *profezia* was owed "to another great Italian, to an Italian of our generation, to the new tribune of Rome: through him Rome has risen anew! . . . It is he who . . . has dared to realize in one blow the ideal of our poets." Abandoning the allusiveness of his veiled reference to Mussolini, the speaker went so far as to declare that in the twenty years since the Duce had seized power, Italy had "indeed come to be seated as a great and powerful queen among the civilized Nations, such that if Petrarch were to return to life he would not fail to epically sing her glories."[26]

In addition to these explicit declarations about the poets' desires, Petrarch and Leopardi were also connected to the regime in ways that were at once more subtle and more specific. By highlighting particular aspects of these poets' thought or work that were amenable to Fascist ideology or policy, many of the texts and some of the visual materials associated with the commemorations drew connections between these authors and the ideology, rhetoric, and goals of the Fascist regime. Both poets were made to appear to stand for, or to support, particular ideas and policies associated with the regime, including views on nationalism, history, and even foreign policy. For example, by emphasizing Petrarch's and Leopardi's love of Italy, these celebrations advanced an argument about the "national" quality of these poets, both of whom lived well before the birth of the Italian nation-state. Their works were cited as evidence of the "spiritual" existence of the Italian nation before political unification, and the poets themselves were presented as distinguished precedents of the Fascists' celebration of Italian national greatness. For example, at the Petrarch commemorations, Eugenio Coselschi anachronistically praised the poet for his "recognition of Italy as a political unit." Likewise, in a commemorative speech on "Leopardi and the Nation" in 1934, Emilio Bodrero argued that Leopardi's patriotic songs (such as his "All'Italia" of 1818) "represent the first, highest, specifically national accent to be sounded in our country at the dawn of the Risorgimento."[27]

Indeed, the Fascists emphasized the patrio-

tism of both poets, even though Leopardi and Petrarch devoted relatively little of their poetry to their political feelings. The text of a plaque unveiled for the Leopardi centenary in Recanati's town hall suggests that the organizers recognized this, and yet sought to work around it: "To Giacomo Leopardi / who even among immortal songs of pain / exalted / the greatness and the hope / of the fatherland / [from] the victorious Italy of Mussolini."[28] Recognizing the same problem in Petrarch, the literary critic Vittorio Cian told the audience at the Convegno Petrarchesco, "I believe that many admirers of [Petrarch's] *Canzoniere* would join me in willingly renouncing some of the many sonnets that sigh with love for Laura, so as to have, in exchange, illuminated and commented in other sonnets pulsating with Roman memory and with prophecy, the events, which then were sadly elusive, of Italian history."[29]

Specific thematic linkages of this kind were also established visually, as for example in Arezzo's national monument to Petrarch. In addition to the images of a heroic male nude, a young woman with a baby, and the she-wolf with Rome's founders, Romulus and Remus (figures 79 and 80), the monument includes the words "Our Leader Rome" (*il nostro capo Roma*), a line from Petrarch's patriotic song "Spirto gentil," (*Canzoniere* LIII). Thus the standing hooded figure of the poet is linked through these surrounding symbols to the valorization of physical strength and athletics, the encouragement of fertility, the reinforcement of traditional gender roles, and the Fascist celebration of ancient Rome. This last point is emphasized both visually and textually on the monument itself. Least subtly, the statue also included a *fascio,* prominently displayed on the base of the sculptural group—a detail that has since been removed.

Petrarch and Leopardi were also tied in this manner to Fascist discourses and symbolism related to the representation of history. For example, in texts emphasizing the love these authors nurtured for Italy's "ancient glory," Fascist writers cast both poets as participants in the larger Fascist discourse on *romanità,* through which the Fascists celebrated ancient (especially imperial) Rome and sought historical legitimacy and justi-

fication for their chauvinist and imperialist policies. The visual "language" used to celebrate Petrarch and Leopardi also inserted both of these post-Roman figures into what could be called the symbolic system of *romanità.* Symbols like the *fasci* that appear with portraits of the poets, or the she-wolf on Petrarch's statue, were matched or even surpassed by the full-scale Roman triumphal arch erected in Recanati on the occasion of Leopoldo's centenary. These are not merely examples of local cultural leaders having found an "excuse" for the display of some of the regime's favored symbols. Rather, this deployment of the rhetoric and symbolism of *romanità* to celebrate these two poets called attention specifically to Petrarch's and Leopardi's cult of ancient Rome, an aspect of these poets' work that Fascist cultural organizers were keen to emphasize. Furthermore, in texts that highlighted the poets' roles in later historical movements of Italian "rebirth," such as Petrarch's link to the Renaissance or Leopardi's connection to the Risorgimento, both poets were presented as forerunners of the historically conclusive regeneration of Italy achieved by Fascism itself.

Indeed, the frequency of references to ancient Rome in these commemorations highlights what was in fact a crucial means by which the two poets were made useful for Fascism. By presenting Petrarch and Leopardi above all through the terms and symbols of the Roman past and the Fascist present, rather than in the historical context of the periods in which they lived, these celebrations assigned both poets curious but significant roles in a Fascist narrative of Italian history. This narrative sought to portray Fascism as the organic and legitimate outcome of an Italian national story that had begun in ancient Rome and had reached its culmination through Fascism. During the Leopardi commemorations, the *Corriere Adriatico* summed up this idea, referring to the Fascist revolution as the *Rivoluzione conclusiva,* which culminated not only the "incomplete revolution" of the Risorgimento, but Italian history itself, "realizing all the aspirations of poets and heroes."[30] On the other hand, Fascism's "completion" of Italian history rested, according to this view, on its success in reviving the spirit and power of ancient Rome. Thus the presenta-

tion of these postclassical poets through the language and symbolism of *romanità* revealed a view of history that is both teleological and cyclical at once, for it is precisely through the Fascists' revival of the past that the nation achieved its historical culmination.

Figures like Petrarch or Leopardi, who wrote poetry that celebrated ancient Rome and linked this celebration to an idea (however vague) of "Italy," were thus ideal for presentation as precursors of the Fascist revival of Rome. At the same time, that revival became the standard through which to understand previous historical encounters with the Roman era and the classical tradition. From the vantage point of Fascism, Petrarch's and Leopardi's engagements with ancient Rome represented milestones (*tappe*) on a kind of predetermined path of Roman revival in Italian history, which Fascism itself had finally completed.

In discussions of Petrarch—the great humanist, lover of the classics, and tremendous enthusiast for ancient Rome—this connection was made with particular frequency. Petrarch's role in reviving the classics, and thus in "starting" the Italian Renaissance, was presented as a foreshadowing of the Fascists' similar efforts at Roman revival. Petrarch's classicism was also explicitly coupled with his supposed role in presaging or calling for Italian national unity. Pierre de Nolhac, a distinguished French *petrarchista* and guest of honor at Arezzo's *onoranze,* summed up this idea by calling Petrarch the "great father of the Fatherland and of *romanità.*"[31] In Ignazio Colli's discussion of the contemporary significance of Petrarch's *Africa*, the author ties Petrarch's identification with the classical world to his role as spiritual founder of a new Italy: "With Petrarch . . . begins the new Italy that feels itself Roman and Latin and reacquires consciousness of having a mission of intellectual and political supremacy over the other peoples of the Earth."[32] Thus Petrarch's Italian patriotism was emphasized in direct connection to his love of ancient Rome. Assigning this political significance to Petrarch's classicism suggested that just as Petrarch's rediscovery of Rome led Italy to the Renaissance, so Fascism's rediscovery of Rome was leading to another period of Italian rebirth. The insistence

on the importance of ancient Rome to Petrarch also helps explain visual representations that couple his image with the iconography of *romanità.* The *fasci* and she-wolves not only served as markers of the regime that honored the poet; they also visually linked Petrarch to the notion, stressed in commemorative texts, that Petrarch was to be imagined and understood above all in terms of his love for and revival of ancient Rome. The symbols helped create a visual binomial—Petrarch/Rome—which reinforced one of the dominant messages of the speeches and texts.

Contemporary discussions of Leopardi made even more explicit connections between ancient Rome and contemporary Italy. An article on the Leopardi celebrations in the *Corriere Adriatico* explained that Leopardi's importance lay not only in poetry but also in politics—a role assigned to him on the basis of his love of Rome. This love, readers were told, made him an important precursor to the resurrection of empire under Fascism: "Giacomo Leopardi leaps into the history of poetry in so far as he was a poet and he leaps even more powerfully into political history not only for his [patriotic] songs but because He turned his attention to Rome, and marked, after the Renaissance, the second step on the Imperial path."[33] Leopardi then followed Petrarch as another precursor of the messianic Roman revival that had now been achieved by Fascism.

The references to "empire" at the Leopardi commemorations of 1937 had a particular relevance in the context of the declaration of the Italian Empire in October 1936 following the Italian conquest of Ethiopia. Mussolini himself frequently emphasized the connection between imperial Rome and Italy's new empire. In addition to the speeches at the commemoration in Recanati, the huge triumphal arch erected in Recanati's Piazza Leopardi for the occasion similarly emphasized the link between Leopardi's love of ancient Rome and contemporary political events. Built in preparation for a visit from Mussolini, who ultimately did not attend, this arch did not portray or even refer to Leopardi, but was adorned instead with eagles, lions, *fasci,* imperial Roman standards, and the repeated title "DVCE DVCE DVCE DVCE." Recanati's celebration of its greatest cul-

tural hero was to serve also as a way of honoring the Duce and, through this kind of imperial Roman iconography, his new Roman-Italian Empire. At the same time, Recanati's local elites used Leopardi to enhance their own status. Leopardi was the most important link that this small provincial community had to the national agenda, offering its citizens a claim to a cultural-political significance far greater than the town's size or history would otherwise have allowed. By linking Leopardi's love of Rome to Mussolini's "Roman" Empire, Recanati was able to celebrate high culture and violent conquest in the same breath, while helping to portray Fascist violence in Africa as the fulfillment of one of Italy's greatest cultural traditions.

The organizers of the Petrarch and Leopardi commemorations were thus less interested in providing a historical context in which to understand these poets as they were in making them understandable in terms of the present. When the poets' own historical periods were discussed at these events, their eras were invariably presented negatively, as dark or decadent moments against which these timeless leaders rebelled. Opening Arezzo's 1928 Petrarch conference, Eugenio Coselschi stated that Petrarch alone had liberated the grandeur of Rome from the "incrustations" of medieval scholasticism. Similarly, in 1937, the *Corriere Adriatico* contended that Leopardi had dreamed of Italy's deliverance from "the 'sick' century" in which he lived and struggled.[34] These attacks on the eras in which the poets lived worked together with the constant emphasis on their connections to Rome to cast the two as prophets of renewal and rebellion against a debased time—just as Fascism led a "Roman" revolt against liberalism. In this way, these authors were actually lifted out of their periods and made understandable and relevant in light of no era so much as the Fascist present.[35]

Several speakers at both commemorations argued precisely that only in the environment of national power and grandeur brought about by Fascism were Italians finally able to understand—and be worthy of—their great forebears. Some of these discussions struck a poignant note about the embarrassment of having had to confront these great Italians from a position of na-

tional weakness, unable to live up to one's great ancestors. Fascism, by making Italy strong, was thus credited with having changed the very nature of Italians' engagement with their own cultural heritage, which now, finally, they were able to confront with pride rather than shame. In the conclusion of his speech at the Convegno Petrarchesco, Nicola Zingarelli contended that in Petrarch's own time, "no one would have known then how to penetrate into his soul, see the treasure resting there, appropriate it, [and] spend it." Now, however, strengthened by Fascism, Italians could reunite "worthily, without feeling themselves humiliated, . . . with the great spirits with whom [Petrarch] lived in spirit at all times." Fascism enabled Italians to see what was best in Petrarch and to make it their own—or, as Zingarelli said, *appropriarselo*.[36] In the 1937 Leopardi commemorations in Naples, Ettore Romagnoli likewise stated that Leopardi's affirmation of "the Genius of Italy" through his poetry was a gift to the fatherland "that we can completely appreciate only in this our era of rebirth." Addressing the poet himself, Romagnoli continued, "This is the Italy that can understand you: because this is the Italy that you dreamt of, that you hoped for (*auspicavi*) in your youthful song."[37]

Although speakers at Petrarch's celebrations in the late 1920s saw the general atmosphere of national strength under Fascism as having endowed the poet with new relevance, after 1936 both Petrarch and Leopardi acquired a more specific significance in the context of the Fascist regime's re-creation of a "Roman" Empire through the conquest of Ethiopia. This imperial connection was made in particular in discussions of Petrarch's epic poem *Africa,* interest in which grew markedly after 1936. In a 1940 commemorative speech, Arturo Marpicati, vice president of the Italy's Royal Academy and later director of the INCF, declared that Petrarch's *Africa* was newly relevant or, as he said, had "returned to youth . . . precisely because of the return of the new Italy into the Africa of the Scipios."[38] Through this somewhat circuitous manner then, both poets were read "backward" in terms of Rome as part of an effort to read them "forward" in terms of Fascism—even to the point that a fourteenth-century poet with a deep love for the

classics became tied to Mussolini's foreign policy initiatives. This link between Petrarch and war in Africa recalls the way that Recanati's celebration of the Leopardi centenary used visual references to ancient Rome to blend the commemoration of its poet with an exaltation of Mussolini's new empire.

This oddly ahistorical presentation of historical figures can be seen as part of a larger pattern in the presentation of the Italian cultural tradition under Fascism. Victoria de Grazia, in her study of the Fascists' after-work leisure organization, the Dopolavoro, has called this pattern the "monumentalization of culture." Through the decontextualized celebration of individual "great Italians," de Grazia writes, "the national tradition was thus reduced to a roster of illustrious but essentially static and isolated cultural 'monuments': Dante, Goldoni, Manzoni, Verdi, Puccini, D'Annunzio—an eclectic mixture, united solely by their similar packaging and consistent presentation to the public."[39] This notion of "monumentalization" seems to apply well to both cases I have examined in this chapter. Both poets were presented precisely as decontextualized symbols of Italian cultural greatness, whose historical role was presented—if at all—only as prefigurations of Fascism's final accomplishment of Roman rebirth.

On the other hand, the texts of the speeches and publications devoted to both poets provide elements of a more defined, if still impressionistic, narrative of Italian cultural history. Many of these elements—the concern with ancient Rome, the use of metaphors of rebirth, and the presentation of preunification figures as unequivocally "Italian"— were stressed in celebrations of other Italian cultural heroes as well. In this way these commemorations presented a narrative of Italian cultural greatness, in which ancient Rome became the key to a reinterpretation of the continuity of Italian culture from Petrarch to Mussolini. As Arturo Marpicati explained in an essay on the theme of Rome in Petrarch's work, Petrarch's desire that modern Italy return to the greatness of ancient Rome is the central idea that links all of Italy's greatest national poets and thinkers. For Marpicati, this desire was also expressed in the deeds and words of Mussolini: "[Petrarch's] voice echoes through the centuries, and we find him in

the company of Machiavelli and Alfieri, of Foscolo and Gioberti, of Leopardi and Carducci; we hear him and we see him to be present in this glorious and continual *restauratio Urbis* of Mussolini, of whom specifically several speeches on Roman subjects seem indeed a brilliant synthesis and a high political comment on the petrarchan songs and poems."[40]

Marpicati's words provide evidence that the presentation of these poets as more or less empty "monuments" of Italian greatness coexisted with another construction in which they appeared as forefathers of specific aspects of Fascist ideology and even foreign policy. The first of these modes of presentation helps explain the long list of seemingly unrelated poets, painters, composers, and other cultural figures who were officially celebrated during the Fascist era. The generally nationalist nature of this type of appropriation meant that almost any great Italian would do. On the other hand, the requirements of Fascist ideology meant that some cultural figures were more useful than others, as in the case of Petrarch and Leopardi. Above all, Petrarch and Leopardi stood for the continuity of the desire that Italy become worthy of its glorious past—a desire embraced in earnest by their Fascist celebrators in Arezzo and Recanati. This desire stood at the root of the project of Italian cultural nationalism that was born in the nineteenth century and that died, along with Fascism, in the 1940s.

These ideological requirements help account for some of the fairly bizarre or flatly incorrect ways that these authors were presented: Leopardi, the melancholy scribe of odes to the moon, as a sort of Bergsonian vitalist, or Petrarch, whose many letters to the Holy Roman emperor begging him to return the seat of empire to Rome, as having desired a strong Italian nation-state in some modern sense. Some of these juxtapositions seem so out of place as to appear almost comic, like the connection between a fourteenth-century humanist and the Italian right to conquest in Africa, or the idea of naming a battleship for a sickly, hunchbacked poet like Leopardi. But connections like these need to be understood in the context of the long-standing political importance of these poets as cultural symbols. Furthermore, they must be viewed in light of the argument,

popular in nineteenth- and early twentieth-century Italy, that the greatness of Italy's high cultural tradition legitimated Italy's aspirations to statehood and, later, to a position of political and military power in Europe, the Mediterranean, and the world.

We have seen that commemorations for both of these poets emphasized the notion that the greatness of Italian culture justified Italian power, as for example when one writer declared that Petrarch helped make clear Italy's "mission of intellectual and political supremacy over the other peoples of the Earth."[41] The Roman arch used in Recanati to celebrate Italian conquest at the same time as it honored the memory of Leopardi sug-gested the same connection through visual means. By way of conclusion, I suggest that this link between nationalist celebrations of high culture and nationalist or imperialist violence should not be overlooked. It helps explain why scholars, writers, and cultural organizers saw fit to draw a connection between Petrarch and war in Africa, and why the idea of naming a battleship for Leopardi did not seem ridiculous to the mayor of Recanati, or Bottai, or Mussolini. It helps make clear that even in the case of commemorations for poets, the violence at the heart of Italy's catastrophic experiment with Fascism was never far from the surface, and cannot be forgotten or aestheticized away.

# The Return of the Repressed

## Tradition as Myth in Futurist Fascism

*Christine Poggi*

*Unfurl the Futurist banner! Ever higher, to exalt the aggressive, forgetful will of man, and to affirm once again the ridiculous nullity of nostalgic memory, of myopic history and the dead past.*

—F. T. Marinetti, "The Birth of a Futurist Aesthetic," 1911

*These twenty years of work have created in the generations of youth a consciousness in harmony with this time—the triumph of the principles of Futurism has attenuated the need for that polemical intransigence that was necessary in the hostile prewar atmosphere.*

*This is why we approach art today with a changed spirit (in comparison to the first Futurists), no longer obsessed with the anxiety of inventiveness, but already rich in "our" tradition. We approach art with constructive goals, more liberated than before from the weight of the past.*

—Fillia, "Landscape in Futurist Painting," 1930

IN THE NEARLY TWENTY YEARS that separate these two statements, Futurism evolved from a subversive avant-garde movement that advocated total rupture with tradition, to one that sought to reestablish a certain harmony between the past and present. During the intervening period, Italy experienced World War I, its aftermath of social turmoil and labor strikes, and the advent of Fascism. Although originally libertarian and

anarchist in its political views, Futurism eventually cast its lot with Fascism, seeing in it an acceptable "minimum program."[1] The two movements initially clashed in their attitudes toward tradition, the role of the state, the sanctity of the family, and religion. As the Futurists aligned themselves with the Fascists, however, they gradually sought to synthesize elements of their own more "revolutionary" stance with that of the regime.

The story told here will follow a particular thread in this complex history: that of the Futurist machine aesthetic and its vicissitudes under Fascism. For the Futurists, as for many other early twentieth century artists, the machine was the very emblem of modernity, the vehicle with which the past would be overthrown. Fetishized in works of art and literature, the machine displaced both the idealized woman and the religious icon, triumphing over those superseded divinities with its cold, hard, and metallic forms. By the later '20s, however, we witness the irruption of the never fully repressed contents—especially erotic desire and religious faith—into the very heart of the machine aesthetic. The strange effects of this uncanny return of tradition in postwar Futurism are not well-known, but nonetheless comprise a revealing chapter in its history.

IN ITS VIRULENT REJECTION of the past, Futurism opposed traditional forms of patriotic cultural regeneration. Rather than emulate the great artists of antiquity or the Renaissance, F. T.

Marinetti advocated flooding the museums;[2] rather than affirm the existing authority of the church or the state, his political program of 1913 envisioned the abolition of Parliament, and took a strongly anticlerical and antimonarchical stance. Italy's rebirth would not depend on historical revivals, but on an affirmation of the freedom of the individual, conceived as a Nietzschean superman who would be beyond social and moral constraints. The only principle to transcend this anarchic conception of the self was the demand for virile, bellicose patriotism, which Marinetti elevated to a supreme law.

It can only appear as a surprising contradiction then, that in the period following World War I many of the Futurists began to modify their former intransigence toward the institutions of the church and state, as well as toward the art and religious traditions of the past. For the prewar Futurists, the "criminal" connection between museum art and religious belief was axiomatic, and doubly to be rejected, because it fostered unquestioning veneration for timeworn dogmas and habits, and because it induced passive forms of contemplation. As the artist Umberto Boccioni stated programmatically in 1910:

> We want ruthlessly to combat religious fanaticism, unconscious snobism of the past, nourished by the dangerous existence of museums. We rebel against the supine admiration for old canvases, old statues, old objects and against the enthusiasm for all that is worm-eaten, filthy, corroded by time. We judge the habitual disdain for everything that is young, new, and pulsating with life, unjust and criminal.[3]

Innovations in artistic and literary forms—including collage, kinetic and multimedia sculpture, and free-word poetry—went hand in hand with the categorical rejection of traditional subjects, such as the nude, the femme fatale, tranquil landscapes, and religious themes. Instead, the Futurists favored the speeding automobile or train, the city under construction, rioting crowds, or the shattering brilliance of electric light. In a text of 1913, with the provocative title "Art of the Fantastic within the Sacred," Gino Severini explained that the subjects of Futurist art stood in direct opposition to those of Italian religious art:

rather than a *Descent from the Cross,* or an *Adoration of the Virgin,* the Futurists painted *An Argentine Tango* (Severini), *Electric Lamp* (Balla), and *The Galleria of Milan* (Carrà).[4] As the "primitives" of a new sensibility, the Futurists played a role analogous to that of the great Italian "primitive" masters of religious art in creating metaphysical art with a social role. But for Severini, Futurism had the advantage of being of its time, of appealing to current beliefs and contemporary experience. Rather than adore "puppets in wax, symbols of a false conception of creation and of human instinct," man would adore himself, as figured in symbols derived from the world of machines.[5]

Within the ahistoricist program of prewar Futurism, then, the machine accrued fetishistic properties and emerged as an object of displaced desire and veneration. Seemingly without a past, the machine provided an antidote to outmoded artistic subjects, forms, and techniques. If the traditional (female) nude was forbidden, an eroticized, overtly phallic machine would take its place; if Christianity was a matter of "puppets in wax," the machine would rise up as an avatar of human self-transcendence and godlike creativity. The Futurists admired the machine as a means of overcoming human limitations while emptying the individual of debilitating sentiments, such as romantic feeling, love of family, humanitarianism, or nostalgia for the past. Significantly, the Futurists did not celebrate the machine as productive tool or associate it with the increasingly organized political identity of the proletariat. For Marinetti, the machine was a vehicle for experiencing a heroic expansion of individual power as manifested in speed and record breaking:

> Ended now the need for wearisome and debasing labors. Intelligence finally reigns everywhere. Muscular work ceases to be servile, now having only three goals: hygiene, pleasure, and struggle—no longer needing to strive for his daily bread, man finally conceives the pure idea of the ascensional *record*. His will power and ambition grow immense.[6]

Marinetti's text extols the end of human drudgery, and indeed of labor, brought about by the development of new technologies that force

the earth to render its material resources and thereby signal the end of "the bitter social question."[7] His enthusiasm is especially roused by the explosive and inexhaustible energies tapped by electric plants, trains, airplanes, and the telegraph.

One of the prewar Futurists' greatest recurring fantasies was the creation of the man-machine hybrid, through which flesh would be fused with metal and the defects of the natural body, including fatigue and even death, would be overcome. During the late nineteenth century, physiologists and other scientists had investigated the mechanistic laws they believed governed inorganic and organic matter alike. Drawing on Rudolf Clausius's discovery of the second law of thermodynamics, which posits the irreversible destruction of energy within an isolated system (entropy), these scientists sought to analyze the expenditure of energy through the precise recording and measurement of movement. When applied to human beings, such analyses often had a prescriptive value, and could be put to use in the efficient management of factory labor or in military training.[8] In Italy, the prominent physiologist Angelo Mosso sought to pinpoint the onset of fatigue with his "ergograph," which allowed him to record the physical traces of repeated movements over time.[9] By the turn of the century, fatigue had replaced idleness as a focus of moral denunciation and scientific study.

Marinetti's response to this widespread discourse on the inevitability of entropy and fatigue was to celebrate the perennial creation of energy through the technical mastery of primordial forces: the wind, the sun, oceans, and electricity. In "Electrical War" he declares: "No vibration of life is lost, no mental energy is wasted. Electrical energy inexhaustibly obtained from heat or chemical energy."[10] Rather than seek inspiration in the altered mental states occasioned by fatigue or illness, as the decadent poets had, Marinetti envisioned the perfect coherence of an invincible, perfected body and the creative imagination it housed. The body itself could transcend the causes of debilitating fatigue, inertia, and passivity through fusion with the machine, with flesh becoming metal in a free interchange of whirring atomic particles. The volatility, speed, and trans-

formability of "matter," understood as an alternate form of energy, displaced the older, feminized term nature.[11] According to this view, the machine was understood as a triumph against the claims of nature, in which recurring cycles of time ultimately led to decay and death. The new man-machine hybrid would exemplify the Nietzschean process of self-overcoming, thereby launching the (noncyclical) drive to the future. Only through the repression of tradition, religious belief, and nature could Futurism imagine a world in which human freedom implied the full realization of the will to power. Heroically virile and militaristic, the Futurist "multiplied man" was impervious to the effeminizing affective bonds of the family as well. As Marinetti put it: "With us begins the reign of the man whose roots are cut, of the multiplied man who mixes himself with iron, who is fed by electricity and no longer understands anything except the lust for danger and daily heroism."[12]

Christian dogma and its moral values clearly were in conflict with this vision, and Marinetti lost no opportunity to denounce the church and its authority. In a manifesto of 1916 entitled "The New Religion-Morality of Speed," Marinetti declared that "Christian morality served to develop man's inner life. Today it has lost its reason for existing, because it has been emptied of all divinity."[13] Instead of Christian morality, he celebrated the experience of transcendence afforded by speed: "If prayer means communication with the divinity, running at high speed is a prayer. Holiness of wheels and rails. One must kneel on the tracks to pray to the divine velocity."[14]

Such ideas held sway even through the social upheavals of the immediate postwar period. They governed Marinetti's political alliance with Mussolini, which culminated in their standing together for election in 1919 with a platform that demanded the "devaticanization" of Italy.[15] In "Beyond Communism" of 1920, an essay that addresses the rise of an organized left in Italy, the Communist revolution in Russia, and the defeat of the Futurist/Fascist political program, Marinetti could still declare: "We want to free Italy from the Papacy, the Monarchy, the Senate, marriage, Parliament. We want to abolish standing armies, courts, police, and prisons, so that our race of gifted men may be able to develop the greatest

number of free, strong, hard-working, innovating, swift men."[16] By 1920, however, taking note of the voting strength of the Catholic *Partito Popolare* in 1919, Mussolini had opportunistically abandoned his denunciations of the church and of the monarchy. According to Marinetti, this reactionary turn in Mussolini's political strategy led him to withdraw from the Fascist Combatants Group in May 1920.[17] Although Marinetti had rejoined the party, he reminded Mussolini as late as 1924 of the glorious days of 1919, when Fascism had stood for individual freedom against the church and the monarchy. His remarks at the Milan Futurist Congress of November 1924, organized in his honor, were addressed to the Fascist leader:

> With a gesture of force by now indispensable, liberate yourself from Parliament. Restore to fascism and to Italy the marvelous spirit of 1919: disinterested, ardent, antisocialist, anticlerical, antimonarchical. Concede to the Monarchy only its provisional unifying function; refute that of suffocating and drugging the greatest, the most spirited, and the most just Italy of tomorrow. . . . Crush the anti-Italian, clerical opposition of Don Sturzo [of the *Partito Populare*], the anti-Italian socialist opposition of [Filippo] Turati . . . with an iron-willed, dynamic aristocracy of armed thought, to supplant the existing demagoguery of arms without thought.[18]

The strange vicissitudes of the Futurist machine aesthetic during this postwar period of political uncertainty and realignment are revealed in the "Manifesto of Futurist Mechanical Art," published by Ivo Pannaggi and Vinicio Paladini in 1922. The authors declare the machine to be the distinctive feature of modern life and the source of new and vital sensations: "*Gears* purify our eyes from the fog and from indecisiveness, everything is *sharper, decisive, aristocratic, distinct*. We feel mechanically and we feel ourselves constructed of steel, we too machines, we too mechanized by the atmosphere."[19] Despite their Communist sympathies, Pannaggi and Paladini emphasize the aristocratic quality of the sensations they seek, just as Marinetti had extolled "a dynamic aristocracy of armed thought" in his appeal to Mussolini. Two drawings accompanied

the manifesto when it was first published in *La Nuova Lacerba* (figure 85). Paladini contributed a "proletarian" man-machine constructed of rods, gears, cylinders, and other machine parts, while Pannaggi's work was ostensibly abstract, but composed of similar elements. If Paladini and Pannaggi shared Marinetti's vision of an aristocratic new machine culture, this was due to their fascination with the machine's promise of allowing men to transcend the desires and limitations of body. Paladini's proletarian man is already a Nietzschean superman: built of steel, he will never experience fatigue, weakness, or nostalgia. Nor will "feminine" sentiment or desire ever cloud his vision.[20] He is conceived as a conduit of energy, with gears ready to engage other gears, and cylinders leading to other mechanical elements; he remains a center or node, but one connected to the larger dynamic apparatus (industrial society). Although Paladini implies his proletarian man is one worker among many, he does not emphasize the productive or collective task to be carried out, but only notes the construction of a new, post-bourgeois type. Attention is focused on the body, its metallization, standardized anonymity, fragmentation into distinct though interconnected parts, and the interchangeability of these parts with the mechanical tools they employ. In a subsequent commentary on the machine aesthetic of 1923, Paladini clarifies that the art he envisions favors cold, eternal, and metallic geometries, rather than the radiant "liquefaction" of forms achieved in Impressionism. The surprising term he employs to describe this Futurist art of "indestructible equilibrium" is "classical."[21]

Paladini's remarks of 1923 were published in the May issue of *Noi*, edited by Enrico Prampolini. They appeared as a rejoinder to the greatly revised version of the "Manifesto of Futurist Mechanical Art" of 1922, which Prampolini also published in the same issue of *Noi*, adding his own signature to that of the original two authors. In appropriating Pannaggi and Paladini's earlier manifesto (without their permission), Prampolini sought to redefine its proposals, bringing them more in line with his own current thinking, and pointing to the direction the Futurist machine aesthetic would take in the '20s with the rise of Fascism. Between the publication of the original

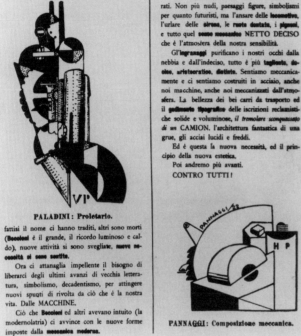

PANNAGGI e PALADINI

# Manifesto dell'arte meccanica futurista

Dal giorno in cui i primi manifesti futuristi furono lanciati, gli anni sono trascorsi pieni di lotte, sommersioni ed emersioni di vittorie ed amarezze di solitudine. Abbiamo lottato, alcuni

Oggi è la MACCHINA che distingue la no" stra epoca. Palegge e volani, buffeni e cilindere, tutte l'acciaio pulito ed il grasse adorante (profumo di azione delle centrali).

Ecco dove ci sentiamo irresistibilmente attirati. Non più nudi, paesaggi figure, simbolismi per quanto futuristi, ma l'ansare delle locomotive, l'urlare delle sirene, le ruote dentate, i pignoni, e tutto quel senso meccanico NETTO DECISO che è l'atmosfera della nostra sensibilità.

Gl'ingranaggi purificano i nostri occhi dalla nebbia e dall'indeciso, tutto è più tagliente, deciso, aristocratico, distinto. Sentiamo meccanicamente e ci sentiamo costruiti in acciaio, anche noi macchine, anche noi meccanizzati dall'atmosfera. La bellezza dei bei carri da trasporto ed il godimento tipografico delle iscrizioni reclamistiche solide e voluminose, il tremolare sconquassato di un CAMION. l'architettura fantastica di una grue, gli acciai lucidi e freddi.

Ed è questa la nuova necessità, ed il principio della nuova estetica.

Poi andremo più avanti.

CONTRO TUTTI!

**PALADINI: Proletario.**

fattisi il nome ci hanno traditi, altri sono morti (Boccioni è il grande, il ricordo luminoso e caldo), nuove attività si sono svegliate, nuove necessità si sono sentite.

Ora ci attanaglia impellente il bisogno di liberarci degli ultimi avanzi di vecchia letteratura, simbolismo, decadentismo, per attingere nuovi spunti di rivolta da ciò che è la nostra vita. Dalle MACCHINE.

Ciò che Boccioni ed altri avevano intuito (la modernolatria) ci avvince con le nuove forme imposte dalla meccanica moderna.

**PANNAGGI: Composizione meccanica.**

Figure 85  Ivo Pannaggi and Vinicio Paladini, "L'arte meccanica." *La Nuova Lacerba* 1 (20 June 1922): 7.

and later versions of the manifesto, Mussolini had accomplished his March on Rome and had installed himself in power. Significantly, the Prampolini version is dated Rome October 1922, no doubt in order to associate it with this "revolutionary" event. Indeed, this later version does register the impact of Fascism's victory in its turn toward more mystical and mystifying language, seeing in the machine "the most exuberant symbol of the mysterious human creative force." Yet the manifesto also clearly rejects the productivist thrust of Fascist (and Communist) ideology, in favor of a more heroic and "disinterested" relation to the machine. In terms that suggest the intervention of Marinetti, the manifesto declares: "We Futurists demand that the Machine tear itself away from its practical function, rise up in the spiritual and disinterested life of art, and become

a lofty and fertile muse."[22] It was not enough to celebrate the precise and coldly metallic harmonies of the machine, as described by Pannaggi and Paladini. For Prampolini (and Marinetti), one must penetrate beyond external appearances to express the machine's lyrical "interiority," its "spirit." The irony that attended Marinetti's 1916 description of the "new religion-morality of speed" seems to have disappeared under the pressure of the new political reality. The "Rome October 1922" version of the "Manifesto of Futurist Mechanical Art" concludes by elevating the machine to an object of religious (nonproductive, irrational) veneration; it echoes the Fascist quest for spirituality and hierarchy without embracing the Fascist support for the church. If prewar Futurism had emphasized man's mastery of the machine he had created in order to enhance his own

power and godlike status, postwar Futurism saw in the machine an autonomous, mysterious entity to whose authoritarian demands the human subject must submit: "The Machine is the new divinity that illuminates, dominates, distributes its gifts and punishes, in this our Futurist time that is devoted to the great Religion of the New."[23] That "this our Futurist time" was consonant with the new reality of Fascism and its own demands for a new divinity—to be located, however, primarily in the state—is also clear. As one young Fascist put it: "Fascism was presented to me, and I presented it to myself, as a total concept, a religion, a divinity all its own: the State, with its own supreme worship . . . ."[24]

Emilio Gentile has observed that during the period from 1923 to 1926, the government strongly emphasized the religious impulse within Fascism as a means of legitimizing its monopoly on patriotism, and therefore its claims to power.[25] In the words of its most influential ideologue, Giovanni Gentile, the state promoted "a cult born of the whole soul of the nation."[26] Despite certain points of resistance, by the mid-1920s most Futurists sought to define themselves as prototypical Fascists and to synthesize elements of their more libertarian and anticlerical program with the overtly spiritual and historicist cultural ideals of the regime. In the remaining part of this chapter I focus on the work of Fillia and on the Futurist leader's wife, Benedetta Cappa Marinetti (known simply as Benedetta), as paradigmatic of the contradictions and shifts that the embrace of Fascism imposed on Futurist artists. Yet the resurgence of spiritual themes, and even of Catholic religious imagery, in their work of the later '20s and '30s may also be interpreted as a response to the failure of Fascism to create an ideal world. The paintings of Fillia and Benedetta suggest a longing for an otherworldly utopia that Fascist Futurism could point to but never realize.

Luigi Colombo, who worked under the pseudonym Fillia, exemplifies the gradual transition from a "left," or politically revolutionary position, in the early '20s, to an enthusiastic embrace of Fascism by the later '20s. Like Paladini and Pannaggi, Fillia was associated with Communist circles in the early postwar period, and in

spring 1922 he contributed to $1 + 1 + 1 = 1$. Dynamite. Proletarian Poetry. Red + Black, a small collection of free-verse poems published anonymously by the Turin Institute of Proletarian Culture (a section of the International Proletkult of Moscow).[27] These poems exhort workers to revolutionary violence, both in order to avenge the injustices of the past and to achieve a society of equals. This new society, however, must be founded on the destruction of the past and the creation of a heroic collective will. One poem declares: "The atavistic cowardice of the slaves will change into a formidable dictatorship and we will burn and destroy everything that is linked with the present and the past."[28] In this brief moment of alliance between Communists and Futurists in Turin, the authors of $1 + 1 + 1 = 1$ define themselves as "against egoism and against religion."[29] Throughout the poems, machines, weapons, and electricity appear as metaphors for the power to destroy and to create anew, to be seized by the proletariat. "The instruments of your work are your weapons / the tools that you employ daily / to maintain in luxury / in vice / in pleasure / the parasites / (and in misery your children) / serve for their death."[30] Despite this emphasis on class war, the authors also extol the exuberance of youth and a revived, healthy patriotism in terms that would find favor with emerging Fascism.

All such calls to violence, and the association of machines with the arms of workers in open revolt, vanished by the mid-'20s, along with the fragile alliance of the Turin Futurists and the Communist Proletkult.[31] Precluded by Fascism (and by his own evolving ideological stance) from promoting the fusion of proletarian and avant-garde ideals, Fillia now aligned himself with the attitudes adumbrated by Prampolini's version of the "Manifesto of Futurist Mechanical Art." In that version the machine becomes an object, not of violent revolution, but of cultic (and erotic) veneration. In 1925 Fillia published a manifesto entitled "The Mechanical Idol," in which he asserts that the aesthetic of the machine, "adored and considered a symbol," had spiritual repercussions beyond the realm of art.[32] Understood as the "synthesis and summation of nature," the machine holds forth the promise of completing

arf

human evolution in the realization of a new world without lack: "We can therefore believe in a whole material and moral complex that will finally resolve human evolution with a definitive perfection."[33] Drawing perhaps on his earlier political affiliations, Fillia further argues that the machine aesthetic—more powerful and absolute than existing particular traditions—would be collective, impersonal, and universal, and therefore beyond the monopoly of any state.[34] The artist, endowed with the power of formal interpretation, would give concrete shape to spiritual ideals that emanated directly from the people. The "mechanical idol" would have an immediate and essential connection to society, fulfilling its dreams and aspirations.

Fillia's *Bicycle: Fusion of Landscape. Mechanical Idol* of about 1925 figures forth the imagined synthesis of mechanical and natural forces (figure 86). In his notes on this painting, Fillia emphasizes the fusion of the rider and his vehicle, an instance of the man-machine hybrid, and its function as the creative center of the image: "The machine and its rider represent an indivisible complex of mechanical forces that dominate the center of the picture: the volume and colors of the landscape depart from this center to expand according to the form of velocity."[35] Indeed the bicycle/rider motif seems to generate a set of overlapping concentric circles that evoke waves of expanding energy, while ordered rows of trees align diagonally with radiating force lines. A church, with its emblematic tower, appears in the distance at the upper left; its presence suggests an affinity between the function of the new idol and traditional religion.

Similarly, in *Mechanical Landscape,* of 1925, a centrally placed machine floats in space, usurp-

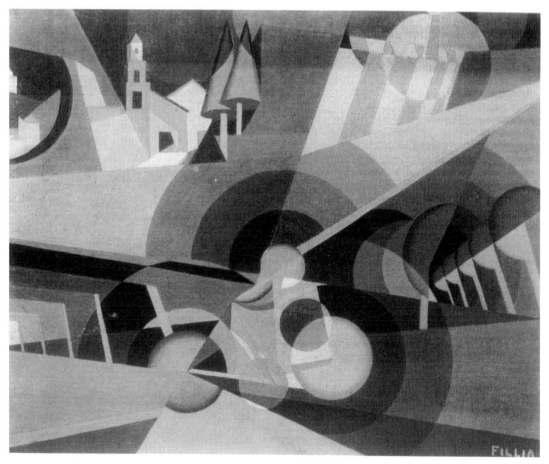

Figure 86 Fillia, *Bicycle: Fusion of Landscape. Mechanical Idol,* oil on cardboard, c. 1925. Massimo Carpi Collection, Rome.

Figure 87  Fillia, *Mechanical Landscape*, oil on canvas, 1925. Galleria Nazionale d'Arte Moderna e Contemporanea, Rome.

ing the position and role of religious imagery (figure 87). This strangely humanoid mechanical being hovers over a terrain that seems barren, although electric wires transmit the power generated by the "idol" to locations beyond the frame. In both paintings, then, the machine functions as a mystical godlike source of infinitely expanding energy that dominates and reorders the traditional landscape, transforming its irregular organic forms and rhythms into precisely rendered geometrical patterns. The softer, more fluid and decorative forms of Impressionism, now construed as feminine, are rejected in favor of what we might call "multiplied nature," a mechanized analogue of the "multiplied man." Both are taken to exemplify the new spiritual sensibility wrought by the advent of the machine, in which the traditionally understood human subject and its relation to the world are superseded:

> The "religion of velocity" and the "mechanical sensuality" clearly indicate the spiritual factors that, beyond simple aesthetic form, inevitably modify our thought and our senses. We affirm therefore that the MACHINE annuls the old spiritual and human world in its entirety to create another, superhuman and mechanical, where MAN loses his own individual superiority to merge with the environment.[36]

Despite this assertion of a desire for an oceanic experience of fusion with forces superior to the self, Fillia also continues to emphasize the magnified power of the man-machine hybrid over the environment, at times invoking "violent possession of the atmosphere."[37] A hierarchical order, in which the mechanical idol dominates its world, is always preserved. Moreover, the viewer is encouraged to imagine the psychic accord of man and machine, attributing spiritual significance to his experience, as an instance of the technological sublime. According to Fillia, the viewer of *Bicycle* does not receive the impression of a merely speeding object, but of the "spiritual importance" of velocity for the rider. The image, understood as a rigorously constructed machine in its own right, is to be centered and expansive simultaneously, and to inspire a strange form of devotion mingled with "an atmosphere of sensuality"—the new virile, metallic sensuality that Fillia also celebrates in his novels.[38] In his poetry collection *Lussuria radioelettrica: Poesie meccaniche* (Radioelectric Lust: Mechanical Poems) of 1925, Fillia treats this familiar Futurist theme with a deliberately ironic, even absurdist, tone. One of the poems, "Futurist Adultery," centers on a "he" who betrays a "she" by running off with "the thin, feminine and extremely seductive body of a metallic bicycle."[39] But the effort to defeat the claims of sexual desire, to become more machinelike, cold, and metallic, is real enough. Even Fillia's irony might be understood in this light as a mode of achieving emotional detachment. The "spiritual" union of man

and bicycle implies the sublimation of erotic feeling, and its transformation into an ego-shattering experience of dispersal that is simultaneously expansive and heroicizing. Hence the unstable oscillation between, and fusion of, the seemingly opposed meanings of a "idol"—religious and erotic—in these works.

Fillia enhances the religious connotations of his machine idols through stylistic references to selected examples of the spiritual art of the past. In *Mechanical Landscape,* the static frontality of the centralized image, its abstracted background, and rigid geometry evoke not only the world of the machine but also the formal character of a Byzantine icon, in however reductive and schematic a form. Even the glowing semicircular form around the head suggests a halo. Such allusions are clearly intentional, despite Fillia's ostensibly secular, even blasphemous, subject. In an essay of 1931 titled "Futurist Spirituality," Fillia declares that only the arts of Egypt, the high medieval period, and Byzantium are alive in the present, because they were created in an atmosphere of pure religiosity. By contrast, Greco-Roman and Renaissance art aimed only for immediate sensuous beauty and idealization, and therefore represent spiritual decadence.[40] Rather than see in the machine the culmination of reason and of streamlined, functional forms, as most other advocates of the machine aesthetic did,[41] Fillia emphasizes its irrational and transcendent qualities: "To sum up: mechanical civilization . . . is not a purely material phenomenon. Mechanical civilization generates an atmosphere of mystery, of the unknown, of the unpredictable; it has all the characteristics of a force superior to all human logic that directs and dominates our life."[42]

Such a view clearly was intended to divorce the machine from its role as a tool of material production within industrial capitalism, under the control of the managerial class. Perceived as mysterious and unpredictable, the machine also bore no relation to those human beings who had conceived its structure, assembled its parts, or made necessary repairs, in order to accomplish precise, rationally defined tasks. (This was in distinct contrast to the views of Le Corbusier, who emphasized "the statement of the problem and its realization" in the construction of the machine.)

As such, the machine was also liberated from any connection to class struggle or to the reality of oppressive work conditions, and hence from the Communist ideology that provided an analysis of these conditions. Indeed, if the machine appeared as a "superior" force to the workers, "dominating and directing" their lives mysteriously, this might also be seen as fully consonant with an ideology that wished to render the social relations of production invisible. Such an ideology took on greater urgency in the years following the war in Italy, when the threatening example of the 1917 revolution in the Soviet Union was keenly felt. The advent of Fascism, with its rhetoric of "producers" and its corporative model, similarly served to mask the inequity of class relations.

Although Fillia's ideas of a "mechanical idol" were consistent with Futurism's "heroic," nonutilitarian enthusiasm for the machine, they may still seem astonishing in the context of its long-standing anticlericalism. They also reveal the extent to which postwar Futurism had abdicated its revolutionary demand to destroy the museums and the aura that attended traditional works of art. Whereas before the war Futurism had defined itself as an oppositional social force, the movement later strove to identify with the regime and to reassert the ritual function of art. But even in the prewar period, many Futurists had been fascinated by occult science, theosophy, and other forms of mysticism. If the dogmas of the Catholic Church, its authority, and its humanitarian ethics had been rejected, the quest for experience of otherworldly mysteries had not. This undercurrent of Futurist thought became more overt after the war, as the Futurists found themselves increasingly barred from a political role within the regime, and as the spiritual life of the Fascist became a matter of concern to government ideologues.

By 1929, at the time of Fascism's concordat with the Catholic Church, Fillia's art became more manifestly linked to the religious art of the past. Significantly, 1929 is also the year when Futurism issued its first manifesto of *aeropittura,* or aerial painting, dedicated to expressing the exhilarating sensations and perspectives afforded by flight.[43] (Fillia and Benedetta were among the signatories of this manifesto in its 1931 version.)

Joining this Futurist theme to Fillia's growing mysticism, his *aeropittura* explicitly evokes the heavens, and imagines spiritual transcendence through aviators and figures in flight.

In *Spirituality of the Aviator* of about 1929, the machine appears only obliquely, through the theme of aviation. Not surprisingly, the hard-edged geometries of the earlier machine aesthetic are also abandoned. Just as Fillia's earlier style owed a great deal to Purism and to the international machine aesthetic of the '20s, by the late '20s his work had absorbed the more organic, unpredictable, and irrational forms of Surrealism. The aviator is a loosely configured biomorphic shape set into a semitransparent, tilted plane; his central aperture may be an attempt to visualize the idea that transcendent beings are simultaneously physically present and dematerialized, having permeable bodies with indeterminate or fluid boundaries. Cloudlike forms rush through this circular opening, carrying in their stream a small group of simple buildings—the embryo or nucleus of a city that appears almost to be born from the aviator's mystical body. Architecture played a crucial role in Fillia's dream of realizing a new spirituality throughout these years, and he was in contact with most of the major architects of the period. His essay of 1930, "Relations between Futurism and Fascism," asserts: "Architecture is the summit of the power, the solidity, the richness of the work and genius of a people. For this reason we Futurists maintain the absolute necessity for Fascism to have its own constructive physiognomy."[44] Here, as in other cultural debates, Fillia finds himself equivocating between the notion that any truly spiritual art would have universal resonance, and the imperative, both Futurist and Fascist, that it nonetheless affirm its unique Italian origins; it must spring from the "genius of a people," determined more by presumed racial characteristics, climate, available materials, and technology than by tradition, although the latter also plays a role. In 1931, Fillia published an anthology of architects' writings, designs, and photographs of important projects, entitled *La nuova architettura*, to demonstrate the universality of the modern aesthetic while nonetheless championing Antonio Sant'Elia as a pioneer.[45] In this and other Futurist texts

written during this period, history returns as a mode of self-reflexive affirmation; the recent past is adduced to promote the central role played by Futurists both in the founding of Fascism and in the invention of "universal" avant-garde practices. The modernist aesthetic in architecture could be understood as both Italian and cosmopolitan, if its progenitor were the Futurist Sant'Elia.

The title of another of Fillia's paintings, *The City of God* (1931), pays direct homage to the philosophy of St. Augustine, thereby again asserting the link between an ideal city and spiritual transcendence, as well as between the past and the future (figure 88). St. Augustine's writings draw on the traditional opposition between the pagan city (often called Babylon), devoted to the pursuit of material values, and the sacred city (often called Jerusalem), founded by the church and devoted to eternal values. To this metaphorical antinomy Augustine adds a temporal dimension, seeing the confrontation of the two cities as occurring within history, epitomized in the battle

**Figure 88** Fillia, *The City of God,* oil on canvas, 1931. Private collection.

between the corrupt Roman Empire and its Christian counterpart and successor. For Augustine, the two cities will remain intertwined despite their separate "wills" until the final Day of Judgment, when they will be separated as body and spirit, each then achieving a distinct and eternal form. The heavenly "City of God" will be characterized by the eternal bliss of the saved, while the dammed will suffer endless unhappiness.[46] In adopting elements of this opposition between earthly and spiritual cities, Fillia must have found himself constrained to imagine a new harmony between the Fascist imperial state, which saw itself as the inheritor of the earthly Roman Empire, and the divine city to be fully realized only in the future. Rather than oppose the Roman and Christian cities, as Augustine had done, Fillia emphasizes the continuity and harmony of modern architecture with that of both past and future. His painting *The City of God* displays simple, archetypal buildings as if they were the alphabetic elements of a single ur-language, whose forms ascend a stepped, metallic structure (itself emblematic of "building") to reach the ideal—visualized in the opened tower at the center-left.

Fillia also suggests temporal and spatial simultaneity through the use of multiple perspectives: the tower contains the forms of modern skyscrapers, one viewed frontally, another from above, and two others from below so that they project beyond its edge. The tower appears at the juncture of two distinct but contiguous realms, the blue sky of the earthly city at right merging into a golden heavenly glow at left. Hovering before these elements are the simplified figures of God, a kneeling Virgin Mary, and what may be a crucifix composed of rock and cloud at left. Even these sacred figures are embodied in forms and materials that juxtapose and harmonize the traditional and modern, concrete and abstract: the hard chiseled stone of God's red mantel is interpenetrated by the dematerialized "pure sky," which Fillia regarded as a kind of "internal light,"[47] and a mere ovoid profile signifies God's visage traced over a traditional halo.

Such a harmony had not been forged without some effort and even cynicism, for the Futurists must have been aware of Futurism's compromised position vis-à-vis the church. Marinetti's truly strange "Manifesto of Futurist Sacred Art" of 1931 (later signed by Fillia) opens with the premise that one need not practice the Catholic religion in order to create masterpieces of sacred art. Yet the authors declare that only the Futurists, who have developed an art of simultaneity, can successfully visualize the mystic dogmas of the church, including the Holy Trinity, the Immaculate Conception, and the Crucifixion.[48]

Fillia's religious themes of the early '30s revolve around the image of the Holy Family, usually hovering in cosmic space next to a metallic tower. The opened profile of this tower frequently reveals a layered cityscape evoking an archeological view into a historical continuum. In *The Holy Family* of about 1931, we find fragments of skyscrapers clustered together with part of a Roman aqueduct, a classical temple façade, and domed structures that probably allude to the vernacular shrines of Libya—Italy's colony in North Africa (figure 89). References to the continuity of the past in the present coexist with references to the geographical range of the regime's dream of a Mediterranean empire. In other works, a more evolutionary schema is at work, so that Futurist architecture represents both the synthesis and culmination of all past architectural styles. In a letter of 1931 to a fellow Futurist, Fillia explains that in his painting *Madonna and Child,* all the figurative elements are enclosed within the sphere of the world, "upon whose profile appear, as if by divine intuition, the constructive lines of the churches (from the cavern of the catacombs to Roman, Byzantine, Romanesque, Gothic, Renaissance architecture, etc. up to the architecture of Futurist churches)."[49] Rather than suppress or forget the past, here Fillia invokes it in order to refer to the continuity of Christian religious architecture, whatever its specific geographic or temporal form. He thereby seeks to justify the quest for a contemporary architecture that would be suitable to "the imperial religion" (the title of another painting of 1931).

In *The Holy Family* and related works, material juxtapositions also establish the harmonious marriage of past and present: a pyramid of chiseled stone represents the "rock" on which the church was metaphorically built, and possibly Mount Zion, the heavenly Jerusalem, while smooth alu-

**Figure 89** Fillia, *The Holy Family,* oil on canvas, c. 1931. Gaudenzi Collection, Genoa.

minum and a polished red circle suggest the language of modern industry as well as a mystical geometry. In his essay "Sacred Futurist Architecture" of 1932, Fillia calls for the use of modern materials, mentioning especially glass, iron, steel, aluminum, reinforced concrete, and crystal. Such materials, he contends, can be interpreted lyrically, and can constitute the modern equivalent of more traditional, noble materials. The modern materials are not to displace the older ones, but are to be added wherever they can fulfill a new aesthetic or structural demand. Their use would obviate the need for simulacra of noble materials when obtaining them proved difficult or costly. Arguing that counterfeit materials are unacceptable in religious architecture, Fillia advocates the use of iron, aluminum, and glass in order to enhance a sense of spiritual purity.[50] Yet he seems untroubled by the painterly simulation of different material substances. His paintings of this period present the paradox of constructing a semiabstract language of pure form from illusionistically rendered, textured and polished elements.

Fillia intended a specific use of color and forms, and a painterly evocation of materials, to enhance the expressive power of his religious themes. In *The Holy Family* a vibrant red circle plays a prominent visual and symbolic role. In a text of 1925 titled "Spiritual Alphabet," Fillia had established what he believed to be a precise color code, in which red stood for "creation—thought—force-domination—originality—intelligence."[51] If the color red represents creativity as well as force-domination, it may allude both to God's original creativity and to the dominating power of the regime. The circle in *The Holy Family* is a similarly multivalent form, symbolizing unity, perfection, and expansiveness in both a religious and secular sense. Marinetti had employed the motif of the expanding circle to articulate a notion of the ideal shape of the patriotic nation in his essay of 1920, "Beyond Communism." According to Marinetti: "The affective circle of our Italian heart expands and embraces the fatherland, that is, the greatest maneuverable number of ideals, interests, and private and common needs linked together without contrasts."[52] In *The Holy Family*, the red circle conjoins this ideal of patriotic unity and expansion, with the es-

sential unity of God's creativity in making the world.

Finally, in *The Adoration* of 1931 these themes are synthesized with an allusion to Christ's death, burial, and resurrection (figure 90). Fillia draws on his color alphabet and on Christian symbolism to suggest that the red sphere, emblem of the spirit, of pure creativity, and of the nation, will spring forth from the dark tomb of sacrifice and death. A brilliant, golden glow emanates from the central, iconic elements, which seem both to rest securely on an absent ground and to hover mysteriously in cosmic space. The work thus seems simultaneously hyperreal—its various elements depicted in a dramatically illusionistic mode—and fantastic, like a sudden apparition of divine revelation.

It seems evident from the title that Fillia intended viewers to respond to this work with devotion. As such, the image was meant to have a ritual or cult value—that is, to serve as an icon for religious (rather than merely aesthetic) contemplation and to be invested with "aura." In 1936 Walter Benjamin famously defined the aura of the ritual work of art through the natural metaphor of the mountain, which is perceived as distant no matter how close it might be.[53] For Benjamin, the spatial and temporal category of distance was a way of describing the phenomenon of "inapproachability" that preserves social and religious hierarchies.[54] In contrast, the impulse of the contemporary (revolutionary) masses was to favor a new perception of the "universal equality of things," by bringing them closer, spatially and humanly.[55] To this end, the masses accepted the mechanically reproduced image (prints, photography, film), in which the aura of the unique, historical original was inevitably lost.

Fillia's painting, with its own metaphorical "mountain," aspires to function like a traditional cult object, to promote a sense of distance, authority, inviolability, and eternal truth. As such it reinstates what for Benjamin were "a number of outmoded concepts, such as creativity and genius, eternal value and mystery—concepts whose uncontrolled (and at present almost uncontrollable) application would lead to a processing of data in the Fascist sense."[56] Not surprisingly, despite Fillia's celebration of the machine and of

Figure 90  Fillia, *The Adoration*, oil on canvas, 1931. Marinetti Collection, Milan.

modern materials, most of his religious works were executed in a most traditional medium—oil on canvas. They reclaim historical precedent and the ritual function of art not only through their subjects but also through this return to the format and medium of the unique easel painting, intended to serve as a devotional image. And in one case, a painting by Fillia, *Nativity—Mystical Motherhood* of 1932, served as the basis for a mural in the Church of Lourtier in Switzerland.[57]

Ironically, however, important members of the church, including Pope Pius XI, were critical of the effort to create Futurist sacred art. In a discourse of October 28, 1932, the pope declared that these works "do not recall and make present the sacred because they disfigure it to the point of caricature, and frequently to the point of actual and true profanation."[58] Although these remarks were prompted in part by the pope's aversion to avant-garde art, his suspicion of Futurist sacred art was not entirely misguided. The transition from Fillia's earlier machine idols (the term "idol" inevitably suggesting a false god) to the more recent religious imagery must have seemed opportunistic and potentially ironic. Arguably the Futurist empyrean, populated by vibrant red spheres and floating atmospheric crucifixes, and navigated by "spiritual aviators" and other semi-abstract figures whose identity was not always certain, simply departed too much from Catholic dogma. From the point of view of the church, religion had not so much been embraced as hopelessly distorted. Alfredo Busa wrote that "Fortunately this art has been banished by the Church," and indeed it was not included in the Second Exhibition of Sacred Art in Rome of 1934.[59]

Benedetta's Futurist paintings of the early and mid-1920s, influenced by the work of her

teacher Giacomo Balla as well as by that of Boc-
cioni, also participated in the machine aesthetic,
and in particular, celebrated the velocity of speed-
ing trains and boats. Her contemporary *sintesi
grafiche* (graphic syntheses), published in her first
novel, *Le forze umane* (The Human Forces) of
1924, reveal an interest in finding abstract visual
signs or equivalents for emotional or spiritual
states of mind. She understood these rapidly ex-
ecuted signs to be the immediate trace of the cre-
ative "forces of the universe," and her own role
as artist to be merely that of a medium.[60] As such
her *sintesi grafiche* would achieve an ecstatic,
mediumistic creativity: "I destroy Time and
Space. I want a creation-miracle: Identity of will
and matter in spirit become reality." Creating art
meant creating the "religion of the future."[61] To
this end the machine aesthetic, destroying the
unity of space and time through aerial perspec-
tives and velocity, could provide a means for
imagining a new mystical harmony of the present
world and the *al di là*.

Benedetta's work of the early '30s, like Fil-
ia's, seeks a synthesis of *aeropittura* with a new
sense of spirituality and the totalizing order of the
Fascist state. The "X" that dominates her paint-
ing of about 1931, *The Great X* (figure 91), may
have been initially inspired by this passage from
the "Manifesto of Futurist Aerial Painting":

> While the airplane is turning, the folds of the
> vision-fan (green hues + brown hues + di-
> aphanous celestial hues of the atmosphere) close,
> in order to launch themselves vertically against
> the vertical formed by the craft and by the earth.
> This vision-fan reopens in the form of an X dur-
> ing the nose-dive, maintaining the intersection of
> the two angles as the only ground.[62]

If so, the presence of the X implies that the paint-
ing represents the exhilarating, unstable optic of
a sheer vertical drop through space. Yet Bene-
detta's work seems too hierarchically organized
and static to conform completely to what is prob-
ably a trope invented by Marinetti, who enjoyed
imagining that the letters of the alphabet could
function as visual equivalents for specific sensory
experiences or emotional states. Although allud-
ing in part to a plunging aerial perspective, the X
probably also refers to the approaching ten-year

anniversary of the March on Rome and the enor-
mous exhibition planned to celebrate the oc-
casion in Rome. Since Marinetti served on the
planning committee for this exhibition, we can
assume that Benedetta was well aware of its
aesthetic program. Indeed the Exhibition of the
Fascist Revolution adopted the X as its special
symbol.[63] The X, or Roman numeral ten, links
modern Fascism to the imperial language of *Ro-
manitas,* thereby alluding to Mussolini's preten-
sions to Roman imperial glory, and to the state's
adoption of a new revolutionary calendar begin-
ning with the 1922 March on Rome. As Jeffrey
Schnapp observes, the X also associates the Fas-
cist revolution with Christian sacrifice, the X of
Christ's cross.[64] The façade of the exhibition was
flanked by two symbolic black Xs almost twenty
feet tall, mounted on red boxes. The visitor who
climbed the central stairway to enter an imposing
arcade would finally have approached the exhi-
bition's doorway, dominated by three jutting Xs.
Another X appeared on the back cover of the ex-
hibition guidebook, overlapping a pattern of ex-
panding verbal cries of "DU-CE DU-CE"; and,
finally, an X was suspended from the ceiling of
one of the exhibition's rooms, the Hall of Honor,
where it presided over the visitors.

Benedetta's X also hovers high in space, in
order to structure an aerial view of a futuristic
city, thereby conflating the perspective of the
"leader/aviator" with spiritual transcendence.
The junction of the X is pierced by a slender ver-
tical projection, recalling a church spire, which
links the lower earthly domain with the heavens
in a single ascending movement. If we peer down
into the aperture that opens up below us, we
glimpse a fragment of the modern city—clean, ef-
ficient, its severe, metallic-gray geometry en-
livened only by red and yellow linear patterns
and lights. Mysteriously, it is unpopulated, with-
out even a tram or automobile to signal human
habitation. Floating light-filled spheres, which
evoke Dante's Paradise, pervade the higher plane
at left, while on the right side, vaguely defined fig-
ures seem suspended in ether. Thus Benedetta's X
divides her painting into opposing but comple-
mentary realms: below, the material world of the
state, and above, a heavenly vision of luminous
spheres and ascending souls, perhaps martyrs of

**Figure 91** Benedetta, *The Great X,* oil on canvas, c. 1931. Musées de la Ville de Paris, Paris.

World War I or the Fascist revolution.[65] As in Fillia's work, architecture expresses the ideal union of the "two cities": an earthly "Rome" redeemed as a purified urban domain of clean, rationalized forms, including an emblematic church spire, and the transcendent spiritual community of the blessed, who are understood to have sacrificed their lives to achieve the new, harmonious, Fascist order.

Indeed the 1932 Exhibition of the Fascist Revolution had a circular room called the Sacrarium dedicated to these martyrs, around whom a cult had sprung up. At the center of this chamber rose a metallic cross, inscribed with the words "Per La Patria Immortale!" (For the Immortal Fatherland!); the cross was framed and surrounded by six elevated, backlit tiers, bearing the glowing words "presente" (present) one thousand times, to signify the eternal presence of the martyrs in this mystical roll call. As George Mosse observes, the cult of the *caduti di guerra,* the fallen in war, played an important role in the postwar period. The cult masked the horror and finality of death, by elevating it to a form of spiritual sacrifice akin to Christ's own death. Within Italian mythology, the cult of the fallen soldier was frequently merged with the cult of the martyrs of the Fascist revolution: both were deemed necessary to the palingenesis of the Fascist state.[66] This theme would have had special significance for Benedetta, whose father had died of nervous trauma as a result of his experiences in World War I. She described his death in terms of Christian sacrifice and redemption in *Le forze umane.*[67] Her graphic synthesis *Achieved Totality,* which accompanies her chapter on his funeral, renders the spiritual harmony she believed her father had finally achieved in transcending his mortal, suffering body: a vertical spire is composed of progressively lighter and more transparent colors as it ascends. From its point emanate concentric spheres and centrifugal rays of light. Psychic and bodily fragmentation is contained, transfigured as pure, radiant, spiritualized form.[68]

Benedetta's *Mystical Interpretation of a Landscape* of 1934 derives from a similar impulse to project redemption into the future (figure 92). The viewer confronts a path lined by two facing columns of strangely elongated, slender trees, which bear mechanical, axe-like forms in the place of leaves. These trees recall the solemn procession of *fasci* in Sironi's *Galleria dei fasci* (figure 18) for the Exhibition of the Fascist Revolution, recasting their monumental forms as organic elements in a landscape setting. Indeed, they suggest that the congealed symbol of the Roman lictorian fasces, comprising a bundle of sticks or rods bound together with an axe, could be returned to the language of living, natural form. Benedetta's alley of trees also evokes the postwar practice, promoted by Dario Lupi (a Fascist deputy and undersecretary of public education), of honoring the memory of the fallen by having schoolchildren in towns throughout Italy plant a park or avenue of trees, one for every local soldier killed in the Great War. These parks of remembrance, or "votive woods," were intended as living monuments, which would symbolize the spiritual community of the survivors with those who had died for the nation. Lupi's decree of November 1922 was embraced with enthusiasm; 2,217 remembrance parks or avenues were planted in 8,703 communes by 1924. Another decree of February 13, 1923, required that the trees also be dedicated to the martyrs of the Fascist revolution, since "the faith that led these to the supreme sacrifice was the same as that which glorified the holy massacre of those who fell in war."[69]

The trope of ascending steps, bordered by mystical trees cum *fasci,* further invites the viewer to engage in a spiritual journey toward salvation guided by Fascist dogma. A related use of steps was a dominant feature of several important monuments to the war dead, including one designed by Giuseppe Terragni in 1932 for the city of Erba Incino, where the processional steps are framed by trees, as well as his simpler *Monument to Roberto Sarfatti.* In Benedetta's painting, ethereal forms at the far right play a mysterious role, perhaps alluding to the souls of those who are about to embark on a journey, and who must choose between meandering deviant paths or the centered, straight path leading to salvation.

Works such as these by Benedetta and Fillia exemplify what Emilio Gentile has called the "sacralization" of Fascism and its symbols,

**Figure 92**  Benedetta, *Mystical Interpretation of a Landscape*, 1934.

achieved by linking traditional Christian themes and rites to Fascist ideology.[70] The paintings of both artists, however, also inadvertently reveal the extent to which Fascism had failed to accomplish its goals. As Fillia explained in 1931:

> We understand art to have a spiritual function, to be a means of rendering images of a mysterious superhuman world. Man has a need to detach himself from the earth, to dream, to desire eternal happiness, continually to forget everyday reality.[71]

For Fillia, Benedetta, and others, fulfillment of the desire for social happiness and spiritual transcendence could never be convincingly pictured in the present; instead it was projected into the future and took the form of mystical faith.

The utopian dream of the Futurists to address and to mobilize a mass public to political and cultural revolution through ahistorical means was thus absorbed and reconfigured. The early celebration of the machine had been a means of refusing the authority of the past and of tradition, and indeed of claiming a triumphant power over nature, at times including the dream of autogenesis. The transformation of the prewar cult of the machine into the cult of the "mechanical idol" of the mid-1920s signals an important ideological shift, for the idol is seen as mysterious, superhuman, a force of domination over humanity requiring devotion. The desire for mystery and objects of worship that inspired veneration for the new idols also promoted the rediscovery of old ones. Yet the traditional Christian symbols and themes invoked by some Futurist paintings in the '30s also betray a loss of confidence in the availability of that tradition. The melancholic mood, otherworldly atmosphere, and enigmatic meanings of much of this art conveys a sense of rupture and confusion even as it seeks to reaffirm the con-

tinuities of (a largely mythical) past with the present. The future also underwent redefinition, becoming the locus of dreams and desires that could not be realized in "everyday reality." That which had been repressed in early Futurism—history, nature, the idealized woman, religion, and the auratic function of the work of art—returned with renewed force. By the early '30s, most Futurists had affirmed the values of a tradition-bound moral and spiritual order under the sign of the Fascist regime.

# Flash Memories
## (Sironi on Exhibit)

*Jeffrey T. Schnapp*

*To fix the degree and the limits to the memory of the past, if it is not to become the gravedigger of the present, we must see clearly how great is the "plastic power" of a man or a community or a culture; I mean the power of specifically growing out of one's self, of making the past and the strange one body with the near and the present, of healing wounds, replacing what is lost, repairing broken molds.*

—Friedrich Nietzsche, *On the Use and Abuse of History for Life*

THE FOLLOWING CHAPTER provides a narrow point of entry into two broad areas of historical inquiry: first, that of ephemeral exhibition architectures and the display practices that accompany them, their impact on the representation of history in twentieth-century culture, and their role as persuaders in everything from political propaganda to commercial advertising; and second, that of the rise of modernist forms of public art in the late '20s and early '30s as evidenced, for instance, by the world-wide resurgence of muralism. Each would be worthy of a separate book-length study, but tying the two together is the problem of how the preservation and presentation of the historical past can be made to harmonize with modernity's embrace of innovation, novelty, and progress. The quandary is a familiar one. On the one hand, the modern era defined itself as a revolt against tradition and the "merely" historical. On the other, it fostered a hitherto unimaginable proliferation of methods and institutions for the conservation, retrieval, and diffusion of artifacts from the past, so much so as to give rise to recurring panics about their impact on the present. For prophets like Nietzsche, the fin-de-siècle cult of history, translated into an ever expanding body of texts, scientific disciplines, and institutions devoted to the commemoration of prior eras, required the countermeasure of a cult of forgetting and a return to the body as the normative locus of values.

Nietzsche's equation between information surplus and a threat to life seems little more that a quaint vitalist illusion when viewed from the perspective of our new millennium, in which bodies themselves are imagined as programmable sets of codes passed from one generation to the next and information is as much about stimulus as it is about memory. Today's panics are of a different sort: about viruses capable of mining the new digital public sphere, about the recrudescence of fundamentalisms, about genetic manipulation and human cloning, about nuclear or environmental apocalypse. But modernity's struggle with the question of how and where to fix the degree of and limits to the memory of the past remains inaugural with respect to the contemporary scene. This is particularly the case with those forms of modern art, design, and architecture that, like those that flourished under Mussolinian Fascism, sought to fulfill the ideals of the modern movement—functionality, rationality, affordability, accessibility to the masses—while pursuing a dialogue with history and tradition. The dialogue was intensified by the ideological climate of Italy's conservative

revolution, by the regime's eclectic patronage practices, by the culture of new/old materials fostered by its politics of economic autarchy. But in no way can the dialogue be deemed reducible to that ideological climate alone. Other contextual factors played defining roles: the ubiquity of traces of centuries past within the Italian landscape, the extremism of the Futurist revolt against tradition and the resulting backlash even within the fold of the avant-gardes, the persistence of traditional craft methods alongside industrial practices in Italian industry, and the prevalence of small to mid-size family-owned businesses. In short, both Italy's emergence in the post-World War II era as one of the world's leading design centers and the eclecticism of Italian interwar culture that now makes it seem perched on the far side of the modern/postmodern divide were the products of a complex gestation. This chapter narrates but one small episode within this larger gestation story.

CAUGHT BETWEEN the imperatives of restoration and innovation, between conflicting urges to remember and renew the past and to build the present and future upon the past's erasure, the Italian Fascist regime (like its socialist counterparts elsewhere in Europe) found in exhibitions an ideal locus for historical self-reflection and representation. What the museum was to the nineteenth-century nation-state, the political exhibition became to twentieth-century revolutionary regimes: a place of nation building where origins could be created and venerated, and genealogies linking the present to the remote or recent past could be forged.

The shift in institutions from museum to exhibition marks a turn against prior forms of historicism. The modalities of cultural memory propagated by the museum were scientific, founded on incremental narratives of development and on the separation between document, mode of display, and surrounding décor. The exhibition instead was put forward as a site of volatile memory: as an agitatory instantiation of counter-memory, a museum in motion in which the life-sapping and grave-digging effects of historicism could be shaken off in the service of redemptive myths. The precise degree to which counter-memory assumed historical or ahis-

torical contours was, of course, conditioned by ideology. Within the framework of socialism's collectivist utopia, Soviet exhibitions staged the erasure of all but the recent past and put on display the accelerated cadences of development inaugurated by the revolution. Fascism's unstable mix of dreams of radical restoration and rupture—its claim that it was a unique product of Italian history yet represented a universally applicable third way to modernization superior to socialism and liberal democracy—imposed a more delicate task on Italian exhibition artists and designers. The challenge they faced was that of developing a rigorously contemporary visual vernacular with national(ist) overtones. In the case of the most advanced forms of Fascist culture, like the ones that this chapter is concerned with, such overtones found themselves introduced less by means of explicit citation or imitation of Italy's artistic heritage than, so to speak, "through the back door." Oblique echo and allusion, the emphatic use of Italian materials and techniques, reduction of historical sources to elemental forms intermingled with objects and icons of the industrial era, gave rise to a complex, forward-looking interpretation of the regime's backward-looking ideals of Italianness (*italianità*) and Romanness (*romanità*).

To a greater extent than any other Italian artist of his generation, Mario Sironi staked out his reputation on ensuring that the public exhibitions of the '20s and '30s fulfilled this mnemonic/counter-mnemonic task. Sironi's embrace of the exhibition form was, from the beginning, nothing short of absolute. It entailed not just his creation of individual works for purposes of display but also his active participation on artistic juries, planning commissions, and directorates. It extended as well to Sironi's work as a militant critic and to the design of medals, diplomas, and posters for competitions on whose boards of directors he sat, such as the 1930, 1933, and 1936 Triennial exhibitions. Most characteristically of all, it meant a deep personal devotion to and a passionate advocacy of all of those arts that contributed to the shaping of public showplaces: practical arts such as lighting design, installation and fixture design, interior decoration, and, especially, architecture.

Sironi's involvement in every aspect of the

design and organization of exhibitions corresponded to a total concept of the exhibition as event: one that, in harmony with the needs of the Fascist regime during its phase of consolidation and consensus, sought to collapse the barriers erected by historicist, liberal, and positivist ideologies of display, representation, and reception.[1] He hoped to sunder the barriers between exhibited objects and their exhibition context; between the spatiality of artworks and the space traversed by spectators; between works of "fine" and "decorative" art; between historical documents and works of the imagination; and between the world of art and everyday life; all this was in the service of an ethical-didactic concept of style and a revolutionary credo. "Through style (and not through content, as communists mistakenly believe), art will succeed in impressing a new shape upon the popular spirit," Sironi wrote in his 1933 "Manifesto of Muralism."[2] Art would provide the laboratory within which the new all-encompassing style could be forged and then imprinted on art and politics' new mass audience. Marked off as an ideal site of communion between individual genius and national collectivity and between the nation's heroic present and glorious eras of its past, exhibition spaces became for Sironi identical with the transformed space of political representation brought about by Fascism. "Every successful exhibition is a revolution," he declared in a barbed rejoinder to his reactionary nemesis, the Fascist hierarch, Roberto Farinacci.[3] From this assertion, we may infer that Sironi also believed that "every successful revolution is an exhibition." In Sironi's mind, Mussolini's modern political style and the Fascist modernism that was being codified by contemporary exhibition organizers, designers, and architects were inseparable. Both had as their mission the granting of "unity of style and grand contours to everyday existence."[4]

For readers familiar only with Sironi's easel paintings, it may come as a surprise that the exhibition projects undertaken by this most solitary and misanthropic of artists were always collaborative in nature. Collaborative here also necessarily means political. This is the case because for Sironi, any move out of the private universe of the artist's studio, whether consisting in the abandonment of the daily ritual of easel painting for

illustration, graphics, mosaics, frescos, stained-glass windows, sculpture, advertising, or architecture, occasioned a reaffirmation of his always ardent Fascist faith. Sironi's first such collaboration was with Giovanni Muzio, a Milanese architect with close ties to the Novecento group, with whom he designed the *Il Popolo d'Italia* pavilion at the 1928 Milan Trade Fair (figure 93). Though little evidence remains as to the interior layout of this pavilion, its exterior offers hints of what were to become Sironi's trademarks as a maker of Fascist style: an austere, obliquely classicizing vocabulary of forms, monumental reliefs composed of fasces and foreshortened flag motifs, the iterative use of stylized portraits, freestanding signage treated as an integral architectural element; and the fasces defined as the columnar order of the Fascist era.[5] If the Doric and Ionic orders were the symbols of ancient Greece, and the Corinthian and Composite orders the symbols of Augustan imperial might, so was the fasces emblematic of Mussolini's Rome. The operation, typical of Sironi, was not historicist in the conventional nineteenth-century sense, for instead of seeking

**Figure 93** Mario Sironi and Giovanni Muzio, *Il Popolo d'Italia* Pavilion, Milan Trade Fair, 1928. *Catalogo ufficiale: Fiera di Milano* (Milan: Fiera, 1928).

**Figure 94**  Mario Sironi and Giovanni Muzio, entrance to cinema, Italian Pavilion, Pressa Exhibition, Cologne, Germany, 1928. *Rivista Illustrata del Popolo d'Italia,* October 1928.

to re-create accurately or to revive the forms of the past, it strove to reinvent them in contemporary terms. In harmony with Nietzsche's ideal of *plastic power,* it presupposed a fundamental rupture between Italy's past and its present—a rupture overcome because of a deeper bond on the plane of values. Sironi was persuaded that, thanks to Fascism, a shared heroic ethos and feeling of national grandeur now linked the present moment to the monuments of the past. This meant that, rather than assuming an ornamental function, historical references could emanate from within the work of art in the form of a stripped-down, archaic universal language. They could arrive already transformed, absorbed into and made one with the living body of the present.

Much better documented than the *Il Popolo d'Italia* installation is Sironi's second collaborative

endeavor with Muzio: the design of the Italian pavilion for the 1928 Pressa Exhibition that was held in Cologne, Germany (figure 94). Mild-mannered by comparison with El Lissitzky's dazzling Soviet counterpart, with its graphic conveyor belts and wall-size photomontages, the Italian pavilion proposed a distinctive fusion of metaphysical/ neoclassical elements with properly Futurist and Rationalist ones—a stylistic merger whose moment of glory would come in the early '30s. Muzio and Sironi's efforts were constrained by the design limitations imposed on them by the preexisting building. In the limpid glass box entrance hall to the pavilion's cinema, they constructed a spatial grid made up of alternating flags and suspended fasces. A banner bearing the word *Italy* hung on the right flank, identifying the pavilion's sponsor, and a pair of fasces graced

the portals. The inner rooms radiated outward from the central Hall of Honor, a large trapezoidal room of symmetrical design within which displays documented the history of the Fascist press.[6] For the left and right walls of the Hall of Honor Sironi designed monumental bas reliefs of the Italian peninsula, flanked on both sides of the room by mock portals. The front wall featured a pseudo-portal in its center, filled with a flag-studded image of the fatherland embracing a leaning stylized fasces. The rear wall was pierced by a series of stained glass windows bearing stylized crests representing Mussolini and King Vittorio Emanuele III and Futurist-inspired geometric compositions. This same cluster of motifs echoed throughout the rest of a room that adroitly pitted a sense of overall spaciousness and geometrical discipline against the local agitation and compression of certain portions of the otherwise cool geometrical grid. Stars, triangles, squares, Italian flags, sheets of paper, and archways all reverberated back and forth across the hall. At the center of this push and pull between the forces of compression and expansion loomed a bust of Mussolini, as portrayed by Adolfo Wildt. Much as it would in the 1932 Exhibition of the Fascist Revolution, the Duce's image was put forward as the pavilion's hermeneutic keystone, as the singular visage which conferred identity and unity on an eclectic, multifaceted revolution.

Despite some inventive features, the display techniques employed by Sironi and Muzio in Cologne remained fairly conventional. Although Soviet-like photographic columns flanked the entrance to the book galleries, far more prevalent were glass cases of the sort that one would have encountered in many turn-of-the-century museums. This relative conservatism would become more conspicuous when, in the latter half of 1929, the press pavilion was transported to Spain and rebuilt within the eclectic decorative framework provided by the architect Piero Portaluppi for Barcelona's International Exposition.[7] Sironi had, in the meantime, added some noteworthy enhancements, among them a showcase celebrating *Il Popolo d'Italia* that consisted of a panel of diagonally arranged front pages framed between columnar printing press rollers. These new fea-

tures aside, the stylistic distance separating the visually busy Italian pavilion from starker modernist rivals, such as Mies van der Rohe's German pavilion, had grown.

The gap would close in Sironi's next undertaking as an exhibition designer and organizer: the May 1930 Triennial Exhibition of Modern Decorative and Industrial Arts. This was the last Triennial held in Monza and the first to appeal both to artists and to industry. For the first time, regional divisions were abolished in the name of the applied arts' integration within Italian national life. Moreover, the program demanded of all artists "modernity in interpretation, originality in invention, technical perfection."[8] Although Sironi played a crucial role in the directorial triumvirate, his principal contribution to the 1930 Triennial assumed the form of yet another collaborative venture with Muzio: the design of the Gallery of Graphic Arts in the Italian pavilion (figures 95 and 96). The gallery proposed a pristine architectural transcription of the repertory of forms that had pervaded Sironi's paintings between 1922 and 1925, "[works] in which the metaphysical experimental poetics of the 1918–1919 period comes to fruition in a highly personal interpretation of *Novecentismo*."[9] Within the gallery, documentation and display cases were relegated to an accessory role in the pursuit of unexpected visual rhythms. Some columns appeared artificially truncated; others, seemingly of Minoan inspiration, did not. Thick arches surfaced, shifted in scale, and were lopped off. Nonfunctional cornices and shelves intruded mysteriously, supporting vaselike light fixtures. Massive illusory doorways receded abruptly and were interrupted by equally massive rectangular volumes. Wall drawings alternated with smooth glass display cases perched atop shallow pedestals and with assemblages of spheres, cones, squares, cubes, and French curves. Wall colors mutely shifted as did the tones of the linoleum flooring. All occurred within the confines of a magical space that was reminiscent of De Chirico, had it not been for Sironi's signature titanic volumes.

The Gallery of Graphic Arts installation was an exceptionally refined accomplishment. But it represented less an end point than a beginning for

**Figure 95**  Mario Sironi and Giovanni Muzio, entrance, Gallery of Graphic Arts, Triennial Exhibition of Modern Decorative and Industrial Arts, Monza, 1930. *Catalogo della Triennale Internazionale delle Arti Decorative e Industriali Moderne* (Monza: Clerici, 1930).

Sironi. It was a "beginning" because the precious experience that he had accrued in Monza, Cologne, and Milan soon came together in two equally memorable contributions to the exhibition culture of the '30s: the 1932 Exhibition of the Fascist Revolution, held in celebration of the tenth anniversary of the March on Rome, and the 1933 Milan Triennial. As I have demonstrated at length in my *Anno X — La Mostra della Rivoluzione Fascista del 1932*, Sironi's role in the first of these events, the pivotal exhibition of Italy's Fascist decades, entailed not just the design of four rooms in the Palazzo delle Esposizioni on Rome's Via Nazionale but also a broader behind-the-scenes presence.[10] The dozen or so artists and architects called on in late April 1932 to translate the epic of the Fascist revolution into plastic form,

and in doing so to "create something ultramodern and audacious, free from melancholy memories of the decorative styles of the past," were an inexperienced and heterogeneous group.[11] The group included Rationalists, Futurists, Selvaggi, and Novecentists, many of whom were still in their twenties.

Within such a setting, Sironi at age forty-seven was easily the most authoritative figure. A Fascist of the first hour closely linked to Mussolini because of his work as a political illustrator for *Il Popolo d'Italia*, Sironi had devoted much of the '20s to developing the distinctive Fascist vocabulary of form that would resonate everywhere in the 1932 exhibition: a vocabulary composed of massive chains, Roman daggers, bayonets, artillery shells; of stone-chiseled images of Mussolini's head, the Italian

**Figure 96** Mario Sironi and Giovanni Muzio, interior of installation, Gallery of Graphic Arts, Triennial Exhibition of Modern Decorative and Industrial Arts, Monza, 1930. *Catalogo della Triennale Internazionale delle Arti Decorative e Industriali Moderne* (Monza: Clerici, 1930).

peninsula, flags, eagles, stars, wedges, columns, and Roman numerals; and, most of all, of thousands of variations on the fasces. Given Sironi's credentials, the assignment to him of rooms P, Q, R, and S is indicative that the event was, in some sense, intended as a Sironian exhibition (see figures 17 and 18 in chapter 2).[12]

This sequence of rooms in the Exhibition of the Fascist Revolution comprised nearly one-quarter of the total space available on the ground floor of the Palazzo delle Esposizioni. It stood right at the heart of the narrative scheme devised by Luigi Freddi, the coordinator of the exhibition's documentation center, and Dino Alfieri, the exhibition president. Rooms P and Q were to portray, respectively, the Naples Rally and the March on Rome: the climactic episodes of the exhibition's historical cycle and the final stops in the

spectator's path around the periphery of the mid-nineteenth-century edifice before entering the central halls. These rooms were to mark an absolute threshold: a point of crossover into a bold new era defined by the advent of a heroic new spatiality and temporality. Alfieri and Freddi's guidebook puts it as follows: "Exiting the Hall [room Q], with one's eyes still filled with the vision of the drama endured by our nation in pre- and post-war years, years over which hovers the spellbinding figure of the Duce, the visitor intuits that *Italy's new history commences from this point on.*"[13] Accordingly, the task of the first two halls along the central axis of the building—room R, the Hall of Honor, and room S, the Gallery of Fasces—was to represent this history after the end of history: to transform the swirling modernist vortex of the diachronic rooms into a synchronic

sequence registering the return to order and discipline under the protagonist of Italy's recent history, Benito Mussolini.

Sironi approached the problem of representing the passage from Fascism as movement to Fascism as regime by crafting a carefully modulated crescendo that took advantage of shifts in volume and scale that were inherent to the building's structure. In the case of rooms P and Q, he took pains to continue the sequence extending from rooms A through O, while introducing stylistic and tonal changes that prepared the way for the grander themes and spaces of the central halls. Rooms P and Q followed directly from room O, in which Sironi's friend Giuseppe Terragni had translated the explosive political scene of early October 1922 into a densely textured assemblage of photomontages, colored wedges, wall reliefs, sloping walls, typographical panels, documents, and objects (see figure 16 in chapter 2). Sironi chose to carry over numerous key motifs from room O, but, in so doing, he radically simplified and opened up Terragni's constructivist tour de force so as to suggest that the March on Rome constituted a moment of clarification after so much confusion. This movement toward apocalypse was transcribed in a threefold manner. First, the sometimes harsh palette of the preceding rooms was reduced to a sober chromatic register composed of charcoal grays, umbers, and ochres, whose earthy materiality was played off against hard-edged black and white signage. Second, this stripped-down palette coincided with an escalating emphasis on uncluttered spaces, on massive elementary forms, and on rudimentary diagonal spatial configurations. Third, the full unveiling of the Duce's image was postponed until the Hall of Honor so as to heighten the drama of his apotheosis.

Sironi subdivided room P into two unequal rectangular sections by means of a massive hanging wall, which showed a large bas-relief dagger, inscribed with the word DUX, in the process of sundering a bulky blood-red chain (symbol of the "gordian knots" that long had "saddened Italian life"). The smaller first section of the room contained a rhythmically arranged series of display cases, blocks of text and diagonally aligned banners. The larger second section integrated display cases of varying depths and heights into spacious wall-size compositions that were made up of inscribed blocks and photomontages. Room Q reworked the same set of elements on a somewhat larger scale (figure 97). Upon entering the room, the viewer stood before a relief of two warriors raising the Roman imperial standard against an immense charcoal backdrop. This image of Fascism's will to power was picked up across the room in a large similarly marbled fasces on whose blade was carved the word DUX.[14] Nested snugly under a brick re-creation of the Arch of Vittorio Veneto, site of one of Italy's major military victories in the Great War, this fasces was echoed in yet another, far larger fasces that extended across much of the linoleum floor. On the back wall, a schematic map of the Italian peninsula and a series of photographic murals showed orders—in the form of lines—emanating from Milan and forces—in the form of arrows—converging on Rome on October 28, 1922. Stylized arcades, banners, and buildings projected alongside the triumphal arch—shadowy prefaces of the great construction projects soon to be undertaken by the Duce. At the end of the funnel-shaped space was a double portal over which Mussolini's words to King Vittorio Emanuele III appeared in bold Roman type: "Your Majesty, I bring you the Italy of Vittorio Veneto." The exhibition's historical cycle thus closed with an identification of Italy's victory at war with the moment of Fascism's triumph.

As the first of four rooms linked by a straight corridor, the Hall of Honor and the Gallery of Fasces presented Sironi with a different set of constraints than did the labyrinthine historical rooms. In them his assignment was not to extend the diachronic sequence of rooms A through Q, but rather to reinscribe that sequence within a ritual order through a fusion of modernizing and archaizing elements. Sepulchral in their sobriety and heroic in their scale, the Hall of Honor and the Gallery of Fasces reflected an overarching theme: the sacred bond between the leader and his followers. Hence the alternation between the celebration of Mussolini's apotheosis (room R) and the commemoration of the Fascist collective (room S). In the room R, set across from a pair of elephantine columns holding aloft an immense X,

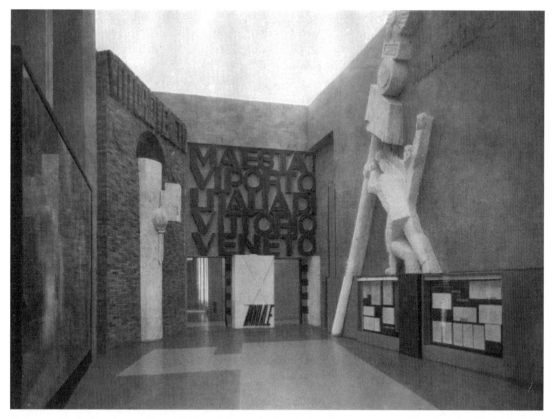

**Figure 97** Mario Sironi, room Q, Exhibition of the Fascist Revolution, Rome, 1932–34. Dino Alfieri and Luigi Freddi, *La Mostra della Rivoluzione Fascista* (Rome: PNF, 1932).

a ponderous sculpture of the Duce towered above the emblazoned title DUX, whose mass seems to have supported the entire upper wall. To the sides of this granite emblem extended flared lateral walls imprinted with the dates 1919 and 1922, marking the time span from the foundation of the Fascist movement to the seizure of power. Below was the room's "altarpiece" and the sole documentary display: a reconstruction of Mussolini's first editorial office at *Il Popolo d'Italia*. Here, printing press rollers acted as columns in an enclosure whose walls were made of heavy steel. The enclosure itself, as well as the entire complex of walls, columns, ceilings and floors, were studded with Sironi's usual repertory of hyper-stylized figures: Xs, flags, muskets, stars, fasces, the words ITALY and DUX. Sometimes presented in bas relief, sometimes in intaglios, these signs functioned much like hieroglyphs, reinforcing the viewer's sense that he or she was advancing to-

ward the inner chamber of some sort of latter-day Assyrian temple.

The air of mystery and solemnity extended into the Gallery of Fasces: a vertical corridor lined by five massive pairs of fasces-like buttresses interspersed with the banners of the original Fascist organizations (see figure 18 in chapter 2). Whereas the preceding room had conveyed a feeling of power by emphasizing massive supports, the crude geometrical fasces in the Gallery were backlit in such as way as to create the contrary illusion: namely, that the ceiling was unsupported and hovering freely above. A sense of magic and expectation, therefore, was meant to seize the visitor as he or she perused the crescendo of dates appearing on the wedge-like cantilevers, and traversed the D-U-C-E and fasces patterns incised into the ceiling, floor, and walls. The hallway ended in a massive wall of unbaked bricks, pierced by a rectangular portal crowned

by a coarsely hewn equestrian sculpture representing "Liberated Italy on the March." Passing through the portal, the visitor reached the Sacrarium of the Fascist Martyrs, the exhibition's holy of holies.

That Sironi's designs for the 1932 Exhibition of the Fascist Revolution represented a continuation of his prior work as an exhibition designer is clear, thanks to numerous self-quotations. To list only two: the ceiling and floor decorations of the Gallery of Fasces recalled the interspersed flags and fasces from the Pressa pavilion entryway; and the press rollers used as dividers in the display cases of room P and as columns in room S were derived from the Barcelona *Il Popolo d'Italia* showcase. As for borrowings from his work as illustrator, there were so many that the 1932 exhibition often must have seemed like a recapitulation of his entire prior career. But what is most distinctive about rooms P through S is the way in which these variegated elements from Sironi's past coalesced within a single rhetoric of structures, surfaces, and forms that was ideally suited to the commemoration of a conservative revolution, or, as he himself designated it, to becoming "the visible form of the new Faith."[15] In his charge to the exhibition artists, Mussolini had asked that they forge a *living* monument: less a memorial of the permanent or static sort than a provisional and evanescent rallying point capable of mobilizing the Italian nation as a whole through its immediacy and, in so doing, of bringing the revolution back to life. Yet, ten years after the March on Rome, the regime had long before abandoned its sense of impermanence and was building up a monumental state. Hence the exhibition's delicate task: to revive the revolution and simultaneously to bury it within contemporary institutions.

This was the doubleness that Sironi's rooms succeeded so effectively in embodying. Their rough materiality testified to the violent craft of the creator and to the obstinate resistance offered by different forms of matter (stone, metals, earth) and by natural forces (gravity, weight, decay). Yet the rooms' serene and heroic spaces offered visible proof that redemption is indeed possible. Out of the struggle between these intractable elements and the indomitable human will to form, power-

ful structures came into being; enduring "objective" structures like new buildings, cultures, ethical systems, and states were shaped from "elements" like a people's history and national character and a nation's climate, topography, and natural resources. It was as though no alternative to this dialectic was available to humankind. All creations of the human spirit must necessarily bear the traces of their tormented, telluric birth, inasmuch as, for Sironi, history and matter are (tragically) inescapable. It, therefore, remained for the artist and his statesman counterpart to strip these fateful givens of all those external accretions that would cause them to "become the gravedigger of the present" and to excavate from deep within them fundamental motives that can and *must* be reinvented in modern terms if the present is to be redeemed.

The Exhibition of the Fascist Revolution opened its doors on October 28, 1932, to immediate public acclaim and, over the biennium that it was open to the public, a total of almost four million visitors attended it.[16] Such unparalleled success rendered the exhibition the de facto answer to debates that had been raging since 1926 over the nature of Fascist art.[17] It marked a decisive, albeit momentary, victory for the forces of cultural modernization and a defeat for their antagonists. In Sironi's own words: "As an architectural and sculptural whole, thanks to its unique plastic lineaments, the Exhibition of the Fascist Revolution seems like a wedge driven into the very heart of the metropolis for purposes of demolishing even the most tenacious resistance that the remaining debunkers of modern art are still able to provide."[18] The exhibition also further consolidated Sironi's standing as the premier visual interpreter of the Fascist spirit. In addition, it strengthened his conviction, first, that under Fascism modern art had at last shed all those subjective, arbitrary, and speciously individualistic elements that had kept it from giving "unity of style and grand contours to everyday existence"; and, second, that these unifying and elevating social functions were best served through the absorption of all the arts, but particularly painting within the field of architecture.[19]

Sironi's next major contribution to the exhibition culture of the '30s put both beliefs to the

test: namely, his work as a member of the directorate of the 1933 Triennial exhibition. The fifth Triennial was the first held in the newly completed Palace of Art, which Muzio designed for this purpose, and involved further addition to the exhibition's title: International Triennial of Modern Decorative and Industrial Arts and of Modern Architecture. Driven in large part by Sironi's growing commitment to muralism, this "official" embrace of modern architecture on the part of the organizers transmuted the entire character of the event.

Sironi was at the center of every aspect of the 1933 Triennial, not least of which its architecture. He designed a set of six abstract arches on a slightly elevated platform to serve as a partition between the park and the palace's Square of Honor (figure 98). He developed a tunnel with Gio Ponti joining the Castello Sforzesco to the Arch of Peace. His were the massive rectangular fountain in the palace's *impluvium,* a columnar fountain for the park, the geometrical decoration of the palace's main stairway, atria, and vestibules, and also the entrances to the architecture and ancient bronze exhibits. To this one must add numerous other projects, including the towering curved gateway to the park, the geometric ceiling of the central hall, and the sculpted monogram that ornamented both.

Sironi's most decisive contribution to the fifth Triennial, however, assumed the form of an unprecedented cycle of mural paintings and sculptures that was intended to coalesce with the show's architectural environments because, as in the political domain, "in the Latin world it is necessary that absolute harmony reign among the arts, as if they were engendered by an identical concept and ruled by a single common law."[20] The moral of muralism was pan-Mediterranean and pan-artistic. To this end Sironi picked out thirty contemporary painters, including Carrà, Depero, Savinio, and Severini. Each was assigned a particular segment of the exhibition and, except in the case of the Hall of Honor, was left free to develop "a program dictated by individual sensibility that embraces, without recourse to trumpery, the enduring values of wall painting."[21] However noble the intent, the results were mixed. The aesthetic, moral, and racial values supposedly inherent to mural painting proved insufficient to avert some glaring discontinuities in the architectural context, scale, technique, theme, style, and quality of execution.

Ironically, even the Hall of Honor in the fifth Triennial was not immune from this fate. There some of the most noted painters—Sironi, Campigli, and De Chirico—collaborated on an immense cycle of murals concerned with solidly Fascist themes like "Labor: Works and Days," "Mothers, Peasant Women, and Female Workers," "Italian Culture" and "Ancient Games" (figure 99). Despite the diversity of idioms and differing degrees of fidelity to classical or high medieval precedent, this set of murals was remark-

**Figure 98**  Mario Sironi, Sequence of Six Arches, International Triennial of Modern Decorative and Industrial Arts and of Modern Architecture, Milan, 1933. *Catalogo della Triennale Internazionale delle Arti Decorative e Industriali Moderne e dell'Architettura Moderna,* V Triennale di Milano, *Catalogo ufficiale,* ed. Agnoldomenico Pica (Milan: Ceschina, 1933).

**Figure 99**  Mario Sironi, *Works and Days*, Palazzo della Triennale, International Triennial of Modern Decorative and Industrial Arts and of Modern Architecture, Milan, 1933. *Catalogo della Triennale Internazionale delle Arti Decorative e Industriali Moderne e dell'Architettura Moderna*, V Triennale di Milano, *Catalogo ufficiale*, ed. Agnoldomenico Pica (Milan: Ceschina, 1933).

ably cohesive. Simplified human forms frozen in motion; landscapes and perspectives constructed in line with fourteenth-century canons; architectural backdrops made up of columns, colonnades, and cupolas; rearing horses, cloudy vistas: all of these common elements gave rise to a pictorial continuum in which the archaic-classical coexisted with the modern-industrial. Smokestacks rise up harmoniously alongside an aqueduct, a Romanesque apse, a classicizing modern building, and an industrial crane in a loosely ordered and rapidly painted 111-square-meter (390 square feet) grid of shallow compositions, each of which depicts and dignifies a single facet of labor. Within this eternal present constituted by human labor, the laborers themselves appear larger than life, even dwarfing the architectural fragments. Their gestures are individualized, but their faces are not. Arrayed vertically and horizontally, this aggregate of gestures makes up a distinctive Sironian version of Hesiod's epic of work: a collective epos within which labor is ennobling precisely because it represents an ideal site of confluence between spontaneity and discipline, between individual effort and the national good.[22]

Because of time constraints, Sironi's mural was, like the rest of the cycle, executed not according to the traditions of fresco painting, but instead using fluosilicate, an industrial chemical heretofore employed in the painting of façades.[23]

The experiment of linking a venerable artistic practice—*pittura a fresco*—with modern industrial-era pigments did not pay off. Because of problems with humidity, the coats of gesso did not set properly, with the result that, even at the time of the opening of the fifth Triennial in May, critics were reporting substantial paint losses, as well as chemical reactions affecting the murals' chromatic balance.[24] These technical deficiencies added fuel to the critical firestorm that the murals provoked. On the cultural right, Farinacci (from the pages of *Il Regime Fascista*) launched a series of attacks against the Novecento in general and the Triennial exhibition in particular. He accused both of "technical poverty, spiritual vapidity, [and] impudent pro-foreign, masonic tastes"; of scorn for art's popular audience; of violating the Fascist ideals of health, beauty, and Italianness.[25] The chorus was joined by Ugo Ojetti, who, from his pulpit at the *Corriere della Sera,* fulminated against Sironi's expressionistic tendencies and against his artworks' unfinished look. Whatever the merits of such criticisms, one can well understand the degree of acrimony: Sironi's muralism had rendered thinkable an integral displacement of private patronage by public commissions and the actual establishment of a state art. Sironi made these ambitions clear in the series of pre- and post-exhibition critical pronouncements that culminated in December 1933 with the publication of the "Manifesto of Muralism." In the "Manifesto," he calls on artists to become "militants . . . in the service of a moral ideal who subordinate [their] individuality to the collective task" and insists on muralism's claims on public buildings and "other places endowed with civic functions." And he boldly asserted that "a *Fascist style* will arise out of mural painting: a style in which our new civilization will recognize its likeness" and criticized another form of state art—socialist realism—in the name of this higher ideal.[26]

Sironi wagered everything on the fifth Triennial. As became increasingly clear in the scandal's wake, he had lost the bet. The Novecento, Margherita Sarfatti's ill-defined and loosely organized movement, effectively disintegrated, and post-1933 Italy failed to embrace mural painting to the extent that its advocates had envisaged. This is not to imply that muralism did not continue to find a place within the Fascist architectural imagination up through the planned (but never realized) 1942 Universal Exposition of Rome. Sironi, for example, was able to resume much the same course as before, undertaking six big mural and mosaic cycles between 1935 and 1941. But these public commissions did not diminish the magnitude of the debacle. By 1934, Sironi found himself excluded from the Venice Biennale. Six years later he was gone from the Triennial organizing committee.

Outside of the context of the Triennial shows, Sironi persevered in his activities as an exhibition designer into the early '40s. Generally speaking, his post-1933 designs link up more closely with the constructivist line of inquiry pursued in the 1932 Exhibition of the Fascist Revolution than with the archaizing one featured in the murals and mosaics. Cases in point are two events staged in Muzio's Palace of Art: the 1934 Exposition of Italian Aeronautics and the 1935 Exhibition on Sports. In the aeronautical exposition, Sironi packed his space with actual warplanes, so as to play off their irregular aerial architecture against the heavy regularity of the room (figure 100). Amid the diagonal configurations of aircraft, he aligned sequences of concentric tricolor circles along the rows of quadrangular piers from which jutted out cornice-like light fixtures. Geometrical podiums, display cases, and stands made from various materials were the only objects on the floor, creating an overall feeling of spaciousness that extended also to the walls, on which were arrayed simple interlocking vertical and horizontal bands made up of photographs, statistics, and blocks of type. The rooms of the Exhibition on Sports employed similar idioms and effects but, in keeping with their theme, involved a greater degree of compression, the rhythmic use of the Olympic rings, and a more animated syntax of forms. Over the next few years Sironi would go on to design the Fiat pavilion at the 1936 Milan Trade Fair, the Italian pavilions at the 1937 Universal Exposition of Paris and the Düsseldorf *Schaffendes Volk* exhibit, and the Fiat pavilion for the 1938 Turin Autarchic Exhibition (figure 101). Remarkably enough, even in the last of these projects there were palpable signs of inno-

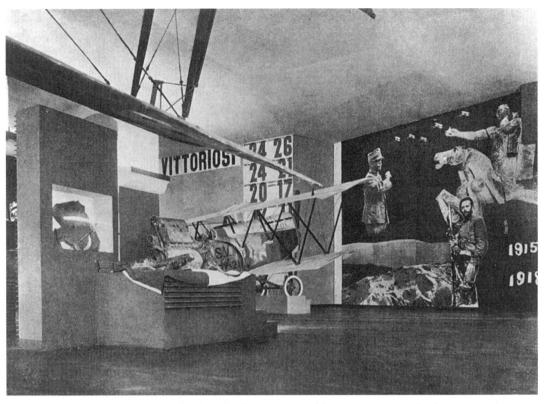

**Figure 100** Mario Sironi, hall dedicated to the role of aviation in World War I, Exposition of Italian Aeronautics, Palazzo dell'Arte, Milan, 1934. *Catalogo dell'esposizione dell'aeronautica* (Milan: Edizioni d'arte, 1934).

vation and growth: the use of juxtaposed negative/positive typographical and statistical blocks; shifts in scale from miniature to life-size to oversize; juxtapositions between gestural wall paintings and hard-edge typography and objects. By the time of the Fiat exhibit at the 1941 Milan Trade Fair, however, Sironi's vein of inventiveness was beginning to run dry and stock solutions appeared that would have seemed out of place in the previous decade.

SIRONI'S PROLIFIC CAREER as an exhibition designer, organizer, and architect thus came to a close precisely as the revolution whose cause these activities had so vigorously espoused hurtled headlong toward disaster. The coincidence is fitting, since the connection between the Fascist cause and the Sironian exhibitions had been ineradicable from the start. Fascism provided Sironi with an ideal vehicle not only for express-

ing his fervently nationalist political convictions and anti-Enlightenment pessimism but also for pursuing his own artistic "return to order" and revolt against Futurism's materialism, anarchic individualism, and wholesale dismissal of the Italian cultural past. The past in question, Sironi felt, represented the shared spiritual patrimony of an entire race, a common language binding Italians to other Mediterranean peoples, and an enduring source of artistic discipline and pride in craft. To dismiss that past out of hand as an obstacle to Italy's development was to condemn oneself to solipsism, superficiality, and sociopolitical irrelevance. To worship it acritically, on the other hand, was to fix no limits on the memory of the past at the expense of modern cultural forms. Fascism's rhetoric of conservative revolution offered Sironi a smooth way out: a middle course between these extremes of forgetting and remembering that tendered the promise of a heroic overcoming of Italy's inglorious past

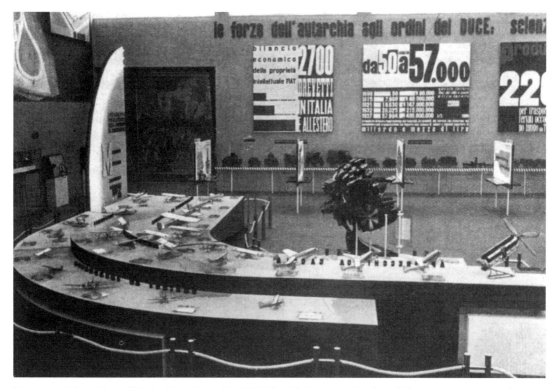

**Figure 101** Mario Sironi, Fiat Pavilion, Autarchic Exhibition, Turin, 1938. *Catalogo della rassegna autarchica di Torino* (Turin: n.p., 1938).

alongside the promise of a rigorously contemporary resumption of Italy's former glory.

Sironi was one of the twentieth century's great mythmakers in this mnemonic/counter-mnemonic sense: a mythmaker no less great than Mexican counterparts such as Diego Rivera, Clemente Orozco, and David Alfredo Siqueiros. In an extraordinary diversity of exhibition projects and media, he strove to build up a solid monumental world, a new (old) world in harmony with what his friend Massimo Bontempelli had defined as *the spirit of architecture:* "Architecture quickly becomes anonymous. Architecture remolds the surfaces of the world. It knows how to prolong itself and to achieve fulfillment in the forms of nature."[27] Anonymity, always linked to the constellation architecture/nature/revolutionary myth, represented for Sironi a twofold ideal. On the one hand, it constituted the necessary precondition of existence for all of those remote historical epochs—Egyptian, Minoan, Etruscan,

archaic Roman, Byzantine, Romanesque—which the modern Italian artist-architect needed to recover in order to overcome the burdens of specious individualism and the trivializing effects of the bourgeois commodification of art. On the other hand, anonymity designated the social mission of the Sironian exhibition: to reintegrate the artist into society as an ordinary man among men, to place his work in the service of a single collective Fascist style, and to imprint his style on the mass audience, thereby naturalizing it. The pursuit of anonymity, therefore, never entailed a total renunciation of one's identity in the name of the collective good, something that "is at odds with the Italian temperament," as Sironi stated in the "Manifesto of Muralism."[28] Rather, it entailed gaining access to at once more elemental and more elevated forms of subjectivity, identity, expression, and being. For Sironi the revolution was a heroic enterprise of precisely this sort: "elemental" inasmuch any adequate plastic analog

would have to provide an intensified experience of the artwork's brute materiality; "elevated" inasmuch as, within the context of this hypermateriality, it would need to elaborate a rhetoric of elemental forms that, via historical resonances and a titanic scale, could suggest that impermanence and instability were at an end. The new kingdom had come, and its foundations were already solidly in place. Art's task was simply to amplify this work of (re)foundation: to provide the spark that provokes the flash that ignites the world.

Here, for once, the mixing of metaphors is obligatory: solidity sparks, foundations flash, monuments ignite. This is because no matter how strong the link between Sironi's drive toward monumentality and the regime's drive toward nation building, one would do well to attend to what Giuseppe Pagano referred to as "the principal condition . . . (or, rather, the 'necessary' condition)" of all exhibitions: namely, their provisional, evanescent nature.[29] Edging up against their inevitable destruction and substitution, Sironi's monuments were always intended as revolutionary *moments*: as monuments in motion, events to be seized, consumed, and then gone beyond. Hence the freedom with which the artist's exhibition rooms were broken up into recyclable parts and rearranged into new configurations. Hence also Sironi's noted disdain for the sale and conservation of artworks and devotion to minor, ephemeral arts. For all its illusory veneer of power and permanence, then, the Sironian monument was animated from within by the deeper reality of a no less monumental will to improvisation—a will that could find no more amenable refuge than within the greatest exhibition halls of the Fascist decades.

## Appendix: Mario Sironi, "The Manifesto of Muralism"

Originally published in the December 1933 issue of *La Colonna*, "The Manifesto of Muralism" was signed by Mario Sironi, Massimo Campigli, Carlo Carrà, and Achille Funi, all four of whom were among the muralists featured at the controversial Fifth Triennial of Modern Decorative and Industrial Arts and of Modern Architecture. The document is defiant in character and seeks to defend mural painting against its conservative detractors by developing a cluster of themes first elaborated by Sironi in an essay published in *Il Popolo d'Italia* on January 1, 1932 (and subsequently picked up by Gio Ponti's *Domus* as a rallying cry): the need to recover the "solar, Mediterranean ideals" of Italian art; the rejection of naturalism in the name of a higher public art consonant with the "grand myths and gigantic revolutions" of modern times; the call for the reintegration of painting, architecture, and the so-called "minor" arts; and the dismantling of the bohemian concept of the artist and his reinsertion into society as a disciplined craftsman and worker. Such was the program that Sironi set out to realize in the course of the subsequent decade: a program that often echoed analogous writings by Fernand Léger and the Mexican muralists (dating from the late '20s through the late '30s), but that the Italian painter insistently invested with nationalist and Fascist meanings. The following translation, the first into English, is based on the reprint of "The Manifesto of Muralism" found in Mario Sironi, *Scritti editi e inediti,* edited by Ettore Camesasca and Claudia Gian Ferrari (Milan: Feltrinelli, 1980), 155–57.

FASCISM IS A way of life, life as lived by today's Italians. No formula will ever succeed in fully defining or containing it. Nor will any formula ever succeed in defining or containing what is here referred to as "Fascist art": which is to say, an art that is the plastic expression of the Fascist spirit.

Fascist art will delineate itself only gradually as a result of the hard work of the very best. What can and should be done at this point is simply to clear away the many confusions that continue to face artists.

Art assumes a social function in the Fascist state: an educational function. It must interpret the ethos [*etica*] of our times. It must confer unity of style and grand contours upon everyday existence. Only thus can art regain the status that it enjoyed during the greatest epochs and within the

greatest civilizations: as a perfect instrument of spiritual rule.

Individualist conceptions of art for art's sake have been eclipsed. A deep incompatibility has resulted between the aims that Fascist art has set for itself and artistic forms informed instead by whim, by the cult of anomaly [*singolarizazzione*] or by the aesthetic particularity of a given group, artistic circle, or academy.[30] The great unease that continues to haunt European art is the product of spiritual eras in which decomposition remains the prevailing trend. After decades of virtuoso technical exercises and of minute, Nordic-inspired probings [*introspezioni*] of naturalistic phenomena, modern painting yearns for a higher spiritual synthesis.[31]

Fascist art rejects the trial balloons, experiments, and tests that proliferated during the past century. It especially rejects the offspring of those experiments whose existence, unfortunately, extends even into the present.[32] However variegated in appearance and often divergent, these experiments all are rooted in a shared materialistic conception of life characteristic of the past century: a conception that seems to us not only foreign but deeply abhorrent.

Mural painting is social painting par excellence. It works upon the popular imagination more directly than any other form of painting, while directly inspiring the decorative arts. The current resurgence in mural painting, especially in the painting of frescoes, helps to frame the question of Fascist art. The practical nature of sites for murals (public buildings, places endowed with civic functions), the laws that govern mural art, the prevalence in muralism of stylistic factors over emotional ones, murals' intimate relation to the art of architecture: all these factors keep artists from yielding to the temptation to improvise or to rely upon facile displays of virtuoso technique. Rather, the mural technique itself dictates decisive and virile execution. It demands mature creations that spring forth fully formed in the artist's mind. Genre painting, forms of painting in which compositional order and rigor do not prevail, fall short when faced with muralism's scale and technical demands.[33]

A "Fascist style" will arise out of mural painting: a style in which our new civilization will recognize its likeness.[34] Painting's educational function is, above all, a question of style. Through the evocation of a climate, through style (and not through content, as communists mistakenly believe), art will succeed in impressing a new shape upon the popular spirit.

Questions of "content" are too easily addressed to be essential in nature. A convenient refuge sought by the pseudo-champions of content, orthodoxy of subject matter is never enough.[35] The style of Fascist painting must be both ancient and ultra-new for it to achieve consonance with the spirit of the revolution. It must vigorously reject the continuing drift towards a small-minded, commonplace art founded upon what is supposed (entirely falsely) to be "common sense"; an art that reflects neither a "modern" nor a "traditional" mentality. It must combat all pseudo-recursions [*ritorni*] in art inasmuch as they represent a cheap aestheticism and a deep affront to a genuine feeling for tradition.[36]

Every individual artist faces a moral challenge: that of renouncing an egocentrism that renders his spirit infertile; that of becoming a "militant," an artist in the service of a moral ideal who subordinates his individuality to the collective task.

Literal anonymity is not the issue here (for it is at odds with the Italian temperament), but rather a sense of intimate dedication to the collective enterprise. We are deeply persuaded that the artist must once again become an ordinary man among men, just as he was during the supreme eras of our civilization.

Nor is our aim to promote hypothetical agreement on a single formula for art—a practical impossibility. Rather, it is to persuade artists that they must rigorously and explicitly free their art from subjective and arbitrary elements, as well as from a specious originality that is desired and fed by vanity alone.

We believe that the voluntary imposition of artistic discipline contributes to the forging of true and authentic talent. Our predominantly decorative, muralistic, and stylistic traditions strongly favor the birth of a Fascist style. This said, elective affinities with the great epochs of Italy's past cannot be felt except by someone who

has a deep understanding of the present era. The spirituality of the early Renaissance is closer to us than the pomp of the Venetian masters. The art of pagan and Christian Rome is closer to us than that of ancient Greece. We have returned to mural painting thanks to aesthetic principles that matured in the Italian soul since the Great War.

Thanks not to chance but to a deep intuition [*divinazione*] of the spirit of our times, the boldest investigations carried out by Italian painters have for some years now focused on mural painting and problems of style. Life has seen to it that these efforts will be pursued until the necessary unity is achieved.

EPILOGUE

# Mussolini's Body as *Fotografia Infamante*

*Roger J. Crum and Claudia Lazzaro*

Late in the night of April 26, 1945, in the final days of Italian Fascism, the puppet Salò Republic, and World War II, a desperate Mussolini joined a small band of retreating German soldiers near Lake Como in the north of Italy. The soldiers were intent on slipping undetected into Switzerland, thereby evading capture by the advancing American and British forces. Fearing inevitable recognition at the border, Mussolini disguised himself by wearing a Luftwaffe coat and a German helmet. Yet not long into this masquerade, the fifty-second Garibaldi brigade of partisans discovered Mussolini's presence when the feeble column was intercepted near Dongo. Two days later, on April 28, a firing squad executed Mussolini before the Villa Belmonte, near the village of San Giulino di Mezzegra. At her request, Clara Petacci, the Duce's mistress of nearly a decade, was executed only minutes before. Their bodies were then driven some thirty-seven miles to Milan, where, at a gas station in Piazzale Loreto, they were unceremoniously dumped onto the ground. Together with the corpses of other key Fascists who had recently been captured and executed, the bodies of Mussolini and Petacci were at the mercy of an angry crowd.[1]

"The dead Mussolini at last," writes R. J. B. Bosworth, "could be attacked with impunity. Not only did the crowd hurl imprecations at their ex-leader and spit at his remains, they also hit out at the corpse with sticks and their bare hands. Local women, it is claimed, urinated on it."[2] When the bodies of Mussolini, Petacci, and the others had been beaten to a point of nearly unrecogniz-

able mutilation, something happened that, in retrospect, transformed those visceral, physical moments of hatred into a highly symbolic display of public defamation. Rino Pachetti, an officer among the Resistance forces, ordered the bodies of the executed to be drawn up on a metal framework at the gas station and suspended ignominiously by their heels (figure 102).[3] The same crowd that moments earlier had struck the detested physical remains became spectators of a scene that was unintentionally rich in historical antecedent.

Throughout the late Middle Ages and Renaissance, Italian communes frequently had defaming representations of convicted criminals and political enemies painted on the exteriors of public buildings.[4] At times these paintings, known as *pitture infamanti,* presented their vilified subjects hanging upside down, much as Mussolini and his associates were suspended by their feet in a display that instantly transformed them into a collective tableau non-vivant. In Piazzale Loreto, death (rather than life) imitated art before the gaze of a Milanese crowd that for years had been trained to experience a very different kind of Fascist spectacle, of which the display of Mussolini's pitiful body made a mockery.

This book analyzes various ways in which Mussolini and the Fascist regime appropriated the art of the Italian past. In death, Mussolini, or rather his body, was similarly made to appropriate a potent image from that tradition. Presented like any number of his forebears in medieval and Renaissance *pitture infamanti*, Mussolini himself

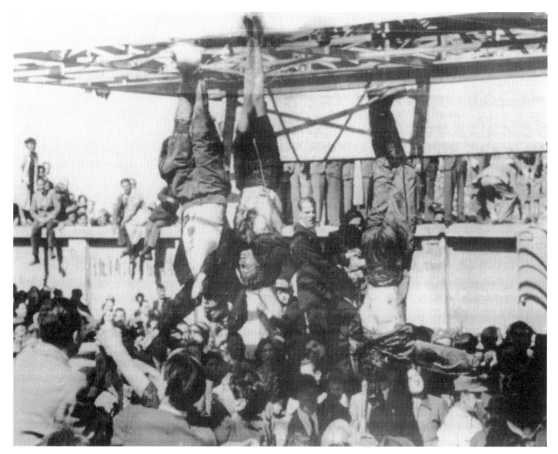

**Figure 102** The public display of the bodies of Benito Mussolini, left, and his mistress, Clara Petacci, center, hanging by their heels, while Achille Starace is being hoisted at the right, Milan, Piazzale Loreto, 1945. AP/Wide World Photos.

became a visual object, especially once the event in the piazza was widely circulated in a photograph as a kind of *fotografia infamante*. In a sense, the scene from Piazzale Loreto made of Mussolini a defamed "Donatello" among the Blackshirts; but as the object of public scorn, he was a Donatello more pitifully human and more passionately reviled than the Duce had ever been presented in the historically informed images of his own visual propaganda.[5] In the end the Blackshirts—those who had long supported the artful construction of their leader's image—remained in Mussolini's company, although now as objects themselves swinging lifelessly in the wind by his side.

# Chronology of Cultural and Political Events

1861    Kingdom of Italy proclaimed

1909    F. T. Marinetti's "Futurist Manifesto"

1914    August: World War I begins; Italy enters May 1915

1918    November: Armistice ending World War I signed

1922    October 28: March on Rome; Mussolini appointed prime minister

       National Library of Archaeology and Art History established in Palazzo Venezia

       Journal *L'Ala d'Italia* (The Wing of Italy) published (1922–43)

1923    Competition for restoration of the Palazzo del Corte in Ferrara

1924    Excavation of Forum of Augustus begins (1924–30)

       Journal *Capitolium* inaugurated

       Istituto LUCE, the government-controlled film agency, formed

1925    January: Mussolini's dictatorship declared

       "Manifesto of Fascist Intellectuals"

       *Italian Encyclopedia* initiated; first volume published 1929

       Institute for Roman Studies established

1926    Royal Academy of Italy established

       Demolition of the western side of the Capitol for the Via del Mare

       Fascist regime adopts the fasces as official emblem

       Victory Monument at Bolzano (1926–28) unveiled

       Museum of the Roman Empire (Museo dell'Impero) inaugurated

       Excavation of the Mausoleum of Augustus begun (1926–30; 1934–38)

1928    Enrico del Debbio designs Mussolini Forum (now Foro Italico) (1928–43)

       Monument to Petrarch unveiled in Arezzo

       First Italian Exposition of Rational Architecture, Rome

1929    Palazzo Venezia in Rome made Mussolini's headquarters

       Lateran Pact with the Catholic Church recognizing the Vatican's independence

       F. T. Marinetti launches *aeropittura futurista* movement (Futurist aerial painting)

       Mussolini officially inaugurates the Royal Academy of Italy

       Town Hall in San Gimignano restored (1929–34); crenellations added 1939

1930    October: Via del Mare inaugurated

       Exhibition of Italian Art 1200–1900, Royal Academy, London

1931    Master Plan of Rome by Marcello Piacentini

       April: Exhibition of the Italian Garden, Florence

       University professors' oath of allegiance to Fascism

       Fillia paintings, *The City of God, The Holy Family,* and *The Adoration*

1932    Via dell'Impero (now Avenue of the Imperial Fora) in Rome constructed

Garibaldian Exhibition (April 30–June 2)

Exhibition of the Fascist Revolution (October 1932–October 1934)

Mussolini Stadium (now Stadium of Statues) inaugurated at Mussolini Forum

University City (Città Universitaria) begun (1932–35)

Giovanni Michelucci designs the Florence train station (1932–36)

March: Michelucci's photo-essay "Contacts between Ancient and Modern Architecture" in *Domus*

Giuseppe Terragni designs Casa del Fascio, Como (1932–36)

Five new towns south of Rome begin (1932–39)

1933    Mario Sironi murals in Fifth Triennial of Modern Decorative and Industrial Arts and of Modern Architecture

December: Mario Sironi's "Manifesto of Muralism"

December 24: designated Day of the Mother and Child

1934    Demolition for the Piazzale Augusto Imperatore begins (1934–40)

Exposition of Italian Aeronautics, Milan

Benedetta painting, *Mystical Interpretation of a Landscape*

1935    October: Italy invades Ethiopia

League of Nations institutes economic sanctions; "autarchy" campaign begins

Town of Guidonia founded, dedicated to aeronautics (completed 1937)

From Cimabue to Tiepolo exhibition, Petit Palais, Paris

Italian Art of the Nineteenth and Twentieth Centuries exhibition, Jeu de Paume, Paris

1936    Mussolini declares victory in Ethiopia and proclaims the Italian empire

Viale dell'Impero at Mussolini Forum inaugurated

Exhibition of Rural Architecture, Milan

Walter Benjamin's "The Work of Art in the Age of Mechanical Reproduction" published

1937    Triumphal Arch in Libya by Florestano di Fausto inaugurated

Axum obelisk brought to Rome from Ethiopia

Bimillennium of the birth of Emperor Augustus

Augustan Exhibition of Romanness (Mostra Augustea della Romanità) (September 1937–November 1938)

Ara Pacis excavated (1937–38)

Vittorio Ballio Morpurgo designs the Piazzale Augusto Imperatore (1937–40)

EUR regulatory plan approved

Centenary of Giacomo Leopardi's death celebrated in Recanati

National Institute for Studies on the Renaissance founded

1938    Hitler visits Mussolini in Italy in May

Fascist Grand Council adopts anti-Semitic legislation, dismisses over ninety academics

Giovanni Guerrini, Ernesto La Padula, and Mario Romano design Palazzo della Civiltà (now Palazzo del Lavoro) at EUR

Adalberto Libera designs Villa Malaparte on Capri

Ostia excavations intensified (1938–42; begun 1909)

Production of Fascist maiolica in Forlì begins

Renato Biasutti's *La casa rurale nella Toscana* initiates the series on rural architecture, *Richerche sulle dimore rurali*

1939    Leopardi's tomb moved next to that of Virgil in Naples

1940    April: Journal *Civiltà* begins

June: Italy enters World War II on the side of Germany

1941    Documentary film *San Gimignano dalle belle torri* produced

1942    Projected Universal Exposition of Rome; work on EUR suspended

1943    Fascist Party dissolved and Mussolini overthrown

1945    April 28: Partisans execute Mussolini

1948    Republic of Italy officially proclaimed

# Notes

## INTRODUCTION

1. On Silvio Berlusconi, prime minister of Italy, see Joe Klein, "The Showman," *Guardian Weekly* (Manchester), 13–19 June 2002, 20–21. Many Web sites promote "Italian design," among them one that traces the history of its current commercial success to the industrial design exhibits of the 1930s (http://www.ueitalia2003.it/EN/Italia/madeItaly/Eccellenze/design.htm). The World Heritage List, in which Italy is tied with Spain for the most entries, is produced by the World Heritage Organization under the aegis of UNESCO (http://whc.unesco.org/heritage.htm). Its title implies that it belongs to us all, not to individual nations.

2. For example, Rory Carroll, "Nostalgic Italy Hails Its Duce Once Again," *Guardian Weekly* (Manchester), 13–19 September 2001, published a photo of a Roman bar displaying wine bottles with pictures of Mussolini and Hitler.

3. On the tourist industry, see D. Medina Lasansky's essay in this volume; and R. J. B. Bosworth, *Italy and the Wider World 1860–1960* (London: Routledge, 1966). On the new legislation, see "Lightning Law to Privatise 'la Bella Italia,'" *Art Newspaper*, July–August 2002, 1 and 9, and "The Devil Is in the Detail," *Art Newspaper*, July–August 2002, 1.

4. The 1947 peace treaty stipulated the return of the obelisk, but until early 2004 this was stalled by Italian procrastination, unrest in Ethiopia, the difficulties of transporting it, and the repair of recent damage by lightning. See *Art Newspaper*, March 2001, 5; also http://www.africaonline.com/site/Articles/1,3,48690.jsp; and http://www.he.net/~archaeol/online/news/axum.html. For one perspective on the Ara Pacis, see http://www.comune.roma.it/cultura/italiano/musei_spazi_espositivi/musei/museo_ara_pacis/pag005.htm. See also Ann Thomas Wilkins's chapter in this volume.

5. David Lowenthal, *The Past Is a Foreign Country* (Cambridge: Cambridge University Press, 1985).

6. See Claudia Lazzaro, "Italy Is a Garden: The Idea of Italy and the Italian Garden," in *Villas and Gardens in Early Modern Italy and France,* ed. Mirka Beneš and Dianne Harris (New York: Cambridge University Press, 2001), 29–60.

7. For Fascism as a secular religion, see Emilio Gentile, *The Sacralization of Politics in Fascist Italy,* trans. Keith Botsford (Cambridge: Harvard University Press, 1996).

8. R. J. B. Bosworth argues the notion of "weak dictator" in *Mussolini* (New York: Oxford University Press, 2002), and in *The Italian Dictatorship: Problems and Perspectives in the Interpretation of Mussolini's Fascism* (London: Arnold, 1998), especially 8–9 and 58–81.

9. Ruth Ben-Ghiat, *Fascist Modernities: Italy, 1922–1945* (Berkeley: University of California Press, 2001), 4 and 9.

10. Antonio Cederna, *Mussolini urbanista: Lo sventramento di Roma negli anni del consenso* (Rome: Laterza, 1979).

11. Robert S. Nelson, "Appropriation," in *Critical Terms for Art History,* ed. Robert S. Nelson and Richard Shiff (Chicago: University of Chicago Press, 1996), 116–18.

12. Kathleen Ashley and Véronique Plesch, "The Cultural Processes of 'Appropriation,'" *The Journal of Medieval and Early Modern Studies* 32, no. 1 (2002): 6.

13. On translatability and memory, see Wolfgang Iser, "Coda to the Discussion," and Gabriel Motzkin, "Memory and Cultural Translation," in *The Translatability of Cultures: Figurations of the Space Between,* ed. Sanford Budick and Wolfgang Iser (Stanford: Stanford University Press, 1996), 294–98 and 263–68.

14. See the chapters by Diane Yvonne Ghirardo and D. Medina Lasansky in this volume.

15. Paul Zanker, *The Power of Images,* trans. Alan Shapiro (Ann Arbor: University of Michigan Press, 1988), v.

## 1. FORGING A VISIBLE FASCIST NATION

1. For ideas of Italy through the eighteenth century, see Claudia Lazzaro, "Italy Is a Garden: The Idea of Italy and the Italian Garden Tradition," in *Villas and Gardens in*

*Early Modern Italy and France,* ed. Mirka Beneš and Dianne Harris (Cambridge: Cambridge University Press, 2001), 29–60.

2. Among the many studies on mass politics and culture, see Alexander De Grand, *Italian Fascism: Its Origins and Development* (Lincoln: University of Nebraska Press, 1982), especially 3; Philip V. Cannistraro, *La fabbrica del consenso: Fascismo e mass media* (Rome: Laterza, 1975); George L. Mosse, *The Nationalization of the Masses* (New York: H. Fertig, 1975); and Mabel Berezin, *Making the Fascist Self: The Political Culture of Interwar Italy* (Ithaca: Cornell University Press, 1997).

3. Eric Hobsbawm, "Introduction: Inventing Traditions," in *The Invention of Tradition,* ed. Eric Hobsbawm and Terence Ranger (Cambridge: Cambridge University Press, 1983), 1–14; Hobsbawm, *Nations and Nationalism since 1780: Programme, Myth, Reality,* 2d ed. (Cambridge: Cambridge University Press, 1992); Benedict Anderson, *Imagined Communities: Reflections on the Origin and Spread of Nationalism* (London: Verso, 1983); and Ernest Gellner, *Nations and Nationalism* (Ithaca: Cornell University Press, 1983).

4. Jeffrey T. Schnapp, "Fascism's Museum in Motion," *Journal of Architectural Education* 45 (1992): 87; and Schnapp, "Epic Demonstrations: Fascist Modernity and the 1932 Exhibition of the Fascist Revolution," in *Fascism, Aesthetics, and Culture,* ed. Richard J. Golsan (Hanover: University Press of New England, 1992), 2.

5. John Gibbons, *Afoot in Italy* (New York: E. P. Dutton, 1932), 204.

6. Antonio Cederna, *Mussolini urbanista: Lo sventramento di Roma negli anni del consenso* (Rome: Laterza, 1979), 32.

7. Gibbons, *Afoot,* 238.

8. Cederna, *Mussolini urbanista,* 32.

9. John Agnew, "The Myth of Backward Italy in Modern Europe," in *Revisioning Italy: National Identity and Global Culture,* ed. Beverly Allen and Mary Russo (Minneapolis: University of Minnesota Press, 1997), 23–42, especially 23–26.

10. For this pluralism, see Laura Malvano, *Fascismo e politica dell'immagine* (Turin: Bollati Boringhieri, 1988); Simonetta Fraquelli, "All Roads Lead to Rome," and Ester Coen, "'Against Dreary Conformism': Giuseppe Bottai and Culture During the Fascist Period," in *Art and Power: Europe under the Dictators, 1930–45,* ed. Dawn Ades et al. (London: Hayward Gallery, 1995), respectively 130–36 and 178–80; and Marla Susan Stone, *The Patron State: Culture and Politics in Fascist Italy* (Princeton: Princeton University Press, 1998), especially 61–94.

11. See "Fascism and Culture," ed. Jeffrey T. Schnapp and Barbara Spackman, special issue, *Stanford Italian Review* 8, nos. 1–2 (1990); Diane Y. Ghirardo, "Italian Architects and Fascist Politics: An Evaluation of the Rationalists' Role in Regime Building," *Journal of the Society of Architectural Historians* 39 (1980): 109–27; Ghirardo, "Archi-

tects, Exhibitions, and the Politics of Culture in Fascist Italy," *Journal of Architectural Education* 45 (1992): 67–75; Emily Braun, "Mario Sironi and a Fascist Art," in *Italian Art in the 20th Century,* ed. Emily Braun (Munich: Prestel-Verlag, 1989), 173–80; Braun, "Speaking Volumes: Giorgio Morandi's Still Lifes and the Cultural Politics of *Strapese*," *Modernism/modernity* 2, no. 3 (1995): 89–116; Schnapp, "Epic Demonstrations"; Stone, *Patron State,* especially 7–10; and Emilio Gentile, "The Conquest of Modernity: From Modernist Nationalism to Fascism," *Modernism/modernity* 1, no. 3 (1994): 55–88. For writers, filmmakers, and other intellectuals, see Ruth Ben-Ghiat, *Fascist Modernities: Italy, 1922–1945* (Berkeley: University of California Press, 2001).

12. This question is posed by Reed Way Dasenbrock, "Paul de Man: The Modernist as Fascist," in *Fascism, Aesthetics, and Culture,* 229–41, especially 240, and is implicit in many of the sources previously cited, particularly Ben-Ghiat, *Fascist Modernities.* On Fascism and modernism, see also Mark Antliff, "Fascism, Modernism, and Modernity," *Art Bulletin* 84 (2002): 148–69, especially 165; and Emily Braun, "The Visual Arts: Modernism and Fascism," in *Liberal and Fascist Italy 1900–1945,* ed. Adrian Lyttleton (Oxford: Oxford University Press, 2002), 196–215.

13. I have applied to this context Dasenbrock's statement that "contemporary critical theory is part of a history that includes modernism and fascism. . . . These . . . have all helped create the intellectual landscape in which we live and work." See Dasenbrock, "Paul de Man," 241.

14. Romke Visser, "Pax Augusta and Pax Mussoliniana," in *The Power of Imagery: Essays on Rome, Italy and Imagination,* ed. Peter van Kessel (Rome: Apeiron, 1993), 110.

15. On *romanità,* see Romke Visser, "Fascist Doctrine and the Cult of the *Romanità,*" *Journal of Contemporary History* 27 (1992): 5–22; Visser, "Pax Augusta," 109–30; Lorenzo Quilici, "Romanità e civiltà romana," in *Dalla mostra al museo: Dalla Mostra archeologica del 1911 al Museo della civiltà romana* (Venice: Marsilio, 1983), 17–25; Mariella Cagnetta, *Antichisti e impero fascista* (Bari: Dedalo, 1979), 9–13, 51–55; and Cagnetta, *Antichità classiche nell'enciclopedia italiana* (Rome: Laterza, 1990), 4–18.

16. For similar myths in Liberal and Fascist Italy, the former sponsored by individuals, the latter by the state, see Cagnetta, *Antichisti,* 11; Visser, "Fascist Doctrine," 6–8; and Visser, "Pax Augusta," 113–15. For Abbé Gioberti's *Del primato morale e civile degli italiani,* see Mario D'Addio, "Political Thought and Nationality in Italy," in *Nationality and Nationalism in Italy and Finland from the mid-19th Century to 1918,* ed. Maija Väinänen (Helsinki: SHS, 1984), 49–54. For the first use of *italianità,* see Salvatore Battaglia, *Grande dizionario della lingua italiana,* vol. 8 (Turin: Unione tipografico-editrice torinese, 1973), 624.

17. Visser, "Fascist Doctrine," 13–17.

18. Prasenjit Duara, *Rescuing History from the Nation:*

*Questioning Narratives of Modern China* (Chicago: University of Chicago Press, 1995), 16.

19. Alesssandro Guidi, "Nationalism without a Nation: The Italian Case," in *Nationalism and Archaeology in Europe*, ed. Margarita Díaz-Andreu and Timothy Champion (Boulder, Colo.: Westview Press, 1996), 108–18. Guidi, 111–12, notes that a theory of the civilizing role of the north over the south in prehistoric times provided a precedent for northern Italy in unification.

20. For example, D. Medina Lasansky, "Tableau and Memory: The Fascist Revival of the Medieval/Renaissance Festival in Italy," *The European Legacy* 4 (1999): 26–53, especially 42; and Diane Ghirardo and Kurt Forster, "I modelli delle città di fondazione in epoca fascista," in *Storia d'Italia. Annuali 8: Insediamenti e territorio*, ed. Ruggiero Romano and Corrado Vivanti (Turin: Einaudi, 1985).

21. Hobsbawm, "Inventing Traditions," 14.

22. Guidi, "Nationalism," 115.

23. Margarita Díaz-Andreu and Timothy Champion, "Nationalism and Archaeology in Europe: An Introduction," in *Nationalism and Archaeology*, 1–23, especially 3.

24. Ronald T. Ridley, "Augusti Manes volitant per auras: The Archaeology of Rome under the Fascists," *Xenia* 11 (1986): 19–46, especially 42–43.

25. Malvano, *Fascismo e politica*, 151–53.

26. For the Capitoline *She-Wolf*, see Francis Haskell and Nicholas Penny, *Taste and the Antique: The Lure of Classical Sculpture* (New Haven: Yale University Press, 1981), 335–37; Phyllis Pray Bober and Ruth O. Rubinstein, *Renaissance Artists & Antique Sculpture* (London: Harvey Miller, 1986), 218; and Wendy Stedman Sheard, *Antiquity in the Renaissance* (Northampton: Smith College Museum of Art, 1979), cat. 17. Livy mentioned a she-wolf erected in 296 B.C.E, and Cicero noted one on the Capitol. At the papal palace at the Lateran from at least the late tenth century, the bronze statue was moved by Pope Sixtus IV in 1471 to the Capitol, where it became associated with the statue cited by Cicero. The twins Romulus and Remus were added in the late fifteenth century in order to conform to ancient descriptions.

27. Otto J. Brendel, *Prolegomena to the Study of Roman Art* (New Haven: Yale University Press, 1979), 148; Diana E. E. Kleiner, *Roman Sculpture* (New Haven: Yale University Press, 1992), 23–24; and Nancy H. Ramage and Andrew Ramage, *Roman Art: Romulus to Constantine*, 2d ed. (Englewood Cliffs: Prentice-Hall, 1996), 33–34.

28. Gibbons, *Afoot*, 37.

29. Tracy H. Koon, *Believe, Obey, Fight: Political Socialization of Youth in Fascist Italy, 1922–1943* (Chapel Hill: University of North Carolina Press, 1985), 21.

30. A she-wolf appears on the monuments to Camillo Cavour and Giuseppe Garibaldi in Rome, both of 1895. See Lars Berggren and Lennart Sjöstedt, *L'ombra dei grandi: Monumenti e politica monumentale a Roma*

*(1870–1895)* (Rome: Artemide, 1996), 83–101. The she-wolf and fasces together appeared on the masthead of the journal *Roma*, issued in 1910–11 in celebration of fifty years of unification. See Haskell and Penny, *Taste and the Antique*, 337 n. 26.

31. *The Oxford Classical Dictionary*, ed. N. G. L. Hammond and H. H. Scullard, 2d ed. (Oxford: Clarendon Press, 1970), 429, 542, and 609; *Enciclopedia italiana di scienze, lettere ed arti*, vol. 14 (Milan: Treves-Treccani-Tumminelli, 1932), 846–47; Philip V. Cannistraro, "Fasces," in *Historical Dictionary of Fascist Italy*, ed. Philip V. Cannistraro (Westport, Ct.: Greenwood Press, 1982), 205; and Simonetta Falasca-Zamponi, *Fascist Spectacle: The Aesthetics of Power in Mussolini's Italy* (Berkeley: University of California Press, 1997), 95–99; Falasca-Zamponi points out that other countries used the fasces as well.

32. Clement Greenberg, "Avant Garde and Kitsch" (1939), reproduced in *Clement Greenberg: The Collected Essays and Criticism*, ed. John O'Brien, vol. 1 (Chicago: University of Chicago Press, 1986), 5–22.

33. Giuseppe Bottai, "Outcome of the Fascist Art Inquiry," *Critica Fascista* (15 February 1927), 61–64, translated and published in *A Primer of Italian Fascism*, ed. Jeffrey T. Schnapp, trans. Schnapp, Olivia E. Sears, and Maria G. Stampino (Lincoln: University of Nebraska Press, 2000), 235.

34. Falasca-Zamponi, *Fascist Spectacle*, 96–99; and Dennis P. Doordan, "Political Things: Design in Fascist Italy," in *Designing Modernity: The Arts of Reform and Persuasion 1885–1945*, ed. Wendy Kaplan (New York: Thames and Hudson, 1995), 225–55, and for the wall lamp, 232 and 342 cat. 220. For another fasces lamp of about 1932, see Doordan, "In the Shadow of the Fasces: Political Design in Fascist Italy," *Design Issues* 13 (1997): 44.

35. John W. Cole and Eric R. Wolf, *The Hidden Frontier: Ecology and Ethnicity in an Alpine Valley* (Berkeley: University of California Press, 1999), especially 57, 91.

36. Ugo Soragni, *Il Monumento alla Vittoria di Bolzano: Architettura e scultura per la città italiana (1926–1938)* (Vicenza: Neri Pozza, 1993), 1–71; and Richard A. Etlin, *Modernism in Italian Architecture, 1890–1940* (Cambridge: MIT Press, 1991), 405–6, fig. 220.

37. Ghirardo, "Architects, Exhibitions," 68; Stone, *Patron State*, 143–45; and Stone, "Staging Fascism," in *Fascism, Aesthetics, and Culture*, 218–21. For the fasces in architecture, see Etlin, *Modernism*, 403–15 and 295–97. Other dramatic photos are reproduced in Fabrizio Brunetti, *Architetti e fascismo* (Florence: Alinea, 1993), 186; and Schnapp, "Epic Demonstrations," 15–16, figs. 3 and 4. Schnapp emphasizes the mass publicity with more than a million and a half photographs, posters, and post cards. Among the contemporary journals that published these photos is F. P. Mulè, "La Mostra della Rivoluzione," *Capitolium* 9 (1933): 1–8.

38. Spiro Kostof, *The Third Rome, 1870–1950: Traffic and Glory* (Berkeley: University Art Museum, 1973).

39. Designed by the Rationalist architect Enrico Del Debbio and constructed in 1928–43, the Foro Mussolini served as headquarters of the Opera Nazionale Balilla (founded 1926), the umbrella organization for Fascist youth groups. See Kostof, *Third Rome,* 72–73; and Tim Benton, "Rome Reclaims Its Empire," in *Art and Power,* 125–27.

40. Valnea Santa Maria Scrinari, "Gli scavi di Ostia e l'E42," in *E42: Utopia e scenario del regime,* vol. 2, ed. Maurizio Calvesi, Enrico Guidoni, and Simonetta Lux (Venice: Marsilio, 1987), 179–88. Excavations had been under way since 1909 but expanded dramatically during the years 1938–42.

41. For the mosaics, based on cartoons by Gino Severini, Achille Canevari, Angelo Capizzano and Giulio Rosso, see Paolo Montorsi, "Il mito di Roma nella pittura di regime (1937–1943): I mosaici del viale dell'impero e le opere decorative per l'E42," *Bolletino d'arte,* 82 (1993): 94–96; *Il Foro Italico e lo Stadio Olimpico: Immagini dalla storia,* ed. Memmo Caporilli and Franco Simeoni (Rome: TOMO, 1990), 135; *Gino Severini: Affreschi, mosaici, decorazioni monumentali, 1921–1941,* ed. Fabio Benzi (Rome: Leonardo-De Luca, 1992), 16 and 72–75; Vincenzo Perugini, *Achille Capizzano Pittore* (Cosenza: Luigi Pellegrini, 1966), 19–24; and Anna Imponente, "Atleti di un impero immaginario," *Art e Dossier,* 58 (1991): 16–21.

42. See Kostof, *Third Rome;* and Liliana Barroero et al., *Via dei Fori Imperiali: La zona archeologica di Roma: Urbanistica, beni artistici e politica culturale* (Rome: Banco di Roma, 1983).

43. For aerial photography, see Karen Frome, "A Forced Perspective: Aerial Photography and Fascist Propaganda," *Aperture,* no. 132 (1993): 76–77.

44. Cederna, *Mussolini urbanista,* x; and for the avenue and demolition, Ridley, "Augusti Manes," 34–35, and Kostof, *Third Rome,* 60–63. For compelling photographs, see Italo Insolera, *Roma fascista nelle fotografie dell'Istituto Luce* (Rome: Editori Riuniti, 2001).

45. Paul MacKendrick, *The Mute Stones Speak: The Story of Archaeology in Italy,* 2d ed. (New York: Norton, 1983), 71 and 178.

46. Alberto M. Racheli, *Restauro a Roma: 1870–1990: Architettura e città* (Venice: Marsilio, 1995); Marco Dezzi Bardeschi, *Il monumento e il suo doppio: Firenze* (Florence: Alinari, 1981); and Piero Giusberti, *Il Restauro Archeologico* (Rome: Fratelli Palombi, 1994).

47. Cederna, *Mussolini urbanista,* xix; Spiro Kostof, "The Emperor and the Duce: The Planning of Piazzale Augusto Imperatore in Rome," in *Art and Architecture in the Service of Politics,* ed. Henry A. Millon and Linda Nochlin (Cambridge: MIT Press, 1978), 287; and Ridley, "Augusti Manes," 19–46, especially 44.

48. Kostoff, "Emperor," 287–89; and Racheli, *Restauro,* 93–103.

49. MacKendrick, *Mute Stones,* 201–6.

50. See Ann Wilkins's chapter regarding the controversy.

51. Antonio Muñoz, *Roma di Mussolini* (Milan: Treves, 1935), 476.

52. For the questions answered, see Ridley, "Augusti Manes," 24–26.

53. Kostof, "Emperor," 289.

54. Dezzi Bardeschi, *Monumento.*

55. Kostof, "Emperor," especially 284–86 and 304 on the Ara Pacis; and Salvatore Settis, "L'Altare della Pace," *FMR* 10 (1983): 85–101. For photographs before the restoration, see Mario Sanfilippo, *La costruzione di una capitale: Roma 1911–1945* (Cinisello Balsamo: Silvana, 1993), 116–19. For the inscriptions, mosaics, and reliefs on Morpurgo's buildings, see Visser, "Pax Augusta," 123–29.

56. William L. MacDonald, "Excavation, Restoration, and Italian Architecture of the 1930s," in *In Search of Modern Architecture: A Tribute to Henry-Russell Hitchcock,* ed. Helen Searing (New York and Cambridge: The Architectural History Foundation and MIT Press, 1982), 298–320.

57. Ugo Ojetti, "Il concorso del giardino italiano a Firenze," *Architettura e Arti Decorative* 10, no. 9 (May 1931): 533–46.

58. For the opening of the Via dell'Impero, for example, see Heather Hyde Minor, "Mapping Mussolini: Ritual and Cartography in Public Art during the Second Roman Empire," *Imago Mundi,* no. 51 (1999): 147–62, especially 151–53.

59. Ridley, "Augusti Manes," 43; Kostof, "Emperor," 285; and Quilici, "Romanità," 17. On Giglioli, see also Visser, "Pax Augusta," 121, and Daniele Manacorda, "Per un'indagine sull'archeologia italiana durante il ventennio fascista," *Archeologia medioevale* 9 (1982), 451–52, who categorizes Giglioli as a *fascista archeologo* (Fascist who does archaeology); and Friedemann Scriba, *Augustus in Schwarzhemd? Die Mostra Augustea della Romanità in Rom, 1937/38* (Frankfurt am Main: Peter Lang, 1995), 60–73.

60. Giulio Quirino Giglioli, "Presentazione," in *Mostra Augustea della Romanità: Catalogo* (Rome: C. Colombo, 1937), vii; and Massimo Pallottino, "La Mostra Augustea della Romanità," *Capitolium* 12 (1937): 519–28.

61. Anna Maria Liberati Silverio, "La Mostra Augustea della Romanità," in *Mostra al museo,* 77–90; also Kostof, "Emperor," 287; Ghirardo, "Architects, Exhibitions," 71; and Marco Rinaldi, "Il volto effimero della città nell'età dell'impero dell'autarchia," in *La capitale a Roma: Città e arredo urbano,* vol. 1, *1870–1945* (Rome: Carte Segrete, 1991), 118–20.

62. Giuseppina Pisani Sartorio, "Mostra al museo," and Daniela Mancioli, "La Mostra archeologica del 1911 e le Terme di Diocleziano," in *Mostra al museo,* 11–16 and 29–32.

63. Ideas about the civilizing role of imperial Rome and thus its primacy also framed the 1911 exhibition. See es-

says by Daniela Mancioli and Vito Fioravanti, "La Mostra archeologica del 1911," in *Mostra al museo,* 29–61. On Rodolfo Lanciani, who originated the exhibition, see Visser, "Pax Augusta," 113–14.

64. Pallottino, "Mostra Augustea," 526; Giglioli, *Mostra Augustea,* xxii; and Silverio, "Mostra Augustea," 85.

65. Giuseppina Pisani Sartorio, "Il Museo della Civiltà Romana," in *Mostra al museo,* 105–10.

66. Silverio, "Mostra Augustea," 77, 80.

67. Quilici, "Romanità," 21.

68. Walter Benjamin, "The Work of Art in the Age of Mechanical Reproduction," in *Illuminations,* ed. Hannah Arendt, trans. Harry Zohn (New York: Schocken Books, 1969), 217–51, especially 220–25.

69. Giglioli, *Mostra Augustea,* xi.

70. Giglioli, "La Mostra Augustea della Romanità," *Palladio* 1 (1937): 202.

71. Pallottino, "Mostra Augustea," 519, characterized the façade by Alfredo Scalpelli as formulated in a most modern fashion (*modernissimamente concepito*) in the form of a triumphal arch.

72. Giglioli, *Mostra Augustea,* xvi.

73. Pallottino, "Mostra Augustea," 520.

74. Giglioli, *Mostra Augustea,* xxiv. For the architects' other projects, see Etlin, *Modernism,* 389, 492, and 657 n. 55.

75. Quilici, "Romanità," 19.

76. "Accessible" is Giglioli's term. Pallottino, "Mostra Augustea," 526, finds the installations conceived in the taste of young and well-known architects. On the façade and installations, see Ghirardo, "Architects, Exhibitions," 70–71. The architects included the modernists Ludovico Quaroni, Vincenzo Monaco, and Francesco Fariello. In contrast to the earlier exhibitions, which are illustrated in *Mostra al museo,* 54–59 and 70–73, the installations of the Augustan Exhibition (illustrated in Pallottino, 520–25, and *Mostra al museo,* 82–86) are striking and novel in presenting texts as prominently as objects.

77. On reduced train fares for the Exhibition of the Fascist Revolution, see Stone, "Staging Fascism," 233–35.

78. Silverio, "Mostra Augustea," 86.

79. G. Giovannoni, "La Mostra Augustea della Romanità," *Palladio* 1 (1937): 204–5.

80. On the Institute for Roman Studies, see Luciano Canfora, *Ideologie del classicismo* (Turin: G. Einaudi, 1980), 94–101; Cagnetta, *Antichisti,* 13–14; Manacorda, "Per un'indagine," 461–64; and Visser, "Fascist Doctrine," 10. Philip V. Cannistraro, "Fascism and Culture in Italy, 1919–1945," in *Italian Art in the 20th Century,* 148, notes that in the '20s the regime brought under its control pre-Fascist cultural institutions, including musical and theatrical companies.

81. Muñoz, *Roma di Mussolini,* 255–59.

82. Cannistraro in *Historical Dictionary,* 183 and 244–45. The wealthy industrialist Giovanni Treccani launched the *Italian Encyclopedia* in 1925, with the support of both the king and Mussolini.

83. For example, Guidi, "Nationalism," 109, notes the exceptional role of foreign scholars in the beginnings of archaeology in Italy in the late eighteenth and nineteenth centuries.

84. Brendel, *Prolegomena,* 41–58, with quotations from 48 and 56. Brendel's project began with a conference presentation in Rome in 1935, followed by an article the next year, which he expanded in 1953, and again in the monograph that he published in 1979. The Latin term *Romanitas* that Brendel and others used and the Italian *romanità* carried similar associations in Fascist Italy, although the Italian was more common. For the problems in any unitary history of Roman art, see Natalie Boymel Kampen, "On Not Writing the History of Roman Art," *Art Bulletin* 77 (1995): 375–78; and Kampen, "On Writing Histories of Roman Art," *Art Bulletin* 85 (2003): 372–73, on Brendel.

85. Brendel, *Prolegomena,* 70. On the German and Italian garden traditions, see my other essay in this volume.

86. Henry A. Millon, "The Role of History of Architecture in Fascist Italy," *Society of Architectural Historians* 24 (1965): 56; and Bottai, "Outcome," in *Primer of Italian Fascism,* 237. On Bottai, see Alexander J. De Grand, in *Historical Dictionary,* 89–90; and Coen, "'Against Dreary Conformism,'" 178–80.

87. Canfora, *Ideologie,* 81–82 and 95–99.

88. Cagnetta, *Antichisti,* 13 and 111–12, following the president of the Institute, C. Galazzi Paluzzi, "Gli studi romani e la romanità dell'Africa," *Roma* 14 (1936): 417–18.

89. Millon, "Role of History," 53–59, and Millon, "Some New Towns in Italy in the 1930s," in *Art and Architecture,* 326–41.

90. Visser, "Fascist Doctrine," 17; and Cagnetta, *Antichisti,* 51.

91. Giuseppe Pagano and Guarniero Daniel, *Architettura rurale italiana* (Milan: Hoepli, 1936), 71.

92. I conflate the exhibition's aims with prevalent Fascist rhetoric, and specifically with a text in the Room of the Immortality of the Idea of Rome in the Augustan Exhibition. This declared that ". . . after the epic undertaking of the battles on African soil, the Roman Empire rises again on the ruins of a barbaric empire." See *Mostra Augustea,* 362–63. Millon, "Role of History," 57 n. 18, finds an aspect of racism in the interest in the vernacular, since it was seen to derive from a common Latin heritage in the Mediterranean.

93. Adrian Lyttelton, *The Seizure of Power: Fascism in Italy 1919–1929,* 2d ed. (Princeton: Princeton University Press, 1987), 379.

94. Pier Vincenzo Mengaldo, *Il Novecento,* Storia della lingua italiana (series) (Bologna: Il Mulino, 1994), 13–16; and Ruth Ben-Ghiat, "Language and the Construction of National Identity in Fascist Italy," *The European Legacy* 2 (1997): 438–43, who notes the increasing regulation of dialects from 1929.

95. Giuseppe Bottai, "Outcome," in *Primer of Italian Fascism,* 237.

96. Millon, "Role of History," 55.

97. Marinella Ferrarotto, *L'Accademia d'Italia: Intellettuali e potere durante il fascismo* (Naples: Liguori, 1977), 20 and 22; and Visser, "Fascist Doctrine," 17, for a related example.

98. Cannistraro, *Fabbrica del consenso,* 49.

99. Dennis P. Doordan, *Building Modern Italy: Italian Architecture 1914–1936* (New York: Princeton Architectural Press, 1988), 109.

100. Ghirardo, "Architects, Exhibitions," 73; and Riccardo Mariani, "The Planning of the E42: The First Phase," *Lotus International,* no 67 (1990): 91–104.

101. Doordan, *Building Modern Italy;* Ghirardo, "Italian Architects," 109–27; and Richard A. Etlin, "Nationalism in Modern Italian Architecture, 1900–1940," in *Studies in the History of Art* 29 (1991): 89–109. For painting and sculpture, see Fraquelli, "All Roads," 134; and David Butler, "Painting and Sculpture," in *Historical Dictionary,* 386–88.

102. Cosimo Ceccuti and Marcello Vannucci, *Immagini nelle parole: Ugo Ojetti* (Milan: Longanesi, 1978), 177–83 and passim; Cederna, *Mussolini urbanista,* xx–xxi, 19, and 23; and Etlin, *Modernism,* 37.

103. Edward R. Tannenbaum, *The Fascist Experience: Italian Society and Culture 1922–1945* (New York: Basic Books, 1972), 291–92.

104. Ghirardo, "Architects, Exhibitions," 115, notes that they also symbolized respectability and class.

105. Millon, "Role of History," 54 n. 4, referring to Gustavo Giovannoni, "Restauro dei monumenti e urbanistica," *Palladio* 7 (1943): 39.

106. Millon, "New Towns," 332. For attacks on modern art as un-Italian, "Jewish," and "Bolshevik," see Fraquelli, "All Roads," 135.

107. *Domus* 5, no. 50 (February 1932): 70–71; no. 51 (March 1932): 134–36; no. 56 (August 1932): 460–61.

108. Benjamin, "Work of Art," 220–25.

109. Plinio Marconi, "Rustica, Architettura," *Enciclopedia italiana,* vol. 30 (Milan: Rizzoli, 1936), 344.

110. Pagano and Daniel, *Architettura rurale;* and Luciano Patetta, "Libri e riviste d'architettura in Italia tra le due guerre," in *Il Razionalismo e l'architettura durante il fascismo,* ed. Silvia Danesi and Luciano Patetta (Milan: Electra, 1988), 47–48. For the Tuscan farmhouses exhibited, see Giovanni Fanelli and Barbara Mazza, *La casa colonica in Toscana: Le fotografie di Piero Niccolò Berardi alla Triennale del 1936* (Florence: Octavo, 1999), who note the role of Rationalist architects in reviving interest in Italian farmhouses.

111. Philip Morgan, *Italian Fascism, 1919–1945* (New York: St. Martin's Press, 1995), 101–4; Cannistraro and Monte S. Finkelstein, *Historical Dictionary,* 43–44; 63–64; 80–81, and 162–64; and Victoria de Grazia, *The Culture of Consent: Mass Organization of Leisure in Fascist Italy* (Cambridge: Cambridge University Press, 1981), 99.

112. Ruth Ben-Ghiat, "Language and Construction," 440, and Lasansky, "Tableau and Memory."

113. Claudia Lazzaro, "Rustic Country House to Refined Farmhouse: The Evolution and Migration of an Architectural Form," *Journal of the Society of Architectural Historians* 44 (1985): 346–67.

114. Eugenio Garin, "La civiltà italiana nell'Esposizione del 1942," in *E42: Utopia e scenario del regime,* vol. 1, ed. Tullio Gregory and Achille Tartaro (Venice: Cataloghi Marsilio, 1987), 3–16.

115. Garin, "La civiltà italiana," 16.

116. Elisabetta Cristallini, "La Rivista dell'Esposizione Universale di Roma: 'Civiltà,'" in *E42,* vol. 2, 266–67.

117. Marina Magnani Cianetti, "L'uso dei materiali costruttivi nella realizzazione delle opere per l'E42," in *E42,* vol. 2, 168.

118. Mariani, "Planning of the E42," 91–104.

119. Etlin, *Modernism,* 494–501; and Ghirardo, "Architects, Exhibitions," 72–74. For which decision came first, economics or *romanità,* see Magnani Cianetti, "L'uso dei materiali," 169; and Mariani, "The Planning of E42," 101. Doordan, *Building Modern Italy,* 3, interprets the design as "reactionary historicism." Mariani, 99–100, and Ghirardo, 73–74, instead find it inspired by young Rationalists. Magnani Cianetti, 168–75, argues that the construction is a creative linking of traditional revetment and modern skeletal construction, while most critics see the revetment as extraneous to the structure and as masking the modern in the old-fashioned. Benton, "Rome Reclaims," 128, finds the EUR project "not without interest," and striking in the scale and sense of harmonious spatial development.

120. Architecture in Como must have been familiar to Rationalist architects, given the renown of Giuseppe Terragni's Casa del Fascio there (completed 1936), in which Pagano saw a relationship with traditional farmhouses. See Etlin, *Modernism,* 470–71.

121. Etlin, *Modernism,* 497, and 658 n. 71, on the crucial phrase "perpetuo ripetersi."

122. MacDonald, "Evcavation," 298–320, especially 311–13.

123. Ibid., 313.

## 2. TO MAKE HISTORY PRESENT

1. Benito Mussolini, "Risposta al Senato sui patti lateranenzi," in *Scritti e discorsi,* vol. 6 (Milan: Hoelpi, 1939), 117. My translation.

2. Benedetto Croce, "Vent'anni fa: Ricordo della pubblicazione di un libro," in *Quaderni della critica* 4, no. 10 (1948): 111–12; my emphasis. Cited in Carlo De Frede, "Il giudizio di Mussolini su Croce," *Storia e politica* 22, no. 1 (1983): 126.

3. De Frede, "Il giudizio," 122.

4. Claudio Fogu, "Actualism and the Fascist Historic Imaginary," *History and Theory* 42, no. 2 (2003): 196–220.

5. Giovanni Gentile, "Politica e filosofia," in *Guerra e fede* (Florence: La Voce, 1919), 145. Actualism (*attualismo*) is the name Gentile chose in 1912 for his philosophical system.

6. Augusto Del Noce, *Giovanni Gentile: Per una interpretazione filosofica della storia contemporanea* (Bologna: Il Mulino, 1990), 268. For a brief introduction to the relationship between Gentile and Fascism, see James Gregor, *Giovanni Gentile: Philosopher of Fascism* (New Brunswick, N.J.: Transaction Publishers, 2001).

7. Hayden V. White, "Historical Emplotment and the Problem of Truth," in *Probing the Limits of Representation: Nazism and the Final Solution,* ed. Saul Friedlander (Cambridge: Cambridge University Press, 1992), 49.

8. T. S. Eliot, "Tradition and the Individual Talent" (1919), cited in James Longenbach, *Modernist Poetics of History: Pound, Eliot, and the Sense of the Past* (Princeton: Princeton University Press, 1987), 22.

9. On the establishment of modern historical culture and semantics, see Reinhart Koselleck, *Futures Past: On the Semantics of Historical Time,* trans. Keith Tribe (Cambridge: MIT Press, 1985).

10. Carlo Ginzburg, "Ekphrasis and Quotations," *Tijdschrift voor Filosofie* 20 (March 1988): 3–19.

11. See David Freedberg, *The Power of Images: Studies in the History and Theory of Response* (Chicago: University of Chicago Press, 1989), especially 161–91.

12. Claudio Fogu, "*Il Duce Taumaturgo:* Modernist Rhetorics in Fascist Representations of History," *Representations* 57 (1997): 24–51.

13. Claudio Fogu, "Fascism and Historic Representation: The 1932 Garibaldian Celebrations," *Journal of Contemporary History* 31 (1996): 317–45.

14. Antonio Monti, "La Mostra Garibaldina a Roma," *Corriere della Sera,* 30 April 1932.

15. The exhibition photographs reprinted here, as well as others, can be found in the archive of the Garibaldian federation (ASFNVG). Once again, I thank both Erika Garibaldi and Giuseppe Garibaldi for allowing me to reproduce these crucial photographs.

16. Hayden V. White, "The Politics of Historical Interpretation: Discipline and De-Sublimation," in *The Content of the Form* (Baltimore: Johns Hopkins University Press, 1990), 58–82.

17. For a discussion of the classic effect of *enàrgeia,* see Andrew D. Walker, "Enargeia and the Spectator in Greek Historiography," *Transactions of the American Philological Association* 123 (1993): 353–77.

18. Giacomo Mattia, "Verso la chiusura della Mostra Garibaldina," *L'Impero,* 10 June 1932.

19. The first two quotations are from *La Tribuna,* 30 April 1932, the third from *L'Impero,* 15 May 1932.

20. P. M. Bardi, "La Mostra Garibaldina ch'è stata inaugurata dal Duce," *Gioventù Fascista* 13 (10 May 1932): 3–4.

21. P. M. Bardi, "Nuove esigenze delle esposizioni" *L'Ambrosiano,* 20 March 1931.

22. P. M. Bardi, "Gli artisti e la Mostra del Fascismo," *L'Ambrosiano,* 13 July 1932.

23. Margherita Sarfatti, "Architettura, arte e simbolo alla Mostra del Fascismo," *Architettura* (January 1933): 2.

24. The MRF has been the main focus of an unpublished dissertation, several articles, and quite a few recent monographs on Fascist mass culture. See Giorgio Ciucci, "L'autorappresentazione del Fascismo: La mostra del decennale della marcia su Roma," *Rassegna di architettura* (4 June 1982): 48–55; Libero Andreotti, "Art and Politics in Italy: The Exhibition of the Fascist Revolution" (Ph.D. diss., MIT, 1989); Fabio Benzi, *Mario Sironi: Il mito dell'architettura* (Milan: Garzanti, 1990); Diane Ghirardo "Architects, Exhibitions, and the Politics of Culture in Fascist Italy," *Journal of Architectural Education* (*JAE*) 45 (1992): 67–75; Libero Andreotti, "The Aesthetics of War: The Exhibition of the Fascist Revolution," *JAE* 45 (1992): 76–86; Jeffrey T. Schnapp, "Fascism's Museum in Motion," *JAE* 45 (1992): 87–98; Schnapp, "Epic Demonstrations: Fascist Modernity and the 1932 Exhibition of the Fascist Revolution" in *Fascism, Aesthetics, and Culture,* ed. Richard J. Golsan (Hanover: University Press of New England, 1992), 1–37; Emilio Gentile, *The Sacralization of Politics in Fascist Italy* (Cambridge: Harvard University Press, 1996), 102–13; Marla Susan Stone, *The Patron State: Culture and Politics in Fascist Italy* (Princeton: Princeton University Press, 1998); and Claudio Fogu, *The Historic Imaginary: Politics of History in Fascist Italy* (Toronto: Toronto University Press, 2003). Most of these scholars (in particular Andreotti, Gentile, Schnapp, and Stone) have explicitly quoted and commented on Sarfatti's authoritative definition of the MRF.

25. Schnapp, "Epic Demonstrations," 13.

26. The intentionality of this division is nowhere more apparent than in Alfieri's distribution of tasks. Although artists and historiographers were teamed up to construct the historic narrative of the revolution in the first fifteen rooms (A—Q), the last four rooms (R = Honor Hall; S = Gallery of Fasces; T = Room of Mussolini; U = Shrine of

the Martyrs) did not require the collaboration of histori-
ographers. Those rooms were entrusted solely to the
artistry of Mario Sironi (R and S), Leo Longanesi (T), and
the architects Adalberto Libera and Antonio Valente (U).

27. Luigi Freddi, "Traccia storico-politica della mostra del
Fascismo" (typewritten manuscript, Rome, 1932), 3.

28. The rise of Mussolini's political star was intimately
connected to his career as a journalist. As a rising socialist
leader in 1912, Mussolini declined to become secretary of
the Italian Socialist Party and instead became director of
its official organ, the *Avanti!* He broke with the party and
resigned from the directorship of *Avanti!* in November
1914 over the question of Italy's intervention in World
War I. Then he founded the newspaper *Popolo d'Italia,*
which after the war became the official organ of the Fas-
cist movement and later the regime. After the March on
Rome, Mussolini resigned his position on the paper but
continued to publish editorials. On the journalistic career
of Mussolini, see Renzo De Felice, *Mussolini giornalista*
(Milan: Rizzoli, 1995).

29. Rooms A and B, "From Sarajevo to the Italian Inter-
vention" (June 1914–May 1915); rooms C and D, "The
War" (May 1915–November 1918); room E, "The Vic-
tory" (November 1918); room F, "From the Armistice to
the Foundation of the Fasces" (November 1918–March
1919); room G, "The Year 1919"; rooms H and I, "The
Year 1920"; rooms L and M, "Fiume and Dalmatia, from
the Roman Pact to the Neptune Agreements"; room N,
"The Year 1921"; room O, "The Year 1922 up to the
Naples Gathering"; and rooms P and Q, "The March on
Rome."

30. Freddi, "Traccia," 97.

31 Dino Alfieri and Luigi Freddi, *La Mostra della Rivo-
luzione Fascista* (Rome: PNF, 1932), 192; Benzi, *Mario
Sironi,* 17; cited in Andreotti, "Art and Politics," 152.

32. I am referring here to W. J. T. Mitchell's definition of
"hypericons" as "figures of figuration, pictures that reflect
on the nature of images." See W. J. T. Mitchell, *Picture
Theory* (Chicago: University of Chicago Press, 1994),
158–60.

33. This harsh judgment was expressed by Bardi in a type-
written review of the exhibition, which he never published
but which survives in his private archive. Photocopies of
roughly three-quarters of this archive are held in the
Archivio Centrale dello Stato: Archivio Bardi, b. 6/119;
the document is n. 2212, and it is entitled "Artisti."

34. In particular, Andreotti, "Aesthetics of War," 80, and
Gentile, *Sacralization,* 97.

35. Andreotti, "Art and Politics," 173–74.

## 3. AUGUSTUS, MUSSOLINI, AND THE
## PARALLEL IMAGERY OF EMPIRE

1. Roger Griffin's concept of "national palingenesis" in
*The Nature of Fascism* (London: Pinter, 1991) is crucial

for Fascist propaganda. See Mark Antliff, "Fascism, Mod-
ernism, and Modernity," *Art Bulletin* 84 (2002): 148–69,
and also Claudia Lazzaro's chapter, "Forging a Visible Fas-
cist Nation," in this volume.

2. Fascist depictions of eagles and she-wolves also recalled
Roman precedent, as did the initials SPQR (Senatus Pop-
ulusque Romanus, or the Senate and the Roman People)
on public works. Mussolini, whose title "Il Duce" derived
from the Latin *dux* (leader), encouraged teaching Latin in
schools and decreed an annual celebration of the founding
of Rome on the traditional date of April 21. See Jasper
Ridley, *Mussolini: A Biography* (New York: Cooper
Square Press, 2000), 221.

3. Tito Vezio, *Le due marce su Roma: Giulio Caesare e
Benito Mussolini* (Mantua: Paladino, 1923), presents Cae-
sar's march as a precedent to Mussolini's. George Seldes,
*Sawdust Caesar* (New York: Harper and Brothers, 1935),
371, contends that Mussolini ordered the name of the Fi-
umicino River changed to Rubicon.

4. The title "Augustus" was used only after 27 B.C.E., be-
fore which he was called Caius Octavius (Octavian) or, af-
ter Julius Caesar's death, as Gaius Julius Caesar. In this
chapter he will be referred to only as Augustus. For Mus-
solini's emulation of Augustan Rome, see Simonetta
Falasca-Zamponi, *Fascist Spectacle: The Aesthetics of
Power in Mussolini's Italy* (Berkeley: University of Califor-
nia Press, 1997); Spiro Kostof, "The Emperor and the
Duce: The Planning of the Piazzale Augusto Imperatore in
Rome," in *Art and Architecture in the Service of Politics,*
ed. Henry A. Millon and Linda Nochlin (Cambridge: MIT
Press, 1978), 270–325; and Kostof, *The Third Rome: Traf-
fic and Glory* (Berkeley: University Art Museum, 1973).

5. The announcement, from the balcony of Palazzo
Venezia, took place on May 9, 1936, as quoted by Scilla
de Glauco, *La nuova Italia* (New York: Nikolas Press,
1939), n.p.

6. *Res Gestae Divi Augusti,* 26–27.

7. Ibid., 26, where Augustus announced his restoration of
peace in Gaul, Spain, and elsewhere.

8. Speech of December 31, 1925, quoted in Ronald T. Rid-
ley, "Augusti Manes volitant per auras: The Archaeology
of Rome under the Fascists," *Xenia* 11 (1986): 19.

9. Publications included pamphlets directed to Italian
youth, journals such as *L'Urbe,* personal memoirs, the
*Quaderni Augustei* (dedicated to ancient Roman studies),
and the vast *Italian Encyclopedia,* which included Mus-
solini's entry "Dottrina del Fascismo." See Jasper Ridley,
*Mussolini,* 230; and Simonetta Fraquelli, "All Roads Lead
to Rome," in *Art and Power: Europe under the Dictators,
1930–45,* ed. Dawn Ades et al. (London: Hayward
Gallery, 1995), 130–36.

10. Tim Benton, "Rome Reclaims Its Empire," in *Art and
Power,* 120; for the exhibition itself, see Friedemann
Scriba, *Augustus in Schwarzhemd? Die Mostra Augustea
della Romanità in Rom, 1937/38* (Frankfurt am Main: Pe-
ter Lang, 1995).

11. *Res Gestae*, 21.

12. Suetonius, *De vita Caesarum,* "Augustus," 28 and 30. Suetonius stated that Augustus, aware of Rome's architectural unworthiness of being the capital and its vulnerability to fire and flood, improved the city's appearance.

13. Ibid., 28. Translation by Robert Graves, *Gaius Suetonius Tranquillus, the Twelve Caesars* (Middlesex, England: Penguin, 1982).

14. For archaeology under the Fascists, see Ronald Ridley, "Augusti Manes," 19–46; E. Christian Kopff, "Italian Fascism and the Roman Empire," *The Classical Bulletin* 76 (2000): 109–15. For photographs of archaeological projects, see Italo Insolera, *Roma fascista nelle fotografie dell'Istituto Luce* (Rome: Editori Riuniti, 2001).

15. Richard A. Etlin, *Modernism in Italian Architecture, 1890–1940* (Cambridge: MIT Press, 1991), 391; and Giorgio Ciucci, *Gli architetti e il fascismo: Architettura e città 1922–1944* (Turin: Giulio Einaudi, 1989).

16. See Diane Favro, *The Urban Image of Augustan Rome* (Cambridge: Cambridge University Press, 1996); and Paul Zanker, *The Power of Images in the Age of Augustus,* trans. Alan Shapiro (Ann Arbor: University of Michigan Press, 1988).

17. K. Kraft "Der Sinn des Mausoleums des Augustus," *Historia* 16 (1967): 200.

18. The mausoleum was a circular structure approximately two hundred eighty-five feet in diameter, with five concentric walls and a series of burial chambers. Despite various interpretations of its original appearance, we assume that the basic form was that of a mound planted with trees and topped by a statue of Augustus. See Strabo, *Geography,* 5.3.9; and Penelope J. E. Davies, *Death and the Emperor* (Cambridge: Cambridge University Press, 2000), 14.

19. Mark Johnson, "The Mausoleum of Augustus: Etruscan and Other Influences on Its Design," *Etruscan Italy,* ed. John F. Hall (Provo, Utah: Brigham Young University, 1996), 232; and Pietro Caligari, *Il Mausoleo di Giulio Cesare nel Campo Marzio* (Rome: Vetera, 2001). Each of these traditions suggests a political agenda. For Etruscan participation in the Augustan regime, see John F. Hall, "From Tarquins to Caesars: Etruscan Governance at Rome," in *Etruscan Italy,* 149–89.

20. Jane Clark Reeder, "Typology and Ideology in the Mausoleum of Augustus: Tumulus and Tholos," *Classical Antiquity* 11 (1992): 265–304.

21. Zanker, *Power of Images,* 72–73.

22. *Res Gestae,* 12. For the Ara Pacis, see Diane Atnally Conlin, *The Artists of the Ara Pacis: The Process of Hellenization in Roman Relief Sculpture* (Chapel Hill: University of North Carolina Press, 1997); Peter Holliday, "Time, History and Ritual on the Ara Pacis Augustae," *Art Bulletin* 72 (1990): 542–47; and David Castriota, *The Ara Pacis Augustae and the Imagery of Abundance in Later Greek and Early Roman Imperial Art* (Princeton: Princeton University Press, 1995).

23. In this chapter, the altar is being considered only as a symbol of Augustan peace and imperial ascendancy as understood by Mussolini.

24. A. Wallace-Hadrill, "Time for Augustus: Ovid, Augustus, and the Fasti," in *Homo Viator: Classical Essays for John Bramble,* ed. Michael Whitby, Philip Hardie, and Mary Whitby (Cambridge: Harvard University Press, 1987). Parts of the Horologium were discovered in 1463 and 1502, and the obelisk was excavated in 1748. Between 1788 and 1792, pieces of the obelisk were taken to the Piazza di Montecitorio for reerection. For obelisks in Rome, see Erik Iversen, *Obelisks in Exile,* vol. 1, *The Obelisks of Rome* (Copenhagen: G.E.C. GAD Publishers, 1968); and Lise Vogel, *The Column of Antoninus Pius* (Cambridge: Harvard University Press, 1973), 117.

25. According to Pliny, *Natural History,* 36.14.64, Romans believed that Egyptian obelisks represented rays of the sun.

26. Favro, *Urban Image,* 153, 170.

27. Edmund Buchner, *Die Sonnenuhr des Augustus: Nachdruck aus RM 1976 und 1985 und Nachtrag uber die Ausgrabung 1980 / 1981* (Mainz am Rhein: von Zabern, 1982), 365, argues that the Ara Pacis and Horologium complex was deliberately planned as part of a whole. For a differing opinion, see Michael Schutz, "Zur Sonnenuhr des Augustus auf dem Marsfeld," *Gymnasium* 97 (1990): 432–57.

28. In 1926, G. Q. Giglioli began extensive restoration work. Enrico del Debbio and a group from the Federazione Fascista dell'Urbe proposed the definitive plan in the following year. In 1932, Antonio Muñoz was placed in charge of the project. See Kostof, "Emperor," 285 and 287.

29. See Kostof, "Emperor," for the project's economic benefits and a photographic record of the streets and residences destroyed.

30. For the excavations under Giglioli (1926–30), see Kostof, "Emperor," and Conlin, *Artists of the Ara Pacis,* 207. For the subsequent plan of 1931, see Benton, "Rome Reclaims," 121.

31. See Kostof, "Emperor," 270.

32. For the archaeological work on the Ara Pacis, see Giuseppe Moretti, "Lo scavo e la ricostruzione dell'Ara Pacis Augustae," *Capitolium* 13, no. 10 (1938): 479–90; and Kostof, "Emperor," 304. Giuseppe Moretti, assisted by Guglielmo Gatti, directed excavations beneath the Palazzo Fiano, which required a sophisticated freezing technique because of the underground springs. See Moretti, 483–84; and Kostof, 304.

33. Mussolini ordered the altar to be set up on axis with the mausoleum between the Lungotevere and the Ripetta, farther north than it was in antiquity, and in a different orientation, which the terrain required. See Kostof, "Emperor," 303–4.

34. Kostof "Emperor," 289–309.

35. In this chapter, discussion of these monuments refers to their state in summer 2001 (when the Fascist pavilion had been demolished and notices condemning the Meier project were displayed) and in fall 2002 (when it appeared that all work had stopped). As of May 2003, according to Richard Meier's office, the status remains the same pending further action on contract negotiations.

36. Kostof, "Emperor," 304.

37. *Res Gestae,* 20.

38. Paolo Ardali, *Mussolini e Pio XI* (Mantua: Paladino, 1926), includes portrait drawings of "i due geni dell'Impero Italico," the two who inspired the Italian Empire. See Kostof, "Emperor," 304–9, for a comparison of Mussolini and Augustus in the restoration of state religion.

39. Kostof, "Emperor," 309.

40. It is debated (based on literary references or their absence) whether Augustus or a later emperor put in place these obelisks, which are now located behind the Church of Santa Maria Maggiore and in the Piazza Quirinale. For the origin of the obelisks in the Old Kingdom as pillars flanking tomb entrances, see Iversen, *Obelisks in Exile,* 15; and Vogel, *Column of Antoninus,* 27.

41. Pliny, *Natural History,* 36.14.70, relates that public curiosity about the ships that transported the obelisks was so great that they were displayed at the docks of Pozzuoli.

42. Before Mussolini, the sixteenth-century pope Sixtus V was Augustus's most notable successor in the use of obelisks.

43. Alex Scobie, *Hitler's State Architecture: The Impact of Classical Antiquity* (University Park: Pennsylvania State University Press, 1990), 45–46; and Peter Aicher, "Mussolini's Forum and the Myth of Augustan Rome," *The Classical Bulletin* 7, no. 2 (2000): 117–39.

44. Another Fascist postage stamp illustrates the Augustus of Prima Porta, the well-known ancient statue that represents the emperor in military glory, hand raised in oratorical fashion. At the lower border, arms and hands raised in Fascist salute reach up to the sculpted image.

45. Richard Pankhurst, "Ethiopia and the Loot of the Italian Invasion: 1935–36," *Presence Africaine,* no. 72 (1969): 85–95. As of March 2004, the return of the Axum obelisk to Ethiopia is imminent.

46. Martin Blinkhorn, *Mussolini and Fascist Italy* (London: Routledge, 1984), 94. It is the only surviving Axumite obelisk that is carved on four sides. The palace on the site is now the home of the United Nations Food and Agriculture Organization.

47. Kostof, "Emperor," 303.

48. The Lion of Judah was placed in front of the memorial but has since disappeared. See Labib Habachi, *The Obelisks of Egypt* (Cairo: American University in Cairo Press, 1984), 124. Because the obelisk obstructed traffic, in 1924 it was moved to its present position in the public gardens between Viale delle Terme and Via delle Terme di Diocleziano.

49. Kostof, "Emperor," 271, 322.

50. Benton, "Rome Reclaims," 121.

51. Kostof, "Emperor," 289.

52. Paul MacKendrick, *The Mute Stones Speak: The Story of Archaeology in Italy* (New York: Norton, 1960), 156; and Georgina Masson, *The Companion Guide to Rome* (Englewood Cliffs, N.J.: Prentice-Hall, 1965). The reference to Lenin still appears in the 1971 edition of Masson's book (207) but was removed from the 1980 edition (196).

53. Alessandra Stanley, "Rome Journal: Colorful Characters Lurk around Monuments," *The New York Times International,* June 29, 2001, A4.

54. Stanley, "Rome Journal," notes that Rutilli has accepted blame for the choice of Meier without a competition. At the time, Meier had been selected already by the Vatican to design the Church of the Millennium, which was consecrated in 2004.

55. Ara Pacis Museum Complex document (1995–2000) of Richard Meier Associates. See also Richard Meier and John Eisler, "Sistemazione museale dell'Ara Pacis, Roma 1996," in *Zodiac 17: International Review of Architecture,* ed. Guido Canella (Milan: Editrice Abitare Segesta, 1997), 129–33.

56. Bruce Johnson, "Prince Urged to Fight Roman 'Monstrosity,'" *Telegraph,* 5 Apr. 2001 (http://www.telegraph.co.uk/). For Meier's reaction to criticism and for the suggestion that the altar be returned to the site where it was found, see Stanley, "Rome Journal."

57. Zanker, *Power of Images,* v.

58. Etlin, *Modernism,* 392.

## 4. "IL PRIMO PILOTA"

1. Guido Mattioli, *Mussolini aviatore e la sua opera per l'aviazione* (Rome: L'Aviazione, 1936), 19, quotes Mussolini identifying himself as an "aviation fanatic" in a letter of 1919, a reference already cited in "Agli ordini del Duce," *L'Ala d'Italia,* November 1933, 5–6. Mattioli, 27 and 29, traces Mussolini's fascination with flight to articles he wrote in 1909. The edition I have consulted cites "L'Aviazione" as the publisher and the Fascist new calendar "Romanism" XV [1936] as the date on the dust jacket and the book cover. The title page, however, cites "Pinciana" and XIV [1935] as publisher and date. Robert Wohl, *A Passion for Wings: Aviation and the Western Imagination, 1908–1918* (New Haven: Yale University Press, 1994), 287–88, pinpoints World War I experiences as fundamental to Mussolini's attitude about aviation. Other books by Mattioli link aviation and empire; other contemporary authors wrote on Mussolini as aviator.

2. Mattioli, *Mussolini aviatore,* 29. All translations are mine, unless otherwise noted.

3. For symbolism, ritualism, aestheticization, and "sacralization" in Italian Fascism, see Günter Berghaus, ed., *Fascism and Theatre: Comparative Studies on the Aesthetics*

*and Politics of Performance in Europe, 1925–1945* (Providence, R.I.: Berghahn Books, 1996). See also Walter Benjamin, "The Work of Art in the Age of Mechanical Reproduction," in *Illuminations,* ed. Hannah Arendt and trans. Harry Zohn (New York: Schocken Books, 1969), 217–52; Russell Berman, "The Aestheticization of Politics: Walter Benjamin on Fascism and the Avant-Garde," in "Fascism and Culture," ed. Jeffrey T. Schnapp and Barbara Spackman, special issue, *Stanford Italian Review* 8, nos. 1–2 (1990): 35–52; Simonetta Falasca-Zamponi, *Fascist Spectacle: The Aesthetics of Power in Mussolini's Italy* (Berkeley: University of California Press, 1997); Emilio Gentile, *The Sacralization of Politics in Fascist Italy,* trans. Keith Botsford (Cambridge: Harvard University Press, 1996); and Herbert W. Schneider and Shepard B. Clough, *Making Fascists* (Chicago: University of Chicago Press, 1929).

4. George L. Mosse put it succinctly: "Fascism aimed to link past and present." See Mosse, *Masses and Man: Nationalist and Fascist Perceptions of Reality* (New York: H. Fertig, 1980), 230.

5. Among useful discussions of the role of *romanità* in Italian Fascism are several essays in Dawn Ades et al., eds., *Art and Power: Europe under the Dictators, 1930–45* (London: Hayward Gallery, 1995); Peter E. Bondanella, *The Eternal City: Roman Images in the Modern World* (Chapel Hill: University of North Carolina Press, 1987), especially 172–206; Emily Braun, "Political Rhetoric and Poetic Irony: The Uses of Classicism in the Art of Fascist Italy," in *On Classic Ground: Picasso, Léger, de Chirico and the New Classicism, 1910–1930,* ed. Elizabeth Cowling and Jennifer Mundy (London: Tate Gallery, 1990), 345–58; Philip V. Cannistraro, "Romanità," in *Historical Dictionary of Fascist Italy,* ed. Philip V. Cannistraro (Westport, Ct.: Greenwood Press, 1982), 461–63; and Romke Visser, "Fascist Doctrine and the Cult of the Romanità," *Journal of Contemporary History* 27 (1992): 5–22.

6. Benito Mussolini, *Scritti e discorsi di Benito Mussolini,* 12 vols. (Milan: Hoepli, 1934), 2:278.

7. Mattioli, *Mussolini aviatore,* 139–40.

8. See David Castriota, ed., *Artistic Strategy and the Rhetoric of Power: Political Uses of Art from Antiquity to the Present* (Carbondale: Southern Illinois University Press, 1986).

9. For visual images in ancient Roman and Augustan politics, see Richard Brilliant, *Gesture and Rank in Roman Art* (New Haven: The Academy, 1963); Niels Hannestad, *Roman Art and Imperial Policy,* trans. P. J. Crabb (Aarhus, Denmark: Aarhus University Press, 1988); Charles Brian Rose, *Dynastic Commemoration and Imperial Portraiture in the Julio-Claudian Period* (Cambridge: Cambridge University Press, 1997); and Paul Zanker, *The Power of Images in the Age of Augustus,* trans. Alan Shapiro (Ann Arbor: University of Michigan Press, 1988).

10. Mattioli, *Mussolini aviatore,* 142–44.

11. For more on *L'Ala d'Italia,* see Gerald Silk, "Fascist Modernism and the Photo-Collages of Bruno Munari," in *Cultural and Artistic Upheavals in Modern Europe, 1848–*

1945, ed. Sally Metzler and Elizabeth Lovett Colledge, Cummer Studies, vol. 1 (Jacksonville, Fla.: Cummer Museum, 1996), 41–76.

12. Certain articles argued that the flowering of modern Italian flight continued fantasies of the ancient world, especially as expressed in mythology. See, for example, Pieri Scarpa, "Il volo nell'arte italiana," *L'Ala d'Italia,* July 1939, 13–18, a review of the 1939 Mostra del Volo nell'Arte Italica (Exhibition of Flight in Italic Art). Discussing Ezio d'Errico's photomosaic incorporating images of a Roman eagle, Italian aircraft, and classical sculpture, Scarpa, 18, notes a major theme of the show: the connections between "modern symbolism [and] the dreams of the antique desire and the actual reality of flight."

13. From the catalogue of the Venice Biennale, 1938. Quoted in Lawrence Alloway, *The Venice Biennale, 1895–1968* (Greenwich, Ct.: New York Graphic Society, 1968), 110.

14. Mattioli, *Mussolini aviatore,* 17–18.

15. For this interpretation of the profile in Renaissance art, see Harry Berger, "Fictions of the Pose: Facing the Gaze of Early Modern Portraiture," *Representations,* no. 46 (Spring 1994): 87–120.

16. See Mosse, *Masses and Man,* 229–45.

17. Mattioli, *Mussolini aviatore,* 18.

18. Benito Mussolini, "Gli uomini del giorno: Latham," *Il Popolo,* 22 July 1909, 2757: 10, and Mussolini, "Gli uomini del giorno: Blériot," *Il Popolo,* 28 July 1909, 2762:10, both quoted in Edoarda Susmel and Duilio Susmel, eds., *Opera Omnia di Benito Mussolini,* vol. 2 (Florence: La Fenice, 1957), 187 and 194–95. Hubert Latham and Louis Blériot were famous French aviators. In the summer of 1909, Latham was the first to attempt to fly the English Channel but failed. Shortly thereafter, Blériot succeeded.

19. Italo Calvino, "The Dictator's Hats," in "Fascism and Culture," 195–209. See also Falasca-Zamponi, *Fascist Spectacle* (especially 15–41), and Giorgio Di Genova, ed., *"L'Uomo della Provvidenza": Iconografia del Duce 1923–1945* (Bologna: Bora, 1997).

20. Barbara Spackman, *Fascist Virilities: Rhetoric, Ideology, and Social Fantasy in Italy* (Minneapolis: University of Minnesota Press, 1996). See also Falasca-Zamponi, *Fascist Spectacle,* especially 17–26.

21. For Balbo, see Claudio G. Segrè, *Italo Balbo, a Fascist Life* (Berkeley: University of California Press, 1987).

22. Mattioli, *Mussolini aviatore,* 277.

23. Ibid., 278.

24. The capitalization of the entire word "DU-CE" in the photocollage, though not necessarily dictated by decree in this instance and certainly used (along with a syllabic hyphen) by the artists for visual, verbal, and acoustic emphasis, was required in all written official acts as of 1933.

25. In a speech commemorating the third anniversary of the March on Rome, Mussolini told the Italian citizenry:

"Each of you must consider himself a soldier: a soldier also when you are not wearing the uniform, a soldier also when you work, in the office, in yards or in the fields; a soldier tied to all the rest of the army, a molecule that feels and beats with the entire organism." See Mussolini, *Scritti e discorsi*, 5:164, quoted and translated in Falasca-Zamponi, *Fascist Spectacle*, 89.

26. A photograph of Mussolini in *L'Ala d'Italia* shows the Duce as the animating spirit of Balbo's 1931 southern transatlantic cruise. The caption of the photo, from an earlier *L'Ala d'Italia* image portraying Mussolini as "Pilot of the New Italy," reads: "l'ideatore e l'animatore dell'eroica Crociera Atlantica" (the idea [or the inventor] and moving force behind the heroic Atlantic Crossing). Mussolini's telegraph to Balbo, also published, declared: "This flight . . . has no precedent. . . . For the first time, the immense distance of the ocean has been overcome by an aerial Squadron." See Mussolini, "La parola del capo del governo," *L'Ala d'Italia*, February 1931, 90–91.

27. Mario Massai, "Le squadre Atlantiche di Balbo," in *Esposizione dell'aeronautica italiana,* ed. Marcello Visconti di Modrone (Milan: E. Bestetti, 1934), 181.

28. Quoted and translated in Edward R. Tannenbaum, *The Fascist Experience* (New York: Basic Books, 1972), 227.

29. F. T. Marinetti, "The Founding and Manifesto of Futurism," in *Le Figaro*, 20 February 1909.

30. Mussolini inaugurated the Italian *autostrada*, one of the first modern highway systems, and he also believed that a strong navy was essential to empire building. Fascist imperialism focused on North Africa as fulfilling the mandate of the Roman Empire and claimed the Adriatic and Mediterranean as the "Italian Ocean," "Roman Sea," or "Roman Lake," and North Africa as its "Fourth Shore."

31. Quoted and translated in Bondanella, *Eternal City,* 187.

32. Like certain Fascist rituals and symbols, the "Roman salute"—which became the official form of greeting after the declaration of a dictatorship in 1925—has a suspect pedigree. Satisfying his apparent mysophobia (fear of germs), Mussolini called this salute "more hygienic, more tasteful, and [it] wastes less time," as quoted in Emil Ludwig, *Talks with Mussolini*, trans. Eden and Cedar Paul (Boston: Little, Brown, 1933), 107. He also saw the Roman salute as fusing dynamism, decorum, and discipline. Bondanella, *Eternal City,* 183, notes that the "poet-soldier" Gabriele D'Annunzio introduced it into both historical epic films and quasi-official usage during his 1919–20 occupation of Fiume. D'Annunzio inspired a variety of Fascist tactics, among them sinking roots in *romanità* and promoting the image of the heroic leader-pilot. See Mosse, *Masses and Man,* 87–103.

33. "La Discussione alla Camera," *L'Ala d'Italia,* May 1928, 427, attributes Italy's aeronautic "miracle" to "First Pilot" Mussolini. "Pilota della nuova Italia," *L'Ala d'Italia,* December 1930, 947.

34. Cesare Redaelli, *Iniziando Mussolini alle vie del cielo* (Milan: Magnani, 1933).

35. For this concept and images of Mussolini, see Di Genova, ed., *Uomo della Provvidenza.*

36. Mattioli, *Mussolini, Aviator and his Work for Aviation* (Rome: L'Aviazione, 1938), 231. Mattioli published *Mussolini aviatore* in several languages, and this sentence does not appear in the Italian edition of Mattioli's *Mussolini aviatore.*

37. Mattioli, *Mussolini aviatore,* 227.

38. *L'Ala d'Italia,* October–November 1936, 5.

39. "Preparazione al bimillenario di Augusto: Progetto di volo sul circuito imperiale," *L'Ala d'Italia,* January 1935, 10–12. The article also relates this tour to other contemporary projects honoring the Augustan Empire, notably the excavation and restoration of the Mausoleum of Augustus. Reference in this article to the "pickax" (which Mussolini used to found new Fascist cities, including Guidonia), a tool of both laborers and archaeologists, implies Fascism's concomitant construction of a proud present and future and rehabilitation of a resplendent past. See Spiro Kostof, "The Emperor and the Duce: The Planning of Piazzale Augusto Imperatore in Rome," in *Art and Architecture in the Service of Politics,* ed. Henry A. Millon and Linda Nochlin (Cambridge: MIT Press, 1978): 271–325. See also William L. MacDonald, "Excavation, Restoration, and Italian Architecture of the 1930s," in *In Search of Modern Architecture: A Tribute to Henry-Russell Hitchcock,* ed. Helen Searing (New York: Architectural History Foundation, 1982): 298–320.

40. For aerial reconnaissance, see Karen Frome, "A Forced Perspective: Aerial Photography and Fascist Propaganda," *Aperture,* no. 132 (1993): 76–77. For the aestheticizing and commodifying of the aerial reconnaissance photography of Edward Steichen, see Allan Sekula, "The Instrumental Image: Steichen at War," *Artforum* 14 (December 1975): 26–35. For more on aerial bombardment, see Segrè, *Italo Balbo,* 145–73. Also see M. K. and Brian R. Sullivan, "Air Force," in *Historical Dictionary,* 8–9.

41. For the fasces, see Falasca-Zamponi, *Fascist Spectacle,* 95–101; Schneider and Clough, *Making Fascists,* 189–191; and Dennis P. Doordan, "Political Things: Design in Fascist Italy," in *Designing Modernity: The Arts of Reform and Persuasion 1885–1945,* ed. Wendy Kaplan (New York: Thames and Hudson, 1995): 225–56.

42. Benito Mussolini, *The Doctrine of Fascism* (Florence: Vallechi, 1935), 18. *The Doctrine* originally appeared in Italian in 1932 and was first published in English in 1933.

43. See Spiro Kostof, *The Third Rome, 1870–1950: Traffic and Glory* (Berkeley: University Art Museum, 1973).

44. Mattioli, *Mussolini aviatore,* 323.

45. Mussolini's proclamation appears in "Nascita di Guidonia," *L'Ala d'Italia,* November 1937, 8–12. Mus-

solini contrasted Guidonia with another new Fascist town, Aprilia, which he acclaimed "the city of the land."

46. Mattioli, *Mussolini aviatore,* 328.

47. For the Roman eagle, see Falasca-Zamponi, *Fascist Spectacle,* 240 n. 49.

48. Marcello Visconti di Modrone, "Presentazione," in Visconti di Modrone, ed., *Esposizione,* 21. For this exhibition, see Marla Susan Stone, *The Patron State: Culture and Politics in Fascist Italy* (Princeton: Princeton University Press, 1998): 221–26.

49. *Esposizione,* 24–25. The caption, "This wing that has taken up flight again will no more be broken," alludes to Mussolini's putatively successful efforts to restore greatness to Italian aviation after its post-World War I decline. The phrase originates in Mussolini's speech to the Aviators of Italy on 4 November 1923, as noted in *L'Ala d'Italia,* June–July 1934, 3. See also Vincenzo Constantini, "Questa ala che ha ripreso il suo volo non sara più infranta," *L'Ala d'Italia,* June–July 1934, 61–65.

50. "La facciata del pittore Erberto Carboni," in Visconti di Modrone, ed., *Esposizione,* 23.

51. In the exhibition, the room devoted to Icarus directly preceded the space called "The Landing of Honor," which housed Mussolini's crashed plane. This "Landing," at the base of stairs leading to the second floor, perhaps was meant as an architectural concretization of notions of ascent and descent associated with flight, literally and figuratively.

52. The inscription reads, in rhyming meter in Italian: "The forehead is / of the Fascist ax / trembling aerial wings the nostrils / from the mouth confidently explodes / with immense echoing sentences / Tank, the chin, the teeth / All this strength defines the new Era."

53. The theme of flight and ascension recurs throughout the treatment of Mussolini and aviation, especially in Mattioli's book and in the pages of *L'Ala d'Italia.* The message is that Mussolini (and similarly Fascism), as an accomplished and daring pilot, will take Italy to a new loftiness in all spheres of life, including spiritual ones. Mattioli, *Mussolini aviatore,* 18, commented that "the gesture of flying displays a particularly significant warning. To guide, to control [govern] with complete and strong-willed mastery is to ascend. That's it: to ascend."

## 5. FASCISM *TRIUMPHANS*

1. On the "translatability" of Rome, in the context of Petrine Russia, see Jurij Lotman and Boris Uspenskij, "Il concetto di 'Mosca terza Roma' nell'ideologia di Pietro I," *Europa Orientalis* 5 (1986): 481–93; Richard A. Etlin, *Modernism in Italian Architecture, 1890–1940* (Cambridge: MIT Press, 1991); Spiro Kostof, "The Emperor and the Duce: The Planning of Piazzale Augusto Imperatore in Rome," in *Art and Architecture in the Service of Politics,* ed. Henry A. Millon and Linda Nochlin (Cambridge: MIT Press, 1978), 270–325; and Giorgio Ciucci, *Atlante del-*

*l'architettura italiana del novecento* (Milan: Electa, 1991). See generally Sanford Budick and Wolfgang Iser, eds., *The Translatability of Cultures: Figurations of the Space Between* (Stanford: Stanford University Press, 1996).

2. "*Lieux de mémoire* are created by a play of memory and history, an interaction of two factors that results in their reciprocal overdetermination." See Pierre Nora, "Between Memory and History: Les Lieux de Mémoire," in *Representations* 26 (1989): 19. See also *Commemorations: The Politics of National Identity,* ed. John R. Gillis (Princeton: Princeton University Press, 1994).

3. Nora, "Between Memory and History," 8.

4. Ibid., 12, 20, 23.

5. On this topic, see the bibliography in *Irresistible Decay: Ruins Reclaimed,* ed. Michael S. Roth (Los Angeles: Getty Research Institute, 1997).

6. Edda Ronchi Suckert, ed., *Malaparte,* vol. 3, *1932–36* (Florence: Ponte alle Grazie, 1992), 759. All translations, unless otherwise indicated, are my own.

7. Ibid., 759.

8. See Avner Ben-Amos, "Les Funérailles de Victor Hugo: Apothéose de l'événement spectacle," in *Les lieux de mémoire,* ed. Pierre Nora (Paris: Gallimard, 1984), 473–522.

9. Aleida Assmann, *Arbeit am nationalen Gedächtnis: Eine kurze Geschichte der deutschen Bildungsidee* (Frankfurt: Campus, 1993), 56.

10. See Volker Ackermann, "'Ceux qui sont pieusement morts pour la France . . . ' Die Identität des Unbekannten Soldaten," in *Der politische Totenkult: Kriegerdenkmäler in der Moderne,* ed. Reinhart Koselleck and Michael Jeismann (Munich: Fink, 1994), 9–20. On national rituals in France and Germany, see George L. Mosse, "Caesarism, Circuses, and Monuments," in *Masses and Man: Nationalist and Fascist Perceptions of Reality* (New York: H. Fertig, 1980), 104–18; and also Reinhart Koselleck, *The Practice of Conceptual History: Timing History, Spacing Concepts,* trans. Todd Samuel Presner et al. (Stanford: Stanford University Press, 2002), 285–326.

11. *Malaparte,* 133.

12. Ibid., 261.

13. Ibid., 260, 264, and 276.

14. Quoted in Marida Talamona, *Casa Malaparte* (New York: Princeton Architectural Press, 1992), 41.

15. See Romke Visser, "Fascist Doctrine and the Cult of the *Romanità,*" *Journal of Contemporary History* 27 (1992): 5–22.

16. Laura Malvano, *Fascismo e politica dell'immagine* (Turin: Bollati Boringhieri, 1988), 151; Emilio Gentile, *Il culto del littorio: La sacralizzazione della politica nell'Italia fascista* (Rome: Laterza, 1993), 146–54; and Simonetta Falasca-Zamponi, *Fascist Spectacle: The Aesthetics of Power in Mussolini's Italy* (Berkeley: University of California Press, 1997), 90–99.

17. Giulio Quirino Giglioli, "La Mostra Augustea della Romanità," in *Scrittori di Roma,* ed. Francesco Sapori (Rome: Sindacato fascista romano degli autori e scittori, 1938), 452–54.

18. Anna Maria Liberati Silverio, "La Mostra Augustea della Romanità," in *Dalla mostra al museo: Dalla Mostra archeologica del 1911 al Museo della civiltà romana* (Venice: Marsilio, 1983), 77–90.

19. On the "triumph" of *romanità* over Fascist modernism in later versions of the 1932 Fascist exhibition, see Jeffrey T. Schnapp, "Epic Demonstrations: Fascist Modernity and the 1932 Exhibition of the Fascist Revolution," in *Fascism, Aesthetics, and Culture,* ed. Richard J. Golsan (Hanover: University Press of New England, 1992), 32. Schnapp, 27, discusses the entrance of the 1932 exhibition, which featured "a fourteen-meter-tall arcade, a shimmering metallic hybrid combining elements from Roman triumphal archways and cathedral entryways."

20. *Mostra Augustea della Romanità: Catalogo* (Rome: C. Colombo, 1937), 436.

21. For Fascism's reuse of Renaissance modes of spectacle, see Dianne Yvonne Ghirardo, "Città Fascista: Surveillance and Spectacle," *Journal of Contemporary History* 31 (1996): 346–64.

22. Uwe Westfehling, *Triumphbögen im 19. und 20. Jahrhundert* (Munich: Prestel, 1977), 79; and Mario Lupano, *Marcello Piacentini* (Rome: Laterza, 1991), 70–71.

23. See the discussion of the march through the Arco dei Caduti in Claudio Fogu, "Fascism and Historic Representation: The 1932 Garibaldian Celebrations," *Journal of Contemporary History* 31 (1996): 331.

24. Rino Alessi, *Scritti politici* (Udine: Istituto delle edizioni accademiche, 1938), 123.

25. See Krystyna von Henneberg, "Imperial Uncertainties: Architectural Syncretism and Improvisation in Colonial Libya," *Journal of Contemporary History* 31 (1996): 375; and also von Henneberg, "Tripoli: Piazza Castello and the Making of a Fascist Colonial Capital," in *Streets: Critical Perspectives on Public Space,* ed. Zeynep Çelik, Diane Favro, and Richard Ingersoll (Berkeley: University of California Press, 1994), 135–50. See also Maria-Ida Talamona, "Italienische Agrarsiedlungen in Lybien," in *Faschistische Architekturen: Planen und Bauen in Europa, 1930 bis 1945,* ed. Hartmut Frank (Hamburg: Christians, 1985), 139–57.

26. See Homi K. Bhabha's definition of cultural hybridity in *The Location of Culture* (London: Routledge, 1994), 128. Bhabha's antiessentialist notion of the colonial space is particularly relevant to the Italian context in which the Fascist project of land reclamation (*bonifiche*) produced an interior colonization as well. The concept of *bonifiche* as a broad metaphor for national mobilization is at the center of Ruth Ben-Ghiat, *La cultura fascista* (Bologna: Il Mulino, 2000).

27. On the simultaneous denial and invention of history in colonial Libya, see Mia Fuller, "Building Power: Italy's Colonial Architecture and Urbanism, 1923–1940," *Cultural Anthropology* 3 (1988): 455–87, especially 473. On the colonial fantasy of the "blank space," see Fuller, "Wherever You Go, There You Are: Fascist Plans for the Colonial City of Addis Ababa and the Colonizing Suburb of EUR '42," *Journal of Contemporary History* 31 (1996): 397–418.

28. See Mariella Cagnetta, "Appunti su guerra coloniale e ideologia imperiale 'romana'" in *Matrici culturali del Fascismo* (Bari: Università di Bari, Facoltà di Lettere e filosofia, 1977), 185–207.

29. Alessi, *Scritti,* 124.

30. Ibid., 126.

31. Ugo Ojetti, "L'arco sulla Littoranea," *Cose viste 1934–1939* (Milan: Mondadori, 1939), 164. See Claudio G. Segrè, *Italo Balbo: A Fascist Life* (Berkeley: University of California Press, 1987), 309; and Alessi, *Scritti,* 118–21.

32. Alessi, *Scritti,* 151–52.

33. See Ferdinand Oscar von Cles, "Lybien als kolonisatorische Leistung," in *Revolution im Mittelmeer: Der Kampf um den italienischen Lebensraum,* ed. Paul Schmidt (Berlin: Paul Schmidt, 1941), 93–110.

34. Massimo Pallottino, "Sotto l'arco riconsacrato," *Roma* 15 (1937): 218.

35. Ottavio Dinale, *Tempo di Mussolini* (Milan: A. Mondadori, 1934), 225, quoted in Gentile, *Culto del littorio,* 237.

36. See Giorgio Ciucci, "Il dibattito sull'architettura e la città fascista," in *Storia dell'arte italiana* (Turin: Einaudi, 1982), 373–78.

37. "Progetto di arco simbolico all'E42 a Roma, 1937–40," in *Adalberto Libera: Opera completa* (Milan: Electa, 1989), 162–63.

38. Ibid.

39. W. Arthur Mehrhoff, *The Gateway Arch: Fact and Symbol* (Bowling Green, Ohio: Bowling Green State University Popular Press, 1992), 17.

40. Ugo Ojetti, "Lettera a Marcello Piacentini sulle colonne e gli archi," *Pegaso* 5 (1933): 213; Marcello Piacentini, "Risposta a Ugo Ojetti," *Casabella* 6, no. 2 (1933): i–x.

41. Ojetti, "Lettera," 213.

42. Massimo Bontempelli, *L'avventura novecentista* (Florence: Vallecchi, 1938), 331–32.

43. "Documentario sulla Casa del Fascio di Como," *Quadrante* 35/36 (1936): 1.

44. Achim Preiss, "Die Grab- und Denkmalbauten Terragnis. Die Bedeutung des Monuments für die Entwicklung der Architektur im 20. Jahrhundert," in Stefan Gerner and Achim Preiss, *Giuseppe Terragni 1904–43. Moderne und Faschismus in Italien* (Munich: Klinkhardt & Biermann, 1991), 125–50.

45. See Vittorio M. Lampugnani, "Architecture, Painting, and the Decorative Arts in Italy 1923–1940 from the First Biennale to the Seventh Triennale," in *Italian Art 1900–1945* (Rome: Bompiani, 1989), 68–76.

46. Curzio Malaparte, *La pelle* (Milan: Mondadori, 1991), 45.

47. Ibid., 261–62, 290.

48. Ibid., 319.

## 6. INVENTING THE PALAZZO DEL CORTE IN FERRARA

1. During its long history, this building was variously known as the Palazzo del Corte, Corte Vecchio, Palazzo Estense, Palazzo del Marchese, Palazzo Ducale, and Palazzo Comunale. To distinguish it from the original Palazzo Comunale (later Palazzo della Ragione), I shall henceforth refer to it as the Palazzo del Corte.

2. In its turn, the previous Palazzo della Ragione had undergone a gothicizing restoration beginning in 1831, according to the designs of the architect Giovanni Tosi.

3. Because the only direct Este descendant in the male line was Alfonso II d'Este, grandson of Alfonso I d'Este through his extramarital relationship with Laura Dianti, daughter of a Ferrarese hatmaker, upon Alfonso II's death in 1597 Pope Clement VIII refused to allow the Estes to continue as ducal rulers of the city. When Cesare d'Este relinquished control of Ferrara and transferred his court to Modena, the city of Ferrara began a long, slow slide into a cultural and economic backwater.

4. The bibliography on the devolution of Ferrara to the papacy is extensive, but two recent publications are important additions: Filippo Rodi, *Annali della città di Ferrara 1587/1598: La devolutione di Ferrara a Santa Chiesa,* transcribed by Carla Frongia (Ferrara: Liceo Classico L. Ariosto, 2000); and Gian Lodovico Masetti Zannini, *La capitale perduta: La devoluzione di Ferrara 1598 nelle carte vaticane* (Ferrara: Corbo, 2000).

5. Filippo Borgatti's map was published in *Atti e memorie della Deputazione Ferrarese di Storia Patria* (Ferrara: Deputazione Ferrarese di Storia Patria, 1895).

6. Carla di Francesco and Lucio Scardino, eds., *Giuseppe Agnelli: Restauro e arti figurative a Ferrara tra otto e novecento* (Ferrara: Liberty House, 1991).

7. Giuseppe Agnelli, *I monumenti di Niccolò III e Borso d'Este in Ferrara: Atti e memorie della Deputazione Ferrarese di Storia Patria* (Ferrara: Deputazione Ferrarese di Storia Patria, 1918). For the history of the reconstruction, see Diane Ghirardo, "Surveillance and Spectacle in Fascist Ferrara," in *The Education of the Architect: Historiography, Urbanism, and the Growth of Architectural Knowledge,* ed. Martha Pollack (Cambridge: MIT Press, 1997), 325–61.

8. Virtually every study of Fascism and urbanism in the postwar period comes to the same conclusions, at times making only passing reference to restorations. See Giorgio Ciucci, *Gli architetti e il fascismo: Architettura e città 1922–1944* (Turin: Einaudi, 1989); Dennis P. Doordan, *Building Modern Italy: Italian Architecture 1914–1936* (New York: Princeton Architectural Press, 1988); and Italo Insolera, *Roma moderna: Un secolo di storia urbanistica, 1870–1970,* 7th ed. (Turin: Einaudi, 1978).

9. For further discussion of this point, see Ghirardo, "Surveillance and Spectacle," 325–61.

10. "Chronicon Estense ab anno MCI cum additamentis usque ad annum 1478," in *Rerum Italicarum Scriptores,* vol. 15, pt. 3, ed. Giulio Bertoni and Emilio P. Vicini (Città di Castello: S. Lapi, 1908). A historical report on the building by Fabio Bondi and others in 1980, of which a typescript resides in the Archivio Storico del Comune di Ferrara, served as the basis for a projected restoration of the palazzo. A later publication summarizes many of the main points about that building's history (which I located after this chapter was written): Alberto Guzzon et al., eds., *Il Volto del Cavallo: Palazzo Municipale di Ferrara: Rilievi ricerche restauri* (Ferrara: Liberty House, 1993), especially 21–45.

11. The best recent survey of the debates about the chronology and history of the buildings on Ferrara's medieval *platea communis* is in Charles M. Rosenberg, *The Este Monuments and Urban Development in Renaissance Ferrara* (Cambridge: Cambridge University Press, 1997), 14–20.

12. Fra Paolino Minorita, "Codice Marciano," Vat. Lat. 1960, c. 267r. Paulus Venetus's map is found in "Chronologia magna," Venice, Biblioteca Marciana, Lat. Z. 399, fol. 98v. Rosenberg publishes both images in *Este Monuments,* 21–22. Girolamo Merenda, "Annali di Ferrara," Biblioteca Comunale Ariostea (hereafter BCA), Cl. I, 107, fascicolo 150. Fragments of late medieval vaults are visible on the ground floor.

13. "Chronicon Estense," col. 385.

14. Mario Equicola d'Alveto, "Genealogia delli signori Estensi," BCA, Cl. II, 349, fascicoli 128, 131.

15. Archivio Storico del Comune di Ferrara (ASCFe), Serie patrimoniale, Busta B, Libro F, Deliberazione dell'anno 1432 a tutto 1444, fascicolo 83, explains the results of the competition for the statue of Niccolò. This document is transcribed in Rosenberg, *Este Monuments,* 209 n. 31.

16. Luigi Napoleone Cittadella, *Notizie relative a Ferrara per la maggiore parte inedite,* vol. 1 (Ferrara: Tipi di D. Taddei, 1864), 418, records the first evidence of activity on the Borso monument in September 1451. The statue was moved to the southern side of the Volto del Cavallo at Ercole I's orders on May 8, 1472. See Giulio and Giacomo Antigini, "Annali di Ferrara dal 1384 a 1514," BCA, Cl. I, 757, fascicolo 33.

17. Thomas Tuohy's detailed account of the various phases of Ercole's building campaign at the Palazzo del Corte is unmatched. See Thomas Tuohy, *Herculean Ferrara: Ercole d'Este, 1471–1505, and the Invention of a*

*Ducal Capital* (Cambridge: Cambridge University Press, 1996), especially 53–95.

18. For the marriage of Maria d'Aragona to Leonello d'Este in 1444, the piazza was filled with trees to simulate woods for a theatrical performance of the city's patron saint George killing the dragon, which was among the earliest public theatrical performances in Ferrara. See "Diario Ferrarese dall'anno 1409 sino al 1502 di autori incerti," in *Rerum Italicarum Scriptores,* vol. 24, ed. Giuseppe Pardi, pt. 1, book vii (Bologna: Nicola Zanichelli, 1928), 27 and 33.

19. "Diario Ferrarese," 78, gives the date as 1471; Filippo Rodi, "Annali di Ferrara a l'anno 1598," BCA, Cl. I, 645, fascicolo 207, gives the completion date of 1473. A less substantial passageway already connected the two buildings; see Tuohy, *Herculean Ferrara,* 60.

20. Mario Equicola d'Alveto, "Annali della città di Ferrara," BCA, Cl. II, 355, anno 1473.

21. Ugo Caleffini, "Cronica di Ferrara, 1471–1494," Vat. Chigi, I.i.4, fascicolo 230; "Diario Ferrarese," 121–22; Zambotti, "Diario Ferrarese," 171–72.

22. Tuohy, *Herculean Ferrara,* 87–89.

23. Ibid., 9.

24. For the Palazzo Ducale in Venice, see Deborah Howard, *The Architectural History of Venice* (New York: Holmes & Meier, 1981), 79–85.

25. G. Sabadino degli Arienti, "De Triumphia Religionis," Vatican Rossiano 176, fol. 51; Tuohy, *Herculean Ferrara,* 65.

26. Cittadella, *Notizie relative,* 447.

27. Biblioteca Estense, It. 429, Alpha H. 5.3, "Alzato di Ferrara."

28. Equicola, "Annali," anno 1578; BCA Cl. I, 107, Merenda, "Annali," fascicolo 173, 14 October 1553, "Cascò in Terra la Torre di Rigobello alli 14 . . . ."

29. BCA, Cartografia, XVI, 63, Gianbattista Aleotti, map of Ferrara in 1605; and BCA, Coll. Iconografica, Serie XVI, no. 2, Ruggiero Moroni, "Iconografia della piazza di Ferrara del 1618." See also the inventory completed by Bartolomeo Colletta, in Archivio di Stato, Ferrara (ASFe), Archivio dei periti agrimensori (Archivio periti), Busta 205, Libro 2, 12 August 1598, and 27 March 1600.

30. Girolamo Baruffaldi, *Dell'istoria di Ferrara* (Ferrara: Pomatelli, 1700), 14; Giuseppe Antenore Scalabrini, *Memorie istoriche delle chiese di Ferrara e de' suoi borghi* (Ferrara: C. Coatti, 1773), 39.

31. Gualtiero Medri, *Ferrara brevemente illustrata nei suoi principali monumenti* (Ferrara: Longhini and Bianchini, 1933), 72. Medri's guidebook was prepared in conjunction with the celebrations in honor of Ferrara's most famous literary figure, Ludovico Ariosto.

32. For the records of the competition for the façade and the reconstruction of the Torre di Rigobello, see ASCFe, XX Secolo, 12, Patrimonio Comunale, Cartello 26, "Stato finale e liquidazione dei lavori di restauro del Palazzo Comunale e costruzione della Torre della Vittoria," and Cartella 26 bis, fascicolo 1, "Concorso di idee per il rifacimento." (I henceforth refer to documents from this file by using the citation ASCFe, Concorso, Cart. 26 or 26bis.)

33. ASCFe, Concorso, Cart. 26bis, "Bando di Concorso," 15 December 1923, no. 22050, item 2. The deadline for entries, initially January 15, 1924, was extended to February 29. Only residents of Ferrara and its province could enter the competition.

34. The jurors included professor Adolfo Magrini, for Ferrariae Decus; engineer Giuseppe Maciga, for Deputazione di Storia e Patria; engineer Enzo Baglioni, for the Collegio Tecnico and Associazione Combattenti; three at-large members, including professor Giuseppe Agnelli, engineer Vico Mantovani, and engineer Ermanno Tedeschi. After the architect Luigi Corsini was not approved by the Ministry of Public Instruction as chair of the jury, the municipal council elected the architect Venceslao Borzani of Genoa. ASCFe, Concorso, Cart. 26bis, letter of Sindaco Raoul Caretti, 18 March 1924.

35. ASCFe, Concorso, Cart. 26bis, Jury Report, 29 March 1924; Ufficio Lavori Pubblici, "Risultato," 3 April 1924, with attached "Relazione della Commissione Giudicatrice," 29 March 1924 (henceforth "Relazione"); and "Verbali delle riunioni tenute dalla Commissione Giudicatrice dei progetti presentati al Concorso pel ripristino della facciata del Palazzo Comunale prospiciente il Duomo e della torre di Rigobello nei giorni 27, 28, 29 Marzo 1924" (henceforth "Verbali").

36. ASCFe, Concorso, Cart. 26bis, "Relazione," 2. The jury eliminated two other projects, *Ars Omnia Vincit* and *Vixi-devixi-redivixi.* The authors of the projects were: *Nobilitàs Estensis:* Giuseppe Castagnoli and Filippo Bordini; *In Bocca al Lupo:* Carlo Luppis; *Fidia:* Renzo Vancini and Leone Tunniati; *Obizzo:* Annibale Zucchi; *Sola Fides Sufficit:* Enrico Alessandri; *Ars Omnia Vincit:* Arrigo Saraceni and Angelo Cherubini; *Vixi-devixi-redivixi:* Gaetano Formentini.

37. ASCFe, Concorso, Cart. 26bis, "Relazione al progetto 'Nobilitas Estensis,'" 1.

38. This image dates after the fire of 1532 but before the Torre di Rigobello collapsed in 1553. It was first published by Donato Zaccarini, "Una scena cinquecentesca con la piazza di Ferrara," *Bollettino Statistico del Comune di Ferrara,* II trimester 1925 (Ferrara, 1926), iv–vii. For a full discussion, see Adriano Franceschini, "Nota sopra un bozzetto scenografico ferrarese del sec. XVI," in Antonio Samaritani and Ranieri Varese, eds., *L'Aquila Bianca: Studi di storia Estense per Luciano Chiappini* (Ferrara: Corbo, 2000), 391–410.

39. The original of this sketch for a stage set can be found in the Biblioteca Comunale Ariostea; despite extensive restoration and preservation, it is now nearly invisible.

BCA, Cartografia, ser. XVI, no. 74: "Scenografia della città di Ferrara, come si trova al presente," 1550–1553.

40. Giulio Bertoni and Emilio P. Vicini, *Il Castello di Ferrara al tempo di Niccolò III: Inventario della suppellettile del Castello 1436* (Bologna, 1907), 77. Since Bertoni and Vicini often confused Castello Estense with both Castelnovo and the Palazzo del Corte, their finding that the balcony faced the piazza may yet refer to a different piazza.

41. Cittadella, *Notizie relative*, 213.

42. Venceslao Borzani completed the reconstruction in 1924.

43. ASCFe, Concorso, Cart. 26bis, "Relazione al progetto 'Nobiltà Estensis,'" 1.

44. Bruno Zevi, *Saper vedere la città: Ferrara di Biagio Rossetti, la prima città moderna europea* (Turin: Einaudi, 1997; rev. ed., *Biagio Rossetti, architetto ferrarese, il primo urbanista moderno europeo*, Turin: Einaudi, 1960), 83.

45. Zevi, *Saper vedere*, 180–87. The restoration was completed in 1935. The most thorough examination of the restoration of this building is Serenella Di Palma, "Dalla casa al museo: Il Palazzo detto di Ludovico il Moro a Ferrara" (thesis, Università degli Studi di Ferrara, 2000). I am indebted to Di Palma for making a copy of her thesis available to me, and for lively discussions over the last four years on the culture of restoration during the Fascist period.

46. When Napoleon's troops invaded Ferrara in 1796, they initiated the destruction of convents and churches that continued through the early nineteenth century. French troops also tore down the original statues of Borso and Niccolò and melted them into cannon.

47. Archivio Centrale dello Stato (ACS), Presidenza del Consiglio dei Ministri, 1931–33, fascicolo 14-2-3237, Renzo Ravenna to S. E. Capo del Governo, 10 November 1932, 1–2.

48. Di Palma, "Dalla casa al museo," 41–42. A room in the Biblioteca Comunale Ariostea devoted to publications on Ferrara and its province contains documentation of much of Agnelli's work during his tenure with these organizations.

49. Di Palma, "Dalla casa al museo," 42.

50. ASCFe, Concorso, Cart. 26bis, "Verbali," 4.

51. Ibid., 5–6.

52. ASCFe, Concorso, Cart. 26, fascicolo 4, Arch. Venceslao Borzani, Correspondenza Varia, contains documentation regarding Borzani's work on the project.

53. ASCFe, Concorso, Cart. 26, fascicolo 4, Borzani, letter to Ermanno Tedeschi, engineer in the office of public works, 12 September 1924.

54. Lucio Scardino, "Architettura del Novecento," in Francesca Bocchi, ed., *Storia illustrata di Ferrara*, vol. 4 (Milan: Grafica Sipiel, 1989), 997.

55. ACS, Roma, Direzione Generale AA. e BB.AA. div. II,

b. 215, letter to Ministry of National Education, Antiquities and Fine Arts, from Carlo Calzecchi-Onesti, 19 January 1934, cited in Di Palma, "Dalla casa al museo," appendix.

56. ACS, Roma, Dir. Gen. AA. e BB.AA., div. II, b. 215, 16 March 1934. Report from the Consiglio Superiore per le Antichità e per le Belle Arti, now in Di Palma, "Dalla casa al museo," appendix.

57. Charles M. Rosenberg has located other representations of both portraits, but much of this material was unknown to Agnelli. Rosenberg, *Este Monuments,* especially 58–59, 71–72, 90–92. For Pellegrino Prisciani's sketch, see "Historiae Ferrariae," ASMo, ms. 131, liber VII, fol. 79v, also in Rosenberg, 70. For a discussion of the events of the '20s, see Ghirardo, "Surveillance and Spectacle," especially 332–41.

58. Ferrara's Jewish community enjoyed a long and distinguished history in Ferrara, dating back to the Este era, when both Ercole I and Ercole II welcomed refugees from Spanish and Portuguese persecutions in the fifteenth and sixteenth centuries. Balbo struggled mightily against the imposition of racial laws in 1938, and continued to show his friendship and support for Ravenna and other Ferrarese Jews until his death in 1940. See Antonella Guarnieri, "Ferrara, il fascismo, gli anni del consenso," in *L'indimenticabile mostra del '33,* ed. Silvanna Onofri and Cristina Tracchi (Ferrara: Liceo Classico L. Ariosto, 2000), 163–89, especially 170, 176–78.

59. Gustavo Giovannoni, "Nota," *Architettura ed arti decorative* 4, nos. 11–12 (1925): 564. Giovannoni, referring to it as "vulgar," was outraged that the "restoration" proceeded even though the special commission appointed by the minister of national education had opposed it and the ministry had suspended the works in August 1925. As it happens, Giovannoni was a member of that commission.

60. For a thorough account of the various phases of this campaign, see Maristella Casciato, "I restauri dell'900: La questione dei merli e le trasformazioni alla facciata del Palazzo Ducale," in *La corte di Pesaro: Storia di una residenza signorile,* ed. Maria Rosaria Valazzi (Modena: Panini, 1986), 67–84.

61. Casciato, "I restauri," 74.

62. ASCFe, Concorso, Cart. 26bis, "Obizzo: Premesse," 19–20.

63. Ibid., 1.

64. ASFe, Concorso, Cart. 26, Renzo Ravenna to Soprintendenza all'Arte Medioevale e Moderna dell'Emilia, 13 December 1926, 3.

65. I have discussed Antonio Gramsci's analysis of organic intellectuals in "Surveillance and Spectacle," and also in Ghirardo, "Architects, Exhibitions, and the Politics of Culture in Fascist Italy," *Journal of Architectural Education* 45 (1992): 67–75.

## 7. TOWERS AND TOURISTS

1. The series of short films entitled *Le bellezze d'Italia* included short films such as *Spoleto: Le bellezze del paesaggio e dele Pievi Umbre intorno a Spoleto* (1936), *Le bellezze artistiche di Pisa* (1934), and *Le bellezze di Italia: Il Mezzogiorno di Domenica a Venezia intorno alla Basilica d'Oro* (1933).

2. Over a million annual screenings reached an audience of 130 million. See Mino Argentieri, *L'occhio del regime: Informazione e propaganda nel cinema del fascismo* (Florence: Vallechi, 1979), 25.

3. Significant recent scholarly interest has examined the relationship between cities and cinema. See David B. Clarke, ed., *The Cinematic City* (London: Routledge, 1997), and Nicholas Reeves, *The Power of Film Propaganda* (London: Cassell, 1999).

4. The city was featured in films shot at studios such as Cinecittà and Cines. For a discussion of Italian feature films, see James Hay, *Popular Film Culture in Fascist Italy: The Passing of the Rex* (Bloomington: Indiana University Press, 1987); Marcia Landy, *Fascism in Film: The Italian Commercial Cinema, 1931–1943* (Princeton: Princeton University Press, 1986); Peter Bondanella, "The Silent Era and the Fascist Period," *Italian Cinema from Neorealism to the Present* (New York, Continuum, 2001); Elaine Mancini, *Struggles of the Italian Film Industry during Fascism, 1930–1935* (Ann Arbor: University of Michigan Press, 1985); and Pierre Sorlin, *Italian National Cinema 1896–1996* (New York: Routledge, 1996). On the so-called *dal vero* film genre shot with real people at real sites rather than with actors on a sound stage, see Giuliana Bruno, *Streetwalking on a Ruined Map: Cultural Theory and the City Films of Elvira Notari* (Princeton: Princeton University Press, 1993).

5. On the Italian film audience, see Ruth Ben-Ghiat, "The Italian Cinema and the Italian Working Class," *International Labor and Working-Class History* 59 (2001): 36–51. For a discussion of the German "culture" films produced during the Third Reich, see Hilmar Hoffmann, "The Nonfictional Genres of Nazi Film Propaganda," in *The Triumph of Propaganda: Film and National Socialism, 1933–1943*, trans. John A. Broadwin and V. R. Berghahn (Providence, R.I.: Berghahn Books, 1996).

6. James Hay, "Piecing Together What Remains of the Cinematic City," in Clarke, ed., *Cinematic City,* 217.

7. For a list of these documentaries and newsreels, see Istituto Nazionale LUCE, *Catalogo generale del soggetti cinematografiche* (Rome: Istituto Luce, 1937), and Istituto Luce, *Antologia di cinegiornali Luce* (Rome: Istituto Luce, n.d.). Documentaries made prior to the introduction of sound in 1932 were often accompanied by short descriptive pamphlets and/or lengthy narrative introductions. Unfortunately, neither the pamphlets nor the sound reels survive.

8. Ruth Ben-Ghiat makes a similar case with respect to the Opera Nazionale Dopolavoro. She contends that the OND mobilized the masses to celebrate popular traditions. See Ben-Ghiat, "Envisioning Modernity: Desire and Discipline in the Italian Fascist Film," *Critical Inquiry* 23 (1996): 114.

9. The General Directorate for Cinematography was established in 1934, with Luigi Freddi as director.

10. ENIT, *San Gimignano* (Rome: Pubblicazione dello Stato, 1931).

11. For a discussion of the way in which the regime deployed the Middle Ages and Renaissance, see D. Medina Lasansky, *The Renaissance Perfected: Architecture, Spectacle, and Tourism in Fascist Italy* (University Park: Pennsylvania State University Press, 2004).

12. All quotations are taken from *Belle torri*. All translations are my own.

13. On the association between lepers and this church, see Iole Vici Imberciadori, *San Gimignano: Edilizia e igiene sociale xiii–xv secolo: Ricerca e documentazione storica attraverso gli statuti ed altre fonti, con accenni ai secoli successivi* (Poggibonsi: Grafiche Nencini, 1980), 128–30.

14. On the role of women during the regime, see Victoria de Grazia, *How Fascism Ruled Women* (Berkeley: University of California Press, 1992).

15. The fountains were built in several stages between the twelfth and fourteenth centuries.

16. The regime sponsored programs to boost birth rates in the rural population, as well as to reinforce traditional values, hard work, healthy and moral living. On the regime's program of ruralization, see Antonio La Stella, "Architettura rurale," in *Giuseppe Pagano fotografo*, ed. Cesare de Seta (Milan: Electa, 1979). In addition, films such as Alessandro Blasetti's *Sole* (1929) and *Terra madre* (1933) featured the reclamation of the countryside.

17. Roland Barthes, "The Eiffel Tower" (1979), reprinted in *Rethinking Architecture: A Reader in Cultural Theory,* ed. Neil Leach (New York: Routledge, 1997), 175.

18. Barthes, "Eiffel Tower," 175.

19. See the letter written by Superintendent Péleo Bacci to the Ministry of Public Instruction, dated 4 December 1927, Archivio Centrale dello Stato (ACS), AABBAA Div. II, 1925–1928, Busta 205, Filza "Zona Monumentale."

20. The frescoes are the only known cycle depicting the life of San Agostino in Tuscan Renaissance art. See Diane Cole Ahl, *Benozzo Gozzoli* (New Haven: Yale University Press, 1996), 121.

21. A rare exception is a guidebook on Gozzoli's work published by Fratelli Alinari in 1908. See Vittorio Alinari, *Benozzo Gozzoli e sua scuola* (Florence: Alinari, 1908). Claudio Paolini's study of the production of neo-Renaissance decorative arts during the late nineteenth and early twentieth centuries notes that in Florence plates with scenes from Gozzoli's *Cavalcata dei Magi* were popular. See Paolini, "Oggetti come specchio dell'anima: Per una rilettura dell'artigianato artistico fiorentino nelle dimore degli anglo-americani," in *Gli Anglo-Americani a Firenze: Idea e costruzione del rinascimento,* ed. Marcello Fantoni (Rome: Bulzoni, 2000).

22. Bernard Berenson, *Italian Painters of the Renaissance* (1907; reprint, Ithaca: Cornell University Press, 1980), 63.

23. See the work of contemporary authors, such as Elena Contaldi, *Benozzo Gozzoli: La vita — le opere* (Milan: Editore Libraio Della Real Casa, 1928). On the reception of Gozzoli, see Ahl, *Benozzo Gozzoli*, 1–2.

24. Contaldi, *Benozzo Gozzoli*, vii.

25. Ibid., ix. See also Contaldi, 47, for one of several references to Gozzoli's indefatigable nature, fecundity, and proficiency.

26. On the use of frescoes during the regime, see Marla Susan Stone, *The Patron State: Culture and Politics in Fascist Italy* (Princeton: Princeton University Press, 1998), 119.

27. On Mario Sironi, see Emily Braun, *Mario Sironi and Italian Modernism: Art and Politics under Fascism* (Cambridge: Cambridge University Press, 2000). Braun, 57, notes that Sironi's compositions recall the quattrocento paintings of Masaccio as well as Piero della Francesca. Among other twentieth-century artists who studied early fresco painting, Carrà looked at Giotto, while Rosai studied Masaccio.

28. See Elisa Bizzarri, Patrizia Luzzato, and Annalisa Zanuttini, *L'utile e il dilettevole: Storia del dopolavoro a Roma negli anni trenta* (Rome: Il Ventaglio, 1988), 68. The OND created a similar school in Rome in 1927. On the school founded in Siena in 1928, see Stefano Cavazza, "Feste popolare durante il fascismo: Invenzione della tradizione e identità locale: La Toscana e la realtà nazionale" (Ph.D. diss., University of Turin, 1991). In 1939, the Mostra dei Istituti d'Istruzione Artistica was held in Rome to celebrate these various institutions of artisanal education.

29. See Mario Sironi, "Manifesto of Mural Painting," in *Art in Theory, 1900–1990: An Anthology of Changing Ideas*, ed. Charles Harrison and Paul Wood (London: Oxford University Press, 1992), 407–9.

30. On the Chiesa di San Jacopo, see Paola Landolfi, "I Templari a San Gimignano: La Chiesa di San Jacopo al Tempio," in *San Gimignano e la Via Francigena, Annuario del Centro Studi Romei* (Poggibonsi: Opus Libri, 1996), 51–72.

31. D'Annunzio was the preeminent Italian poet and playwright from the late nineteenth century until his death in 1938, and, like Dante, had a complex relationship with his mother country. He lived in exile in France from 1910 until 1915, but at the onset of World War I went to the Italian front as a correspondent for *Corriere della Sera* and returned to Italy a decorated military hero. His writings captured the attention of Mussolini, and in 1937 he was nominated as president of the prestigious Accademia d'Italia. On his death, D'Annunzio received a state funeral. See Annamaria Andreoli, *D'Annunzio* (Paris: Réunion des Musées Nationaux, 2001). Andreoli, 53, notes that in 1915 Charles Léandre captured the Dante/D'Annunzio parallel on an illustrated magazine cover.

32. The music was scored by C. Alberto Pizzini.

33. For discussions of German, Soviet, and Italian cinema, see Renzo Renzi, ed., *Il cinema dei dittatori: Mussolini, Stalin, Hitler* (Bologna, Grafis, 1992).

34. Ben-Ghiat, "Envisioning Modernity," 115, notes that Ethiopia provided a forum for reinforcing racial and social order.

35. Cinema structures ways of seeing, as Laura Mulvey points out in her formative study on film, "Visual Pleasure and Narrative Cinema," *Screen* (1975), reprinted in Laura Mulvey, *Visual and Other Pleasures* (Bloomington: Indiana University Press, 1989), 15.

36. In his critical study of restoration projects, Alfredo Barbacci, *Il restauro dei monumenti in Italia* (Rome: Istituto Poligrafico dello Stato, 1956), 121, argues that the thirteenth-century towers of Monteriggioni were rebuilt to evoke Dante's image of them as "orribili giganti" in *Inferno* 31.40–45.

37. Archivo Comunale di Arezzo, Deliberazione del Podestà, 1932, no. 282.

38. The restoration of buildings was typically initiated on the local level, most often by the *podestà*, the Pro-loco, or monument brigade. Following typical protocol, these local leaders and groups then contacted the regional office of the superintendent to advise of their plans or to seek design advice. The superintendent in turn studied the proposed project to determine whether the structure was of historic or artistic interest. The superintendent's report and recommendation were then submitted to the Ufficio delle Antichità e Belle Arti in Rome. Local architects, artists, and historians, as well as PNF leaders and mayors, were all involved—contributing designs, organizational skills, and resources.

39. On the extensive work carried out at San Agostino, see Soprintendenza dei Monumenti di Siena (SMS), Filza H-31, "Chiesa di San Agostino." For a discussion of the renovations undertaken in San Gimignano, see D. Medina Lasansky, "Urban Editing, Historic Preservation, and Political Rhetoric: The Fascist Redesign of San Gimignano," *Journal of the Society of Architectural Historians* 63 (2004): 320–53.

40. The painted stucco trompe l'oeil neoclassical façade of the church had already been stripped in 1896. For letters, contracts, and expenses related to the restoration of the Collegiata, see SMS, Filza H-40, "La Collegiata." The De Matteis firm was hired to reposition the ten windows in the central nave and to construct new medieval-style windows in the transept, similar in style to those on the façade.

41. See "Il Nuovo Altare della Basilica di S. M. Assunta e La Sistemazione del Coro," *La Nazione*, 30 April 1937.

42. SMS, Filza H-40, "La Collegiata."

43. In 1937, the Florentine painter Bruno Masini was asked to design a new historicizing stained-glass window for the central choir. Bacci, who examined Masini's plans for the figure of San Gimignano, wrote to Masini on February 8, 1937, saying that the window should be fifteenth-century in style with the figure situated in a semi-arch. SMS, Filza H-40, "La Collegiata."

44. According to Bacci, this project was inspired by the discovery of a fourteenth-century document that made reference to the "loggia of the Palazzo del Comune." See Péleo Bacci, "La loggia del xiv secolo attigua al Palazzo del Popolo in San Gimignano: Note e doccumenti relativi all'identificazione e al ripristino," *Bollettino senese di storia patria: Rivista delle 'Istituto d'arte e di storia del comune di Siena* 71 (1934): 227–53.

45. In 1929, Giuseppe Castellucci restored the Palazzo Comunale in San Giovanni Valdarno (province of Arezzo). See ACS, AABBAA, Div. II, 1934–40, Busta 179.

46. Castellucci restored the Palazzo Pretorio from 1926 to 1930 for the Ufficio Regionale per la Conservazione dei Monumenti. See ACS, AABBAA. Div. II, 1929–33, Busta 142.

47. The crenellations of the Palazzo del Podestà were added when Bacci unearthed a hypothetical nineteenth-century rendition of the town hall that included them. See SMS, Filza H-177, "Palazzo del Podestà," letter dated 10 July 1926.

48. As Ben-Ghiat, "Envisioning Modernity," 123, points out, films such as Matarazzo's *Treno popolare* provided the means of controlling and ordering leisure time.

49. See Péleo Bacci, "La loggia del xiv secolo," and Gino Chierici, "A Proposito di S. Gimignano che se ne va," *Miscellanea storica della Valdelsa* 31 (1923): 52–61.

50. See Hay, "Piecing Together," 219.

51. In addition to the short documentaries, feature films such as Luis Trenker's 1937 *Condottiero* celebrated the medieval Tuscan countryside. *Condottiero* chronicled the chivalric adventures of Giovanni delle Bande Nere, a favorite Fascist hero whose courage was frequently compared to that of Mussolini's *camicie nere.*

52. "Aspetti della bellezza toscana," *L'Illustrazione Toscana* (December 1929): 11.

53. Victoria de Grazia, *The Culture of Consent: Mass Organization of Leisure in Fascist Italy* (Cambridge: Cambridge University Press, 1981), 53.

54. De Grazia, *Culture of Consent,* 53. On the OND, see also Enrico Beretta, *Realizzazioni e sviluppi dell'Opera Nazionale Dopolavoro* (Borgo San Dalmazzo: OND, 1933), and Bizzarri, Luzzato, and Zanuttini, *L'utile e il dilettevole.*

55. Antonio Crispo, *Le ferrovie italiane: Storia politica ed economica* (Milan: Dott. A. Giuffrè, 1940), 284.

56. Ben-Ghiat, "Envisioning Modernity," 114.

57. Ibid., 123.

58. Ibid., 109–44.

59. On the redesign of the festivals, see D. Medina Lasansky, "Tableau and Memory: The Fascist Revival of the Medieval/Renaissance Festival in Italy," in *Post-Modern Fascism,* ed. Richard Bosworth, special issue, *The European Legacy* 4, no. 1 (1999): 26–53; and "Political Allegories:

Siena's Panforte, Palio and the Patron Saint," in *Rethinking Allegory: Embodying Meaning in Early Modern Culture,* ed. Cristelle Baskins and Lisa Rosenthal (forthcoming).

60. On the reintroduction of the *panforte,* see Cavazza, "Feste popolare."

61. On the realist aesthetic, see Ruth Ben-Ghiat, "Fascism, Writing, and Memory: The Realist Aesthetic in Italy, 1930–1950," *The Journal of Modern History* 67 (1995): 631.

62. The Ente per le Attività Toscane (EAT), for example, launched by Enrico Barfucci in Florence, sponsored frequent guided visits to neighboring towns.

63. Henri Lefebvre, *The Production of Space* (London: Blackwell, 1991).

## 8. SHAPING THE FASCIST "NEW MAN"

1. For a history of the Kunsthistorisches Institut, see Hans W. Hubert, *Das Kunsthistorisches Institut in Florenz von der Gründung bis zum hundertjährigen Jubiläum (1897–1997)* (Florence: Il Ventilabro, 1997).

2. For Donatello's *St. George* and its history through the nineteenth century, see H. W. Janson, *The Sculpture of Donatello* (Princeton: Princeton University Press, 1963), 23–32; Silvana Macchioni, "Il San Giorgio di Donatello: Storia di un processo di musealizzazione," *Storia dell'arte,* no. 36/37 (1979): 135–56.

3. Beginning in the eighteenth century, plaster copies of Donatello's statue were made for museums and art academies throughout the world. For this history, see Paola Barocchi, ed., *Omaggio a Donatello, 1386–1986* (Florence: Museo Nazionale del Bargello, 1985).

4. For this Florentine history, see John Najemy, *Corporatism and Consensus in Florentine Electoral Politics, 1280–1400* (Chapel Hill: University of North Carolina Press, 1982). For Bruni's concern, see Marvin B. Becker, *Florence in Transition,* vol. 2 (Baltimore: Johns Hopkins University Press, 1968), 217.

5. Frederick Hartt, "Art and Freedom in Quattrocento Florence," in *Modern Perspectives in Western Art History,* ed. W. Eugene Kleinbauer (New York: Holt, Rinehart and Winston, 1971), 293–311. Hartt's essay was originally published in *Essays in Memory of Karl Lehmann,* ed. Lucy Freeman Sandler (New York: Institute of Fine Arts, 1964), 114–31.

6. Hans Baron, *The Crisis of the Early Italian Renaissance: Civic Humanism and Republican Liberty in an Age of Classicism and Tyranny,* 2 vols. (Princeton: Princeton University Press, 1955). Princeton University Press also published a revised, one-volume edition in 1966.

7. Baron, *Crisis* (1966), 205. In a footnote to this statement, Baron observes that "the possible impact of Florence's struggle-for-independence on Florentine art has now been traced in some suggestive detail by Frederick Hartt," and he follows with a reference to Hartt's essay,

"Art and Freedom." See Baron, *Crisis* (1955), 505 n. 20c.

8. Hartt, "Art and Freedom," 297.

9. Ibid., 300.

10. Arnold von Borsig and Ranuccio Bianchi-Bandinelli, *Tuscany: 200 Photographs by Arnold von Borsig* (New York: Studio Publications, 1955).

11. *La Nazione,* 6 May 1938, 3. This photograph is one of many that *La Nazione* published in early May 1938 featuring the decorations in the city and the events of Hitler's visit.

12. Archivio Storico del Comune di Firenze, Lavori Pubblici, Buste 264 B.A., 5350, 5576, 5592, 5617, 5945, 5947; and Disegni, Cartella 73.

13. For Hitler's visit to Italy and images of the various decorations, see *Hitler in Italia* (Rome: Società Editrice di Novissima, 1938); Richard A. Etlin, *Modernism in Italian Architecture, 1890–1940* (Cambridge: MIT Press, 1991), 571–75; Carlo Cresti, *Architettura e fascismo* (Florence: Vallecchi Editore, 1986), 329–37; Alberto Marcolin, *Firenze in camicia nera* (Florence: Edizioni Medicea, 1993), 73–76; Luciano Artusi and Vincenzo Giannetti, *Quando Firenze era il salotto di Mussolini* (Firenze: Lito Terrazzi, 1999), 275–94; and Ranuccio Bianchi Bandinelli, *Hitler e Mussolini: 1938: Il viaggio del Führer in Italia* (Rome: Edizioni e/o, 1995).

14. Artusi and Giannetti, *Quando Firenze,* 288.

15. Archivio Storico del Comune di Firenze, Disegni, Cartella 73. For this map, see Artusi and Giannetti, *Quando Firenze,* 280–81.

16. As quoted in Simonetta Falasca-Zamponi, *Fascist Spectacle: The Aesthetics of Power in Mussolini's Italy* (Berkeley: University of California Press, 1997), 2. For additional discussion of the identity and imagery of Italy as a warrior state, see the section "War, Violence, and Action in Fascist Mythology" in Tracy H. Koon, *Believe Obey Fight: Political Socialization of Youth in Fascist Italy, 1922–1943* (Chapel Hill: University of North Carolina Press, 1985), 21–26.

17. Etlin, *Modernism,* 572.

18. Ibid.

19. For the relationship between Mussolini and Hitler, their meeting in 1938, and the eventual formulation of the Axis, see Elizabeth Wiskemann, *The Rome-Berlin Axis* (London: Collins, 1966); Philip V. Cannistraro, ed., *Historical Dictionary of Fascist Italy* (Westport, Ct.: Greenwood Press, 1982), 45–50; Denis Mack Smith, *Mussolini: A Biography* (New York: Vintage Books, 1982), 213–45; and R. J. B. Bosworth, *Mussolini* (London: Arnold, 2002), 310–56.

20. For how contemporaries articulated these connections, particularly in relation to Florence and Germany, see the issue dedicated to "Firenze e la Germania" of *L'Illustrazione Italiana,* May 1938.

21. Etlin, *Modernism,* 572.

22. Ibid.

23. Ibid.

24. Ibid., 575.

25. Walter Benjamin, "The Work of Art in the Age of Mechanical Reproduction" (1935), in *Illuminations,* ed. Hannah Arendt and trans. Harry Zohn (New York: Schocken Books, 1969), 241.

26. For the Fascist "New Man," see Falasca-Zamponi, *Fascist Spectacle,* 26–241 passim. The whole spectacle of Florence redecorated for Hitler's arrival was itself part of the conscious transformation of Italy through ritual and spectacle that had characterized Fascist domestic politics and propaganda since the inception of the regime. This process of ritual spectacle under the Fascist regime has been aptly described as the sacralization of politics. For this notion and its roots in Risorgimento Italy of the nineteenth century, see Emilio Gentile, *The Sacralization of Politics in Fascist Italy,* trans. Keith Botsford (Cambridge: Harvard University Press, 1996).

27. Falasca-Zamponi, *Fascist Spectacle,* 33.

28. Ibid., 89.

29. Ibid., 26.

30. Walter L. Adamson, *Avant-Garde Florence: From Modernism to Fascism* (Cambridge: Harvard University Press, 1993).

31. Adamson, *Avant-Garde Florence,* 262.

32. Falasca-Zamponi, *Fascist Spectacle,* 23.

33. Jeffrey T. Schnapp, *Staging Fascism: 18BL and the Theater of the Masses for Masses* (Stanford: Stanford University Press, 1996).

34. However, one aspect of the Renaissance that was problematic for the Fascists was Renaissance individualism. See Koon, *Believe Obey,* 71–74. In her chapter, "Fascistization of the School Curricula," Koon explains that university courses stressed Roman imperialism (and downplayed Renaissance individualism) and also emphasized the Risorgimento, the Italian national mission, and the corruption of the liberal state.

35. Falasca-Zamponi, *Fascist Spectacle,* 25.

36. Gentile, *Sacralization,* 62.

37. Falasca-Zamponi, *Fascist Spectacle,* 35.

38. Gentile, *Sacralization,* 63.

39. Ibid., 61.

40. Ibid., 61–62.

41. Koon, *Believe Obey,* 98. For the training of the citizen-soldier, see Koon, 98–104, and Achille Starace, *Fasci giovanili di combattimento* (Milan: A. Mondadori, 1933).

42. Hartt, "Art and Freedom," 302.

43. For the Palazzo del Littorio design entry, see Cresti, *Architettura e fascismo,* 30.

44. See Diane Y. Ghirardo and Kurt W. Forster, "I modelli delle città di fondazione in epoca Fascista," in *Insediamenti e territorio,* ed. Cesare De Seta (Turin: Giulio Einaudi, 1985), 646–49.

45. Falasca-Zamponi, *Fascist Spectacle,* 49–50.

46. Ibid., 50.

47. Antonio Beltramelli, *L'uomo nuovo* (Milan: Mondadori, 1923). On the cult of the Duce, see Piero Melograni, "The Cult of the Duce in Mussolini's Italy," *Journal of Contemporary History* 11 (1976): 221–37.

48. Falasca-Zamponi, *Fascist Spectacle,* 65; and Koon, *Believe Obey,* 16.

49. Margherita Sarfatti, *DUX* (Verona: Mondadori, 1926). See Margherita Sarfatti, *The Life of Benito Mussolini,* trans. Frederic Whyte (New York: Frederick A. Stokes, 1925), 230.

50. Falasca-Zamponi, *Fascist Spectacle,* 65; and *Koon, Believe Obey,* 17.

51. Falasca-Zamponi, *Fascist Spectacle,* 49; and Koon, *Believe Obey,* 46. According to Koon, the Fascist party apologist Giovanni Gentile referred to Mussolini as the "powerful *condottiere* of whom Machiavelli had dreamed."

52. Etlin, *Modernism,* 572.

53. Object number 85.7.241. I thank Marianne Lamonaca of the Wolfsonian-Florida International University for bringing this plate to my attention.

54. For Fascism, youth, and Mussolini, see Koon, *Believe Obey,* 250–51 and 16. For contrived images of Mussolini as youthful and vigorous, see Falasca-Zamponi, *Fascist Spectacle,* 74 and 154.

55. On the use of streets as settings for Fascist political "theater," see Diane Y. Ghirardo, "Architecture and Theater: The Street in Fascist Italy," in *Event Arts and Art Events,* ed. Stephen C. Foster (Ann Arbor: UMI Research Press, 1988), 175–99.

56. For this photograph, see Falasca-Zamponi, *Fascist Spectacle,* 81.

57. For these photographs, see ibid., 80, 83, and 102.

58. For this photograph, see Schnapp, *Staging Fascism,* 127, fig. 65. The photograph depicts Mussolini at a performance of *Oedipus Rex* at the Roman theater at Sabratha.

59. Baron, *Crisis* (1955), 40: "One cannot trace the history of this explosive stage in the genesis of the states-system of the Renaissance without being struck by its resemblance to events in modern history when unifying conquest loomed over Europe. In a like fashion, Napoleon and Hitler . . . waited for the propitious time for their final leap—until the historic moment had passed and unforeseen development had upset the apparently inevitable course of fate. This is the only perspective from which one can adequately reconstruct the crisis of the summer of 1402 and grasp its material and psychological significance for the political history of the Renaissance, and in particular for the growth of the Florentine civic spirit." Baron also referred to and rejected the ideas of another scholar who discusses with approval historical examples of political unification and expansion on the Italian peninsula in relation to Mussolini's political "successes" of the early '20s. See Baron, *Crisis* (1955), 504 n. 38. Among the studies that reconsider Baron's biography and scholarship are Riccardo Fubini, "Una carriera di storico del rinascimento: Hans Baron," *Rivista storica italiana* 104 (1992): 501–44; Riccardo Fubini, "Renaissance Historian: The Career of Hans Baron," *The Journal of Modern History* 64 (1992): 541–74; James Hankins, "The 'Baron Thesis' after Forty Years and Some Recent Studies of Leonardo Bruni," *Journal of the History of Ideas* 56 (1995): 309–30; and Ronald Witt, "The Crisis after Forty Years," *American Historical Review* 101 (1996): 110–18. The Fascist regime itself drew such parallels, as when Mussolini's government bought all copies of Bortolo Belotti's *Il dramma di Gerolamo Olgiati* (Milan: L. F. Cogliati, 1929), a work that deals with Milanese despotism in the Renaissance, for fear of encouraging comparisons between past and present. For this Fascist suppression, see Vincent Ilardi, "The Assassination of Galeazzo Maria Sforza and the Reaction of Italian Diplomacy," in *Violence and Civil Disorder in Italian Cities, 1200–1500,* ed. Lauro Martines (Berkeley: University of California Press, 1972), 72–103.

60. Frederick Hartt, *Florentine Art under Fire* (Princeton: Princeton University Press, 1949). Hartt served as a fine arts and archives officer for Tuscany while a 1st lieutenant in the U.S. Army Air Corps, 1942–46. For his military service, Hartt was made an honorary citizen of Florence on February 25, 1946.

61. Ibid., 69.

62. Frederick Hartt, *History of Italian Renaissance Art* (New York: Harry N. Abrams, 1969), 11. Although Hartt's book continues to be in print, most recently in a fifth edition co-authored by David G. Wilkins (New York: Harry N. Abrams, 2002), the historical underpinnings of his influential work have yet to be examined in full.

63. Hartt, *History,* 111–12.

64. Ibid., 211.

65. Hartt, "Art and Freedom," 306. For the notion of the "finest hour" in the context of World War II, see Winston S. Churchill, *The Second World War,* vol. 2, *Their Finest Hour* (Boston: Houghton Mifflin, 1949).

66. Personal communications with Eugene Markowski and Craig Hugh Smyth. Florence and Tuscany were clearly Fascist strongholds, and this may well have been apparent to Hartt as a young man. For Fascism in Florence and Tuscany, see Simonetta Soldani, "La Toscana nel regime Fascista, 1922–1939," *Studi storici,* no. 10 (1969): 644–52; *La Toscana nel regime Fascista, 1922–1939,* ed. A. Binazzi and I. Cuasti (Florence: Olschki, 1971); Roberto Vi-

varelli, "La Toscana nel regime Fascista," *Rivista storica italiana,* no. 85 (1973): 689–97; and Frank Snowden, *The Fascist Revolution in Tuscany 1919–1922* (Cambridge: Cambridge University Press, 1989).

67. *A Soldier's Guide to Florence,* prepared by Morale Services Section, HQ, SOS, Natousa and the Subcommission for Monuments and Fine Arts, Allied Control Commission, North African Theater of Operations, U.S. Army, 1945.

68. In the context of Rosie the Riveter, a fictional character made most famous through Norman Rockwell's image for *The Saturday Evening Post,* it is noteworthy that in 1928 the same magazine ran a serial biography of Mussolini. See Falasca-Zamponi, *Fascist Spectacle,* 52.

9. MUSSOLINI, MOTHERS, AND MAIOLICA

1. Massimo Livi-Bacci, *A History of Italian Fertility during the Last Two Centuries* (Princeton: Princeton University Press, 1977); and Carl Ipsen, *Dictating Demography: The Problem of Population in Fascist Italy* (Cambridge: Cambridge University Press, 1996).

2. Jacqueline Marie Musacchio, *The Art and Ritual of Childbirth in Renaissance Italy* (New Haven: Yale University Press, 1999).

3. Ann G. Carmichael, *Plague and the Poor in Early Renaissance Florence* (Cambridge: Cambridge University Press, 1986), 60–61.

4. David Herlihy and Christiane Klapisch-Zuber, *Tuscans and Their Families* (New Haven: Yale University Press, 1985), 60–92.

5. Jacqueline Marie Musacchio, "Imaginative Conceptions in Renaissance Italy," in *Picturing Women in Renaissance and Baroque Italy,* ed. Sara F. Matthews Grieco and Geraldine Johnson (Cambridge: Cambridge University Press, 1997), 42–60; and Katharine Park, "Impressed Images: Reproducing Wonders," in *Picturing Science, Producing Art,* ed. Caroline A. Jones and Peter Galison (New York: Routledge, 1998), 254–71.

6. Benito Mussolini, "Il discorso dell'Ascensione," in *Opera omnia,* ed. Edoardo and Duilio Susmel, vol. 22 (Florence: La Fenice, 1957), 364.

7. For Fascist population policies and their relationship to child-care concerns, see Pietro Corsi, *The Protection of Mothers and Children in Italy* (Rome: Società Editrice di Novissima, 1938); and Riccardo Korherr, *Regresso delle nascite: Morte dei popoli* (Rome: Libreria del Littorio, 1928).

8. Benito Mussolini, "La situazione economica," in *Opera omnia,* ed. Edoardo and Duilio Susmel, vol. 26 (Florence: La Fenice, 1958), 259.

9. ONMI films make this evident; see Lesley Caldwell, "*Madri d'Italia:* Film and Fascist Concern with Motherhood," in *Women and Italy: Essays on Gender, Culture,*

and *History,* ed. Zygmunt G. Baranski and Shirley W. Vinall (London: Macmillan, 1991), 43–63.

10. Istituto Centrale di Statistica del Regno d'Italia, "L'azione promossa dal governo nazionale a favore dell'incremento demografico," *Annali di statistica* 7 (1943); Livi-Bacci, *History of Italian Fertility,* 277–78; Ipsen, *Dictating Demography,* 173–94; and Victoria de Grazia, *How Fascism Ruled Women: Italy, 1922–1945* (Berkeley: University of California Press, 1992), 43–45, 69–71, 92, and 112–13.

11. See, for example, the 1934 marriage of twelve young couples in Piazza San Marco in Venice, illustrated on the cover of *L'Illustrazione Italiana,* 11 February 1934.

12. Ipsen, *Dictating Demography,* 66.

13. John F. Pollard, *The Vatican and Italian Fascism, 1929–32: A Study in Conflict* (Cambridge: Cambridge University Press, 1985); and Giorgio Angelozzi Gariboldi, *Pio XII, Hitler e Mussolini: Il Vaticano fra le dittature* (Milan: Mursia, 1988).

14. Claudia Carlen, ed., *The Papal Encyclicals 1903–1930,* vol. 3 (Ann Arbor: Pierian Press, 1990), 391–414.

15. Anonymous, "L'assistenza alla maternità ed all'infanzia in Italia," *Maternità e Infanzia,* January–February 1940, 28.

16. De Grazia, *How Fascism Ruled,* 92.

17. Giuseppe Morittu, *Meriti e decorazioni 1839–1945* (Padua: CS, 1989), 126. For an award ceremony, see anonymous, "Nel 3. annuale delle famiglie numerose," *L'Illustrazione Italiana,* 10 March 1940, 288.

18. De Grazia, *How Fascism Ruled,* 72, 74–75; and Roberto Curci, ed., *Marcello Dudovich, cartellonista, 1878–1962* (Trieste: Edizioni della Cassa di Risparmio di Trieste, 1976).

19. De Grazia, *How Fascism Ruled,* 77–78; and Caldwell, "*Madri d'Italia,*" 54.

20. Raffaello Biordi, "Uno gentile costumanzà che ritorna: La tazza da parto," *Il Piccolo,* 3 June 1939.

21. De Grazia, *How Fascism Ruled,* 210–18; and Perry R. Willson, "Women in Fascist Italy," in *Fascist Italy and Nazi German: Comparisons and Contrasts,* ed. Richard Bessel (Cambridge: Cambridge University Press, 1996), 88.

22. *L'Illustrazione Italiana,* 23 September 1934, cover illustration.

23. Anonymous, "In attesa del lieto evento," *L'Illustrazione Italiana,* 23 September 1934, 464.

24. *L'Illustrazione Italiana,* 30 September 1934, cover illustration.

25. Antonino Procida, "Il battesimo della Principessa Maria Pia di Savoia," *L'Illustrazione Italiana,* 30 December 1934, 1020–21.

26. Ipsen, *Dictating Demography,* 183.

27. Anonymous, "Informazioni e notizie," *Maternità e Infanzia,* March–April 1940, 105.

28. Ipsen, *Dictating Demography,* 183.

29. Fascist demographic policy often sought justification in history. Ancient birth rituals were cited as precedent in Giuseppe Alberti, "La puericultura nell'oriente antico," *Maternità e Infanzia,* July–October 1939, 307–15.

30. James Westfall Thompson, "The Aftermath of the Black Death and the Aftermath of the Great War," *The American Journal of Sociology* 26 (1921): 565–72.

31. Alessandro del Vita, "Un'usanza gentile del rinascimento: I vasi amatori," *Le Vie d'Italia,* May 1940, 496–97.

32. Terisio Rovere, "Arte minore: La ceramica: Il servizio ad 'impagliata,'" *ABC Rivista d'Arte,* July 1939, 17.

33. Eugene Müntz, "Les plateaux et les coupes d'accouchées aux XVe e XVIe siècles: Nouvelles recherches," *La revue de l'art ancien et moderne* 1 (1899): 426–28. Even today, there are few sources. See Giovanna Bandini, "'Delle impagliate' ossia annotazioni intorno alle maioliche da puerpera cinquentesche," in *Da donna a madre: Vesti e ceramiche particolari per ornamenti speciali* (Florence: Scientific Press, 1996), 55–109; Franco Crainz, *La tazza da parto* (Rome: Janssen, 1986); Claudia Silvia Däubler, "La tazza da parto nella collezione Pringsheim," *Ceramicantica* 6 (1994): 26–39; and Musacchio, *Art and Ritual,* 91–123.

34. Luigi Servolini, "Il dono simbolico della città di Forlì alla principessa di Piemonte: La 'tazza da parto' romagnola," *L'Illustrazione Italiana,* 10 March 1940, 304.

35. Alberti, "Puericultura," 307–15.

36. Luigi Servolini, "Sorrisi della maternità nell'arte: Le tazze e i deschi da parto," *Progressi di Terapia* 30 (January/February 1941): 30, 32, and Crainz, *Tazza da parto,* 24–25.

37. Cipriano Piccolpasso, *I tre libri dell'arte del vasajo* (Rome: Stab. Tipografico, 1857). More recently, see Cipriano Piccolpasso, *I tre libri dell'arte del vasaio,* trans. Ronald Lightbown and Alan Caiger-Smith (London: Scholar Press, 1980).

38. Modern Faentine ceramists also reproduce the wares, and the Fictilia and Mazzotti workshops made sets for a recent exhibition; see Comune di Faenza and the Istituto Italiano di Cultura of New York, *Treasures for the Table: An Exhibition of Contemporary Table Settings: Majolica from Faenza* (Faenza: Litografie Artistiche Faentine, 1983), 42–45.

39. Photocopies of the following articles are at the Museo Internazionale delle Ceramiche, but because of their obscure nature, determining precise citations has not been possible: C. L., "La tazza della maternità," *L'Artigiano,* 26 March 1940, reprinted in *Corriere dei Ceramisti,* July–August 1940; A. B. Fassio, "La tazza da parto," *Maternità e Infanzia,* July–October 1939, 321–23; and Cesare Marchesini, "Rinascita di una tipica tradizione italiana: La tazza

da parto," *Salsomaggiore Illustrata,* 31 October 1940, 185–87. More reliable sources are those by Luigi Servolini of Forlì, "Vasi durantini e tazze d'impalliata," *Sapere,* 15 April 1939, 256–57; "Dono simbolico," 304; and "Sorrisi della maternità," 26–34; and by Giuseppe Liverani of Faenza, "La tazza da impagliata," *Faenza* 29 (1941): 11–16; "La tazza da impagliata per le donne di parto," *Corriere Padano,* 19 March 1941; and "Ancora la tazza da parto," *Popolo di Romagna,* 26 April 1941, reprinted in *Corriere Padano,* 2 May 1941. Even these more reliable sources contain errors, however, and romantic interpretations still persist. See Ferdinando Rigon, "La tazza della comare," in *Nascere a Venezia dalla Serenissima alla prima guerra mondiale,* ed. Lia Chinosi (Turin: Gruppo Editoriale Forma, 1985), 80–83.

40. Marchesini, "Rinascita," 187. Marchesini also states that childbirth wares were inscribed frequently with the word *maschio,* yet only one tray with this word can be identified. See Carmen Ravanelli Guidotti, *Ceramiche occidentale del Museo Civico Medievale di Bologna* (Bologna: Grafis, 1985), 116.

41. Servolini, "Vasi durantini," 256.

42. Servolini, "Dono simbolico," 304.

43. Marchesini, "Rinascita," 187.

44. For dietary recommendations, see Marchesini, "Rinascita," 185; Servolini, "Vasi durantini," 257; and Fassio, "Tazza da parto," 322–23.

45. A four-piece set by Aldo Zama, now in the Museo Civico in Imola, is dated to circa 1930, or before the Fascist revival. See Carmen Ravanelli Guidotti, *Musei Civici di Imola: Le ceramiche* (Imola: Analisi, 1991), 288. According to Dottoressa Claudia Pedrini, this date is confirmed by marks on the vessel (personal correspondence, May 1998). However, Aldo Zama won the competition of 1941 with a similar set. If the Imola set dates to 1930, it indicates interest in reviving the genre prior to the period under discussion here.

46. *Atti della Società Italiana di Ostetricia e Ginecologia,* no. 35 (October 1938): xli; see also Crainz, *Tazza da parto,* 11; Fassio, "Tazza da parto," 322; and Alberti, "Puericultura," 7.

47. De Grazia, *How Fascism Ruled,* 225–26; Anonymous, "75,000 donne fasciste nell'urbe: La più grande adunata femminile di tutti i tempi," and anonymous, "Un antica tradizione," *Corriere della Sera,* 27 May 1939, 1.

48. Giuseppe Alberti, "Origine, vicende, e rinascita della 'tazza da parto': conferenza tenuta dal Dott: Alberti," *Lucina* 6 (July 1939): 9. This attitude was common. See Rovere, "Arte minore," 17.

49. Liverani, "Tazza da impagliata," 11–12. For announcements and lists of winners, see *Faenza,* no. 29 (1941): 19, 77, and *Faenza,* no. 30 (1942): 32, 101, as well as catalogues of the resulting exhibitions: Città di Faenza, *III Concorso nazionale della ceramica* (Faenza, 1941), 32–33, and *IV Concorso nazionale della ceramica* (Faenza, 1942), 61.

50. Gian Carlo Bojani (personal correspondence, October 1997).

51. Crainz, *Tazza da parto*, 24. Also see note 39.

52. Servolini, "Dono simbolico," 304, and Marchesini, "Rinascita," 185–88.

53. Servolini, "Dono simbolico," 304.

## 10. POLITICIZING A NATIONAL GARDEN TRADITION

1. Claudia Lazzaro, "Italy Is a Garden: The Idea of Italy and the Italian Garden Tradition," in *Villas and Gardens in Early Modern Italy and France,* ed. Mirka Beneš and Dianne Harris (Cambridge: Cambridge University Press, 2001), 29–60.

2. Guy Lowell, *Smaller Italian Villas and Farmhouses* (New York: Architectural Book Publishing, 1916), 1.

3. Otto J. Brendel, *Prolegomena to the Study of Roman Art* (New Haven: Yale University Press, 1979), 48–57.

4. Frank A. Waugh, *The Natural Style in Landscape Gardening* (Boston: Badger, 1917), 19–20, cited by Vincenzo Cazzato, "La 'decontestualizzazione' americana del giardino italiano," in *Arte dei giardini* 1 (1991): 79.

5. Brendel, *Prolegomena*, 38–101.

6. For the Italianate garden in America, see Cazzato, "'Decontestualizzazione,'" 65–82; and Rebecca Davidson, "Images and Ideas of the Italian Garden in American Landscape Architecture" (Ph.D. diss., Cornell University, 1994). For England, see David Ottewill, "Outdoor Rooms: Houses into Gardens in Britain at the Turn of the Century," in *Cecil Pinsent and His Gardens in Tuscany,* ed. Marcello Fantoni, Heidi Flores, and John Pfordresher (Florence: Edifir, 1996), 1–13. For Cecil Pinsent's designs, see Giorgio Galletti, "Cecil Pinsent, architetto dell'umanesimo," in *Il giardino europeo del novecento 1900–1940,* ed. Alessandro Tagliolini (Florence: Edifir, 1993), 183–205; and Vincent Shacklock and David Mason, "Villa Le Balze, Florence: A Broad Assessment of 'A Modern Garden in the Italian Style,'" *Journal of Garden History* 15 (1995): 179–87.

7. Among the authors are Charles A. Platt, Edith Wharton, George R. Sitwell, John C. Shepherd, and Geoffrey A. Jellicoe. For British and American versus Italian conceptions, see Claudia Lazzaro, "The Italian Garden in the Early Twentieth Century: Two Different Concepts," in *Ville e giardini italiani: I disegni dell'American Academy in Rome,* ed. Vincenzo Cazzato (Rome: American Academy and Soprintendenza dei Monumenti, forthcoming).

8. I am applying to gardens the argument made with respect to archaeology by Margarita Díaz-Andreu and Timothy Champion, "Nationalism and Archaeology in Europe: An Introduction," in *Nationalism and Archaeology in Europe,* ed. Margarita Díaz-Andreu and Timothy Champion (Boulder, Colo.: Westview Press, 1996), 1–11.

9. Luigi Piccinato, "Giardino," in *Enciclopedia italiana di scienze, lettere, ed arti,* vol. 17 (Milan: Rizzoli, 1933), 69.

10. Joachim Wolschke-Bulmahn and Gert Groening, "The Ideology of the Nature Garden: Nationalistic Trends in Garden Design in Germany during the Early Twentieth Century," *Journal of Garden History* 12 (1992): 73–77; and Wolschke-Bulmahn, "The Nationalization of Nature and the Naturalization of the German Nation: 'Teutonic' Trends in Early Twentieth-Century Landscape Design," in *Nature and Ideology: Natural Garden Design in the Twentieth Century,* ed. Joachim Wolschke-Bulmahn (Washington, D.C.: Dumbarton Oaks, 1997), 187–219.

11. Wolschke-Bulmahn and Groening, "Ideology," 78.

12. Luigi Dami, *Il giardino italiano* (Milan: Bestetti e Tuminelli, 1924), 12.

13. Luigi Dami, *The Italian Garden,* trans. L. Scopoli (New York: Brentano's, 1925), 22.

14. Virgilio Vercelloni, "Attorno alla banalità dell'attenzione italiana al giardino negli anni trenta," in *Il giardino europeo del novecento 1900–1940,* ed. Alessandro Tagliolini (Florence: Edifir, 1993), 208 and 210. Dami ignored nearly one hundred books on Italian gardens published in the early twentieth century by non-Italian authors.

15. Vincenzo Cazzato, "Riflessioni per una storia del restauro del giardino italiano attraverso le rappresentazioni grafiche degli inizi del novecento," in *Il giardino storico nel Lazio: Indirizzi per la conservazione e il restauro* (Rome: Associazione Dimore Storiche Italiane, 1990), 42–63; Cazzato, "Frammenti per una storia del restauro del giardino storico," in *Il giardino e il tempo: Conservazione e manutenzione delle architetture vegetali,* ed. Maurizio Boriani and Lionella Scazzosi (Milan: Guerini, 1992), 59–73; and Cazatto, "The Restoration of Italian Gardens in the Early Nineteenth Century," in *Cecil Pinsent,* 91–109.

16. Claudia Lazzaro, *The Italian Renaissance Garden* (New Haven: Yale University Press, 1990), chap. 2.

17. Cazzato, "Restoration," 95, 96, 100; and Cazzato in *La memoria, il tempo, la storia nel giardino italiano fra '800 e '900,* ed. Vincenzo Cazzato (Rome: Istituto Poligrafico e Zecca dello Stato, 1999), 376, 392 (Caprarola); 47, 49 (Villa Carlotta); and 16, 373–74, 414–15 (Villa Madama). For the Villa Madama, see also Cazzato, "Frammenti," 64–67. Francesco Nuvolari, "Il giardino all'italiana dal XIV al XIX secolo in Lombardia," in *Il giardino storico,* ed. Francesco Nuvolari (Milan: Electa, 1992), 43, notes that the Italian government sequestered the Villa Carlotta in 1922. Its state before 1906 is illustrated in Alessandro Tagliolini, *Storia del giardino italiano* (Florence: La Casa Usher, 1988), 278, fig. 187; the current hedges are shown in John C. Shepherd and Geoffrey A. Jellicoe, *Italian Gardens of the Renaissance* (London: E. Benn Ltd., 1925), plate 4.

18. Piccinato, "Giardino," 71.

19. Vincenzo Cazzato, "Firenze 1931: La consacrazione del 'primato italiano' nell'arte dei giardini," in *Il giardino:*

*Idea, natura, realtà,* ed. Alessandro Tagliolini and Massimo Venturi Ferriolo (Milan: Guerini e Associati, 1987), 81–82. Virgilio Vercelloni, *Il giardino a Milano, per pochi e per tutti, 1288–1945* (Milan: Edizioni l'Archivolto, 1986), 324–25, notes the nationalism in both exhibition and Dami's book; and see Vercelloni, "Attorno," 207–15, regarding the exhibition.

20. Cazzato, "Firenze," 78 and 97–103.

21. Monte S. Finkelstein, "University Oath," in *Historical Dictionary of Fascist Italy,* ed. Philip V. Cannistraro (Westport, Ct.: Greenwood Press, 1982), 557.

22. Nello Tarchiani, "La mostra del giardino italiano," *Domus* 4, no. 38 (February 1931): 15; emphasized by Cazzato, "Firenze," 80.

23. Ugo Ojetti in *Mostra del giardino italiano,* 2d ed. (Florence: Palazzo Vecchio, 1931), 23. Vercelloni, "Attorno," 209, characterizes Tarchiani and Ojetti as political journalists, rather than intellectuals.

24. Mario Tinti, "La mostra del giardino italiano," *Casabella,* no. 41 (May 1931): 39.

25. *Mostra del giardino;* for the exhibition and related events, see Cazzato, "Firenze," 77–108; and Cazzato, "I giardini del desiderio," in *Il giardino romantico,* ed. Alessandro Vezzosi (Florence: Alinea, 1986), 80–87. For the flowers, see "La mostra del giardino italiano a Firenze," *Domus* 4, no. 41 (May 1931): 58.

26. Cristina Acidini Luchinat, "Enrico Lusini, modello di giardino mediceo (1931)," in *L'architettura di Lorenzo il Magnifico,* ed. Gabriele Morolli, Cristina Acidini Luchinat, and Luciano Marchetti (Florence: Amilcare Pizzi Editore, 1992), 51. Vercelloni, "Attorno," 212, observes that the limited documentation in the catalogue and the lack of a permanent collection seriously diminished the exhibition's future usefulness.

27. Ojetti in *Mostra,* 24. "Mostra del giardino italiano," 58.

28. Gherardo Bosio, "Invito alla visita delle ville Medicee: A proposito della mostra fiorentina del giardino," *Domus* 4, no. 39 (March 1931): 56.

29. Cazzato, "Giardini," 83, cites *Il Popolo d'Italia,* 12 April 1931. For the newspaper founded by Mussolini in 1922, see Philip V. Cannistraro, "*Il Popolo d'Italia,*" in *Historical Dictionary,* 432–33.

30. Cited in Cazzato, "Firenze," 81.

31. Mario Recchi, "La villa e il giardino nel concetto della rinascenza italiana," *La critica d'arte* 2 (1937): 134–35.

32. For nature as female, see Claudia Lazzaro, "Gendered Nature and Its Representation in Sixteenth-Century Garden Sculpture," in *Looking at Italian Renaissance Sculpture,* ed. Sarah McHam (Cambridge: Cambridge University Press, 1998), 246–73.

33. Tracy H. Koon, *Believe Obey Fight: Political Socialization of Youth in Fascist Italy, 1922–1943* (Chapel Hill: University of North Carolina Press, 1985), 5. Jeffrey T.

Schnapp, *Staging Fascism: 18BL and the Theater of Masses for Masses* (Stanford: Stanford University Press, 1996), 115, explains the gender of the "mother truck," the protagonist in the 18BL spectacle, as symbolizing the Fascist masses, who were always feminized.

34. Simonetta Falasca-Zamponi, "The Gendered Masses: Politics and Aesthetics in the Making of the Fascist Dux," *The European Legacy* 2, no. 5 (1997): 854–67; and Falasca-Zamponi, *Fascist Spectacle: the Aesthetics of Power in Mussolini's Italy* (Berkeley: University of California Press, 1997), 17–21.

35. Giovanni Lazzari, *Le parole del fascismo* (Rome: Argileto Editioni, 1975), 30–45; and Barbara Spackman, "The Fascist Rhetoric of Virility," in "Fascism and Culture," ed. Jeffrey Schnapp and Barbara Spackman, special issue, *Stanford Italian Review* 8, nos. 1–2 (1990): 81–101.

36. Antonio Cederna, *Mussolini urbanista: Lo sventramento di Roma negli anni del consenso* (Rome: Laterza, 1979), 91–92.

37. Diane Yvonne Ghirardo, "Italian Architects and Fascist Politics: An Evaluation of the Rationalists' Role in Regime Building," *Journal of the Society of Architectural Historians* 39 (1980): 125–26.

38. Mariolina Graziosi, "Gender Struggle and the Social Manipulation and Ideological Use of Gender Identity in the Interwar Years," in *Mothers of Invention: Women, Italian Fascism, and Culture,* ed. Robin Pickering-Iazzi (Minneapolis: University of Minnesota Press, 1995), 26–51, especially 36; and Koon, *Believe Obey,* 25.

39. Victoria de Grazia, *How Fascism Ruled Women: Italy 1922–1945* (Berkeley: University of California Press, 1992); and see chap. 9.

40. For women under Fascism, see De Grazia, *How Fascism Ruled;* Graziosi, "Gender Struggle"; Barbara Spackman, "Fascist Women and the Rhetoric of Virility," in *Mothers of Invention,* 100–20; Perry R. Willson, "Women in Fascist Italy," in *Fascist Italy and Nazi Germany: Comparisons and Contrasts,* ed. Richard Bessel (Cambridge: Cambridge University Press, 1996), 78–93; and Elda Guerra, "Memory and Representations of Fascism: Female Autobiographical Narratives," in *Italian Fascism: History, Memory and Representation,* ed. R. J. B. Bosworth and Patrizia Dogliani (New York: St. Martin's Press, 1999), 195–215.

41. Cazzato, "Giardini," 81–82, and Cazzato, "Firenze," 85. Cristina Acidini Luchinat, "Modello," in *Giardini Medici: Giardini di palazzo e di villa nella Firenze del quattrocento,* ed. Luchinat (Milan: F. Motta, 2000), 141; Luchinat, "Enrico Lusini," 51; and Luigi Zangheri, "Il museo del giardino," in *La città degli Uffizi: I musei del futuro* (Florence: Sansoni, 1982), 185. The models, preserved in the Villa Petraia, are under restoration.

42. *Mostra,* 232. Adolfo Callegari characterized the Italian garden as "il giardino architettonico, con le piante mortificate dalle cesoie," noted by Cazzato, "Giardini," 81.

43. Jacopo Bonfadio, *Le lettere e una scrittura burlesca,*

ed. A. Greco (Rome: Bonacci, 1978), 96. For these differing views of nature, see Lazzaro, "Gendered Nature," 246–48.

44. Archivio Communale di Firenze, Filza 5939. Only the preliminary versions are housed in the Communal Archive, all illustrated in Cazzato, "Giardini," 80–81, although thirty thousand of the final posters were produced.

45. Cazzato, "Restoration," 97–99.

46. Luigi Piccinato, "Le zone verdi del nuovo piano regolatore di Roma," *Capitolium* (1931): 234–42, cited and illustrated in Alessandro Tagliolini, *I giardini di Roma* (Rome: Newton Compton Editori, 1980), 291.

47. Tarchiani, "Mostra," 15–16, quoted by Cazzato, "Firenze," 80.

48. Ugo Ojetti, "Mostra del 1931: Concorso per il giardino," *Architettura e arti decorative* 10, nos. 5–6 (January–February 1931): 306–7; and Cazzato, "Firenze," 87–93. Gherardo Bosio, "Il concorso di Firenze per un giardino privato moderno all'italiana," *Domus* 4, no. 40 (April 1931): 22–27, 84, illustrates seven of the proposals for private gardens.

49. Cazzato, "Firenze," 103.

50. "Il concorso del giardino italiano a Firenze," *Achitettura e arti decorative* 10, no. 11 (July 1931): 533–46; and the review by Tinti, "Mostra," 40, 67.

51. Vercelloni, *Giardino a Milano*, 327.

52. In *Giardino a Milano*, 326–27, Vercelloni notes a relationship with Le Corbusier as well as the landscape architect Robert Mallet-Stevens. Alessandro Tagliolini, "Il giardino moderno e le avanguardie artistiche del primo novecento," in *Il giardino europeo del novecento 1900–1940*, ed. Tagliolini (Florence: Edifir, 1993), 5, suggests the influence of Cubism and the comparison with a painting by Braque.

53. These are illustrated in "Concorso," 536–38, and another is in Tinti, "Mostra," 37.

54. Ojetti, "Mostra del 1931," 306. Cazzato, "Giardini," 87 and 87 n. 33, and "Firenze," 88, note the professions excluded and their protests again it.

55. Joachim Wolschke-Bulmahn, "The 'Wild Garden' and the 'Nature Garden': Aspects of the Garden Ideologies of William Robinson and Willy Lange," *Journal of Garden History* 12 (1992): 183–95.

56. "Concorso del giardino italiano," 540.

57. Cazzato, "Firenze," 81.

58. Alberta Campitelli, "Eclettismo e revival nei giardini romani," in *Memoria, il tempo*, 385–86.

59. The Scuola Superiore di Architettura was founded in 1921 and Piacentini was the first to hold the chair of *Edilizia cittadina e arte dei giardini*. See Spiro Kostof, *The Third Rome: 1870–1950: Traffic and Glory* (Berkeley, Calif.: University Art Museum, 1973), 31–32. The architect Ernesto La Padula, most famous for his design of the

Palazzo della Civiltà Italiana at EUR (see figure 8 in chap. 1), began his teaching career as an assistant in Piacentini's course, and Luigi Piccinato received his degree in *Edilizia cittadina* in 1923. See Silvia Danesi Squarzina, "Occasioni perdute: gli architetti lombardi all'E42," in *E42: Utopia e scenario del regime*, vol. 2, ed. Maurizio Calvesi, Enrico Guidoni, and Simonetta Lux (Venice: Marsilio, 1987), 106; and Ernesto B. La Padula, *Ernesto B. La Padula: Opere e scritti, 1930–49*, ed. Massimiliano Casavecchia (Venice: Cluva, 1986), 16–17. For the professionalization of urban planning, see Robert C. Fried, *Planning the Eternal City: Roman Politics and Planning since World War II* (New Haven: Yale University Press, 1973), 30; and for the new architecture school, see Richard A. Etlin, *Modernism in Italian Architecture, 1890–1940* (Cambridge: MIT Press, 1991), 9.

60. Henry A. Millon, "Some New Towns in Italy in the 1930s," in *Art and Architecture in the Service of Politics*, ed. Henry A. Millon and Linda Nochlin (Cambridge: MIT Press, 1978), 326–41.

61. Planning began in January 1937 with a team of five architects, but by that December Piacentini was made director. See Luigi D. Majo and Italo Insolera, *L'EUR e Roma dagli anni trenta al duemila* (Rome: Laterza, 1986), ix–x, and the illustrations of the versions with a brief account of the chronology and changes.

62. Kostof, *Third Rome*, 49–50; and Fried, *Planning*, 20–39 for the history of master plans to 1931.

63. For EUR, see Kostof, *Third Rome*, 37–38 and 74; and Etlin, *Modernism*, 481–515.

64. The whole was 400 hectares, or 988 acres; the planted area was 210 hectares, compared with the 74 hectares of the Villa Borghese. The dimensions are from Gaetano Minnucci, "Il piano regolatore," *Architettura* 17 (December 1938): 731, and 756–75 for photographs of the site before work started, in a special issue devoted to "L'Esposizione Universale 1942." Also see Minnucci, "I giardini dell'Esposizione Universale di Roma," *Civiltà* 2, no. 7 (October 1941): 40.

65. Minnucci discusses the contradictions in "Piano regolatore," 731, and the planting in "Giardini dell'Esposizione," 40. Cristina Marcosano dell'Erba, "E42, disegno urbano e disegno tecnico nella stesura definitiva del piano," in *E42–EUR: un centro per la metropoli*, ed. Vieri Quilici (Rome: Olmo Edizioni, 1996), 43–51, presents the planning decisions in terms of this contradiction, and cites Minnucci, 43 n. 6.

66. Minucci was co-organizer with Adalberto Libera of the First Italian Exposition of Rational Architecture in 1928 and co-organizer with Luigi Piccinato of the group of Roman city planners. In the '30s Minucci worked under Piacentini at the new Città Universitaria. See Etlin, *Modernism*, 238, 247, 422; Dennis P. Doordan, *Building Modern Italy: Italian Architecture 1914–1936* (New York: Princeton Architectural Press, 1988), 65, 75, and 81 on his "conservative" version of Rationalist architecture; and Giorgio Ciucci, *Gli architetti e il fascismo: Architet-*

*tura e città 1922–1944* (Turin: Giulio Einaudi, 1989), 23 n. 6.

67. Minnucci, "Piano regolatore," 731, 740 for the translation. Minnucci is cited in dell'Erba, "E42, disegno urbano," 44 n. 12, and in Fabrizio Brunetti, *Architetti e fascismo* (Florence: Alinea, 1993), 295. For Piacentini, the transformation of the plan, and the ensuing criticisms of Giuseppe Pagano, see Brunetti, chap. 20.

68. Massimo De Vico Fallani, *Parchi e giardini dell'EUR: Genesi e sviluppo delle aree verdi dell'E42* (Rome: Nuova Editrice Spada, 1988), 147–52.

69. Minnucci, "Giardini dell'esposizione," 34; and Etlin, *Modernism*, 247, 253, and 383–84, for the extreme nationalist rhetoric in the catalogue preface to the First Italian Exposition of Rational Architecture, cowritten with Adalberto Libera.

70. Minnucci in "Piano regolatore," 743, and De Vico Fallani, *Parchi e giardini*, 149 and fig. 48.

71. Massimo de Vico Fallani, "(1937–1943:) Contributo alla storia dei parchi e giardini dell'E42," in *E42*, 158, on the canceling of the exhibition in March 1940, and De Vico Fallani, *Parchi e giardini*, 149.

72. Minnucci, "Piano regolatore," 734 and 743 for the translation.

73. Minnucci, "Giardini dell'esposizione," 40, 44–45. For the enormous numbers of trees, shrubs, and plants required, see De Vico Fallani, "(1937–1943)," 158–59 and 161.

74. Marcello Piacentini, "Classicità dell'E42," *Civiltà*, 1 (April 1940): 23–30.

75. Minnucci, "Piano regolatore," 734. De Vico Fallani, "(1937–1943)," 157, cites Minnucci and notes that the regular ponds are closer in character to the grand French parks of the seventeenth and eighteenth centuries than to Italian gardens.

## 11. LEONARDO'S SMILE

1. Raymond Escholier, curator of the Petit Palais, recounted Mussolini's words during their meeting at the Palazzo Venezia in 1934: "'Je veux que ce soit magnifique! Si vous éprouvez la moindre résistance, faites-le moi savoir.' Je compris que la partie était gagnée, mais je ne pouvais concevoir encore avec quel ampleur." Raymond Escholier, "Ce qu'on ne reverra jamais," in *L'art italien: Chefs-d'oeuvres de la peinture* (Paris: Librarie Plon, 1935), n.p.

2. Giovanni Poggi (*soprintendente* for the region of Tuscany), quoted by Nello Tarchiani, "L'arte italiana al Petit Palais," *Pan* 5 (August 1935): 552. Tarchiani, director of the Florentine museums, assisted in the installations at the Petit Palais. The journal *Pan* was directed by Ugo Ojetti, whose central curatorial role in the exhibition is discussed at length in this chapter. As late as January 11, 1935, a letter from the Prefetto di Firenze requested—unsuccessfully—that the exhibition be postponed to the fall so as not

to damage the summer tourist season. See Archivio Centrale dello Stato (ACS), Presidenza del Consiglio dei Ministri, 1934–36, 14-1-1381.

3. Escholier, "Ce qu'on ne reverra jamais," n.p.

4. The number is recorded in a laudatory telegram from Senatore Borletti to Mussolini, dated 22 July 1935 (ACS, Presidenza del Consiglio dei Ministri, 1934–36, 14-1-3181), which was then published in "Le mostre di Parigi: I telegrammi del sen: Borletti al Duce e a Laval," *L'Ambrosiano*, 27 July 1935. Under pressure from the French government, the show remained open for an additional six days—until July 21—to accommodate the start of vacation for schoolteachers, professors, and students. See the correspondence contained in ACS, Ministero della Cultura Popolare, Dir. Gen. Propaganda, Francia, 1935, b. 71, f. "Mostra di Parigi" sf. "Parte generale/2."

5. F. T. Marinetti, "A di là del comunismo" (1920), reprinted in Luciano De Maria, *Marinetti e il futurismo* (Milan: Mondadori, 1981), 237.

6. On the London show, see Francis Haskell, "Botticelli, Fascism and Burlington House—the 'Italian Exhibition' of 1930," *Burlington Magazine* 141 (August 1999): 462–73. This exhibition was also touted as unprecedented and unrepeatable, only to be outdone by the spectacle in Paris. Haskell's essay is published in a slightly different version in *The Ephemeral Museum: Old Master Painting and the Rise of the Art Exhibition* (New Haven: Yale University Press, 2000), 107–27.

7. *Exposition de l'art italien de Cimabue à Tiepolo*, Petit Palais, Paris, 1935; and Ugo Ojetti, "La mostra al Petit Palais," *Corriere della Sera*, 16 May 1935.

8. Tarchiani, "L'arte italiana," 53.

9. Ugo Ojetti, preface to *Exposition de l'art italien*, xii.

10. Ugo Ojetti quoted in "L'Esposizione d'arte italiana s'inaugura domani a Parigi: Fervide manifestazioni della vigilia," *Il Popolo d'Italia*, 15 May 1935.

11. The use of temporary exhibitions to promote a nationalist agenda is analyzed in Haskell's *Ephemeral Museum* essay, especially 98–106. See also Benedict Anderson, *Imagined Communities: Reflections on the Origins and Spread of Nationalism* (London: Verso, 1983).

12. Tony Bennett, "The 'Exhibitionary Complex'" in *Culture/Power/History: A Reader in Contemporary Social Theory*, ed. Nicholas B. Dirks, Geoff Eley, and Sherry B. Ortner (Princeton: Princeton University Press, 1994), 123–54.

13. Francis Haskell, *History and Its Images: Art and the Interpretation of the Past* (New Haven: Yale University Press, 1993).

14. *Chefs d'oeuvres de l'art français*, Palais National des Arts, Paris, 1937. Catalogue essays include those by Georges Huisman and Henri Focillon and a preface by Léon Blum, président du conseil des ministres.

15. The history of Mussolini's meeting with French repre-

sentatives is recounted by Georges Huisman, "Avant-Propos," in *Exposition de l'art italien,* I–II, though there are no official records of it in the ACS, Seg. Part. del Duce, nor in the Presidenza del Consiglio dei Ministri. In a letter dated 29 September 1934, Senatore Borletti wrote to Galeazzo Ciano, Mussolini's son-in-law, asking for a meeting to follow up on various cultural activities proposed by the Comitato Italia-Francia—including the exhibition—which had been approved in a meeting with Mussolini (ACS, Ministero della Cultura Popolare, Dir. Gen. Propaganda, Francia, 1935, b. 70, f. "Mostra di Parigi" sf. "Parte generale/1."). According to Huisman, and to his published statements ("Ce qu'on ne reverra jamais,"), Raymond Escholier then concluded the final details with the Duce in a personal audience; documents in ACS, Ministero della Cultura Popolare, Dir. Gen. Propaganda, Francia, 1935, b. 70, f. "Mostra di Parigi" sf. "Parte generale/1," esp. no. 01113, show that Escholier and Mussolini met on February 9, 1935. Escholier was in Rome as part of the delegation of French curators—including André Dezarrois and later Huisman—convening with Ojetti, Borletti, and Antonio Maraini.

16. Enrico Decleva, "Relazioni culturali e propaganda negli anni '30: I comitati 'France-Italie' e 'Italia-Francia,'" in *Il vincolo culturale fra Italia e Francia negli anni trenta e quaranta,* ed. Jean-Baptiste Duroselle and Enrico Serra (Milan: F. Angeli, 1986), 108–57. For a contemporary account of the pivotal role of De Jouvenel, Borletti, and the Comitato Italia-Francia in improving relations between the two nations, see Enrico Serretta, "Feconda fraternità latina: Il trionfale successo delle mostre d'arte a Parigi," *L'Ambrosiano,* 17 May 1935. Borletti (1880–1939) made his fortune in textiles and munitions and gave financial backing to Gabriele D'Annunzio for the Fiume enterprise. He joined the PNF in 1924 was made a senator in 1929.

17. Escholier, "Remerçions le Duce," *L'Amour de l'Art* 16 (May 1935): 150.

18. On Ojetti's career as a museum curator, see Roberto Longhi's not impartial recollections in "Mostre e musei," in *Critica d'arte e buongoverno, 1938–1969* (Florence: Sansoni, 1985), 61–64.

19. The copious amount of correspondence pertaining to the loan negotiations with Borletti acting as middle man, and the directives issued by Ciano and Ottavio De Peppo in response to Ojetti's demands, are found in ACS, Ministro della Cultura Popolare, Dir. Gen. Propaganda, Francia 1935, b. 70, f. "Mostra di Parigi," sf. "Parte generale/1." As with the London show, however, no works could be pried from Prince Trivulzio in Milan, whose family collection was being notified by the state.

20. Dozens of documents on insurance and shipping arrangements are found in ACS, Ministero della Cultura Popolare, Dir. Gen. Propaganda, Francia 1935, b. 71, f. "Mostra di Parigi," sf. "Parte generale/2."

21. ACS, Ministero della Cultura Popolare, Dir. Gen. Propaganda, Francia 1935, b. 71, f. "Mostra di Parigi," sf. "Scorta ferroviaria." Ojetti confirmed the safe arrival of all fifteen cars in a telegram dated 11 May 1935, in ACS,

Presidenza del Consiglio dei Ministri, 1934–36, 14-1-3181.

22. Documents pertaining to the possible appearance of the GUF are found in ACS, Ministero della Cultura Popolare, Dir. Gen. Propaganda, Francia 1935, b. 71, f. "Mostra di Parigi," sf. "Parte generale/2." See in particular the letter from Ciano to Achille Starace, 8 May 1935, in which he writes of the negative view of the Quai d'Orsay (the French Foreign Ministry). On the opening dress, see the telegram from De Peppo to Ojetti, 2 May 1935, "Informo V.E. che per cerimona inaugurazione Mostra Parigi non est necessaria uniforme ma est sufficiente tight . . ." (ACS, Ministero della Cultura Popolare, Dir. Gen. Propaganda, Francia, 1935, b. 71, f. "Mostra di Parigi," sf. "Cerimonia ufficiale").

23. Memo from Borletti, 7 March 1935, and circulated to members of the Comitato Italia-Francia, in ACS, Ministero della Cultura Popolare, Dir. Gen. Propaganda, Francia 1935, b. 70, f. "Mostra di Parigi," sf. "Parte generale/1."

24. The following discussion of French-Italian relations is indebted to H. James Burgwyn, *Italian Foreign Policy in the Interwar Period 1918–1940* (Westport, Ct.: Praeger, 1997). See also Renzo De Felice, *Mussolini il Duce* (Turin: Einaudi, 1974), and R. J. B. Bosworth, *Italy and the Wider World 1860–1960* (London: Routledge, 1966), 36–53.

25. ACS, Ministero della Cultura Popolare, Dir. Gen. Propaganda, Francia 1935, b. 71, f. "Mostra di Parigi," sf. "Parte generale/2": letter from Ojetti to De Peppo, 8 April 1935, concerning the progress of the loans.

26. Burgwyn, *Italian Foreign Policy,* 75.

27. Ibid., 110–12. Burgwyn's account of the Rome Agreements is based on DDI (Documenti Diplomatici Italiani) 7, XVI, 391 and 399, 5 and 6 January 1935; 7, XVI, 403, 7 January 1935; 8, III, 106, 23 January 1936; and 8, III, 252, 19 February 1936. The French ceded certain economic interests, but maintained rights to the port of Djibouti and the Addis Ababa railway, and made clear their political disinterest in Ethiopia. As Burgwyn notes, this implicitly ruled out the French consent to total military conquest but much remained uncertain in the exchanges between the two men "not known for their attention to detail." Laval swiftly communicated the deal to Sir John Simon, the British foreign secretary who "accommodated Mussolini by blocking Ethiopia from bringing its case before the League."

28. Revisionist attitudes toward Italy in the French press during the rapprochement of 1934–35 and the Rome Agreements are documented by Pierre Milza, in *Le fascisme italien et la presse française 1920–1940* (Paris: Editions Complexe, 1987), 181–207.

29. Léon Blum, *Le Populaire,* 5 January 1935, quoted in Milza, *Fascisme italien,* 199.

30. Georges Huisman, "Avant-Propos," in *Exposition de l'art italien,* II.

31. Speech by Galeazzo Ciano at the Hotel de Ville, Paris,

at the inauguration of the exhibition (ACS, Ministero della Cultura Popolare, Dir. Gen. Propaganda, Francia 1935, b. 71, f. "Mostra di Parigi," sf. "Cerimonia ufficiale"), reprinted in "L'Exposition d'art italien e été inaugurée hier par M. Lebrun et le comte Ciano," *Le Figaro,* 17 May 1935. See also "Déclarations au 'Figaro' du comte Ciano di Cortellazo gendre de M. Mussolini," *Le Figaro,* 16 May 1935. Detailed accounts of the opening ceremonies are found in "La grande Esposizione d'arte italiana a Parigi," *Il Popolo d'Italia,* 17 May 1935, and "Le grandi mostre d'arte italiana inaugurate a Parigi dal Presidente Lebrun e da Galeazzo Ciano," *Corriere della Sera,* 17 May 1935.

32. Albert Marquet in "L'Exposition de l'art italien: Les peintres fra maîtres italiens," *Monde,* 23 May 1935.

33. Examples of the fawning reviews from the centrist and right-wing press include Camille Mauclair, "L'art italien au Petit Palais," *L'Art e les Artistes* 30 (July 1935): 325–36; a special issue of *L'Amour de l'Art* (May 1935) with the lead story by Escholier, "Remerçions Le Duce," and contributions by, among others, Germain Bazin, Waldemar George, and Margherita Sarfatti. Similar rhetoric is found in the coverage of the Jeu de Paume exhibition, as discussed in the body of this chapter.

34. Jean-Louis Vaudoyer, "Tableaux italiens," *Le Figaro,* 8 May 1935. The prevalent description of the exhibition as "enchanting" and like "a fairy tale" was duly noted by Longhi in "Mostre e musei," 63. In his introduction to *Ephemeral Museum,* 6, Haskell furthers the fairy-tale analogy, observing that blockbusters, "like Cinderella's ball gown," can exist only for a strictly limited time; the magic results from the public awareness that the experience is short-lived.

35. See Anna Laetitia Pecci Blunt, "Lettre de Rome: Printemps italo-français," *Le Figaro,* 13 May 1935, and Andre Rousseaux, "Sur une Vénus du Petit Palais," *Le Figaro,* 16 May 1935.

36. Marziano Bernardi, "Il fiore dell'arte italiana nelle sale del Petit Palais," *La Stampa,* 16 May 1935. See also "Sette secoli d'arte italiana alla mostra di Parigi: Civiltà latina," *L'Ambrosiano,* 16 May 1935; Enrico Serretta, "Il trionfale successo delle mostre d'arte a Parigi," *L'Ambrosiano,* 17 May 1935; "L'Esposizione d'arte italiana s'inaugura domani," *Il Popolo d'Italia,* 15 May 1935; "La mostra d'arte italiana che si inaugura oggi a Parigi: Primato mondiale della nostra civiltà," *Il Popolo d'Italia,* 16 May 1935; "La grande Esposizione d'arte italiana a Parigi," *Il Popolo d'Italia,* 17 May 1935; Carlo Cattaneo, "Ambascerie d'arte," *Quadrivio,* 19 May 1935, and Cattaneo, "Italia al Petit Palais," *Quadrivio,* 26 May 1935.

37. Ugo Ojetti, "La mostra al Petit Palais," *Corriere della Sera,* 16 May 1935.

38. "Musei, monumenti, esposizioni, venditi: Exposition de l'art italien de Cimabue à Tiepolo," *L'Arte* 6 (July 1935): 337. Unlike Roberto Longhi or Pietro Toesca, Lionello Venturi was an outspoken anti-Fascist.

39. Paul Signac, quoted in "L'Exposition de l'art italien: Les peintres fra maîtres italiens," *Monde,* 23 May 1935.

40. Georges Besson, "L'Exposition d'art italien: La ruée," *Monde,* 23 May 1935; and Besson, "L'Exposition d'art italien: II—Quelques aspects," *Monde,* 6 June 1935.

41. Les Deux Aveugles, "La France donne à Italie un leçon de modeste," *La Bête Noir* (June 1935): 5. The October 1935 issue contains a follow-up, "Ce que pensent les peintres de l'Exposition d'art italien," 4.

42. On the image of the modern nation-state, see Homi K. Bhabha, "Narrating the Nation," in *Nation and Narration,* ed. Homi K. Bhabha (London: Routledge, 1990).

43. The catalogue contributors were Georges Huisman, Paul Valéry, Paul Jamot, Ugo Ojetti, and Raymond Escholier. The French museums issued a number of richly illustrated promotional books, including Escholier's *L'art italien: Exposition du Petit Palais* (Paris: Floury, 1935), and by the same author, *L'art italien: Chefs-d'oeuvres de la peinture* (Paris: Librarie Plon, 1935); Paul Vitry, *L'art italien au Petit Palais (la sculpture)* (Paris: A. Calavas, 1935); *L'art italien: Chefs-d'oeuvre de la sculpture,* preface by I. L. Schneider (Paris: Plon, 1935); Gilles de la Tourette, *L'art italien au Petit Palais (la peinture)* (Paris: Librarie des Arts Décoratifs, 1935).

44. Antonio Maraini to Mussolini, 13 May 1935, ACS, Presidenza del Consiglio dei Ministri, 1934–36, 14-1-318.

45. This description of the exhibition itinerary is found in "Udienza di Giovedi 28 Marzo 1935," ACS, Ministero della Cultura Popolare, Dir. Gen. Propaganda, Francia 1935, b. 70, f. "Mostra di Parigi," sf. "Parte generale/1."

46. See the numerous documents in the ACS, Ministero della Cultura Popolare, Dir. Gen. Propaganda, Francia 1935, b. 70, f. "Mostra di Parigi," sf. "Parte generale/1." Maraini gave the most space to Felice Casorati and Felice Carena, followed by artists of the Novecento, the Tuscan naturalists, and the Italiens de Paris (De Chirico and Severini). The Futurists were barely represented by Boccioni and Prampolini, the abstract artists not at all, and the sculpture section was dominated by academic fare. In the standard invitation letter, dated 19 February 1935, in which he addressed them as "Comrades," Maraini asked for the best works, but "not the most recent, nor any from commercial galleries."

47. Romano Romanelli to Galeazzo Ciano, 17 April 1935, cited in Decleva, "Relazioni culturali e propaganda negli anni '30," 131.

48. André Dezarrois, "Introduction," *L'art italien des XIXe et XXe siècles* (Paris: Jeu de Paume des Tuileries, 1935), 31–35. The catalogue also included texts by Huisman and Maraini.

49. Maraini, "Préface," *L'art italien des XIXe et XXe siècles,* 17.

50. Maraini's argument was undermined by Adolfo Wildt's portrait busts of the king and Mussolini at the entrance to the show (positioned on each side of Primo Conti's image of Mussolini on horseback), proving just how well Napoleonic conventions survived in the context of imperialist invocations.

51. Maraini, "Préface," 25.

52. Eugeni d'Ors, *Fiat* (July 1935), reprinted in Comitato Italia-Francia, *La Mostra d'arte italiana dell'800 e '900 al Jeu de Paume nella stampa francese* (Rome: Ministero della Stampa e Propaganda, 1935). This commemorative volume contained twenty-five favorable reviews by the participating French curators and by Waldemar George, Paul Fierens, Camille Mauclair, Claude Roger-Marx, and André Salmon.

53. Mario Mascarin, "La grande pitiée de l'art en Italie," *Monde*, 22 March 1935. Written two months before the opening, and perhaps in response to the Rome Quadriennale, this article on contemporary art under Fascism knowingly anticipated the cultural politics behind the Jeu de Paume exhibition. Given the Italian first name, and the pun on masquerade involved in the second, the author's name is likely a pseudonym for an anti-Fascist exile in Paris.

54. Les Deux Aveugles, "La France donne à Italie," 4.

55. ACS, Ministero della Cultura Popolare, Dir. Gen. Propaganda, Francia 1935, b. 71, f. "Mostra di Parigi," sf. "Parte generale/ 2."

56. Escholier, "Remerçions Le Duce."

57. Laval became prime minister again in June 1935. He was executed in October 1945 by the French government after being convicted as a collaborator under Vichy.

12. CELEBRATING THE NATION'S POETS

1. Eugenio Coselschi, cited in Reale Accademia Petrarca di Scienze, Lettere ed Arti in Arezzo, *Convegno Petrarchesco: Tenuto in Arezzo il XXV e XXVI Novembre MCMXXVIII,* ed. G. Paliotti (Arezzo: presso la R. Accademia Petrarca, 1930), xx. This volume narrates the events and reproduces the speeches of the Arezzo celebration.

2. The main record of these events is *Leopardi: Primo Centenario della morte (14 Giugno 1837–14 Giugno 1937)* (Recanati: Comune di Recanati, 1938).

3. On ancient Rome and Fascist *romanità,* see Mariella Cagnetta, *Antichisti e impero fascista* (Bari: Dedalo, 1979); Luciano Canfora, *Ideologie del classicismo* (Turin: G. Einaudi, 1980); Dino Cofrancesco, "Appunti per un'analisi del mito romano nell'ideologia Fascista," *Storia contemporanea* 11 (1980): 383–411; Emilio Gentile, "Il fascismo come religione politica," *Storia contemporanea* 21 (1990): 1079–1106, and *The Sacralization of Politics in Fascist Italy,* trans. Keith Botsford (Cambridge: Harvard University Press, 1996); articles by Cagnetta and Canfora in *Matrici culturali del fascismo,* ed. Ernesto Quagliarello (Bari: Università di Bari, Facoltà di Lettere e Filosofia, 1977), 185–207; and Romke Visser, "Fascist Doctrine and the Cult of the Romanità," *Journal of Contemporary History* 27 (1992): 5–22.

4. Eugenio Coselschi to Mussolini, 14 February 1927, Archivio Centrale dello Stato (ACS), Presidenza del Consiglio dei Ministri, 1928–30, 14-2-1526.

5. *Leopardi: Primo Centenario,* 59.

6. For the texts of speeches given at these events, see Arturo Farinelli, *Giacomo Leopardi: Discorso per il Centenario della morte pronunziato alla R. Accademia D'Italia il 15 Marzo 1937–XV* (Celebrazioni e Commemorazioni, no. 22, Rome: Reale Accademia D'Italia, 1937); Ettore Romagnoli, *Giacomo Leopardi: Discorso per il Centenario della morte pronunziato al R. Teatro S. Carlo di Napoli il 14 Giugno 1937–XV* (Celebrazioni e Commemorazioni, no. 24, Rome: Reale Accademia D'Italia, 1937).

7. *Leopardi: Primo Centenario,* index: "Commemorazioni tenute in Italia," "Commemorazioni tenute all'Estero." Gentile's presentation was part of a series of *Letture Leopardiane* at the Lyceum of Florence; see also Jolanda De Blasi, *Prefazione alle Letture Leopardiane* (Florence: Sansoni, 1938).

8. Giovanni Papini, *Felicità di Giacomo Leopardi: Discorso tenuto nell'Aula Magna dell'Ateneo di Napoli, nella solenne adunanza della Reale Accademia d'Italia del 22 Febbraio 1939–XVII in occasione della traslazione dei resti mortali di Leopadi da S. Vitale Fuorigrotta al Parco Virgiliano* (Celebrazioni e Commemorazioni, no. 33, Rome: Reale Accademia D'Italia, 1939), 15.

9. ACS, Presidenza del Consiglio dei Ministri, 1937–38, 14-6-488, Appunto per il Duce, 5 August 1938. The idea was suggested to Bottai by Recanati's mayor (see Bottai to PCM, 26 July 1938), who reminded him that warships had already been named for the Italian authors Alfredo Oriani, Giosuè Carducci, Vincenzo Gioberti, and Vittorio Alfieri.

10. Ignazio Colli, "Attualità del poema africano del Petrarca," *Annali dell'Africa italiana* (1941): 334; and F. S. Giovanucci, *Commemorazione di Francesco Petrarca* (Rome: Edizioni Roma, 1940), 7.

11. Carlo Dionisotti, "Varia fortuna di Dante," in *Geografia e storia della letteratura italiana* (Turin: Einaudi, 1967), 215.

12. See Carlo Dionisotti's narrative of this year's clashes in "Varia fortuna," 232. More recent examinations of the politics of Dante in pre-Fascist Italy include Wolfgang Krogel, "Dante und die Italienische Nation: Untersuchung der 600-Jahr-Feiern zu Ehren Dantes in Florenz, 1865 bis 1921," *Archiv für Kulturgeschichte* 77, no. 2 (1995): 429–58; and Andrea Ciccarelli, "Dante and the Culture of the Risorgimento: Literary, Political or Ideological Icon?" in *Making and Remaking Italy: The Cultivation of National Identity around the Risorgimento,* ed. Albert Russell Ascoli and Krystyna von Henneberg (New York: Berg, 2001): 77–102.

13. See Gentile, *Sacralization,* 33.

14. Of the wide literature on Fascist spectacle and ritual, see in particular Mabel Berezin, *Making the Fascist Self: The Political Culture of Interwar Italy* (Ithaca: Cornell University Press, 1997); Simonetta Falasca-Zamponi, *Fascist Spectacle: The Aesthetics of Power in Mussolini's Italy* (Berkeley: University of California Press, 1997); and Gentile, *Sacralization.* Berezin, for example, has explicitly dis-

pensed with discussion of "content," arguing that Fascist mass events are meaningful above all in their form as a frequently repeated appropriation of public space by Fascism. On the importance of the Fascists' control over the organization of culture rather than its content, see Victoria de Grazia, *The Culture of Consent: Mass Organization of Leisure in Fascist Italy* (Cambridge: Cambridge University Press, 1981); and Mabel Berezin, "The Organization of Political Ideology: Culture, State, and Theater in Fascist Italy," *American Sociological Review* 56 (October 1991): 639–51.

15. On public space, see Falasca-Zamponi, Berezin, and especially Diane Yvonne Ghirardo, "Città Fascista: Surveillance and Spectacle," *Journal of Contemporary History* 31 (1996): 358–63, which examines events conducted in conjunction with the commemoration of the fourth centenary of the death of the Renaissance poet Ludovico Ariosto.

16. This photograph appeared in the popular national weekly *L'Illustrazione Italiana*. Similar images also appeared in *La Domenica del Corriere della Sera* (2 December 1928), *Legionario* (1 December 1928), *Rivista Illustrata del Popolo d'Italia* (2 December 1928), *Secolo Illustrato* (1 December 1928), *Vita Femminile* (January 1929), and *New York Times* (16 December 1928), among many others. For press coverage of the inauguration, see Archivio di Stato di Arezzo, Comune di Arezzo, Onoranze a Petrarca, Busta 8; and Archivio dell'Accademia Petrarca, Arezzo, Misc. XV, 5.

17. The fact that "the people" were invited to participate in the celebration of Italy's decidedly elite "high" cultural tradition obviously raises fascinating questions about the class politics of the Fascist engagement with the nation's cultural past, which I plan to explore in future research.

18. *Convegno Petrarchesco*, xxii.

19. *Leopardi: Primo Centenario*, 38.

20. Giovanni Papini, *Felicità di Giacomo Leopardi*, 7.

21 Ibid., 14–15.

22. "Onoranze a Francesco Petrarca," Arezzo 1928, handbill, in ACS, Presidenza del Consiglio dei Ministri, 1928–30, 14-2-1526.

23. A stamp edition of 1932 appears to have been prepared by the Società Dante Alighieri; it was used on a letter of 21 October 1932 to Mussolini, ACS, Presidenza del Consiglio dei Ministri, 1931–33, 14-5-5817. Another commemorative stamp was proposed in 1938, for which a series of drawings by local artist Cesare Peruzzi was presented to Mussolini's office, but it apparently was never produced. See ACS, Presidenza del Consiglio dei Ministri, 1937–39, 14-6-488.

24. *Leopardi: Primo Centenario*, 59; "Celebrazione," *Corriere Adriatico*, 29 June 1937, 3.

25. Coselschi to Mussolini, 14 February 1927, ACS, Presidenza del Consiglio dei Ministri, 1928–30, 14-2-1526.

26. Giovannucci, *Commemorazione*, 11–12.

27. *Convegno Petrarchesco*, LXI; and Emilio Bodrero,

"Leopardi e la Nazione," in Emilio Bodrero, *Studi, saggi ed elogi: Pubblicazione celebrativa per il XXV dell'insegnamento universitario* (Padua: CEDAM, 1941). This speech was originally given on September 13, 1934, in Ascoli Piceno as part of a series of *Celebrazioni Marchigiane*, celebrating cultural heroes of the central Italian region of the Marche, including Raphael, Pergolesi, and Leopardi. See also ACS, Presidenza del Consiglio dei Ministri, 1934–36, 14-6-1889.

28. *Leopardi: Primo Centenario*, 58.

29. Vittorio Cian, "Politica e poesia in Francesco Petrarca," in *Convegno Petrarchesco*, 20.

30. "Celebrazione," *Corriere Adriatico*, 29 June 1937, 3.

31. *Convegno Petrarchesco*, xxiv.

32. Colli, "Attualità del poema africano," 333.

33. "Celebrazione," *Corriere Adriatico*, 29 June 1937, 3.

34. *Convegno Petrarchesco*, xxi; "Celebrazione," *Corriere Adriatico*, 29 June 1937, 3.

35. Claudio Fogu argues that the presentation of the past as "present" was the very essence of the Fascists' representation of history. In the regime's 1932 celebrations for Garibaldi, he states, "it was not Fascism that gained legitimacy from the affirmation of its historical continuity with the past, but rather the past that gained real presence and meaning only through the Fascist-historic act of representation." (See chap. 2.) If we treat the Fascists' own claims with more skepticism, however, and recognize the immense cultural-political significance already borne by Italy's national poets, the commemorations of Petrarch and Leopardi suggest on the other hand that the two acts—gaining legitimacy from history and giving meaning to the past—need not be mutually exclusive. What better way for Fascists to derive legitimacy from Italy's cultural heritage than to suggest that its "true" meaning is only accessible through Fascism?

36. *Convegno Petrarchesco*, lxxv–lxxvi.

37. Romagnoli, *Giacomo Leopardi*, 20.

38. Arturo Marpicati, *L'Incoronazione del Petrarca in Campidoglio* (Vienna: A. Schroll, 1940), 24. Like Ignazio Colli in "Attualità," Marpicati also discusses Petrarch's *Africa* and recent publications on the poem in his *Roma nell'opera del Petrarca*, 2d ed. (Rome: Istituto di Studi Romani, 1938).

39. De Grazia, *Culture of Consent*, 192.

40. Marpicati, *Roma nell'opera del Petrarca*, 18.

41. Ignazio Colli, "Attualità," 333.

## 13. THE RETURN OF THE REPRESSED

1. F. T. Marinetti, *Futurismo e fascismo* (Foligno, 1924), reprinted in *Teoria e invenzione futurista*, ed. Luciano De Maria (Milan: Mondadori, 1968), 430. Hereafter cited as *TIF*.

2. F. T. Marinetti, "The Founding and Manifesto of Futurism," in *Let's Murder the Moonshine: Selected Writings by F. T. Marinetti*, ed. R. W. Flint, trans. R. W. Flint and Arthur A. Coppotelli (Los Angeles: Sun and Moon Classics, 1991), 50–51.

3. Umberto Boccioni, Carlo Carrà, Luigi Russolo, Giacomo Balla, Gino Severini, "Manifesto dei pittori futuristi," in Umberto Boccioni, *Gli scritti editi e inediti*, ed. Zeno Birolli (Milan: Feltrinetti, 1971), 3. All translations, unless otherwise indicated, are my own.

4. Gino Severini, "Art du fantastique dans le sacré" (1913), in *Écrits sur l'art* (Paris: Editions Cercle d'Art, 1987), 51.

5. Ibid., 52.

6. F. T. Marinetti, "Electrical War (A Futurist Vision-Hypothesis)," in *Let's Murder*, 114.

7. Ibid., 114.

8. The most famous of the time-management studies is Frederick W. Taylor, *The Principles of Scientific Management* (New York: Harper and Brothers, 1911).

9. See Angelo Mosso, *La fatica* (Milan: Treves, 1891); *Fatigue*, trans. Margaret Drummond and W. B. Drummond (New York: G. P. Putnam's Sons, 1904).

10. Marinetti, "Electrical War," 114.

11. For the concept of matter as a virile substitute for a feminized nature, see Christine Poggi, "Dreams of Metallized Flesh: Futurism and the Masculine Body," *Modernism/modernity* 4, no. 3 (September 1997): 19–43.

12. F. T. Marinetti, "We Abjure Our Symbolist Masters, the Last Lovers of the Moon," in *Let's Murder*, 75.

13. F. T. Marinetti, "The New Religion-Morality of Speed," in *Let's Murder*, 102.

14. Ibid., 104.

15. F. T. Marinetti, "Discorso di Firenze" (October 1919), in *TIF*, 463.

16. "Beyond Communism," in *Let's Murder*, 161.

17. F. T. Marinetti, "Futurismo e fascismo," in *TIF*, 442.

18. F. T. Marinetti, "Dichiarazioni politiche acclamate dal congresso," 25 November 1924, in *Il Futurismo*, no. 11 (11 February 1925); cited in Claudia Salaris, *Artecrazia: L'avanguardia futurista negli anni el fascismo* (Scandicci: Nuova Italia, 1992), 63.

19. Ivo Pannaggi and Vinicio Paladini, "Manifesto dell'arte meccanica futurista," *La Nuova Lacerba* 1 (20 June 1922); reprinted in *Pannaggi e l'arte meccanica futurista*, ed. Enrico Crispolti (Milan: Mazzotta, 1995), 178.

20. Paladini and Pannaggi's manifesto accompanied a Futurist theatrical production they put on for the Circolo delle cronache d'attualità at the Casa d'Arte Bragaglia in Rome in June 1922. Their "Ballo meccanico futurista" (Futurist Mechanical Ballet) featured three actors dressed in metallic robot-like costumes. Performed by three Russian dancers to the varied noise rhythms of two motorcycles, the "Ballet" dramatized the dilemma of a proletarian worker, torn between his attraction for a machine and for a woman. This struggle pitted the values of mechanical virility against "feminized" tradition and sentiment, although the woman, like the "machine" and the robotman, wore a costume made of cardboard, shiny polychrome papers, and other colored and metallic materials. Paladini had been associated with the Communist Party in Rome, and maintained his Russian connections. For a discussion of Paladini's attempt to integrate his Communist views with Futurism, see Günter Berghaus, *Futurism and Politics: Between Anarchist Rebellion and Fascist Reaction, 1909–1944* (Providence, R.I.: Berghahn Books, 1996), 197–217.

21. Vinicio Paladini, "Estetica meccanica," *Noi*, series 11, vol. 1, no. 2 (May 1923): 2; reprinted in *Pannaggi*, 175–76.

22. Enrico Prampolini, Ivo Pannaggi, and Vinicio Paladini, "L'arte meccanica: Manifesto futurista" (Rome, October 1922), *Noi*, series 11, vol. 1, no. 2 (May 1923): 1–2; reprinted in *Pannaggi*, 174–75.

23. *Pannaggi*, 175. This line is absent in the far shorter manifesto written by Pannaggi and Paladini alone.

24. *Autobiografie di giovani del tempo fascista* (Brescia: 1947); cited in Emilio Gentile, *The Sacralization of Politics in Fascist Italy*, trans. Keith Botsford (Cambridge: Harvard University Press, 1996): 61–62.

25. Gentile, *Sacralization*, 55.

26. Giovanni Gentile, *Che cosa è il fascismo* (Florence: Vallechi, 1925), 145; cited in Gentile, *Sacralization*, 58.

27. This collection of poems is reproduced in Claudia Salaris, *Storia del futurismo: Libri, giornali, manifesti* (Rome: Editori Riuniti, 1985), 261–83. According to Enrico Crispolti and Pierro Valducci, the three authors were Fillia, Pasquali, and Galezzi. See *Fillia, fra immaginario meccanico e primordio cosmico*, ed. Enrico Crispolti (Milan: Nuove edizioni Gabriele Mazzotta, 1988), 135.

28. These lines are from the poem "Noi" (We), in *Storia del futurismo*, 269.

29. From the poem "Visione simbolica" (Symbolic Vision), in *Storia del futurismo*, 267.

30. From the poem "Al popolo" (To the People) in *Storia del futurismo*, 266. This poem was not written by Fillia, but is consistent in tone and imagery with his poems.

31. The Communist Proletkult in Turin was founded on January 6, 1921 by Carlo Emanuele Croce and Giovanni Casale (members of Antonio Gramsci's circle), for the social and cultural emancipation of the proletariat. For a close analysis of the failed alliance between the Futurists and Communist workers in Turin during the immediate postwar period, see Giovanni Lista, *Arte e politica: Il futurismo di sinistra in Italia* (Milan: Multipla Edizioni, 1980), 54–114.

32. Fillia, "L'idolo meccanico," *L'Impero*, July 1925; reprinted in *Fillia, fra immaginario meccanico*, 72.

33. *Fillia,* 72.

34. Ibid.

35. Fillia, Caligaris, Curtoni, "L'idolo meccanico, Arte sacra meccanica, Manifesto futurista," *La Fiamma* (2 May 1926); reproduced in Luciano Caruso, ed., *Manifesti, proclami, interventi, e documenti teorici del futurismo, 1909–1944* (Florence: SPES [1990]), no. 179, n.p. A variant of this manifesto was published in "Vetrina futurista," 2d series (Turin, 1927), and is reprinted in *Fillia, fra immaginario meccanico,* 73. The passage cited here is substituted with another description in the later version of the manifesto.

36. Fillia, Caligaris, Curtoni, "L'idolo meccanico, arte sacra meccanica, manifesto futurista"; in *Fillia, fra immaginario meccanico,* 73.

37. See Fillia's comment on the "Aeroplane" of Curtoni, ibid.

38. Ibid. Among his contemporary writings that deal with the issue of mechanical sensuality, see *La morte della donna, novelle* (The Death of Woman, Short Stories) (Turin: Edizioni Sindacati Artistici, 1925); *Sensualità, Teatro d'eccezione* (Sensuality, Exceptional Theater) (Turin: Edizioni Sindacati Artistici, 1925); *Lussuria radioelecttrica: Poesie meccaniche* (Radioelectric Lust: Mechanical Poems) (Turin: Edizioni Sindacati Artistici, 1925); "Sensualità meccanica" (Mechanical Sensuality), *La Fiamma* (4 April 1926):2; and *L'uomo senza sesso* (The Man without Sex) (Turin: Edizioni Sindacati Artistici, 1927).

39. Cited in *Fillia, fra immaginario meccanico,* 64.

40. Fillia, "Spiritualità futurista," in *Fillia pittore futurista* (Turin: A.R.S., 1931); reproduced in Caruso, *Manifesti,* no. 195, n.p.

41. Fillia painted a series of still lifes of bottles and vases on tables in the mid-1920s that were clearly inspired by Purist (and Cubist) work. As his ideas evolved towards an emphasis on lyrical expression in the '30s, he argued that "French" architects Le Corbusier and Mallet-Stevens, unlike Gropius, understood the importance of "poetic emotion" in architecture. See "Lirismo e Razionalismo" (Lyricism and Rationalism), *Il Secolo XIX,* Genoa (15 March 1933); reprinted in *Fillia, fra immaginario meccanico,* 79–80.

42. Fillia, "Spiritualità futurista," n.p.

43. F. T. Marinetti, "Prospettive di volo e aeropittura," *La Gazzetta del Popolo,* Turin, 22 September 1929; another text, which retained only parts of the earlier one, was published on the occasion of an exhibition in 1931. Signed by Balla, Benedetta, Depero, Dottori, Fillia, Marinetti, Prampolini, Somenzi, and Tato, this text was titled "La prima affermazione nel mondo di una nuova arte italiana: L'Aeropittura: Un manifesto di Marinetti," *Il Giornale della Domenica* (1–2 February 1931), front page, reprinted in *Fillia, fra immaginario meccanico,* 75–76. For other *aeropittura* paintings, see chap. 4. See also Massimo

Duranti, *Aeropittura e aeroscultura futuriste* (Perugia: Fabrizio Fabbri Editore, 2002).

44. Fillia, "Rapporti tra Futurismo e Fascismo," in *Arte futurista: Pittura, scultura, architettura, ceramica, arredamento,* catalogue of the exhibition organized by S.G.U.F. (Alexandria, Egypt: 22–31 March 1930); reprinted in Caruso, *Manifesti,* no. 196, n.p.

45. Fillia, ed., *La nuova architettura* (Turin: UTET, 1931).

46. For a discussion of the metaphor of the two cities in Augustine, see Gerard O'Daly, *Augustine's City of God: A Reader's Guide* (Oxford: Clarendon Press, 1999).

47. See this description of the painting *Madonna and Child,* which is closely related to *The City of God,* in Fillia's letter to Tullio d'Albisola, 11 March 1931; cited in *Fillia e il manifesto dell'arte sacra futurista* (Turin: Galleria d'Arte Narciso, 2000), n.p.: "The figure of the Madonna is seated in the foreground, on top of a ground of rock. The landscape is rendered irreal and miraculous by the apparition of the dematerialized cross, that is, formed of pure sky. This cross also appears in the body of the Madonna, almost internal light."

48. F. T. Marinetti, "Manifesto dell'arte sacra futurista," *La Gazzetta del Popolo,* Turin, 23 June 1931, and "La Provincia di Padova," *Padua,* 23 June 1931; later signed also by Fillia, in *Il Piccolo della Sera,* Trieste, 8 July 1931; reproduced in Caruso, *Manifesti,* no. 202.

49. Fillia, letter to Tullio d'Albisola, n.p.

50. Fillia, "L'architettura sacra futurista," *Futurismo* 1, no. 4 (2 October 1932): 219; reproduced in Caruso, *Manifesti,* no. 219.

51. Fillia, Bracci, Maino, "Alfabeto spirituale," in *Sale futuriste* (Turin: Palazzo Madama, 1925); reproduced in Caruso, *Manifesti,* no. 175.

52. Marinetti, "Al di là del Comunismo," *TIF,* 412.

53. Walter Benjamin, "The Work of Art in the Age of Mechanical Reproduction," in *Illuminations,* ed. Hannah Arendt and trans. Harry Zohn (New York: Schocken Books, 1969), 222–23.

54. Ibid., 243 n. 5.

55. Ibid., 223.

56. Ibid., 218.

57. This church, in the Canton of Vallese, was constructed by Alberto Sartoris, a Rationalist architect who had many ties to the Futurists.

58. "Discorso di Pio XI del 28 ottobre 1932," in *Arte Sacra,* July–December 1932, 293–95; quoted in Salaris, *Artecrazia,* 115.

59. Alfredo Busa, *Classicismo e futurismo* (Enna: Il Littorio, 1933); quoted in Salaris, *Artecrazia,* 114. The Futurists had exhibited their works in a room devoted to them at the First Exhibition of Sacred Modern Christian Art held in Padua in May 1931, an exhibition promoted by the

church. Fillia exhibited *The City of God* and *Adoration* among other works. Marinetti first issued the "Manifesto of Futurist Sacred Art" to coincide with this show.

60. Benedetta (Benedetta Cappa Marinetti), *Le forze umane: Romanzo astratto consintesi grafiche* (Foligno: Campitelli, 1924); reprinted in the trilogy comprising Benedetta's three novels, *Le forze umane. Viaggio di Gararà. Astra e il sottomarino,* preface by Simona Cigliana (Rome: Edizioni dell'Altana, 1998), 118.

61. Benedetta, *Le forze umane. Viaggio di Gararà. Astra e il sottomarino,* 116.

62. Balla, Benedetta, Depero, Dottori, Fillia, Marinetti, Prampolini, Somenzi, Tato, "L'Aeropittura: Manifesto futurista," 75.

63. For an excellent discussion of the Exhibition of the Fascist Revolution, see Jeffrey T. Schnapp, "Epic Demonstrations: Fascist Modernity and the 1932 Exhibition of the Fascist Revolution," in *Fascism, Aesthetics, and Culture,* ed. Richard J. Golsan (Hanover: University Press of New England, 1992), 1–37.

64. Schnapp, "Epic Demonstrations," 26–30.

65. Marinetti described *Il grande X,* exhibited in 1931 at the Quadriennale di Roma, as "the plastic synthesis of the collision of four realities: Worlds, Atmosphere, Feeling, Everyday social reality." See "Note ai Testi," in *Le forze umane. Viaggio di Gararà. Astra e il sottomarino,* 229.

66. See George L. Mosse, *Fallen Soldiers: Reshaping the Memory of the World Wars* (New York: Oxford University Press, 1990).

67. See Benedetta, *Le forze umane: Romanzo astratto.*

68. See the chapter of *Le forze umane* titled "Totali Raggiunti," in *Le forze umane. Viaggio di Gararà. Astra e il sottomarino,* 96.

69. Dario Lupi, *La riforma Gentile e la nuova anima della scuola* (Milan: Mondadori, 1924), 230–31; cited in Gentile, *Sacralization,* 35. See also Dario Lupi, *Parchi e viali della rimembranza* (Florence: R. Bemporad e figlio, 1923); and George L. Mosse, *Masses and Man: Nationalist and Fascist Perceptions of Reality* (New York: H. Fertig, 1980), chap. 11.

70. See Gentile, *Sacralization.*

71. Fillia, "Spiritualità futurista," n.p.

## 14. FLASH MEMORIES

1. On Fascism's use of exhibitions as tools for political consensus building, see Marla Susan Stone, *The Patron State: Culture and Politics in Fascist Italy* (Princeton: Princeton University Press, 1998), 129–76 and 222–53. On Sironi's contributions to '20s and '30s exhibition culture, see Emily Braun, *Mario Sironi and Italian Modernism: Art and Politics under Fascism* (Cambridge: Cambridge University Press, 2000), 105–8, 142–86; and

Jeffrey T. Schnapp, "Ogni mostra realizzata è una rivoluzione ovvero le esposizioni sironiane e l'immaginario fascista," in *Mario Sironi: 1885–1961,* ed. Fabio Benzi (Rome: Electa, 1993), 48–61, the essay on which the present text is based.

2. Mario Sironi, *Scritti editi e inediti,* ed. Ettore Camesasca and Claudia Gian Ferrari (Milan: Feltrinelli, 1980), 156.

3. "Basta!" *Il Popolo d'Italia,* 31 May 1933; reprinted in Sironi, *Scritti editi,* 144.

4. Mario Sironi, "Manifesto della pittura murale," in *Scritti editi,* 155.

5. On the circumstances of this first collaboration, see Braun, *Mario Sironi,* 142–43; on the pavilion's design, see Fabio Benzi, *Mario Sironi: Il mito dell'architettura* (Milano: Mazzotta, 1990), 86.

6. The plans for this room are reprinted in Benzi, *Mito dell'architettura,* 99.

7. On the Barcelona exhibit, see Fabio Benzi and Andrea Sironi, *Sironi illustratore: Catalogo ragionato* (Rome: De Luca, 1988), 258.

8. Carlo Alberto Felice, cited in Agnoldomenico Pica, *Storia della Triennale 1918–1957* (Milano: Edizioni del Milione, 1957), 24, and 23–27 on the fourth Triennial exhibition.

9. Benzi and Sironi, *Sironi illustratore,* 258. If his sketches are indicative, it would appear that the gallery was almost entirely designed by Sironi himself and that Muzio was concerned mostly with the practicalities of realizing Sironi's vision.

10. Jeffrey T. Schnapp, *Anno X — La Mostra della Rivoluzione Fascista del 1932* (Pisa-Rome: Istituti Editoriali e Poligrafici Internazionali, 2003).

11. The quotation is from Mussolini, cited by Dino Alfieri and Luigi Freddi, *La Mostra della Rivoluzione Fascista* (Rome: PNF, 1932), 8–9. In the Muzio archives Fabio Benzi has found evidence that, at some early point, Muzio too may have figured within this group or, at the very least, may have started out as Sironi's collaborator on rooms S and R. See Benzi, *Mito dell'architettura,* 90–91.

12. Sironi alone was granted four entire rooms, those that the catalogue describes as *le più vaste e forse le più importanti della Mostra* (the largest and perhaps most important in the exhibition). See Alfieri and Freddi, *Mostra della Rivoluzione Fascista,* 192. Esodo Pratelli, a fellow Novecentist, was assigned two rooms (A and B) plus one collaborative project with Guido Mauri (room N), but none was of comparable importance to Sironi's.

13. Alfieri and Freddi, *Mostra della Rivoluzione Fascista,* 210; my emphasis.

14. Alfieri and Freddi, *Mostra della Rivoluzione Fascista,* 204.

15. Cited from Libero Andreotti, "Art and Politics in Fascist Italy: The Exhibition of the Fascist Revolution" (Ph.D. diss., Massachusetts Institute of Techonology, 1989), 174.

16. On attendance figures and audience composition, see Francesco Gargano, *Italiani estranieri alla Mostra della Rivoluzione Fascista* (Turin: SIAE, 1935), 1.

17. On these debates, see *A Primer of Italian Fascism,* ed. Jeffrey T. Schnapp, trans. Schnapp, Olivia E. Sears, and Maria G. Stampino (Lincoln: University of Nebraska Press, 2000), 207–96.

18. "L'architettura della Rivoluzione," *Il Popolo d'Italia,* 18 November 1932; cited from Sironi, *Scritti editi,* 132.

19. Sironi, "Manifesto della pittura murale," in *Scritti editi,* 155.

20. Sironi, "La pittura murale e la scultura decorativa," in *V Triennale di Milano—Catalogo ufficiale,* ed. Agnoldomenico Pica, 4th ed. (Milan: Ceschina, 1933), 66. The overall context of the turn to muralism is evoked by Stone, *Patron State,* 113–20.

21. Sironi, "La pittura murale e la scultura decorativa," in *V Triennale di Milano—Catalogo ufficiale,* 66.

22. An English edition of the Labor Charter may be found in Schnapp, ed., *Primer of Italian Fascism,* 308–13.

23. Gino Severini, "Architettura e decorazione," *L'Ambrosiano,* 26 April 1933. Severini continues: "Now employed to an artistic end, it may well be that this new technique will yield satisfactory results, even if the knowledgeable will still feel a longing for the splendor and solidity of true fresco technique." Compare Gabriele Mucchi's description: "I agreed to use Silexore because it had been successfully used in Germany. . . . In reality, the walls were humid and ill-prepared [thereby defeating the chemical stability of Silexore]." From *Quadrante,* October 1933; cited from Ester Coen, *1935: Gli artisti nell'Università e la questione della pittura murale,* ed. Ester Coen and Simonetta Lux (Rome: Multigrafica, 1985), 19.

24. See, for instance, Virginio Ghiringhelli, "Pitture murali nel Palazzo della Triennale," *Quadrante* 2 (June 1933): 8–10; reprinted in Rossana Bossaglia, *Il "Novecento italiano": Storia, documenti, iconografia* (Milano: Feltrinelli, 1979), 157–59.

25. Farinacci, "Fronte, cobezzoli!, unico," *Il Regime Fascista,* 20 June 1933; reprinted in Bossaglia, *Il "Novecento italiano,"* 154–55. On the critical reception of the Triennial's murals, see Bossaglia, 48–55; Ettore Camesasca and Claudia Gian Ferrari, *Mario Sironi 1885–1961,* 196–98; and Braun, *Mario Sironi,* 476–88.

26. Sironi, *Scritti editi,* 156.

27. Massimo Bontempelli, *L'avventura novecentista* (Milan: Mondadori, 1975), 757.

28. Sironi, *Scritti editi,* 156.

29. Giuseppe Pagano, "Parliamo un po' di esposizioni," *Casabella,* March–April 1941, 3.

30. Though broad in its scope, the criticism was particularly aimed at '30s Futurists whose aeropaintings Sironi dismissed in his critical writings: "The old Cubist-minded Futurism . . . doesn't gain much by taking to the air. In its place, an odd metaphysical graphic style executed in precious hues has triumphed. Its meaning is abstract and shrouded in mysterious linear enigmas. But the new line of exploration does nothing to remedy [Futurism's] futility." *Scritti editi,* 109.

31. Compare the following passage in "Pittura murale": "What is being envisaged is a renewal of rhythms, balance, a constructive spirit, in the name of restoring all those meanings that the triumph of northern realism in the 19th century destroyed." *Scritti editi,* 114.

32. Sironi's intended allusion is, most likely, to architectural Rationalism, which he had fiercely attacked in "Architettura e arte," an essay from January 1933: "Nothing is more banal than this sort of modernism without culture or modesty. The past—for us hardly to be conceived of as the Umbertine era—is neither obsolete nor useless. Rather, it has never been more alive. The past represents the spiritual high road (Via dell'Impero), even if the occasional Johnny-come-lately feels humiliated by having to go back and study it." *Scritti editi,* 138.

33. The argument had been anticipated in "Pittura murale": "When I speak of muralism, I mean more than merely expanding the scale of conventional paintings . . . while embracing the same effects, the same technical procedures, the same pictorial aims. I see, rather, new challenges for painting: challenges that are spatial, formal, expressive; that involve taking on lyrical, epic or dramatic content." *Scritti editi,* 114.

34. That the likeness in question was a *national* likeness was made explicit in the anti-French polemics of "Pittura murale": "We must disrupt the circle of silence that French artistic dominance has built around the great Italians. . . . The return to muralism means a return to Italian models and to Italian tradition: a tradition that has, to this day, remained inaccessible, despite the fact that one has often felt the spell of its modernity and intuited the powerful impact that its exemplary discipline could have upon modern art." *Scritti editi,* 114.

35. As made clear by the allusion to "communism," Sironi is here frontally attacking the doctrines of socialist realism.

36. Though it here assumes a different complexion, Sironi's polemics against pseudo-returns to the past date back to his Futurist years, when he was coauthor (along with Leonardo Dudreville, Achille Funi, and Luigi Russolo) of a 1920 pamphlet entitled "Contro tutti i ritorni in pittura—Manifesto futurista" (reprinted in *Scritti editi,* 13–17).

## EPILOGUE

1. For Mussolini's final hours and the events in Piazzale Loreto, see Denis Mack Smith, *Mussolini: A Biography* (New York: Vintage Books, 1982), 316–20; and R. J. B. Bosworth, *Mussolini* (London: Arnold, 2002), 31–33,

410–13. The other displayed corpses included those of Nicola Bombacci, Alessandro Pavolini, Paolo Zerbino, Luigi Gatti, Roberto Farinacci, and Achille Starace. A German firing squad had executed fifteen Italian partisans in Piazzale Loreto on August 10, 1944, which gave the site its symbolic value.

2. Bosworth, *Mussolini,* 411.

3. We thank Ivano Tognarini, president of the Istituto Storico della Resistenza in Toscana, for information concerning the role of Rino Pachetti in the Piazzale Loreto.

4. Samuel Y. Edgerton Jr., *Pictures and Punishment: Art and Criminal Prosecution during the Florentine Renaissance* (Ithaca: Cornell University Press, 1985).

5. Mussolini as eventual object, rather than as artist, is an inversion of the roles of the Duce as artist-leader and of Italy as object shaped in the image of Fascism that Simonetta Falasca-Zamponi presents in *Fascist Spectacle: The Aesthetics of Power in Mussolini's Italy* (Berkeley: University of California Press, 1997). Falasca-Zamponi, 185, writes: "The death of the dictator exorcised political phantasms: the image of the Duce turned on his head symbolically reversed and redressed Italy's political path. The miserable spectacle of Mussolini's degraded dead body concluded the spectacular unfolding of fascist power—a power that continuously evoked, and profited from, symbols and rituals, festivals and celebrations, visual pageants and audio productions."

# Contributors

Emily Braun is professor of the history of art at Hunter College and the Graduate Center, City University of New York. She has published widely on the culture of the Italian Fascist period and on twentieth-century art. She is currently working on *The Power of Conversation: Jewish Women and Their Salons: 1780–1945.*

Roger J. Crum is associate professor of art history at the University of Dayton, where he also holds the Graul Chair in Arts and Languages. He is preparing a monograph on the Medici Palace and politics in fifteenth-century Florence and is coeditor with John T. Paoletti of *Florence: The Dynamics of Space in the Renaissance City* (Cambridge University Press, forthcoming). Professor Crum has held the Samuel H. Kress Foundation Fellowship to the Kunsthistorisches Institut, Florence, and has been a member of the Institute for Advanced Study, Princeton.

Claudio Fogu teaches European cultural and intellectual history at the University of Southern California. His first book, *The Historic Imaginary: Politics of History in Fascist Italy,* was published by Toronto University Press in 2003. His scholarly interests range from philosophy of history to the intellectual history of modernism and the development of mass visual culture. He is currently working on a cultural history of Italian style.

Diane Yvonne Ghirardo is professor of the history and theory of architecture at the University of Southern California and at the University of Cape Town, South Africa. She has published four books: *Building New Communities: New Deal America and Fascist Italy* (Princeton University Press, 1989), *Out of Site: A Social Criticism of Architecture* (Bay Press, 1991), *Mark Mack* (Wasmuth, 1994), and *Architecture after Modernism* (Thames and Hudson, 1996), as well as more than thirty articles and book chapters. She is currently writing a book about women and spaces in Renais-

sance Italy and a second book on the cultural history of architecture in twentieth-century Italy.

D. Medina Lasansky is assistant professor in the Department of Architecture at Cornell University, where she teaches the history of architecture and urbanism. Her research focuses on the intersection of politics, popular culture, and the built environment. She is the author of *The Renaissance Perfected: Architecture, Spectacle, and Tourism in Fascist Italy* (Pennsylvania State University Press, 2004) and coeditor of *Architecture and Tourism: Perception, Performance and Place* (Berg Publishers, 2004).

Claudia Lazzaro, professor of history of art at Cornell University, has published widely on Italian Renaissance gardens, villas, and garden sculpture. She became interested in Fascism through her work on gardens, which led to an investigation of national and cultural identity in the essay "Italy Is a Garden: The Idea of Italy and the Italian Garden" in *Villas and Gardens in Early Modern Italy and France* (Cambridge University Press, 2001). She is currently writing a book on visual representations of collective identity in sixteenth-century Florence.

Benjamin George Martin, a Ph.D. candidate in the Department of History at Columbia University, is currently completing a dissertation entitled "German-Italian Cultural Initiatives and the Idea of a New Order in Europe, 1936–1945." He was a Fulbright Fellow in Rome (1996–97), where he conducted the research for his contribution to this volume, as well as a German Chancellor Fellow of the Alexander von Humboldt Foundation (2001–2).

Jacqueline Marie Musacchio is assistant professor of art at Vassar College. Her area of specialization is Italian Renaissance domestic art, on which she has published an award-winning book, *The Art and Ritual of*

*Childbirth in Renaissance Italy* (Yale University Press, 1999), as well as articles on birth trays, marriage chests, domestic devotional art, and dowry goods. She is currently writing two books: *Art, Marriage, and Family in the Florentine Renaissance Palazzo* and *Bianca Cappello: Art and Cultural Politics in Late Renaissance Florence.*

**Christine Poggi** is associate professor of the history of art at the University of Pennsylvania. She is the author of *In Defiance of Painting: Cubism, Futurism, and the Invention of Collage* (Yale University Press, 1992). The essay in this volume is part of a work in progress titled *Modernity as Trauma: The Cultural Politics of Italian Futurism.*

**Jeffrey T. Schnapp** is the founder and director of the Stanford Humanities Laboratory and occupies the Rosina Pierotti Chair in Italian Studies at Stanford University. His two most recent books are *Anno X — La Mostra della Rivoluzione Fascista del 1932* (Istituti Editoriali e Poligrafici Internazionali, 2003) and *Building Fascism, Communism, Liberal Democracy — Gaetano Ciocca: Architect, Inventor, Farmer, Writer, Engineer* (Stanford University Press, 2004).

**Gerald Silk,** professor of art history at Tyler School of Art, Temple University, has written widely on modern and contemporary art. His books include *Automobile and Culture* and *Museum Discovered: the Wadsworth Atheneum.* He has written catalogue essays and has curated exhibitions for museums and galleries internationally, including the Museum of Contemporary Art, Los Angeles; the National Air and Space Museum, Washington, D.C.; and the Palazzo Grassi, Venice. He has been a Rome Prize Fellow and a Senior Fellow at the Center for Advanced Studies in the Visual Arts at the National Gallery, Washington, D.C.

**Jobst Welge** holds a Ph.D. in comparative literature from Stanford University and is currently visiting assistant professor in the Department of French and Italian at the University of California–Santa Barbara. His major research interests lie in the fields of Renaissance literature/culture and European modernism/Fascism, on which he has published "The Paradox of Convergence: Fascist Modernism (Jünger/Marinetti)," in *Modernism,* ed. Astradur Eysteinsson and Vivian Liska, forthcoming.

**Ann Thomas Wilkins** is associate professor of classics at Duquesne University. She is the author of *Villain or Hero: Sallust's Portrayal of Catiline* and articles, most recently on the classical tradition, including studies of Ovid's influence on Bernini and of the Roman prison called the Tullianum. Her current research project is on the architecture of New Hampshire's public libraries.

# Index

*Page numbers in italics refer to figures.*